C000270028

ART GALLERIES
OF THE WORLD

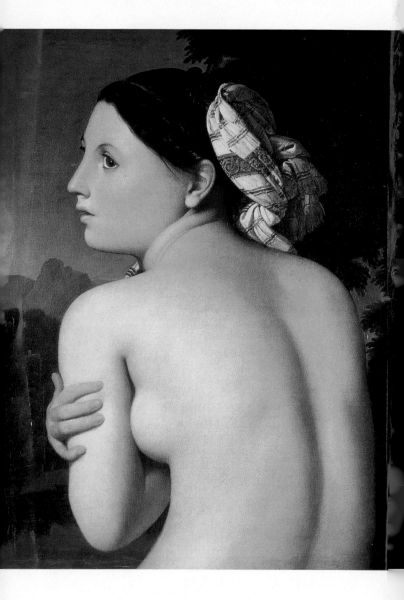

La Baigneuse, *Jean Auguste Dominique Ingres,*
Musée des Beaux-Arts, Rouen

ART
GALLERIES
OF THE
WORLD

HELEN LANGDON

PALLAS ATHENE

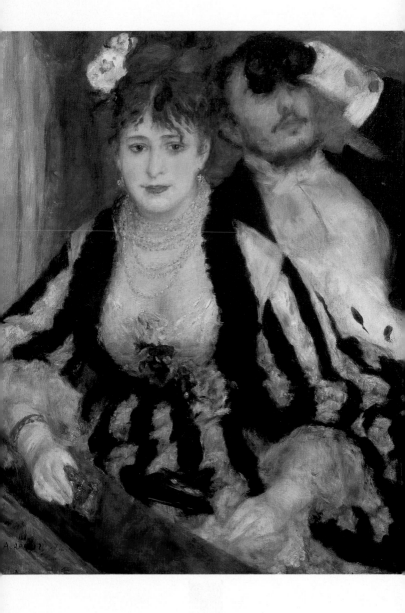

La Loge, *1874, Renoir, Courtauld Gallery, London*

Contents

How to use the book

This book is basically concerned with painting but also includes sculpture of outstanding importance and some collections of sculpture, particularly those in parks and gardens. For reasons of space I have limited the works described to the western tradition from the early Renaissance to the present day.

I have included all the major museums and many minor but equally fascinating museums, churches, villas and houses. My approach has been empirical; I have tried to respond to the experiences that each city has to offer, mentioning, for example, the *scuole* in Venice, the overwhelming sculpture in Detroit Plaza and the *avant-garde* galleries of New York.

For easy reference the book is organized alphabetically by country, then by town and museum. Works of art are generally organized by the nationality of the artist. If an artist whose work you see or are interested in is not mentioned in the text, consult the A-Z section for further information. Names of galleries are given in the native language so that you can easily locate them when you are in the country (a translation is given if the English is more commonly known). Addresses are given throughout except for Italian churches situated in the *piazza* or *campo* of the same name.

While every effort has been made to give the correct opening hours for the collections listed in this book, there will inevitably be some unforeseen changes (Italian institutions are particularly notorious in this respect). Check the opening hours before your visit with the local tourist office or the museum itself.

Some museums show a selection of their works in rotation so occasionally, a work described in this book may not be on view. However, it is often possible, on application to the museum director, to see works that are not on show. If you are making a special visit to see a particular painting check before you set out that it has not been sent elsewhere on loan.

A few works of art have been emphasized. *** Between one and three stars denote the importance of a work of art.

a. *active*	esp. *especially*	N *north*
amb. *ambulatory*	fl. *flourished*	R *right*
attrib. *attributed*	ill. *illustration*	S *south*
C *century*	inc. *include(s)*	w. *working*
E *east*	L *left*	W *west*

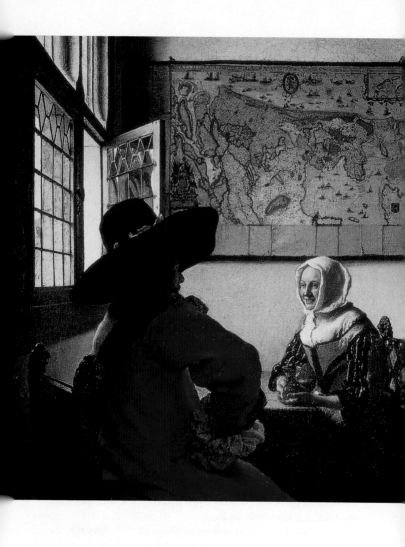

Officer and Laughing Girl, *Vermeer,*
The Frick Collection, New York

Introduction

The vast potentials of modern tourism have created a new kind of traveller, one who is set down for a weekend or even a day in Rome, Paris or St Petersburg and expected to 'do' the great sites. The result is often disappointment; an art gallery can all too easily seem bewildering, boring and tiring, a shrine that zealously guards its secrets from the uninitiated.

We no longer have a shared cultural heritage; the paintings of once instantly familiar biblical stories seem peopled by strangely remote figures and the beauties of classical antiquity are lost in a mystifying array of personifications and complex symbols; the whole language of allegory and emblem is dead. The names of Rubens and Titian retain the kind of glamour that go with sale-room prices, yet how many tourists enjoy their confident and sensual beauties? The art of our own period is the most baffling of all and we tend to rely with relief on the safe pleasures of Impressionism and the Dutch 17C.

This short guide attempts to overcome some of this general reaction of dismay to an important aspect of our cultural heritage. It draws attention to those masterpieces that must not be missed and gives some indication of their historical and cultural context. The choice of works is a personal one and whilst I have attempted to achieve a kind of balance, and taken care not to forget the *Mona Lisa* or *Night Watch*, my own preferences necessarily emerge, perhaps too clearly. Often the choice is influenced not so much by preference as by the accidents of specialist knowledge. I hope that this will prove an advantage, and suggest to the tourist the interest of some schools of paintings such as the Milanese, Neapolitan or Florentine Seicento which are usually overshadowed by the more accessible charms of the early Renaissance.

I have given between one and three stars to works which should not be missed for their fame and historical importance and also draw attention to work which might otherwise be overlooked. Where a gallery is particularly rich in certain works the whole collection has been starred.

Looking at art

The interest of an art gallery often extends beyond the pictures themselves. The great national collections are often dominated by

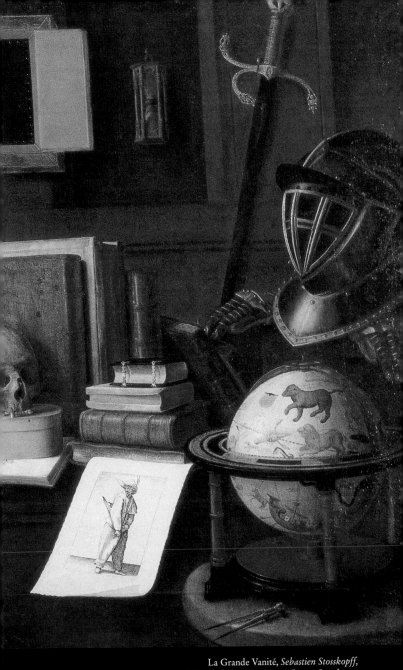

La Grande Vanité, *Sebastien Stosskopff,*
Musée de l'Œuvre Notre-Dame, Strasbourg

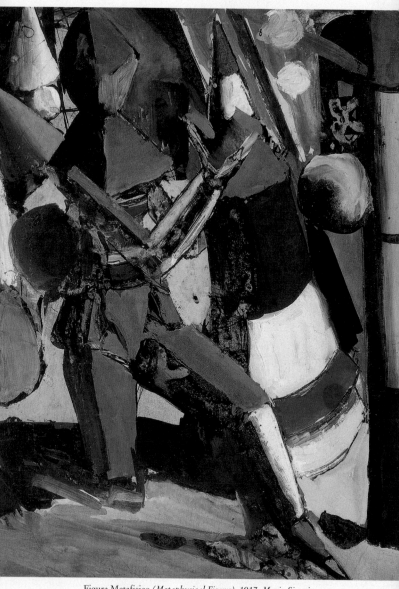

Figura Metafisico *(Metaphysical Figure)*, 1917, Mario Sironi,
Estorick Collection of Modern Italian Art, London

royal taste and give an impression of the past glories of an histor-
ical period. Many private collections often reflect the fascinating
personalities of their founders – the macabre collection of Sir John
Soane in London springs to mind. Some museums are highly
evocative of a period, and one should wander round them to enjoy
the atmosphere of, say, the rococo charms of the Cognaq-Jay
Museum in Paris. Some of the most interesting are the single-
artist museums, such as the gloomy studio of Meunier in Brussels,
or the fascinating house of Gustave Moreau in Paris. In the last two
decades very many new art museums have been created, with
buildings by celebrated architects, and often revolutionary in the
way they present art and relate to the surrounding world. Some of
these, such as Frank Gehry's museum at Bilbao, have brought
new life to decaying cities. Their immense popularity suggests
that they now satisfy a need for artistic and spiritual pilgrimage that
was once sought in cathedrals.

Each country has something special to offer. Many of the great
American galleries, financed by millionaire collectors, include a
range of material undreamed of by earlier collectors. In England
the country house collections provide a view of the taste of the
English aristocrat throughout the centuries. In France, although the
châteaux have been stripped, the provincial museums are particu-
larly rich. In Italy the great pleasure is seeing works *in situ*, and in
Holland the strong sense of regional schools is particularly attractive.

When visiting the great national collections it is of fundamen-
tal importance, and so obvious it is startling how rarely it is
appreciated , to realize that you cannot see a whole gallery in one
visit. Decide exactly what you want to see and stick to your plans.
You may want to concentrate on a period, a school, or an individual
artist; or to trace the development of painting in northern Europe,
Italy or France. It is particularly interesting to choose two contrast-
ing areas – to move, say, from the spiritual intensity of Spanish 17C
painting to the undemanding charms of the French 18C. Occa-
sionally a whole section of a gallery may be hung around a theme.

Remember above all that an art gallery is for enjoyment – be
bold enough to walk past the *Mona Lisa* and the *Night Watch* if
they bore you and concentrate on those works which, for what-
ever reason are more deeply attractive.

Australia

National Holidays: Jan 1, 28 (or last Mon in Jan), Labour Day, Good Fri, Easter Sat, Mon, Tues (for public buildings only), Apr 25 (Anzac Day), June 16 (NSW and ACT only), Oct 6 (NSW and ACT only), Oct 13 (SA only), Dec 25, 26, 31.
Museums close on Jan 1, Good Fri, Anzac Day and Dec 25, 26.

Art in Australia

Most striking of the works by colonial artists are Eugene von Guérard's sublime landscapes and John Glover's vivacious pastoral scenes. In the 1880s a recognizable national school of landscape painters, the 'Heidelberg School', arose: Tom Roberts, Arthur Streeton and Charles Conder painted fresh and spontaneous outdoor works on cigar-box lids. Later Roberts and Fred McCubbin responded to the heroism of Australian life and history. By the 1940s the modern movement had produced artists of sufficient stature to compete with the Heidelberg School, not only in figurative works with specifically Australian themes, such as Sidney Nolan's Ned Kelly series, but also in American-influenced non-figurative art. In the 1970s aboriginal artists, while rooted in ago-old traditions and spiritual beliefs, began to explore new techniques and media. In the central and western deserts painters, working in acrylic on canvas, covered entire surfaces with dots symbolising the landscape, with its myths, ceremonial sites, water sources and food supplies. Emily Kngwarreye, Rover Thomas and John Mawurndjul stand out as artists who have vividly blended the past with contemporary concerns.

Opposite: Dhornbal/Guwatjuru ga Nungala/Bimbudi (Lawyer vine and water plants), *David Daymirringu, c.1984, Museum of Contemporary Art, Sydney*

ADELAIDE
SOUTH AUSTRALIA

Art Gallery of South Australia
North Terrace,
Adelaide SA 5000.
Tel (61 8) 8207 7000
Fax (61 8) 8207 7070
www.artgallery.sa.gov.au
Mon to Sun 10-5.
Café, restaurant.
Late 18C, 19C and 20C Australian, European and American paintings.
Australian: a good collection, with Glover's *A View of the Artist's House and Garden, in Mills Plains, Van Diemen's Land* 1835 and Eugène von Guérard *Stony Rises, Lake Corangamite* 1857, a moving and melancholy work, with the Aboriginals against a symbolic sunset, and a spectacular and dynamic Tom Roberts, *A Breakaway!* 1891; works by Conder and H. J. Johnstone.
British: collection from Omega workshops; works by Holman Hunt, Sickert, Gainsborough and Wilson.
European: an early Claude*, with the sun setting over the Forum; Rosa, and Fantin Latour.

BRISBANE QUEENSLAND

Queensland Art Gallery
Melbourne Street,
South Brisbane,
Queensland 4101.
Tel (61 7) 3840 7303, 3840 7350
Fax (61 7) 3844 8865
qag@qcc.qld.gov.au
Mon to Sun 10-5. Café.
A lovely light airy gallery which forms part of the Queensland Cultural Centre on the south bank of the Brisbane river; it is building up a lively contemporary collection, with an emphasis on art across cultures, and on Australian art and Indigenous Australian art. A second building, the Queensland Art Gallery of Modern Art, is planned.
Australian: a large collection inc. works from the colonial period to the present (inc. Sid Long's *Spirit of the Plains*) and a good collection of Queensland-based and Aboriginal and Torres Strait Islander artists.
European: the highpoints are 18C British portraiture, inc. Romney, and French painting inc. Degas and Vuillard. Picasso's *Dutch Girl.* Works by Rubens and Van Dyck.

CANBERRA ACT

National Gallery of Australia
King Edward Terrace,
Parkes Place, ACT 2601.
(Postal address GPO Box 1150, Canberra, ACT 2600).
Tel (61 2) 6240 6411
Fax (61 2) 6240 6529
www.nga.gov.au
Mon to Sun 10-5. Café.
The gallery is in a green and beautiful site, with a Sculpture Garden leading down to the shores of Lake Burley; within, the new wing overlooks Fiona Hall's *Fern Garden*.* The four outstanding works are Rubens' dashing *Self-Portrait*,* Tiepolo's ceiling painting, *Marriage Allegory of the Cornaro Family*,* Sidney Nolan's *Ned Kelly* series**, Jackson Pollock's *Blue Poles*.**
Australian: a chronological display

inc. landscapes by Glover and Von Guérard's *Ferntree Gully in the Dandenong Ranges*; paintings of the Heidelberg School, inc. Roberts and Conder – an attractive group of 9" x 5" paintings on cigar box lids suggests their debt to Whistler; Sidney Nolan's *Ned Kelly* series conveying, in a bold new language, the violence of Australian legend and the landscape of northern Victoria; expressionist works by Arthur Boyd.

Australian Aboriginal: material from the last 30 years, inc. *The Aboriginal Memorial*** of hollow log coffins; bark paintings; famous 'dot' paintings from Central Desert artists; works from the Kimberley by Rover Thomas*, and works by Emily Kame Kngwarreye*.

Modern and Contemporary: a small but choice collection of modern art inc. Abstract Expressionism; Bacon's *Triptych*; Morandi's *Still Life*. Contemporary art inc. minimal and conceptual works; Tingueley; Beuys; Kiefer.

Nolan Gallery
Lanyon, Tharwa Drive
ACT 2620
Tel (61 2) 6237 5192
Fax (61 2) 6237 5204
Tues to Sun 10-4.
In the grounds of Lanyon, an historic house museum, and a brilliantly evocative Australian setting, this gallery houses a collection of Sidney Nolan's paintings*; they range from his Ned Kelly pictures of the 1940s, celebrating an Australian legend, to powerfully expressive landscapes of central Australia.

MELBOURNE
VICTORIA

National Gallery of Victoria
PO Box 7259,
285-321 Russell Street,
Melbourne VIC 8004.
Tel (61 3) 9208 0222
Fax (61 3) 9208 0245
enquiries@ngv.vic.gov.au
Daily 10-5.
This gallery has a fine collection of Australian art, and the best collection of European art in the southern hemisphere, dominated by Tiepolo's vast and shimmering canvas, the *Banquet of Cleopatra***.

Australian: inc. Glover; works by Arthur Streeton and Tom Roberts, both small, intimate sketches, such as *Quiet Study,* and *Shearing the Rams,* an ambitious painting of 'strong masculine labour'. Frederick McCubbin's triptych, *The Pioneers**, is a seminal and religious commemoration of the virtues of the early settlers, while David Davies' *Moonrise Temple-Stowe* brought a new lyrical quality to the Australian landscape. Works by John Russell and Max Meldrum, esp. *Pitcherits Farm.* Nolan, and John Brack's *Collins St 5pm.*

British: a good collection, esp. of portraiture (Van Dyck*, Romney, Raeburn, Reynolds) and neo-Romanticism. 18C conversation pieces, with their small garden temples and stiff figures, such as Devis' *The Clavey Family in the Garden at Hampstead* seem touchingly nostalgic here. Landscapes by Constable and Turner, and a lovely Nash, *Landscape of the Summer Solstice**, Graham Sutherland and Hepworth.

French: works by Claude (a small, early landscape) and Poussin's *Crossing of the Red Sea**; four Corots inc. two beautiful, feathery, late landscapes; good representative collection of Impressionists; Rodin and Chagall.

Italian: a good collection, with some intriguing works, such as the anonymous 15C *Garden of Love**, and an oval 16C unattributed *Portrait of a Youth**, which creates a powerfully mysterious mood; Annibale Carracci and a fine wild and stormy Rosa landscape. Bernini bust and bozzetto.

Northern schools: Memling, Rembrandt and Rubens. A representative collection of Dutch landscape, genre and still life inc. a lush de Heem.

The Australian collection is to be shown in a new, state of the art gallery, The Ian Potter Centre, in Federation Square, to open in mid-2002. The Old Master collection will return to its dour former home at 180 St Kilda Rd, comprehensively refurbished and very much enlarged, in 2003.

SYDNEY
NEW SOUTH WALES

Art Gallery of New South Wales
Art Gallery Rd,
The Domain, NSW 2000.
Tel (61 2) 9225 1744
Fax (61 2) 9221 6226
www.artgallery.nsw.gov.au
artmail@ag.nsw.gov.au
Mon to Sun 10-5. Café.
An imposing 19C building in green

parkland, expanded in 1988, this gallery has particularly attractive light and airy spaces, and a café with a spectacular view over the harbour.

Australian: Colonial works inc. Glover's *Natives on the Ouse River, Van Diemen's Land.* Well loved works inc. those by Emanuel Phillips Fox and icons such as Tom Roberts' *Bailed Up* and Arthur Streeton's *'Fire's on' Lapstone Tunnel.* Many paintings by Heidelberg school painters (Conder's *Departure of the SS Orient*), works by Sidney Nolan, William Dobell, Russell Drysdale, Arthur Boyd, Grace Cossington Smith, and Fred Williams, esp. his *Waterfall* triptych. A good collection of Australian Aboriginal art.

British: 18C works inc. Reynolds and Wilson, and from the late 19C to early 20C is a strong section, esp. English Victorian painting; Poynter's *Visit of the Queen of Sheba to Solomon.* A representative collection of modern and contemporary international and Australian art. There is also a small group of European Old Masters, inc. Mannerist works by Beccafumi and Bronzino*; Strozzi; a jewel-like early Claude*.

Museum of Contemporary Art
Circular Quay West, The Rocks,
Sydney, NSW 2000.
Tel (61 2) 9252 4033
www.mca.com.au
Mon to Sun 10-6. Café.
A collection of contemporary art, with a good aboriginal section (see ill. p.16), housed in the splendid

1950s building of the former Maritime Services Board building; its fine terrace café has a spectacular view of Sydney Harbour and Opera House. The Museum has provocative temporary exhibitions.

Portrait of a Young Man in Black Clothing, *F. G. Waldmüller, 1842*
Österreichische Galerie Belvedere, Vienna

Austria

Opening hours: museums often close on Monday.
National holidays: Jan 1, 6, Easter Mon, May 1, Ascension Day,
Whit Mon, Corpus Christi, Aug 15, Oct 26, Nov 1, Dec 8, 25, 26.
Museums generally close on these days.
Tourist information: Verkehrsverein; Kurkommission.
Useful words: See p. 127

Art in Austria

The dominions of the eastern Alps were given their character by
the consolidation of Habsburg power (in 1282). This area of central
Europe was involved throughout the 16C and 17C in the
devastation wrought by the Thirty Years' War and the bitter
struggle against the Turks; the development of the arts was
fragmentary. There is a new and powerful realism in Michael
Pacher's St Wolfgang altarpiece (1471-81). At the beginning of
the 16C the new feeling for wild, alpine scenery evident in
paintings of the Danube school spread to Austria: most important
were Wolf Hüber and Rueland Frueauf. No significant artists
emerged during the 16C and 17C. 18C was the great era of Austrian
Baroque. The best works are visible *in situ* – vast decorative
schemes for churches and palaces. Most exciting are the visionary
works of Franz Anton Maulbertsch; other important artists were
Paul Troger and Johann Schmidt. There are several tendencies in
the early 19C: the Nazarenes, the Romantics, and the quiet real-
ism of the Viennese Biedermeier, especially Waldmüller.

The Vienna Secession was founded in 1897; its first president
was Gustav Klimt whose art – *fin-de-siècle* in its sense of spiritual
weariness and morbid eroticism – is remarkably daring in its use
of flat, geometrical patterns and in its lively, ornate decorative
elements. His boldness encouraged the younger Austrian
Expressionists, Richard Gerstl, Egon Schiele and Oscar Kokoschka.
Schiele's paintings, deeply influenced by Freudian psychology,
suggest the pain and distress of human loneliness. Kokoschka
developed a highly individual Expressionist style between
1908-14; many of his works are loosely handled town scenes
and landscapes painted from a high viewpoint.

BREGENZ

Kunsthaus Bregenz
Karl-Tizian-Platz,
A-6900 Bregenz.
Tel (43 5574) 4859 40
Fax (43 5574) 4859 48
www.kunsthaus-bregenz.at
kub@kunsthaus-bregenz.at
Tues to Sun 10-6; Thurs 10-9.
Closed Mon.
Close to Lake Constance, Zumthor's museum* is a startling glass cube that seems to dissolve in light; it is an entirely abstract space for the display of changing exhibitions of contemporary art.

GRAZ

Alte Galerie des Steiermärkischen Landesmuseum Joanneum
Neutorgasse 45, A-8010 Graz.
Tel (43 316) 8017 9770
Fax (43 316) 8017 9847
post@lmj-ag.stmk.gv.at
Tues to Sun 10-5. Closed Mon.
Renaissance, Mannerism and Baroque: collection of paintings, sculptures and oil sketches inc. Cranach, Jan Breughel, Maulbertsch, Troger and Martin Johann Schmidt.

HERZOGENBURG

Kunstausstellung Stift Herzogenburg
Stiftsgasse 3,
A-3130 Herzogenburg.
Tel/Fax (43 2782) 83113
Apr-Oct: Mon to Sun 9-12, 1-5.
German 14C and 15C panel paintings (four by Jörg Breu); 16C paintings by members of the Danube school. Frescoes by Altomonte on the vaulting of the Festsaal main hall.

INNSBRUCK

Dom zu St Jakob (St James's Cathedral)
Mon to Sun 11.30-4.
The *Virgin c.*1520 by Cranach the Elder (above the high altar).

Hofkirche
Entrance: Volkskunstmuseum,
Universitätsstr. 2.
May-Sept: Mon to Sun 9-5
Oct-Apr: 9-12, 2-5.
The spectacular tomb of Emperor Maximilian I, surrounded by life-size, darkened bronze statues of the Emperor's ancestors and relatives.

Tiroler Landesmuseum Ferdinandeum
Museumstr. 15,
A-6020 Innsbruck.
Tel (43 512) 59489
Fax (43 512) 594 9888
Oct-Apr: Tues to Sat 10-12, 2-5;
Sun 9-12; May-Sept: Mon to Sat
10-5; Thurs 7-9.
The main emphasis is on Tyrolean artists from Gothic to the 20C, but there is also a small but important collection of German Renaissance art inc. Amberger, Baldung, Breu and Seisenegger. Large collection of Austrian Baroque works. Some Dutch, inc. small early Rembrandt, *Bust of an Old Man in a Fur Cap**, and Italian 17C and 18C paintings.

Above: *Portrait of a Lady, Gustav Klimt, Neue Galerie der Stadt Linz*
Overleaf: Easter Morning, *c.*1331,
Master of the Verso of the Verdun Altarpiece, Stift Klosterneuburg

KLOSTERNEUBURG

Museum des Chorherrenstifts Klosterneuburg
Stiftsplatz 1,
A-3400 Klosterneuburg.
Tel (43 22 43) 4111 54
Fax (43 22 43) 4111 56
www.stift-klosterneuburg.at
kultur@stift-klosterneuburg.at
May-Nov: Tues to Sun 10-5.

Closed Mon.
Guided tours of the abbey year-round, Mon to Sun 10-5
Works by Rueland Frueauf the Younger and Egon Schiele. A few Italian paintings; Netherlandish paintings of the 17C and 18C. (Most famous for the 12C enamel altarpiece by Nicholas of Verdun**.)

LINZ

Neue Galerie der Stadt Linz
Blütenstr. 15, A-4040 Linz
Tel (43 732) 7070 3600
Fax (43 732) 7361 90
www.neuegalerie.linz.at
Neue.Galerie@mag.linz.at
Mon to Sun 10-6; Thurs 10-10.
July-Aug: Sat 10-1. Closed Sun.
German and Austrian art of the 19C and 20C inc. Friedrich, Liebermann, Corinth, Nolde, Pechstein, Schiele, Klimt (see ill. p.25) and Kokoschka. Also international 20C and contemporary art.

MELK

Stiftskirche (Melk Abbey).
Mon to Sun 9-12, 2-5.
In the spectacular Abbey Church, pictures by Fanti, Rottmayr and Troger; in the Chapel of the Prelates, paintings by Frueauf the Younger (c.1520) and Jörg Breu (1502).

ROHRAU

Schlossmuseum Rohrau
Graf Harrach'sche
Familiensammlung
Schloss I, A-2471 Rohrau.
Tel (43 2164) 22538
Fax (43 2164) 22515
arco.zinneberg@direkt.at
Apr-Oct: Tues to Sun 10-5.
Closed Mon.
A splendid private collection, shown with fine furnishings, inc. Spanish, Neapolitan (Giordano, Solimena) and Dutch Baroque works; small collection 18C Italian and Spanish.

ST FLORIAN

Augustiner Chorherrenstift St Florian (Abbey of St Florian)
Tel (43 7224) 8902 54
Fax (43 7224) 8902 60
Apr-Oct: guided tours at 10, 11, 2, 3 and 4.
One of the most splendid monuments of Austria. The **Marmorsaal** (Marble Hall), 1718-24, is decorated with frescoes by Bartolomeo Altomonte. The **Altdorfer Galerie** has the remains of Altdorfer's *St Sebastian* altarpiece** with scenes from the *life of St Sebastian* and the *Passion of Christ*, inc. the *Flagellation* and some dramatic night scenes.

ST WOLFGANG

St Wolfgang
A-5360 St Wolfgang.
Tel (43 6132) 240 0071
15C altarpiece of *St Wolfgang*** with painted shutters by Michael Pacher; the central panel is a *Coronation of the Virgin***.

SALZBURG

Rupertinum
Wiener-Philharmoniker-Gasse 9, A-5010 Salzburg.
Tel (43 662) 8042 2541
Fax (43 662) 8042 2542
rupertinum@land-sbg.gv.at
Tues to Sun 10-5, Wed 10-9.
During summer exhibitions Tues to Sun 9-5. Closed Mon.
In a 17C palace, two floors are devoted to contemporary exhibitions. A permanent collection

focuses on late 19C European art down to contemporary Austrian art, with works by Köllwitz, Dix, Kubin, Günter Brus and Attersee.

Salzburger Barockmuseum Sammlung Rossacher

Orangeriegarten, Mirabellpark, p.o. 88, A-5024 Salzburg.
Tel (43 662) 8774 32
Fax (43 662) 8774 3217
www.land-sbg.gv.at/kultur-sport/ museen
office@barockmuseum.at
Tues to Sat 9-12, 2-5; Sun 10-1.
Closed Mon.

Oil sketches, and terracottas used in the preparation of monumental 17C and 18C work, inc. Bernini, Tiepolo and the Guardis.

Residenzgalerie Salzburg

Residenzplatz 1,
A-5010 Salzburg.
Tel (43 662) 8404 51
Fax (43 662) 8404 5116
www.land-sbg.gv.at/ residenzgalerie
post@residenzgalerieland-sbg.gv.at
April-Sept: Mon to Sun 10-5.
Oct-March: Thurs to Tues 10-5.
Closed Wed.

Residence of the Prince Archbishops from 1595 to 1700. European paintings from the 16C to 19C with an emphasis on 17C Dutch works (genre, landscape and still life) and Austrian art of the 18C, 19C and 20C inc. Rottmayr, Troger, Maulbertsch and Klimt. Some 17C French and Italian works.

WIEN (Vienna)

Akademie der Bildenden Künste

Schillerplatz 3, A-1010 Wien.
Tel (43 222) 5881 60
Fax (43 222) 5861 6137
www.akbild.ac.at
Tues to Fri 10-2; Sat, Sun 9-1.
Closed Mon.

Mainly Dutch and Flemish art of the 17C. Important sketches by Rubens; a *Self-Portrait* by Van Dyck. Rich in Dutch landscapists who worked in Rome. The de Hooch collection also inc. early, savagely expressive works by Cranach the Elder; Bosch's terrifying *Last Judgement*** triptych wherein the central panel – the earth – is engulfed by fire and storm and the souls of the damned endure innumerable and ingenious tortures; also a *Tarquin and Lucretia* by ?Titian; several works by F. Guardi. Giordano. 19C and 20C Austrian art, inc. teachers at the academy, such as Wotruba and Ramer.

Kunsthistorisches Museum

Burgring 5, A-1010 Wien.
Tel (43 1) 5252 40
Fax (43 1) 5252 4503
www.khm.at
info@khm.at
Tues, Wed, Fri to Sun 10-6, Thurs 10-9. Closed Mon. Café.

A fine survey of the whole tradition of western European art, with outstanding groups of works by Pieter Bruegel the Elder and Velázquez. Its major strengths, strongly marked by Habsburg taste, are in early Netherlandish, 16C Venetian and 17C Flemish art.

Early Netherlandish* inc. Van Eyck*, Van der Weyden*, Van der Goes and Geertgen*. A room is devoted to the works of Bruegel***. These range from the early works satirizing human folly (*Children's Games* and *Battle between Carnival and Lent* where the spectator looks down on the frenzied and pointless activities of ant-like figures) to the profound treatment of biblical subjects, painted as incidents from contemporary life (in the *Procession to Calvary* the theme is man's frightening indifference to his destiny). Four paintings from a series of the *Months*, 1565; man's activities, in harmony with nature's rhythms, are seen in vast landscapes of truly cosmic grandeur. In 1566 he began to paint genre scenes on a new monumental scale – *Peasant Dance* and *Peasant Wedding Feast* treat human frailty with a new humour and generosity.

Dutch inc. some of the graver, more dignified genre scenes by Aertsen; Hals, three *Self-Portraits* by Rembrandt**; Vermeer**.

Flemish: a large group of works by Van Dyck*, both portraits and religious paintings. Two magnificent Rubens altarpieces with the oil sketches made for them, painted before 1620 for the high altar of the Antwerp Church of the Jesuits (*The Miracles of St Ignatius** and *The Miracles of St Francis Xavier**); painted to promote the Jesuit cause, these works have all the compositional clarity and human warmth that characterize Rubens' art of this decade, each incident being shown with vivid reality. Also a late triptych, the *Ildefonso Altar**, 1630-32. In his later years Rubens

responded anew to the colour and rhythms of Titian; the *Feast of Venus** is a tribute to the Venetian. *Helena Fourment in a Fur Cloak*** is perhaps the most movingly erotic of all paintings.

German: important paintings by artists of the Danube school inc. Altdorfer and Cranach and Baldung Grien, inc. mysterious and poetic night scenes. Works by Dürer* and Holbein* inc. the rather prim and patterned *Jane Seymour* and the late *Unknown Young Man at his Office Desk*. From the 18C a group of works by Schönfeld.

Italian: Venetian school* particularly well represented, inc. Bellini*, Giorgione's *The Three Philosophers****, Titian*, Tintoretto, esp. *Susannah and the Elders***; Veronese** (inc. *Lucretia* and an *Adoration of the Magi*). Florentine High Renaissance represented by Raphael**; *Self-Portrait* by Parmigianino**. From the 17C works by Caravaggio and the Caravaggisti, inc. the *Madonna of the Rosary**; as though in the apse of a church, a group of barefoot Neapolitans pray to the Madonna, while a militant row of Black Friars warn against heresy; Annibale Carracci, Feti, Reni and Rosa. In the sculpture galleries Cellini's salt-cellar**.

Spanish: Velázquez series of portraits of the *Infanta Margarita Teresa*** trace the development away from the charm of the round-faced and chubby sitter in a portrait of *c.*1653 – a stunning display of silvery pinks, blues and greens – to the hints of a more formal pose in the full-length in a white dress of 1656. In the moving portrait of

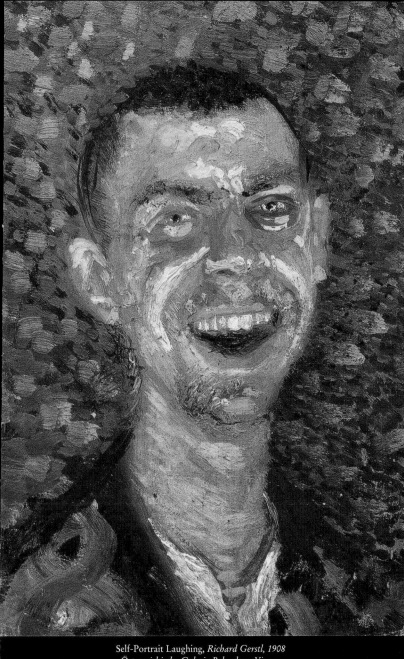

Self-Portrait Laughing, *Richard Gerstl, 1908*
Österreichische Galerie Belvedere, Vienna

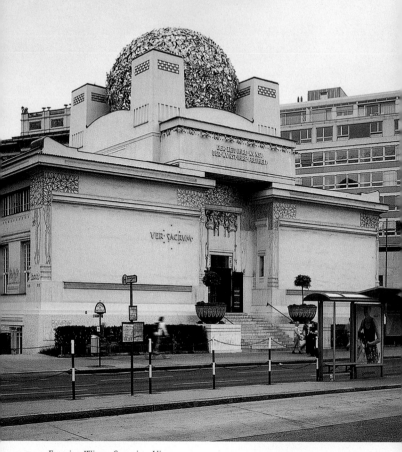

Exterior, Wiener Secession, Vienna

1659 the small child, fragile and solemn, seems scarcely able to support the grandeur of her role.

Österreichische Galerie Belvedere
Prinz Eugen-Str. 27, A-1037 Wien.
Tel (43 1) 7955 70

Fax (43 1) 798 4337
www.belvedere.at
belvedere@belvedere.at
Tues to Sun 9-5. Closed Mon.
The palaces of the Lower and the Upper Belvedere were built by Lukas von Hildebrandt for the Austrian general, Prince Eugene of

Savoy. They house three collections covering the whole history of Austrian art.

Upper Belvedere

Collections of 19th and 20th Century Art: A fine collection of Austrian 19C (inc. Friedrich – see ill. p.130 – and Waldmüller – see ill. p.22) and 20C painting. The highpoint is the late 19C and 20C, where the *fin-de-siècle* fascination with death and morbid sexuality opens with Segantini's *The Evil Mother*, and moves to Klimt's mosaic-like *The Kiss***; and his two heavily sensual female portraits*, glittering with gold and jewels; and on to the tormented Schiele's *Death and the Maiden* and *The Family**, which shows the artist and his wife, naked, with their unconceived child. Works by Kokoschka and Gerstl (see ill. p.31).

Lower Belvedere

Rennweg 6, A-1030 Wien.
Barockmuseum: Austrian Baroque art from *c.*1680-1780 inc. self-portraits by Maulbertsch and Kupetzky and works by Rottmayr and Troger.
Museum Mittelalterlicher Kunst: Austrian Gothic art. Outstanding works inc. Michael Pacher and Rueland Frueauf the Elder.

Museum Moderner Kunst Stiftung Ludwig Wien Palais Liechtenstein

Fürstengasse 1, A-1090 Wien.
Tel (43 1) 3176 900
Fax (43 1) 317 6901
www.mmkslw.or.at/mmkslw
museum@mmkslw.or.at
Tues to Sun 10-6. Closed Mon.
Worth a visit for the late 17C decoration by Marcantonio Franceschini and Andrea Pozzo, so oddly out of keeping with the collection.

Painting and sculpture from *c.*1900 to the present day. There are special rooms dedicated to major movements of the 20C, inc. Expressionism, Cubism, Futurism, Constructivism, Surrealism and Pop Art. International painting of the 1980s and 1990s.

Neue Galerie in der Stallburg

Stallburg 2.
Tues, Wed, Thurs 10-3; Sat, Sun 9-1. Closed Mon and Fri.
19C and 20C painting and sculpture. German Romanticism, French Impressionism and Post-Impressionism; inc. works by C. D. Friedrich and Liebermann.

Wiener Secession

Friedrichstr. 12, A-1010 Wien.
Tel (43 1) 587 5307
Fax (43 1) 5875 307 34
www.secession.at
office@secession.at
Tues to Sun 10-6; Thurs 10-8.
Guided tours Sun 11. Café.
The building, white and gold, with an openwork dome with gilt laurel leaves, is the Art Nouveau masterpiece of Joseph Maria Olbrich. For the long room here Klimt painted his erotic *Beethoven frieze***, a vast allegory of the power of music, glittering with gold and semiprecious stones.

Portrait of Elisabeth Vekemans, *Cornelis de Vos, 1651,*
Museum Mayer van den Bergh, Antwerp

Belgium

Opening hours: museums are generally open from 10-12 and 1-5. Hours may vary according to the season. Some close on Monday or Tuesday. Many are free. Churches usually close at 12. Most are closed to visitors on Sunday. Several are closed for long-term restoration – their contents may be displayed in local museums. Some churches are only open for services. An entrance fee is often charged for museums and for churches containing celebrated works.
National holidays: Jan 1, Easter Mon, May 1, Ascension Day, Whit Mon, July 21, Aug 15, Nov 1, 11, 15, Dec 25, 26. Museums close Dec 25 and Jan 1.
Tourist information: Syndicat d'Initiative (French) and Dienst voor Toerisme (Flemish).
Useful words: for French word list see p. 73; Flemish; *huis* house; *kerk* church; *Onze Lieve Vrouw* Notre Dame; *schone kunsten* fine art.

The great pleasure of looking at art in Belgium is the immense variety of experiences contained within a comparatively small area; it is possible to choose a centre and make day excursions to most of the important art centres (many of the smaller towns such as Bruges, Louvain and Ghent contain works of superlatively high quality). The great national collections are in Antwerp and Brussels, but the exhausting pleasures of these should be complemented with visits to smaller, more personal collections. Many artists' houses and studios have been turned into museums and the often idiosyncratic and fascinating works of minor artists may be seen in settings that retain a highly personal character.

Flemish art
The first great Flemish painter whose life and work are well documented is Jan van Eyck (d. 1441). He perfected the art of oil painting; the new transparency of the paint enabled him to study the fall of light and to observe, with infinite patience, the beauty of surface and texture of trees, flowers, rocks, jewels and fabrics. His portraits introduced a modern quality of life-like immediacy. His contemporary Robert Campin developed a more robust

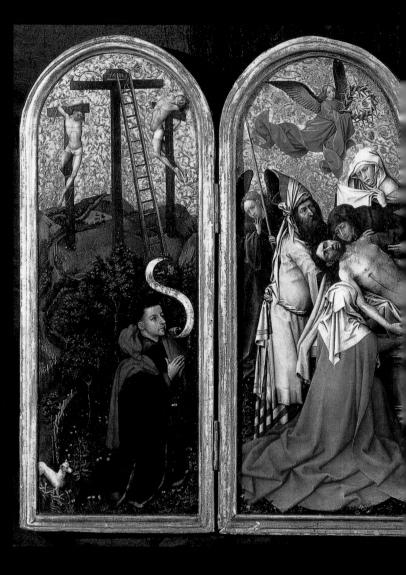

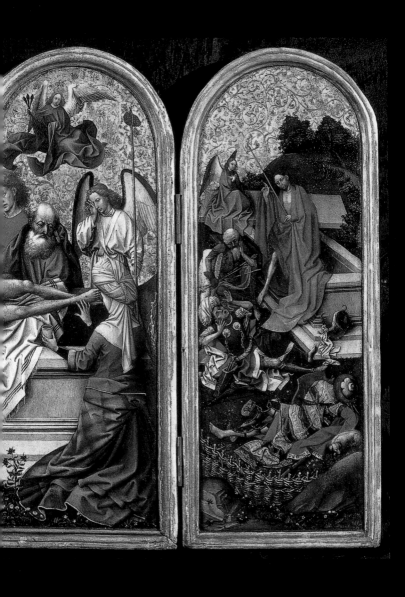

Triptych: The Entombment *(centre panel)*, Two Thieves with the Empty Cross and a Donor; The Resurrection *(wings) c.1420,* *Master of Flémalle, Courtauld Institute Gallery, London*

Rinaldo and Armida, *Van Dyck, Baltimore Museum of Art*

realism. Roger van der Weyden, a subtle colourist and fine draughts-
man, was more concerned with the expression of emotion. The
solemn works of Dirk Bouts, restrained and full of pathos, show
an unusual responsiveness to effects of light. In Bruges, Hans
Memling and Gerard David painted in a conservative style that has
an attractive serenity; occasionally Memling's portraits, with charm-
ing landscapes that influenced Italian painters, attain real power.

 In the 16C northern artists began to respond to the glamorous
achievements of the Italian Renaissance. Quentin Massys' reli-
gious works achieve a harmonious balance between Italian
monumentality and northern detail. Many northern artists visited
Italy; in the works of Jan Gossaert, Barend van Orley and Frans
Floris grandiose imitations of Raphael and Michelangelo threatened
to stifle a native tradition. More important are developments in

landscape and genre, especially the vigorous scenes of everyday life by Pieter Aertsen and the cosmic landscapes of Patinir. At the end of the 15C Hieronymus Bosch, obsessed by evil, had painted hellish landscapes peopled by demons and monsters, strange minerals and plants. Such subjects were revived by Pieter Bruegel, who became famous as a painter of peasant life. His peasants are unidealized; they struggle to maintain a harsh existence whose pleasures are scarce and earthy. Everywhere the ugliness of man is contrasted with the grandeur of nature; no earlier artist had recorded with such subtlety effects of changing weather.

In the 17C Flemish art was dominated by Rubens. He visited Italy between 1600 and 1608 and united the monumentality of Italian art, the result of a deep study of Michelangelo and the Venetians, with a northern responsiveness to nature. The passionate Baroque of Rubens and his assistants Jacob Jordaens and Anthony van Dyck exalts the sufferings, martyrdoms and ecstasies of the triumphant Roman Catholic faith. Rubens united his Catholicism with a love of pagan beauty, evident in his many mythological and historical scenes; his later work is lyrical and tender, alive to the subtleties of human passion. Van Dyck holds a special place in 17C art as the creator of the Baroque court portrait; his graceful portraits are images of an idealized aristocracy.

In the 18C Flemish art became more bourgeois. Religious and history painting declined; most prolific were specialists in landscape, still life and genre.

In the early 19C Belgian Romanticism encouraged a return both to nature and to the style of Rubens: Louis Artan specialized in landscape; Antoine Wiertz painted apocalyptic visions of madness, hunger and crime; and Charles de Groux and Constantin Meunier endowed peasant life with an almost sacred nobility. In the later 19C Félicien Rops and James Ensor painted macabre and erotic subjects; Ensor used the mask as a symbol of the evil of society.

The early 20C saw an attempt by a group of Belgian artists who settled in the village of Laethem-St-Martin to establish a new Belgian tradition of Expressionism; they chose realistic subjects from the Belgian countryside: Gustave de Smet and Constant Permeke painted scenes from rural life with bold simplicity. Rik Wouters, painter and sculptor, depicted tender scenes of domestic life in a style close to the Nabis. The Surrealist René Magritte questioned the nature of reality in his straightforward portrayals of strangely juxtaposed objects.

AALST (Alost)

St Martens
Rubens' *St Roch Receiving from Christ the Gift of Healing the Plague-Stricken* (S transept).

ANTWERP

Koninklijk Museum voor Schone Kunsten Antwerpen
Leopold de Waelplaats,
B-2000 Antwerpen.
Tel (32 3) 238 7809
Fax (32 3) 248 0810
www.antwerpen.be/cultuur/kmska
edco@kmska.be
Tues to Sun 10-5. Café.
A gloomy and forbidding museum, but with a wonderful collection of five centuries of Flemish art, supplemented by some good works by foreign schools. At its centre is a vast hall displaying a splendid group of Rubens' altarpieces from Antwerp churches.
Flemish 15C: Jan van Eyck's tiny yet monumental *Madonna of the Fountain*** and grisaille *St Barbara***, with the saint before her tower; Roger van der Weyden's *Seven Sacraments*** triptych, with the sacraments shown as scenes from 15C life (note esp. the young boys, suddenly hopeful, setting off after confirmation in a luminous Gothic church); Memling, Gerard David and Patinir.
16C: Frans Floris' Mannerist *Fall of the Rebel Angels*, Van Orley's *Last Judgement*, works by Quentin Massys, esp. the *Entombment**. Genre scenes of boisterous peasants by Aertsen, Brueghel the Younger and Vinckboons.

17C collection dominated by Rubens, particularly by his altarpieces from Antwerp churches. Most important are the *Baptism of Christ** 1605, painted in Italy and massively Michelangelesque; the *Last Communion of St Francis** 1619, of great human warmth and clarity; and the *Adoration of the Magi**. Also sketches and the small *Prodigal Son*. Portraits and religious works by van Dyck and Jacob Jordaens.
Dutch: small collection inc. works by Frans Hals.
Italian: inc. works by Simone Martini (fragments of a portable altar*), Antonello da Messina* and Titian.
Belgian 19C and 20C: inc. many works by Ensor, Permeke, de Smet and Rik Wouters*. 20C inc. works by Belgian Surrealists, and some artists from other schools, inc. Appel, Chagall, and Modigliani.

Museum Mayer van den Bergh
Lange Gasthuisstraat 19,
B-2000 Antwerpen.
Tel (32 3) 2322 37
Fax (32 3) 231 7335
museum.mydb@dma.be
Tues to Sun 10-5. Closed Mon. Café.
The museum is a tribute to the connoisseur Chevalier Fritz Mayer van den Bergh (d. 1901). It is housed in an imitation 16C patrician house and the small panelled rooms are crowded with collections of sculpture, tapestry, ivories and medals. The collection of paintings is particularly rich in landscape, still life and genre.
Flemish 15C, 16C, 17C: Bruegel's *Dulle Griet*** (Mad Meg, a crazy

housewife, storms the gates of Hell). Works by Aertsen, Jan Breughel, Cornelis Massys, Quentin Massys, D. Seghers and Cornelis de Vos (see ill. p.34).

Museum Ridder Smidt van Gelder

Belgielei 91, B-2000 Antwerpen.
Tel/Fax (32 3) 239 0652
Tues to Sun 10-5. Closed Mon.
Café.
An 18C mansion houses the collection of furniture, tapestry, paintings and china made by the wealthy connoisseur Pieter Smidt van Gelder. The paintings, mostly small and intimate, are of landscape, still life, genre and flowers.
Dutch: good 17C landscapes (Van Goyen, Porcellis, S. van Ruysdael), still lifes (Claesz and Kalf) and 19C paintings.
French: a few 18C works by Lacroix, Pater and Hubert Robert.

Openlucht-museum voor Beeldhouwkunst Middelheim (Open-air Sculpture Museum)

Conservator Menno Meewis,
Middelheimlaan 61,
B-2020 Antwerpen.
Tel (32 3) 828 1350
Fax (32 3) 825 2835
10-dusk.
Maillol, Meunier, Moore, Rodin, Wouters and Zadkine.

Rockoxhuis

Keizerstraat 12,
B-2000 Antwerpen.
Tel (32 3) 231 4710
Fax (32 3) 231 7681
Tues to Sun 10-5.
Closed Mon. Café.
Nicolas Rockox, a burgomaster of

Antwerp, was a patron of Rubens and Van Dyck. His house was restored in 1977: furniture and paintings recreate the taste of a distinguished 17C collector.
Paintings largely 16C and 17C Flemish, esp. landscape, genre and biblical scenes. Two paintings by Rubens.

Rubenshuis

Wapper 9, B-2000 Antwerpen.
Tel (32 3) 201 1555
Fax (32 3) 227 3692
Mon to Sun 10-5. Café.
Built between 1610-17, Rubens' house opens the history of the Baroque in Flemish secular building. Only the arcade between the forecourt and the garden and the pavilion are original; the rest has been restored and furnished in accordance with the taste of Rubens' time. Rubens designed the house himself, and his presence is palpable in the studio and rotunda built to display ancient sculpture. He painted the portico and garden in several pictures.
Rubens: *Self-Portrait**; a very early, ugly *Adam and Eve* 1600; an *Annunciation*; some sketches, esp. *Henry IV at the Siege of Paris.* Also works by Brouwer, Jordaens, D. Seghers and Lucas van Uden.

Churches

Cathedral (Onze Lieve Vrouw)

Groenplaats.
Tel (32 3) 231 3033
Fax (32 3) 231 6564
Mon to Fri 10-5; Sat 10-3; Sun 10-4.
Three major altarpieces by Rubens painted in the traditional form of

Rubens tour

Antwerp is, above all, the city of Rubens, richest in his great Baroque altarpieces, some of which may still be seen *in situ* in the churches in the northern part of the city: **St Paulus** has three works, **St Carolus Borromeus** has an altarpiece in the Lady Chapel, and the **Cathedral** has four major works (particularly important are the *Raising* and *Descent from the Cross*). To add to your awareness of the times in which he worked, you can visit Rubens' own house, the house of his patron Rockox, and the Plantin-Moretus Museum (Vrijdagmarkt 22. Tel (32 3) 234 1283. Mon to Sun 10-5), Once a world famous printing house, this museum contains drawings and illustrations by artists who worked for the firm. Rubens was a friend of Balthasar Moretus and worked for Plantin as an illustrator; there are sketches, paintings and engravings by him. There is also a room where Justus Lipsius, great

humanist scholar and friend of Rubens, worked. Close by (at Reyndersstraat 4) is the house of Jacob Jordaens, a pupil of Rubens, which has been restored. In the south of Antwerp, visit

Moonlit Landscape, *Peter Paul Rubens,*
Courtauld Institute Gallery, London

the Museum voor Schone Kunsten to see Rubens' altarpieces
from Antwerp churches.

the triptych: the recently restored *Raising of the Cross*** and the *Descent from the Cross*** (now against the piers of the crossing) and the *Resurrection** (in the 2nd amb. chapel). The slightly later *Descent* is more restrained and classical than the powerfully modelled *Raising*. Rubens' *Assumption** 1626 (on the high altar) has the sweeping movement and blazing colour of the full Baroque. Also works by Van Veen and Martin de Vos (S transept).

St Carolus Borromeus
Hendrik Conscienceplein 12.
Tel/Fax (Presbytery) (32 3) 289 4153
www.kerknet.be/kerkvlaan-deren/index.htnl
Mon to Fri 10-12.30, 2-5; Sat 10-6; Sun open for worship only.
The Lady Chapel, with its altar-piece, the *Assumption of the Virgin*, was decorated after Rubens' designs; it is all that remains of his vast decorative project destroyed by fire in 1718. It is a fine example of Flemish Baroque, exploiting the effects of coloured marbles, twisted columns and concealed lighting: painting, sculpture and decoration work together.

St Jacobus
Lange Nieuwstraat 73.
Tel (32 3) 232 1032
April 1 to Oct 31: Mon to Sat 2-5; Nov 1st to Mar 31: Mon to Sat 9-12. Closed Sun.
Still in situ is Rubens' *Madonna with Saints***, one of his tenderest altarpieces, painted for his burial chapel in this opulently decorated church.

St Paulus
Veemarkt, B-2000 Antwerpen.
Tel/Fax (32 3) 232 3267
Sirjacobs.Sint-Pauluskerk @pi.be
May 1 to Sept 30: 2-5.
A late Gothic church, transformed in the 17C into a full-blooded expression of the Baroque; its decoration, furniture and iconographical programme are a superb visual statement of the ideals of the triumphant church. Over the S transept altar, Rubens' *Disputà** 1609-10 has magnificent figures and dramatic lighting; N transept, Rubens' *Adoration of the Shepherds*; a series of the *Mysteries of the Rosary** inc. Rubens' *Scourging*, Van Dyck's *Carrying of the Cross*, Jordaens' *Crucifixion*, Cornelis de Vos' *Adoration of the Shepherds*; other works by earlier Antwerp artists.

BRUGGE (Bruges)

Brangwyn Museum
Dijver 16, B-8000 Brugge.
Tel (32 50) 4487 11
Fax (32 50) 4487 78
Mar-Sept: Mon to Sun 9.30-12, 2-6. Closed Tues. Oct-Feb: Mon to Sun 10-12, 2-7. Closed Tues.
Sir Frank Brangwyn, British painter and etcher (1867-1956), gave this collection of his own work to the city in 1936.

Groeningemuseum
Stedelijke Musea, Dijver 16, B-8000 Brugge.
Tel (32 50) 4487 11
Fax (32 50) 4487 78
Mar-Sept: Mon to Sun 9.30-12. Closed Tues. Oct-Feb: Mon to

Sun 10-12, 2-5. Closed Tues.

One of the most enjoyable small museums and the best place to get a general idea of the Bruges school of 15C painting. Jan van Eyck's *The Madonna of Canon van der Paele*** (1436) is the largest and most ambitious of his late works, painted with an almost over-whelming technical command; small portrait of Van Eyck's wife**. Works by Gérard David*, Hugo van der Goes (his disturb-ingly powerful *Death of the Virgin***), and Memling. Also 16C and 17C Flemish art, and a grow-ing collection of 19C and 20C works, inc. pictures by Khnopff, who painted Bruges as the dead city of Symbolist writers.

Memlingmuseum

Sint-Jans Hospitaal, Mariastraat 38, B-8000 Brugge.
Tel (32 50) 4487 11
Fax (32 50) 4487 78
Apr-Sept: Mon to Sun 9.30-5;
Oct-Mar: Thurs to Tues 9.30-5.
Closed Wed.

Large collection of works by the Bruges painter Memling, housed in a medieval hospital for which the two triptychs, the *Marriage of St Catherine** and the *Floreins Altarpiece**, were commissioned. *The Shrine of St Ursula** (1489): separate panels illustrate the story of the saint and 11,000 virgins, successfully set in the calm beauty of the landscape backgrounds. *The Diptych of Martin van Nieuwenhove** shows the Virgin and Child (L panel) and the donor (R). This very rare survival shows an unusual command of space.

Onze Lieve Vrouw

St Katelijnestraat.
*The Madonna of Bruges***, an early work in marble by Michelangelo.

BRUSSELS (Bruxelles)

Musée Constantin Meunier

Rue de l'Abbaye 59,
B-1050 Brussels.
Tel (32 2) 648 4449
Fax (32 2) 508 3232
Tues to Sun 10-12, 1-5. Closed
Mon and every other weekend.

The sculptor's house, which still retains the attractively desolate quality of an abandoned working studio, displays about 170 sculp-tures and 120 paintings. His paintings, small oil sketches and charcoal drawings of industrial subjects – docks, mines and facto-ries – are moving images of urban misery; his sculptures of workers exalt the dignity of labour.

Musées Royaux des Beaux-Arts – Musée d'Art Ancien

Rue de la Régence 3,
B-1000 Brussels.
Tel (32 2) 508 3211
Fax (32 2) 508 3232
www.fine-arts-museum.be
info@fine-arts-museum.be
Tues to Sun 10-12, 1-5.
Closed Mon. Café.

This museum houses a collection of paintings from the 14C to 19C, mainly by Flemish artists, but including some Dutch, German and French works. Different coloured signs lead you through rooms connecting works of differ-ent periods: blue – 14C, 15C, 16C and the Delporte Bequest; brown –

17C and 18C; red – temporary. The yellow circuit – which covers the late 18C and 19C – is in the Musée d'Art Moderne. The gallery is lavishly supplied with rest and study rooms, although the bleak décor and the tendency to isolate outstanding works do not enhance the paintings.

Blue circuit. Netherlandish: 14C and 15C inc. Dirk Bouts' two paintings of the *Judgement of the Emperor Otto***, remarkable for their restrained yet poignant expression of emotion; Petrus Christus' *Pietà**; unusual works by the Master of the Aix Annunciation*; Hugo van der Goes; portraits by Hans Memling and Roger van der Weyden**. 16C works by Gerard David (*Madonna of the Porridge Bowl**), Quentin Massys (*Legend of St Anne** 1509), Van Orley (*Job Altarpiece*). Genre scenes by Aertsen and Beuckelaer. Most famous are works by Bruegel**, unattractively displayed in a large empty room. A very early *Adoration of the Magi*; *Fall of the Rebel Angels**; *Census at Bethlehem***, set in a 16C winter village scene; *Fall of Icarus***. 16C German school inc. works by Bruyn, Cranach and Seisenegger. Delporte Bequest: 15C and 16C Netherlandish and French works inc. Bruegel's *Winter Landscape with Bird Trap**.

Brown circuit. Flemish: many works by Rubens**, inc landscapes, portraits, altarpieces (inc. the furious late work *Martyrdom of St Livinus** and *Via Crucis*) and oil sketches (a series commissioned for Philip V's hunting-lodge are tender, witty depictions of scenes

from Ovid*). Also works by Van Dyck (*Genoese Lady and her Daughter**), Fyt, Jordaens, Siberechts* and Snyders. Dutch 17C: small, high quality collection inc. an unusual Frans Hals*, a portrait by Rembrandt, and landscapes (inc. Hobbema). French 17C: inc. Philippe de Champaigne and La Tour. A late Claude of *Aeneas Hunting*, a mysterious but sadly damaged work.

Yellow Circuit. Belgian: many works by 19C Belgian artists inc. sculptures by Meunier and paintings by Artan, Ensor, Dillens, Khnopff* and Stevens. Also 19C French: inc. David's terrifyingly clear-sighted *Death of Marat***, Gauguin, Seurat, Signac and Sisley.

Musées Royaux des Beaux-Arts – Musée d'Art Moderne

Place Royale, 1, B-1000 Brussels.
Tel (32 2) 508 3211
Fax (32 2) 508 3232
www.fine-arts-museum.be
info@fine-arts-museum.be
Tues to Sun 10-1, 2-5.
Closed Mon.

A good collection of international contemporary art and Belgian 19C and 20C. Delvaux's trancelike paintings, with skeletons and chilly naked women in ghostly urban settings; Rik Wouters; Magritte*; and works by Spilliaert, a self-taught and highly individual Symbolist artist too little known outside Belgium. His dreamlike *Woman on a Sea Wall**, with its flat surfaces and undulating wavy lines, is characteristic of his style.

International contemporary art inc. the major 20C movements. CoBrA, Expressionism, Futurism,

Surrealism, and Dada; artists inc. Matisse, Miró, Picasso, Appel, Allen Jones, Donald Judd, Segal, Tony Cragg and Richard Long.

Musée Wiertz
Rue Vautier 62,
B-1050 Brussels.
Tel (32 2) 648 1718
www.fine-arts-museum.be
info@fine-arts-museum.be
Tues to Sun 10-12, 1-5.
Closed Mon.

The vast empty studio of the Romantic painter Antoine Wiertz (1806-65) contains gigantic visions of madness and destruction, skeletons and coyly erotic nudes. The smaller rooms contain sketches for them, sketches after Rubens, and some attractive studies of Italianate scenery.

DENDERMONDE

Onze Lieve Vrouw
Van Dyck's *Crucifixion** (baptistery) and *Adoration of the Shepherds* (N aisle).

GENT (Ghent)

Museum of Fine Arts
Citadel Park, B-9000 Gent.
Tel (32 9) 222 1703
Fax (32 9) 221 6015
www.gent.be
museum.bsk@gent.be
Mon to Sun 9.30-5.

Flemish: Hieronymus Bosch*, Van Dyck, Jordaens, and some Rubens sketches. An unusual and splendid series, *The Four Elements**, by Joachim Beuckelaer, crowded with lively genre details.

French inc. a Philippe de Champaigne, some early 19C works and Rouault.

19C Belgian school: large collection with emphasis on Symbolism and Impressionism.

Contemporary art inc. Pop and Minimal art

St Baafskathedral (St Bavo)
Bisdomplein 1, B-9000 Gent.
Tel (32 9) 269 2065
Fax (32 9) 269 2066.

Hubert and Jan van Eyck's altarpiece *The Adoration of the Lamb****, a huge polyptych and the most famous painting in Belgium. Originally painted for a small chapel, the painted light was subtly adjusted to match the light from the window. It is now displayed in the Villa chapel, and is one of the disasters of mass tourism with the light effects destroyed and the small space almost always overcrowded and then unbearably noisy. It is worth trying to get there the minute it opens. The altarpiece shows, on the back of the shutters, an *Annunciation* and the portraits of the donors. The muted colours contrast with the brilliant colours of the front, which shows, on the upper row, brutally realistic figures of Adam and Eve; between them God in majesty; the Virgin, John the Baptist and music-making angels. Lower row: against the startling greens and endless variety of detail of the Paradisial landscape, processions of figures advance towards the lamb.

See also Laurent Delvaux's voluptuous Rococo pulpit, and, in the transept, Rubens' *Conversion*

47

of St Bavo faces a stiff work by his teacher, Otto van Veen's *Raising of Lazarus*. Crypt: important *Crucifixion* attributed to Justus van Ghent.

JABBEKE

Museum Constant Permeke
Gistelsesteenweg 341,
B-8220 Jabbeke.
Tel (32 50) 8112 88
Fax (32 50) 8056 26
Easter-Sept: Mon to Sat 10-12.30,
1.30-6. Oct-Easter: Tues to Sun
10-12.30, 1.30-5.30. Closed Mon.
From 1930-52 this was the house of the leading Belgian Expressionist painter and sculptor, Constant Permeke. Much of his work is displayed.

KORTRIJK (Courtrai)

Onze Lieve Vrouw
Van Dyck's *Raising of the Cross** (N transept).

LEUVEN (Louvain)

St Pieter
Grote Markt.
The unusual and moving sight of Early Flemish altarpieces *in situ*. Two triptychs by Dirk Bouts: *Martyrdom of St Erasmus* (5th amb. chapel) and *Last Supper*** (10th amb. chapel).

MECHELEN (Malines)

Cathedral (St Rombout)
Van Dyck's *Crucifixion*.

Onze Lieve Vrouw van Overdijl
Onze Lieve Vrouwstraat.
Rubens' *Miraculous Draught of Fishes* (S transept).

St Jan
Klapgat.
Rubens' *Adoration of the Magi**.

NAMUR

Musée Félicien Rops
Rue Fumal 12, B-5000 Namur.
Tel (32 81) 2201 10
Fax (32 81) 2254 47
www.ciger.be/rops
Collection of the morbid paintings and engravings of Rops (1833-98) with the themes of Satanism, women and eroticism. Closed until October 2002.

OOSTENDE (Ostend)

Ensorhuis (Ensor House)
Vlaanderenstraat 27,
B-8400 Oostende.
Tel (32 59) 8053 35
Fax (32 59) 8028 91
Easter, June-Sept: Mon, Wed to
Sun 10-12, 2-5. Closed Tues.
Other months: Sat, Sun 2-5.
Closed Oct and All Saints.
The house of James Ensor: an extraordinary magic toyshop of strange curios, mirrors, shells, toys, creating an evocative and stifling atmosphere.

PMMK – Museum of Modern Art
Romestraat 11, B-8400 Oostende.
Tel (32 59) 5081 18
Fax (32 59) 8056 26
www.pmmk.be

Tues to Sun 10-6. Closed Mon.
A survey of modern and contemporary art in Belgium; the museum has interesting exhibitions, related to works from the permanent collection.

Brazil

National holidays: Jan 1, 20 (Rio), 25 (São Paulo), Feb/Mar Carnival (3 days preceding Ash Wed), Good Fri, Apr 21, May 1, Corpus Christi, Oct 12, Sept 7, Nov 2, 15, Dec 25, 26.
Tourist information: Cebitur, Touring Club do Brasil, Riotur.

RIO DE JANEIRO

Museu de Arte Moderna
Av. Infante Dom Henrique 85,
Parque Brigadeiro Eduardo
Gomes, 20021-140 Rio de Janeiro.
Tel (55 21) 210 2188
mam@mamrio.com.br
Tues to Sun 12-6.
An important example of modern Brazilian architecture (by A. E. Reidy, 1948), set in a large landscaped park containing modern sculpture. The museum shows changing exhibitions of 20C European and Brazilian art. Permanent collection inc. Brancusi, Giacometti, Lipchitz, Pollock, Fontana.

Museu da Chácara do Céu (Museus Castro Maya)
Rua Murtinho Nobre 93,
Santa Teresa, CEP 20241-250,
Rio de Janeiro, .
Tel/Fax (55 21) 224 8981,
224 8524
www.visualnet.com.br/cmaya
cmaya01@visualnet.com.br
Wed to Mon 12-5. Closed Tues.
House of Raymundo de Ottoni de Castro Maya (d. 1968) containing his collection of modern European (Dalí, Modigliani, Monet, Picasso) and Brazilian art.

Museum of Contemporary Art
Mirante da Boa Viagem,
Boa Viagem, Niteroi,
CEP 24210-390, Rio de Janeiro.
Tel/Fax (55 21) 6202 400,
6202 481
www.macnit.com.br
Tues to Sun 11-7; Sat 1-9.
Poised on a cliff top, against sea and rocks, this brilliant white marble museum, circular, and with sweeping lines, is a late and daring monument to Modernism; it was created by the 93-year-old Oscar Niemeyer, whose earlier buildings

Museu de Arte Moderna,
Rio de Janeiro

transformed Rio. The collection, of post-war Brazilian art, with an emphasis on sculpture and installation work, struggles to live up to the building.

Museu Nacional de Belas Artes
Av. Rio Branco 199, 20040-008, Rio de Janeiro.
Tel (55 21) 240 9869
Tues to Fri 10-6; Sat, Sun 2-6.
Nucleus of collection brought from France by the 'French Mission' who formed an academy in 1816. Minor Italian, Spanish, Portuguese and Netherlandish works, and an important collection tracing the development of Brazilian art.

SÃO PAULO

Museu de Arte Contemporanea da Universidade de São Paulo
Rua de Reitoria 160, 05508-900, Sao Paulo .
Tel (55 11) 818 3039
Fax (55 11) 212 0218
Tues to Sun 10-7.
20C European: Surrealist works by Arp, Ernst, Miró, De Chirico; Constructivists represented by Albers and Vasarély, Futurism by Boccioni; highlight is Modigliani's *Self-Portrait.*

Modern Brazilian inc. *The Idiot* 1917 by Anita Malfatti, who introduced Expressionism to Brazil; Tarsila do Amaral; Segal; Brazilian avant-garde (*arte concreta e neo-concreta*), Pop Art and art from the 1970s to '90s.

Museu de Arte de São Paulo Assis Chateaubriand
Av. Paulista 1578, 01310-200, São Paulo.
Tel (55 11) 251 5644
Fax (55 11) 284 0574
atemasp@masp.art.br
Tues to Sun 11-6.
A good collection of European Old Master and modern paintings, with 20C South American works.
Italian: large collection; note esp. Maestro del Bigallo's tender *Virgin and Child*, Mantegna's *St Jerome** and a *Resurrection* by Raphael.
Flemish inc. Memling, Bosch and a Rembrandt *Self-Portrait.*
British: Holbein*, Constable*, Gainsborough and Turner.
Spanish: Velázquez's huge portrait of the arrogant *Olivares**, five Goya portraits and an El Greco *Annunciation.*
French: 17C and 18C; Poussin; 13 Renoirs; five Cézannes inc. *The Great Pine**; five Van Goghs.

Canada

National holidays: Jan 1, Good Fri, Easter Mon, Mon before May 24, July 1, first Mon in Sept, Oct 9, Nov 11, Dec 25, 26. Museums generally close on Jan 1 and Dec 25.

Art in Canada

Some major figures in Canadian art emerged just before 1900. Best known of the earlier artists are Cornelius Krieghoff, who painted lively scenes of contemporary life in Quebec, and Paul Kane, who, fascinated by the Indians, painted scenes from their life.

By 1900 many artists began to respond to French Impressionism; most important was James Wilson Morrice from Quebec whose flat and decorative works opened up to younger painters the possibilities of pure painting. In 1920 the Group of Seven was founded in Ontario; its members (including Tom Thomson and A. Y. Jackson) had begun, since 1910, to paint the wildness and drama of the Canadian landscape in strong colours, striving to produce an identifiably national art. Emily Carr created mystical forest landscapes and recorded the art and artefacts of the North-west Coast Indians. Between 1940 and 1955 some of the most exciting developments took place in Montreal; Borduas, Pellan and Jean-Paul Riopelle were in close contact with current movements in Paris, and their work culminated in the formation of the 'Automatiste' movement. Riopelle became a leading international exponent of Tachism; his works are characterized by very thick slabs of paint laid on with the palette knife. Since the late 1950s widespread public sponsorship has resulted in a flourishing of Canadian contemporary art and several artists have now gained an international reputation, including Demus Burton, Alex Colville and other East Coast Super-Realists.

Opposite: Exterior, National Gallery of Canada

FREDERICTON
NEW BRUNSWICK

Beaverbrook Art Gallery
703 Queen St,
Fredericton NB, E3B 5A6.
Tel (1 506) 458 8545
Fax (1 506) 459 7450
www.beaverbrookartgallery.org
bag@fundy.net
1 June-30 Sept: Mon to Fri 9-6,
Sat, Sun 10-5; 1 Oct-31 May:
Tues to Fri 9-5, Sat 10-5, Sun 12-5.
Closed Mon.
British and Canadian paintings of all periods, inc. many works by Krieghoff; English country house portraits; contemporary Canadian art.

KLEINBERG ONTARIO

McMichael Canadian Collection
Islington Av, Kleinberg,
Ontario L0J 1C0.
Tel (1 905) 893 1121
Fax (1 905) 893 0692
www.mcmichael.on.ca
1 May-31 Oct: daily 10-5; 1 Nov-
30 Apr: Tues to Sat 10-4, Sun
10-5; 26 Dec-3 Jan: 10-5.
The log and field stone gallery is set in 100 acres of forest and has grown from the small personal collection of Canadian works made by Robert and Signe McMichael. The building was designed to enhance the brilliant colours of the many paintings by Tom Thomson and the Group of Seven whom he inspired.

MONTREAL QUEBEC

The Montreal Museum of Fine Arts
1379-1380 Sherbrooke Street West.
Postal address: PO Box 3000,
Station H, Montreal P.Q.,
H3G 2T9.
Tel (1 514) 285 1600
Info (1 514) 285 2000
www.mmfa.qc.ca
webmaster@mbamtl.org
Tues to Sun 11-6. Closed Mon.
Temporary exhibitions: Wed
5.30-9. Café.
A good collection of Canadian art ranges from early portraits of native people to works by artists of the Group of Seven and a large collection of pictures by James Wilson Morrice. Paintings by Pellan, Borduas (*Black Star*, 1957) and Riopelle. Contemporary works inc. Montreal artist Betty Goodwin.
British: 18C and early 19C schools of landscape and portraiture are well represented.
French: Poussin, but richest in 19C works, inc. Daumier's wild *Nymphs Pursued by a Satyr** and Barbizon pictures; Impressionist (Renoir's *Young Girl with a Hat*) and Post Impressionist.
Italian Schools: small group of early Florentine and Sienese inc. Nicolo di Pietro Gerini's *Coronation of the Virgin*; grisaille paintings by Mantegna. 17C and 18C inc. Rosa's astonishingly proto-romantic *Jason and the Dragon*; works by Canaletto, Piazzetta, Tiepolo.
Netherlandish: Memling's *Portrait of a Young Man*; small collection of high quality Dutch works inc. de Witte and Ruisdael.
Spanish: El Greco and Goya.

20C & International contemporary art: a good collection of small bronzes; Rouault, Dalí and Otto Dix; American artists inc. Nevelson and Rauschenberg; European Rebecca Horn and Barry Flanagan.

Museum of Contemporary Art
185 St Catherine St,
Montreal H2X 1Z8.
Tel (1 514) 847 6226
Fax (1 514) 847 6291
info@macm.org
Tues to Sun 11-6; Wed 11-9. Café.
Canadian art from 1940 to the present day inc. work by Borduas, Riopelle. Also American and European artists.

OTTAWA ONTARIO

National Gallery of Canada
380 Sussex Drive,
PO Box 427, Station A,
Ottawa, Ont K1N 9N4.
Tel (1 613) 990 1985
Fax (1 613) 993 4385
www.national.gallery.ca
info@gallery.ca
Oct-Apr: Wed to Sun 10-5; Thurs 10-8. Closed Mon and Tues.
May-Sept: daily 10-6, Thurs 10-8.
The largest and most comprehensive collection of Canadian painting and sculpture** in the country. Early pictures by Krieghoff and Kane (*The Chief and his Companions*). Paintings by the Group of Seven inc. Tom Thomson's *Jack Pine**, an icon of Canadian art, A. Y. Jackson's *Terre Sauvage*, sublime pictures of ice and moonlight by J. E. H. MacDonald, and mystical forest landscapes* by Emily Carr. Good collection of modern and contemporary art inc. important works by video and installation artists.

British and American art: some unusual works inc. Hans Eworth's sharp and characterful *Portrait of Lady Dacre*, and Benjamin West's celebrated *The Death of Wolfe**. 20C American works inc. Pollock, Rothko and Newman's *Voice of Fire* (1967).

French: good Chardin, Poussin, Claude's arcadian *A Temple of Bacchus**, and a rather miscellaneous collection of French 19C.

Italian: good Renaissance works inc. Simone Martini and Cariani's *Portrait of a Man*, powerfully set against a stormy sky; Piero di Cosimo's *Vulcan and Aeneas** (a touchingly eccentric vision of the beginnings of civilisation), miscellaneous and dullish Venetian works and some interesting 17C works, inc. Bernini.

Dutch and Flemish: Rubens' copy after Caravaggio's *Entombment*; Rembrandt's *The Toilet of Esther*; Dutch landscape and genre.

TORONTO ONTARIO

Art Gallery of Ontario
Grange Park, 317 Dundas Street,
Toronto, Ont M5T 1G4.
Tel (1 416) 977 0414
Fax (1 416) 979 6646
From 27 Apr: Tues to Fri 12-9;
Sat, Sun 10-5.30. Café.
A large and growing collection in a splendid 1970s pavilion.

American: New York School. Large works by Ellsworth Kelly, Nolan and Frans Kline.

Canadian: a comprehensive and

high quality collection inc. works by Tom Thomson and the Group of Seven.

European: 17C works inc. Hals' *Isaak Massa** 1626; an early Poussin; and Claude's *Carlo and Ubaldo Embarking in Pursuit of Rinaldo** 1667; a superb Terbrugghen. 18C: Chardin's *Jar of Apricots*, and Gainsborough's *The Harvest Wagon**. 19C and 20C works by Dufy, Braque, Bonnard and Picasso.

Henry Moore Sculpture Center*
Designed to contain a gift from the sculptor of over 200 works; preliminary sketches and the original plaster casts.

VANCOUVER
BRITISH COLUMBIA

Vancouver Art Gallery
750 Hornby St, Vancouver, BC, V6Z 2H7.
Tel (1 604) 662 4700
Fax (1 604) 682 1086
webmmaster@vanartgallery. bc.ca
Tues to Sun 10-5.30;
Thurs 10-9; hols 12-5. Café.
Main emphasis on British Columbian and contemporary art. Works by the highly individual artist Emily Carr, who worked in remote Indian villages and created a bold and monumental style, esp. *Big Raven* and *Scorned as Timber, Beloved of the Sky*. Some British and 17C Dutch painting.

Croatia

National holidays: Jan 1, Epiphany, Easter, May 1, 30, June 22, Aug 15, Nov 1, Dec 25, 26.

Moderna Galerija
A. Hebranga 1, 10000 Zagreb.
Tel/Fax (385 1) 492 2368.
modernagalerija@zg.hinet. hr
Tues to Sat 10-6; Sun 10-1.
Closed Mon.
Contemporary Croatian artists inc. Meštrović. French Impressionists inc. Renoir and Degas.

Strossmeyer Gallery of Old Masters
Trg Nikole Subica Zrinjskog 11, 10000 Zagreb.
Tel (385 1) 487 2902
Fax (385 1) 481 9979
sgallery@hazu.hr
Tues to Sun 10-1.
Closed Mon.
A gallery donated to the Croatian people by the collector Josip Strossmayer, Bishop of Djakovo. The main emphasis is on Italy, with minor Early Italian paintings, and Fra Angelico; Venetian works inc. Carpaccio and Piazzetta; 17C and 18C Giordano, Schedoni, Batoni and Pannini. From northern Europe, the Master of the Virgo inter Virgines, Ruisdael, Gros.

Czech Republic

National holidays: Jan 1, Easter Mon, May 19, Oct 28, Dec 25, 26.
Tourist information: Čedok.

The history of Bohemia and Moravia, which now form the Czech Republic, has always been marked by their position at the very centre of Europe. Prague, as the imperial capital, had a brilliant dawn under Charles IV, who imported German and French architecture and art, favouring an intense, jewelled style best represented by Master Theodoric. After the Czech lands were brought under Habsburg domination in 1526, Prague reached its zenith as an artistic centre under Rudolf II. The Emperor surrounded himself with artists such as Arcimboldo, Spranger and Hans von Aachen who could satisfy his taste for weirdness and ultra-refined eroticism. Most of his huge collection was either transferred to other Habsburg centres or was swept away in the devastation of the Thirty Years War (1618-48). In the 18C Prague effectively became a provincial satellite of the imperial capital at Vienna and the art of the region reflects this. During the 19C, however, Bohemia was seized with the nationalism that swept across all of Central Europe, and many local painters turned out historical scenes, depictions of folk traditions and celebrations of the landscapes associated with the events of the past.

The art nouveau style flourished in Prague and produced Alfons Mucha, the first Czech artist to have an unquestioned European reputation. František Kupka, who worked mainly in Paris, was one of the earliest pioneers of abstraction, and in the years preceding the First World War Prague became the centre of a strong local school of Cubists who went on the develop an unique style of Cubist architecture. Between the wars the Republic of Czechoslovakia had an exceptionally lively avant-garde art culture, where all the main European trends of the time were represented, but there has not been anything noteworthy since then.

KROMĚŘÍŽ

Archbishop's Palace
Snemovni namesti 1,
767 01 Kroměříž.
Tel (42 0634) 5020 11
Fax (42 0634) 3392 18
www.azz.cz
zamek@azz.cz
June-Oct: Tues to Sun 9-5.
Huge 17C palace remodelled in Rococo taste after a fire in 1752. The outstanding item in the picture collection is Titian's disturbing *Flaying of Marsyas*** in the painter's extreme late style. Also good 16C and 17C Italian, German and Flemish paintings, inc. works by Cranach, Bassano, Annibale Carracci and Van Dyck. The hall on the second floor contains a fresco of the apotheosis of the Prince-Bishops, in the style of Tiepolo, by the Austrian painter F. A. Maulbertsch.

NELAHOZEVES

The Lobkowicz Collection
Nelahozeves Castle,
Nelahozeves cp. I,
PSC 277 51.
Tel (420) 2057 091 38
Fax (420) 2057 091 33
collections@lobkowicz.cz
Tues to Sun 9-5. Closed Mon.
Tours every half hour. Café.
The most important family collection in the Czech Republic, shown in 25 refurnished rooms. A fine collection of portraits, works by 16C Flemish Mannerists; also Velázquez and Rubens. The outstanding work is Bruegel's *Haymaking***, from his famous series of the *Months*, and his most cheerful and attractive work. Also two spectacular Canalettos, his largest English paintings.

PRAHA (Prague)

Obrazárna Pražského Hradu (Prague Castle Gallery)
(2nd courtyard of Prague Castle),
119 08 Praha-Hrad
Tel (420 2) 2437 3368, 2437 2434
www.hrad.cz
Mon to Sun 10-6.
A small remnant of the outstanding castle collections which were largely built up by Rudolf II, now laid out to show the sad history of their depletion and former glory. 16C Venetian paintings inc. Titian. Individual works (inc. Feti, Reni, Codazzi, and Saraceni) indicate the variety of local Italian schools in 17C. Also Czech works of the 18C.

The Mucha Museum
Panská 7, 110 00 Praha 1.
Tel (420 2) 628 4162
Fax (420 2) 628 4163
www.mucha.cz
museum@mucha,cz
Mon to Sun 10-6.
Guided tours on request. Café.
An 18C palace housing a museum devoted to the works and personal memorabilia of the Czech artist Alfons Mucha, one of the most celebrated artists of Art Nouveau, and an ardent Czech nationalist.

Obecní Dům (Municipal House)
Náměští Republiky 5, Praha 1.
Tel (420 2) 232 5858
www.obecni-dum.com

Art Nouveau building** in Prague, richly decorated by sculptures, mosaics, murals and paintings by leading Czech artists, among them Mucha and Karel Špillar.

Národní Galerie v Praze (National Gallery in Prague)

The collections of the National Gallery are displayed in the following historic buildings around the Castle and in the Old Town:

Šternbersky Palác (Sternberg Palace)

Hradčanské náměstí 15,
Praha 1-Hradčany.
Tel (420 2) 5732 0536, 5352 40
Guided tours (420 2) 5732 0889
Fax (420 2) 5391 62
ssu-jk@ngprague.cz;
ssueduc@ngprague.cz (Education Dept.)
Tues to Sun 10-6. Closed Mon.
The National Gallery's collection of non-Czech European art is housed in an 18C palace. The outstanding work is Dürer's *The Festival of the Rose-Garlands***, in which he emulated the rich glow of Venetian colour and the calm symmetry of Bellini – the musical angel is a direct quotation. A few **early Italian pictures** inc. Lorenzo Monaco; the **German Renaissance** section is richer, and inc. works by Altdorfer and Cranach. **17C and 18C European** schools inc. Vouet, van Dyck and Rubens. The **Dutch** holdings are extensive, and inc. a representative collection of landscape, still life and genre.

Klášter sv. Anežky České (Convent of St Agnes)

Milosrdnych 17,
119 00 Praha 1 - Staré Město.
Gothic and Renaissance art from Bohemia and elsewhere in Central Europe, including Cranach the Elder and Altdorfer.

Klášter sv. Jiří (Convent of St George)

Jirské náměstí 33,
119 00 Praha 1 - Hrad.
Part of the National Gallery showing Czech art of the Late Renaissance and Baroque periods, inc. works by artists associated with Rudolph II, Roelandt Savery, Hans von Aachen, Joseph Heintz and a *Risen Christ** by Spranger.

Veletržní Palác (Trade Fair Palace)

Dukelskych hrdinů 47
Prague 7 – Holešovice 1500.
A vast modern constructivist building which houses the National Gallery's collection of Czech 20C art, with emphasis on Kupka, and some good French 19C and 20C pictures.

Portion of the plaster cast collection at Charlottenborg, *Christen Købke,*
Den Hirschsprungske Samling, Copenhagen

Denmark

Opening hours: museums are open for fewer hours in winter and they are often closed on Monday.

National holidays: Jan 1, Maundy Thurs, Good Fri, Easter Mon. Store Bededag (4th Fri after Easter), May 1, Ascension Day, Whit Mon, June 5, Dec 24, 25, 26. Museums close at Easter and Christmas.

Useful words: *samling* collection; *kunst* art; *museet* museum.

Art in Denmark

The great Neo-Classical sculptor Bertel Thorvaldsen was the first Danish artist to be internationally acclaimed. The period *c.*1830-50 was the 'Golden Age' of Danish painting. It opens with the Roman scenes of C. W. Eckersberg – small pictures, highly detailed and strongly lit, with bright, clear colours. There followed the works of Købke, Wilhelm Bendz and Hansen, who painted realistic subjects – small portraits, moments in everyday life, and the Danish countryside. Købke's works unite realism with geometrically structured compositions that create an intense and quiet poetry.

ÅLBORG

Nordjyllands Kunstmuseum, Museum of Modern Art
Kong Christians Alle 50,
9000 Ålborg.
Tel (45) 9813 8088
Fax (45) 9816 2820
Sept-June: Tues to Sun 10-5.
Closed Mon. July-Aug: Mon to
Sun 10-5. Café.
A famous building by Elissa and Alvar Aalto and Jean-Jacques Baruel shows Danish and foreign art from the late 19C onwards.

ÅRHUS

The Århus Art Museum
Vennelystparken, 8000 Århus C.
Tel (45) 8613 5255
Fax (45) 8613 3351
Tues to Sun 10-5, Wed 10-8.
Closed Mon.
A good collection of Golden Age Painting inc. marine pictures by Eckersberg; Købke; Bendz's portrait of Marie Raffenberg. Skagen school painters; 20C and contemporary art inc. CoBrA group and Richard Mortensen.

COPENHAGEN

Ny Carlsberg Glyptotek

Dantes Plads 7, 1556 København V.
Tel (45) 3341 8141
Fax (45) 3391 2058
www.glyptoteket.dk
Tues to Sun 10-4. Closed Mon.
Free Wed and Sun. Café.

The ancient and modern collections of the Glyptotek meet in the Mediterranean atmosphere of the domed conservatory. Mainly a museum of sculpture, it has a large collection of Danish sculpture after Thorvaldsen (esp. Henning and Kai Nielsen) and a representative collection of 19C Danish painting. **French 19C****: a large sculpture collection inc. Carpeaux, Rodin, and a complete set of Degas' bronzes; paintings inc. good works by the Impressionists Degas*, Gauguin* and Bonnard*.

Den Hirschsprungske Samling (Hirschsprung Collection)

Stockholmsgade 20,
DK 2100 København Ø.
Tel (45) 3542 0336
Fax (45) 3543 3510
www.hirschsprung.dk
dhs@hirschsprung.dk
Thurs to Mon 11-4; Wed 11-9.
Closed Tues.

An enjoyable collection of 19C and early 20C Danish art, where the Golden Age pictures are shown frame to frame in small room interiors. Outstanding are pictures by Eckersberg (esp. *Woman Standing in Front of a Mirror**); a strong group by Købke, inc. *Portion of the Plaster Cast Collection at Charlottenborg** (see p. 62), and portrait of the *Landscape Painter F.*

*Sødring**, both of which, in their evocation of the contemporary passion for classical antiquity, seem to encapsulate a whole social and artistic era; W. Bendz's magically detailed *Amaliegade Interior**. From the later 19C a good collection of Skagen school paintings inc. Anna Ancher and P. S. Krøyer, esp. the dreamily Whistlerian *Summer Evening at the South Beach, Skagen**.

Statens Museum for Kunst

Sølvgade 48-50, DK 1307,
København K.
Tel (45) 3374 8404
Fax (45) 3374 8494
smk@smk.dk
Tues, Thurs to Sun 10-5;
Wed 10-8. Closed Mon. Café.

Danish: the largest collection of Danish art, with the main emphasis on Golden Age and Romantic painting. These remarkable pictures are now becoming better known outside Denmark, and this collection inc. Eckersberg, esp. his Roman pictures, such as *The Marble Steps Leading to the Church of Sta Maria in Aracoeli in Rome**, with its bright sunlight and complex play of line, and *In the Gardens of the Villa Borghese**; Jensen; Hansen's *Group of Danish Artists in Rome*, and his strong, austerely structured *Portrait of Elise Købke*. Many works* by Købke inc. his touchingly expressive portrait of an old woman, *Johanne Ployen*, and his famous, quintessentially Danish *View of one of the Lakes in Copenhagen**. **Flemish and Dutch:** 17C Dutch landscape, still life and marine painting. Jordaens. A grisly Terbrugghen.

The Children's Feast, *Jan Steen, Nivaagaards Malerisamling, Niva*

French, German and Spanish: works by Nattier, Poussin, and Rigaud: Lucas Cranach the Elder. **Italian:** richest in 16C and 18C Venetian painting (Lotto, Titian, Tiepolo); also a fine Mantegna* and two vast, macabre canvases* by Rosa, showing *Diogenes* and *Democritus***, who laughed at human folly; here he grieves over a splendid array of symbols of transience and vanity.

A new extension shows 20C with many good works by Cubist and Fauve painters with emphasis on Matisse*. Also works by Nolde, and by Per Kirkeby, Denmark's most celebrated contemporary artist.

Thorvaldsen's Museum

Posthusgade 2,
DK 1213 København K.
Tel (45) 3332 1532
Fax (45) 3332 1771.

This monument to Danish Neo-Classicism is a gloomy, little visited, but mysterious and fascinating museum. Thorvaldsen's return to Denmark from Rome in 1838 was celebrated as a triumph, and the building is decorated with a frieze showing the transportation of his sculptures in great and touching detail. Within are Thorvaldsen's sculptures and drawings (a complete collection of originals, casts and copies) and his collection of ancient and modern art. The evocative painting by Ditlev Blunck of Thorvaldsen and his artist friends feasting in an inn in Trastevere, surrounded by idyllic scenes of Italian folk life, is especially charming.

HUMLEBAEK

Louisiana Museum of Modern Art

Gl. Strandvej 13,
DK-3050 Humlebaek.
Tel (45) 4919 0719
Fax (45) 4919 3505
Mon to Tues, Thurs to Sun 10-5;
Wed 10-10. Café.

Set in a beautiful park overlooking the sea, this highly active cultural centre houses a superb collection of modern art. In the low modern gallery is a good collection of Danish art (esp. CoBrA) and some fine works by 20C American and European artists. In the park is a strong collection of 20C sculpture inc. Arp, Giacometti, Moore, Miró, Ernst and Calder, whose *Nervures Minces* is dramatically silhouetted against the sea.

Louisiana Museum of Modern Art, Humlebaek: North Wing – the terrace with sculptures by Alexander Calder in front of the cafeteria with a view over the Sound

NIVÅ

Nivaagaards Malerisamling
Gammel Strandvej 2, 2990 Nivå.
Tel (45) 4914 1017
www.nivaagaard.dk
Feb-Nov: Tues to Fri 12-4;
Sat, Sun, hols 11-5.
Dec-Jan: weekends and hols 11-5.
Dutch 17C paintings inc.
Rembrandt and Steen (see ill. p65).
French, German and Italian Old
Masters inc. a fine middle-period
Claude; also works by Bellini, Lotto
and Luini. Danish 19C works.

RIBE

Ribe Art Museum
Sct. Nicolai Gade 10, 6760 Ribe.
Tel (45) 7542 0362
15 June-31 Aug: Mon to Sun 11-5
1 Sept-14 June: Tues to Sat 1-4,
Sun 11-2. Closed Mon. Closed Jan
but open by special arrangement.
A good collection of Golden Age
painting inc. good portraits, esp.
Juel's *Young Man in Red*, and
works by Eckersberg (an almost
magically precise *View through a
Window to a Courtyard in Rome**)
and Købke; late 19C and early 20C
Danish art, esp. Michael Ancher's
*Christening in Skagen Church**.

SILKEBORG

Silkeborg Kunstmuseum
Gudenaavej 7-9, 8600 Silkeborg.
Tel (45) 8682 1499
Fax (45) 8681 2688
Apr-Oct: Tues to Sun 10-5
Nov-Mar: Tues to Fri 12-4; Sat,
Sun 10-7. Closed Mon.
The home town of Asger Jorn, who
donated many of his paintings and
ceramics to the museum. A collec-
tion of non-figurative European
art (unusual in Denmark) inc.
Appel, Arp, Léger and Dubuffet*.

SKAGEN

Michael and Anna Ancher's House
Markvej 2, DK-9990 Skagen.
Tel (45) 9844 3009.
In the late 19C an influential artists'
colony flourished at Skagen, where
artists flocked to paint out of doors
in the sharp northern light. At its
centre were Michael and Anna
Ancher, and their daughter Helga,
and their house shows many
Skagen school pictures, inc.
Michael Ancher's *The Girl with
the Sunflowers*, and Anna Ancher's
portrait of the Norwegian painter,
Kitty Kielland.

Skagens Museum
Brøndumsvej 4, 9990 Skagen.
Tel (45) 9844 6444
Fax (45) 9844 1810
*April: Tues to Sun 11-6, closed
Mon; May: Mon to Sun 10-5;
June-Aug: Mon to Sun 10-6;
Sept: Mon to Sun 10-5;
Oct: Tues to Sun 11-4, closed
Mon; Nov-Mar: Wed-Fri 1-4, Sat
11-4, Sun 11-3, closed Mon and Tues.*
Works by Scandinavian painters
who worked in Skagen in the late
19C. Note esp. works by P. S.
Krøyer, inc. *Summer Evening on
the Southern Beach** and *Artists'
Breakfast*, which shows the leading
members of the colony. Paintings
of fishermen by Michael Ancher,
and light-filled portraits by Anna
Ancher.

Finland

National holidays: Jan 1, Epiphany, Good Fri, Easter Mon, May 1, Ascension Day, Whit Sat, Midsummer's Day, All Saints Day, Dec 6, 24, 25. 26.
Tourist information: Matkailun Ebistamiskeskus.
Useful words: *taidemuseo* art museum.

Art in Finland

A national style developed in the decorative Symbolist paintings of Akseli Gallén-Kallela (1865-1931), who expressed in modern terms the wildness of the Finnish landscape and the romance of the Kalevala legends. The Septem Group (1912) was influenced by the brilliant colours of the Post-Impressionists; the November Group (1917), dominated by Tyko Sallinen, was a group of Expressionist painters. From the 1950s Finnish artists have responded to international artistic trends, with a tendency to lyrical abstraction rather than the extremes of hard-edge.

HELSINKI

Amos Andersonin Taidemuseo
Yrjönkatu 27, FIN-00101, Helsinki.
Tel (358 9) 684 4460
Fax (358 9) 6804 446 22
www.amosanderson.fi
museum@amosanderson.fi
Mon to Fri 10-6; Sat, Sun 11-5.
Café.
Finnish art of the 20C, small collection of 15C and 16C European paintings, and temporary exhibitions.

Didrichsenin Art Museum
Kuusilahdenkuja 1, Kuusisaari, FIN-00340 Helsinki.
Tel (358 9) 4890 55
Fax (358 9) 4891 67
www.didrichsenmuseum.fi
office@didrichsenmuseum.fi
Wed, Sat, Sun 11-5.
During special exhibitions Tues to Sun 11-6.
The highly personal collection of Marie-Louise and Gunnar Didrichsen of Finnish traditional and modern art, and international modern art is shown in an annexe and in the lovely gardens of their country home. Sculptures by Moore and Arp, paintings by Kandinsky, Picasso and Miró.

The Gesellius-Lindgren-Saarinen house, Hvitträsk, Luoma

Finnish National Gallery

The Finnish National Gallery consists of three independent museums with their own collections and exhibitions: Ateneum – the Museum of Finnish Art; Kiasma – the Museum of Contemporary Art; and Sinebrychoff – the Museum of Foreign Art.

Ateneum
Museum of Finnish Art
Kaivokatu 2,
FIN-00100 Helsinki.
Tel (358 9) 1733 6401
www.fng.fi/ateneum.htm
Tues, Fri 9-6; Wed 9-8;
Sat, Sun 11-5. Closed Mon. Café.
Predominantly Finnish art from 18C to the 1950s. Note esp. the early, naturalistic works of Gallén-Kallela (*Hand Milling* 1886) and Hugo Simberg (*The Artist's Aunt*).

Sallinen introduced Expressionism to Finland with *Washerwoman** 1911; see also his large visionary canvas *The Sectarians**. The delicate still lifes and searching *Self-Portrait* of Helene Schjerfbeck are impressive. Tirronen's *Super Girl* 1969 approaches Pop Art, Kaivanto's *Navark's Dream** romantic abstraction.

Kiasma
Museum of Contemporary Art
Mannerheiminaukio 2,
FIN-00100 Helsinki.
Tel (358 9) 1733 6501
www.kiasma.fi
Tues 9-3; Wed to Sun 10-10.
Closed Mon. Café.
A new and popular art museum, in a gleaming glass and aluminium building that reflects the northern light. A collection of post-war art

is set against lively temporary exhibitions. The museum is fully involved in exploiting the new opportunities offered by the Internet, with exhibitions of Net art, and interactive performances by groups of international artists.

Sinebrychoff
Museum of Foreign Art
Bulevardi 40,
FIN-00120 Helsinki.
Tel (358 9) 1733 6460
www.fng.fi/sinebrychoff.htm
Mon, Thurs, Fri 9-6; Wed 9-8;
Sat, Sun 11-5. Closed Tues.
A small collection of European painting, with some 16C (Francesco Salviati) and 17C works, and an emphasis on artists of the Barbizon school, Corot, Daubigny and Diaz. Large collection of miniatures.

HELSINKI ENVIRONS

Gallén-Kallela Museo
Gallén-Kallelantie 27,
FIN-02600 Espoo.
Tel (358 9) 541 3388
Fax (358 9) 541 6426
www.gallen-kallela.fi
tarvaspaa@gallen-kallela.fi
1 Sept-14 May: Tues to Sat 10-4;
Sun 10-5. Closed Mon.
15 May-31 Aug: Mon to Thurs
10-8; Fri to Sun 10-5.
The studio of Akseli Gallén-Kallela, designed by the artist, houses a collection of his paintings, graphics and industrial art.

Hvittrask
Lúoma, Kirkkonummi.
Tel (358 9) 4050 9630
Fax (358 9) 297 6033
1 June-31 Aug: daily 10-7
1 Sept-31 May: 11-6
(1 Nov-31 Mar: closed Mon).
The country house of three Finnish architects (Saarinen, Gesellius and Lindgren) that has the feeling of a creative community (a kind of Finnish Bloomsbury Group), in which every surface and corner is decorated.

TURKU

Turun Taidemuseo
(Turku Art Museum)
Puolalanpuisto,
FIN-20100 Turku.
Temporary address:
Vartiovuorenmäki,
FIN-20700 Turku.
Tel (358 2) 274 7570
Fax (358 2) 274 7599
www.turuntaidemuseo.fi
Tues to Sat 10-4, Thurs 10-7; Sun
10-6. Closed Mon.
A collection of 19C and 20C Finnish art. Works by Gallén-Kallela inc. an early naturalistic work, *Old Woman and Cat*, and the most famous of his large *Kalevala* pictures. Note also works by R. W. Ekman, Pekka Halonen, Helene Schjerfbeck and Albert Edelfelt. Gunnar Berndtson (see ill. p.68).

'April', *from the* Très Riches Heures du duc de Berry,
Limbourg Brothers, Musée Condé, Chantilly

France

Opening hours and admission: Museums: National museums are closed on Tuesdays; other museums are generally closed on Monday, open 10-12, 2.30-5. An entrance fee is usually charged; sometimes free on Sunday. Churches: most are open all day until 6; some close between 12 and 2.

National holidays: Jan 1, Easter Sun and Mon, May 1, Ascension Day, Whitsun and Whit Mon, July 14, Aug 15, Nov 1, 11, Dec 25. Museums often close on these days.

Tourist information: Office de Tourisme (Syndicat d'Initiative), Délégation Régionale.

NB Many of the French provincial museums are undergoing extensive restoration and modernization.

Useful words: basilica *basilique*; castle, or stately home *château*; cathedral *cathédrale*; chapel *chapelle*; church *église*; closed *fermé*; entrance *entrée*; exhibition *exposition*; exit *sortie*; gallery *galerie*; museum *musée*; open *ouvert*; painting *peinture, tableau*; palace *palais*; school *école*; sculpture *sculpture*; ticket *billet*; town hall *hôtel de ville*.

Quite apart from the great artistic wealth of Paris, there is also an extraordinarily rich store of treasures in provincial France, reflecting its long and varied cultural history. Avignon, for example, was a major artistic centre in the 14C as was Aix in the 15C and subsequently in the 16C and 17C when it was capital of Provence. Burgundy, with Dijon as its capital, flourished during the 15C. In all these places, remnants of former glories are to be found. In Northern France, Rubens and van Dyck painted works for the churches and convents of Lille, Cambrai, Valenciennes and Arras; the galleries in these towns are now rich in their works. Unexpected groups of Goyas can be seen at Agen and Castres. There are also many fascinating single-artist galleries; for Ingres you must go to Montauban, for Toulouse-Lautrec to Albi. You will also find many Géricaults in Rouen and Courbets in Montpellier. The French Riviera is especially rich in works by the great 20C artists.

French art

Towards the end of the 14C, International Gothic, an aristocratic style that blended decorative splendour with naturalistic detail, flourished at the court of Burgundy, throughout the 15C the most important artistic centre outside Italy. Knowledge of 15C French painting is scarce; the major painter was Jean Fouquet and there are great works by the Master of the Aix Annunciation and by the Master of Moulins. The enlightened patronage of François I (reigned 1515-47) brought France into the mainstream of European art; François Clouet painted courtly jewelled portraits; French and Italian artists working at Fontainebleau created a highly original decorative style; their elongated nudes have a stylish grace reminiscent of the work of Parmigianino.

The 17C saw both the most perfect achievements of French Classicism and the creation of the spectacular decorative style at Versailles, a tribute to the centralized autocracy of Louis XIV. Nicolas Poussin and Claude Lorrain worked in Rome. Poussin's austere works brought a new moral gravity to subjects from ancient Greece and Rome; Claude's approach to Antiquity is more poetic, and his ideal landscapes recreate the sunlit harmony of a lost Golden Age. The classical current is evident in different ways in the still and contemplative night scenes of Georges de la Tour and in the dignified genre of Louis le Nain.

Towards the end of the century a tendency towards the Baroque became more marked (de la Fosse, Jouvenet, Rigaud) and in the early 18C the grand pomp of Versailles was superseded by the grace and informality of the Rococo – developing from the touching melancholy of Watteau, creator of the *fête galante*, to the voluptuousness of Boucher. Chardin's domestic scenes, tender and serious, seem a rebuke to this frivolity and the lightness of the Rococo was soon criticized. The cult of *sensibilité* was nurtured by Diderot and Greuze; in the second half of the century Neo-Classical artists emulated the seriousness and simplicity of Roman art. The most passionately committed Neo-Classical painter was the revolutionary Jacques-Louis David; Ingres' Classicism was more sensual and more bourgeois, reconciling a search for ideal beauty with a fascination for realistic details of 19C fashions.

From 1830, the passionate imaginings of Romantic artists – the obsession with death, conflict and madness of Géricault, the energy, colour and turbulent images of Delacroix – challenged the severity of Neo-Classicism. Yet from the 1840s a new desire to be of one's own time inspired Courbet's choice of new and

An Autumn Pastoral, 1749, *François Boucher, The Wallace Collection, London*

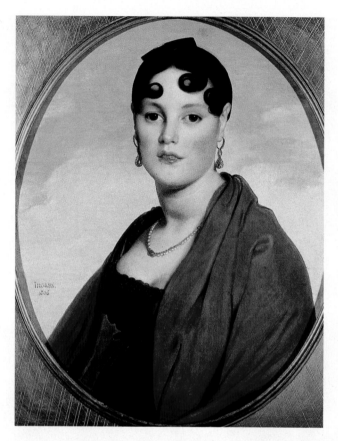

Mme Aymon ('La Belle Zélie'), *Ingres, Musée des Beaux-Arts, Rouen*

vividly realistic subjects from ordinary life and the naturalistic landscapes and peasant scenes of the Barbizon painters. The rebellious and anti-academic art of Manet in the 1860s had paved the way for Impressionism. His contemporary subjects and his sharp juxtapositions of light and shadow had scandalized the public more than the politically disturbing works of Courbet.

The second half of the 19C was dominated by Impressionism, the most significant artistic development of the century, and the beginning of modern art. The Impressionists were less concerned with social realism than with rendering visual impressions by

means of light and colour; they were chiefly landscape painters, concerned with capturing the elusive effects of light on water, coloured reflections on snow, or sunlight falling through leaves.

The greatest period of Impressionism was from 1870 to 1880, when Sisley and Pissarro painted fresh and beautifully atmospheric landscapes; Renoir and Monet painted the Seine at Argenteuil. Later Monet, the most passionately committed to visual truth, painted a series of pictures in which the object is seen at different times of day under different weather conditions. Renoir, whose art has an 18C charm, painted nudes, portraits and radiant scenes of contemporary life,

In this decade Manet and Degas were loosely associated with Impressionism but they were not landscape painters. They had a wider range of subject (ballet dancers, laundresses, cafés, brothels, etc) and tried to create a new kind of composition dependent on unexpected viewpoints, close-ups and figures abruptly cut off by the frame to capture the dynamism of urban life. With the openly political *Execution of the Emperor Maximilian* Manet created a new kind of modern history painting.

Execution of the Emperor Maximilian, 1867,
Edouard Manet, Städtische Kunsthalle Mannheim

Te Rerioa (The Dream), Paul Gauguin,
Courtauld Institute Gallery, London

Impressionism was a short-lived movement and by the 1880s the limitations of an art founded on pure perception were felt both by the Impressionists themselves and by younger artists. Gauguin, Redon and their Symbolist followers brought back into art the world of dreams and of the imagination, using colour and line to express states of mind, Van Gogh's fevered line and dramatic use of pure colour led on to Fauvism and Expressionism; both Cézanne and Seurat were concerned, in different ways, to give a deeper reality to the ephemeral discoveries of the Impressionists. Toulouse-Lautrec painted with a lurid *fin-de-siècle* melancholy the world of the brothel, cabaret and music-hall.

Detail, The Gates of Hell, *Auguste Rodin, Musée Rodin, Paris*

Westminster, 1906, *André Derain, Musée de l'Annonciade, Saint-Tropez*

From the 1890s until the second world war Paris became the international centre of the avant garde. In the 1890s the Nabis (Bonnard, Vuillard) explored flat patterns of colour and rhythmic line. Fauvism (Matisse, Derain, Vlaminck) activated colour, while the Cubism of Braque and Picasso explored a new language of space and volume. The 1920s and 30s were dominated by Dada and Surrealism. After the war the giants of Modernism - Léger, Braque, Matisse, Picasso – were revered, and continued to create new forms. The 50s and 60s were dominated by the art brut of Jean Dubuffet, and by the Nouveau Réalisme group. Yves Klein, Arman, and Martial Raysse inspired the creative climate of the Ecole de Nice, with its emphasis on art made from junk and scrap metal, and mass produced items. Most famous are the mono-chrome blue paintings of Yves Klein. Among contemporary artists Daniel Buren is known for installations of white and coloured stripes, and Christian Bołtański for monuments and memorials dealing with death. A group of younger artists (Claude Closky, Rebecca Bournigault) are fascinated by the trivia of everyday life, while others (Matthieu Laurette, Marie Sester) work in video.

AGEN

Musée des Beaux-Arts
Place du Docteur Picuse-Esquivol,
47916 Agen.
Tel (33 3) 53 69 47 23
Fax (33 3) 53 66 25 61
yannick-linz@ville-agen.fr
Wed to Mon 11-6; Thurs 11-8.
Closed Tues.
Interesting works by Goya*, esp. his *Self-Portrait*; some good 18C paintings and a few Impressionist paintings.

AIX-EN-PROVENCE

Aix enjoyed a period of great splendour during the reign of Prince René of Anjou (1442-80), who was famous as both poet and painter, and is said to have introduced to Provence the methods of Flemish painters; his court painter was Nicolas Froment. Two of the most celebrated and beautiful French 15C paintings remain in churches in Aix.

Cathédrale de St-Sauveur
Nicolas Froment's strange and beautiful *Triptych of the Burning Bush**; on the wings are powerfully realistic portraits of Prince René and his wife. The triptych is kept locked, and can usually only be seen for a few minutes as part of a tour or with permission from the caretaker.

Musée Granet – Palais de Malte
Place Saint Jean de Malte,
13100 Aix-en-Provence.
Tel (33 4) 42 38 14 70
Fax (33 4) 42 26 84 55
Wed to Mon 10-12, 2-6.
Closed Tues.

The highpoint of the collection is Ingres' *Jupiter and Thetis** and his stormy and dashing portrait of his friend, the painter François Marius Granet*. Granet's own sketches of Roman sites echo the background of Ingres' painting. Other charming studies of Rome by French artists inc. Didier Boguet's *View from the Villa Aldobrandini.*
French school inc. works by Clouet and the School of Fontainebleau*; some good 17C and 18C inc. Le Nain and Rigaud; 20C opens with eight works by Cézanne.
Dutch and Flemish: primitives; Rubens (inc. an unusual pair of early portraits and the late *Beheading of St Paul**). Dutch landscape and genre paintings (esp. good minor works) are beautifully displayed. A small, sketchy *Self-Portrait** by Rembrandt, until recently believed to be a 19C picture.
Italian: 17C and 18C works.

St Marie Madeleine
The *Annunciation*** c.1442 by the Master of the Aix Annunciation (?Jean Chapus, active c.1400-50).

AIX-EN-PROVENCE ENVIRONS

Fondation Vasarély
Avenue Marcel Pagnol,
13090 Aix-en-Provence.
Tel (33 4) 42 20 01 09
Fax (33 4) 42 59 14 65
www.fondationvasarely.com
1 Jul-30 Sept: daily 10-7
1 Oct-30 June: Wed to Mon 9.30-12.30, 2-6. Closed Tues.

A building and exhibition devoted to the works of Vasarély. The building is made up of seven hectagons that open into one another so that the whole environment echoes Vasarély's works. Upstairs, in push-button show cases, are his architectural projects and large photos of his public commissions.

AIX-LES-BAINS

Musée du Docteur Faure
Bd des Côtes, 73100 Aix-les-Bains.
Tel (33 4) 79 61 06 57
Fax (33 4) 79 88 49 38
Daily, except Tues, 10-12, 1.30-6.
A delightfully undemanding museum in which a small but high quality collection of 19C pictures and sculptures are attractively arranged. The most splendid works are by Degas (a late pastel*) and Vuillard*, but the collection is predominantly of quietly attractive landscapes of the 1860s and 70s – there are paintings by Boudin, a wall of works by Jongkind, small Pissarro sketches and watercolours, a Sisley, unexpected and beautiful works by less well-known artists (Cottet, Vignon) and some lovely studies of the Seine by Lépine. Works by Rodin.

AJACCIO CORSICA

Musée-Palais Fesch
Rue Cardinal Fesch 50-52,
2000 Ajaccio.
Tel (33 4) 95 21 48 17
Fax (33 4) 95 50 13 84
Mon to Sun 9-12, 2.30-6

Winter: 2-5.
The most important collection in France, after the Louvre, of early Italian painting and of Italian still lifes from the 17C and 18C. Works by Botticelli, Giovanni Boccati, Lorenzo di Credi, Titian and Cosmè Tura. Also Poussin. The paintings were collected by Cardinal Fesch, Napoleon's uncle, and there is also a large Napoleonic section with works by Vernet and Sablet.

ALBI

Musée Toulouse-Lautrec et Galerie d'Art Moderne
Palais de la Berbie, 81000 Albi.
Tel (33 5) 63 49 48 70
Fax (33 5) 63 49 48 88
mairie.albi@inlink.fr
Oct: Wed to Mon 10-12, 2-5.30,
closed Tues; Nov-Jan: Wed to
Mon 10-12, 2-5, closed Tues;
Mar: Wed to Mon 10-12, 2-5.30,
closed Tues; Apr-May: daily 10-
12, 2-6; June-Sept: daily 9-12,
2-6; July-Aug: daily 9-6.
A large but low key collection of drawings, paintings and posters by Toulouse-Lautrec, housed in the gloomy rooms of the former episcopal palace, with a charming view of the formal gardens from the terrace. Many juvenilia, including landscapes and hunting scenes on wood. Highpoints are *The Milliner**, dominating a room of slightly dull portraits of women; a brothel scene, *In the Salon at the des Moulins**; and witty studies of Yvette Gilbert in astonishing yellow gloves. Also a dreary collecton of 20C French art.

The modern art museums of the Riviera

This corner of France, where many of the greatest 20C artists lived and worked, makes a fascinating tour through lovely countryside with little hilltop towns to see works that are either still in situ or in museums specially created for them.

Begin the tour at **Vallauris**, a Communist pottery-making town which Picasso found in decline in 1947 and to which he gave new artistic life and popularity by decorating the Temple of Peace with murals and ceramics which depict fauna, goddesses and bulls. Then drive to **Antibes** where Picasso re-discovered the Hellenic beauty of the Mediterranean after the dreary war years. His paintings in the Picasso Museum, joyously pagan, with a light and springing line, reflect his new freedom. Turn inland to **Biot**: the Léger museum was designed to display his mosaic which covers the 40m façade; a vast quantity of Léger's works is shown in white-washed rooms lit by wide expanses of glass.

Drive on to the wonderful sculpture garden of the Maeght Foundation at **St Paul-de-Vence**, with its superb views, and Matisse's chapel at Vence (NB open only on Tuesday and Thursday), the culmination of his late simplified style. Even Picasso, not given to admiring anyone else, grudgingly acknowledged the greatness of Matisse's achievement. St Paul first came to prominence thanks to the entreprise of an energetic hotelier, Paul Roux. His small inn founded just after the First World War began to attract the cream of the Parisian avant-garde. Roux not only began to accept paintings in lieu of payment, he even began to buy them himself. As a result, Picasso called him 'Roux the Magnificent' and his inn, now called the Colombe d'Or became famous for its superb art collection (Matisse, Dufy and many others). Sadly, St Paul is far from being an unspoilt Provençal village and the Colombe d'Or today is a four-star hotel, where tourists are now obliged to stay or to eat (expensively) if they want to see the collection.

After St Paul, head back to the coast and on to the Matisse and Chagall museums at **Nice**.

La Fourche, *Joan Miró,*
Fondation Maeght, St Paul-de-Vence

AMIENS

Musée de Picardie
48 rue de la République,
80000 Amiens.
Tel (33 2) 22 91 36 44
Fax (33 2) 29 92 51 88
Tues to Sun 10-12.30, 2-6.
Closed Mon.

An ostentatious museum. The most remarkable feature is the decoration of the grand staircase – huge paintings on canvas by Puvis de Chavannes set into the walls. In the gallery are two large works, *Bellum and Concordia* 1861 also by Puvis. There is an assortment of other 19C works, mostly bad but interesting. Otherwise the main emphasis is on French 18C painting** inc. works by Boucher, Chardin, Quentin de la Tour's *Self-Portrait*, Fragonard and Hubert Robert; 9 hunting scenes* from Versailles by Boucher, Parrocel, Van Loo, Peter, Lancret and de Troy. Also some interesting primitive works from northern France. Good collection of 19C and 20C French art. Other artists inc. Hals, El Greco*, Van Goyen and Ribera*.

ANTIBES

Musée Picasso
Château Grimaldi,
06600 Antibes.
Tel (33 4) 92 90 54 20
Fax (33 4) 92 90 54 21
musee.picasso@antibes.juanles-pins.com
Mon to Sun 10-6;

Winter: Wed to Mon 10-12, 2-6.
Closed Tues.

In 1946 Picasso returned to Antibes with his new mistress, Françoise Gilot, and a museum director encouraged him to work in the ancient palace of the Grimaldi. He decorated the museum in two months with 22 panels (on hardboard – canvas was scarce) ranging in subject from studies of the local people to the large *Joie de Vivre** and the later work *Ulysses and the Sirens*. All Picasso's works of this period are in the museum – drawings, ceramics, sculptures, lithographs. Other works inc. Léger, Calder, Hartung.

ARRAS

Musée d'Arras, Ancienne Abbaye de Saint-Vaast
22 rue Paul-Doumer,
62000 Arras.
Tel (33 3) 27 71 26 43
Fax (33 3) 21 23 19 26
musee.arras@wanadoo.fr
Fri to Tues 10-12, 2-6;
Wed 10-12, 3-6; Thurs 10-6.
Closed Mon.

A large collection with the main emphasis on Dutch and Flemish painting from the 12C to 18C and on French painting of the 17C and 18C inc. works by Vignon, Philippe de Champaigne, Jouvenet, Lebrun, La Hyre. Joseph Parrocel's *St John the Baptist Preaching* has freedom and brilliance of colour rare at that period (1694). The Salle des Mays is a new gallery

Opposite: Martyrdom of St Matthew, *Claude Vignon, Musée d'Arras*

showing huge religious paintings for Notre Dame de Paris. Also works by Corot and Delacroix, and vast salon paintings.

AUTUN

Musée Rolin

Hôtel du Chancelier Rolin,
3 rue des Bancs, 71400 Autun.
Tel (33 3) 85 52 09 76
Fax (33 3) 85 52 47 41
Mar-Sept: Wed to Mon 9.30-12,
2.30-7; Oct-Mar: Wed to Mon
10-12, 2-4. Closed Tues.

A charming museum, mainly of Romanesque sculpture, but also a *Nativity** attributed to the Master of Moulins.

AVIGNON

In 1305 Clement V, former Archbishop of Bordeaux, made Avignon the Papal seat; he was succeeded by seven French popes, and Avignon became one of the most important artistic centres in Europe. The many churches and the magnificent Papal palace bear witness to the glories of its past. Simone Martini worked in Avignon in 1340-41. From 1440 the town became the centre of a highly original school of French painters. Its founder was Enguerrand Charonton, whose compositions have a monumental simplicity and grandeur; the minute realism of the Flemish tradition is tempered by a sense of abstract design closer to Italian art.

Musée Calvet

65 rue Joseph Vernet,
84000 Avignon.
Tel (33 4) 90 86 33 84
Fax (33 4) 90 14 62 45
musee.calvet@wanadoo.fr
Wed to Mon 10-1, 2-6.
Closed Tues.

A series of large paintings by Hubert Robert, Vernet and Panini are displayed in charmingly faded 18C rooms overlooking the elegant courtyard of the Hôtel de Villeneuve-Martignan. Also works by Mignard, Parrocel, Chassériau and an unusual David*; works by Soutine, Utrillo, Vlaminck.

Musée du Petit Palais

Place du Palais des Papes,
84000 Avignon.
Tel (33 4) 90 86 44 58
Fax (33 4) 90 82 18 72
musee.petitpalais@wanadoo.fr
Oct-May: 9.30-1, 2-5.30
June-Sept: 10-1, 2-6.

The collection of Italian paintings from the 13C to 16C and paintings and sculptures from Avignon (12C to 16C) is superbly displayed in the beautiful and appropriately Italianate palace. A remarkable collection of paintings from the rare **School of Avignon** inc. 14C frescoes from Sorgues; Charonton's *Virgin and Child between Two Saints**. Italian collection inc. works by Taddeo Gaddi, Pietro di Domenico da Montepulciano, Giovanni di Paolo, Botticelli, Carpaccio.

Opposite: Shipwreck, *Claude-Joseph Vernet, 1777, Musée Calvet, Avignon*

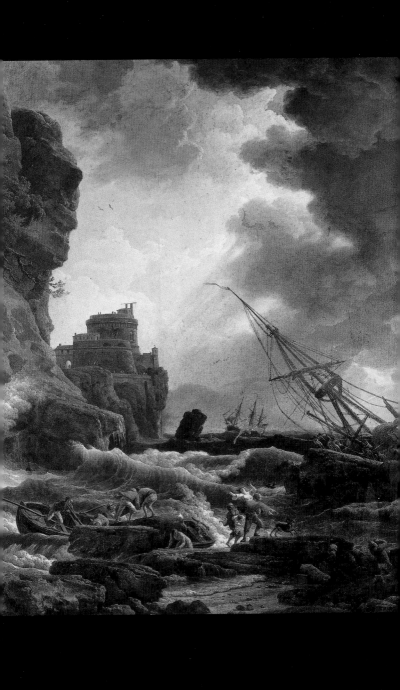

Interior, Musée Bonnat, Bayonne

Palais des Papes
Place du Palais des Papes,
89000 Avignon.
Tel (33 4) 90 86 03 32
Fax (33 4) 90 86 61 21
July, Aug: guided tours every 30
mins from 8-11.30, 2-7
(in English at 10.15 and 3.45).
1 Nov-30 Apr: at 9, 10, 11, 2, 3
and 4 (also at 5 in May; also at 6
in June).

The most interesting paintings in
the palace, exhibited in the **Salle
des Festins**, are the sinopie of fres-
coes by Simone Martini painted
for Notre-Dame-des-Doms. The
chapel of **St Martial** was decorated
by Matteo Giovanetti da Viterbo in
the pontificate of Clement VI. In
the Palais-Neuf the Chambre du

Cerf (the wardrobe room) is decorated with lively scenes of fishing and hunting by painters of the French school (c.1343).

BAYONNE

Musée Bonnat
5 rue Jacques Laffitte,
64100 Bayonne.
Tel (33 5) 59 59 08 52
Fax (33 5) 59 59 53 26
Wed to Mon 10-12.30, 2-6.
Closed Tues. Café.
The nucleus of the museum is the collection formed by the painter Bonnat, with many of his works. The highpoints are one of the most important collections of Rubens in France, inc. several sketches* for the Torre de la Parada, amongst his most spontaneous works; Spanish painting, with works by El Greco, Goya and Ribera; and early 19C French painting, inc. David, Degas, Delacroix, and a large number of works by Ingres and Géricault.

BEAUNE

Hôtel-Dieu
Rue de l'Hôtel Dieu,
21200 Beaune.
Tel (33 3) 80 24 45 03
Fax (33 3) 80 24 45 99
Mon to Sun 9-11.15, 2-4.15.
Guided tours compulsory.
Roger van der Weyden's *The Last Judgement*** commissioned by Nicolas Rolin, Chancellor of the Duchy of Burgundy, for the Hôtel-Dieu, founded by him in 1442. The painting brought before the eyes of the sick the terrors of the future; the treatment of the Good and the Wicked is unusually human and tender. The painting originally hung in the chapel at the end of the paupers' ward, which both retain all the beautiful detail of their original appearance.

BESANÇON

Musée des Beaux-Arts
1 Place de la Révolution,
25000 Besançon.
Tel (33 4) 81 82 39 89
Fax (33 4) 81 81 81 09
Wed to Mon 9.30-12, 2-6.
Closed Tues.
French: paintings from the 16C to 19C, inc. a series of chinoiseries by Boucher; 19C inc. an important series by Courbet*, David and Ingres. 20C inc. Bonnard, Matisse, Marquet.
Italian: Bellini*, Bronzino**.
Other schools inc. Cranach, Goya*, and many Flemish and Dutch still lifes. Zurbarán.

BIOT

Musée National Fernand Léger
Chemin du Val de Pome,
06410 Biot.
Tel (33 4) 92 91 50 30
Fax (33 4) 92 91 50 31
Summer: Wed to Mon 10-6.
Closed Tues. Winter: 10-12.30, 2-5.30. Café in summer.
A complete survey of the work of Fernand Léger from 1905 to 1955; bronzes, tapestries, mosaics, ceramics as well as paintings and drawings.

BORDEAUX

Musée des Beaux-Arts
*Jardin de la Mairie, 20 Cours
d'Albret, 33000 Bordeaux.*
Tel (33 5) 56 10 20 56
Fax (33 5) 56 10 25 13
*www.culture.fr/culture/bordeaux
musbx@mairie-bordeaux.fr*
*Thurs-Mon 11-6; Wed 11-8.
Closed Tues.*
One of the richest provincial museums, with pictures of all schools: a special emphasis on the 18C and 19C.
French: 17C inc. a fine series of Caravaggesque works, esp. Aubin Vouet's provocative *David with the Head of Goliath.* 18C inc. Chardin, Quentin de la Tour, Nattier, Perroneau. 19C inc. Delacroix, Gros, Redon*. From the 20C many works by Lhote, Marquet, and Rouault. Sculptures by Carpeaux and Despiau.
Flemish and Dutch: 17C Dutch paintings esp. Van Goyen and Terbrugghen.
Italian: 16C Venetian painting; Pietro da Cortona.

CAPC Musée d'Art Contemporain
*Entrepôt, 7 rue Ferrère,
33000 Bordeaux.*
Tel (33 5) 56 00 81 50
Fax (33 5) 56 44 12 07
*www.mairie-bordeaux.fr/musees/
capc/capc.htm
capc@mairie-bordeaux.fr*
*Tues to Sun 11-6; Wed 11-8.
Closed Mon. Café.*
In a vast converted warehouse, this collection concentrates on both French and International art of the last thirty years; it shows the major movements of the 1970s, Land Art, Arte Povera and Conceptual art, and the Transanvanguardia of the 1980s. There is a special emphasis on Richard Long, Mario Merz, Sol LeWitt and Christian Bołtanski.

BROU

L'Eglise de Brou
Daily.
Chapel of Margaret of Austria**: tombs of Margaret of Austria and Philibert of Savoy with effigies by Conrad Meit. Panofsky has called this chapel 'the most enchanting of all places dedicated to the memory of the dead'.

CAEN

Musée des Beaux-Arts
*Esplanade du Château,
14000 Caen.*
Tel (33 2) 31 85 28 63
Fax (33 2) 21 79 16 47
mba@ville-caen.fr
www.ville-caen.fr/mba
Mon to Sun 9.30-6. Closed Tues.
A light and airy modern gallery is tucked inside the precincts of William the Conqueror's castle. A rich collection with an emphasis on Italian, and Flemish and French 17C painting.
Flemish: Van Dyck, Jordaens, Rubens.
French: 17C inc. Poussin's *Death of Adonis** and Philippe de Champaigne's *Vow of Louis XIII*; 19C landscape paintings. Good 18C paintings inc. Boucher. 20C inc. good collection of French Cubists.
Italian: Perugino*, Veronese*, Tiepolo.

CAGNES-SUR-MER

Le Musée Renoir
Le Domaine des Collettes,
Avenue des Collettes,
06800 Cagnes-sur-Mer.
Tel (33 4) 93 20 61 07
May-Sept: Wed to Mon 10.30-
12.30, 1.30-6; Oct-Apr: Wed to
Mon 10-12, 2-5. Closed Tues and
three weeks in Oct to Nov.
Renoir, old and ill, moved here in
1903, and it is most worth visiting
for the charm of the gardens, which
still evoke his presence. Also 11
original pictures, inc. *Coco Reading.*

CASTRES

Musée Goya
Hôtel de Ville, B.P. 406,
81108 Castres.
Tel (33 5) 63 71 59 30
Fax (33 5) 63 71 59 26
www.ville-castres.fr
goya@ville-castres.fr
Sept-June:Tues to Sun 9-12, 2-6;
July-Aug: Mon to Sun 9-12, 2-6.
An unexpected coll. of Spanish
painting, with the attractively
heavy and old fashioned atmos-
phere of a 19C collection. Goya's
vast and threatening *The Royal
Philippine Company in Secession**
stands out, but also important
works by Pacheco, Ribera; Goya
prints.

CHANTILLY

Musée Condé
Château de Chantilly,
60500 Chantilly.
Tel (33 3) 44 62 62 62
Fax (33 3) 44 62 62 61
museeconde.chantilly@wanadoo.fr
1 Mar-31 Oct: 10-6; 1 Nov-28 Feb:
10.30-12.45, 2-5. Closed Tues.
The most famous work of art at
Chantilly is the *Très Riches Heures
du Duc de Berry*** c.1410, commis-
sioned from the workshop of the
Limbourg brothers; it combines all
the elegance and gaiety of the Inter-
national Gothic with a direct realism
that anticipates Brueghel, see ill. p.72.
(Good facsimiles are displayed.)
Also 40 miniatures by Fouquet for
the *Heures d'Etienne Chevalier*.*
French works inc. a superb series
of 16C portraits; a group of 7 paint-
ings by Poussin*, most beautiful
is the Titianesque *Youth of
Bacchus*; 18C inc. 4 pictures by
Watteau; early 19C inc. Delacroix
and Ingres*.
Italian: works by Piero di
Cosimo**and Raphael*. 17C inc. a
series of hideous religious paint-
ings by Rosa. Also Flemish, Dutch
and English works.

CHERBOURG

Musée Thomas Henry
*Hôtel de Ville, Place de la
République, 50100 Cherbourg.*
Tel (33 2) 33 23 02 25
Fax (33 2) 33 23 02 27
Tues to Sun 9-12, 2-6. Closed Mon.
The main emphasis is on the
French school inc. Chardin, David,
and Millet*. Millet was born near
Cherbourg and in 1840, after three
years in Paris, returned there to
paint the provincial bourgeoisie.
The gallery has a good collection of
his early portraits; the earliest (such
as *Armand Ono* 1841) are austere,

direct, and simply posed; *Armand Ono, the Man with a Pipe* 1843, is more relaxed and painterly; the strange *Madame Simon de Vaudeville and her Mother, Madame Deslongchamps* is yet more sensuously handled and compositionally complex. Also some Spanish, Italian (esp. Fra Angelico* and Filippo Lippi) and Netherlandish paintings (esp. Master of St Ursula).

COLMAR

Musée d'Unterlinden
1 Place d'Unterlinden,
68000 Colmar.
Tel (33 3) 89 20 15 50
Fax (33 3) 89 41 26 22
info@musee-unterlinden. com
1 Apr-31 Oct: daily 9-6;
1 Nov-31 Mar: Wed to Mon 10-5.
Closed Tues.
Grünewald's *Isenheim Altarpiece****. An altarpiece with a shrine, carved by Nicolas Hagnover, with a series of movable painted wings; now displayed so that all the panels may be seen. One of the greatest paintings of the Western tradition. On the outer wings, the brutal *Crucifixion* in which every detail heightens the passionate intensity of Christ's suffering; behind, in radiant light and colour, the *Nativity* and *Resurrection*; the *Temptation of St Anthony*, a horrifying depiction of the monsters and syphilitic demons that haunted the late medieval world; the *Meeting of St*

Anthony and St Paul the Hermit. Also works by Schongauer; Lucas Cranach the Elder's famous *Melancholy (*1532) (See opposite). A collection of 19C and 20C art inc. Renoir, Bonnard and Picasso.

DIJON

In the late 14C the prosperous Duchy of Burgundy with its capital at Dijon challenged the power of France; Philip the Bold and his brother, Jean, Duc de Berry, were great patrons of the arts. In the 1380s Philip the Bold founded the Chartreuse de Champmol (now a hospital), and many of the leading artists of the time worked there. Most celebrated is the sculptor Claus Sluter whose works are more monumental and more vividly realistic than those of his Gothic predecessors.

Chartreuse de Champmol
Hôpital de Chartreuse, 1
Boulevard Chamoine Kir, Dijon.
Tel (33 4) 80 43 23 23
Mon to Sun 8.30-11.30, 2-5.30.
Remnants of the great works of Claus Sluter may be seen in the hospital grounds; the majestic portal with its powerfully realistic donor portraits (1391-97), and the *Well of Moses***, once the base of a huge Calvary; six massive, dramatically life-like figures of Prophets grieve over the forthcoming Passion of Christ.

Opposite: Melancholy, *Lucas Cranach the Elder, 1532,*
Musée d'Unterlinden, Colmar

Musée des Beaux-Arts

Palais des États de Bourgogne,
1 Rue Rameau, B.P. 1510,
21033 Dijon.
Tel (33 3) 80 74 52 70
Fax (33 3) 80 74 53 44
www.ville-dijon.fr
museedesbeauxarts@ville-dijon.fr
Wed to Mon 10-6. Closed Tues.
The buildings and museum's collection suggest the courtly splendour of 15C Burgundy. Outstanding are works executed for the Chartreuse de Champmol inc. a carved altarpiece by Jacques de Baerze with wings* painted by Melchior Broederlam (an early example of International Gothic, most original in its treatment of light on landscape) and tombs** designed by Claus Sluter celebrated for the expressive power of the procession of mourners. Other works inc. French painting from 16C to 19C, esp. works by Georges de la Tour, Philippe de Champaigne, Nattier (portrait of *Marie Leczinska*), Manet, Rigaud and Prud'hon's powerfully proto-romantic portrait of *Monsieur Anthony**; a good collection of Swiss and Rhenish primitives (inc. Konrad Witz); a *Nativity*** by Robert Campin. Also **Dutch** and **Flemish** 16C and 17C paintings; **Italian** works inc. Sassetta, Lotto and Luini. 20C inc. Delaunay, Gris, Kandinsky.

The Guard Room in the Dijon Museum 1847, *Auguste Mathieu, Musée des Beaux-Arts, Dijon*

97

FONTAINEBLEAU

Le Palais
77300 Fontainbleau.
Tel (33 1) 60 71 50 70
Fax (33 1) 60 71 50 71
Nov-Apr: Wed to Mon 9.30-
12.30, 2-5; May-June: Wed to
Mon 9.30-5; July-Aug: Wed to
Mon 9.30-6; Sep-Oct: Wed to
Mon 9.30-5. Closed Tues.

The most beautiful of the build-
ings were erected by François I
(reigned 1515-47). In the 1530s he
called the Italians Rosso, Primat-
iccio and Niccolò dell'Abbate to
Fontainebleau where they created
a new and brilliant kind of decora-
tion – an ingenious and highly
elegant combination of painted
panels and stucco ornament and
sculpture. The series of rooms
decorated by them remain the chief
glory of the palace, despite damage,
loss and heavy restoration. The
Galerie François I* was Rosso's
main work (*c.*1533-40); it is deco-
rated with mythological paintings
and allegories and an extraordinary
variety of beautiful stucco motifs.
After the death of Rosso, Primat-
iccio decorated the **Chambre de
la Duchesse d'Etampes*** and the
Salle de Bal (much restored); these
works have a new grace and
extreme refinement close to the
styles of Parmigianino and Cellini.
Under Henri IV, artists of the
Second School of Fontainebleau
attempted to revive their style; the
best survival is Ambrose Dubois'
Theagenes and Chariclea cycle in
the **Salle Ovale**. The **Salle du
Conseil** is decorated by Boucher.

GORDES

Musée Didactique Vasarély
Château de Gordes,
84220 Gordes.
Tel (33 4) 90 72 02 89
Mon to Sun 10-6.

Vasarély's brilliantly coloured
tapestries line the walls of one of
the rooms in this 16C château.
Many of his works are shown in
sequence, in push-button show-
cases, and a fascinating collection of
his early works show his develop-
ment towards Op Art.

GRENOBLE

Musée de Peinture et de Sculpture
5 Place de Lavalette, 38000 Grenoble.
Tel (33 4) 76 63 44 44
Fax (33 4) 46 63 44 10
Daily, except Tues, 11-7;
Wed 11-10. Café.

A major museum, with a series of
outstanding 17C masterpieces and
an important collection of modern
art. The gallery is an odd mixture
of decaying grandeur and frag-
ments of ultra-modern décor; the
heavy marble stairs are hung with
large Pop Art paintings, inc. a fine
Wesselmann.

French: a good collection of 17C
painting inc. outstanding works by
Claude*, Georges de la Tour* and
Philippe de Champaigne*. 19C
opens with a group of early land-
scapes; David and Delacroix's *St
George**. An unusual group of
portraits by Fantin-Latour*; Monet;
Neo-Impressionists. A fine collec-
tion of Fauve painting is dominated
by Matisse; most splendid is his

large *Interior with Aubergines***
1911. A glowing Bonnard*; Vuil-
lard; Picasso's *Woman Reading*
1921; examples of Surrealism,
Cubism, École de Paris, Expres-
sionism.

Flemish: dominated by Rubens'
*St Gregory and Domitilla***, a semi-
nal work (1607-8) in which the
ecstatic expressions, billowing
draperies and glowing colour
herald the full Baroque.

Italian: Perugino; 16C Venetian;
Canaletto and Guardi.

Spanish: Ribera, and four cele-
brated paintings by Zurbarán**.

LILLE

Musée des Beaux-Arts
Le Palais des Beaux Arts de Lille,
Place de la République,
59000 Lille.
Tel (33 3) 32 06 78 00
Fax (33 3) 20 06 78 15
consvmba.lille@wanadoo.fr
Mon 2-6; Wed, Thurs, Sat, Sun
10-6; Fri 10-7. Closed Tues. Café.
A rich new display of a remark-
ably diverse major collection. Most
celebrated are two paintings by
Goya* and a large collection of
French 18C and 19C paintings and
sculptures.

French: Chardin; small and attrac-
tive sketches by Boilly*; an
important group of paintings by
David*, Delacroix* (*Medea*, and
an unusual flower painting) and
Courbet*. Uninspiring Impres-
sionist pictures but note Manet's
portrait of *Berthe Morisot*.

Italian: Liss, *The Finding of Moses**

Netherlandish: 17C Flemish esp.
strong, with altarpieces by

Rubens*, Jordaens and Van Dyck*;
Dutch landscape and genre inc. an
unusual Jacob Vrel.

A rich Renaissance gallery of
sculptures and paintings inc. Dirk
Bouts* and Donatello*.

LYON

Musée d'Art Contemporain
81, Cité Internationale,
69006 Lyon.
Tel (33 4) 72 69 17 18
Fax (33 4) 72 69 17 00
www.moca-lyon.org
mac@mairie-lyon.fr
Tues to Sun 12-7. Closed Mon. Café.
A new, state of the art museum,
part of the Cité Internationale, with
offices, hotels, cinemas, all designed
by Renzo Piano. From the covered
arcade outside the visitor sees,

Boxing Cat, 1996, Alain Séchas
Musée Art Contemporain, Lyon

through a vast glass wall, a wall of video images, criss-crossed by stairs and figures moving up and down, against the still flat surfaces of monochrome paintings. It creates a new kind of urban environment, where art and life, interior and exterior, mix and blend. It has a vast collection of specially commissioned installation art by Paolozzi, Bołtański, Merz, Viola etc.

Musée des Beaux-Arts

Palais St Pierre, 20 Place des Terreaux, 69001 Lyon.
Tel (33 4) 72 10 17 40
Fax (33 4) 78 28 12 45
www.mairie-lyon.fr
Wed to Mon 10.30-6.
Closed Tues. Café.

An enormous major museum, authoritatively displayed in an ancient Benedictine convent, with good works from all periods and schools. Puvis de Chavannes was Lyonnais, and his vast stairwell murals**, poetic evocations of a lost classical world, are perhaps his most successful works.

French: 17C and 18C inc. very large pictures by Jouvenet and Le Brun; Philippe de Champaigne; three large and splendid Vouets. The early 19C is a highpoint, with Delacroix's *Odalisque*, Géricault's *Madwoman*, a wall of Corots. Degas' pastel *Aux Ambassadeurs*, witty and sharp, with dazzling effects of light and colour, dominates a collection of Impressionist and Post-Impressionist works. 20C inc. Vlaminck, Braque, Picasso, Chagall's *Le Coq**.

Dutch and Flemish: A small Quentin Metsys**, vivid with tiny detail; Rubens, Jordaens, an early

and unusual Rembrandt, *The Stoning of St Stephen*, in which all the torturers look like Rembrandt himself. Good collection of still life, inc. Jan Breughel.

Italian and Spanish: Veronese* and Zurbarán*, but outshone by the 17C Italian collection, which inc. good works from all the regional schools, some by rare painters. Highpoints are the Pietro da Cortona**, a light and transparent Reni**, a majestic Guercino**, and a dark, exotic mythological work by Luca Giordano**.

In the chapel, exploiting its varied levels, a display of 19C French sculpture.

MARSEILLE

Musée des Beaux-Arts

Palais Longchamp, 13004 Marseille.
Tel (33 4) 91 14 59 30
Fax (33 4) 91 14 59 31
1 Oct-31 May: Tues to Sun 10-5
1 Jun-30 Sep: 11-6. Closed Mon.

Housed in an ornate Second Empire Building with a monumental staircase (and frescoes by Puvis de Chavannes), the collection consists mainly of the French school, 17C and 19C. Superb range of drawings and sculptures by Puget. Daumier is represented by lithographs and sculptures. Also paintings by Perugino*, Rubens* and David.

MONTAUBAN

Musée Ingres

Ancien Palais des Evêques, 19 rue de l'Hôtel-de-Ville,

82000 Montauban.
Tel (33 5) 63 22 12 91
Fax (33 5) 63 92 16 99
July-Aug: daily 9.30-12, 1.30-6
Sept-June: Tues to Sun 10-12, 2-6.
Closed Mon.

An unrepresentative collection of Ingres, mostly very early (five portraits) or very late, displayed in a cavernous bishop's palace; note especially the weird *Dream of Ossian* and the portrait drawing of *Madame Ingres*. Alaux's *Ingres' Roman Studio* is full of atmosphere, and Ingres' own art collection, fascinatingly diverse, is also displayed. Large, dreary collection of Bourdelle.

Cathédrale

Ingres' *Vow of Louis XIII* is a homage to Philippe de Champaigne and Raphael.

MONTPELLIER

Musée Fabre

39, Boulevard Bonne Nouvelle,
34000 Montpellier.
Tel (33 4) 67 14 83 00
Fax (33 4) 67 66 09 20
musee.fabre@ville-montpellier.fr
www.ville-monpellier.fr
Tues to Fri 9-5.30; Sat, Sun 9.30-5.

Most fascinating is the collection of the rich and eccentric Alfred Bruyas,

Bonjour Monsieur Courbet, *Gustave Courbet, Musée Fabre, Montpellier*

The Flea Catcher, *Georges de la Tour,*
Musée Historique Lorrain, Nancy

whose paintings by contemporaries – Delacroix and Géricault, Corot and Courbet – were the most up-to-date of his time. Courbet's *Bonjour Monsieur Courbet*** (see ill. p.101) shows the svelte Bruyas paying homage to the unfettered genius of Courbet, the wandering Bohemian. Yet it is the centrepiece of a group of portraits (inc. one by Delacroix) which flatter Bruyas himself. Other paintings show him enjoying a picnic (this work by Glaize), chatting to artists in the studio, and discussing his collections with connoisseurs. The 15 canvases by Courbet inc. the romantic *Man with a Pipe** and the *Portrait of Baudelaire**. Fine works by Géricault and Delacroix inc. the latter's second version of the *Women of Algiers**. Interesting works by Bazille. Earlier French pictures inc. an unusually erotic early Poussin*; La Hyre; Bourdon; Vouet. A room of 18C paintings, all Prix de Rome winners: Aved's *Portrait of Madame Crozat** 1741, important groups of works by Houdon* and Greuze*. 19C and 20C paintings. Also a good collection of Old Masters of other schools inc. Veronese*; Zurbarán; a Rubens sketch*; a good collection of Dutch and Flemish landscape and genre* inc. Potter, Dou, Metsu and Steen.

NANCY

Musée des Beaux-Arts
3 Place Stanislas, 54000 Nancy.
Tel (33 3) 83 85 30 72
Fax (33 3) 83 85 30 76
mba@mairie-nancy.fr

Wed to Mon 10-6. Closed Tues.
Recently much enlarged, and in one of the most elegant squares in Europe, this is a rich French provincial museum. The collection of French painting from the 16C onwards is especially strong and now includes a good representative 20C display in the newly built galleries. Claude Lorrain came from Nancy, and the gallery has a small, naturalistic early *Pastoral Landscape*. 19C inc. Manet*, and the Nabis, esp. Vuillard. The collection of 16C and 17C Italian art includes a number of unusual names (Mico Spadaro, Dandini, Cigoli, Castello) and significant works by Reni and Ribera. The highpoints are Pietro da Cortona's *Tiburtine Sibyl Telling Augustus of the Birth of Christ**; Rubens' vast *Transfiguration**, an early work, painted in Italy, and a passionate response to the colour and light of Venice and to Roman monumentality; and Caravaggio's *Annunciation**. The new display is in general excellent, though the Rubens has lost its previous dominant position and is now crowded into a room that is much too small for it.

Musée Historique Lorrain
Palais Ducal, 64-66 Grande Rue, 54000 Nancy.
Tel (33 3) 83 32 18 74
Fax (33 3) 83 32 87 63
2 May-30 Sept: Wed to Mon 10-12.30 1.30-6. Closed Tues.
1 Oct-30 Apr: Wed to Mon 10-12, 2-5 (2-6 Sun & hols). Closed Tues.
Mainly items illustrating the history of Lorraine. Four paintings by Georges de la Tour oddly

displayed in pitch darkness, inc. the *Flea Catcher*** (c.1638) see ill. p.102; the abstract power of the composition is perfectly reconciled with the realism of the subject: a young woman searching for fleas. Also the *Discovery of the Body of St Alexis*, probably a copy of a lost composition by La Tour; a good old copy of La Tour's *Hurdy Gurdy Player in Profile*. Also etchings by Callot* and works by Bellange and Deruet.

NANTES

Musée des Beaux-Arts
10 rue Georges-Clémenceau,
44000 Nantes.
Tel (33 2) 40 41 65 65
Fax (33 2) 40 41 67 90
musees@mairie-nantes.fr
Mon to Sat 10-6, Fri 10-9,
Sun 11-6. Closed Tues.
French: Outstanding are three works by Georges de la Tour which move from the early, savagely realistic and yet delicate *Hurdy Gurdy Player* c.*1631-4 to the still mystery of the candle-lit *Dream of St Joseph** c.*1639-41. The later *Denial of St Peter c.*1650 is more awkward in its treatment of both figure and composition. Also an exceptional collection of Caravaggesque paintings. 18C works; an important series of 19C paintings inc. Delacroix, Géricault and Gros; Ingres' *Madame de Senonnes** and Courbet's grave *Winnowers**, exceptionally light in colour. Some Impressionist works; paintings of the School of Pont-Aven; some modern works. Room devoted to Kandinsky. Picasso.

Other schools inc. works by Perugino, Tura; Rubens.

Important display of newest forms of art inc. Boltański and Viola.

NICE

Le Musée d'Art Moderne et d'Art Contemporain
Promenade des Arts,
06300 Nice.
Tel (33 4) 93 62 61 62
Fax (33 4) 93 13 09 01
Mon to Wed 10-6.
Closed Tues, hols. Café.
A gleaming new building, with dazzling views over Nice, stressing the contemporary as well as the modern, and placing School of Nice artists in the context of American and international movements. Representative collection of American Pop Art and New York abstract art; Minimalist art; an Yves Klein room with 20 pictures. Sculpture garden.

Musée des Beaux-Arts
33 Avenue des Baumettes,
06000 Nice.
Tel (33 4) 93 44 50 72
Fax (33 4) 93 97 67 07
Tues to Sun 10-12 and 2-6.
Closed Mon.
Two large collections: of Carpeaux, and of works by one of the museum's founders, Jules Chéret, shown in rotation.

A few Italian 17C works but main emphasis on French art, inc. the Van Loos, and Fragonard; Impressionist works by Boudin, Sisley, Monet and Renoir (*Les Grandes Baigneueses*), Van Dongen.

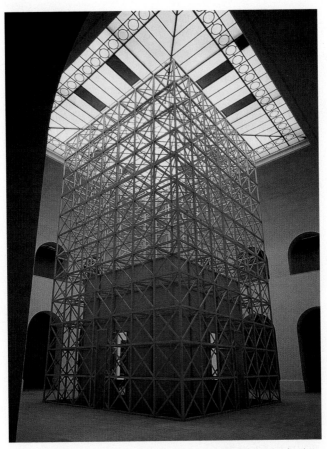

Au commencement, le son de la lumière, à l'arrivée,
Sarkis, 1997, Musée des Beaux-Arts, Nantes

The Raoul Dufy collection and the Symbolist painter Gustav Adolf Mossa collection are now exhibited at 77 and 59 quai des États-Unis respectively at the **Galerie Musée Dufy** and **Galerie-Musée Mossa**.

Musée Marc Chagall
Avenue Docteur-Ménard,
06000 Nice.
Tel (33 4) 93 53 87 20
Fax (33 4) 93 53 42 22
July-Sept: Wed to Mon 10-7
Oct-June: 10-12.30, 2-5.30.
Closed Tues. Café.
Collection entirely devoted to the

works of Chagall inc. paintings, gouaches, engravings, sculptures, stained glass and mosaics.

Musée Matisse

164 Avenue Arènes-de-Cimiez,
06000 Nice.
Tel (33 4) 93 53 40 53
Fax (33 4) 93 53 00 22
matisse@nice-coteazur.org
1 Oct-31 Mar: Wed to Mon 10-5
1 Apr-30 Sept: Wed to Mon 10-6.
Closed Tues.

Donated by the artist's family, the collection consists of paintings, drawings, engravings, sculptures, ceramics and book illustrations which show Matisse's evolution and the differing aspects of his work. Chronologically it ranges from the sombre *Still Life* (1890) to the brilliant preparatory studies for the decoration of the Vence Chapel (1948-51) and his dazzling cut-outs. Almost all Matisse's sculptures are on display.

NIMES

Carré d'Art – Musée d'Art Contemporain

Place de la Maison Carrée,
30000 Nîmes.
Tel (33 4) 66 76 35 70
Fax (33 4) 66 76 35 85
Tues to Sun 10-7. Closed Mon.

Most famous for Norman Foster's building**, which reflects and echoes the nearby Roman temple, the Maison Carrée. International contemporary art from the 1960s onwards, inc. Polke.

ORLEANS

Musée des Beaux-Arts

1 rue Fernand Rabier,
45000 Orléans.
Tel (33 2) 38 79 21 55
Fax (33 2) 66 76 35 85
Tues to Sun 10-6. Closed Mon.

A wide-ranging collection with the main emphasis on 17th and 18th century **French** painting. One work stands out: Le Nain's *Bacchus and Ariadne***, an idyllic work, with an almost fairy-tale charm, and unusual for these painters of dour peasants. 17C inc. interesting works by Claude Deruet, *The Four Elements*, painted for Richelieu, and a strong Baugin; 18C inc. a famous Boucher landscape, *Le Moulin de Charenton** and good collection of portraits, both sculpted (terracotta busts by Houdon and Pigalle) and painted (Drouais' *Mme de Pompadour**); 19C and 20C Courbet*, Gauguin*, Soutine, and a room devoted to Max Jacob.

Among the **foreign** paintings Velázquez' *St Thomas**, and a *Holy Family* by Correggio. Van Goyen and Ruysdael.

PARIS

Musée d'Art Moderne de la Ville de Paris

11 Av du Président Wilson,
75116 Paris.
Tel (33 1) 53 67 40 40
Fax (33 1) 47 23 35 98
Tues to Fri 10-5.30; Sat, Sun 10-7.
Closed Mon.

This museum does not offer a comprehensive survey of modern

Delacroix's studio, Musée National Eugène Delacroix, Paris

art, but is particularly rich in certain areas – inc. works by Robert and Sonia Delaunay, Rouault, in paintings of the Ecole de Paris (Chagall, Pascin, Soutine, Modigliani) and in Abstract paintings (Hartung, Magnelli, Soulages). Dufy's vast *La Fée Electricité* (60m x 10m) occupies a special room.

Musée Cognacq-Jay
Hôtel Donon, 8 rue Elzévir,
75002 Paris.
Tel (33 1) 40 27 07 21
Fax (33 1) 40 27 89 44
www.paris-france.org/musees
Tues to Sun 10-5.40. Closed Mon.
Apart from an early Rembrandt, virtually everything here is 18C: Boucher's *Diana after the Hunt**, Fragonard, Pater, Nattier, Greuze; portrait pastels by Quentin de la Tour and Perroneau; Guardi and Tiepolo.

Musée National Eugène Delacroix
6 rue de Fürstenberg,
75006 Paris.
Tel (33 1) 44 41 86 50
Fax (33 1) 43 54 36 70
Wed to Mon 9.30-5. Closed Tues.
Delacroix's studio-apartment is worth a visit more for its charm than for the paintings; nonetheless there are some drawings, sketches, and engravings of interest inc. a *Self-Portrait*. Particularly attractive are the sketches and studies that he made in North Africa.

Musée Gustave Moreau
14 rue de la Rochefoucauld,
75009 Paris.
Tel (33 1) 48 74 38 50
Fax (33 1) 48 74 18 71
Thurs to Sun 10-12.45, 2-5.15;
Mon and Wed 11-5.15.
Closed Tues.

Perhaps the most fascinating of all single-artist museums; the vast house and studio were arranged as a museum by Moreau himself, and the greater part of his work has remained intact. The total effect – the spiral staircase, the many drawings and watercolours arranged in revolving cabinets – has something of the intricacy of Moreau's decadent works. Outstanding large-scale works are *Salome Dancing, The Apparition* and *Orpheus at the Tomb of Eurydice*. Note too his brilliantly coloured and often astonishingly abstract watercolours.

Musée Jacquemart-André

158 Bd Haussmann,
75008 Paris.
Tel (33 1) 42 89 04 91
Fax (33 1) 42 25 09 21
www.musee-jacquemart-
andre.com
groupes@musee-jacquemart-
andre.com
Open daily 10-6.
The museum was built in the 1870s by a rich banker as a kind of show house in which to display his collections; it has a rich and sumptuous eclectic 19C atmosphere, with grand rooms decorated with 18C boiseries and Gobelins tapestries, a monumental staircase, and winter garden. The most extraordinary thing to find here is the group of frescoes by Giambattista Tiepolo which inc. a decorative scheme of three rather faded wall paintings and a ceiling from the Villa Contarini at Mira.
Dutch and **Flemish** inc. Van Dyck, three works by Rembrandt (an early and dramatic *Supper at Emmaus*), Ruysdael, and Hals'

direct and astonishingly freely painted *Portrait of a Man**.
French: Boucher, David's *Portrait of Comte Antoine François de Nantes***, a highly detailed yet idealised work, Fragonard and Nattier, Chardin.
Italian: an Italian museum displays a high quality collection of Renaissance sculpture, marbles, bronzes and polychrome wood, arranged with paintings and furniture in a decorative display of shapes and styles; marbles inc. a bust attributed to Laurana, and small bronzes inc. three close to Donatello. Florentine pictures inc. a version of *St George and the Dragon* by Uccello, and Venetian a *Virgin and Child** by Bellini and good works by Cima, Mantegna and Crivelli.

Musée du Louvre

Rue de Rivoli,
75001 Paris.
Tel (33 1) 40 20 50 50
www.louvre.fr
info@louvre.fr
Main entrance via the pyramid. Other entrances: via Porte des Lions (direct access to Arts of Africa, Asia, Oceania and Americas), Galerie du Carrousel, (99, rue de Rivoli or the Carrousel Gardens) and Passage Richelieu (for groups and visitors with museum passes). Open every day except Tuesday and certain public holidays. Permanent collections 9-6, evening openings Mon (part of the museum only) and Wed (the whole museum) until 9.45. Tickets can be bought in advance, from Fnac stores in France and in Belgium, and by telephone, 33 1 49 87 54 54. Thurs

to Sun 9-6; partial evening openings Mon and Wed 9-9.45. Closed Tues.

The Louvre is one of the largest and most exhausting galleries in the world; no other country has so overwhelming a central museum. It was developed by the heroic art collector Louis XIV, and embellished by the passionate looting of Napoleon. In 1993 the 'New Louvre' was opened, doubling the space and creating a new entrance complex under the transparent pyramid designed by I. M. Pei. The result is that it is now very hard to visit, and its sheer scale makes it seem inhuman and cold. There are immense queues, and the pyramid looks silly, except at night when it creates dazzling reflections of water and light. The *Mona Lisa*, in the dark Salle d'États, encourages vast groups to flood through other rooms and to cause unpleasant crowding and noise before some of the loveliest Venetian pictures. But all this is compensated for by the new clarity and beauty of the displays (perhaps especially the French 16C and 18C, and the Flemish pictures). It means, however, that it is unusually important to make a plan of exactly what you want to see, and to avoid floundering around in what rapidly becomes a disorientated way. Buy tickets in advance if possible.

French sculpture: the vast glazed sculpture courts of the Richelieu wing, the Cour Marly and the Cour Puget, display French monumental and garden sculptures in settings evocative of their original grandeur; Guillaume Coustou's flamboyant *Horse Tamers*, from the château of Marly, top dizzyingly lofty pedestals; in the adjacent court are Puget's *Milo of Croton,* and his relief, *Alexander and Diogenes,* the most celebrated works of this individual sculptor. Around these entresol courts, on the ground floor, are the French Renaissance sculptures, among them works by Goujon and Pilon. In Pilon's tomb of *Valentina Balbiani** the emaciated dead woman is presented with extraordinary and moving grace.

Italian sculpture: (ground floor, Denon wing): two works dominate; Michelangelo's *Slaves**,* and Canova's erotic *Cupid and Psyche*.*

French paintings: (first floor, Denon wing): large format French paintings include the most glorious and gory achievements of French Neo-Classicism and Romanticism, among them David's *Oath of the Horatii*** and *Coronation of Joséphine,* Gros' *Pesthouse at Jaffa** and *Eylau*,* and Géricault's *Raft of Medusa*.* French paintings from the 14C to 19C (2nd floor, Richelieu and Sully wings): inc. Enguerrand Charonton's *Villeneuve -lès-Avignon Pietà,* and many small courtly portraits by Clouet and Fouquet. The 17C is dominated by 36 pictures by Poussin**, which move from the baroque of his *Madonna del Pilar,* to his romantic and Venetian interpretations of Ovidian scenes; from the severity of his tragic *Judgement of Solomon* to the awesome grandeur of his *Four Seasons.* The Claude collection* is rich in port scenes, which, from the most elegant Renaissance architecture,

create an imaginary world, made glamorous by theatrical effects of the setting sun on water. Paintings by La Tour, esp. the poetically candle-lit *St Sebastian Tended by St Irene**, and Le Nain represent other aspects of French classicism; Le Nain's *Peasant at Supper* has a classic clarity and repose. The huge 17C pictures by Le Brun and Philippe de Champaigne contrast with smaller and lighter 18C works by Chardin, Boucher, Fragonard and Watteau; note esp. the small still lifes of Chardin, and Watteau's *Gilles* and his *Pilgrimage to Cythera***. Among the 19C works, Ingres' *Grande Odalisque**, exotic *The Turkish Bath,* and unflinchingly real *Monsieur Bertin**, Corot's *Woman with a Pearl.*

Dutch, Flemish and German: (second floor, Richelieu wing). 15C century Netherlandish works inc. Van Eyck's *Madonna of Chancellor Rolin**** with a miraculous study of light on a distant river, and Van der Weyden's *Annunciation*, a hushed domestic interior, unusually rich in detail, and *Braque Family Triptych***. 17C century Dutch is dominated by Rembrandt, esp. *Bathsheba***, a painting of great sensual beauty and human complexity; but also Hals' freely painted *Gypsy Girl** and Vermeer's small and intensely concentrated *Lacemaker***. A grand but dreary new gallery displays Rubens' *Life of Marie de Medici*, a flamboyant series of allegorical pictures, crowded with wonderful nudes, and characterised by high flown rhetoric and wit; his portrait of his wife and children*, and his fairy-tale landscape, *Tourney at the*

Castle reveal Rubens in a more tender mood. The Van Dycks are varied, with a Genoese portrait that conveys the essence of aristocracy, and the elegant *King Charles I Hunting**, a study of innate nobility. Dürer's early *Self-Portrait**, beautiful and narcissistic: Holbein. **Italian:** (first floor of the Denon wing) paintings from the 14C and 15C centuries move from Cimabue's *Maestà* through works by Fra Angelico*, Botticelli, Ghirlandaio* (his *Portrait of an Old Man and a Young Boy* is a direct and tender meditation on youth and age), Mantegna*. The great masters of the High Renaissance – Leonardo, Titian, Raphael and Veronese – are all represented by works of outstanding importance; compare the mysterious soft shadows and delicate modelling of the *Mona Lisa**** with the confident eloquence of Raphael's *Baldassare Castiglione*** and with the apparently effortless simplicity of Titian's *Man with a Glove***. A rich collection of 16C Venetian painting opens with the lyrical poetry of Giorgione and Titian's *Concert Champêtre****, embraces the rich sensuousness of Titian's *Pardo Venus*** and the exuberant drama of Veronese's newly cleaned and massive *Marriage at Cana****, a wedding feast set in gleaming architecture and packed with worldy, sumptuously clad figures, and deepens to the violence of Titian's *Crowning with Thorns.* The 17C has a good contrast of classicising Bolognese works and Caravaggesque naturalism; the light and lyrical mood of Caravaggio's *Gypsy Fortune Teller*, a subtle

study in deceit, contrasts with his painful and bleak meditation on the *Death of the Virgin***. 18C Piazzetta's *Assumption of the Virgin***.

English and **Spanish** paintings: (first floor of the Denon wing) less well represented, but inc. works by Ribera (*Boy with a Club Foot*), Zurbarán and good portraits by Goya. Gainsborough's *Lady Alston**.

Musée Marmottan
2, rue Louis-Boilly,
75016 Paris.
Tel (33 1) 42 24 07 02
Fax (33 1) 40 50 65 84
Tues to Sun 10-5. Closed Mon.
A tribute to the late style of Monet. The 75 paintings by him inc. a series of paintings of different motifs from his garden at Giverny – the *Weeping Willow*, the *Japanese Bridge*, the *Rose Alley*, and series of irises, agapanthuses, waterlilies – viewed under different effects of light. In each series one may see Monet moving closer to abstraction; his broad touch increasingly stresses a two-dimensional pattern, and the subject is only glimpsed through rich layers of paint. Also works from the First Empire and a few Impressionist paintings from the 1870s, inc. Caillebotte, Morisot, Pissarro, and the Monet which gave its name to the whole movement, *Impression: soleil levant* (1874).

Musée National d'Art Moderne – Centre Georges Pompidou
Place Georges Pompidou,
75191 Paris.
Tel (33 1) 44 78 12 33
Fax (33 1) 44 78 13 00
www.cnac-gp.fr
Wed to Fri, Mon 12-10. Sat, Sun and public hols 10-10. Closed Tues.
The Pompidou centre, opened in 1977, is an ultra-functional building by Piano and Rogers that looks more like a gaily painted chemical factory than a museum. In the piazza Niki de Saint Phalle's jangly fountains * – giant lips, hats, twisting snakes – together with the street performers create a lively and cheerful atmosphere. Within, the art is shown on the 4th and 5th levels, set against splendid views of the Parisian skyline, mediated by sculpture terraces. It gives a good idea of 20C art, opening with the works of the great founders of Modernism, Matisse, Picasso, Braque, Kandinsky, and especially rich in Cubism. One successful display unites the blue paintings of Miró and Yves Klein, framed by Rothkos, with the sky beyond. Surrealism represented by oppressive installations by Kienholz and Dorothy Tanning*, Jackson Pollock and Beuys. More recent movements include Pop Art, Nouveau Realisme, l'Arte Povera and conceptual art. Two extraordinary packages stand out. One is the Op Art antechamber for the private rooms of the Elysée Palace, commissioned by President Pompidou from Yaacov Agam. The other is Ben Vautier's shop from the Rue Tonduttie de l'Escarène in Nice, originally a kind of highly personal miniature art gallery, now exhibited as a work in its own right.

In the forecourt of the Centre is the **Atelier Brancusi**.
Entrance 55, rue Rambuteau.

Mon to Fri 12-8; Sat, Sun and public holidays 10-8. Closed Tues and 1 May.

In 1965 Brancusi left his studio (not far from Montparnasse) to the French state, on the condition that they should reconstruct it as it was on the day of his death. Piano's reconstruction brilliantly preserves the sense of secrecy and silence of Brancusi's studio, and the harmony and unity between sculptures – in veined marble, polished bronze, wood and stone - and surrounding space. *Leda*, polished bronze on black marble base, turns slowly on a steel disc, creating a constant play of coloured reflections.

Musée d'Orsay

62 rue de Lille,
75345 Paris cedex 07.
Entrance 1, rue de Bellechasse;
1, rue de la Légion d'Honneur.
Tel (33 1) 40 49 48 14
Info (33 1) 1 45 49 11 11
Fax (33 1) 45 48 56 60
www.musee-orsay.fr
21 Sept-19 June: Tues to Sat 10-6, Thurs 10-9.45, Sun 9-6;
20 Jun-20 Sept: Tues to Sat 9-6, Thurs 9-9.45, Sun 9-6. Closed Mon.

Opened in 1986, the museum occupies the splendid buildings of the former railway station, the Gare d'Orsay, and it brings together the arts of the French 19C, painting, furniture, sculpture, architecture and the beginnings of photography. The museum collections cover the years 1848 (2nd Republic) to the First World War; the collection of Impressionist paintings is the best in the world, but the display successfully sets them in context, contrasting small and intimate spaces with a grander display of sculpture and placing their sunny pictures among vast and luridly gloomy Realist works and salon history paintings and landscapes. It has a festive atmosphere, with good cafés, (one behind the great station clock) and a grand restaurant, glittering with gold and with a splendid ceiling painting of the *Olympian Gods* (1900) by Gabriel Ferrier.

On the ground floor, the vast spaces of the central aisle display sculpture, among them many saccharine nudes. Around them smaller spaces lead through Neo-Classical and Romantic painting, with works by Ingres and Gerôme, and Cabanel's *Birth of Venus*. A large collection of Daumier, many works by Barbizon painters, Courbet's vast *Burial at Ornans** and *The Artist's Studio**, and Puvis de Chavannes' melancholy *Poor Fisherman* precede early Impressionism. Here, with a sudden change of tempo the viewer enters the relaxed and informal world of artist's studios (Bazille paints Monet recuperating at Chailly with an injured leg; Renoir paints Bazille hunched before his easel), and an outdoor world of picnics, geranium-filled gardens, windy northern beaches, trains transporting escaping city dwellers through sunny fields. Central are Manet's *Olympia*** and *Déjeuner sur l'Herbe**, and Monet's bold fragments of the *Picnic**. On the upper level Impressionism unfolds, with works by Degas, Morisot, and Whistler's *Mother***, Renoir's *Le Moulin de la Galette**, through Monet's scenes of pleasure boat-

ing at Argenteuil, Sisley's quiet evocation of the tranquil villages by the Seine, and Pissarro's strongly seasonal pictures of a working rural landscape (*Kitchen Garden, Trees in Blossom**). The three artists are juxtaposed in a triptych, made up of Pissarro's *Road to Louveciennes*, Monet's *Pleasure Boats*, and Sisley's *Ile St Denis*. Post Impressionism opens with late Impressionism, Renoir's overblown nudes and Monet's waterlilies, symbolist pastels by Redon** (gleaming shells, and a bouquet of wild flowers, part real, part imaginary, in a magical light), and works by Degas** (sharp and insistently modern studies of urban life, *Absinthe** and *Women Ironing*), Cézanne (*The Bridge at Maincy**), Le Douanier Rousseau*, Gauguin and the Pont Aven school, Van Gogh, Seurat, and Toulouse Lautrec. On the middle floor are the Nabis, Vuillard and Bonnard, and, among the art nouveau collection of Gallé glass, Boldini's portrait of *Robert de Montesquieu* and Blanche's portrait of *Proust*.

Musée du Petit Palais

Av. Winston-Churchill, 75008 Paris.
Tel (33 1) 42 65 12 73
Fax (33 1) 42 65 24 60
Tues to Sun 10-5.40. Closed Mon.
A varied collection, richest in 17C Dutch, Flemish and French works, inc. Jordaens, Poussin and an enchanting early Claude*, showing the port of Santa Marinella set in an imaginary bay; Rembrandt (an early, swaggering *Self-Portrait*,

dressed as an Oriental, and accompanied by an odd, but presumably aristocratic, poodle), Rubens and in 19C French works, inc. Corot, Courbet*, Delacroix, Doré; Bonnard and Vuillard; Manet*, Fantin-Latour and Redon*. Sculptures by Carpeaux. Closed for renovation.

Musée National Picasso

Hôtel Salé, 5 rue de Thorigny, 75003 Paris.
Tel (33 1) 42 71 25 21
Fax (33 1) 42 71 25 21
1 Apr-30 Sept: Mon to Wed 9.30-6, Thurs 9.30-8;
1 Oct-31 Mar: Mon to Wed 9.30-5.30, Thurs 9.30-8. Closed Tues.
The museum, in a fine 17C town house, has a vast collection of works by Picasso, paintings, ceramics, collages and prints. The display is chronological and inc. the main periods of Picasso's life, with an emphasis on late works. The museum also shows Picasso's own collection of Impressionist pictures.

Musée Rodin

Hôtel Biron, 77, rue de Varenne, 75007 Paris.
Tel (33 1) 44 18 61 10
Fax (33 1) 45 51 17 52
www.musee-rodin.fr
Summer: 9.30-5.45.
Winter 9.30-4.45. Closed Mon.
There are now so many bronze duplications of Rodin's works (see ill. p.80) that one's response to them has perhaps become blunted. Yet this collection, set in a beautiful oasis in Paris, of a vast number of his works – bronzes, marbles, drawings

Overleaf: La Danaïde, Auguste Rodin, marble, Musée Rodin, Paris

and watercolours from every period – are overwhelming in the sense they give of the range and passion of Rodin's symbolic treatment of human life. They are most beautiful when most erotic.

Musée de la Vie Romantique
16 rue Chaptal, 75009 Paris.
Tel (33 1) 48 74 95 38
Fax (33 1) 48 74 28 42
Tues to Sun 10-5.40. Closed Mon.
The house and studio of the once celebrated painter Ary Scheffer. There are no outstanding works, but a pleasurable evocation of the artistic and literary atmosphere of Montmartre in the Romantic era; Liszt, George Sand, Dickens, Pauline Viardot all sat for Sheffer in his grand studio.

Three rooms are devoted to memorabilia of George Sand, inc. Auguste Charpentier's famous portrait of the writer.

Orangerie des Tuileries
Palais du Louvre,
75041 Paris.
Tel (33 1) 42 97 48 16
Fax (33 1) 42 61 30 82
Mon to Sun 10-12.30, 2-5.30 when there are temporary exhibitions.
Monet's *Nympheas*** exhibited in two purpose-built oval rooms convey the gentle movement of water and light, and the magical and mysterious contrasts between dawn and dusk, drawing the spectator into a world of the imagination. Closed for restoration.

Palais de Luxembourg
15 rue de Vaugirard,
75006 Paris.
Sun only, 9.30-11, 2-4

Guided tours only.
Murals by Delacroix in the library; ceiling of the library annexe by Jordaens.

PARIS ENVIRONS

See entries in alphabetical listing for: Chantilly, Fontainebleau, Saint-Denis, Versailles.

PAU

Musée des Beaux-Arts
rue Mathieu Lalanne, 64000 Pau.
Tel (33 5) 59 27 33 02
Fax (33 5) 59 98 09 63
Wed to Mon 10-12, 2-6.
Closed Tues.
The outstanding work is Degas' detached and impersonal modern genre scene, *The Cotton Exchange, New Orleans** 1873. Collection of French 19C works; some Flemish and Spanish paintings.

PERPIGNAN

Musée Rigaud
16 rue de l'Ange, 66000 Perpignan.
Tel (33 4) 68 35 43 40
Fax (33 4) 68 34 73 47
1 Oct-30 Apr: Wed to Mon 11-5.30. 2 May-30 Sept: Wed to Mon 12-7. Closed Tues.
A small but high quality collection in a splendid 17C palace. Rigaud, a native of Perpignan, was court painter to Louis XIV and XV, and the museum has three *Self-Portraits** and a portrait of *Cardinal Bouillon*, a flamboyant baroque work characteristic of his official style. 18C

and 19C French inc. Natoire and Ingres*. 20C: a room devoted to Maillol, Picasso and Dufy; also Appel. Some Catalan primitives. Collection of contemporary art.

QUIMPER

Musée des Beaux-Arts
40 place Saint-Corentin,
29000 Quimper.
Tel (33 2) 98 95 45 20
Info (33 2) 98 95 86 85
Fax (33 2) 98 95 87 50
www.mairie-quimper.fr/musee
Wed to Mon 10-12, 2-6. Closed
Tues; 1 Nov-31 Mar: closed Sun
a.m. (except during Christmas
hols) 1 July-31 Aug: daily 10-7
The main emphasis of the collection is on minor Dutch masters, French Rococo painters (Boucher, Fragonard, Hubert Robert) and painters of the Pont Aven School – Bernard, Denis, Lacombe, Sérusier – who, influenced by Gauguin, painted Breton peasants and landscapes in a boldly simplified style. Also Annibale Carracci, Reni and a Rubens sketch.

REIMS

Musée Saint-Denis
Abbaye St-Denis,
8 rue Chanzy, 51100 Reims.
Tel (33 3) 26 47 28 44
Fax (33 3) 26 77 75 33
Wed to Mon 10-12, 2-6.
Closed Tues.
A large collection, with the main emphasis on French 19C painting, esp. Corot and early 19C landscape; some Impressionists,

Gauguin*. Amongst the Old Masters are good 17C French paintings (Poussin, Le Nain, Vouet*) and a remarkable series of portrait drawings* by Cranach.

RENNES

Musée des Beaux-Arts
20 Quai Emile-Zola, 35000 Rennes.
Tel (33 2) 99 28 55 85
Fax (33 2) 99 28 55 99
musee@mbar.org
Wed to Sun 10-12 and 2-6.
Closed Tues.
The French paintings are the best, and the outstanding work La Tour's *The Newborn Child*** 1646-8. The two figures, still and silent, their forms reduced to smooth planes of colour by the candlelight, contemplate the miracle of Christ's birth. Chardin* and many 19C works, esp. the Pont Aven School. European old masters inc. Rubens' *Tiger Hunt**, and Veronese's *Perseus and Andromeda.*

ROUEN

Musée des Beaux-Arts
Sq. Verdrel, 76000 Rouen.
Tel (33 2) 35 71 28 40
Fax (33 2) 35 15 43 23
museesderouen-publics@wanadoo.fr
Mon to Sun 10-6.
A rich collection of French painting from the 16C to 20C, with some outstanding works from other schools.
French: 17C inc. Poussin* and an important series of sketches by Jouvenet (note his flamboyant *Self-Portrait*). 18C inc. Fragonard and

Slaves Stopping a Horse, *Théodore Géricault,*
Musée des Beaux-Arts, Rouen

Hubert Robert; 19C inc.
Delacroix's massive *The Justice of
Trajan* and a spectacular group of
paintings by Géricault*; Ingres*
(see ill. p.2 and p.76); good collec-
tion of Impressionism (esp. Monet*);
contemporary works.
Other schools: inc. Gerard David*,
Rubens, and Velázquez*; 17C
Dutch landscapes and portraits. A
*Flagellation of Christ** hopefully
attributed to Caravaggio.

SAINT-DENIS

Basilique de Saint-Denis
*1 rue de la Légion d'Honneur,
93200 Saint-Denis.
Tel (33 1) 48 09 83 54
1 Apr-30 Sept: daily 10-7, Sun 12-7;
1 Oct-31 Mar: daily 10-5, Sun 12-5.*
The necropolis of the kings of
France. Most interesting tombs are:
in the N transept the tomb of
*Henri II and Catherine de
Medicis** by Primaticcio and
Germain Pilon, 1563-70; on the top
of the tomb are powerfully realis-
tic bronze kneeling figures of the
King and Queen, beneath the
canopy are moving representations
of the figures in death. In the N
aisle is the earlier tomb of *Louis
VII and Anne de Bretagne** by
Antonio and Giovanni Giusti; here
the charm of the kneeling effigies
contrasts with the grimness of the
dead, rendered in grisly detail with
embalming incisions and stitching.

SAINT-PAUL-DE-VENCE

Fondation Maeght
06570 Saint-Paul.
Tel (33 4) 93 32 81 63
Fax (33 4) 93 32 53 22
contact@fondation-maeght. com
1 Oct-30 June: 10-12.30, 2.30-6
1 July-30 Sept: 10-7. Café.
Between the sea and the Alps, the architect José Louis Sert has created an environment to display every kind of modern art; mosaics by Chagall and Tal Coat, sculptures by Miró (see ill. p85), a vast stabile by Calder, sculptures by Hepworth, works by Braque and Kandinsky. Miró's strange images rise dramatically against sky and hills; an interior courtyard, bare and enclosed, heightens the sense of isolation conveyed by Giacometti's elongated figures. The collection also

has many works by younger artists, inc. Adami, Alechinsky, Sam Francis, Kelly, Rebeyrolle, and Tapiès.

SAINT-TROPEZ

Musée de l'Annonciade
Place Georges-Grammont,
83990 Saint-Tropez.
Tel (33 4) 94 94 04 01
Fax (33 4) 94 97 87 24
Wed to Mon 10-12, 2-6.
Apr-Sept: 3-7. Closed Tues.
A converted chapel houses an exceptional collection of modern paintings inc. Bonnard*, Braque, Derain (see ill. p.81), Matisse*, Signac, Vlaminck, Vuillard. It is a great pleasure to see these artists' works in the town they made famous with, through the windows, views of the coast they painted.

Saint-Tropez, the Quay, 1899, *Paul Signac, Musée de l'Annonciade, Saint-Tropez*

St Catherine
and St Mary
Magdalene,
*Konrad Witz,
Musée de
l'Œuvre
Notre-Dame,
Strasbourg*

STRASBOURG

Musée des Beaux-Arts
*Palais Rohan, 2 place du
Château, 67000 Strasbourg.
Tel (33 3) 88 52 50 00
Fax (33 3) 88 52 50 09
Daily, except Tues and Sun, 10-6.
Sun 10-5. Closed Tues.*

Paintings of the major European schools from 14C to 19C. The best works are a Memling polyptych and a sketch by Rubens; Correggio's *Judith*; one of the best Italian period Van Dycks in France; works by Goya and El Greco. Also some good 17C Dutch landscapes; French 18C and early 19C paintings inc. Largillière's *La Belle Strasbourgeoise.*

Musée d'Art Moderne et Contemporain
*1 place Jean Arp, 67000 Strasbourg.
Tel (33 3) 88 23 31
Fax (33 3) 88 23 31 32
Daily except Mon 11-7;
Thurs 12-10. Closed Mon.*

A new glass and concrete museum, reflecting the surrounding landscape. Late 19C and early 20C European collection inc. Monet, Bonnard, Klimt. Later works inc. German Neo-Expressionist and Fluxus works, Arte Povera, Buren, Bołtański. Also an emphasis on Alsatian artists, inc. Gustave Doré and Jean Arp.

Musée de l'Œuvre Notre-Dame
3 place du Château,
67000 Strasbourg.
Tel (33 3) 88 52 50 00
Fax (33 3) 88 52 50 36
Daily, except Tues and Sun,
10-12, 1.30-6.30; Sun 10-5.
A good coll. of 15C and 16C sculp-
ture inc. Nikolaus Gerhaert's
supposed *Self-Portrait**; also one
outstanding painting – Konrad Witz's
St Catherine and St Mary Magda-
*lene*** (see ill. p.121). Stosskopff's
La Grande Vanité, a virtuoso display
of illusionistic skill (see pp. 12-13).

TOULOUSE

Les Abattoirs Espace d'Art Moderne et Contemporain
76 allées Charles-de-Fitte
31300 Toulouse.
Tel (33 5) 62 48 58 00
Fax (33 5) 62 48 58 01
www.lesabattoirs.org
lesabattoirs@lesabattoirs.org
Tues to Sun 10-8. Closed Mon.
Good typical 1990s conversion of
red brick industrial building. Spec-
tacular Picasso stage curtain, but
otherwise dispiriting collection,
mainly of messy abstract painting
of the 1950s and 1960s.

Fondation Bemberg
Hotel D'Assezat, 31000 Toulouse.
Tel (33 5) 61 12 06 89
Tues, Wed, Fri, Sat 10-6;
Thurs 10-9. Closed Mon.
A Renaissance palace houses the
collection of Georges Bemberg,
with an outstanding group of late
19C and early 20C French paint-
ings**, from Impressionism to
Fauvism. It reveals a highly
personal taste for vivid, out-of-
door, cheerful and above all
painterly works; most attractive
are the Fauve pictures, with
unusual Marquet, witty and lively
Matisse, Derain*, Vlaminck, and
good works by less famous artists.

Musée des Augustins
2 rue d'Alsace Lorraine,
31000 Toulouse.
Tel (33 5) 61 22 21 82
Fax (33 5) 61 22 34 69
courrier@augustins.org
www.augustins.org/en/
informations
Wed to Mon 1-6. Closed Tues.
An imaginative and beautiful
conversion of the cloisters and
church of the Augustins; many of
the best religious paintings are
shown in the church (where
Rubens' *Christ on the Cross**
hangs, as though still an altarpiece)
and create a powerful and moving
effect.
French: Main emphasis on 17C,
inc. Philippe de Champaigne, and
on painters from Toulouse, inc. the
powerful Caravaggesque painter
Tournier*, Valentin*. Vast Baroque
compositions by Aubin Vouet. 18C
and 19C inc. Vigée Le Brun, Gros,
Ingres*, Delacroix* and Courbet.
Italian: Perugino and some inter-
esting 17C pictures by Guercino,
Guido Reni, and G. M. Crespi.

TOURS

Musée des Beaux-Arts
Place François-Sicard,
37000 Tours.
Tel (33 2) 47 05 68 73
Fax (33 2) 47 05 38 91

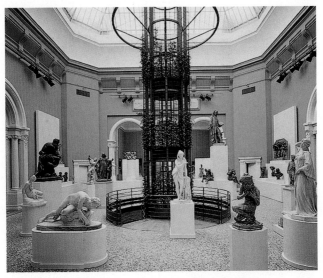

Interior, Musée des Beaux-Artes, Valenciennes

Wed to Mon 9-12.45, 2-6.
Closed Tues.
The collection is housed in a 17C/18C episcopal palace which still has much of the original decoration in the principal rooms where works of art of the period are displayed – portraits by Rigaud, Largillière, Perroneau; decorative panels by Boucher*; sculptures by Coysevox and Houdon; precious *objets* from Chanteloup. Other rooms illustrate the art and decoration of other periods. Also see works by Mantegna** (*Christ in the Garden of Olives* and *The Resurrection*); Massys; Fouquet; the French and Italian Caravaggisti; Jean Restout's powerful *Death of St Scholastica** (1730); Degas and Delacroix.

VALLAURIS

Musée National Picasso
Place de la Libération,
06220 Vallauris.
Tel (33 4) 93 64 18 05
Apr-Sept: Mon to Sun 10-12, 2-6
Oct-Mar: 2-5.
Picasso's mural *War and Peace* painted on the uncomfortably slanting walls of this 'Temple of Peace'.
See also
In the public square Picasso's *Man with a Lamb* (1944).

VALENCIENNES

Musée des Beaux-Arts
Boulevard Watteau,
59300 Valenciennes.
Tel (33 3) 27 22 57 20

Fax (33 3) 27 22 57 22
Wed to Mon 10-6. Closed Tues.
Newly renovated and expanded, this is a strong collection, esp. in Flemish paintings and in Valenciennes 18C artists inc. Watteau and Carpeaux.

French: inc. a vigorous Watteau portrait of *Antoine Pater** and two early works; works by Pater; a large collection of sculptures, drawings and paintings by Carpeaux.

Flemish: dominated by large religious works by Rubens, inc. a *Descent from the Cross*, a triptych, *The Stoning of St Stephen**, and a powerfully emotional Van Dyck from his second Antwerp period, *The Martyrdom of St James**. Jordaens*; Bosch*.

VENCE

Chapelle du Rosaire
468 Avenue Henri Matisse,
06040 Vence.
Tel (33 4) 93 58 03 26
Tues and Thurs 10-11.30, 2.30-5.30.
The great work of Matisse's old age; all the decoration – stained glass windows, sculptures, and the painted ceramic tiles on the walls – is by him. The white interior is coloured by the light shining through the windows; the black lines on the tiles, often broken and agitated, evoke, in simple, almost abstract images, the Virgin and Child, and the Stations of the Cross.

VERSAILLES

Musée National du Château de Versailles et des Trianons
Château de Versailles,
78000 Versailles.
Tel (33 1) 30 84 74 00
Fax (33 1) 30 84 76 48
www.chateau-versailles.fr
Tues to Sun 9.45-5.30. Closed Mon.
Versailles was originally built as a small hunting lodge, but in the 17C a vast team of artists and craftsmen transformed it into a spectacular symbol of the autocratic power of Louis XIV. Most interesting of the apartments which may be visited without a guide are the **Chapel**, with a ceiling painted by Antoine Coypel and a painting by Jouvenet; the **Salon d'Hercule** with paintings by Veronese and a ceiling by Lemoine; the **Salon de Diane**, with paintings by de la Fosse and Blanchard, a bust of *Louis XIV*** by Bernini; the **Salon de la Guerre**, with sculptures by Coysevox; and the **Galerie des Glaces** with ceiling paintings by Lebrun; the **Salle du Sacre** has famous paintings by David and Gros; and the **Galerie des Batailles**, where amongst poor 19C historical compositions may be seen Delacroix's superb *Battle of Taillebourg*.

Musée de l'Histoire de France
Tel/Fax (33 1) 30 83 77 90
aflahault@chateau-versailles.fr
A museum founded by Louis Philippe in 1837 to display vast works devoted to the history of France. Works by Rigaud, Mignard, David*, Ingres. A fine Gros, *Napoleon on the Bridge at Arcole*, and his *Battle of Aboukir*.

The Gardens

Open daily from sunrise to sunset.
The Gardens contain decorative statuary and fountains, the most impressive being Girardon's *Grotto of Thetis* and Coysevox's *Bashful Venus*. Bernini's equestrian statue of *Louis XIV* stands at the edge of the park.

VILLENEUVE-LES-AVIGNON

Musée Pierre de Luxembourg

3 rue de la République,
30400 Villeneuve-lès-Avignon.

1 Apr-30 Sept: Mon to Sun 10-12.30, 3-7; 1 Oct-31 Jan, Mar: Tues to Sun 10-12, 2-5.30.
Closed Mon. Closed Feb.

This museum is guardian of an outstanding work: Enguerrand Charonton's *Coronation of the Virgin*. One of the two documented works by the artist, it is one of the most remarkable 15C French paintings. The landscape across the bottom shows, as the contract stipulated, 'part of the city of Rome' and 'part of Jerusalem', yet it is made intensely moving by delightfully naturalistic glimpses of Provençal scenery.

Germany

Opening hours: museums are generally open weekdays 10-5, Sundays (and often Saturdays) 10-1; usually closed on Mon. Churches are often closed between 12 and 2.

National holidays: Jan 1, Good Fri, Easter Mon, May 1, Ascension Day, Whit Mon, Corpus Christi, June 17, Aug 15, Nov 1, Wed nearest 20, Dec 25, 26.

Useful words: *art* Kunst; *bookstall* Bücherverkaufsstand; *castle, stately home* Schloß; *catalogue* Katalog; *cathedral* Kathedrale, Dom, Münster; *church* Kirche; *closed* geschlossen; *entrance* Eingang; *entrance ticket* Eintrittskarte; *exhibition* Ausstellung; *exit* Ausgang; *picture gallery* Gemäldegalerie; *guide* Führer; *guided tour* Führung; *lecture* Vortrag; *information* Auskunft; *monastery* Stift/Kloster; *open* geöffnet; *painting* Gemälde; *parish church* Pfarrkirche; *sculpture* Plastik; *street* Straße.

Art in Germany

Until 1871, when the country was united, Germany consisted of a bewildering number of autonomous kingdoms, principalities, duchies and free cities, many of which possessed their own proud cultural history. The history of German art is therefore the complex and often confusing history of local schools and regional developments.

In the 15C Cologne was a brilliant centre. Here the sweet grace of International Gothic persisted in the paintings of Stephan Lochner. Elsewhere the bulky figures and spatial illusionism of Konrad Witz broke more dramatically with the past. The influence of Netherlandish art was strong in the emotionally powerful works of Martin Schongauer at Colmar (Alsace), who was deeply respected by the young Dürer.

The Renaissance came to Germany late, in the 16C. It was not a coherent development but was dominated by three great artists: Dürer, Grünewald and Hans Holbein the Younger. At Nuremberg Dürer sought to attain the monumental style and high status of the Italian painter; he was consumed with curiosity about the natural

Opposite: Exterior, Kunstmuseum Bonn

world and fascinated by the discoveries of the Italian Renaissance. By contrast Grünewald was a visionary artist, loyal to the Gothic tradition; his expressive paintings attained an unprecedented emotional power. Holbein came from Augsburg, an important centre, but moved to Basle. His detached realism is a perfect synthesis of the monumental grandeur of the Italian Renaissance and the northern passion for accurately observed detail.

Outstanding amongst Dürer's pupils was Hans Baldung. In his late works he moved away from the influence of Dürer to explore the darker side of human experience – the erotic, the demonic and the sensual. Lucas Cranach the Elder was the first outstanding Saxon painter: his paintings of mythological subjects reveal a more sophisticated and courtly eroticism. Artists of the Danube school developed a particular interest in landscape; the most beautiful are Albrecht Altdorfer's wooded scenes, with their sense of the eerie strangeness and remoteness of nature untouched by man. In the 17C the tiny intense landscapes of Elsheimer are indebted to the Danube school; he later travelled to Italy, where he became famous for night scenes lit by several sources.

In the 17C the effects of the Thirty Years War slowed the pace of artistic development. The great achievements of German Baroque and Rococo belong to the 18C; the brothers Asam (Cosman Damian and Egid Quirin) fused to splendid effect architecture, sculpture and painting.

In the 19C Neo-Classic painting and Romantic art vied for supremacy; Caspar David Friedrich painted landscapes charged with religious emotion. Philip Otto Runge painted portraits and allegories. The Nazarene Brotherhood, founded by Friedrich Overbeck, drew fresh inspiration from the Italian Renaissance. From 1815 to 1848 Biedermeier painters (Spitzweg, Gaertner, Kersting) produced highly finished cityscapes and scenes of domestic life. Realism was represented by Wilhelm Leibl and Adolf von Menzel, at his best in light filled interiors

Impressionism only arrived in Germany towards the end of the 19C, and even then (as shown by the work of Max Liebermann, Slevogt and Corinth) it failed to match the freshness and brilliance of the French originals. Paula Modersohn-Becker produced boldly simplified paintings of peasant life. The influence of the Post-Impressionists formed the basis of a subjective and colourful style – Expressionism.

The earliest Expressionists were a group called Die Brücke, founded in Dresden in 1905. The works of Kirchner, Bleyl, Heckel,

Crucifixion, *Grünewald, Staatliche Kunsthalle Karlsruhe*

Nolde and Schmidt-Rotluff are harsh and morbid, painted in bright, crude colours and brutally drawn; they were concerned with expressing the psychic anxiety of the modern city-dweller. The Blaue Reiter group (Macke, Kubin, and Franz Marc) exhibited in Munich in 1911 and 1912 and was more radical in its ideas; another member, the Russian emigré Kandinsky, developed one of the earliest forms of abstract painting (c. 1912).

Until Hitler's rise to power in 1933 Expressionism remained in the forefront of the European avant-garde. After the First World

Cliff landscape in the Elb Sandstone Mountains,
Caspar David Friedrich, 1822, Österreichische Galerie Belvedere, Vienna

Freiburg Cathedral, *1914, August Macke,*
Kunstsammlung Nordrhein-Westfalen, Düsseldorf

War, Berlin, Hanover and Cologne were important centres of
Dada activity. The Bauhaus school of art and design was founded
in Weimar.

During the inter-war years another style developed – Neue
Sachlichkeit (New Objectivity); it was essentially realistic but it was
anything but objective. The savage descriptions of society in works
by Grosz, Dix and Schad are politically acute and emotionally
harrowing.

Nazi cultural policy opposed anything modern and thought-

provoking. It supported a revival of traditional, tired styles and attempted to stamp out all avant-garde activity.

After the war German painting suffered from an uncritical and hasty adoption of styles which the artists were not able entirely to understand; pre-eminently French Tachism, American Abstract Expressionism and Pop Art.

But although the recovery of cultural life was slow, since the 1960s German artists have created the most intellectually ambitious art in Europe. Düsseldorf in the 1960s was dominated by Gerhardt Richter, Beuys and Polke, who were creating a radical art about art; in Berlin artists were confronting the past, in the monumental, expressive canvases of Baselitz and in the grieving canvases of Kiefer. The great trio – Beuys, Polke and Kiefer – dominate very many German art museums. In recent years there has been an explosion of photo-based art, especially in Düsseldorf.

Opposite: La Rivoluzione siamo noi, *1972, Joseph Beuys,*
Germanisches Nationalmuseum, Nürnberg

AACHEN

Suermondt-Ludwig-Museum
Wilhelmstr. 18, D-52070 Aachen.
Tel (49 241) 4798 00
Fax (49 241) 37075
Tues, Thurs and Fri 11-7; Wed
11-9; Sat and Sun 11-5.
Closed Mon.
A sculpture collection, mainly medieval and Baroque, but with some paintings, inc. works by Ribera and Zurbarán.

ALTENBURG

Staatliches Lindenau-Museum
Ernst-Thälmann-Str. 5,
D-04600 Altenburg.
Tel (49 3447) 2519
Fax (49 3447) 2510
Tues to Sun 9-12.30, 1.30-5.30.
Closed Mon.
A remarkable collection of 14C and 15C Italian painting, made by Bernhard August von Lindenau (1775-1854), when German Romantics were passionately re-discovering the art of 'Pre-Raphaelite' painters. **Italian:** 13C and 14C Sienese school inc. Taddeo di Bartolo and the Lorenzetti; Florentine school inc. Fra Angelico, Botticelli, Daddi, and Lorenzo Monaco; Umbrian school inc. Perugino and Signorelli. German and Belgian 19C sculpture and paintings.

ASCHAFFENBURG

Staatsgalerie im Schloss Johannisburg
Schlossplatz, 63739 Aschaffenburg.
Tel (49 6021) 3304 46

Fax (49 6021)4188771
Apr-Sept: Tues to Sun 9-12, 1-5;
Oct-Mar: Tues to Sun 10-12, 1-4.
Closed Mon.
A small collection of Flemish and Dutch paintings, inc. 16C and 17C genre and landscape. Seven Passion scenes, from a cycle of 22, by Aert de Gelder. Cranach and his circle, and some 18C paintings, esp. Kobell.

AUGSBURG

Staatsgalerie in der Kunsthalle
Imhofstr. 7-13,
D-86159 Augsburg.
Tel (49 821) 324 2178
Fax (49 821) 324 2271
Wed to Sun 10-4.
Closed Mon and Tues.
German painting and sculpture of the 19C and 20C. A good representation of late 19C and early 20C inc. Leibl, and Impressionist and Symbolist painters. From the 20C Marc, Macke, Klee, and representative collection of later 20C art.

Schaezlerpalais
Staatsgalerie
Maximilianstr. 46,
D-86150 Augsburg.
Tel (49 821) 5103 50
Fax (49 821) 324 4105
1 May to 31 Oct Tues to Sun
10-5, 1 Nov to 30 Apr 10-4
Closed Mon.
One of the most important collections of early German painting, whose concentration on painting at Augsburg and in Swabia creates its highly individual character. The collection inc. works by Leonhard Beck, Hans Burgkmair, Hans Holbein the Elder, Martin Schaffner's

first Wettenhausen altar; and Hans Schaufelein. Outstanding is the series of *Seven Churches*, painted for the blind arcading of the chapter-house in the Dominican convent of St Catherine. Note esp. Holbein the Elder's *S. Paolo Fuori le Mura** – within a framework of painted tracery he shows 14 scenes from the life of the apostle; the story is told forcefully and the sense of real space is impressive. Burgkmair contributed three basilicas; his St Peter's shows the first use of Renaissance detail in German painting. Dürer's portrait of *Jacob Fugger**.

Also in the Schaezlerpalais:
Deutsche Barockgalerie
Tel (49 821) 324 4117
Fax (49 821) 324 4105
Tues to Sun 10-5. Closed Mon
Baroque artists inc. Baumgartner, Bergmüller, Holzer and Schönfeld, whose *Time* is perhaps his most poetic and melancholy treatment of a favourite theme.

Dom
Eight altarpieces by Hans Holbein the Elder.

St Anne
The **Fuggerkappelle (1518)*** A richly decorative ensemble, in Italianate style, to which many German sculptors contributed. Two monuments designed by Dürer. The grand and austere altar is by Hans Daucher.

BAMBERG

Dom
A splendid array of Late Gothic and Renaissance sculpture inc. the *Bamberg Rider*** (*c.*1240), the *Visitation* group, Tilman Riemenschneider's tomb of Henry II**, at his best in *The Emperor's Dream*; and Veit Stoss' *St Mary Altarpiece***, a late majestic work; note esp. the brilliant economy of the *Flight into Egypt*.

BERLIN

Alte Nationalgalerie: Kunst des 19. Jahrhunderts
Bodestr. 1-3, D-10178 Berlin.
Tel (49 30) 2090 5800
Fax (49 30) 2090 5802
Tues to Sun 9-6. Closed Mon.
This gallery shows an important collection of 19C sculpture and painting, and now incorporates the collections of the Galerie der Romantik. These inc. 24 works by Caspar David Friedrich, with such famous paintings as *Monk by the Sea**, *Man and Woman Contemplating the Moon**, *Woman at a Window**. Nazarene works inc. Overbeck's *Portrait of the Painter Franz Pforr**; also works by German artists in Italy, esp. Carl Blechen. From the Biedermeier period works by Gaertner and Spitzweg.

The original Alte Nationalgalerie collection inc. Adolf Menzel's light-filled interiors**, and a superb group of French

Overleaf: Dans la Serre, Edouard Manet, Alte Nationalgalerie, Berlin

Impressionists**, esp. Manet (see ill. pp.136-7) and Cézanne.

Brücke Museum

Bussardsteig 9,
D-14195 Berlin-Dahlem
Tel (49 30 8) 3120 29
Fax (49 30 8) 3159 61
Wed to Mon 11-5. Closed Tues.
In a distant leafy suburb this small and enjoyable modernist museum was built to house a collection of paintings, prints and sculptures by artists of Die Brücke. The major artists are well represented, with menacing works by Nolde, and a taut Max Kaus, *Pair in a Green Room*, but the main emphasis falls on Schmidt-Rottluff and Erich Heckel. Works from every phase of Schmidt Rottluff's career suggest that the movement's high-point was in the years immediately before and after the First World War.

Bode-Museum

Museumsinsel.
Closed until October 2004.
The national sculpture collection, with emphasis on German sculpture from the early medieval period to the Rococo, and inc. works by Nikolaus Gerhaert*, Tilman Riemenschneider*, Ignaz Günther and Joseph Anton Feuchtmayer. Also a fine collection of Italian Renaissance works, inc. Donatello's *Pazzi Madonna***, and portrait busts by Desiderio da Settignano*, Francesco Laurana* and Mino da Fiesole.

Friedrichswerdersche Kirche – Schinkelmuseum

Werderscher Markt, Berlin-Mitte,
D-10117, Berlin.

Tel (49 30) 208 1323
Tues to Sun 10-6. Closed Mon.
A display of 19C German sculpture, most worth visiting for the splendour of the setting in a neo-Gothic church designed by Schinkel.

Gemäldegalerie

Kulturforum, Berlin-Tiergarten,
Matthaikirchplatz,
D-10785 Berlin.
Tel (49 30) 266 2109
Fax (49 30) 266 2103
gg@smb.spk-berlin.de
Tues, Wed and Fri 10-6,
Thurs 10-10, Sat and Sun 11-6.
Closed Mon. Café.
An austere new building with fine lighting, houses the reunited collections, amongst the most splendid in Europe. The highpoints are the German Renaissance paintings and the Early Netherlandish, perhaps the finest collection in the world.
Dutch and Flemish: a large group of Rembrandts, most of them rather dull and ugly. Most interesting is the long-celebrated *Man with the Golden Helmet*, with shadowy face and solid helmet, now demoted to Circle of Rembrandt. Good works by the major landscapists and genre painters, Vermeer*, de Hooch and Terborch. A varied group of Hals inc. the astonishingly free *Malle Babbe*. Rubens, Van Dyck and Jordaens.
Early Netherlandish:* all the major masters from Van Eyck to Bruegel are represented by major works. Outstanding are Van Eyck's tiny *Madonna in a Church***, three triptychs** by Rogier van der Weyden, and two altarpieces by

Hugo van der Goes. The monumental grandeur of his *Adoration of the Magi***contrasts with the violent expressionism and crowded space of the later *Adoration of the Shepherds***. Among the portraits note Campin's touchingly naturalistic *Portrait of a Fat Man**, a sharp contrast to Petrus Christus' refined *Portrait of a Young Woman**. Bruegel's *Two Monkeys***.

French: Poussin, Claude, Watteau.

German: a good representation of the major 15C and 16C painters, inc. works by Altdorfer*, Dürer*, and Holbein, whose *George Gisze***is a spectacular display of illusionistic skill.

Italian: a good collection of Florentine and Sienese art. inc. Botticelli, Pollaiuolo*, Masaccio* and Raphael. Filippo Lippi's strange *Adoration in the Forest*** comes from the chapel dec. by Gozzoli in the Florentine Palazzo Medici. 16C painting is best represented by portrait painters (Bronzino, Franciabiagio, Rosso). From Venice a fine wall of portraits, at their centre Giorgione's *Portrait of a Youth***, and Sebastiano del Piombo's *Portrait of a Young Roman Woman***. Lotto, Titian, and Tiepolo. From the 17C Caravaggio's outrageously erotic *Victorious Love***, which triumphs over a painting by his enemy, Baglione, of *Divine Love*. This hangs opposite, as it did in the palazzo of the patron, Benedetto Giustiniani.

Hamburger Bahnhof Museum für Gegenwart
Invalidenstr. 50-51, Berlin-Tiergarten, D-10557, Berlin.

Tel (49 30) 397 8340
hbf@smb.spk-berlin.de
Tues to Fri 10-6; Sat, Sun 11-6.
Closed Mon. Café.

A splendid conversion of railway station into art gallery, with bright white spaces, a plethora of lights by Dan Flavin, and framing an urban view of silver birches and goods trains that looks like a Kiefer painting sprung to life. There is a gallery of works by Warhol; a tired and dreary collection of Rauschenberg and Cy Twombly; a dull Richard Long, a revolting Damien Hirst, and a mournful Kiefer* of lead books; many recent works by video artists and artists working with light, among them Christine Kubisch.

Käthe Kollwitz Museum
Fasanenstr. 24,
D-10719 Berlin-Charlottenburg.
Tel (49 30) 882 5210
Fax (49 30) 881 1901
inf@kaethe-kollwitz.de
Wed to Mon 11-6. Closed Tues.

A much visited collection of the prints of Käthe Kollwitz, an extraordinarily powerful and compassionate artist who dealt with themes of illness, hunger, death, civil strife and oppression. A series of self-portraits is esp. moving.

Neue Nationalgalerie
Berlin-Tiergarten, Potsdamer Str. 50, D-10785 Berlin.
Tel (49 30) 266 2651
Fax (49 30) 262 4715
Tues to Fri 10-6; Sat, Sun 11-6.
Closed Mon. Café.
If there is a temporary exhibition on much of the permanent collection is closed, so find out if

Dora with untidy hair, *Pablo Picasso, Sammlung Berggruen, Berlin*

you can see what you want before you pay.

The gallery, a modernist temple of glass and steel** designed by Mies van der Rohe, is so transparent that it seems almost immaterial, reflecting clouds and sky, and sculptures (alas too small and mostly dull) on the encircling terrace gardens; it now seems oddly frail and isolated amid the vast and threatening building sites all round. The display opens with melancholy and meditative Symbolist works by Munch, Hodler and Lehmbruck. There follow Expressionist paintings – Kirchner's sinister *Potsdamer Platz**, Kokoschka's *Portrait of Adolf Loos**, Beckmann's paintings of *Birth*** and *Death***, all of which create an almost overpowering sense of anguish and isolation and of a new awareness of a complex and disturbing inner consciousness. Among them are works by Bacon and a gloomy late Picasso. Later sections are less interesting, with some Bauhaus painting, and Barnet Newman's *Who's Afraid of Red, Yellow and Blue IV.*

Sammlung Berggruen

Schlossstr. 1, Westlicher Stüler Bau, D-14059 Berlin-Charlottenburg.
Tel (49 30) 326 9580
Fax (49 30) 326 95819
Tues to Fri 10-6; Sat, Sun 11-6.
Closed Mon.

An elegant and high quality display of works by Picasso, his immediate forerunners (Cézanne, Van Gogh) and his contemporaries. Perhaps most astonishing are Picasso's portraits of women from the 1930s, esp. Dora Maar, with extraordinary green fingernails, and a woman in a richly decorative yellow pullover. Also some of Picasso's wittiest sculptures, shown with Benin bronzes.

Schloss Charlottenburg

Spandauer Damm 20, D-10585 Charlottenburg.
Tel (49 30) 3209 11
Fax (49 30) 3209 1200
Tues to Fri 10-6; Sat, Sun 11-6.
Closed Mon.

The **Knobelsdorff wing** was added to the palace by Frederick II. Fine works by Watteau and Chardin are shown just beyond the Golden Gallery, which, with its light greens and glittering ornament, creates a suitably enchanted Rococo setting. Watteau's plangent *Embarkation to Cythera*** (a second version of the famous work in the Louvre) contrasts with the later *L'Enseigne de Gersaint***. The latter was painted as a sign for his friend Gersaint's shop, probably as part of the façade, and invites the spectator to step from the street into an elegant room. Louis XIV is shuffled off into a packing case, and the connoisseurs are treated with a touch of realism and satire new in Watteau's work.

BIELEFELD

Kunsthalle

Artur-Ladebeckstr. 5, D-33602 Bielefeld.
Tel (49 521) 5124 79
Fax (49 521) 5134 29
info@kunsthalle-bielefeld.de
Tues, Wed, Fri, Sat, Sun 11-6; Thurs 11-9. Closed Mon.

A celebrated building, clad in red sandstone, by Philip Johnson, housing a collection of 20C art, predominantly German (Die Brücke, Der Blaue Reiter, artists of the Bauhaus); also works by Robert and Sonia Delaunay; recent American painting, esp. Post-Painterly Abstraction.

BONN

Kunstmuseum Bonn
Friedrich-Ebert-Allee 2,
D-53113 Bonn.
Tel (49 228) 7762 60
Fax (49 228) 7762 20, 7762 06
kunstmuseum@bonn.de
Tues to Sun 10-6; Wed 10-9.
Closed Mon. Café.
An elegant, light-filled building by Axel Schultes (see ill. p.126). The main emphasis of the collection is on the works of August Macke, who lived and worked in Bonn, and of artists associated with him. Also 19C German art of the Düsseldorf and Munich schools. 20C inc. Beuys, Polke and Kiefer.

BRAUNSCHWEIG (Brunswick)

Herzog-Anton-Ulrich Museum Kunstmuseum des Landes Niedersachsen
Museumstr. 1,
D-38100 Braunschweig.
Tel (49 531) 12250
Fax (49 531) 1225 2408
www.museum-braunschweig.de
info@museum-braunschweig.de
Tues to Sun 10-5; Wed 1-8.
Closed Mon.

The most spectacular paintings in this former ducal collection are Rembrandt's late *Family Group*** and a *Self-Portrait*** by Giorgione. Dutch and Flemish: Lucas van Leyden's *Self-Portrait*; a good collection of Mannerist and Caravaggesque paintings. Landscape is well represented, and inc. Pieter de Molijn's *Dunes* 1626, a work seminal to the development of tonal landscape. Works by Rubens (a sinister *Judith and Holofernes***) and Vermeer**.
Italian: from the 16C, Tintoretto and Veronese; 17C Cavallino, Lanfranco and Mola*.

BREMEN

Kunsthalle Bremen
Am Wall 207, D-28195 Bremen.
Tel (49 421) 3290 80
Fax (49 421) 329 0847
www.Kunsthalle-Bremen.de
office@Kunsthalle-Bremen.de
Wed to Sun 10-4, Tues 10-9.
Closed Mon.

German and Italian 18C painting and German and French 19C and 20C works, with an emphasis on the Worpswede school, esp. Paula Modersohn-Becker*.
Dutch: landscape and genre; Aert de Gelder's *David before Saul*.
Flemish: small collection inc. Van Dyck and Rubens.
Early German: inc. Altdorfer, Cranach.
Italian: some interesting Renaissance paintings inc. works by Masolino and Vivarini.

Paula Modersohn-Becker Museum

Böttcherstr. 6-10, D-28195 Bremen.
Tel (49 421) 336 5066, 336 5077
Fax (49 421) 339 8295
paula@pmbm.de
Tues to Sun 11-6. Closed Mon.
Contains many important works by Paula Modersohn-Becker and Bernhard Hoetger.

COLOGNE see KÖLN

DARMSTADT

Hessisches Landesmuseum

Friedensplatz 1,
D-64283 Darmstadt.
Tel (49 6151) 1657 03
Fax (49 6151) 28942
Tues, Thurs, Fri, Sat 10-5; Wed 10-9; Sun 11-5. Closed Mon.
Dutch and Flemish: inc. Bruegel's *Magpie on the Gallows***, a painting in which a breathtaking sweep of landscape is combined with a wealth of minute detail; works by Brouwer, Van Dyck and Rubens.
German: good collection of Old Masters of the middle Rhine, inc. the Friedberger altarpiece and the Ortenberger altarpiece. Works by Baldung, Cranach the Elder, Holbein the Elder, Lochner*. Also German Romantic paintings and some fine Expressionist works. The Beuys-Block contains 300 works by Beuys.
Italian: some good 16C Venetian works.

Schloss Darmstadt

Residenzschloss, Glockenbau,
D- 64283 Darmstadt.
Tel (49 6151) 24035
Guided tours Mon to Thurs 10-1, 2-5; Sat, Sun 10-1. Closed Fri.
In the picture gallery is Holbein the Younger's *Meyer Madonna*** 1526. The painting shows the Madonna of Mercy sheltering the praying family of Jakob Meyer beneath her cloak. The symmetry and calm grandeur of the composition are deeply influenced by the Italian Renaissance; the soft painting of the flesh reveals the influence of Leonardo, yet the portraits retain a northern realism and the work is both majestic and intimate.

DONAUESCHINGEN

Fürstenberg-Sammlungen

Karlsplatz,
D-78166 Donaueschingen.
Tel (49 771) 86563
Tues to Sat 10-1, 2-5; Sun & hols 10-5. Closed Mon.
The picture gallery has mainly German paintings inc. the Wildenstein altarpiece by the Master of Messkirch, two Grünewalds, and Holbein the Elder.

DORTMUND

Museum am Ostwall

Ostwall 7, D-44122 Dortmund.
Tel (49 231) 502 3247
Fax (49 231) 502 5244
MuseumOstw@aol.com
Tues to Sun 10-5. Closed Mon.
20C painting with an emphasis on German Expressionism.

DRESDEN

Gemäldegalerie Alter Meister
Der Zwinger, Sophienstr.,
D-01067 Dresden.
Tel (49 351) 491 4621
Fax (49 351) 491 4616
info@staatl-kunstsammlungen-
dresden.de
www.staatl-kunstsammlungen-
dresden.de
Tues to Sun 10-6. Closed Mon.
The gallery's greatest wealth is in late Renaissance and Italian and Dutch Baroque. Raphael's *Sistine Madonna****, Giorgione's *Sleeping Venus*** and Jan van Eyck's *Madonna and Child*** triptych are amongst the most famous paintings in the world. The pictures have been little restored and retain an unusual beauty of surface.
Dutch 17C: one of the finest collections anywhere. Good Rembrandts, esp. of the middle period. An unrivalled collection of genre, inc. two Vermeers* (one an unusual early work); Ruisdael's *The Jewish Cemetery**.
Flemish 17C: represented by Van Dyck and Rubens.
French: 17C and 18C inc. Poussin's *The Kingdom of Flora***, Claude**, and Watteau.
German: 16C inc. Dürer* and Holbein. 17C: a magical Elsheimer interior.
Italian: 15C Antonello da Messina: 16C inc. Correggio, Parmigianino*, Raphael and Andrea del Sarto. Very fine Venetian collection*. Intensely moving coll. of Belotto's views of Dresden**.
Spanish: Ribera and Zurbarán.

Gemäldegalerie Neuer Meister
Albertinum, Brühlsche Terrasse,
D-01067 Dresden.
Tel (49 351) 491 4622
Fax (49 351) 491 4619
info@staatl-kunstsammlungen-
dresden.de
www.staatl-kunstsammlungen-
dresden.de
Mon to Wed, Fri to Sun: 10-6.
Closed Thurs.
French Impressionists; German Romantic*, Impressionist, Expressionist (inc. Dix's *War* triptych) and contemporary works.

DUISBURG

Wilhelm-Lehmbruck-Museum
Düsseldorferstr. 51,
D-47049 Duisburg.
Tel (49 203) 283 2630
Fax (49 203) 283 3892
www.duisburg.de/lehmbruck
lehmbruckmuseum@stadt-
duisburg.de
Tues to Sat 11-5; Sun 10-6.
Closed Mon. Café.
A collection of the works of Wilhelm Lehmbruck and an important, dramatically displayed collection of modern sculpture by Arp, Brancusi, Gabo, Giacometti and Duane Hanson. Also works by the German Expressionists and Joseph Beuys.

DÜSSELDORF

Kunstmuseum Düsseldorf
Ehrenhof 5, D-40479 Düsseldorf.
Tel (49 211) 899 2460
Fax (49 211) 892 9173

Portrait of Max Jacob, *1916, Amadeo Modigliani,*
Kunstsammlung Nordrhein-Westfalen, Dusseldorf

Tues to Sun 11-6. Closed Mon.
Café.
Paintings from the 15C to 20C inc.
Cima, Rubens, and Zurbarán, but
the main emphasis is on a large
collection of German Romantic
painters and 20C Impressionists
and Expressionists, inc. Macke,
Marc, Kirchner and Nolde.

Kunstsammlung Nordrhein-
Westfalen
Grabbeplatz 5, D-40213
Düsseldorf.
Tel (49 211) 83810
Fax (49 211) 838 1202
www.kunstsammlung.de
info@kunstsammlung.de
Tues to Sun 10-6, Fri 10-8.
Closed Mon. Café.

An elegant modern gallery. A large collection of paintings by Klee* from 1906-38 (exhibited in rotation) is at the centre of this fine collection of 20C art. Also important Expressionist works by Nolde and Beckmann, whose *Night** is the most impressive of his early post-war paintings. A bourgeois household is torn apart by criminals – the painting is both a description of the violence of post-war Germany and a universal statement about human evil. Also works by Macke (see ill. p.131) and Schwitters; a good collection of Cubist works inc. Gris*, Léger and Picasso and of Surrealist works inc. Ernst, Miró* and Magritte; works by contemporary European and American artists inc. Beuys, Newman, Judd.

ESSEN

Museum Folkwang
Goethestr. 41, D-45128 Essen.
Tel (49 201) 884 5314
Fax (49 201) 8884 50
Tues, Wed Thur, Sat, Sun 10-6;
Fri 10-midnight.
Closed Mon. Café.
The main emphasis is on 19C and 20C French and German art.
French: Impressionist works, esp. Renoir; post-Impressionists, esp. Cézanne, Van Gogh (*Portrait of a Young Man**) and Gauguin**. 20C: Braque, Matisse*, Picasso.
German: paintings by Friedrich and Liebermann. Expressionists inc. Kirchner, Nolde's *Death of Mary*, Beckmann's *Perseus Triptych* and Feininger. Sculpture by Barlach, Lehmbruck and Minne.

FRANKFURT-AM-MAIN

Frankfurt Museum für Moderne Kunst
Domstr. 10,
D-60311 Frankfurt am Main.
Tel (49 69) 2123 0447
Fax (49 69) 2123 7882
www.frankfurt-business.de/mmk
Tues, Thurs to Sun 10-5;
Wed 10-8. Closed Mon. Café.
An extraordinary triangular building by Hans Hollein, exciting and stimulating to visit, with its highly idiosyncratic ground plan and strangely shaped exhibition spaces. The collection is less interesting, with works by Walter De Maria, Jochen Flinzer, Bruce Nauman, a vastly pretentious late Beuys. Andreas Slominski's *Child's Bicycle*, overladen with plastic bags and absurdly claiming to pose existential questions. Liveliest are the works of Marko Lehanka**, inc. a cigarette vending machine near the toilets, and his precarious wooden sculpture of the Brandenburg Gate, which poses wittier questions about this German symbol.

Städelsches Kunstinstitut und Städtische Galerie
Dürerstr. 2,
D-60596 Frankfurt am Main.
Tel (49 69) 605 0980
Fax (49 69) 6101 63
Tues to Sun 10-5; Wed 10-8.
Closed Mon.
One of the best general collections in Europe.
Early Netherlandish: inc. four important panels** by the Master of Flémalle, a fragment of the *Bad Thief* from a large *Crucifixion* and the wings of the Flémalle

Portrait of Hendrickje Stoffels, *Rembrandt,*
Städelsches Kunstinstitut und Städtische Galerie, Frankfurt-am-Main

Altarpiece. Van Eyck's *Lucca Madonna*** c.1436, a small, jewel-like work which nonetheless has the majesty of his late style. Van der Weyden's *Virgin and Child with Saints**, probably commissioned by an Italian patron and close to an Italian *sacra conversazione*.

Dutch: collection dominated by Rembrandt's *Blinding of Samson***, a work of almost unbearable violence, in which the theatrical brutality of the action is lightened by the beauty of the colouring and the subtlety of Delilah's mocking expression. Vermeer's *Astronomer** is by contrast coolly rational. Works by Hals, Van Goyen and Ruisdael.

Flemish: Brouwer's *The Bitter Drink* c.1635, one of the most powerful 17C studies of expression. French: 17C paintings inc. Claude, and Poussin's *Pyramus and Thisbe**, a tragic work in which Poussin analysed the effects of a storm; despite the violence of the elements the composition retains a classical balance.

German: 15C inc. Altdorfer, Cranach, Dürer and both Holbeins*. 15C Rhenish Master, *The Garden of Paradise***. Hans Baldung's *Two Witches** shows witches about to depart for the Sabbath; the blazing colours and iridescent tones make this one of his most stunning works. From the 17C a remarkable group of paintings by Elsheimer***. Outstanding are five panels from his most ambitious work, a seven-part house altar, with scenes painted in oil on silvered copper: *The Finding and Exaltation of the True Cross***. From 18C Tischbein's *Portrait of Goethe*.

Italian: outstanding are a Botticelli profile portrait, Pontormo* and Tiepolo.

19C and 20C works: French Impressionists, esp. Monet's *Luncheon***, an unusually rich and ambitious work. Khnopff's enigmatic *Game Warden*. German inc. Beckmann, Liebermann, Kiefer.

FREIBURG IM BREISGAU

Augustinermuseum
Gerberau 15, D-79098
Freiburg im Breisgau.
Tel (49 761) 201 2531
Fax (49 761) 2015 97
Apr-Dec: Tues to Sat 10-5, Sun 10-1. Closed Mon.
Dec-Mar: Mon to Fri 10-12, 2-4, Sun 10-1. Closed Sat.
Mainly medieval art but also the right wing of Grünewald's Aschaffenburg altarpiece showing the *Miracle of the Snow*.

Münster
Münsterplatz,
D-79098 Freiburg im Breisgau.
July-Sept: Mon to Fri 10-12, 2.30-5. Closed Sat, Sun.
The **high altar**, completed in 1616, is Hans Baldung's masterpiece. The central panel is a *Coronation of the Virgin*, a radiant picture crowded with detail. The mystical beauty of the Adoration depends on startling effects of light; the radiance from the Christ Child catches shadowy figures held in the darkness of night. On the reverse, the *Crucifixion*, strange and sinister, hints at the fear expressed in Baldung's later work. In the University Chapel are two side

panels of the Oberried altarpiece* 1521 by Hans Holbein the Younger (the portraits of donors are probably by Hans Holbein the Elder).

FREISING

Dom
Mon to Sun 8-12, 2-6 (winter 2-5).
On the vault of the nave, a large fresco of the *Glorification of St Corbinian* by C. D. Asam. Deeply influenced by the ceiling of the Gesù, Rome, the figures pour over the painted frame into the real space of the church.

HAMBURG

Ernst Barlach Haus
Stiftung Hermann F. Reemtsma Baron-Voght-Str. 50A, Jenischpark, D-22609 Hamburg. Tel (49 40) 8260 85 Fax (49 40) 8264 15 www.barlach-haus.de info@barlach-haus.de Tues, Wed, Fri to Sun 10-6; Thurs 10-9. Closed Mon.
A collection of the works of Ernst Barlach inc. the many works collected by his patron, Hermann Reemtsma, in the sculptor's final years.

Kunsthalle
Glockengiesserwall, D-20095 Hamburg. Tel (49 40) 4285 426 12 Fax (49 40) 4285 424 82 www.hamburger-kunsthalle.de info@hamburger-kunsthalle.de Tues to Sun 10-6, Thurs 10-9. Closed Mon. Café.

There are small French, Italian and Spanish collections, but the main emphasis falls on North German and Netherlandish art.
German: early works inc. Master Bertram, Master Francke, Cranach and Holbein the Elder. 17C and 18C European works inc. Claude's *Dido and Aeneas at Carthage***, Tiepolo and Bernini. 19C painting inc. a large number of works by Friedrich, Runge* and Menzel*. Leibl's *The Three Women in Church*; Manet's *Nana**. An important collection of 20C art inc. Gris, Paula Modersohn-Becker, Munch and Klee. A special emphasis on artists of Die Brücke and Der Blaue Reiter inc. Kirchner's *Self-Portrait with a Model**.
Dutch: a large collection, inc. Rembrandt's *Presentation in the Temple**. Also many landscape paintings with a stress on Ruisdael and Aert van der Neer.

Contemporary Art Wing
Directly opposite the Kunsthalle rises the austere white cube of the contemporary gallery, designed by Ungers. It shows art from about 1960, with groups of works by major artists, such as Beuys and Polke, set against the wider backgrounds of 20C movements. Works commissioned for the gallery include Ian Hamilton Finlay's *Saint-Just Remarks*, and two rooms designed by Ilya Kabakov for symbolic art therapy. Video art.

The Eiffel Tower, *Robert Delaunay, Staatliche Kunsthalle, Karlsruhe*

HANNOVER

Niedersächsische Landesmuseum Hannover – Landesgalerie
Willy-Brandt Allee 5,
D-30169 Hannover.
Tel (49 511) 980 7621
Fax (49 511) 980 7640
www.nlmh.de
Tues to Sun 10-5; Thurs 10-7.
Closed Mon.
The main emphasis is on medieval painting and sculpture; art of the German Renaissance (Cranach, Holbein); Italian painting from the 14C to the 15C); Dutch and Flemish painting of the 17C (Van Dyck, Kalf, Rembrandt, Rubens); German painting of the 19C and early 20C, esp. from Worpswede (Modersohn, Modersohn-Becker) and German Impressionism (Corinth, Liebermann, Slevogt). Note also Poussin's *Inspiration of the Lyric Poet**.

KARLSRUHE

Staatliche Kunsthalle
Hans-Thoma-Str. 2,
D-76133 Karlsruhe.
Tel (49 721) 926 3355
Fax (49 721) 926 6788
Tues to Fri 10-5,
Sat and Sun10-6. Closed Mon.
(Orangerie 10-5). Closed Mon.
German: early paintings by the Master of the Karlsruhe Passion; Baldung, Cranach*; Grünewald (a late *Crucifixion* (see ill. p.129) and *Christ Carrying the Cross*, showing an increase in Italian Renaissance elements); Pencz. 19C German painting inc. Menzel and Friedrich.

17C and 18C: Liss, Schönfeld, Maulbertsch.
Dutch and Flemish: outstanding is a self-portrait by Rembrandt. An extensive collection of Dutch pictures; Jordaens and Rubens.
French: 17C inc. Claude*, Philippe de Champaigne, Poussin*; 18C Chardin and Largillière.
Orangerie: 19C French painting, Matisse, Delaunay (*Eiffel Tower**). Der Blaue Reiter, Beckmann, Nolde and Kirchner.

KASSEL

Neue Galerie
Schöne Aussicht 1, D-34117 Kassel.
Tel (49 561) 7096 30
Fax (49 561) 709 6345
Mar-Oct: Tues to Sun 10-5;
Nov-Feb: Tues to Sun 10-4.
Closed Mon.
Paintings from 18C to 20C. There is particular emphasis on German art with groups of works by Tischbein, by the German Romantic painters, by German Impressionists (Corinth and Liebermann) and the Expressionists. Pop Art is represented by Warhol, Hamilton and a room of Beuys. Sculptures by Archipenko and Laurens.

Staatliche Kunstsammlungen
Schloss Wilhelmshöhe,
D-34131 Kassel.
Tel (49 561) 93777
Fax (49 561) 937 7666
Tues to Sun 10-5. Closed Mon.
A major collection of 17C Dutch and Flemish painting.
Dutch: outstanding are 11 works by Rembrandt**. These inc. an early *Self-Portrait c.*1629, already

boldly original in its use of deep shadow and variety of texture. The profile portrait of *Saskia* suggests the influence of 16C portraits by Beham or Cranach. From the 1640s one of his few realistic painted landscapes, the fresh and spontaneous *Winter Scene*. The *Holy Family*** has all the human warmth of Rembrandt's middle period. Finally, the late *Jacob Blessing the Sons of Joseph*** – one of his most moving religious works in which he concentrates on the tender expressions of the figures, telling the story without external drama. Also works by Van Heemskerk, Honthorst, Hals*. Terbrugghen's two half-length flute players** are his most tenderly poetic works – dark figures against light grounds, an effect later developed by the school of Delft.

Flemish: good collections of Van Dyck, Jordaens and Rubens, inc. his poetic night scene *The Flight into Egypt**, indebted to both Caravaggio and Elsheimer.

German: Altdorfer, Cranach and Dürer; 17C Liss and Schönfeld.

Italian: a portrait by Titian; 17C paintings by Cavallini, Preti and Reni.

Spanish: a small collection.

KÖLN (Cologne)

Dom
Mon to Sun 6-7.30.
Stephan Lochner's *Dombild***, a triptych with an *Annunciation* on the shutters: inside, an *Adoration of the Magi*; on the wings, the patron saints of Cologne. The style still indebted to the Gothic tradition in Cologne but the realistic treatment of detail and the modelling of the figures show the influence of Van Eyck. The painting was one of the most famous of its time and Dürer in his journal records paying to have the shutters opened.

Museum Ludwig
Bischofsgarten Str. 1, D-50667 Köln.
Tel (49 221) 22370
Fax (49 221) 24114
Tues 10-8; Wed to Fri 10-6;
Sat, Sun 11-6. Closed Mon.
20C art: Die Brücke and Emil Nolde are esp. well represented. The *Flower Garden* is one of Nolde's most beautiful treatments of this favourite theme. Kirchner's *Painters of Die Brücke**, executed in bold, flat areas of colour, shows Müller, Kirchner, Heckel and Schmidt-Rottluff. Paintings by Chagall, Munch* and Kandinsky.

Pop Art: Lichtenstein, Rauschenberg, Wesselmann. Later trends: Dekkers and Dibbets. Two rooms devoted to Picasso.

Wallraf-Richartz-Museum/ Museum Ludwig
Martinstr. 39, D-50667 Köln.
Tel (49 221) 21119
Fax (49 221) 22629
Tues 10-8; Wed to Fri 10-6;
Sat, Sun 11-6. Closed Mon.
German: mainly panel paintings from the school of Cologne, culminating in Stephan Lochner.

Netherlandish and Flemish: varied collection of 16-18C inc. Rubens, Hals and a late and unpleasant *Self-Portrait* by Rembrandt.

Italian, French and Spanish: small, high quality collection with

good Venetian pictures, esp. Piazzetta*; Claude; Boucher; Ribera and Mélendez.

A large 19C collection emphasizes German and French Realism and Impressionism, esp. Leibl, who was born in Cologne.

LEIPZIG

Museum der Bildenden Künste
Grimmaische Str. 1-7,
D-04109 Leipzig.
Tel (49 341) 2169 90
Fax (49 341) 960 9925
Tues, Thurs to Sun 10-6;
Wed 1-9.30. Café.
An eclectic collection from the medieval period onwards. The main emphasis is on German art, with good early paintings, and a fine Baldung Grien; a collection of 19C art inc. Romanticism (Tischbein, Spitzweg, Friedrich* and Overbeck), Realism and Impressionism (Menzel and Liebermann) and early 20C (Beckmann). Dutch and Flemish art inc. Hals* and Rubens. Small collection of Italian and unusual early Netherlandish panels.

LINDENHARDT

Pfarrkirche
The Lindenhardt altarpiece attrib. to Grünewald. On the back of the shrine, *Man of Sorrows the Instruments of the Passion*, on the wings the *Fourteen Helpers in Need*. Inside, reliefs and carved figures.

LÜBECK

Behnhaus
Königstr. 11, D-23552 Lübeck.
Tel (49 451) 1224 18
Fax (49 451) 122 4183
Apr-Sept: Tues to Sun 10-5
Oct-Mar: Tues to Sun 10-4.
Closed Mon.
Paintings by Edvard Munch and Friedrich Overbeck (Nazarene painter).

St Annen-Museum
St Annenstr. 15,
D-23552 Lübeck.
Tel (49 451) 122 4134
Fax (49 451) 122 4183
Apr-Sept: Tues to Sun 10-5
Oct-Mar: Tues to Sun 10-4
Closed Mon. Café.
Mainly a collection of carved altarpieces, but inc. Memling's *Altarpiece of the Passion*.

LUDWIGSHAFEN

Wilhelm-Hack-Museum
Berlinerstr. 23,
D-670512 Ludwigshafen.
Tel (49 621) 504 3411
Fax (49 621) 504 3780
Tues to Sun 10-5.30; Thurs 10-8.
Closed Mon.
A balanced collection of the major tendencies in 20C art with particular emphasis on Russian and Dutch Constructivism and the German Expressionists.

MANNHEIM

Städtische Kunsthalle
Moltkestr. 9, D-68165 Mannheim.
Tel (49 621) 293 6413, 293 6430

Fax (49 621) 293 6412
kunsthalle@mannheim.de
Tues to Sun 10-5; Thurs 12-5.
Closed Mon. Café
19C and 20C painting and sculp-
ture. Outstanding amongst works
by French Impressionists are
Cézanne's *Pipe Smoker* and
Manet's *Execution of the Emperor
Maximilian of Mexico*** (see ill.
p.77), the last of a series of works
on this subject. This work, based
on careful research into eye-witness
accounts and photographs, records
the terrible event with apparent
detachment; it is a Realist history
painting, a plain assertion of the
facts where the quality of under-
statement has its own power. Also
works by Pissarro, Monet and
Sisley. The main emphasis is on
artists of Die Brücke and the Blaue
Reiter groups, with several works
by Beckmann. Important works
by artists of the Neue Sächlichkeit
inc. Otto Dix and Grosz; his
*Portrait of the Poet Max-Hermann
Neisse** 1925 is a powerful and
disturbing work where the detail –
esp. the gnarled hands – continue
the tradition of Grünewald. Sculp-
tures by Brancusi and Moore.

MÜNCHEN (Munich)

Alte Pinakotek
*Barerstr. 27, D-80799 München.
Tel (49 89) 2380 5216
Fax (49 89) 2380 5221
Tues to Sun 10-5; Thurs 10-10.
Closed Mon. Café.*
One of the most enjoyable collec-
tions anywhere, with an un-
paralleled collection of German
painting, but also fine 15C Flemish,

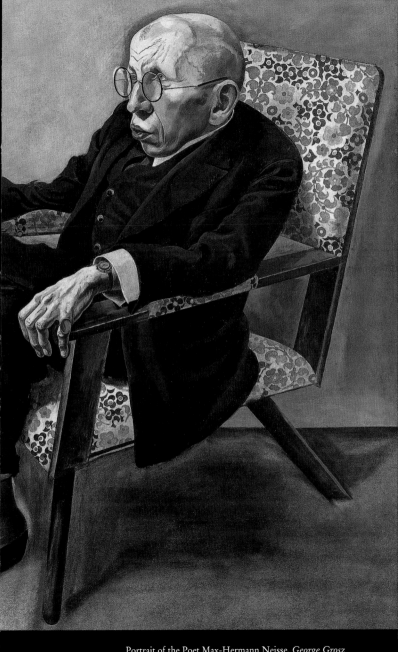

Portrait of the Poet Max-Hermann Neisse, *George Grosz*
Städtische Kunsthalle Mannheim

Baroque and Rococo church interiors

Architecture, painting and sculpture are unified in the designs of the Baroque and Rococo architects, such as those of the Asam brothers, Fischer von Erlach, Neumann, and Zimmermann. Make a detour to see some breathtaking examples: St John Nepomuk (the 'Asam Kirche'), Munich; Abbey Church, Otto-beuren; Vierzehnheiligen; Weltenburg Abbey (see p. 161); Wies.

and some of the most stunning of all Rubens.

Early Netherlandish: a good collection dominated by Roger van der Weyden's *St Columba Altar-piece***. Works by Dirk Bouts, Memling and Lucas van Leyden.

Dutch: inc. Rembrandt's series of paintings of the *Passion and the Life of Christ** executed in the 1630s for Prince Frederick Henry of Orange, which reveal Rembrandt's admiration for the Baroque drama of Rubens, and yet remain stubbornly naturalistic. A good collection of landscape inc. several works by Jacob van Ruisdael. Genre is well represented, and inc. Sweert's curiously solemn *Inn Parlour*.

Flemish: inc. Bruegel's *Land of Cockayne** but richest is a series of works by Rubens** inc. mythological, history and religious paintings, oil sketches, landscapes and portraits. Rubens' *Self-Portrait with Isabella Brant*** is a marriage portrait; the young couple are urbane, charming and successful. Rubens' attitude to his second wife was more touchingly proud and protective. She is the subject of a sumptuous portrait in the silvers, golds and violets of her wedding dress, and in another, unusually intimate work Rubens shows himself leading her around their elegant Italianate garden. Also *Rape of the Daughters of Leucippus***. Vast and wonderful flower painting by Jan Breughel*.

German: from the 15C Michael Pacher's *The Church Fathers Altar-piece** (early 1480s), showing his awareness of the art of Mantegna and a bold use of mathematical perspective. Several works by Altdorfer inc. the *Battle of Issus*** where the cosmos itself seems to reflect the magnificent drama of the battle (compare with Burgk-mair's *Battle of Cannæ*). Works by Dürer inc. the *Baumgartner Altar-piece** and the *Self-Portrait in a Fur Coat**. The rigidly frontal pose, the severe, dark brown dress and long hair suggest an image of Christ – Dürer is perhaps suggesting that the creative powers of the artist derive from God. *The Four Apostles***, Dürer's most perfect attainment of the calm grandeur of the High Renaissance. Grünewald's earliest known painting, *The Mocking of Christ c.*1504, is reminiscent of Bosch. Amberger's *Portrait of Christoph Fugger* is a perfect

synthesis of northern art with the grand style of Venetian painting. Burgkmair's *St John Altarpiece** with, set against a beautifully green landscape magically alive with birds and flowers, the red-robed and tormented St John on Patmos. Also works by Cranach. Elsheimer's *Flight into Egypt***.

Italian: Renaissance inc. Fra Angelico, Antonello**, Fra Filippo Lippi, Perugino*, Raphael, and Titian's *Portrait of Charles V** and *Crowning with Thorns***. Fine 17C and 18C collection inc. Guido Reni and outstanding Tiepolos.

French: Claude Lorrain**

Neue Pinakothek/Staatsgalerie Moderne Kunst

Barerstr. 29, D-80799 München.
Tel (49 89) 2380 5195
Fax (49 89) 2380 5221
Wed to Mon 10-5; Thurs 10-10.
Closed Tues. Café.

An opulent and comfortable gallery with top-lit airy galleries and many chairs and fountains. The main emphasis is on 19C German art but there are also outstanding 19C French works. Many of the gallery's wonderful 20C paintings will soon be re-housed in a new museum currently under construction.

French: Delacroix; Barbizon painters; outstanding Impressionist and Post Impressionist collection, with good works by all the major artists, esp. Manet. In 1874 Manet and Monet spent the summer together at Argenteuil, and Manet painted Monet working in his studio boat**, which hangs close to Monet's *Bridge over the Seine at Argenteuil***, similar in its fresh-

ness and brightness. Van Gogh's lyrical *View of Arles*** and a gloomy *Sunflowers***.

German: Romanticism, inc. Friedrich; German artists in Rome; Nazarenes, esp. Overbeck's *Italia and Germania**, Biedermeier; Realism and Impressionism inc. Menzel, Corinth.

Other schools inc. Khnopff's compellingly neurotic and claustrophobic work, *I close the door upon myself*** and an erotic polychromatic bust* by Klinger.

Schack-Galerie

Prinzregentenstr. 9,
D-80538 München.
Tel (49 89) 2380 5224
Fax (49 89) 2380 5221
Wed to Mon 10-5. Closed Tues.

19C German works inc. Böcklin, Feuebach, Marees, and Spitzweg.

Städtische Galerie im Lenbachhaus

Luisenstr. 33, D-80333 München.
Tel (49 89) 2333 2000
Fax (49 89) 2333 2003
Tues to Sun 9-4.30; Tues 9-8.
Closed Mon. Café.

The villa of the 19C painter Franz von Lenbach, with many of his paintings in rooms which recreate the original decor. Their heavy, eclectic style contrasts sharply with the gallery's chief attraction, a large coll.of dazzling landscapes** by Kandinsky, early works with simplified forms and saturated prismatic colours which seem to take on a life of their own. Also works by Macke, Klee, Jawlensky.

Stuck Villa
Prinzregentenstr. 60,
D-81675 München.
Tel (49 89) 4555 5125
Fax (49 89) 4555 124
Tues to Sun 10-6. Closed Mon.
Overwhelming artist's house
designed by the Bavarian decadent
Franz von Stuck, teacher of
Kandinsky and Klee. Mainly a
showcase for Stuck's own frescoes,
paintings and graphic art.

NEUSS

Museum Insel Hombroich
Kappellenerstr., Neuss-Holzheim.
Tel (49 1282) 2094
Mon to Sun, Feb-Mar 10-5,
Apr-Sept 10-7, Oct 10-6, Nov 10-5.
Closed Dec and Jan. Restaurant.
An unusual and beautiful museum,
on a small island in a river, and
inspired by its creator, Erwin
Heerich's, highly personal philos-
ophy of uniting art and nature.

The painter Michael Wolgemut, *Albrecht Dürer,*
Germanische Nationalmuseum, Nürnberg

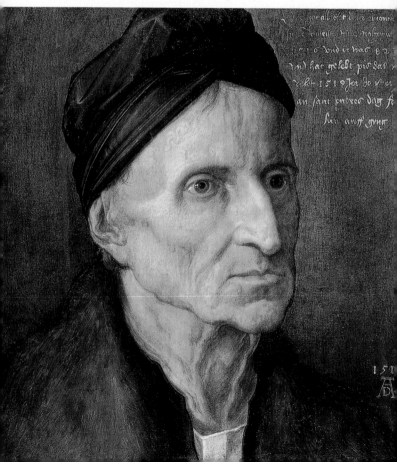

Twelve pavilions, whose formal geometric beauty is set off by surrounding park, woods and marshes, invite the viewer to wander, and contemplate an exotic blend of the art of different cultures. 20C works (Arp, Calder, Picabia, Brancusi, Klimt) are displayed amongst Egyptian sculptures, and African, Oceanic and Pre-Columbian art.

NÜRNBERG (Nuremberg)

Germanisches Nationalmuseum
Kartäusergasse 1, D-90402 Nürnberg.
Tel/Fax (49 911) 133 1200
Tues to Sun 10-5; Wed 10-9.
Closed Mon.
A large museum of German culture, with gloomy modern galleries added somewhat uneasily to a medieval charterhouse. Konrad Witz's *Annunciation*** (ground floor) is a seminal work in the development of a new realism; the room is bare, aggressively unadorned, and the steep perspective almost stifling. On the first floor, German Renaissance paintings inc. Dürer's portrait of *Michael Wolgemut***; a group of Reformation portraits by Cranach; Altdorfer* and Baldung Grien. Dutch and Flemish Mannerists and an unusual Caravaggesque Liss. A small and spontaneous *Self-Portrait** is a recent attribution to Rembrandt. Modern works inc. Beuys (see ill. p.133).

St Lorenz-Kirche
Veit Stoss' *Annunciation***. At the base of the 15C tabernacle is a sandstone self-portrait of the sculptor, Adam Kraft*.

POTSDAM

Bildergalerie
Park Sanssouci, D-14414 Potsdam.
Tel (49 331) 969 4200
Mid May-mid Oct: Tues to Sun 10-12, 12.30-5. Closed Mon.
This picture gallery of Frederick the Great, with picture frame to frame, inc. works by Rubens and Van Dyck. Most famous is Caravaggio's shockingly naturalistic *Doubting Thomas***.

REGENSBURG

Museum der Stadt
Dachauplatz 2-4,
D-93047 Regensburg.
Tel (49 941) 507 1440
Fax (49 941) 507 5449
Apr-Sept: Tues to Sun 10-1, 2-5;
Mar-Oct: Tues to Sun 2-4.
Closed Sun pm and Mon.
Paintings by Altdorfer inc. the *Last Supper*; masters of the Danube school.

SAARBRÜCKEN

Moderne Galerie des Saarlandsmuseums
Bismarckstr. 13-15,
D-66111 Saarbrücken.
Tel (49 681) 99640
Fax (49 681) 66393
info@saarlandmuseum.de
Tues, Thurs to Sun 10-6,
Wed 10 -10. Closed Mon.
German Impressionism and some of the most important representations of Expressionism. 19C and 20C sculpture inc. Rodin, Renoir, Maillol, Pomodoro and Archipenko.

SCHWEINFURT

Museum Georg Schäfer
Bruckenstrasse 20,
97420 Schweinfurt.
Tel (49 9721) 51919
Fax (49 9721) 51371
info@mgs-online.de
Tues to Sun 10-5, Thurs 10-9.
Closed Mon
A new museum, built to display
Georg Schäfer's collection of
German art from the 18C to early
20C, and particularly rich in works
by Carl Spitzweg and Adolf
Menzel.

SCHWERIN

Staatliches Museum
Am Alten Garten,
D-19055 Schwerin.
Tel (49 385) 5924 00
Fax (49 385) 5630 90
Tues to Sun 10-6.30.
Closed in winter.
A varied 17C Dutch collection inc.
a rare work by Carel Fabritius, the
*Guardsman**. Flemish, inc. Jan
Breughel; Savery. Miscellaneous
18C works; Oudry; Gainsborough.
German Symbolism; Duchamp.

SEEBÜLL

Stiftung Seebüll
Ada und Emil Nolde
D-25927 Neukirchen, Seebüll.
Tel (49 4664) 364
Fax (49 4664) 1475
Mon to Sun,Mar-Nov 10-6,
Nov 10-5. Café.
A strange Art Nouveau house built
by Nolde in this remote village

where he lived and worked in isola-
tion. There are works from every
stage of his career – landscapes,
flower pieces, garden paintings,
religious subjects and fantasies.
They inc. the *Life of Christ***
polyptych – Nolde's most impor-
tant work. Deeply influenced by
primitive art and by the harsh
agony of Grünewald's *Isenheim
Altarpiece*, he interprets the
traditional subject with new
vigour; his drawing is brutal, his
colours a violent clash of red, green
and blue, and his imagery passion-
ately simple. Forbidden to paint in
the Second World War, Nolde
executed small watercolours in
secret – many of these 'unpainted
pictures' (which became the basis
of larger oils after 1945) are exhib-
ited here. The house is surrounded
by a garden designed by Nolde.

STUTTGART

Staatsgalerie Stuttgart
Konrad-Adenauer-Str. 30-32,
D-70038 Stuttgart.
Tel (49 711) 212 4050
Fax (49 711) 236 9983
info@staatsgalerie.de
Tues to Sun 10-6; Thurs 10-9.
Closed Mon. Café.
The exterior of Stirling's celebrated
1980s extension – a brightly coloured
blend of the monumental and the
informal, its open-air rotunda a
contemporary homage to the
Pantheon – overwhelms the duller
exhibition spaces. 20C German art,
and an unexpected room devoted
to a cycle of paintings* by Burne-
Jones, are the highpoints, but there
is a collection of early German and

Netherlandish painting; an intriguing picture of tomb robbers by Schönfeld; two Rembrandts and a beautiful Sweerts; Venetian pics, esp. Tiepolo sketches. 19C inc. Friedrich*, Impressionism, esp. Monet's *Poplars in the Spring**; Fauves; Braque, Picasso* (one canvas, used back and front from the blue and rose periods, and Cubist works). 20C German art well covered, esp. Beckmann, Franz Marc, Grosz. Unexciting international contemporary art (Newman, Baselitz etc).

TIEFENBRONN

Pfarrkirche
Apr-Oct: Mon to Sat 9.30-11.30, 1.30-5, Sun 11-12, 1-4.
Lucas Moser's *St Mary Magdalen Altarpiece*** 1431, his only certain painting, executed on sheets of parchment applied to panel. In its treatment of space and of delicately observed detail it shows an awareness of the innovations of Van Eyck. The shutters, when closed, show scenes from the life of Mary Magdalene; the seascape in *The Voyage to Marseille* is particularly fresh and charming.

WELTENBURG

Weltenburg Abbey
Spectacularly situated on the banks of the Danube, where one may enjoy a pleasant out-of-doors meal and beer brewed by the monks, is the Abbey Church. On the upper ceiling of the nave C. D. Asam's fresco of the *Reception of the Virgin*

Staatsgalerie Stuttgart

in Heaven and the Community of Saints. On the high altar by E. Q. Asam the over-life-size figure of St George seems to stride into the church; he is framed by twisted columns reminiscent of Bernini's baldacchino in St Peter's, Rome.

WIESBADEN

Museum Wiesbaden
Friedrich-Ebert-Allee 2, D-65185 Wiesbaden.
Tel (49 611) 3352 170
Fax (49 611) 3352 192
info@museum-wiesbaden.de
Wed to Sun 10-4, Tues 10-8.
Closed Mon.
Mainly 19C and 20C German art. Works by Paula Modersohn-Becker, Mueller and the most important collection of works by

Alexej Jawlensky, who died in Wiesbaden.

WUPPERTAL

Von der Heydt-Museum
Turmhof 8, D-42103 Wuppertal.
Tel (49 202) 563 6231
Fax (49 202) 563 8091
Tues, Wed, Fri to Sun 11-6
Thurs 11-8. Closed Mon.
The main emphasis falls on German and French painting from 1800 to the present day; some 17C Dutch landscapes. Examples of Romanticism, Realism, Impressionism, Art Nouveau, Cubism and Futurism.

WÜRZBURG

Residenz
Theatrestr. 12, 97070 Würzburg.
Apr-Sept: Tues to Sun 9-5;
Oct-Mar: Tues to Sun 10-4.
Closed Mon.
The greatest decorative ensemble of the 18C. Architecture by Balthazar Neumann and frescoes (1750-53)*** by Giambattista Tiepolo.
Kaisersaal: Tiepolo was originally commissioned by the reigning Prince Bishop Carl Philipp von Grieffenklan, whose name would otherwise have long since been forgotten, to fresco the Kaisersaal, a magnificent Rococo room full of light, stucco and multi-coloured marble. The chosen theme for the paintings was an obscure incident from 12C history - the homage of the Prince Bishop to Frederick Barbarossa, interpreted by Tiepolo in the great ceiling painting *Apollo Brings Barbarossa his Bride* and two small paintings, the *Marriage of Barbarossa* and the *Investiture of Bishop Harold*. He transforms the story into a splendid pageant, full of echoes of 16C Venice. Apollo's chariot sails weightlessly through the illusionistic clouds.
Treppenhaus (grand staircase): Tiepolo also frescoed this ceiling. Again the theme is absurdly pompous – the four continents paying homage to the Prince Bishop, and again Tiepolo has translated it into a fabulous iridescent world of pure delight, as effortless and spontaneous as a sketch. Ascending the staircase, as the vast span of the ceiling slowly unfolds overhead, is one of the great delights of European art.

Mainfränkisches Museum
Festung Marienburg
97082 Würzburg.
Tel (49 931) 43016
Fax (49 931) 43018
Apr-Sept: Tues to Sun 10-5
Oct-Mar: Tues to Sun 10-4
Closed Mon.
Excellent array of sculpture by Riemenschnieder**.

Hungary

National holidays: Jan 1, Easter Mon, Apr 4, May 1, Aug 20, Nov 7, Dec 25, 26.

NB Entrance to museums is generally free on Saturdays.

Tourist information: IBUSZ.

BUDAPEST

Magyar Nemzeti Galéria (Hungarian National Gallery)

H-1014 Budapest, Dísz tér 17,
H-12500 Budapest, P.O.B. 31.
Tel (36 1) 375 7533, info 423
Fax (36 1) 375 8898, 212 7356
mng@ella.hu
Tues to Sun 10-6. Closed Mon
and days following hols.

This gallery, housed in the renovated Royal Palace of Buda, has three collections of Hungarian art; the Old Hungarian collection, from 11C to 18C; 19C and 20C; and the modern collection. The highpoints are the Old Hungarian collection of panel paintings, esp. 15C devotional pictures (The Virgin at the Spinning Wheel from Nemetujvar, and the small Virgin with the Rose from Kassa), wooden sculptures and, above all, the elaborate 15C and 16C winged altarpieces*, with both sculpture and painting, and soaring, intricate pinnacles, displayed in the great throne room.

Szépművészeti Múzeum (Museum of Fine Arts)

1146 Budapest, Dózsa György út 41.
Tel (36 1) 343 9759
Fax (36 1) 343 8298
info@szepmuveszeti.hu
Tues to Sun 10-5.30. Closed Mon.

Wide-ranging collection, but esp. rich in Spanish painting and the art of the Italian Renaissance.

Spanish*: seven El Grecos. 17C paintings by Cano, Murillo, Zurbarán, Velázquez. Good collection of Goya, inc. The Water Carrier and The Knife Grinder.

Dutch: 17C; rich in genre, landscape and seascape.

Flemish: inc. Bruegel's The Sermon of St John the Baptist*.

French: small number of works, inc. Claude* and Philippe de Champaigne. Dullish Impressionists.

German: Cranach, Liss.

Italian: small collection of 14C and 15C works, 16C inc. Raphael's Esterhazy Madonna*, and Correggio. An outstanding Venetian and Lombard section, esp. portraits, with Giorgione's dreamy Portrait of a Man** and a romantic three-quarter-length Veronese Portrait of a Man*, in an ermine-lined cloak. Tiepolo's St James the Greater**.

Self-Portrait as Timanthes, *James Barry,*
National Gallery of Ireland, Dublin

Ireland, Republic of

National holidays: Jan 1, March 17, Easter Mon, Whit Mon, first Mon in May, June 22, Aug 6, Oct 29, Dec 25, 26.

Irish art

For most of its history Ireland has been politically and economically dominated by England and this is reflected in its art. While Dublin always supported artists who catered for the local monied clientele, the most notable talents tended to gravitate abroad. In 17C and 18C Ireland portraiture (Charles Jervas) and landscape (John Butts, George Barrett) were the dominant genres; Nathaniel Hone and James Barry won international recognition abroad. In the 19C William Orpen, Walter Osborne and John Lavery were Irish counterparts to Impressionism, while from the later 19C specifically Irish subject matter – often with a nationalist slant and celebrating the endurance of the peasantry – became popular. The most important painter of that kind was Jack B. Yeats, who painted in a gestural post-Impressionist fashion and has now become a national icon. In the 20C Irish artists, (Maine Jellet, Evie Hone, Norah McGuinness, Mary Swanzy) were attracted by Parisian Modernism and Maine Jellett became a pioneer of Cubism in Ireland, while other painters, such as Sean Keating, remained strongly traditionalist.

BLESSINGTON, Co Wicklow

Beit Collection
Russborough, Blessington,
Co. Wicklow.
Tel (353 45) 8652 39
Fax (353 45 8650 54
www.castlesireland.com/
russborough.htm
May to Sept: Mon to Sun 10.30-
5.30. April (from Easter) and Oct:
Sun and bank holidays 10.30-5.30.
Vermeer's *Lady Writing a Letter**
and Goya portrait.

CORK

Crawford Municipal Art Gallery
Tel (353 21) 427 3377
www.synergy.ie/crawford
crawfordinfo@eircom.net
Irish painting from 18C onwards, James Barry, Nathaniel Grogan, Paul Henry, Jack B. Yeats.

DUBLIN

The Hugh Lane Municipal Gallery of Modern Art

Parnell Square, Dublin 1.
Tel (353 1) 874 1903
Fax (353 1) 872 2182
www.hughlane.ie
info@hughlane.ie
Tues, Thurs 9.30-6; Fri, Sat 9.30-5; Sun 11-5. Closed Mon.

Pictures by artists born after 1860. The collection of Sir Hugh Lane has been divided into two groups following a dispute over his will, and these are shown alternately at the National Gallery, London and in Dublin for 5-year periods: they inc. important Impressionist works, amongst them Manet's *Eva Gonzales* and *Music in the Tuileries Garden**, and Renoir's *The Umbrellas**. Other works inc. a series of portraits of Irish men and women by Lavery, Sargent, Shannon and Jack B. Yeats. Contemp-orary works by Albers, Agnes Martin, Michael Farrell and Colin Middleton. Francis Bacon's recon-structed studio has been donated to the gallery.

National Gallery of Ireland

Merrion Square W, Dublin 2.
Tel (353 1) 661 5133
Fax (353 1) 6153 72
www.nationalgallery. ie
Mon to Sat 10-5.30;
Thurs 10-8.30. Sun 2-5. Café.

A fine collection of the major European schools, recently enriched by Caravaggio's rediscovered *The Taking of Christ***, which once hung with the National Gallery of England's *Supper at Emmaus*.
British: a large collection, with two

portraits by Dobson, inc. works by the major 18C portraitists, esp. Hogarth, Gainsborough and a characteristic Raeburn, romanti-cally backlit.
Dutch and Flemish: works by

Above: Interior of Francis Bacon's studio, Reece Mews, London,
The Hugh Lane Municipal Gallery of Modern Art, Dublin

Rembrandt (an unusual landscape, *Rest on the Flight into Egypt**) and his followers. Genre (esp. Duyster; also Troost – see ill. p.263) and landscape painters, inc. Ruisdael*; Van Dyck and Rubens.

French: the main emphasis falls on the 17C. A romantic early Poussin, *Acis and Galatea***, and a severe late work, *Lamentation over the Body of Christ****, one of the most passionate and austere of his

167

Christ Bidding Farewell,
Gerard David,
National Gallery of Ireland, Dublin

religious works. Claude**. 18C
well represented inc. early David.
Small coll. of early 19C painting
inc. Delacroix and Impressionists.
Italian: a rich collection, with some
good Renaissance painting inc.
Mantegna** and Perugino. Good
collection of 16C and 18C North
Italian and Venetian painting, inc.
Moroni and Tiepolo. Most unusual
is the collection of Italian baroque
painting*, with good works by rare
Florentine painters; Caravaggio**
and his followers, inc. Gentileschi;
a vast and dazzling Procaccini;
Castiglione.
Spanish: Murillo, Zurbarán, Goya.
Velázquez' *Kitchen Maid with the*
*Supper at Emmaus***, an early
naturalistic work.
Irish: A large collection, from the
late 17C, of portraiture, landscape,
and genre, inc. Nathaniel Hone's
The Conjuror, an attack on Reynolds
for plagiarism, and James Barry's
Self-Portrait as Timanthes (see p. 164).
Within the gallery a new museum is
devoted to the works of Jack B.
Yeats.

Irish Museum of Modern Art
Royal Military Hospital,
Military Road, Kilmainham,
Dublin 8.
Tel (353 1) 612 9900
Fax (353 1) 612 9999
www.modernart.ie
info@modernart.ie
Tues to Sat 10-5.30, Sun and
bank holidays 12-5.30.
Closed Mon.
Conversion of 17C hospital to
house national collection of 20C
and 21C Irish and non-Irish art.

Israel

In its short life Israel has built up an impressive collection of Western art, with the emphasis on modern works.

Opening hours:if planning to visit a museum on the Sabbath (Saturday), buy an admission ticket in advance.

National holidays: Purim (Mar), Passover (several days in Apr), May 7, Lagvarmer (May), Shavout (2 days Apr/May/June), New Year (Sept), Yom Kippur (Sept/Oct), two other days in Oct.

JERUSALEM

The Israel Museum
Gerat Ram, Jerusalem.
Tel (972 2) 670 8811
Fax (972 2) 6318 33
www.imj.org.il
Mon, Wed, Thurs, Sun 10-5;
Tues 4-10; Fri and hol eves 10-2;
Sat and hols 10-4.
This museum complex includes:
Bezalel National Museum of Art
Main emphasis is on Impressionist, Post-Impressionist and contemporary painting.
Billy Rose Art Garden Designed by Noguchi, a spectacular setting for a very important collection of modern sculpture, donated by Billy Rose, the New York showman, inc. Archipenko*, Arp, Lipchitz*, Nevelson, Moore, Picasso*.

TEL AVIV

Tel Aviv Museum of Art
27 Shaul Hamelech Blvd,
61332 Tel Aviv.
Tel (972 3) 695 7361
Fax (972 3) 695 8099
Mon, Wed 10-4; Tues,
Thurs 10-10; Fri 10-2; Sat 10-4.
Closed Sun.
Some 17C and 18C European paintings; Impressionists and Post-Impressionists; contemporary art. Note esp. works by Pissarro, Renoir, Chagall and Archipenko*.

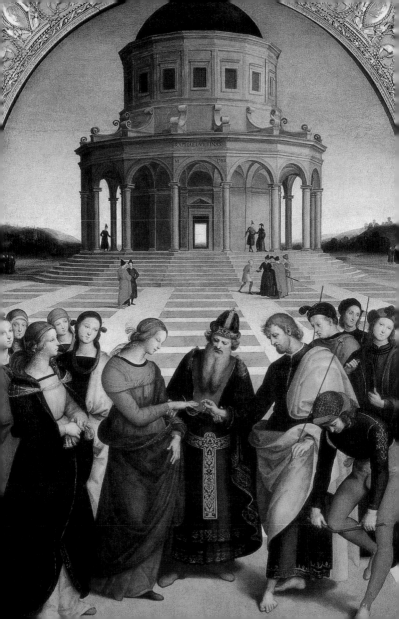

Italy

Part of the delight of being in Italy is discovering an important work in a dark, deserted church, or the sculpture of a famous artist in the town square. Almost every small town has something to offer, and the special pleasure of seeing a work of art in situ is characteristically Italian. NB churches are usually dimly lit which makes viewing paintings very difficult. Take plenty of coins for the timed lighting or automatic commentary which is sometimes available, or take a torch.

Opening hours: Italian museums are notorious for their erratic opening hours. Check with the local tourist office for the most recent hours, and that the museums and churches you want to see have not been closed for restoration (*per restauro*). Fairly common opening hours for state museums are Tuesday to Saturday 9-2, Sunday and some holidays 9-12. Most state museums close on Monday. Churches are usually closed between 12 and 3.30 and after 6.

National holidays: Jan 1, Easter Mon, Apr 25, May 1, Aug 15, Nov 1, Dec 8, 25, 26. Museums close on the most important holidays; open mornings only on other holidays.

Tourist information: EPT, ENIT.

Useful words: art *arte*; castle *castello*; catalogue *catalogo*; cathedral *duomo, cattedrale*; cemetery *camposanto*; chapel *cappella*; church *chiesa*; closed *chiuso*; coffee bar *bar/caffè*; entrance *entrata*; exhibition *esposizione/mostra*; exit *uscita*; gallery *galleria*; information *informazioni*; museum *museo*; open *aperto*; painting *quadro*; picture gallery *pinacoteca*; restaurant *ristorante*; school *scuola*; sculpture *scultura*; square *piazza*; ticket *biglietto;* 14C *trecento;* 15C *quattrocento;* 16C *cinquecento;* 17C *seicento*

Opposite: Betrothal of the Virgin, *Raphael,*
Pinacoteca di Brera, Milan

Art in Italy

The three great centres of Italian painting are Florence, Rome and Venice. Nonetheless, in different ways and at different times other great schools of painting have arisen, and for this reason I have included brief introductions to the major cities and regions where appropriate.

In very broad terms, in the 14C, with Duccio in Siena, and Giotto in Padua and Florence, there was a break with the Byzantine past, and the beginnings of a new naturalism. In Renaissance Florence artists developed this naturalism, studying anatomy, perspective, and the fall of light and shade, and their discoveries spread aound Italy. Sienese art remained more decorative, while Venetian painters – Giorgione, Titian, Veronese – were more interested in colour and in light and shade. In northern Italy independent developments took place in Padua and in the small duchies of Mantua and Ferrara; in the 16C Correggio brought importance to Parma.

In the early 16C the Rome of Pope Julius II, made splendid by Michelangelo and Raphael, became dominant; Rome was to continue to attract artists from all over Europe throughout the 17C. The Baroque also saw the emergence of new and important centres – in Milan, Naples, Genoa and Bologna. 17C Venice was less interesting, but the development of the Rococo brought new glory both there and to Naples.

In the mid-18C Rome became the centre of the Neo-Classical movement – the sculptor Antonio Canova worked there from 1779. The 19C saw the decline of great art in Italy; the Macchiaioli, dominated by Giovanni Fattori, were a school of *plein-air* painters influenced by French Realism. More original are the Impressionist sculptures of Medardo Rosso. The timidity of Italian painting was attacked by the Futurists (1909-15), who demanded a radically new art which expressed the speed and glamour of a new environment, created by the power of machinery. Dominant was Boccioni, whose works stress the interaction between the object and surrounding space. Modigliani, famous for his nudes, worked in Paris. In the pessimistic atmosphere of the post-war years Carra and De Chirico painted dreamlike empty squares, inhabited by disturb-

Opposite: Madonna of the Rose Garden,
Stefano di Verona,
Museo di Castelvecchio, Verona

Modern Idol, *Umberto Boccioni,*
Estorick Collection of Modern Italian Art, London

ing mannequins, and classical statues, redolent of a lost past, and in the inter-war years many artists, among them Morandi and Casorati, sought a new classicism. After the Second World War the red stained sackcloth collages of Burri, so evocative of blood, or Guttoso's aggressive Social Realist pictures are a response to terror. In the 1960s American styles dominated the art world, and Italian art reflected international contemporary movements – Arte Povera, Kinetic Art, Happenings, and Superrealism (Pistoletto). But the Post Modernism of the 1980s encouraged a return to Italian traditions; Mariani linked past and present by the exploration of classical myths and forms; Clemente and Chia restored a painterly art, with an expressive style that often used dream symbolism and archetypal Mediterranean myths.

AREZZO

Casa Vasari
Via 20 Settembre 55,
52100 Arezzo.
Tel (39 0575) 40 90 40
Mon and Wed to Sat 8.30-7.30;
Sun 8.30-12.30. Closed Tues.
The house was decorated by Vasari with frescoes charmingly celebrating the status of the artist.

Duomo
In the N aisle, a fresco by Piero della Francesca, *Mary Magdalene**.

San Francesco
Via Cavour.
Tel (39 0575) 90 04 04
www.pierodellafrancesca.it
Weekdays 9-7; Sats and days before hols 9-6.15; Suns and hols 1-6.15. Booking obligatory.
In the chancel, frescoes by Piero della Francesca depicting the *Legend of the Holy Cross****. The abstract beauty of these works, with their geometrically patterned surfaces, solemn figures, precise outlines, and cool clear light, has particularly appealed to the 20C, and this is perhaps now the most celebrated Renaissance fresco cycle.

ASSISI

Basilica di S Francesco
Piazza S. Francesco.
The great pilgrimage church was begun two years after S Francis's death in 1226, and during the following century some of the most famous artists in Italy came to this corner of Umbria to work on it.

The **Lower Church** contains frescoes by the Master of S Francesco (nave) and Pietro Lorenzetti** (L transept) with illusionistic painted bench by Lorenzetti. The **Chapel of S Martin** has splendid stained glass and fresco cycle by Simone Martini*. Cimabue *Maestà* with portrait of S Francis is in R transept. The **Upper Church** has ruined fresco cycle by Cimabue in apse and transepts. Top register of nave has frescoes probably by Roman painters. Lower register of nave has famous cycle of *Scenes of Life of S Francis*** by the school of Giotto, though his own involvement is debatable. Surprisingly little was damaged in the recent earthquake.

BASSANO DEL GRAPPA

Museo Civico
Piazza Garibaldi, PC 36061.
Tel (39 0424) 52 22 35
Fax (39 0424) 52 39 14
Tues to Sat 9-12.30, 3.30-6.30;
Sun 3.30-6.30. Closed Mon.
An important collection of works by Jacopo Bassano, his family and followers; key works in the development of Bassano's style. Other Venetian paintings inc. works by Magnasco, Longhi, Ricci and Zais. Sculptures by Canova.

BERGAMO

Accademia Carrara di Belle Arti
Piazza Carrara 81a,
Via S. Tomaso, 24100 Bergamo.
Tel (39 035) 39 96 40, tickets 43
Fax (39 035) 22 45 10
segr@accademia.carrara.bergamo.it

Accademia Carrara di Belle Arti,
Bergamo

www.accademia.carrara.bergamo.it
Wed to Mon 9.30-12.30,
2.30-5.30. Closed Tues.
A small choice and intensely enjoy-
able regional collection, emphasing
Bergamese painting. Other Renais-
sance schools inc. a Pisanello
portrait*; two Bellini *Madonnas*;
a Mantegna *Madonna*; and a small
Madonna and Child, probably by
Titian. Works by Lotto inc. the
enigmatic portrait of Lucina
Brembate**, rich in mysterious
symbolism, and the *Mystic Marriage
of St Catherine**. A room of direct
and descriptive portraits* by
Moroni (see ill. p.181). From the 18C
paintings of musical instruments by
Baschenis**, startlingly modern in
their fascination with geometric
shapes and space. Across the road a
pretty Renaissance palazzo houses a
small and personal 20C collection,
with a compelling Casorati *Still Life*.

Cappella Colleoni
Mar-Oct: Tues to Sun 9-12, 2-6.30;
Nov-Feb: Tues to Sun 10-12,
2.30-4.30. Closed Mon.
On the façade, marble reliefs by

Giovanni Antonio Amadeo of the
Life of Adam and Eve. Inside:
tomb of Colleoni by Amadeo; fres-
coes by Tiepolo*.

Trescore Balneario
Suardi Oratory, nr Bergamo.
Tel (39 035) 94 47 77.
Guided tour.

The Holy Family, *Lorenzo Lotto,*
Accademia Carrara di Belle Arti, Bergamo

A small chapel frescoed by Lorenzo Lotto* with unusually vivid scenes, full of everyday detail, telling the lives of St Barbara and St Bridget, and intended to defend Catholicism against northern heresy.

Lorenzo Lotto worked for some time in Bergamo and several churches have altarpieces by him.

Most important are **San Bernardino in Pignolo, San Michele al Pozzo Bianco** (a fresco-cycle with scenes from the *Life of the Virgin*) and Santo Spirito. Lotto also designed the extraordinary intarsia choir stalls in **S. Maria Maggiore**.

Art in Bologna

In the 14C Bolognese art was dominated by the highly dramatic style of Vitale da Bologna; later Costa and Francia created a sweet and tranquil Renaissance style. But in the 17C the Bolognese dominated painting from Piacenza to Rimini. In the mid-1580s the Carracci family attempted to save art from the abstractions of Mannerism and to restore the clarity and grandeur of the High Renaissance through a deep study of nature and of the Old Masters. Annibale Carraci's early style is solid and classically balanced, Ludovico's intensely emotional and Baroque. After 1622 the classicism of Guido Reni dominated. Towards the end of the century, G. M. Crespi introduced a new informality; he painted tender and direct genre scenes and portraits.

Madonna and Child, *Guido Reni, North Carolina Museum of Art, Raleigh*

BOLOGNA

Collezioni Comunali d'Arte

Piazza Maggiore 6, 40126 Bologna.
Tel (39 051) 20 35 26
Fax (39 051) 23 23 12
museicivici@bologna.it
Tues to Sun 10-6. Closed Mon.

A collection of – mainly Bolognese – paintings and misc. artwork housed in the medieval Palazzo Comunale. Contains exceptional collection of Donato Creti. Also works by Barnaba da Modena, Vitale da Bologna, Francia, G. M. Crespi etc.

Museo Morandi

Piazza Maggiore, 40126 Bologna.
Tel (39 051) 20 33 32
mmorandi@comune. bologna.it
Tues to Sun 10-6. Closed Mon.

A fascinating museum devoted to the Bolognese painter Giorgio Morandi (1890-1964). Located alongside the Collezioni Comunali in the Palazzo Comunale, it contains a large collection of paintings and graphic work from throughout his career, a reconstruction of his studio and collections of memorabilia including many of the objects that are familiar from his still lifes.

Pinacoteca Nazionale

Via delle Belle Arti 56,
40126 Bologna.
Tel (39 051) 24 32 22
Tues to Sat 9-2; Sun 9-1.
Closed Mon.

A grandiose and too little visited collection of predominantly Bolognese paintings from 14C to 18C, though the most famous work is Raphael's *St Cecilia***. From the 14C dramatic works by Vitale da Bologna. The 15C and 16C inc. Tura, Cossa and Parmigianino*. The Carraccis are all represented by major works; compare the High Renaissance solidity and symmetry of Annibale's *Virgin with St John and St Catherine* with the irrational space and lighting of Ludovico's *Madonna degli Scalzi**. Guercino's *St William of Aquitaine**, with its flickering patterns of light and shade, and swirling movement, is one of the earliest fully Baroque works. Contrast with the bold simplicity and hieratic composition of Reni's *Madonna della Pietà** and with the desolate poetry of his *Samson***, where graceful line and beauty blend with detailed realism. Also a group of informal genre scenes by G. M. Crespi*.

San Domenico

Piazza S Domenico.

The chapel of S Domenico (frescoed by Guido Reni, 1605) contains the marvellous marble *arca di S Domenico***. The urn and main structure of this monument (1267) are by the workshop of Nicola Pisano, the surmounting arch (1473) is by Niccolo dell'Arca, who took his name from this work, while the small figures of an angel and of *Saints Proclusus* and *Petronius* (1494) are early works by Michel-angelo. Among the many paintings in the church are works by Giunta Pisano, Filippino Lippi and Guercino.

San Giacomo Maggiore

Via Zamboni 15.

An important Gothic church, rich in works from 14C -17C Cappella

Bentivoglio contains a high altar by Francia and *Triumphs of Fame and Death* by Costa (1497-90). Cappella Poggi designed and decorated by Tibaldi. Oratory of St Cecilia with paintings by Francia, Costa and Aspertini.

Santa Maria dei Servi
Strada Maggiore 41.
Cimabue's *Madonna in Trono**. Frescoes by Vitale da Bologna.

Santa Maria della Vita
Via Clavature.
Amazing, emotionally charged terracotta group of the *Lamentation** (*c*.1485) by Niccolo dell'Arca.

See also other works by Annibale Carracci in the **Palazzo Magnani**, **Palazzo Salem** (Credito Romagnolo), **San Gregorio** and **Sta Maria della Carità**.

BRESCIA

Pinacoteca Tosio Martinengo
Piazza Moretto 4, 25100 Brescia.
Tel (39 030) 377 4999
Tues to Fri 9-12.30, 3-5; Sat, Sun 9-12.30, 3-6. Closed Mon.
Housed in a cavernous, somewhat forlorn palace, this is the place to see 16C Brescian painting with its unique blend of Venetian colour and Lombard down-to-earth realism. Major works by the school's great masters Savoldo, Romanino and Moretto. Note two charming pieces by Savoldo, a wayward *Adoration of the Shepherds** and a haunting *Flute Player**. In the 18C, the Lombard tradition of realism culminated in Ceruti's unsettling paintings of beggars and cripples. *The Two Wretches** here is one of the most famous.

San Nazzaro e San Celso
Piazza Moretto, 4.
Paintings by Moretto, Pittoni, and Titian's Averoldi altarpiece** over the high altar. Made as a polyptych at the patron's insistence, this immediately became famous for the powerful modelling and warm lighting of the landscape.

CASTELFRANCO VENETO

Cattedrale di San Liberale
Piazza del Duomo.
An altarpiece in its original chapel by Giorgione: *The Madonna Enthroned with St Francis and St Liberale**** 'The Castelfranco Madonna' with dreamy figures set against a romantic landscape. The house of Giorgione, in the same square, has a frieze attributed to him.

CASTIGLIONE OLONA

Battistero
Via Cardinale Branda.
Frescoes of the *Life of St John*** 1435, by Masolino, show a return to his early graceful charm.

Chiesa della Collegiata
Via Cardinale Branda 1, 21043 Castiglione Olona.
Tel (39 0331) 85028
Oct-Mar: 10-12, 2.30-5; Apr-Sept: 10-12, 3-7.
Frescoes by Masolino and Lorenzo Vecchietta.

Art in Bergamo and Brescia

In the 16C Moretto and his pupil, Moroni, painted quietly realistic portraits with some of the warmth and style of Venetian art. From 1640-1740 painters known as the 'Lombard painters of reality' specialized in genre, portraiture and still-life. Baschenis painted elegant arrangements of musical instruments; Fra Galgario painted warmly human portraits; Giacomo Ceruti produced sordid and unsympathetic pictures of beggars and cripples.

Portrait of a Young Man, *Giovan Battista Moroni,*
Accademia Carrara di Belle Arti, Bergamo

CITTA DI CASTELLO

Collezioni Burri

Palazzo Albizzini, Piazza Garibaldi, and at Tabacchi Rignaldello, 06012 Città di Castello.
Tel (39 075) 855 4649
Fax (39 075) 855 4649.

Alberto Burri was one of the most famous Italian artists in the second half of the 20C. A representative collection of his work fills the Renaissance Palazzo Albizzini. More extraordinary is the colossal installation in the tobacco-drying sheds on the outskirts of the town.

CORTONA

Museo Diocesano

Chiesa del Gesù, Piazza del Duomo 2, 62044 Cortona.
Tel (39 0575) 62830
Nov-Mar: Tues to Sun 9-1, 3-5;
Apr-Oct: Tues to Sun 9-1, 3-6.30.
Closed Mon.

A small museum with outstanding works. Most ravishing is Fra Angelico's *Annunciation*** (in the predella, an enchanting view of Lake Trasimene). Luca Signorelli*, Pietro Lorenzetti* and an unexpected but fine G. M.Crespi.

CREMONA

Duomo

Piazza del Comune.
Frescoes by Boccacino, Romanino, and passionate, powerfully illusionistic works by Pordenone*.

Museo Civico Ala Ponzone

Palazzo Affaitati, Via Ugolani Dati 4, 26100 Cremona.
Tel (39 0372) 46 18 85
museo.alaponzone@rccr.cremona.it
Tues to Sat 8.30-6; Sun 10-6.
Closed Mon.

A collection of mainly Cremonese paintings, with works from local churches. Still lifes by Panfilo Nuvolone, of rustic motifs – windfall apples, a basket of chestnuts – that suggest the influence of Caravaggio. Outstanding are Caravaggio's tormented *St Francis**, perhaps painted in the Alban hills when the artist was on the run after killing a man; and G. C. Procaccini's *Death of the Virgin**, and *Guardian Angel*, an unusual polychromed wooden sculpture. Works by Sofonisba Anguissola and her sisters; Sofonisba, admired by Vasari and Michelangelo, was a big tourist attraction in 16C Cremona.

San Sigismondo

Piazza Bianca Maria Visconti (2.5 km outside the city centre, towards Casalmaggiore).
Dazzlingly rich and festive frescoes* by 16C Cremonese artists, esp. the Campi family.

ESTE

Duomo

Piazza Santa Tecla.
Tiepolo's *St Tecla Delivering Este from the Plague**, a stupendous and theatrical work, in poor condition.

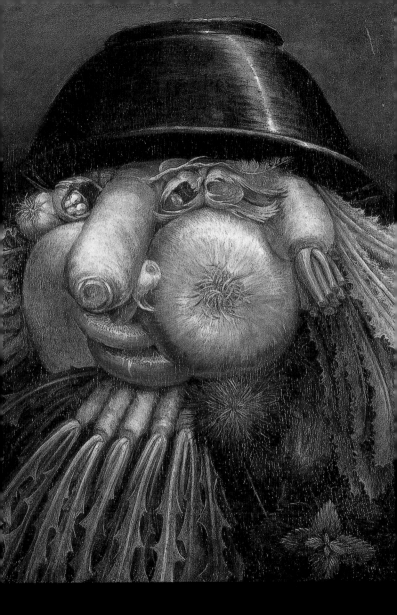

Vegetable Head, *Giuseppe Arcimboldo,*
Museo Civico ala Ponzone, Cremona

Room of the Months: May, Francesco del Cossa and Ercole de' Roberti, Palazzo Schifanoia, Ferrara

Art in Ferrara

The highly cultivated art amateur Leonello d'Este (who reigned from 1441-50) attracted to the court of Ferrara learned scholars, poets and painters, amongst them Pisanello and Piero della Francesca. Under Duke Borso (1450-71) Ferrarese painters developed a strange, dry style; in the works of Cosmè Tura and Francesco del Cossa fantastic canopies and thrones mingle with vividly naturalistic detail. Dosso Dossi (d.1542) was the last of the Ferrarese painters. He painted Giorgionesque idylls with rich landscape backgrounds.

FERRARA

Museo del Duomo

Piazza della Cattedrale,
44100 Ferrara.
Tel (39 0532) 32969
Tues to Sat 10-12, 3-5;
Sun 10-12, 4-6. Closed Mon.
A marble *Madonna* by Jacopo della Quercia, and organ shutters** with *St George and the Dragon,* and the *Annunciation**, a seminal and extraordinary work by Cosmè Tura, worth the climb up very steep stairs. (The museum is moving to S. Romano.)

Palazzo Schifanoia

Via Scandiana 23, 44100 Ferrara.
Tel (39 0532) 62038
Fax (39 0532) 74 06 85
Mon to Sat 9.30-7. Closed Sun.
The summer palace of Duke Borso. A fresco series of the *Months*** within an astrological framework by Francesco del Cossa and Ercole de' Roberti, although much damaged, gives a charming picture of life in 15C Ferrara, enlivened by many fresh and individual touches.

Pinacoteca Nazionale

Palazzo dei Diamanti, Corso
Ercole I d'Este 21, 44100 Ferrara.
Tel (39 0532) 20 58 44
Tues, Wed, Fri, Sat 9-2;
Thurs 9-7; Sun 9-1. Closed Mon.
In one of the most spectacular Renaissance palaces, a collection of mainly Ferrarese painting from the 14C; other schools inc. works by Mantegna and Gentile da Fabriano. 15C inc. Ercole de' Roberti and Cosmè Tura. Note esp. the two *Muses* from a series painted for the studiolo of Lionello d'Este. 16C inc. Dosso Dossi and Garofalo; 17C Carlo Bonone.

FIRENZE (Florence)

Bargello

(see Museo Nazionale)

Galleria dell'Accademia

Via Ricasoli 60, 50122 Florence.
Tel/Fax (39 055) 238 8609
www.sbas.firenze.it
GalleriaAccademia@sbas.firenze.it
Tues to Sun 8.30-7; Sat 8.30-10
(June-Sept). Closed Mon.
Michelangelo's *David**** (the original – there are two copies in Florence), and his four unfinished *Slaves**, sculpted for the tomb of Pope Julius II. The *Palestrina Pietà* is attrib. to Michelangelo. Also Florentine paintings from 13C to 16C.

Galleria d'Arte Moderna

Palazzo Pitti, Piazza Pitti 1,
50125 Firenze.
Tel (39 055) 238 8616
Fax (39 055) 265 4520
Tues to Sun 9-2. Closed Mon.
Closed 2nd and 4th Sun and 1st,
3rd and 5th Mon every month.
The museum, in the Pitti palace, includes many rooms painted in Neo-Classical style during the period of Napoleonic rule. It is devoted to 19C painting and sculpture in Tuscany, and gives an exemplary account of it, with informative placards in Italian and English. It includes the best of all collections of work by the Macchiaioli group of realist painters of the 1860s, still not as well known outside Italy as they deserve. Note the startlingly modern study of a cloister by Abbati and *La Rotonda di Palmieri* by Fattori. In contrast, the display of 20C Tuscan work is meagre and depressing.

Five sibyls seated
in niches,
attributed to Botticelli,
Christ Church, Oxford

Florentine art

In the early years of the 15C, Florence – a prosperous and stable
merchant city dominated by the Medici – became the important
centre of the Renaissance. The flat patterning and flowing grace
of the International Gothic were destroyed by the austere, ener-
getic figures of Masaccio and the sculptor Donatello, dependent
on a new study of the human body and on the discovery of the
mathematical laws of perspective. Masaccio was the true heir to
the new three-dimensionality of Giotto's figure style. In the
later 15C artists became less concerned with solidity and more
with movement (Pollaiuolo) and with the beauties of line (Botti-
celli). 15C painting is radiantly fresh, alive to the rediscovered
beauty of the natural world. The art of the minor masters,

Gozzoli and Ghirlandaio, with their festive descriptions of everyday life, is a delight.

In the early 16C Florence became, for a short time, the home of the great High Renaissance painters – Leonardo, Michelangelo, and Raphael. By the end of the 1520s Pontormo, Rosso and the younger Bronzino had begun to develop the irrational treatment of space and form and the strange, cold colour harmonies of Mannerism. 17C Florentine painting has a hot-house, decadent atmosphere; there is a pervasive interest in the macabre and the erotic; the century produced the morbid sensuality of Furini and the intense piety of Carlo Dolci. In the 19C Florence was an important centre, and the Macchiaoli created a new kind of fresh and direct landscape painting.

Galleria Palatina

Palazzo Pitti, Piazza Pitti 1,
50125 Firenze.
Tel (39 055) 238 8611, 238 8614
Fax (39 055) 21 66 73
www.sbas.firenze.it/palatina
Tues-Sun 8.30-6.50. Closed Mon.
The pictures, richly grouped, frame-to-frame, are housed in the former Medici grand ducal apartments and the gallery still retains something of its princely splendour. The absolute power of the Medici is given brilliant expression in the decoration of Pietro da Cortona, in the light and enchanting frescoes of the Sala della Stufa*, and in the sequence of five rooms opulently adorned with stucco and painting. **Italian:** main character of-the collection depends on the important works by the most famous artists of the Florentine and Venetian High Renaissance and Baroque. Large altarpieces by Raphael, Andrea del Sarto, Fra Bartolommeo, Rosso. Portraits by Raphael** and Titian**. From the Florentine Seicento, morbidly erotic works by Furini and Cristofano Allori (*Judith*); landscapes by Rosa. **Other schools** inc. Rubens*, Van Dyck's *Cardinal Guido Bentivoglio*, painted with unusual Baroque vivacity, and a group of small cabinet pictures by northern artists.

Galleria degli Uffizi

Loggiato degli Uffizi 6,
50122 Firenze.
Tel (39 055) 238 8651
Fax (39 055) 238 8699
Tues to Sat 9-7/ Tues to Thurs
8.30-10.30; hols 8.30-8; Fri and
Sat 8.30-11.30. Closed Mon.

One of the most famous galleries in the world, generally overrun with coach tours except in December and January.
Italian: Tuscan and Sienese 13C and 14C: compare the flat patterning and linear grace of the *Maestàs* of Cimabue* and Duccio* with the solidity of Giotto's *Ognissanti Madonna**. Works by Lorenzetti, Simone Martini** and Gentile da Fabriano (whose *Adoration of the Magi* is a splendid achievement of International Gothic). Florentine 14C, 15C and 16C: early Renaissance is well rep, inc. Fra Angelico*, Piero della Francesca*, Filippo Lippi* and Uccello (his *Rout of San Romano* reveals his passion for the new science of perspective). From the later 15C, works by Ghirlandaio*, Filippino Lippi* and Pollaiuolo*. The paintings by Botticelli*** are the chief glory of the collection – the *Primavera* and the *Birth of Venus* are intensely personal, both in their poetic response to classical mythology and in their delicate line and decorative treatment of surface, so alien to the solidity of the early Renaissance. From the early 16C, paintings by Leonardo**, Michelangelo*, Raphael** (his *Leo X and Two Cardinals* is remarkable for its brutal psychological realism and almost Northern detail), and Andrea del Sarto*. Mannerists are well represented by a group of cold, highly polished portraits by Bronzino**; Pontormo and Rosso; and the Emilian Parmigianino's *Madonna of the Long Neck**, whose precious elegance is the quintessence of Mannerism. From Central Italy, Perugino and

Signorelli. From Venice, a good collection of 16C painting inc. Bellini* and Titian (*Flora* and *Venus of Urbino***). From the 17C Caravaggio's fleshy and indolent *Bacchus**; Annibale Carracci; Guercino. Also 18C Venetian painting.

Early Netherlandish: inc. Van der Weyden, Van der Goes' *Portinari Altarpiece*** (note the beauty of the wintry landscape and the rough realism of the shepherds which impressed his Florentine contemporaries). Portraits by Memling: compare their placid realism with the dreamy grace of Botticelli's *Man with a Medal*.

Flemish and Dutch: small collection with good works by Rembrandt, Rubens: some landscapes and genre scenes.

German: collection of Renaissance painting inc. important works by Dürer** and Holbein*.

French: *Harbour Scene* by Claude. The **Corridoio Vasariano** (*guided tours by arrangement only*) leads from the Uffizi and links the Palazzo Vecchio and the Palazzo Pitti. It now shows many 17C and 18C paintings, sketches and selections from the iconographical coll. Most interesting is a collection of self-portraits begun by Cardinal Leopoldo de Medici; note esp. Raphael, Bernini, Pompeo Batoni and Delacroix.

Museo degli Argenti
Palazzo Pitti, Piazza Pitti 1, 50125 Firenze.
Tel (39 055) 238 8710
Fax (39 055) 21 25 57
Tues to Sat 8.30-1.50; open 1st, 3rd, 5th Sun of month. Closed Mon.
Room 5 has light-hearted, bucolic and witty murals by Giovanni da San Giovanni, and by Cecco Bravo and Furini.

Museo della Casa Buonarroti
Via Ghibellina 70, 50122 Firenze.
Tel (39 055) 24 17 52
Fax (39 055) 24 16 98.
www.casabuonarroti.it
casabuonarroti@theta.it
Wed to Mon 9.30-7. Closed Tues.
Michelangelo's first surviving works, the *Battle of the Centaurs* and the *Virgin of the Steps*; also working models, drawings and letters.

Museo dell'Opera del Duomo
Piazza Duomo 9, 50122 Firenze.
Tel (39 055) 239 8796
Fax (39 055) 230 2898
Mon to Sat 9-7. Closed Sun.
Sculptures from the Campanile, the Cathedral and the Baptistery inc. panels*** from the E door of the Baptistery, the *Gates of Paradise* by Ghiberti and the *Pietà** by Michelangelo (the figure of Nicodemus is a self-portrait). Also important works by Donatello* (esp. the wooden statue of *Mary Magdalene***). Compare the sweet and static poetry of Luca della Robbia's *Cantoria** (Singing Gallery) with the frenzied revelry of the same subject by Donatello, although the later panels of Luca's gallery reveal a tentative response to Donatello's vivacity.

Museo Nazionale (Bargello)
Palazzo del Bargello, Via del Proconsolo 4, 50122 Firenze.
Tel (39 055) 238 8606
Tues to Sat 8.30-1.50. Open 2nd and 4th Sun and 1st, 3rd and 5th Mon of month.

Madonna and
Child, *Desiderio da
Settignano,
Museo Nazionale
(Bargello), Florence*

An unrivalled collection of Florentine Renaissance sculpture. Far less crowded than the Uffizi, it is still possible to wander around the Bargello and discover unexpected works. Outstanding works by Donatello**, Michelangelo** (*Drunken Bacchus,* tondo of *Mary with the Infant Christ and St John*) and Cellini. Donatello created the first free-standing life-size bronzes of the Renaissance, reviving the types of Classical Antiquity. Compare the languorous feminine grace of his nude *David* with the more martial air of Verrocchio's *David,* and with the pagan energy of his own *Amor Atys,* a work both intensely naturalistic and laden with classical motives. A series of portrait busts opens with Mino da Fiesole's rigid *Piero de Medici* (the earliest dated work of this kind) followed by the sensitive charm of Desiderio's *Pensive Girl*,* Verrocchio's *Bust of Flora* and culminating in the sensual immediacy of Bernini's *Costanza Buonarelli*.* Also works by Giambologna* and Cellini* (*Narcissus,* statuettes and relief from pedestal of *Perseus* and bust of *Cosimo I*). Two bronze panels* by Brunelleschi and Ghiberti of the *Sacrifice of Isaac,* entries for the famous competition of 1401 to decide on the artist for the doors of the Baptistery.

Museo di San Marco

Piazza San Marco 3, 50121 Firenze.
Tel (39 055) 238 8608
Fax (39 055) 238 8704
Mon to Fri 8.30–1.50;
Sat 8.30–6.50; Sun 8.30–7.
A Dominican monastery, with monks' cells* decorated by Fra Angelico and assistants, and Fra Angelico's celebrated *Annunciation**. Also a museum of works by Fra Angelico, inc. the majestic *Madonna of the Linen Guild** and the *Deposition** In the refectory, Ghirlandaio's *Last Supper.*

Palazzo Medici Riccardi

Via Cavour 1, 50129 Firenze.
Tel (39 055) 276 0340
Mon, Tues, Thurs to Sat 9-12.45, 3-5.45; Sun 9-12, 3-5. Closed Wed.
Chapel: charming frescoes of the Journey of the *Magi** (1459) by Benozzo Gozzoli – a festive procession of Medici princes. **Gallery:** frescoed in a lovely light-hearted style by L. Giordano**; a prelude to the Rococo.

Palazzo Pitti

See Galeria d'Arte Moderna, Galleria Palatina *and* Museo degli Argenti.

Piazza della Signoria

In the Loggia dei Lanzi are statues by Cellini** and Giambologna*. The *Judith and Holofernes* and *David* outside the Palazzo Vecchio are copies.

Palazzo Vecchio

Piazza Signoria, 50122 Firenze.
Tel (39 055) 276 8325
Fax (39 055) 288 049
gestione.musei@comune.firenze.it
Mon to Fri 9-7; hols 8-1.
Closed Thurs.

*Judith and Holofernes** by Donatello. Michelangelo's *Victory Group* – its spiral composition (the *figura serpentinata*) was seminal to the development of Mannerist sculpture. The *Studiolo** of Francesco de Medici was decorated by Vasari and other Mannerist painters. Verrocchio's *Putto Holding a Dolphin** (together with a replica as fountain in courtyard). Frescoes by Bronzino* in the apartments of Eleonora de Toledo.

Churches

Battistero (San Giovanni)

Piazza del Duomo.
Mon to Sat 12-6.30; Sun 8.30-1.30.
Exterior: S doors by Andrea Pisano; N doors by Ghiberti; the panels of the E door have been replaced by copies but the beautiful frames (inc. a self-portrait) remain in place.
Interior: tomb of Baldassare Coscia by Donatello and Michelozzo.

Grotesque, Giorgio di Vasari,
Palazzo Vecchio, Florence

Cenacolo di Sant'Apollonia

Convento di S. Apollonia,
Via 27 Aprile 1, 50129 Firenze.
Tel (39 055) 287 0774
Mon to Sun 8.30-1.50, except 1st,
3rd and last Sun in month and
4th Mon in month.
The major works of Andrea del Castagno.

Duomo (Santa Maria del Fiore)

Piazza del Duomo.
Mon to Sun 8.30-12, 2.30-6.
The dome which dominates Florence was designed by Brunelleschi.
N aisle: Two celebrated frescoed monuments* to condottiere by Uccello and Andrea del Castagno. Also works by Benedetto da Maiano, Ghiberti and Luca della Robbia.

Ognissanti

Borgo Ognissanti 38.
Mon to Sun 8.30-12.30, 3.30-6.30.
Botticelli's *St Augustine**; Ghirlandaio's *St Jerome.*
Cenacolo di Ghirlandaio
Ghirlandaio's *Last Supper.*

Orsanmichele

Via dei Calzaiuoli.
Mon to Sun 9-12, 4-6. Closed first
and last Mon of every month.
Exterior: decorated with statues in niches, this is a monument to the development of Renaissance sculpture in the first quarter of the 15C. Compare the Gothic grace of Ghiberti's *St John the Baptist** with the classicizing style of Nanni di Banco's *Four Crowned Martyrs** and also with the intense psychological realism of Donatello's *St George* (original in the Bargello). The small marble panel beneath (copy) is revolutionary in its use of

linear and atmospheric perspective. *The Incredulity of St Thomas** by Verrocchio is a masterpiece of High Renaissance sculpture.

Interior: a richly decorated tabernacle* by Orcagna houses a *Virgin* by Daddi.

Santissima Annunziata

Piazza della S. Annunziata.
Mon to Sun 7.30-12.30, 4-6.30.
Frescoes in the atrium by Baldovinetti (with one of the earliest realistic landscapes in Italian art), Andrea del Sarto, Pontormo, Rosso and Franciabigio. Interior: Andrea del Castagno*. In the Cloisters of the Dead, Andrea del Sarto's *Madonna del Sacco**.

Santa Croce

Piazza S. Croce.
Mon to Sat 8-12.30, 3-6.30; Sun 3-6.
A vast Franciscan church, full of works of art. R aisle: a *Madonna* by Antonio Rossellino; an *Annunciation** by Donatello; the tomb of *Leonardo Bruni** by Bernardo Rossellino. Compare this with the similar tomb of *Carlo Marsuppini**, by Desiderio da Settignano, in the opposite aisle. Both are monuments to great humanist scholars, and in both ancient and Christian worlds pay homage to intellectual distinction; the Desiderio is more delicate and lyrical. In the R transept, the Baroncelli chapel decorated by Taddeo Gaddi**, who experiments with new effects of light and space. First two chapels R of chancel: damaged but imposing frescoes** by Giotto. End of N transept: a wooden crucifix attrib. to Donatello. Other works by Benedetto da Maiano and Agnolo Gaddi.

Night, *detail, Michelangelo, Medici Chapel, San Lorenzo, Florence*

Museo dell'Opera di Santa Croce
Thurs-Tues 10-6. Closed Wed.
Cimabue, Donatello* and Gaddi.

Santa Felicità
Piazzetta di S. Felicità.
Mon-Sun 8-12, 3.30-6.30.
The Capponi chapel**: decorated by
Pontormo, assisted by Bronzino. *The
Deposition* is Pontormo's masterpiece.

San Lorenzo
Piazza S. Lorenzo.
Mon to Sun 7-12, 3.30-6.30.
Built by Brunelleschi. N and S
pulpits by Donatello*, unorthodox
and violent late works. Desiderio da
Settignano's *Tabernacle of the
Sacrament**.

Door leading from N transept:
Old Sacristy: bronze doors by
Donatello** and painted stucco

reliefs**. Verrocchio's bronze
tomb* for Giovanni and Piero de'
Medici. In the L transept: Filippo
Lippi's *Annunciation*.
Medici Chapels
*(entrance: Piazza Madonna degli
Aldobrandini 6).*
Tues to Sat 8.15-5;
Sun, hols 9-1.50. Closed Mon.
New Sacristy: the Medici tombs
by Michelangelo***.

Santa Maria del Carmine
Piazza del Carmine.
Tel (39 055) 238 2195
Mon to Sat 10-5; Sun 1-5.
Closed Tues.
Brancacci chapel*** (S transept:
separate entrance to R of church):
frescoes by Masaccio and Masolino,
finished by Filippino Lippi. Masac-
cio's frescoes, with their massive

figures and profound grasp of humanity, brought a new and austere realism to Renaissance painting.

S. Andrea Corsini chapel: ceiling by Luca Giordano and sculptures by Foggini.

Santa Maria Novella
Piazza di S. Maria Novella.
Tel (39 055) 28 21 87
N aisle: Masaccio's wall painting *The Holy Trinity***; a revolutionary work, both in its use of mathematical perspective, and in the austere grandeur of the figures. Chancel: frescoes by Ghirlandaio*, in which the lives of the *Virgin and St John* are shown as scenes from fashionable Florentine life, full of charming realistic detail and contemporary portraits. Other works by Spinello Aretino, Bronzino, Filippino Lippi, Ghiberti*, and Orcagna. In the cloisters, frescoes** by Uccello.

San Miniato al Monte
Monte alle Croci
Cardinal of Portugal's chapel**: architecture, sculpture and painting work together to produce one of the most harmonious and lyrical of all early Renaissance projects. The tomb is by Antonio and Bernardo Rossellino; the altarpiece by the Pollaiuolo brothers; frescoes by Baldovinetti; the ceiling of glazed terracotta by Luca della Robbia.

Santa Trinità
Via Tornabuoni.
Mon to Sat 8-12; Sun 4-6.
Sassetti chapel** (2nd R of chancel): Ghirlandaio's frescoes of the *Life of St Francis*. His altarpiece the *Adoration of the Shepherds* is a moving blend of pagan and Christian worlds, of the dignity of Italian art and of the lively realism of the north. Also a gorgeous altarpiece* by Lorenzo Monaco, and important works by Luca della Robbia and Desiderio da Settignano.

FONTANELLATO

Museo Rocca Sanvitale
Rocca Sanvitale, Piazza Matteotti 1, 43012 Fontanellato.
Tel (39 0521) 82 23 46, 82 90 55
Fax (39 0521) 82 25 61
www.fontanellato.org
fontanellato@tin.it
Apr-Oct: Mon to Sun 9.30-12.30, 3-7; Nov-March: Tues to Sun 9.30-12.30, 3-6.
NB: All visits are accompanied and last visits start one hour before the above closing times.
The romantic, moated, Sanvitale castle (now the local council offices) in the centre of this little town contains the surpassingly beautiful *Diana and Actaeon* chamber, frescoed by Parmigianino in 1524. Concentrate hard, as visits are liable to be limited to a few minutes for conservation reasons.

GALLUZZO NR FLORENCE

Museo della Certosa del Galluzzo
Winter: Tues to Sat 9-12, 3-5; Summer: Tues to Sat 9-12, 3-7. Closed Mon.
Five large frescoed lunettes** by Pontormo. Very damaged, they remain impressive.

Throne Room (1844), Palazzo Reale, Genoa

Art in Genoa

The great period of Genoese art runs from *c.*1565-1720 when the Genoese trading families were at the height of their prosperity. For them Rubens and Van Dyck (who worked in Genoa from 1623-27) created the Baroque court portrait. The close contact with Flanders encouraged rustic genre; Bernardo Strozzi painted powerful kitchen scenes; Castiglione specialized in 'Journeys of the Patriarchs', paintings crowded with animals piled high with pots and pans. The magnificent Baroque palaces that line the Via Garibaldi were richly decorated with frescoed apartments on the top floor, and housed splendid private collections. Remains of some of these still survive, and may be seen in the palaces listed on the following page.

GENOVA (Genoa)

Galleria Nazionale
di Palazzo Spinola
Piazza Pelliceria 1,
16123 Genova.
Tel (39 010) 270 5300
Fax (39 010) 270 5322
spinola.artige@arti.beniculturali.it
Tues to Sat 9-8; Sun and hols 10-8.
Closed Mon.
The artistic taste of the old Genoese aristocracy is vividly alive in the rich furnishings, frescoes, and picture gallery which has important 17C and 18C Genoese works; some good early Netherlandish and Flemish works.

Palazzo Bianco
Via Garibaldi 11,
16124 Genova.
Tel (39 010) 29 18 03
Fax (39 010) 20 60 22
Tues to Fri, Sun 9-1; Wed, Sat 9-7.
An important collection of 17C Genoese painting; some good Flemish works inc. Memling, Van Dyck, Rubens; Dutch painting; A weak *Ecce Homo* attrib. to Caravaggio.

Palazzo del Principe
(Palazzo Doria Pamphilj)
Via Adua 6, 16124 Genova.
Tel (39 010) 25 55 09
Tues to Sun 10-5. Closed Mon.
Frescoes by Perino del Vaga*, pupil of Raphael. 16C and 17C family portraits inc. Sebastiano del Piombo*.

Palazzo Reale
(former Palazzo Balbi-Dunazzo)
Via Balbi 10, 16126 Genoa.
Tel (39 010) 271 0272
Mon to Sun 9-8
Mainly 17C Genoese paintings in lavishly-frescoed royal apartments; Castiglione*, Van Dyck. The Sala del Castello frescoed by Valerio Castello. Sculptures by Parodi*.

Palazzo Rosso
Via Garibaldi 18, 1-16124 Genoa.
Tel (39 010) 247 6351
Fax (39 010) 247 5357
Tues, Thurs, Fri 9-1;
Wed, Sat 9-7; Sun 10-6.
A magnificent Baroque palace, whose highpoint is the second-floor rooms, frescoed by Genoese artists (*Four Seasons*** by De Ferrari and Piola). A highly important collection of Italian 16C and 17C art, esp. Veronese's gory *Judith*, Guercino's *Cleopatra***, Reni's *St Sebastian*, Gentileschi. Fine Genoese portraits** by Van Dyck and Flemish genre scenes.

Churches

The churches are rich in 17C and 18C Genoese paintings; many are profusely decorated with fresco and high relief gilding. The Carlone brothers were the most prolific decorators, but their work is not of high quality. The list of churches is highly selective; for the enthusiast there are many more interesting pictures to be seen in the dark corners of elusive churches.

Cattedrale di San Lorenzo
Piazza San Lorenzo.
Chapel R of choir: Barocci's *Vision of St Sebastian*. Chapel L of choir: works by Cambiaso and B. Castello. The Chapel of St John the Baptist has a imposing Renaissance marble screen.

Chiesa del Gesu
(SS Ambrogio e Andrea)
Piazza Matteotti.
High altar: a *Circumcision** by
Rubens, an early work deeply
influenced by Tintoretto. L aisle:
Rubens' *St Ignatius** altarpiece;
works by Piola, Vouet, Reni and
Pozzo.

San Luca
Piazza San Luca.
*Mon to Sun 3-7; also occasionally
open in the morning.*
L of high altar: Castiglione's *Nativ-
ity**. Piola and Parodi.

S. Maria Assunta in Carignano
Piazza di Carignano.
Works by Maratta (2nd altar R);
F. Vanni (4th altar); Guercino (1st
altar L); Procaccini (2nd altar L);
Baroque statues below the dome
by Puget* and Parodi.

LORETO

Pinacoteca
*Palazzo Apostolico, Piazza del
Santuario, 60025 Loreto.*
Tel (39 071) 97 02 91
Fax (39 071) 97 01 02
Thurs to Tues 9-1, 3-6. Closed Wed.
Famous for eight pictures by Lotto,
esp. the huge *St Christopher** and
the late, sketchy *Presentation in
the Temple.*

Santuario della Santa Casa
Piazza del Santuario.
Tel (39 071) 97 01 04
Fax (39 071) 97 68 37
www.santuarioloreto.it
lorcongr@tin.it
Daily 6 am-8 pm
The church is built over the

supposed house of the Virgin,
miraculously translated from
Nazareth, and it is still a major
pilgrimage centre. The miraculous
house itself is surrounded by a
marble screen decorated with
reliefs of the *Life of the Virgin* by
Sansovino. In the **Sacristy of
St John** frescoes by Signorelli. In
the cupola of the **Sacristy of St
Mark** phenomenally illusionistic
painted *Angels** by Melozzo da
Forlí. **Treasury** frescoed by
Roncalli.

LUCCA

Duomo
Piazza S. Martino.
L transept: Jacopo della Quercia's
tomb of Ilaria del Carretto**. 2nd
chapel: Fra Bartolommeo. Works
by Tintoretto and Ghirlandaio.

MANTOVA (Mantua)

Palazzo Ducale
Piazza Sordello, 39.
Tel (39 0376) 32 02 83, 32 08 56
Fax (39 0376) 22 13 64
Tues to Sat 9-2, 2.30-6;
Sun 9-2, 4-10. Closed Mon.
*Camera degli Sposi: booked
appointments necessary for
individuals and groups.*
Vast Gonzaga palace contains
chivalric Pisanello frescoes*, with
their sinopie, of questing knights
and jousting, and tapestries after
Raphael cartoons. (To see Isabella
d'Este's second studiolo and secret
garden, ask the guide.) The art
gallery has dull works by Feti, and
Rubens'* large early painting, *The

Room of the Giants, Guilio Romano, Palazzo Tè, Mantua

*Gonzaga Family in Adoration of the Most Holy Trinity**. The Camera degli Sposi is visited separately, and has Mantegna's frescoes*** of the Gonzaga court. The family, relaxed and informal, are vividly realistic, and the painted setting seems an extension of real space. Note esp. the playful illusionism of the ceiling, which seems open to the sky. Beyond this room are Isabella d'Este's first studiolo and grotto, rooms frescoed by Giulio Romano*, and Duke Vincenzo I's Galleria della Mostra.

Palazzo Tè

Viale Tè, 46100 Mantua.
Tel (39 0376) 32 32 66
Mon 1-6; Tues to Sun 9-6.
Built and decorated by Giulio Romano**. The interior depends on extravagant contrasts from room to room of style and moods.

Most famous is the *Room of the Giants*, in which giants and boulders seem to tumble about the spectator.

MESSINA SICILY

Museo Nazionale
Viale della Libertà 461,
98121 Messina.
Tel (39 090) 36 12 92

Fax (39 090) 36 12 94
Tues to Sat 9-2; Sun, hols 9-1.
Closed Mon.
Two works by Caravaggio*: the *Raising of Lazarus** has the expressionist intensity and large areas of darkness of his late works; the *Adoration of the Shepherds** is full of a sense of pity for the vulnerability of the child. Also see a polyptych by Antonello da Messina.

MILANO (Milan)

The gentle charm of Milanese Renaissance art, led by Vincenzo Foppa, was transformed by the overwhelming influence of Leonardo da Vinci, in Milan c.1483-99. His followers, Predis, Boltraffio, Luini and Sodoma vulgarized his ideas, and his search for delicacy of modelling and subtlety of facial expression tended to degenerate into coy prettiness and black shadows. In the early 17C the leading painters (Cerano, Morazzone, Procaccini, and the sombrely realistic Daniele Crespi) gave expression to the passionate piety of the Counter-Reformation; they were influenced by St Charles Borromeo and his nephew Archbishop Federico Borromeo, and drew strength from the popular realism of the Sacri Monti of Lombardy. The period closed with the works of Francesco del Cairo who heightened passion to hysteria in the depiction of swooning heroines.

Galleria d'Arte Moderna

Via Palestro 16,
20121 Milan.
Tel (39 02) 600 2819
Fax (39 02) 78 46 88
Tues to Sun 10-12, 3-6.
An important collection of 19C Italian art, ranging from Milanese Neo-Classicism to Romanticism and Realism, and to those Italian painters who were influenced by French Impressionism. Many works are by Marino Marini; some 19C French painting. In the **Pavilion of Contemporary Art** are works from the Futurist period to the present day, with particular emphasis on Boccioni.

Musei del Castello Sforzesco

Piazza Castello,
20121 Milan.
Tel (39 02) 6208 3940
Fax (39 02) 6208 3943
www.mimu.it
Tues to Sun 9.30-5.30. Closed Mon.
A large modern museum complex within the fortress built 1451-1466 by Francesco Sforza. Among the remains of frescoes is Leonardo's interweaving foliage in the Sala delle Asse. Sculpture includes the equestrian monument of *Bernabò Visconti* by Bonino da Campione, the monument of *Gaston de Foix* by Bambaia and the *Rondanini Pietà***, Michelangelo's last work. Many 16C and 17C Lombard works, ending with two typically hysterical pieces by Francesco del Cairo. Among a collection of other Northern Italian paintings Lotto's *Portrait of a Youth with a Book* is notably intimate and direct.

Museo Poldi Pezzoli

Via Manzoni 12, 20121 Milan.
Tel (39 02) 79 48 89
Fax (39 02) 869 0788
Tues to Fri, Sun 9.30-12.30,
2.30-6; Sat 9.30-12.30, 2.30-7.30.
Closed Mon.
Crowded with rare objects and pictures, it retains the atmosphere of a private collection. Emphasis is on Venetian and Lombard works (esp. the School of Leonardo); also Pollaiuolo's *Portrait of a Woman** and Botticelli's *Madonna and Child*. Other works by Tiepolo, Mantegna and Piero.

Pinacoteca Ambrosiana

Piazza Pio XI 2, 20123 Milan.
Tel (39 02) 80 69 21
www.ambrosiana.it
info@ambrosiana.it
Sun to Sat 10-5.30. Closed Mon.
A collection formed by Cardinal Federico Borromeo, and recently reopened with a hang based on his printed catalogue, *Musæum* (1625). It includes many religious works by Titian (the *Adoration of the Magi** was Federico's favourite painting), Raphael**, and the followers of Leonardo; still lifes and landscapes by Flemish artists, esp. Jan Breughel*, whom the Cardinal met in Rome. To Federico the lovely detail of these works conveyed a spiritual joy in God's creation. Caravaggio's *Basket of Fruit** hangs alone, the Cardinal lamenting that he could not find another of similar beauty and excellence. Leonardo da Vinci's *Portrait of a Musician**.

Opposite: Interior, Portinari Chapel, S. Eustorgio, Milan, frescoed by Foppa

Pinacoteca di Brera
Via Brera 28, 20121 Milan.
Tel (39 02) 72 26 31
Fax (39 02) 7200 1140
Tues to Sat 9-5.30; Sun 9-12.30.
Closed Mon.
A major collection of Venetian and Lombard painting from 15C to 18C. Most famous are Piero della Francesca's *Sacra Conversazione***, Raphael's *Betrothal of the Virgin*** (see ill. p.170) and Mantegna's *Dead Christ**. Frescoes of the Lombard Renaissance; fine altarpieces by Savoldo; Francesco Cossa*. Venetian paintings by Bellini**, Tintoretto** and Titian, 17C: Caravaggio's *Supper at Emmaus**. Many 17C Milanese paintings, inc. the celebrated 'three-master-picture', the *Martyrdom of St Rufina and St Seconda* by Cerano, Morazzone and Procaccini. 20C Italian, inc. Boccioni, Balla, Carra and Morandi.

Churches

Duomo
Piazza del Duomo
As part of the campaign leading to Carlo Borromeo's canonisation in 1610 the Duomo was filled with a series of enormous paintings of his life and miracles by the leading Lombard artists. These are still displayed in the Duomo at certain times of the year and it is well worth checking if they are on show. Nothing else is so atmospheric of the Counter-Reformation in Northern Italy.

Sant' Eustorgio
Piazza S. Eustorgio 3
A vast Dominican basilica, it contains the charming Renaissance

Cappella Portinari, 1468: frescoes by Foppa.

Santa Maria delle Grazie
Piazza S. Maria delle Grazie.
Tel (39 02) 498 7588
Tues to Sun 8.15-7. Closed Mon.
In the **Cenacolo Vinciano** (Refectory) Leonardo da Vinci's *Last Supper****. This much damaged fresco is perhaps the most famous painting of the Western tradition.

Santa Maria della Passione
Via Conservatorio.
First chapel L: D. Crespi's *The Fast of St Charles Borromeo**, the major work of the Lombard Seicento. The simple realism and stark composition typify the spirit of the Counter-Reformation.

MODENA

Galleria Estense
Palazzo dei Musei, Piazza Sant'
Agostino 337, 41100 Modena.
Tel (39 059) 22 21 45
Fax (39 059) 23 01 96
www.galleriaestense.it
galleriaestense@interbusiness.it
Tues, Fri, Sat 9-7; Wed,
Thurs 9-2; Sun 9-1. Closed Mon.
The main emphasis is on 16C and 17C Emilian paintings. Some good Venetian works; Italian and foreign Caravaggisti; Bernini's bust of *Francesco I d'Este**; Rosa.

MONTEFALCO

Museo Pinacoteca ex chiesa San Francesco
Via della Ringhiera Umbra.
Tel (39 0472) 79147

Fax (39 0742) 37 95 06
Nov-Feb: Tues to Sun 10.30-1,
2.30-5; Mar-May and Sept-Oct:
Tues to Sun 10.30-1, 2-6;
Jun-Aug: Tues to Sun 10.30-1,
3-7. Closed Mon.
A museum in a severe 14C Fran-
ciscan church, with outstanding
frescoes by Benozzo Gozzoli.* In
the right aisle his scenes from the
Life of St Augustine, in the apse
his fresco cycle of the *Life of St
Francis*. These are light and charm-
ing narrative scenes, which set St
Francis in the nearby countryside,
showing Montefalco and Assisi,
Umbrian hills and fields.

MONTE OLIVETO NR SIENA

Monte Oliveto Maggiore
Abbazia di Monte Oliveto
Maggiore, 53020 Chiusure
(Siena).
www.ftbcc.it/monteoliveto
This large monastery isolated
among cypresses south of Siena
contains fresco cycle of *Life of S
Benedict** by Signorelli and
Sodoma (note his self-portrait with
pet badger) and one of the best sets
of intarsia choir stalls* in Italy.

MONTERCHI

Spazi Espotivi
Via Reglia 1, Monterchi,
52035 Arezzo.
Summer: 9-1, 2-7 (June-July 9.30-
12 midnight); winter 9-1, 2-6.
Closed Mon.
Those who remember finding Piero
della Francesca's *Madonna del
Parto*** in an obscure cemetery

chapel out in the fields will find
that the detached fresco is now the
centrepiece of an over-didactic
display in a disused school in the
tiny town of Monterchi. The
change (and the admission charge)
have doubtless been forced by the
requirements of conservation. But
the magic has gone.

NAPOLI (Naples)

In the 17C the Spanish colony of
Naples emerged as an important
artistic centre. Neapolitan paint-
ing tends to be dark and brutal,
full of a profound sense of compas-
sion for the poor and suffering.
Caravaggio visited the city and his
influence is predominant in the first
quarter of the century. The
Spaniard Ribera's often violent
subjects have an aggressive vitality.
From the mid-1630s the influence
of Bolognese classicism tempered
this tough and dramatic art; after
1650 the daring, free works of
Mattia Preti opened a new era.

Decorative painting rose to new
heights with Luca Giordano and
Francesco Solimena, whose light
and airy style introduced the
Rococo. In the 18C and early 19C
Naples was a centre of view and
landscape painting.

Museo Cappella Sansevero
Via F. De Sanctis, 19, Naples.
Tel (39 081) 551 8470
www.icnapoli-com/sansevero
sansevero@na.cybernet.it
*1 Nov-30 June 10-5; 1 July-31
Oct 10-6. Closed Tues.*
One of the most bizarre and virtu-
oso sculptural ensembles of the

18C; it includes Queirolo's *Deceit Unveiled*, a nude figure struggling in an astonishingly illusionistic marble net; Corradini's *Modesty Veiled**, where thin drapery sexily veils breasts and stomach; Sammartino's disturbing *Veiled Christ***.

Museo e Galleria Nazionali di Capodimonte

Parco di Capodimonte, 80136 Naples.
Tel (39 081) 749 9111
Fax (39 081) 749 9198
Tues to Sun 8.30-7.30.
Closed Mon. Café.

One of the most splendid Italian galleries, hung on three floors, one dedicated to pictures which formed the celebrated Farnese collection, one to painting in Naples from Simone Martini to the age of Caravaggio, and one to 20C and contemporary art.

The Farnese collection opens with a group of Titians, inc. his portraits of the Farnese**, and his *Danae***. Italian Renaissance works inc. Masaccio's *Crucifixion***. Bellini's *Transfiguration***, and portraits by Mantegna*, Lotto, Sebastiano del Piombo and Parmigianino**. Northern schools inc. works by Bruegel, es *The Blind Leading the Blind***, and Claude's *Landscape with the Nymph Egeria**, an idealisation of the landscape round Nemi, with the silvery greys and greens that characterise his late style.

Painting in Naples inc. Simone Martini* and 16C works but its main emphasis is on 17C and 18C Neapolitan schools. Its darkness and brutality is introduced by Caravaggio's *Flagellation***, and

developed in Caracciolo's tragic works, and Artemesia Gentileschi's *Judith and Holofernes*, Ribera's *Drunken Silenus*, and Francesco Guarino's erotically bloodstained *St Agatha*. But Cavallino painted lyrical, poetic scenes (*The Singer*), and the mysterious Master of the Annunciations* painted the Neapolitan poor with rare compassion. A fine collection of Neapolitan still life. Late 17C and 18C dominated by Luca Giordano and Solimena.

On third floor, 19C Neapolitan and contemporary art.

Museo Nazionale di San Martino

Largo di San Martino, 80129 Naples.
Tel/Fax (39 081) 578 1769
Tues to Sun 8.30-7.30. Closed Mon.

A great monument to early Neapolitan Baroque.

In the **Church**, richly decorated with intarsia, the eye is drawn to a large *Crucifixion** by Lanfranco on the rear wall. On the high altar: a *Nativity** by Guido Reni. Choir on L: *Communion of the Apostles** by Ribera, a masterpiece of Baroque classicism. R: Caracciolo's *Washing of the Feet**. On the entrance wall, Massimo Stanzione's *Pietà*, one of the most famous 17C Neapolitan works. Paintings by Ribera, and in the spandrels of the nave arcade, his series of over-life-sized *Prophets***, intensely real and human figures, yet grave and dignified. **Sacristy:** paintings by the Cavaliere d'Arpino and Stanzione. **Treasury:** works by Ribera* and ceiling* by L. Giordano. **Coro dei Conversi*:** frescoes by Micco Spadaro. Other works by Caracci-

olo, Stanzione, Vaccaro and Vouet.
Pinacoteca: a historical collection of paintings of Neapolitan life and scenes from its history; the 15C Tavola Strozzi** is the first modern view painting. Astounding 18C cribs. 19C Neapolitan paintings; frescoes by Micco Spadaro.

Churches

Cattedrale di San Gennaro
Via del Duomo, Naples.
Beneath the main altar is the Renaissance Cappella Carafa, with a kneeling statue of *Cardinal Carafa* by Tomaso Malvita. The Cappella del Tesoro di San Gennaro (first on the R), built to preserve the relics of San Gennaro, is a splendid High Baroque ensemble**, gleaming with silver and bronze, painting and sculpture. The dome was frescoed by Lanfranco, the pendentives by Domenichino, who also painted four of the altarpieces on copper. The *Martrydom of St Januarius*is by Ribera. Finelli, a Bernini pupil, designed the bronze statues around the altar.

Chiesa del Pio Monte della Misericordia
Via Tribunali 253, 80139 Napoli. Tel (39 081) 44 69 44.
An octagonal church with seven altars. Caravaggio's *The Seven Works of Mercy*** combines extraordinary compositional freedom with great depth of human feeling. The seven altars illustrate the individual acts of mercy; note Caracciolo's *Liberation of St Peter*, 1608-9.

NOVARA

San Gaudenzio
Via San Gaudenzio.
Frescoes by Tanzio da Varallo and Morazzone. Tanzio's masterpiece, *The Battle of Sennacherib*, is an emotional response to the darkness and terror of Caravaggio.

ORVIETO

Duomo
Piazza del Duomo.
(Bookings are necessary for the recently restored Capella di San Brizio.)
The four piers of the colourful 14C façade are covered with reliefs, of which the most famous are *The Creation and Fall*** on the L pier, and the *Last Judgement*** on the R, attrib. to Lorenzo Maitani and his workshop. Within, a *Madonna* by Gentile da Fabriano; a 14C silver and enamel reliquary* by Ugolino di Vieri; and the Cappella di San Brizio**. Decoration begun by Fra Angelico and completed by Signorelli with a series of frescoes** of the *End of the World*, the *Coming and Fall of Anti-Christ*, and the *Last Judgement*.

PADOVA (Padua)

One of the most ancient and interesting cities in northern Italy, with important works by Giotto, Donatello, Titian and Mantegna.

Museo Civico

Piazza Eremitani,
35100 Padova.
Tel (39 049) 875 1153, 985 2321
Fax (39 049) 65 08 45
musei.comune@padovanet. it
Apr-Oct: Tues to Sun 9-7;
Nov-Mar: Tues to Sun 9-6.
Closed Mon.

A large gallery with some master-pieces, and also quite a lot of dross. Giotto *Crucifix** from Arena Chapel; wonderfully fresh, small *Portrait of a Senator** by Bellini; interesting altarpieces by Romanino and Campagnola; terrific Piazzetta and Tiepolo. *The Portrait of a Venetian Captain* by Sebastiano Mazzoni is a grotesquely over-the-top piece of swaggering baroque exaggeration, and in a frame to match.

Piazza del Santo

Donatello's great equestrian statue, *Gattamelata***.

Churches

Basilica del Santo

Piazza del Santo.
Frescoes, esp. by Altichiero and Avanzi (Cappella di San Felice) owing much to Giotto. High altar by Donatello; bronze statues and highly emotive relief sculptures (esp. *The Deposition***). Other sculptors inc. the Lombardi and Sansovino.

On the right of the piazza before the church are the **Oratorio di San Giorgio**, with frescoes by Altichiero and Avanzo, esp. *The Crucifixion*, and the **Scuola del Santo**, with frescoes by a number of artists, inc. the young Titian. Note esp. the scene of the *Jealous Husband**, famous for its land-scape background.

Sala del Romanino, Musei Civico, Padua

Chiesa degli Eremitani
Piazza degli Eremitani.
Cappella Ovetari: remains of frescoes* by Mantegna showing novel experiments in perspective.

Duomo
Piazza del Duomo.
Baptistery: a very complete and beautiful 14C fresco cycle* by Giusto de Menabuoi.

Santa Giustina
Via Cavazzana.
www.chiesacattolica.it/ilp
ilp.santa.giustina@pd.nettuno.it
Many altarpieces by 17C Venetian artists and frescoes by S. Ricci. Veronese's *Martyrdom of St Giustina.*

Santa Maria Annunziata dell' Arena: Cappella degli Scrovegni (Arena Chapel)
Corso Garibadi, 35121 Padova.
Entrance at Museo Civico.
Tel (39 049) 820 4551
Fax (39 049) 820 4585
www.padovanet.it/monumenti
musei.comune@padovanet.it
Feb-Oct: 9-7; Nov-Jan: 9-6.
This small chapel contains Giotto's fresco cycles*** (1304) of the *Life of the Virgin* and the *Life of Christ*. It is one of the most important places in the history of western art, since Giotto's grasp of form marks the first great break from Gothic traditions and looks forward to the early Renaissance 100 years later. Giotto was also one of the greatest narrative painters who has ever lived, and his spare account of the familiar biblical scenes remains an intensely moving experience. Also sculpture of the *Madonna** by G Pisano.

Arena Chapel, Giotto, Padua

PALERMO SICILY

Galleria Regionale della Sicilia
Palazzo Abbatellis, Via Alloro 4, 90133 Palermo.
Tel (39 091) 623 0011
Fax (39 091) 617 2187
Mon, Wed, Fri 9-2; Tues, Thurs 9-2, 3-8; Sun 9-1.
Sicilian painters from 12C to 18C. 15C fresco of the *Triumph of Death**; Francesco Laurana's *Bust of Eleonora of Aragon**; an *Annunciation** by Antonello da Messina.

Oratorio della Compagnia del Rosario di San Domenico
Via Bambinai. Apply to guardian at no. 16 but often closed without reason.
Van Dyck's *Virgin of the Rosary** is the most important work from his stay in Italy; Novelli. Stuccoes* by Giacomo Serpotta, who created fantastical decorations in many churches in Palermo. Other celebrated examples are in **S. Francesco d' Assisi** and the **Oratorio di Santa Cita.**

PARMA

In the 1520s the astonishingly precocious works of Correggio, (particularly his use of illusionistic effects on the ceilings and cupolas of churches) anticipated both the Baroque and the voluptuous grace of the Rococo and made Parma into an important artistic centre. Parmigianino (1503-40), deeply influenced by the works of Correggio, developed a mannered grace and elegance. The last important works from the school of Parma came from Lanfanco and Bartolommeo Schedoni who produced some highly personal paintings.

Camera di San Paolo
Via M. Melloni, 43100 Parma.
Tel (39 0521) 23 33 09
Mon to Sun 9-2.
Ceiling decorated by Correggio** in 1519. Here, for the first time, he used these illusionistic effects, imitating Mantegna's *Camera degli Sposi* (Mantua).

Galleria Nazionale
Palazzo Pilòta, 43100 Parma.
Tel (39 0521) 23 33 09
Mon to Sun 9-2.
A vast rambling museum with a collection of celebrated paintings by Correggio, inc. the *Deposition* and the *Madonna of St Jerome*. Works by Fra Angelico, Bronzino, Cima*, Van Dyck, and Parmigianino. Seminal altarpiece by Annibale Carracci and two pictures by Schedoni – the *Entombment* and the *Three Marys at the Tomb*.

Churches

Duomo
Piazza del Duomo.
Tel (39 0521) 23 58 86
Mon to Sun 7.15-12.30, 3-7.
A dour medieval building, transformed by the ethereal softness of Correggio's frescoes on the cupola**.

San Giovanni Evangelista
Piazzale San Giovanni.
Mon to Sun 7-12, 3-7.
Frescoes by Correggio** and Parmigianino.

Sta Maria della Stecceta
Via Garibaldi.
Mon to Sun 7-12, 3-7.
Frescoes by Parmigianino.

PERUGIA
(See Umbrian painting, opposite)

Collegio del Cambio
Palazzo dei Priori, Corso Vannucci, 25, Perugia.
Tel (39 0751) 572 8599
Tues to Sun 9-12.30, 2.30-5.30.
Closed Mon.
The council chamber is frescoed by Perugino and his assistants. Note esp. the Virtues, each accompanied by an appropriate historical personage and inc. a small self-portrait by Perugino.

Duomo
Piazza Danti.
Barocci's *Descent from the Cross*.

Galleria Nazionale dell'Umbria
Corso Vanucci, Palazzo dei Priori, 06100 Perugia.
Tel/Fax (39 075) 574 1257
direzionegnu@edisons.it

Mon to Sun 9-8. Closed 1st and 3rd Mon of every month.
Beautiful and informative display of mainly Umbrian painting, with some Tuscan works, in a splendid medieval civic palace. Among the 14C works a vast *Cruficix* by the Master of San Francesco, and a *Madonna and Child* by Duccio; from the 15C, works by Gentile da Fabriano, Fra Angelico, and a large polyptych by Piero della Francesca* (accompanied by a useful video). The Prior's chapel has frescoes by Bonfigli in situ, which celebrate Perugia's stormy history, and inc. fascinating views of the city. A small collection of 17C works inc. Pietro da Cortona.

Oratorio di San Bernardino
Via dei Priori.
Highly decorated Renaissance façade** (1457-61) by Agostino di Duccio: exquisitely refined marble reliefs.

PESARO

Musei Civici
Palazzo Mazzolari Mosca,
Piazza Toschi Mosca, 29,
61100 Pesaro.
Tel (39 0721) 38 75 41, 38 75 23
Fax (39 0721) 38 75 24
www.comune.pesaro.ps.it
musei@comune.pesaro.ps.it
Sept-June: Tues to Sun 9.30-12.30, 4-7; July-Aug: Tues to Sun 5-11pm. Closed Mon.
Outstanding is Bellini's large altarpiece, *The Coronation of the Virgin***, still in its Renaissance frame; Guido Reni and Simone Cantarini.

Umbrian painting

The most famous Umbrian painter is Perugino (*c.*1445/50-1523) whose harmonious religious scenes, gentle and tender in feeling, and alive to the calm beauties of the landscape, typify the Umbrian school. He may have absorbed a feeling for clarity from Piero della Francesca, and it was inherited by his pupil Raphael. The high point of this tour is the recently restored fresco decoration** in Spoleto Cathedral, by Fillipo Lippi, with fresh colours and dramatic open landscape.

A tour through Umbria

Umbria is particularly rich in small towns with interesting art galleries and a pleasant circular tour may be taken from **Perugia** to **Assisi, Foligno** (Pinacoteca Civica: chapel painted by Ottaviano Nelli; the Room of the Liberal arts and of the Planets), Trevi (Pinacoteca), **Spoleto** (Cathedral; Pinacoteca Comunale), **Terni** and **Todi**.

PIACENZA

Duomo
Piazza del Duomo.
Works by Procaccini, Morazzone and Guercino.

Museo Civico
Palazzo Farnese, Piazza Cittadella, 29100 Piacenza.
Tel (39 0523) 32 82 70
Fax (39 0523) 32 82 70
www.farnese.net
info@farnese.net
Tues to Thurs 9-1; Fri, Sat 9-1, 3-6; Sun 9.30-1.30. Closed Mon.
The vast block-like Farnese palace, one of the grandest in Italy, has recently been restored to its original splendour. A 17C-18C cycle of paintings, (among them works by Sebastiano Ricci and Franceso Monti), celebrating the deeds of the Farnese, have been returned to their settings in opulently stuccoed rooms. Also works by Bocaccino and Lanfranco, and Genoese painters.

Piazza del Cavalli
Two superb equestrian statues by Francesco Mochi*.

PISA

Camposanto e Museo dell'Opera
Piazza del Duomo, 56100 Pisa.
Mon to Sun.
Cathedral cemetery with famous 14C and 15C frescoes, sarcophagi, sinopie, inc. Gozzoli.

Museo Nazionale
Monastero di S. Matteo, Lungarno Mediceo, 56100 Pisa.
Tel (39 050) 54 18 65

Fax (39 050) 50 00 99
Tues to Sat 8.30-7.30; Sun 9-2; 8.45-11 on last four days of the month. Closed Mon.
An evocative and atmospheric gallery, with many paintings and sculptures of the Pisan Trecento; an important polyptych by Simone Martini**; Florentine Renaissance painting. Nicolo Pisano; Donatello*, Masaccio.

POGGIO A CAIANO
NR FLORENCE

La Villa Medicea
Piazza de' Medici 14, 50046 Poggio a Caiano.
Tel (39 055) 877 0121
Mon to Sun, Nov-Feb: 8.30-3.30; Mar: 8.30-4.30; Apr, May, Sept: 8.30-5.30; June-Aug: 8.30-6.30. Closed 2nd and 3rd Mon of the month.
The central salon has 16C frescoes of stories from ancient history alluding to the deeds of the Medici by Allori, Franciabigio, Andrea del Sarto and Pontormo. Note esp. Pontormo's lunette *Vertumno and Pomona**.*

POSSAGNO

Gipsoteca Museo Canoviano
Via Canova 84, 31054 Possagno.
Tel/Fax (39 0423) 54 43 23
May-Sept: Tues to Sun 9-12, 3-6; Oct-Apr: Tues to Sun 9-12, 2-5. Closed Mon.
Contains an extensive collection of drawings, sketches, plaster casts, reliefs and marble statues by Antonio Canova, the Neo-Classical sculptor, born here in 1757.

Tempio di Canova
(Temple of Canova)

Designed by Canova, with his tomb and marble self-portrait. Also by him is a *Deposition*; remarkable altarpieces by Palma the Younger and Giordano.

PRATO

Duomo

Piazza del Duomo.
In the apse, frescoes** by Filippo Lippi, his richest and most dramatic works. Donatello's reliefs of dancing putti**, from the external Pulpit of the Holy Girdle, are now displayed in the Museo dell' Opera del Duomo.

Museo Civico

Piazza del Comune, 50047 Prato.
Tel (39 0574) 61 63 02
Mon and Wed to Sat 9.30-12.30,
3-6.30; Sun 9.30-12.30.
Closed Tues.
Outstanding amongst the small collections of Tuscany. The nucleus of the collection is 14C and 15C Florentine art, inc. a polyptych by Bernardo Daddi and two works by Filippino Lippi.

Centro per l'Arte Contemporanea Luigi Pecci (Pecci Centre for Contemporary Art)

Viale della Reppublica,
277, C.P. 1149, 1-59100 Prato.
Tel (39 0574) 5317
Fax (39 0574) 53 19 00, 53 19 01
www.comune.prato.it/pecci
pecci@mbox.comune.prato.it
Wed to Mon 10-7. Closed Tues.
Café.

Opened in 1988, the museum hosts many exhibitions and events. Its growing permanent collection inc. works by the Italians Enzo Cucchi, Mario Merz, Fabrizio Plessi, and, from other schools, Julian Schnabel, Anish Kapoor and Barbara Kruger.

RAVENNA

Pinacoteca Comunale

Loggetta Lombardesca,
Via di Roma 13, 48100 Ravenna.
Tel (39 0544) 82874
Fax (39 0544) 35625
Mon, Wed, Fri and Sat 9-1; Tues
and Thurs 9-1, 2.30-5.30; Sun,
hols 2.30-5.30.
Mainly local paintings, but two astonishing works; Cecco Bravo's *Apollo and Daphne*, with bravura brushwork; Tullio Lombardo's intensely beautiful effigy of *Guidarello Guidarelli**.

RIMINI

Tempio Malatestiano

Via 4. Novembre, 47900 Rimini.
Tel (39 0541) 51130
Fax (39 0541) 24024
Mon to Fri 7.50-12.30, 3.30-6;
Sat, Sun 9-1, 3.30-6.
Sigismondo Malatesta's unfinished memorial to his love for Isotta degli Atti, and to his Renaissance pride. The highly personal imagery is both pagan and Christian; the interior is encrusted with magically delicate reliefs by Agostino di Duccio. Also see the damaged portrait of *Sigismondo Malatesta* by Piero della Francesca.

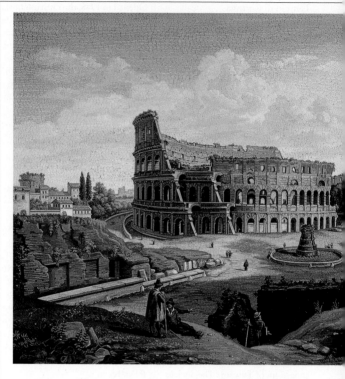

Art in Rome

Rome replaced Florence as the centre of Western European art in the early 16C. Pope Julius II (one of the greatest patrons of art) summoned Michelangelo in 1505, and Raphael in 1508: over the next ten years the High Renaissance ideals of harmony and balance were brought to perfection. In 1527 Rome was sacked: Raphael and Michelangelo's works from this period are more dramatic and their wilful distortions anticipate the abstractions of Mannerism. The Counter-Reformation was a period of austerity, but in the early 17C artists sought to return to nature and to express again deep emotional truths. Caravaggio brought into great art the world of the poor and suffering; Annibale Carracci's frescoes in the Farnese Palace returned to

The Colosseum,
Domenico Moglia, Gilbert Collection, London

the ideals of Raphael. From 1630 artists of the High Baroque, supported by the lavish patronage of the popes, displayed with passion the renewed confidence of the Roman Catholic Church. The era was dominated by Bernini: his use of illusionism and his attempt to fuse architecture, painting and sculpture in effects of unprecedented splendour typify the Baroque. Rome attracted artists from all over Europe, and Northern European artists developed new kinds of subject matter – landscapes, still life, genre. Classical, Baroque and realist styles exist side by side throughout the century.

Rome reassumed importance in the mid-18C when it became the centre of the Neo-Classical movement; Antonio Canova, one of the earliest and most influential Neo-Classical sculptors, arrived there in 1779.

ROME

Casino dell'Aurora Pallavicini
Via XXIV Maggio 43, 00184 Rome.
1st day of every month 10-12, 3-5.
Ceiling fresco *Aurora*** by Guido
Reni – a graceful reinterpretation of
Raphael and the Antique.

Galleria Borghese
Villa Borghese, Porta Pinciana,
Via Veneto, 00197 Rome
Tel (39 6) 854 8577
www.galleriaborghese.it
Ticket reservation needed.
Online booking: www.ticketeria.it.
Tues to Sun 9-7. Closed Mon.
Café.
The Villa Borghese was built in
1613 as a place of entertainment
by Cardinal Scipione Borghese, the
pleasure-loving nephew of Pope
Paul V. He was an imaginative
albeit unscrupulous collector, and
his inspired patronage influenced
17C art. His fleshy features and
good humour are wonderfully
captured in Bernini's *Portrait Bust*.

The gallery has recently re-
opened after a long closure, and
has lost most of its faded charm: it
is now packaged, immensely
crowded, full of gesticulating and
noisy guides, and time on the upper
floor is limited to half an hour. It is
necessary to buy a ticket in
advance. The collection is splen-
did, but in season it is almost
impossible to get more than a
glimpse of the most celebrated
works.

On the ground floor major
sculptures are displayed at the
centre of rooms where paintings
and antiquities echo their themes.
The display opens with Canova's

Neo-Classical *Pauline Borghese***,
whose nudity so startled contem-
poraries. There follow a brilliant
group of early sculptures** by
Bernini, inc. *David, Apollo and
Daphne,* and *Pluto and Proserpine.*
The *Apollo and Daphne* creates, in
marble, richly pictorial effects (the
virtuoso hair was carved by Finelli,
Bernini's assistant) and pictures by
Dosso Dossi and the 18C ceiling
frescoes echo the subject. Four
works by Caravaggio, a little lost
amongst contemporary pictures,
inc. the early *Sick Bacchus* and *Boy
with a Basket of Fruit,* both
displays of his naturalism and illu-
sionistic skills. The *Madonna of
the Serpent***, painted for a chapel
in St Peter's but rejected for its lack
of decorum, was snapped up by
Scipione, while the *David with the
Head of Goliath*** was perhaps
painted after Caravaggio had been
condemned to death for homicide
and exiled from Rome. The head of
Goliath is a self-portrait, and
maybe Caravaggio intended it as a
gift for Scipione, a plea to the
Cardinal to save him from execution.

The upper floor, with vault fres-
coes by Lanfranco (Room XIV)
shows the superb painting collec-
tion, with the emphasis on 16C
Venetian and Florentine paintings
and 17C works. **16C:** the highpoint
is Titian's *Sacred and Profane
Love*** whose bright detail and
clarity contrasts with the more
broadly handled *Venus Blindfold-
ing Cupid.* Also Raphael's
Entombment, a seminal early
work, Bellini*, Correggio's extra-
ordinarily erotic *Danae*, Lotto's
Portrait of a Man, and works by
Veronese and Savoldo*. **17C:** rare

paintings by Bernini; an unusual early Rubens; good works by Barocci, Domenichino (esp. the exquisitely coloured and unexpectedly sexy *Hunt of Diana**), Reni, Guercino.

Galleria Colonna

Palazzo Colonna, Via della Pilotta 17, 00187 Rome.
Tel (39 06) 679 4362
Sat 9-1 only.

The splendid late Baroque decoration of the Great Hall* by Giovanni Coli and Filippo Gherardi is the main feature: a dazzling and tumultuous fresco, the *Battle of Lepanto*, is set in an elaborate framework. Works inc. A. Carracci's *Bean Eater**; a series of gouache landscapes by Gaspard Dughet; Veronese's *Portrait of an Unknown Man*. Also good works by minor 17C artists: Cerquozzi, Mola, Salvator Rosa, Testa.

Galleria Doria Pamphilj

Piazza del Collegio Romano 2, 00186 Rome.
Tel (39 06) 679 7323
Fax (39 06) 678 0939
www.doriapamphilj.it
Fri to Wed 10-5. Closed Thurs.

Antique sculptures, tapestries, rich 18C furniture and decoration create an opulent setting for the display of the most spectacular Roman patrician collections. Nowhere else in Italy may the richness and variety of 17C Italian and northern landscape artists be more fully appreciated. A small cabinet contains the finest works: Velázquez's portrait** and Bernini's bust of *Pope Innocent X;* Velázquez's almost brutal objectivity contrasts with

Bernini's kindlier treatment.

Italian 16C: fine double portrait by Raphael, Titian's *Salome*, and Venetian painting*. **Early 17C:** Caravaggio* – the early *Landscape with the Flight into Egypt* is unusually tender; *Mary Magdalene*. Good works by his followers, and by artists of the Bolognese school, inc. Guercino's romantic *Erminia and Tancred**. **17C Landscape:** important series of lunettes by Annibale Carracci* and his followers laid the foundations of ideal landscape. Five pastoral and idyllic works by Claude* contrast with the wilder scenes of G. Dughet and S. Rosa. Landscapes by Van Bloemen, Bril, Swanevelt, Tassi, Torrigiani, and Vanvitelli. **16C:** Bruegel.

Galleria Nazionale d'Arte Antica – Palazzo Barberini

Via Quattro Fontane 13, 00184 Rome.
Tel (39 06) 481 4591
Tues to Fri 9-9; Sat 9-11.30; Sun, hols 9-8. Closed Mon.

A grandiose palace built for the nephews of the 17C Barberini Pope Urban VIII, enriched by Pietro da Cortona's fresco** in the great hall, overwhelming in its illusionism and flattery of the Pope, at its centre the great bees of the Barberini arms. Unfortunately, the great hall may ony be visited when exhibitions are held there. The rest of the gallery is gloomy and badly lit. Its 17C collection is strongest, but earlier periods inc. works by Filippo Lippi*, and Piero di Cosimo*, good 16C works by Raphael (La Fornarina)*, Beccafumi and Andrea del Sarto. **17C:** Caravaggio's gory *Judith and*

The Sicilian Vespers, *Francesco Hayez, 1846, Galleria Nazionale d'Arte Moderna, Rome*

*Holofernes**, and his darkly sensual *Narcissus** (beware, these are usually absent, jet-setting around the world); good Caravaggesque works, and works by Reni and Guercino, esp. the dusky *Et in Arcadia Ego**. 18C pictures inc. Hubert Robert and Vanvitelli.

Galleria Nazionale d'Arte Moderna
Viale delle Belle Arti 131, 00196 Rome.
Tel (39 06) 32 29 81
Fax (39 06) 322 1579
Daily 9-7. Closed Mon. Café.
A grandiose and gloomy gallery, with a new, informative and handsome hang of Italian art from 1790 to 1970, with a few foreign works (Courbet, Klimt*) to provide a

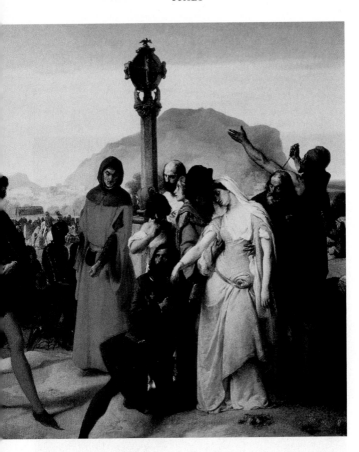

context. The 19C starts with attractive Neapolitan plein air paintings, and good Tuscan pictures, especially the fresh and bright, sunlit sketches of Raffaello Sernesi: Sivestro Lega's *The Visit**, its delicate geometric structure so reminiscent of Florentine 15C frescoes, and a vivid and intimate Boldini. But interest rapidly dwindles in many rooms of dull southern landscapes, symbolist visions and vast celebrations of the Risorgimento. The 20C picks up, opening with blood-red works by Alberto Burri: Felice Casorati's *The Portraits** and Virgilio Guidi's *In Tram** dominate a group of austere works by Novecento artists, characterised by an interest in pure form and simple iconography. The sculptures are unexpected and often charming, especially the lyrical and whimsical terracottas of Arturo Martini. A

strong group of Futurist works, with an emphasis on movement and speed, forms a sharp contrast. The major names of the 50s and 60s – Fontana, Pomodoro, Vedova, Pascali – are increasingly placed in an international context (Pollock, Twombly).

Portrait of Busoni,
U. Boccioni, Galleria Nazionale d'Arte Moderna, Rome

Galleria Nazionale di Palazzo Corsini

Via della Lungara 10,
00165 Rome.
Tel (39 06) 68 80 23 23
Tues to Fri 9-7; Sat 9-2; Sun 9-1.
Closed Mon.

One of the most enjoyable galleries in Rome, a fine old palace, little visited, quiet, where one can browse amongst some of the lesser known 17C and 18C painters, particularly of genre. The outstanding work is Caravaggio's *St John the Baptist***, where the saint is shown almost as genre, a Roman street boy with work-roughened hands. Also works by Gentileschi, Mola and Guido Reni. Good paintings by the *bamboccianti*, 17C painters of Roman street life, inc. Cerquozzi, and Lingelbach's *Water Seller* and *The Cake Vendor*, his best works, classically constructed and romantically lit.

Galleria Spada

Palazzo Spada,
Piazza di Capo di Ferro 3,
00186 Rome.
Tel (39 06) 686 1158
www.galleriaspada.it
Tues to Fri 9-7; Sun 9-1.
Closed Mon.

Four rooms on the first floor were designed to house the collection of Cardinal Bernardino Spada. Its great appeal is that it remains the small private collection of this 17C patron; furniture, wall and ceiling decorations, and paintings form an indivisible whole. Niccolò dell'Abbate's *Landscape*; direct portraits by Passarotti. **17C:** Guido Reni's *Portrait of Cardinal Bernardino** (a harmony of silvery reds and pinks).

Gentileschi, Testa and grandiose paired history paintings by Guercino* and Reni*. Works by Pieter van Laer, and Michelangelo Cerquozzi (*Revolt of Masaniello* is of exceptional historical interest) suggest the 17C collectors' passion for genre.

Palazzo Farnese

Piazza Farnese (French Embassy).
Written permission required.

Frescoed by Annibale Carracci 1597-1604 with scenes from the loves of the gods*** – of seminal important to the development of the Baroque.

Pinacoteca Capitolina

Palazzo dei Conservatori,
Piazza del Campidoglio,
00186 Rome.
Tel (39 06) 67 10 20 71
pinacoteca@comune.roma. it
Tues to Sun 9.30-7. Closed Mon.

16C Venetian: early Titian *Baptism**.
Roman Baroque*: Caravaggio's *St John the Baptist* and *Gypsy Fortune-Teller**. Three works by Pietro da Cortona, esp. *Rape of the Sabines**, brought new grandeur and warmth to antique myth and fable. **17C Bolognese:** Albani; Domenichino; Lanfranco; Guercino's *Burial and Reception into Heaven of St Petronilla** (huge, dramatically lit altarpiece); five of Guido Reni's late silvery sketchy works.

Villa Farnesina

Via della Lungara 230,
00165 Rome.
Tel/Fax (39 06) 68 80 17 67
Mon to Sat 9-1. Closed Sun.

16C villa decorated by Raphael,

Giulio Romano, Giovanni da Udine, Peruzzi, Sebastiano del Piombo and Sodoma. Ground floor decorated with Raphael's light-hearted frescoes of the *Legend of Psyche***. His *Galatea*** is a masterpiece of elaborate High Renaissance design recreating the lost radiance of classical poetry.

Churches

Sant'Agostino
Piazza di S. Agostino.
Caravaggio's *Madonna of Loreto** (1604-5) (1st chapel L). Raphael's *Prophet Isaiah* (nave, 3rd pillar R). Sansovino; Lanfranco.

Sant'Andrea delle Fratte
Via Capo le Case.
Tel (39 06) 68 80 11 62
Bernini's *First Angel with the Superscription** and *Angel with the Crown of Thorns** (1667-9).

Sant'Andrea della Valle
Corso Vittorio Emanuele.
Lanfranco's *Assumption of the Virgin** (1625-7) in the dome – use of Correggiesque illusionism opened up a new era in Baroque dec. Domenichino *Four Evangelists (1627-8)* on the pendentives. In the vaulting of the apse: frescoes by Domenichino (1623-7); below: frescoes by Mattia Preti (1650-1).

Santa Bibiana
Via G. Giolitti.
Pietro da Cortona: three early frescoes of the *Life of St Bibiana** brought to the classical story a new boldness and plastic richness. Bernini's *St Bibiana* (1624-6; high altar).

San Carlo ai Catinari
Piazza Cairoli.
Dramatic late altarpiece by Pietro da Cortona, *Procession of St Carlo Borromeo* (1667). Pendentives by Domenichino.

Santa Cecilia in Trastevere
Piazza di Sta Cecilia.
Frescoes by Bril; Maderno's *St Cecilia**.

San Clemente
Piazza San Clemente.
Frescoes by Masolino.

San Francesco a Ripa
Piazza di S. Francesco d'Assisi.
Altieri chapel: Bernini's *Death of the Blessed Ludovica Albertoni*** (1674). Vouet*.

Il Gesù
Piazza del Gesù.
Most gorgeous Baroque interior in Rome. Illusionistic ceiling fresco by G. Battista Gaulli, *The Adoration of the Name of Jesus** (1674-9). Altarpiece by Carlo Maratta *The Death of St Francis Xavier*.

Sant'Ignazio
Piazza di S. Ignazio.
Overwhelming illusionistic ceiling fresco *Allegory of the Missionary Work of the Jesuits* (1691-4) by Andrea Pozzo; find the precise viewing point in the nave.

San Lorenzo in Lucina
Piazza di Spagna.
Bust of *Gabriele Fonseca* by Bernini, (1668-75). Vouet. Reni *Crucifixion**.

San Luigi dei Francesi
Piazza di S. Luigi dei Francesi.
Tel (39 06) 683 4086.
Caravaggio made his name with the three paintings*** from the *Life of St Matthew* in the Contarelli chapel in the L nave. With these works he introduced his famous cellar lighting, and his ability to re-think religious imagery by setting sacred stories in his own violent times, with figures painted from life. *The Call of St Matthew* shows gaudy young men in the courtyard of a dark Roman palace; Matthew is martyred in a gloomy Roman church, with Caravaggio himself as witness. Take plenty of coins for the lights; the pictures are almost too dark to see. Across the nave Domenichino's bright and clear frescoes of the *Life of St Cecilia** present a sharp contrast.

Santa Maria sopra Minerva
Piazza della Minerva.
Michelangelo's *The Risen Christ* (*c.*1518-21); Bernini's memorial to Maria Raggi (on pillar), S transept; frescoes by Filippino Lippi. R nave Barocci.

Santa Maria del Popolo
Piazza del Popolo.
Pinturicchio's *Adoration of the Magi* (1st chapel R). N transept, 1st chapel; altarpiece by Annibale Carracci *Assumption of the Virgin* 1601; *Conversion of St Paul* and *Crucifixion of St Peter* 1600-1 by Caravaggio**. The patron of this chapel enjoyed setting the idealising style of Annibale against Caravaggio's dark naturalism, and St Paul's great carthorse seems to thrust his rump against Annibale's altarpiece. Chigi Chapel designed by Raphael. Bernini's *Daniel** and *Habbakuk**. Opposite, fine Maratta.

Santa Maria in Vallicella
Corso Vittorio Emanuele.
Frescoes by Pietro da Cortona (from 1647) in the dome, nave and apse. Main altar and paintings on side wall of choir by Rubens* in Rome in 1608 – seminal to the development of early Baroque. Barocci's *Visitation**.

Santa Maria della Vittoria
Via 20 Settembre 15.
Cornaro chapel: Bernini's *Ecstasy of St Theresa** (1645-52) unites architecture, sculpture and painting and all the resources of Baroque illusionism to communicate in physical terms the mystic experience of the saint. The group seems miraculously suspended between dark columns; the concentration on physical detail and the vitality of the draperies communicate the intensity of the vision. The scene is observed by carved spectators, with whom we are intended to identify.

San Pietro in Montorio
Via Garibaldi.
Sebastiano del Piombo's *Flagellation** (1st chapel R) is based on drawings by Michelangelo. Dirck van Baburen.

San Pietro in Vincoli
Piazza S Francesco di Paola.
Michelangelo's *Moses** *c.*1515 – part of the unfinished tomb of Julius II. Originally intended to be a corner figure on a much larger project to be viewed from below.

Bernini tour

Bernini's finest achievement was his overall plan for the Vatican. However, the whole city of Rome displays and reflects his work.

Start out at the **Borghese Gallery**. Here you will find an outstanding group of four works carved for Cardinal Scipione Borghese; *Aeneas and Anchises* (his first large-scale commission), *Pluto and Proserpine, Apollo and Daphne* and *David*. With their stress on energetic action, startling naturalistic treatment of the marble, and their attempt to connect the sculpture with the space of the spectator, they introduced the Baroque statue. Also a very early work, the *Goat Amalthea* 1615; a static bust of *Pope Paul V* 1618 which contrasts with the lively animation of the two busts of *Cardinal Scipione Borghese* (the earlier, more lively, of these revealed a crack in the marble and Bernini rapidly made a copy). The unfinished *Truth Revealed by Time* 1652 shows signs of the elongation and ecstatic spirituality of his late style. There are also two painted self-portraits.

In the afternoon visit **Santa Maria del Popolo**. For Raphael's Chigi chapel Bernini carved *Daniel* and *Habbakuk*, 1655-61. The figures project from their niches and bring to life the entire space of the chapel. From here move on to the **Piazza Barberini** with Bernini's *Triton Fountain* and hence to **Santa Maria dell Vittoria** (see p. 221).

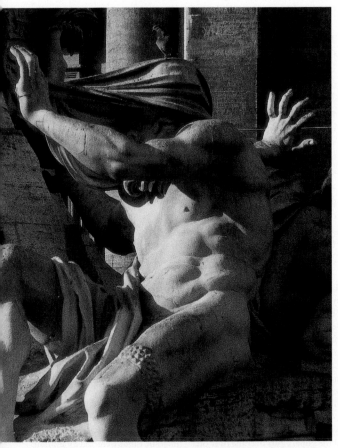

River Nile, *from the* Four Rivers Fountain, *Bernini, Piazza Navona, Rome*

Round off the day with an evening stroll to the **Piazza Navona**, the most famous Baroque square in Rome, which contains the most spectacular of Bernini's fountains, the *Four Rivers Fountain*. Personifications of the rivers are grouped around a massive 'natural' rock, hollowed out and washed by flowing water, and surmounted by an obelisk.

Città del Vaticano (Vatican City)

This tiny independent state, centre of the Roman Catholic Church, contains some of the world's greatest art treasures. Exhausting and often frustrating to visit, it is, nonetheless, a must: decide exactly what you want to see and stick to your plan. The collections are too vast to appreciate in a single visit. The one-way systems may seem designed to distract you from your goal but as long as you are not in a group it is possible to ignore the restrictions to some extent. The Sistine Chapel is the main tourist attraction so try to get there as soon as the palace opens and work backwards. Alternatively, Raphael's Stanze are generally least crowded in the half hour before closing time when most people have moved on to the Chapel. The Pinacoteca is rarely crowded and is worth a separate visit.

The Vatican museums are open Mon to Fri 8.45-4.45, Sat 8.45-12.45; closed Sun and religious hols. For info call (39 06) 69 88 33 33.

Basilica di San Pietro in Vaticano (St Peter's)

The works of Bernini dominate St Peter's. His lavish sculptural decorations made it the supreme visual expression of the restored Roman Catholic Church. His achievement may be best appreciated by reconstructing the path of the 17C pilgrim, a path carefully planned to celebrate the role of St Peter's as symbol of the spiritual leadership of the Pope. Cross over the river on the Ponte S. Angelo. Notice the ten angels, carved under Bernini's direction, carrying instruments of the Passion. Then enter the huge oval piazza which symbolizes the all-embracing arms of the Church. Above the colonnade innumerable statues of saints and martyrs bear witness to a glorious faith. Above the central entrance to the portico is Bernini's large relief *Pasce Oves Meas*. On the right, at the foot of the Scala Regia, is Bernini's statue of *Constantine the Great* on a rearing horse at the moment of conversion. Then approach the entrance to the Basilica. Through the central door the eye of the pilgrim is irresistibly drawn to the goal of his journey, the *Cathedra Petri*, which appears at first like a distant vision framed by the twisted columns of the *baldacchino* (a majestic canopy erected by Bernini over the tomb of St Peter) and later as a mixture of free-standing sculpture, relief and painting.

Other works include: Giotto's heavily restored mosaic of the *Navicella* (entrance to the portico). Four giant statues in the niches of the crossing – *St Longinus* (Bernini), *St Andrew* (Duquesnoy), *St Veronica* (Mochi), *St Helen* (Bolgi). R aisle: Michelangelo's *Pietà**** (the

most famous work of art in St Peter's); Bernini's *Tomb of the Countess Matilda*. In the **Cappella del SS Sacramento:** life-size bronze angels by Bernini 1673-4. Above the altar: a *Trinity* by Pietro da Cortona. In the niche **R of the apse,** Bernini's *Tomb of Urban VIII* 1628-47. **L aisle:** Bernini's *Tomb of Alexander VII* (in a narrow passage above a door); Algardi's marble altarpiece of the *Meeting Between St Leo and Attila;* Pollaiuolo's *Tomb of Innocent VIII.* Also works by Canova.

Musei Vaticani e Cappella Sistina
Viale Vaticano 165,
00120 Città Vaticana.
Tel (39 06) 69 88 49 47
Fax (39 06) 69 88 50 61
Mon to Sat 8.45-4.45.

Pinacoteca Vaticana*
Founded by Pius VI 1775-99. **Italian 14C*, 15C:** Bernardo Daddi, Giotto, Pietro Lorenzetti, Lorenzo Monaco, Giovanni di Paolo, Sassetta; Fra Angelico's *The Virgin between St Dominic and St Catharine of Alexandria*;* Gentile da Fabriano's *Miracles of St Nicholas*;* frescoes by Melozzo da Forlì. **High Renaissance:** the lyrical grace of Raphael's early *Madonna of Foligno*** 1512 contrasts with the monumentality and drama of his last work, *The Transfiguration**.* Works by Leonardo, Sebastiano del Piombo, Titian, Veronese. Five works by Barocci (esp. the windswept *Blessed Michelina*) prelude the Baroque. 17C: Caravaggio's *Deposition*;* Domenichino's *Last Communion of St Jerome** is remarkable for its

warm human feeling and clarity of composition; Andrea Sacchi's *Vision of St Romuald* (his most successful work); Guido Reni's early Caravaggesque *Crucifixion of St Peter.* Pietro da Cortona, Guercino*, Mola, Poussin (an unusual altarpiece). **Modern:** a very depressing and dreary display inc. Carrà, de Chirico, Morandi, Rouault, Utrillo.

Stanze di Raffaello**In 1509 Julius II called Raphael to Rome to decorate a suite of four stanze (rooms). The frescoes of the Stanza della Segnatura and the Stanza d'Eliodoro are the most perfect achievements of High Renaissance painting***. Spend some time absorbing the beauty of the compositions, the careful relationship of group to group, figure to figure, and of one wall to another. Notice the transition from the perfect harmony and serenity of Raphael's *School of Athens* 1509-11 to the wild and dramatic *Fire in the Borgo* 1514.

Stanza della Segnatura The theme of this room is the power of the human intellect. Three principal frescoes: *The School of Athens,* representing Philosophy, the *Disputà,* Theology, and *Parnassus,* Poetry.

Stanza d'Eliodoro 1512-14. The frescoes of this more dramatic room illustrate miraculous intervention to protect the Church. *Mass at Bolsena, Deliverance of St Peter* (nocturnal scene), *Expulsion of Heliodorus from the Temple.*

Stanza dell'Incendio 1517 and the **Sala di Costantino** 1517-28 were largely painted by Raphael's assistants, and his share in the execution is a matter of considerable

controversy. *Fire in the Borgo**.

The Chapel of Nicholas V adjoins the Room of the Chiaroscuri. Decorated by Fra Angelico* with scenes from the *Life of St Stephen* (upper series) and *St Lawrence* (lower series).

Cappella Sistina (Sistine Chapel)*** Built for Sixtus IV (1473-84). The walls were decorated during his reign with two series of frescoes: *Life of Christ* (R) and *Life of Moses* (L) by Ghirlandaio, Pinturicchio, Cosimo Rosselli, Signorelli, Botticelli (*Moses in Egypt and Midian**, 2nd L, *The Punishment of Corah and the Sons of Aron** 5th L), and Perugino (his masterpiece *The Delivery of the Keys**, R).

Vault of ceiling frescoed by Michelangelo*** 1508-12. Mighty images of prophets and sibyls (above side walls in vaultings) are of more than human grandeur. In the central field are scenes from Genesis. In *The Creation of Man** the divine touch brings to life the perfect beauty of Adam. The theme is taken up by the beautiful seated youths (in the framework between the pictures). The sense of supreme confidence in the human body is lost in the desperate frescoes of the *Last Judgement* 1536-41 (painted after the Sack of Rome). Both ceiling and *Last Jugdement* recently, and controversially cleaned, revealing exceptionally vibrant colours.

SAN GIMIGNANO

Sant'Agostino
Piazza S. Agostino.
Chancel: lively and charming frescoes* of the *Life of St Augustine* by Benozzo Gozzoli. Also works by Pollaiuolo and Benedetto da Maiano.

Museo Civico
Palazzo del Duomo,
53037 San Gimignano.
Tel (39 0577) 94 03 40
Tues to Sun, Nov-Feb: 9.30-12.50,
2.30-4.50; Mar-Oct 9.30-7.30.
Closed Mon.
Pay here for Collegiata also.
A pretty interior courtyard and external staircase which leads into the Sala di Dante, frescoed by Lippo Memmi. Paintings from 13C to 15C; in the tower charming 14C frescoes of amorous adventures etc.

Collegiata (Duomo)
Reverse of the façade: *Martyrdom of St Sebastian* by Gozzoli and *Annunciation** by Jacopo della Quercia. R of nave: violent fresco cycle of *Life of Christ** by Barna da Siena. **The Chapel of St Fina****: one of the most harmonious works of the early Renaissance, designed by Giuliano da Maiano, an altar by Benedetto da Maiano, frescoes by Ghirlandaio*. In the **loggia of the Baptistery**: an *Annunciation** by Ghirlandaio.

SANSEPOLCRO

Museo Civico
Via Aggiunti 65,
52037 Sansepolcro (Arezzo).
Tel (39 0575) 73 22 18
Fax (39 0575) 74 03 38
1 June-30 Sept: Mon to Sun 9-
1.30, 2.30-7.30; 1 Oct-31 May:
Mon to Sun 9.30-1, 2.30-6.
Piero della Francesca's *Madonna della Misericordia** and *The Risen Christ***. Pontormo; Signorelli.

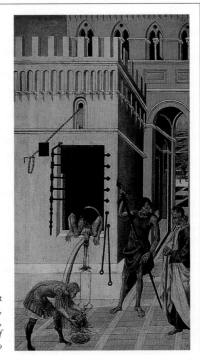

The Beheading of Saint
John the Baptist, *1450/60,
Giovanni di Paolo,
The Art Institute of
Chicago*

Art in Siena

The most important Sienese artists were working in the first half
of the 14C. The lasting influence of Byzantine and Gothic art
from the north distinguishes their painting from that of their
Florentine contemporaries. Duccio painted small scenes on
gilded wooden panels; Simone Martini's work has a courtly
elegance and splendour; much of the Lorenzetti brothers' work
is lost. but Ambrogio's surviving frescoes show a combination
of Sienese elegance with a knowledge of Giotto's work and
stunning powers of invention. Sassetta and Giovanni di Paolo
dominated the 15C, uniting the new discoveries of Florence
with traditional, decorative elements: in the 16C Sodoma and
Beccafumi were leading artists, the latter creating a highly
personal and emotional Mannerist style.

SIENA

Battistero di San Giovanni

Piazza S. Giovanni.
16 Mar-31 Oct: 9-7.30 (Oct 9-6)
1 Nov-15 Mar: 10-1, 2.30-5.
15C frescoes and a 15C baptismal font** with panels by Jacopo della Quercia, Ghiberti and Donatello, esp. the *Feast of Herod**; statuettes of *Faith* and *Hope* by Donatello.

Duomo

Unique pavement* with figurative designs by Sienese artists inc. Beccafumi and Matteo di Giovanni. From L aisle opens the Piccolomini Library* (fee) frescoed by Pinturicchio with gaily anecdotal scenes of the *Life of Pope Pius II*. Chapel of S Giovanni Battista also frescoed by Pinturicchio and with bronze *St John the Baptist** by Donatello. Pulpit** by Nicola Pisano, with crowded dramatic narrative panels. L transept bronze floor monument* by Donatello portraying Bishop Pecci's body lying in its bier. On pillars either side of presbytery eight bronze *Angels** by Beccafumi. In R aisle Chigi chapel with marble *St Jerome** and *St Mary Magdalene** by Bernini.

Museo dell'Opera

Piazza Duomo 8, 53100 Siena.
Tel (39 0577) 28 30 48
Fax (39 0577) 28 06 26
www.operaduomo.it
operaduomo@iol.it
15 Mar-31 Oct: Mon to Sun 9-7.30 (Oct: 9-8); 1 Nov-14 Mar: Mon to Sun 9-1.
Duccio's magnificent *Maestà***, a double-sided altarpiece designed for the Cathedral's high altar. *Birth of the Virgin** by P. Lorenzetti; statues** by G. Pisano from the Cathedral façade.

Palazzo Pubblico (Town Hall)

Piazza del Campo, 53100 Siena.
Tel (39 0577) 29 21 11
Mon to Sat 10-6; Sun 9.30-1.30.
Many works by Sienese artists inc. Simone Martini's frescoed *Maestà** and the *Guidoriccio da Fogliano** on horseback; in the Sala della Pace are Ambrogio Lorenzetti's allegorical frescoes of the *Effects of Good and Bad Government**. Also frescoes by Spinello Aretino and Taddeo di Bartolo.

Pinacoteca Nazionale

Palazzo Buonsignori,
Via S Pietro 29, 53100 Siena.
Tel (39 0577) 28 11 61
Fax (39 0577) 27 05 08
Tues to Sat 8.15-7.15;
Mon 8.30-1.30; Sun 8.15-1.15.
Very important collection of Sienese painting (nearly all of it religious) from early 13C to 17C. Duccio's small *Madonna of the Franciscans** is outstandingly delicate, Bartolo de Fredi's *Procession of the Magi* full of lively detail. Madonnas by Simone Martini and Lippo Memmi. Outstanding group of works by Pietro and Ambrogio Lorenzetti includes Ambrogio's small devotional *Maestà** and *Annunciation*, and Pietro's *Madonna of the Carmelites** where the weight of the main figures contrasts with the lively *predella* panels. Note two small landscape panels* attributed to Ambrogio. In 15C Sassetta, Giovanni di Paolo,

Matteo di Giovanni and Neroccio di Bartolomeo Landi continued to work in a sweet archaising mode. Among 16C works Beccafumi's early *St Catherine Receiving the Stigmata** and late *Birth of the Virgin** are both exceptional.

Sant'Agostino
Via Sagata.
Perugino's *Crucifixion*; works by Sodoma and Matteo di Giovanni, an unusual *Maestà* by A. Lorenzetti.

San Francesco
Frescoes* by the Lorenzetti inc. a *Crucifixion* by Pietro, and scenes by Ambrogio of *St Louis of Toulouse* and the *Martyrdom of Franciscan Monks of Ceuta, Morocco.*

Spedale S Maria della Scala
Piazza Duomo.
Tel (39 0577) 22 48 11
Fax (39 0577) 22 48 29
infoscala@comune.siena.it
www.santamaria.comune.siena.it
Mon to Sun 10.30-1.30 and various later hours in summer.
A great medieval hospital facing the Duomo. The main hall with extensive 15C frescoes by Domenico di Bartolo and others. Adjoining is the hospital church; on high altar *Risen Christ* by Vechietta. Frescoes by Beccafumi.

SIRACUSA (Syracuse)

Museo Regionale di Palazzo Bellomo
Via Capodicci 14-16, 96100 Siracusa.
Tel (39 0931) 69511
Fax (39 0931) 69511
Tues to Sun 9-7. Closed Mon.

A charming and shady Gothic palace, with two outstanding but damaged works; Antonello da Messina's astonishingly Flemish *Annunciation**, and Caravaggio's *Burial of St Lucy**, with piteous figures beneath a vast area of darkness – a recurrent theme of Caravaggio's late art.

SPELLO

Santa Maria Maggiore
Piazza Santa Maria Maggiore
The Baglione chapel has a richly decorative and wonderfully preserved cycle of frescoes** by Pinturicchio, showing the *Nativity* and *Annunciation*, and inc. a proud self-portrait.

SPOLETO

Duomo
Piazza del Duomo.
Apse frescoes** by Filippo Lippi, recently restored, and now with brilliant colours. Also **Pinacoteca Comunale**.

TORINO (Turin)

Castello di Rivoli
Piazza Mafalda di Savoia, 10098 Rivoli (Torino).
Tel (39 011) 956 5222
info@castellodirivoli.torino.it
www.castellodirivoli.torino.it
Tues to Fri 10-5; Sat, Sun 10-7. Closed Mon. Restaurant and café.
An imaginative conversion of an 18C residence of the court of Savoy, left incomplete by the great Rococo

architect Juvarra, and retaining many 18C frescoes. It creates startling juxtapositions of the old and the new, and shows contemporary Italian art, and European art from the 1950s onwards, with an emphasis on Minimalist art and Arte Povera.

Galleria d'Arte Moderna
Via Magenta 31,
10144 Torino.
Tel (39 011) 562 9911
Fax (39 011) 562 8637
www.gam.intesa.it
Mon to Sun 9-8.
One of the most important collections of 20C paintings in Italy. 19C Italian painting; Futurists and early 20C painting and sculpture, esp. Medardo Rosso; Casorati, Morandi. Surrealists; Neo-Dada; Pop Art.

Galleria Sabauda
Via Accademia delle Scienze 6,
10123 Torino.
Tel (39 011) 54 74 40
Fax (39 011) 54 95 47
Tues to Sun 8.30-7.30. Closed Mon.
Italian: Piedmontese paintings of the 15C and 16C. A group of works by Tuscan and Venetian painters inc. Fra Angelico, Bronzino, Pollaiuolo and Veronese*. The main emphasis is on 17C painting, inc. works by Bolognese and Milanese painters. Outstanding are works by Guercino; an elegant Gentileschi*; Francesco del Cairo. **Dutch and Flemish:** an unusually fine collection for an Italian gallery. ?Van Eyck*, Dou, Rembrandt, Ruysdael, Rubens*.

TRENTO

Castello del Buonconsiglio
Via Bernardo Clesio 5,
38100 Trento.
Tel (39 0461) 23 37 70
Fax (39 0461) 23 94 97
www.buonconsiglio.it
fausta.slanzi@provincia.tn.it
1 Apr-30 Sept: 9-12 and 2-5.30;
1 Oct-31 Mar: 9-12 and 2-5;
during summer exhibitions 10-6.
Closed Mon.
The early 15C *Activities of the Months*** in the Torre dell'Aquila are the most complete International Gothic secular fresco cycle anywhere. They are also the most delightful (eg January's scene of snowballing lords and ladies). Visits are accompanied, with a maximum of 20 people, so it is advisable to go to the Torre dell'Aquila quickly. The rest of the castello includes fine frescoes by Dossi and esp. Romanino*.

Museo di Arte Moderna e Contemporanea di Trento e Rovereto
Palazzo delle Albere,
via R. da Sanseverino 45, Trento.
Tel (39 0461) 23 48 60.
The charming moated 16th cent palace hosted sessions of the Council of Trent and retains frescoes of the period. Permenant coll. of 19C and 20C Italian art (Hayez, Segantini). Notably good temporary exhibitions.

Opposite: Activities of the Months: April, *Torre dell'Aquila, Castello del Buonconsiglio, Trento*

TREVISO

Duomo
Piazza del Duomo.
Chapel of the Annunciation: *The Annunciation* by Titian and frescoes by his rival, Pordenone. Pietro and Tullio Lombardo.

Museo Civico
Borgo Cavour 24, 31100 Treviso.
Tel/Fax (39 0422) 59 13 37
Tues to Sat 9-12, 3-6 (Oct-Apr 2-4); Sun, hols 10-12. Closed Mon.
Tommaso da Modena's fresco cycle of *The History of St Ursula* is outstanding; dullish Madonnas by Bellini and Cima and portraits by Titian (*Speroni*), Lotto, Rosalba Carriera and the Longhis.

UDINE

Duomo
Piazza del Duomo.
Paintings by Tiepolo, Fontebasso and Dorigny.
Oratorio della Purità (across the street: ask the sacristan): Giambattista Tiepolo's *Assumption* with monochrome frescoes by his son, Giandomenico.

Palazzo Arcivescovile
Museo diocesano e Gallerie del Tiepolo. Piazza Patriarcato, 1.
Tel (39 0432) 25003
Wed to Sun 10-12, 5.30-6.30. Closed Mon and Tues.
Dazzling series of frescoes** by the young Tiepolo which herald his Rococo style.

Hagar and the Angel, *Giambattista Tiepolo, Museo Diocesano e Gallerie del Tiepolo, Udine*

A Piero della Francesca tour

Major works by Piero della Francesca are to be found in the beautiful area of Italy where Tuscany, Umbria and the Marches meet. Start out at **Arezzo** and see the frescoes in San Francesco and the Cathedral. From here drive to **Monterchi**. Here you will see Piero's altarpiece, the *Madonna del Parto*; the grave Madonna, pointing at her rounded belly, is revealed to the traveller by painted angels who draw aside curtains. At **Sansepolcro**, on entering the Palazzo Comunale, the *Risen Christ* appears as a vision before you; see also the early painting of the *Madonna della Misericordia*. From here take a longer drive to Urbino (see below). Other works may be seen in Florence, Perugia, Milan and Venice.

URBINO

The Ducal Palace and the National Gallery of the Marches: Galleria Nazionale delle Marche
Palazzo Ducale, Piazza Duca Federico, 61029 Urbino.
Tel (39 0722) 2760
Fax (39 0722) 4427
231@rpv.beneculturali.it
Mon to Sun 10-1.
Sometimes guided tours only.
The gallery is housed in Federico da Montefeltro's Ducal Palace, the epitome of Renaissance ideals of proportion and harmony. In the Duke's apartment are Piero della Francesca's *Madonna of Senigallia* and the inscrutable, mathematically constructed *Flagellation***. The Duke's *Studiolo*** is decorated with a humanist programme of *trompe l'œil* inlaid panels. Outstanding works inc. Pedro Berreguete's *Federico da Monte-feltro and his son, Guidobaldo**;

Justus of Ghent's *Communion of the Apostles*, commissioned by Federico, who liked Flemish oil painting, with a *predella* by Uccello; works by Titian and Raphael. 16C and 17C works inc. splendid Baroccis and a strong Gentileschi*.

Oratorio di San Giovanni Battista
Via Barocci.
Mon to Sun. May-Sept: 10-12.30, 4-7; Oct-Apr: Mon to Sun 10-12.30, 3-5.
A small oratory, entirely covered with decorative frescoes, full of amusing and charming detail, by Lorenzo and Giacomo Salimbeni.

VARALLO

Sacro Monte
Piazza della Basilica, 13019 Varallo.
Tel (39 0163) 53938

Fax (39 0163) 54047.
One of the most spectacular examples of Counter-Reformation art in northern Italy: 45 chapels decorated by 16C Lombard artists with dramatic ensembles of fresco and intensely realistic life-sized sculptured figures who act out the Life and Passion of Christ.

VARESE

Museo Lodovico Pogliaghi
Villa Pogliaghi, 21100 Varese.
Tel (39 0332) 22 60 40
Tues to Sun, 10-12, 2.30-5-30.

Closed Mon.
Pogliaghi was an art nouveau sculptor, famous for the doors of Milan cathedral. His romantically eclectic villa, near the village of Santa Maria del Monte at the summit of the Sacro Monte, is a rich Aladdin's cave of all kinds of art, including a terracotta bozzetto by Bernini and a model for the cathedral doors.

Sacro Monte
14 chapels line a route up the mountainside; note esp. the 7th chapel which has frescoes by Morazzone and sculptures by Martino Redo.

Chapel of the Way to Calvary: detail of frescoes by Morazzone and sculptures by Tabacchetti, Sacro Monte di Varallo

Venetian art

Venice, closely linked with the east, responded more slowly to the new style of the Renaissance than did other Italian cities. A deep love for the decorative and the sumptuous persisted throughout the 15C; the workshops of the Vivarini family and Carlo Crivelli (d.1495/1500) produced complex altarpieces. The new naturalism of Florence gradually spread to the north although the predominant interest of the Venetian school from the 15C to 18C was in light and colour. Bellini responded to the space and forms of his brother-in-law, Mantegna, but a warmer atmosphere fills his paintings; tiny natural details are joyfully observed; his Madonnas are grave and gentle. The new beauty of his colour depended on his use of pure oil paint; Antonello da Messina, who had seen Flemish oils, came to Venice c.1475; Giorgione (1478-1510) painted small pictures, idyllic stories from classical literature which introduced a new vein of melancholic poetry. Titian's world, in contrast, was dynamic and heroic; he painted altarpieces, portraits, poesie; his pagan pictures are radiant visions of the lost beauty of Antiquity. In the later 16C Veronese was painting light and decorative works – gorgeous festivals of opulently clad figures. Tintoretto's paintings, tense and weirdly lit, are dependent on dramatic effects of perspective.

17C painting was less interesting, although Feti, Liss and Strozzi all worked in Venice.

In the 18C patronage moved away from the Venetian aristocracy to rich foreigners. Painting was reborn in a burst of light colour and flickering brushwork. The luminous charm of the Venetian Rococo owed much to a rediscovery of the works of Veronese – Tiepolo's frescoes, flooded with clear light, are peopled with radiantly beautiful figures from the Venice of Veronese. The 18C also saw poetic sobriety of Piazzetta, the amusing genre scenes of Longhi and the views of Venice by Canaletto and Guardi. Canaletto's world is hard and clear cut, sharply revealed in every detail by brilliant sunlight; Guardi's is more evocative; the light hazy and the forms merely sketched.

Opposite: Holy Family, *Andrea Mantegna, Museo di Castelvecchio, Verona*
Overleaf: Perseus and Andromeda, *Titian, The Wallace Collection, London*

VENEZIA (Venice)

Ca' Rezzonico

Dorsoduro 3136, 30123 Venezia.
Tel/Fax (39 041) 241 0100
www.comune.venezia.it/
museicivici
mkt.musei@comune.venezia.it
1 Nov to 3 Mar 10-5; 1 Apr to 31
Oct 10-6. Closed Tues.

Grand palace with magnificent furniture and decoration. Delightful frescoes by G. D. Tiepolo; ceiling by G. B. Tiepolo; two early Canaletto views* (the only paintings by him still in Venice). Coll. recently much enlarged with interesting Renaissance and later works.

Gallerie dell'Accademia

Campo della Carità,
30121 Venezia.
Tel (39 041) 522 2247
accademia.artlive@arti.benicul-
turali.it
Tues to Sun 8.15-7.15; Mon 8.15-2.

A gloomy, ill lit, and intensely enjoyable gallery, housed in former monastic buildings. Giorgione's *Tempesta****, one of the most celebrated Western paintings, hangs with an exceptional collection of Bellinis in a small and crowded room, stiflingly hot in summer. The collection is mainly of Venetian painting, esp. Bellini and Carpaccio: fewer works by Titian and Canaletto than one would expect. The subject matter of Giorgione's *Tempesta* – a knight and gypsy in a stormy landscape – seems to have been obscure even to his contemporaries, but the gypsy's gaze, and the dreamlike mood, are magical. It contrasts sharply with his *La Vecchia***, a haunting image

of old age. Among the Bellinis, note esp. the *Madonna with St Catherine and the Magdalene***, and the *Madonna and Saints***, with a dazzling harbour scene. Good Cimas inc. *The Madonna of the Orange Tree**, with a lyrical Italian landscape. 16C inc. fine Lotto; Veronese, esp. *The Mystic Marriage of St Catherine*** and the *Feast in the House of Levi**, whose colourful genre details enraged the Inquisition. Titian's large *Pietà*, unfinished at the time of his death, and Tintoretto's *The Miracle of the Slave**. Carpaccio's *St Ursula*** series, full of vivid scenes of Venetian daily life. The 17C and 18C are duller, but some good Tiepolos, and Piazzetta. The gallery concludes with Titian's *Presentation in the Virgin***, painted to be hung here. The diminutive figure of the Virgin contrasts poignantly with the splendid onlookers and the strikingly naturalistic old woman with a basket of eggs.

Galleria d'Arte Moderna

Ca' Pesaro, 30100 Venezia.
Tel (39 041) 524 0695
Closed for restoration.

A dullish collection of 19C Italian painters, modern Italian and foreign artists.

Galleria Franchetti

Ca' d'Oro, Canal Grande,
Canareggio, 30100 Venezia.
Tel (39 041) 523 8790
Tues to Sun 8.15-7.15; Mon 8.15-2.

No longer gilded, the 'Golden House' remains a magical setting for an individual collection of mainly Renaissance paintings, small sculptures (esp. Tullio Lombardo,

Cristofero Romano, Riccio) and medals. Outstanding is Mantegna's over-life-size and powerfully expressive *St Sebastian***.

Galleria Querini Stampalia
Santa Maria Formosa 5252, 4778 Venezia.
Tel (39 041) 271 1411
Fax (39 041) 271 1445
www.provincia.venezia.it/querini
querini.stampalia@provincia.venezia.it
Fri and Sat 10-1, 3-10. Closed Mon. Café.
A gallery of great charm, full of 18C furniture and painted ceilings, containing many pleasing genre scenes by Pietro Longhi. A fine *Judith* by Catena, and a portrait by Tiepolo. Garden by Scarpa*.

Museo Correr
Piazza San Marco, 30124 Venezia.
Tel (39 041) 522 5625
Fax (39 041) 520 0935
www.comune.venezia.it/civicmusei
pressmusei@comune.venezia.it
Nov-Mar: 9-5 (ticket office 9-3.30). Apr-Oct: 9-7 (ticket office 9-5.30).
Most interesting are a number of early works by Bellini*, *Pietà* by Antonello da Messina, Carpaccio's *Two Ladies** and section devoted to Canova.

Palazzo Ducale
(Doge's Palace).
Piazza San Marco 1, 30124 Veniezia.
Entry from Riva degli Schiavoni, Porta del Frumento.
Tel (39 041) 522 4951
Fax (39 041) 528 5028
www.comune.venezia.it/
museicivici
correr@comune.venezia.it
Mon to Sun. Nov-Mar: 9-5; Apr-Oct: 9-7.
A visit to the Doge's Palace can be long and tiring – seek out and concentrate on the best works. These inc., on the second floor, pictures in the **Doge's Apartment** by Bellini, Bosch and Tiepolo. In the **Sala del Maggior Consiglio** (Grand Council Chamber) Tintoretto's overwhelmingly ambitious *Paradise*, most famous for its vast scale. On the third floor the **Anti-collegio** (Waiting room) is the most enjoyable room in the palace. It contains Veronese's *Europa** and four mythological paintings by Tintoretto. In the **Collegio** (College hall) are ceiling pictures by Veronese* and, on the walls, pictures by Tintoretto and his assistants.

Palazzo Labia
Cannaregio, Campo S. Geremia 275, 30121 Venezia.
Tel (39 041) 78 12 77, 78 12 03
Fax (39 041) 71 92 10
girolimetto@rai.it
Radio and TV centre; main hall open Wed to Fri 3-4 – depending on activities. Booking necessary.
Main hall: Tiepolo's *Antony and Cleopatra*** frescoes, his most splendid decorative scheme in Venice. The elaborate illusionistic architecture was painted by G. M. Colonna.

Peggy Guggenheim Collection
Dorsoduro 701, 30123 Venezia.
Tel (39 041) 240 5411
Fax (39 041) 520 6885
info@guggenheim-venice.it

Ca d'Oro (Galleria Franchetti), Venice

A weekend in Venice

Seeing the sights in the area around St Mark's and the Doge's Palace could occupy a weekend, but there are many smaller and perhaps more enjoyable sights which should not be missed – many people would rather see Carpaccio's frescoes in San Giorgio degli Schiavone than the tiring Tintorettos in the Doge's Palace.

On the first day spend the morning at the Accademia, or the Scuola di San Rocco and the Frari; in the afternoon visit the Doge's Palace and perhaps the Correr Museum or the Madonna dell'Orto and Sant'Alvise (remote places but with special charm). On the second day spend the morning in San Zaccaria, the Scuola di San Giorgio degli Schiavoni and San Giovanni in Bragora; in the afternoon take a relaxing boat trip to Torcello, for its magnificent (but restored) mosaics.

Wed to Mon 10-6. Apr-Oct,
Sat 10-10. Closed Tues. Café.
In the palace of Peggy Guggen-
heim, with a terrace overlooking
the grand Canal, this is her collec-
tion of modern art; it has a fine
Kandinsky; good Cubist works,
esp. Juan Gris, a strong collection
of Surrealism (she was once
married to Max Ernst); Abstract
Expressionists. Also displayed is
the Gianni Mattioli collection, with
works by the Futurists and Morandi.
An attractive sculpture garden.

Churches

Chiesa dell'Angelo Raffaele
Campo dell'Angelo, Dorsoduro.
The parapet of the organ is deco-
rated with pictures by F. or A.
Guardi; their prettiness and flick-
ering surfaces are one of the most
extreme manifestations of Venetian
Rococo. R wall: Palma Giovane's
St Francis Receiving the Stigmata.

The Frari
(S. Maria Gloriosa dei Frari)
www.basilicadeifrari.it
basilica@basilicadeifrari.it
Mon to Sat 9-6; Sun, hols 1-6.
Two outstanding works by
Titian***, the *Pesaro Madonna*
(2nd altar, N aisle), and the
Assumption of the Virgin, revolu-
tionary in the glorious contrasts of
reds and blues, in the physical
grandeur and dynamism of the
figures, and in its exalted visionary
power. In the sacristy, a triptych by
Bellini**. In the chapel R of the
chancel, Donatello's *St John the
Baptist.* Other works by Sansovino
and Vivarini*.

The Gesuiti (S. Maria Assunta)
Campo dei Gesuiti, Cannaregio.
1st chapel L, Titian's *Martyrdom
of St Lawrence**.

The Gesuati
(S. Maria del Rosario)
Zattere ai Gesuati.
Mon to Sun 9-6.
Ceiling paintings* by Tiepolo; 1st
altar on the R by Tiepolo*. Works
by Piazzetta*, Tintoretto and Ricci*.

La Madonna dell'Orto
(S. Maria dell'Orto)
*Campo Madonna dell'Orto,
Canaregio.*
Famous for its pictures by Tintoretto,
inc. the *Presentation of the Virgin**
and two huge early works, *The Last
Judgement* and the *Worship of the
Golden Calf.* Cima.

Sant'Apostoli
Campo Sant'Apostoli, Cannaregio.
Tiepolo's *Communion of St Lucy.*
Veronese and Francesco Maffei.

San Bartolomeo
*Campo S. Bartolomeo
(Carlo Goldoni).*
Most important are two double
pictures by Sebastiano del Piombo,
once organ doors**. These are now
in the Accademia but will be
returned.

San Giorgio Maggiore
Isola di S. Giorgio.
Mon to Sun 9-12.30, 2.30-4.30.
Two pictures by Tintoretto on the
presbytery walls: *The Last Supper*
and the *Fall of Manna.* In the
chapel R of the chancel, S. Ricci's
Madonna and Child with Saints,
1708, a work which, derived from
Veronese, initiated the gracefulness

and casual grouping of the Rococo. Bassano's *Nativity*.

San Giovanni in Bragora
Campo Bandiera e Moro, Castello.
Mon to Sat 8.30-11, 3.30-7;
Sun 8.30-11.
Above the high altar, Cima da Conegliano's *Baptism of Christ**, with a splendid landscape. Works by Vivarini.

San Giovanni Crisostomo
Salizzada S. Giovanni.
Mon to Sat 8.30-12.30, 3.30-7;
Sun 10-12.
Important works by G. Bellini*, S. del Piombo and Tullio Lombardo.

SS Giovanni e Paolo
Campo SS Giovanni e Paolo.
Mon to Sat 9-12.30, 3.30-6;
Sun 3.30-6.
An altarpiece by Bellini (2nd altar, S aisle). In the Rosary chapel, three ceiling paintings by Veronese. In the chapel before the R transept, a ceiling by Piazzetta (his only fresco-style picture)*. Lotto*.
See also outside the church the equestrian statue of *Colleoni*** by Verrocchio.

San Marco (St Mark's)
Piazza S. Marco.
Though essentially a great work of Byzantine art, there are also works by Renaissance artists inc. Sansovino.

Santa Maria della Salute
Dorsoduro.
Mon to Sun 9-12. 3-5.
In the sacristy: Tintoretto's *Marriage at Cana**. On the ceiling, pictures by Titian** (1540-50) that initiated a new phase in his development;

the stress is less on allurements of colour than on violent action, bold foreshortenings and sudden contrasts of scale. Above the altar, an early work by Titian. In the nave: works by Titian and Luca Giordano.

San Sebastiano *
Campo San Sebastiano, Dorsoduro.
Mon to Sat 10-5. Closed Sun.
Decorated throughout by Veronese**; most remarkable are the scenes on the ceiling, *Esther Before Ahasuerus*, *Esther Crowned Queen by Ahasuerus* and the *Triumph of Mordecai*.

San Zaccaria
Campo San Zaccaria, Castello.
Mon to Sun 10-12, 4-6.
Giovanni Bellini's *Madonna with Saints*** 1505. The great masterpiece of Bellini's old age; the figures are grave and dignified, the composition subtly balanced, and the atmosphere warm and glowing.

Scuole
These uniquely Venetian institutions were a combination of guilds and religious fraternities.

Scuola di San Giorgio degli Schiavoni
Calle Furlani, Castello.
Tel (39 041) 522 8828
Tues to Sat 10-12.30, 3-6;
Sun 10-12.30. Closed Mon.
Decorated with pictures by Carpaccio**, perhaps the most charming sight in Venice. They are both funny and unassumingly dignified, and full of delightfully observed naturalistic detail and wonderful effects of light.

Main upper room, Scuola Grande di San Rocco, Venice

Scuola Grande dei Carmini *
Campo Carmini,
Dorsoduro 2617, 30123 Venezia.
Tel/Fax (39 041) 528 9420
Apr-Oct: Mon to Sat 9-6, Sun 9-4;
Nov-Mar: Mon to Sat 9-4, Sun 9-1.
Nine Tiepolo canvases; the ceiling
painting, *The Madonna of Mount
Carmel***, is perhaps his greatest
religious work. The spectator
shares the vision of St Simon as
he kneels before the radiantly white
and sublimely triumphant Madonna.

Scuola Grande di San Rocco**
Campo San Rocco, 3052,
30125 Venice.
Tel (39 041) 523 4864
Fax (39 041) 524 2820

snrocco@libero.it
28 Mar-2 Nov: Mon to Sun 9-5.30;
3 Nov-27 Mar: Mon-Sun 10-4.
A wonderful series of 56 pictures
by Tintoretto**. Outstanding is
the *Crucifixion* in the Sala dell'Al-
bergo on the upper floor. The main
upper room is filled with Tintoret-
tos on the walls and ceiling; also
works by Giorgione, Titian and
Tiepolo. The paintings on the
ground floor inc. the spectacular
Annunciation and the two narrow
canvases, *The Magdalen* and *St
Mary of Egypt* – small figures set
against desert landscapes which
have an eerie and almost visionary
intensity.

245

A tour of the villas of the Veneto

The Veneto contains hundreds of villas, built by aristocratic families from the 15C to the 18C. Palladio is the most important architect, while the frescoes of Veronese and Tiepolo are the most dazzling with their spectacular *trompe l'œileffects.*

Start out at Vicenza at the **Villa Capra** (La Rotonda), one of Palladio's most admired works and the model for many villas in England and America. A few minutes drive away is the **Villa Valmarana***, decorated with frescoes by Giambattista Tiepolo illustrating episodes from Virgil and Tasso. The guesthouse is frescoed with lighter, genre scenes by his son.

Two villas designed by Palladio are situated between Castelfranco and Asolo; the **Villa Emo** at Fanzolo frescoed by Zelotti in the 16C, with mythological scenes; **Villa Barbaro**** (or Volpi) at Maser, one of the most successfully planned and decorated villas in Italy. Palladio's mature architecture is adorned by Veronese's delicate, witty frescoes.

A boat tour along the River Brenta from Padua to Venice will take you past the many villas built along its banks: Palladio's **Villa Malcontenta** is memorable: **Villa Pisani**** at Strà is decorated by various 18C artists including Tiepolo.

VERONA

Museo di Castelvecchio
Corso Castelvecchio 2,
37121 Verona.
Tel (39 045) 59 47 34
Fax (39 045) 801 0729
museo-castelvecchio@id.it
Tues to Sun 9-7. Closed Mon.
A seminal museum display by Carlo Scarpa and L. Magagnato (note Scarpa water garden at entrance). It fully surveys the arts in Verona, though much (eg rooms of Liberale da Verona, Caroto etc) may mainly interest experts. But two outstanding International Gothic works, the early *Madonna of the Quail** by Pisanello and the *Madonna of the Rose Garden** by Stefano da Verona (see ill. p.173), exhibited together. Mantegna (see ill. p.237).

Scaliger tombs
Via Arche Scaligere.
Tel (39 045) 59 47 34
Fax (39 045) 801 0729
museo-castelvecchio@id.it
Jun-Aug: Tues to Sun 9-7.
Closed Mon.
Ticket inc. Torre dei Lamberti.
Astonishing fairy-tale graveyard of the 14C rulers of Verona, fenced off from the real world by an

Equestrian Statue of Cangrande I, *Unknown sculptor, 14C,*
Museo di Castelvecchio, Verona

intricate wrought-iron screen. The elaborate tombs are surmounted by equestrian effigies, presenting the Scaligers as ideals of chivalry. (Original of equestrian effigy of Cangrande I now in Castelvecchio museum.)

Churches

Duomo
Piazza del Duomo.
Titian's *Assumption,* portal sculptures by Master Niccolò.

Sant'Anastasia
Piazza Sant'Anastasia.
Frescoes by Altichiero and Pisanello, whose *St George and the Princess** shows his elegant International Gothic style.

San Fermo Maggiore
Stradone S. Fermo.
Fresco by Pisanello of the *Annunciation.*

San Giorgio in Braida
Via Sant'Alessio.
Works by important 16C artists Moretto, Tintoretto and Veronese's *The Martyrdom of St George*** (colourfully crowded with Palladian architecture).

San Zeno Maggiore
Piazza S. Zeno.
High altar: Mantegna's *San Zeno Altarpiece*** in its original carved frame – a key work in the development of the *sacra conversazione.*

VICENZA

Basilica di Monte Berico
Viale X Giugno.
In the refectory of the monastery, Veronese's *The Supper of St Gregory the Great.*

Museo Civico d'Arte e Storia
Palazzo Chiericati, 36100, Vicenza.
Tel (39 0444) 32 13 48
Fax (39 0444) 54 66 19
museocivico@comune.vicenza.it
Tues to Sun 9-5. Closed Mon.
(Tickets from nearby Teatro Olimpico.)
Displayed in one of Palladio's most important palaces, this contains a great deal of enjoyable painting. The early rooms have been refurbished into a didactic review of art in Vicenza up to early 16C. Later rooms include a fine Veronese, a great deal of Maffei (including the important *Glorification of Alvise Foscarini*), Liss's superbly painterly bozzetto for the St Jerome altarpiece, Van Dyck's *Three Ages of Man**, and good quality Saraceni, Cairo, Piazzetta, Tiepolo and Luca Giordano.

Santa Corona
Contrà Santa Corona.
Bellini's marvellous late *Baptism***, Veronese *Adoration of the Shepherds**, Pittoni *Virgin and Saints**.

Villa Valmarana
Via dei Nani.
Mon to Sun 10-12, 4-6.
Frescoes by the Tiepolos**. In the villa, freely painted, with wonderful colour, fabulous mythological and romantic scenes by the father. In the *foresteria*, tamer, more realistic genre scenes by the son, Giandomenico

VITERBO

Museo Civico
Piazza Crispi 2, 01100 Viterbo.
Tel (39 0761) 34 82 75
Fax (39 0761) 34 82 76
Summer: Tues to Sun 9-7; Winter
Tues to Sun 9-4. Closed Mon.
Sebastiano del Piombo's *Pietà***
based on a cartoon by Michelangelo. Also his *Flagellation*.

VOLTERRA

Pinacoteca
Palazzo Minucci Solaini,
Via dei Sarti 1.
Tel (39) 87580
16 Mar -1 Nov: Mon to Sun 9-7;
2 Nov- 15 Mar: Mon to Sun 9-2.
Contains Rosso Fiorentino's *Deposition***, one of the most famous
16C paintings. It deserves better
than this cramped, ill-lit display.

Japan

Japan's main public collections of Western art are particularly rich in 19C and 20C French paintings, built up mostly during the last three decades.
National holidays: Jan 1, 15, Feb 11, Mar 21, Apr 29, May 3, 4, 5, Sept 15, 23, Oct 10, Nov 2, 23, Dec 23.

KURASHIKI
WESTERN JAPAN

Ohara Bijutsukan
(Ohara Museum of Art)
1-1-15 Chuo, Kurashiki,
710-8575 Okayama.
Tel (81 86) 422 0005
Fax (81 86) 427 3677
Tues to Sun 9-5. Closed Mon.
European, esp. modern French paintings (with artists such as Braque, Picasso, Rouault, Matisse surprisingly well represented). Several richly-patterned and exotic paintings, inc. Gustave Moreau's *Song of Songs* and Gauguin's *Tahitian Woman*. Also an *Annunciation* by El Greco.

TOKYO HONSHU

Bridgestone Bijutsukan
(Bridgestone Museum of Art)
10-1, Kyobashi 1-chome,
Chuo-ku, Tokyo 104-0031.
Tel (81 3) 3563 0241
Fax (81 3) 3561 2130
www.bridgestone-museum.gr.jp
Tues to Sun 10-6. Closed Mon.
Main collection is of 19C and 20C works by French painters and Japanese artists working in the Western style, often particularly influenced by Impressionist techniques. Also modern European sculpture.

Tokyo Kokuritsu
Kindai Bijutsukan
(National Museum of Modern Art, Tokyo)
3 Kitanomaru Koen,
Chiyoda-ku, Tokyo 102-8322.
Tel (81 3) 3214 2561
Fax (81 3) 3213 1340
www.momat.go.jp
pr@momat.go.jp
Tues to Sun 10-5. Closed Mon and Dec 28-Jan 4.
Collection of 20C Japanese art, both traditional and Western-style, inc. some abstract paintings.

Kokuritsu Seiyo
Bijutsukan (National Museum of Western Art)
7-7 Ueno-koen, Taito-ku,
Tokyo 110-0007.
Tel (81 3) 3828 5131
Fax (81 3) 3828 5135
www.nmwa.go.jp
Tues to Sun 9.30-5; Fri 9.30-7.
Café.

Building designed by Le Corbusier. Fine collection of post-Renaissance European paintings but most important is the Matsukata collection of 19C and 20C French paintings inc. 12 works bought by the collector from Monet. Rodin. **European Old Masters** inc. works by Claude*, Cranach, El Greco (*Crucifixion*). Rubens, Ruysdael and Tintoretto.

Malta

National holidays: Jan 1, Mar 31, Good Fri, May 1, Carnival (May), Aug 15, Dec 13, 25.

Art in Malta

Malta attracted many artists from Italy, most famously Caravaggio, who arrived in Malta in 1608 and was received into the Order of the Knights of St John as a Knight of Obedience. He was expelled as a 'corrupt and foul member' later in the year. In 1661 Mattia Preti settled there, bringing with him the dark and dramatic style of the Neapolitan Baroque; very many of his altarpieces are to be found in Maltese churches. (Amongst the best are those in Zurrieq church, and in St Lawrence's church, Vittoriosa.) In the 18C the dominant artists were Francesco Zahra and Antoine Favray; Favray's most successful works are grandiloquent portraits of dignitaries of the Order.

VALLETTA

Valletta is a perfect Renaissance fortress city, built on a grid plan and intended to ensure the island's safety after the Grand Siege of 1565.

National Museum of Fine Art
South Street, Valletta.
Tel (356) 2330 34/2257 69
Fax (356) 2399 15
1 Oct-15 June:
Mon to Sun 8.30-4.30;
16 June-30 Sept: Mon to Sun 8.30-1.30. Closed public hols.
A good survey of art in Malta, with main strengths in the 17C. A room devoted to Preti, esp. *Beheading of St Catherine;* ugly and gruesome works by the Caravaggesque artist

Matthias Stomer; Valentin*; Ribera; Guido Reni*. 18C portraits inc. a late *Self Portrait* by Favray, and a series of opulent portraits of the Grand Masters.

St John's Co-Cathedral
Tel (356) 2444 76
Fax (356) 2395 82
Mon to Fri 8.30-12.30, 1.30-4.30;
Sat 9.30-12.30.
Closed on Sun and public hols.
Once the conventual church of the Order of the Knights of St John, and splendidly enriched by the knights. The decoration of the vault*, painted in oil, is an illusionistic tour de force by Preti, who also contributed altarpieces, esp. *St George Killing the Dragon.* On the high altar, a marble *Baptism*

Detail of The Beheading of St John, *Caravaggio,
St John's Museum, Valletta*

of Christ by Giuseppe Mazzuoli. But the highpoint is a *Crucifix**, by Polidoro da Caravaggio.

Also:

St John's Museum and Oratory
Tel (356) 2205 36
Fax (356) 2336 23
Mon to Fri 8.30-12.30, 1.30-4.30;
Sat 9.30-12.30.
Closed on Sun and public hols.

In the Oratory: Caravaggio's *Beheading of St John****. Caravaggio was made a Knight in 1608, and this work was almost certainly painted in lieu of the large sum of money prospective knights paid to the Order; it is signed in the blood, *fra Michelangelo*, conveying pride in his works and in his knighthood. But, ironically, public assemblies were held in the Oratory and Caravaggio was soon defrocked, in absentia, before this picture. Also his *St Jerome**. Silver and gilt monstrance throne by Ciro Ferri*.

ZURRIEQ

St Catherine
Mattia Preti's dark, dramatic *Martyrdom of St Catherine**.

253

Mexico

National holidays: Jan 1, Feb 5, Mar 21, Maundy Thurs, Good Fri, May 1, 5, Sept 15, 16, Oct 12, Nov 1, 2, 20. Dec 25. Museums close on all holidays.

Tourist information: Secretaria de Turismo.

Art in Mexico

Mexican artists have brought fresh vigour to the tradition of mural painting in the 20C. Inspired by the ideals of the 1910 Revolution, artists have attempted to create a national popular art by depicting, with epic power, the struggles of the Mexican people. Particularly significant are the tragic works of Orozco, Siqueiros' vigorous glorification of labour and the decorative paintings of Rivera. Rivera's wife, Frida Kahlo, is now the most celebrated Mexican artist outside her own country; she painted her own life in a series of strange and psychologically compelling images of sickness and suffering. André Breton called Mexico 'the Surrealist place *par excellence*' and in the 1930s many Surrealist writers and painters, amongst them Leonora Carrington and Remedios Varo, worked there.

Murals in Mexico City

Important murals may be seen in the **Hotel del Prado** (Rivera); **Casa de los Azulejos**, *Avenida Madero* (Orozco); **Galería de Historia,** *Castillo de Chapultepec* (O'Gorman, Orozco, Siqueiros); **Palacio Nacional**, *Zócalo* (Rivera); **Escuela Nacional Preparatoria**, *Calle San Ildefonso* (Orozco*, Leal and Rivera); and the **Polyforum de Siqueiros**, *Avenida Insurgentes Sur* (Siqueiros).

Opposite: Detail of Riveria's murals in the Palacio Nacional, Mexico City

MEXICO CITY

Dolores Olmedo Patiño Museum

Hacienda La Noria,
5483 Av. Mexico-Xochimilco.
Most famous for its outstanding paintings by Frida Kahlo, inc. *The Broken Column** (a self-portrait as martyr, locked in an orthopædic corset), *Self-Portrait with Monkey** and *Henry Ford Hospital** (a nightmarish painting of her miscarriage).

Museo de Arte Alvar Carmen T. de Carrillo Gil

Av. Revolución 1608, Col. San Angel Inn, Mexico D.F.
Tel (52 5) 550 6284
Fax (52 5) 550 4232
Tues to Sun 10-5. Closed Mon.
Paintings by Orozco, Rivera, Siqueiros, Palaen, Gerzsò, and other modern Mexican artists.

Museo Frida Kahlo

247 Londres, Coyoacan.
Tel (52 5) 658 8732
Tues to Sun 10-6. Closed Mon.
A magical cobalt blue house, where Kahlo and Rivera lived, and filled with their collections of pre-Columbian art, masks, ex-votos, toys. Kahlo's portrait of her father.

Museo Mural Diego Rivera

Balderas y Colón s/n, Centro Histórico, Mexico, D.F. 06040.
Tel (52 5) 512 0754
Fax (52 5) 510 2329
www.arts-history.mx/museo-mural.html
mmdr@correo.inba.gob.mx
Tues to Sun 10-6. Closed Mon.
Sun free.

Purpose-built museum inaugurated 1988 to house Rivera's huge mural *Dream of a Sunday Afternoon in the Alameda* (transferred from Hotel del Prado after earthquake damage). The mural is a synthesis of the entire history of Mexico and of Rivera's own life, inc. portraits of many people who were important to him, inc. Frida Kahlo. Also didactic display on Rivera's life and work.

Museo de Arte Moderno

Paseo de la Reforma y Ganhi,
Bosque de Chapultepec,
Mexico D.F.
Tel (52 5) 553 6113
Fax (52 5) 553 6211
www.arts-history.mx/museos/mam/home.html
Tues to Sun 10-5. Closed Mon.
Sun free.
A good coverage of Mexican painting, from the Muralists to the present time, and some works by European artists, esp. those who have worked in Mexico. Most celebrated is Frida Kahlo's *Two Fridas***, which shows two self-portraits, one in white Victorian dress, the other in Tehuana skirt, joined by hearts that bleed. Works by the Surrealists inc. Leonora Carrington and Remedios Varo. Good collection of Tamayo Rufino.

Museo Nacional de San Carlos

Puente de Alvarado 50,
Colonia Tabacalera,
C:P: 06030, Mexico D.F.
Tel (52 5) 566 8085, 566 8522
www.mnsancarlos.org.mx
mnsancarlos@compuserve.com.mx
Wed to Mon 10-6. Closed Tues.
Sun free.

Small collection of European Old Masters, with works by Pontormo, Goya and Zurbarán.

Palacio de Bellas Artes
Av. Juarez y Eje Central,
LazaroCardenas,
Centro Histórico, Mexico, D.F.
Tel (52 5) 510 1388
Tues to Sun 10-5. Closed Mon.
The first two levels house temporary exhibitions of both Mexican and European artists: on the third are murals by Siqueiros, Orozco, Tamayo (particularly his experimental abstract murals using vinylite on canvas), O'Gorman and Rivera (the copy of his *Man in Control of his Universe* commissioned for the Rockefeller Center in New York).

MONTERREY

Museo de Monterrey
Avenida Alfonso Reyes 2202 Norte,
Colonia Bella Vista, Monterrey,
Nuovo León, CP 64442.
Tel (52 83) 2860 50 and 52
Fax (52 83) 2860 68
informacion@museodemonterey.
org.mx
Tues to Sun 11-8, Wed 10-8.
Closed Mon.
Important collection of Mexican art from early 20C to present day. Also collection of other 20C Latin American (esp. Argentinian) art, charting regional schools, influences etc.

Detail of Orozco's murals, Escuela Nacional Preparatoria, Mexico City

The Kitchen Maid, *Johannes Vermeer,*
Rijksmuseum, Amsterdam

The Netherlands

The national museums have rich collections of Dutch art from the 'Golden Age' of the 17C to the more recent important developments beginning with the foundation of De Stijl. Many Dutch museums are in fine old buildings and especially pleasant to visit.

Opening hours: museums are generally open Tuesday to Saturday 10-5, Sunday 1-5. Hours may vary according to the season and are generally longer in Amsterdam. Some museums stay open in the evening on certain days in the summer.

National holidays: Jan 1, Good Fri, Easter Mon, Ascension Day, Whit Mon, Dec 25, 26. Museums usually close on Dec 25 and Jan 1; opening hours on other holidays as for Sun.

Tourist information: 'V V V' information centres.

Useful words: *stedelijk museum* municipal museum; *schone kunst* fine art.

The art of the Netherlands

In the 15C the most interesting developments were taking place in the southern Netherlands (today's Belgium), when the astonishing verisimilitude of Jan van Eyck's paintings opened a new era in Netherlandish art. The most important artists who practised the new realism in the northern Netherlands were Albert van Ouwater, his pupil Geertgen tot Sint Jans, Jan Mostaert and the Master of the Virgo inter Virgines. Of these Geertgen, whose figures are melancholy, and whose work explores landscape, is the most individualistic.

In the 16C artists began to assimilate an Italian æsthetic; a new interest in large-scale figure pictures is evident in the graceful, Raphaelesque works of Jan van Scorel and those of Lucas van Leyden. By the end of the century the influence of Antwerp Mannerism had spread to the north; Bloemaert, Wtewael and van Haarlem were interested in virtuoso spatial design and in elaborately arranged elongated figures.

The 17C is dominated by the great names of Hals, Rembrandt, Vermeer and Steen, yet it is also unique in the wealth and variety of the minor masters. Artists became highly specialized in the separate categories, and the development of still-life, landscape, and

Previous pages: The Nightwatch, *Rembrandt, Rijksmuseum, Amsterdam;*
and above: Portrait of a Woman, *Franz Hals, Michaelis Collection, Cape Town*

genre brought to fulfilment the northern taste for recording the
details of the everyday world, in which they were encouraged by
the rich bourgeois patrons of the newly independent country.
Landscape painters of the early years – Jan van Goyen, Salomon
van Ruysdael, Esaias van de Velde – painted, in a subtle range of
greys and greens, the unassuming beauty of the flat countryside.
In the later years of the 17C Jacob van Ruisdael, Cuyp and Koninck
introduced a new majesty and grandeur. Vermeer and Steen repre-
sent the opposite poles of genre painting: Vermeer's paintings are

images of tranquillity, Steen's are crowded festive scenes. Frans Hals' series of group portraits are the most elaborate achievements of a characteristic Dutch tradition. Rembrandt brought to both portraits and scenes from the Bible a new and tender humanity; he developed chiaroscuro as a subtle device to suggest both the mystery and tragedy of the human predicament.

In the 18C painting was influenced by France and became lighter and more informal. Cornelis Troost painted genre scenes and relaxed family portraits; many painters continued to produce flower paintings in a 17C tradition.

The Dilettanti, *Cornelius Troost, National Gallery of Ireland, Dublin*

Alexander Reid, *Vincent van Gogh, Glasgow Museums*

In the 19C Dutch painters had links with the Barbizon school and with French Impressionism; Breitner painted city views; in the Hague a group of artists concentrated on light and atmosphere. Towards the end of the century Jan Toorop and Thorn Prikker made important contributions to Symbolism, producing flat decorative works full of fin de siècle melancholy and eroticism. A more powerful attempt to restore meaning to art was made by Van Gogh, who experimented with the expressive power of colour and line to convey a strong emotion to reach even the simplest heart.

From 1917 the artists of De Stijl tried to make a radical break with the art of the past. The flat works of Theo van Doesburg, Bart van der Leck and Mondrian explore the relationships between squares and rectangles, and between the primary colours and black and white. Other artists continued to paint figuratively; Charley Toorop produced minutely realistic, almost surreal works; Constant, Appel and Corneille joined an international group, CoBrA, and painted violently Expressionist works. In the 1970s Ger Van Elk and Jan Dibbets explored the dualities of photography, Van Elk producing gloomy comments on public life.

AMSTERDAM

Amsterdams Historisch Museum

Kalverstraat 2,
1012 RM Amsterdam.
Tel (31 20) 523 1822
Fax (31 20) 620 7789
Mon to Sat 9.30-5; Sun 1-5. Café.
The former city orphanage, in the small garden of the Begijnenhof, has been beautifully and imaginately transformed to display paintings, prints and objects showing the history of Amsterdam. The 'Civic Guard Gallery' shows a collection of group portraits of civic guards, regents and anatomy lessons, and inc. Rembrandt's *Anatomy Lesson of Dr Deijman.* Many works by Breitner, CoBrA.

Museum voor Moderne Kunst (CoBrA Museum)

Sandbergplein 1-3,
1181 ZX Amstelveen.
Tel (31 20) 547 5050
Fax (31 20) 547 5025
cobram@xs4all.nl
www.cobra-museum.nl
Tues to Sun 11-5. Closed Mon.
Café.
Wonderfully unexpected in this busy shopping district, this is an austerely beautiful museum, built around the idea of light, and reflecting surrounding trees and lake. The collection concentrates on art between 1945 and 1955, especially by members of the CoBrA movement, whose works are shown in varied exhibitions.

Rembrandthuis

Jodenbreestraat 4-6,
1011 NK Amsterdam.
Tel (31 20) 520 0400
Fax (31 20) 520 0401
museum@rembrandthuis.nl
www.rembrandthuis.nl
Mon to Sat 10-5; Sun 1-5. Café.
A splendid 17C house which was Rembrandt's home from 1639 to 1658, now restored to capture the atmosphere of his daily life, as painter, art dealer, husband and father. Here Rembrandt welcomed his clients in his office with a glass of white wine, and displayed his status with his cabinet of curiosities – a collection of majolica, casts of Roman busts, dried animals, weapons, armour. Works by his pupils, and a group of paintings by his teacher, Lastman, revelatory about the formation of Rembrandt's style. In the new wing a selection of his etchings.

Rijksmuseum

Stadhouderskade 42,
1071 ZD Amsterdam.
Tel (31 20) 674 7047
Fax (31 20) 674 7001
www.rijksmuseum.nl
info@rijksmuseum.nl
Mon to Sun 10-5. Café.
A superlative collection of Dutch 17C pictures. At its centre is Rembrandt's *Night Watch**** (see ill. pp. 260-1), which shows a parade of the militia company of Captain Frans Banning Cocq. It is displayed with group portraits which originally hung with it in the musketeers'

Opposite: Rembrandt's Cabinet of Art and Curios;
view from the entrance, Museum het Rembrandthuis, Amsterdam

The Jewish Bride, *Rembrandt, Rijkmuseum, Amsterdam*

hall, and the glamorous lighting, bold grouping, and overpowering illusionism of Rembrandt's work stand out. A contemporary wrote that it made all other works 'stand there beside it like playing cards'. Van der Helst's group portraits are nonetheless intensely enjoyable, with their wonderful detail of flamboyant characters, dress, drinking horns, and food.

Other Rembrandts inc. an early *Self portrait**, *The Stone Bridge** *The Jewish Bride*** and *The Sampling Officers of the Drapers Guild*** so vivid in expression and eloquent in gesture that the figures seem to react to someone outside the picture. A rich collection of genre and still life inc. four Vermeers, esp. *The Kitchen Maid**** (see ill. p.258) and the *Letter Reader***; de Hooch, Terborch and Steen, Claesz's *Still Life with a Turkey Pie**, with dazzling reflections. Landscape moves from Esias van de Velde's *The Ferry**, 1622, the beginning of realistic landscape, to Ruisdael's heroic *The Mill at Wijk***. Portraits by Hals and Verspronck. Saenredam stands alone in Dutch art; his *Interior of St Odolphus Church, Assendelft*** unites the formal beauty of light and space with vivid figures.

15C and 16C works inc. Lucas van Leyden; a small collection of foreign schools inc. some Italian,

Van Gogh Museum, Amsterdam

Spanish and Flemish works.

Van Gogh Museum
Paulus Potterstraat 7
PO Box 75366,
1070 AJ Amsterdam.
Tel (31 20) 570 5200
Fax (31 20) 673 5053
www.vangoghmuseum.nl

info@vangoghmuseum.nl
Mon to Sun 10-6. Café.
The building was designed by the De Stijl architect Gerrit Rietveld. 19C works (Realist peasant paintings, seascapes, a Whistler) form a prelude for a large collection of works by van Gogh. Gloomy works painted in the Netherlands

– still lifes, studies of peasants –
are followed by still lifes and street
scenes painted in Paris (1886-8),
lighter in colour and impressionist
in technique. In Arles he responded
to the brilliant southern light with
*The Sunflowers*** and a series of
Provençal orchards; the magical
beauty of the *Pink Peach Tree in
Blossom*** seems a symbol of hope
and rebirth. From Saint-Rémy
(1889) come olive trees and
cypresses, and the *Wheatfield with
a Reaper***, which Van Gogh saw
as 'an image of death' and from
Auvers (1890) the turbulent *Crows
in a Wheatfield***. Impressionist,
Symbolist and Expressionist works
suggest van Gogh's context and
influence; they include portraits by
Gauguin and Bernard, a bold van
Dongen, unusual flower pieces by
Redon* and Pissarro*.

Stedelijk Museum
Paulus Potterstraat 13,
1071 CX Amsterdam.
Tel (31 20) 573 2911
Fax (31 20) 675 2789
www.stedelijk.nl
Mon to Sun 11-5. Café.
A new building is planned for this
excellent collection of art from
1850, whose once cutting-edge
sculpture garden has been replaced
by a supermarket. A brilliantly
bold mural by Appel enlivens the
restaurant, while his *Appelbar***
(1951), a small coffee-shop, covered
on walls and ceiling by strange
birds, fish, children and plants,
creating an enclosed and magical
space, is now displayed as a work
of art. Two major founders of
abstract art, Malevich and Mondrian,
are well represented, Malevich**

by a unique collection. Chagall,
and good coll. of German Expres-
sionism, esp. Beckmann*. Works
by Dubuffet, de Kooning and
Matisse, a spectacular cut out, *The
Mermaid and the Parakeet.* *
Major trends of 20C art are repre-
sented, esp. Conceptual Art, and
recent artists inc. Baselitz, Immen-
dorff, Nauman, and Birza.

DORDRECHT

Dordrechts Museum
Museumstraat 40,
3311 XP Dordrecht.
Tel (31 78) 648 2148
Fax (31 78) 6141 766
Tues to Sun 11-5. Closed Mon.
17C collection concentrates on the
best pupils of Rembrandt: Van
Hoogstraten, Maes, De Gelder and
paintings by the Cuyp family.
Good 19C Dutch collection inc.
many works by Ary Scheffer. 20C
Toorop and CoBrA.

GRONINGEN

**Groninger Museum voor
Sta den Lande**
Museumeiland 1, 9711 ME
Groningen.Postal address: Post-
bus 90, 9700 ME Groningen
Tel (31 50) 366 6555
Fax (31 50) 312 0815
www.groninger-museum.nl
gronmus@inn.nl
Tues to Sun 10-5. Closed Mon.
Important cutting-edge buildings
on an island site. The decorative
tiling is an obvious reference to
the Dutch tradition, while the
structure's explosive assembly of

Groninger Museum, Groningen

steel plating refers to the region's shipbuilding past. Interior spaces range between stark industrial and pastiche art deco. This astonishing plant would overwhelm a much stronger collection than the one here (some 17C Dutch, Fabritius, Vrel; some 19C Dutch; Warhol, Jeff Koons) but this is an unmissable example of the contemporary museum as *meraviglia*.

DEN HAAG (The Hague)

Haags Gemeentemuseum
Stadhouderslaan 41,
PO Box 72, 2501 CB, Den Haag.
Tel (31 70) 3381 11
Fax (31 70) 338 1112
www.hhgm.denhaag.nl
post@gm.denhaag.nl
Tues to Sun 11-5. Closed Mon.
Modern art (19C and 20C); Mondrian** (251 items, the largest collection of his work). Dutch

Realist and Symbolist works are dsplayed with their European contemporaries, inc. Monet and German Expressionists.

Mauritshuis

Route Vijverberg 8, Den Haag;
PO Box 536, 2501 CM
Den Haag.
Tel (31 70) 302 3435
Fax (31 70) 365 3819
communicatie@mauritshuis.nf
Tues to Sat 10-5; Sun 11-5.
Closed Mon.

An intimate and enjoyable collection, in one of the most perfect Dutch classical buildings, and most famous for two celebrated Vermeers, *The Girl with a Pearl Ear Ring****** and the *View of Delft******. The main strength is in 17C Dutch paintings, but there are some earlier works (van der Weyden, Holbein*) and strong Rubens and van Dyck. The flower paintings range from Bosschaert's symmetrical *Flower Piece**, close to botanical illustration, to De Heem's freer composition*, gleaming with perfect detail, and on to the intense simplicity of Adriaan Coorte's tiny *Still Life with Wild Strawberries**. Among the still lifes, note Pieter Claesz's *Still Life with Candle**, a play on shadow and reflections. Genre paintings inc. Terborch's *Letter Writer**, and an erotically enticing Steen, *The Oyster Eater**. Landscapes inc. a De Vlieger *Beach Scene**, a union of vast sea and sky with vivid social contrasts. The Rembrandts inc. an early *Presentation in the Temple**, *The Anatomy Lesson of Dr Tulp**** and his last *Self-Portrait****, his cap a tour de force of his fabulous technique.

Museum Bredius

Lange Vijverberg 14,
2513 AC, Den Haag.
Tel (31 70) 392 3456
Tues to Sun 12-5. Closed Mon.

Splendid 18C house, rich in silver and porcelain, with a small personal collection of Dutch 17C painting. Rembrandt's *Head of Christ*, but more interesting are the high quality works by minor masters, such as an unusual early Kalf, a landscape by Seghers, *Four Tulips in a Vase** by Bosschaert.

Schilderijengalerij Prins Willem V. (The Prince William Gallery of Paintings)

Buitenhof 35,
2513 AH, Den Haag.
Tel (31 70) 318 2486
Tues to Sun 11-4. Closed Mon.

A reconstruction of Prince William V's 18C gallery, and most interesting for its hang, so startling to modernist eyes; the walls are crowded, from top to bottom, with small pictures, mainly 17C Dutch genre and landscape.

Panorama Mesdag

Zeestraat 65b,
2518 AA, Den Haag
Tel ((31 70) 310 6655
Fax (31 70) 345 0431
info@panorama-mesdag.com
May-Sept: Mon to Sat 10-5; Sun 12-5; Oct-Nov, Mar, Apr: Mon to Sat 10-4, Sun 12-4; Dec to Feb: Mon to Sat 10-3; Sun 12-3.

A rare complete survival of a 19C panorama, which creates an astonishing illusion of Scheveningen beach as it was in 1880, an effect heightened by sand and rigging.

A De Stijl Tour

The best place to start is at **The Hague** in the Gemeentemuseum, where a large collection of Mondrian traces his development from the early naturalistic period (1895-1907), in *Summer's Night*, through the series of towers, windmills and sand-dunes and the Symbolist triptych *Evolution* (1910-11), to two series, *Still-Life with Ginger Jar* and *Apple Tree*, which show his progress towards abstraction. Similarly compare van Doesburg's versions of Card Players. His *Contra-Composition of Dissonances XVI* (1925) enraged Mondrian by its introduction of the diagonal. Works by G. C. van der Heyden (1960s) continue Mondrian's interest in basic elements. In **Amsterdam** the Stedelijk Museum has works

Blue Picture, *1916*, Theo van Doesburg,
Stedelijk Museum de Lakenhal, Leiden

by Mondrian, van Doesburg and van der Leck; examples of De Stijl typography and interior design, and furniture by Rietveld. Here Dutch abstraction may be compared with the unique collection of Malevich, ranging from his early peasant scenes and Cubist works to the mysterious whites of *Suprematist painting* (1917-18). Pause at **Hilversum** to see some De Stijl architecture – the Zonnestraal Sanatorium by J. Duiker and the AVRO studios by B. Merkelbach and C. Karsten, or divert to **Utrecht** to see Rietveld's Schröder House. Proceed to **Otterlo** to see the Kröller-Müller Museum which has Mondrian's series of the pier at Scheveningen (where the landscape is reduced to plus and minus signs) and a large collection of van der Leck.

Museum Mesdag

Laan van Meerdervoort 7f,
2517 AB Den Haag.
Tel (31 70) 362 1434
Fax (31 70) 361 4026.
mumesdag@xs4all.nl

A museum housing the collection of the 19C painter and collector, H. W. Mesdag, now incorporating his studio house, and rehung amongst a rich display of ceramics, carpets and oriental pieces, as was originally intended. It shows Dutch taste of the late 19C, with good Barbizon and Realist works, and Mesdag and his Dutch contemporaries presented as their heirs.

HAARLEM

Frans Halsmuseum

Groot Heiligland 62,
2011 ES Haarlem.
Tel (31 23) 511 5775
Fax (31 23) 531 1200
franshalsmuseum@haarlem.nl
Mon to Sat 10-5; Sun 12-5
25 Mar-14 May: also Sat and
Mon evenings; Easter Sun and
Whit Sun, Sat, 15 July-1 Sept: also
evenings 8.30-10.30. Café.

In a splendid Lieven de Key building, once a hospice for old men, the museum shows a fine collection of Haarlem school painting. It inc. vast 16C works, esp. Martin van Heemskerk's *St Luke painting the Virgin**, and groups of still life (Floris van Dyck, Claesz and Heda) and landscape (Vroom, a stormy Haarlem sketch by Ruisdael*). But the collection is dominated by the group portraits of Frans Hals, ranging from the early *Banquet of the Officers of the*

*St George Civic Guard Company*** (1616) through the 1620s and '30s – the *Banquet of the Officers of the St Hadrian Militia Company*** (c.1627) and the *Banquet of the Officers of the St George Militia Company** (c.1627), fine examples of his silvery light, vivacious grouping and incredible swaggering characters – to the most profoundly moving works of his old age, the sombre *Regents*** and *Regentesses of the Old Men's Alms House*** (c.1664).

LEIDEN (Leyden)

Stedelijk Museum De Lakenhal

Oude Singel 28-32,
2312 RA Leiden.
Tel (31 71) 516 5360
Fax (31 71) 513 4489
www.Leiden.nl/lakenhal
postbus@lakenhal.demon.nl
Tues to Fri 10-7; Sat, Sun 12-5.
Closed Mon. Café.

A charming museum, displayed in the elegant 17C and 18C rooms of the old cloth hall. The high points are Lucas van Leyden's triptych of *The Last Judgement***, a strange, visionary work, with Mannerist colour harmonies and Italianate figure style, and David Bailly's *Self-Portrait**, where the artist shows himself both young and old, among complex vanitas symbols, a Leyden speciality. A small but enjoyable collection of 17C Leyden school painters, who specialised in highly polished surfaces and tiny detail, inc. an early Rembrandt figure painting, and a group of works by Dou and van Mieris, esp. a touchingly boastful portrait of three

Portrait of van Jenny Kamerlingh Onnes, *Menso Kamerlingh Onnes,*
Stedelijk Museum de Lakenhal, Leiden

generations of the van Mieris family. 20C less interesting but inc. van Doesburg's *Blue Picture* (see ill. pp.274-5).

OTTERLO

Rijksmuseum Kröller-Müller
Houtkampweg 6, Postbus 1,
6730 AA Otterlo.
Tel (31 31) 859 1041
Fax (31 31) 859 1515
www.kmm.nl
information@kmm.nl
Tues to Sun 10-5. Closed Mon.
Sculpture Garden closes at 4.30.
Café.

The museum, designed by Henri van de Velde, is set in the heathy and wooded country of the National Park and makes a pleasant day out from Amsterdam.

The collection was begun in 1907 by Mrs Kröller-Müller with the aim of representing contemporary developments in art. Her first enthusiasm was for Van Gogh and there are 272 of his works in the collection. Later she bought paintings by Seurat, important early Cubist works and abstract paintings by Mondrian and Van der Leck*. Divisionist and Symbolist schools well represented. **Van Gogh*** collection covers his career. Early black chalk drawings of peasants and a second version of the *Potato Eaters;* café scenes, still lifes and flowers painted in Paris; from Arles the *Café Terrace at Night* and *La Berceuse*; from Saint-Rémy *Road with Cypress and Star*. Some examples of Dutch and French Impressionism; Seurat*; French Symbolism represented by Puvis de Chavannes, Denis and Redon*; Dutch Symbolism by the sinisterly erotic *Bride* of Thorn Prikker and Jan Toorop's *The Three Brides*. Cubist works by Léger*, Gleizes, Gris, Picasso and Braque.

Around the museum and in the Sculpture Park are works by Hepworth, Maillol, Moore, Rodin, Oldenburg, Serra.

ROTTERDAM

Museum Boymans-van Beuningen
Mathenesserlaan 16-20,
3015 CK Rotterdam.
Tel (31 10) 441 9400
Fax (31 10) 436 0500
Tues to Sat 10-5; Sun 11-5.
Closed Mon.

A high quality and attractive collection, with some unusual and vivid works. **15C and 16C Netherlandish** schools inc. Van Eyck's *The Three Marys at the Open Sepulchre*; works by Bosch*, Bruegel*, Geertgen, Massys and Memling. **17C Dutch** art is well represented by a balanced collection of landscape, still life and genre. Fine works by minor and rare artists: Dou's *The Quack*, Fabritius' *Self-Portrait* and H. Seghers' *River Landscape*. The small, jewel-like still lifes, such as Dirk van Delen's *Tulip in a Chinese Vase* are esp. charming. Small Rembrandt collection inc. *Titus at his Desk*; the first certain portrait of his son aged 14. **17C Flemish** inc. 7 of 8 small grisaille oil sketches of scenes from the *Life of Achilles* by Rubens. Works by Van Dyck and Fyt. **18C French**: Boucher, Chardin* and Pater. Modern and

contemporary paintings are featured in the new wing of the museum. Monet and Van Gogh. Good collection of Surrealism; Klee and Kandinsky*; Abstract art; Bissière, Dubuffet and Riopelle; Pop Art and Colour-field painting. Recent German and American art.

UTRECHT

Centraal Museum
Nicolaaskerkhof 10,
3512 XA Utrecht.
Tel (31 30) 236 2362
Fax (31 30) 233 2006
www. centraalmuseum.nl
Tues to Sun 11-5. Closed Mon.
A collection of works by painters of the Utrecht school. 16C is represented by Jan van Scorel and also by Wtewael and Bloemaert. In the 17C Utrecht was dominated by the influence of Italy; Terbrugghen, Dirk van Baburen and Honthorst

brought back a style based on the naturalism and *chiaroscuro* of Caravaggio; they introduced new genre subjects – flautists, singers, card players and brothels. The gallery has four very fine Terbrugghens and good works by Honthorst and other Caravaggisti; also works by Paulus Bor, Van Poelenburch and Roeland Savery.

Museum Catharijneconvent
Lange Nieuwstraat 38/Nieuw-
gracht 63, 3512 LG Utrecht.
(Postal address: PO Box 8518,
3503 RM Utrecht).
Tel (31 30) 2231 3835
Fax (31 30) 231 7896
www.catharijneconvent.nl
Tues to Fri 10-5; Sat, Sun 11-5.
The collection illustrates the history of Christianity in the Netherlands. Paintings inc. an early Rembrandt; a *Pietà* by Geertgen; Hals; Aertsen; Dirk van Baburen.

New Zealand

National holidays: Jan 1, Feb 6, Good Fri, Easter Mon, Apr 25 (Anzac Day), First Mon in June (Queen's Birthday), Last Mon in Oct (Labour Day), Dec 25, 26. Museums close Jan 1, Good Fri, Anzac Day and Dec 25, 26.

Art in New Zealand

In the pre-Colonial era European artist travellers, (William Hodges; Augustus Earle) recorded the landscape and peoples of New Zealand. After the foundation of the modern state of New Zealand in 1840 many amateur artists produced topographical landscapes, which sometimes create, as in the works of John Buchanan and Charles Heaphy, a spiritual sense of a new and untouched world. In the middle years of the century a more Romantic, Turneresque vein flourished. In the 1890s the Dutch artist Petrus van der Velde painted genre scenes, and around 1900 portraiture became popular. Throughout the history of New Zealand art Maori themes have recurred, in paintings which are sometimes documentary and ethnological, and sometimes inspired by contemporary Maori life. The most celebrated artist has been Frances Hodgkins, who was associated with the British Bloomsbury Group and Neo-Romanticism. In the 1940s and 1950s Modernism found its devotees, and in the 1960s an increasingly severe abstract art dominated; but other artists sought a New Zealand identity, in regionalism (Don Binney, Brent Wong) and in an art influenced by Maori myths and forms (Gordon Walters, Richard Killeen).

AUCKLAND

**Auckland Art Gallery
Toi o Tamaki**
Corner Wellesley and Kitchener Sts.
Tel (64 9) 307 7693

Info (64 9) 309 0831
Fax (64 9) 302 1096
www.akcity.govt.nz/artgallery/
Mon to Sun 10-5; free guided tours daily, 2pm.
Main Gallery: European section is

Opposite: Detail from Te Whenua, Te Whenua, *Robyn Kahukiwa, 1987, Auckland Art Gallery Toi o Tamaki*

richest in British art (18C portraits; Victorians esp. Alma Tadema, Leighton). Unrivalled New Zealand collection.

New Gallery: contemporary art collection.

CHRISTCHURCH

Robert McDougall Art Gallery and Annex
Botanic Gdns, Rolleston Ave, PO Box 2626, Christchurch.
Tel (64 3) 365 0915
Fax (64 3) 365 3942
Oct-Apr: Mon to Sun 10-5.30;
May-Sept: Mon to Sun 10-4.30.
New Zealand: 19C and 20C works inc. a notable collection of works by Petrus Van der Velden. Goldie.
British: late 19C and early 20C

works. The Annex shows contemporary art.

DUNEDIN

Dunedin Public Art Gallery
The Octagon, Dunedin.
(Postal address: POBox 566).
Tel (64 3) 474 3240
Fax (64 3) 474 3250
Mon to Fri 10-5; Sat, Sun,
public hols 11-5.
New Zealand: 40 works by Frances Hodgkins, born in Dunedin; Van der Velden's *Otira Gorge*.
British 18C and 19C watercolours; minor works by Reynolds, Gainsborough and Constable. Victorian paintings.

Refugee Children, c. 1916, Frances Hodgkins, Auckland Art Gallery Toi o Tamaki

Saint Sebastian, *Guido Reni, Auckland Art Gallery Toi o Tamaki*

WELLINGTON

Te Papa
Cable St, Wellington
(Postal address: PO Box 467)
Tel (64 4) 381 7000
Fax (64 4) 381 7070
mail@tepapa.govt.nz

Open every day of the year 10-6,
Thurs 10-9. Restaurant.
A vast new museum project, which celebrates New Zealand's cultural diversity; its art collections focus on New Zealand art, with strong works by Frances Hodgkins, Richmond, Petrus van den Velden.

283

Kneeling Man Embracing Standing Woman,

Norway

National holidays: Jan 1, Maundy Thurs, Good Fri. Easter Mon, May 1, 17, Ascension Day, Whit Mon, Dec 25, 26. Museums generally close on all holidays.

Useful words: *samlinger* collection; *museet* museum; *rådhuset* town hall.

Art in Norway

In the early 19C Norwegian painting opened grandly, with the works of J. C. Dahl and Thomas Fearnley, who discovered the Norwegian landscape as a subject. In the mid 19C painters were influenced by the objectivity and gloom of French Realism, but in the 1880s and 1890s Romanticism was reborn. Many painters, inc. Kitty Kielland, Halfdan Egedius and Harald Sohlberg painted the mystic, dusky beauty of a Nordic landscape, while Harriet Backer's still interiors, often in moody blues and greens, convey nostalgia for the timeless beauty of Norwegian folk life. Munch, who worked in Germany and France from 1889-1909, stands apart. He painted powerful images of despair, fear, frustration, illness, jealousy and death. His use of flat areas of colour and undulating lines was influenced by Gauguin and Van Gogh.

BERGEN

Bergen Kunstmuseum

Rasmus Meyers Alle 3,
N-5016 Bergen.
Tel (47) 5556 8000
Fax (47) 5556 8011
www.bergenartmuseum.no
bbg@bgnett.no
Mon to Sun 11-5.
The Kunstmuseum consists of three separate collections, the Bergen Billedgalleri, the Rasmus Meyers Samlinger and the Stenersens Samling.

Bergen Billedgalleri

Best known for its collection of Norwegian painting, inc. romantic landscapes by J. C. Dahl, (esp. small oil sketches), Christian Krøhg and Munch.

Rasmus Meyers Samlinger

Norwegian: esp. Harriet Backer's *By Lamplight**, a mysterious and poetic study of a single figure in a still interior lit by artificial light, and important works by Munch*, esp. *Spring Evening on Karl Johan* 1892, *The Three Stages of Woman*

and *Jealousy*.

Stiftelsen Stenersens Samling
Collection of 20C art inc. 36 paint-
ings by Klee. Also Asger Jorn, Miró,
Munch and Picasso.

OSLO

Astrup Fearnley Museum of Modern Art
Dronningens GT. 4, N-0107 Oslo.
Tel (47) 2293 6060
Fax (47) 2293 6065
www.af-moma.no
Tues, Wed and Fri 12-4; Thurs 12-7; Sat and Sun 12-5. Closed Mon.
A lively and growing collection of
international art since the 1940s,
inc. Francis Bacon, Lucian Freud,
Gary Hume, Cindy Sherman and
Matthew Barney. A sculpture hall
inc. Damien Hirst and Richard
Deacon, while a room* dedicated
to Anselm Kiefer shows both
paintings and sculpture, esp. his
High Priestess/Zweistromland, a
grandiose and gloomy bookshelf
with crumbling books of lead.

Munch-Museet
Tøyengt 53, N-0578 Oslo.
Tel (47) 2324 1400
Fax (47) 2324 1401
www.munch.museum.no
mm@munch.museum.no
June 1-Sept 15: Mon to Sat 10-6;
Sun 10-6; Sept 16-May 31: Tues,
Wed, Fri and Sat 10-4, Thurs 10-6, Sun 10-6. Closed Mon.
A collection built around Munch's
bequest of 1940 which inc. paint-
ings, drawings, watercolours and
sculptures. From the 1890s (when
he painted his most intensely
disturbing works) note esp. *The*

*Voice, Anxiety** and *Inheritance**,
a horrifying image of death and
disease. In later years his style
brightened; he introduced new
subjects – tough, virile pictures of
workers (*Workers Returning Home*
and *Workers in the Snow**)and
radiant landscapes (*Starry Night**).
Also self portraits from every stage
of his career.

Nasjonalgalleriet
Universitetsgaten 13,
N-0164 Oslo.
Tel (47) 2220 0404
Fax (47) 2236 1132
nga@nasjonalgalleriet.no
Mon, Wed, Fri 10-6, Thurs 10-8,
Sat 10-4, Sun 11-4. Closed Tues.
Norwegian: the gallery's richest
possessions are the 58 paintings by
Munch** which trace his develop-
ment from the Impressionist *Rue
Lafayette* (1891) to a group of
works from the *Frieze of Life*, a
series about life, love and death.
These inc. *Ashes***, a haunting
picture of sexual despair, *Puberty,
The Scream*** (an archetypal
symbol of the alienation of man)
and the *Dance of Life* (1900).
Also a fine collection of 19C and
20C works. Dahl's vast *View from
Stalheim over the Naeroydalen,*
(1842), an icon of national senti-
ment, towers over a room devoted
to landscape, with small oil sketches
and works by Fearnley. An
outstanding group of works by
Kitty Kielland and Harriet Backer
inc. Kielland's *Summer Night*,*
(1886), where the stillness and the
blue light epitomise Norwegian
Romanticism. The summer twilight
was a favourite theme, and this
picture makes an interesting

comparison with works by Eilif Peterssen* and Harald Sohlberg*. Backer, a strong colourist, is far too little known outside Norway. *Christening in Tanum Church*** (1892), is her most famous work. Formally daring, it sets the blue and green tonalities of a church interior against the bright sunlight of the outside world, creating an intensely spiritual effect.

Other schools: a small collection of Old Masters inc. Cranach and good works by both Orazio and Artemesia Gentileschi. 20C works inc. CoBrA.

Museet for Samtidskunst (Museum for Contemporary Art)

Bankplassen 4,
Postboks 8191 Dep,
N-0034 Oslo.
Tel (47) 2286 2210
Fax (47) 2286 2220
www.museumsnett.no/mfs
info@mfs.museum.no
A collection of contemporary art after 1945.

Rådhuset

1 May-30 Sept: Mon to Sat 9-5,
Sun 12-5; 1 Oct-30 Apr: Mon to
Sat 9-4; Sun 12-4.

Norway's most decorated building; scheme inc. murals, paintings and friezes representative of the years around 1950.

Vigeland-Museet

Nobelsgt, 32, N-0268 Oslo.
Tel (47) 2254 2530
Fax (47) 2254 2540
www.vigeland.museum.no
May-Sept: Tues to Sat 10-6;
Sun 12-6; Oct-Apr: Tues to Sun
12-4; Thurs 12-7. Closed Mon.
Artist's home open Sun only.
Sketches and full-scale models for almost all Vigeland's sculptures are displayed in his former home and studio. Also early works and woodcuts, many intensely erotic.

Vigeland Park, Frogner

Kirkevien.
Open all year.
The Sculpture Park displays bombastic works in bronze and granite – *The Monolith* (a column 46 feet high), surrounded by 36 groups of figures, *The Fountain*, and *The Bridge* – by the megalomaniac sculptor Gustav Vigeland. His allegories, a kind of 'sculptural Wagnerism', relate vaguely to such universal themes as the cycle of life (see ill. p.284).

Poland

National holidays: Jan 1, Easter Mon, May 1, 3, Corpus Christi, Aug 15, Nov 1, 11 Dec 25, 26. Museums generally close on Mondays and days after holidays.
Tourist information: Orbis.
Useful words: *muzeum narodowe* national museum, *malarstwo* painting, *obraz* picture, *rzeźba* sculpture, *sztuka* art, *zbiory* collections.

Despite destruction and losses in World War II and earlier, much art survives in Poland. Stanislas Augustus, the last king (1764-95), had ambitious plans for the regeneration of Polish art, but the partitions and eventual disappearance of Poland in 1795 meant that the collection of Old Masters assembled for him went to the Dulwich College Art Gallery in London. Poland's first public museums and art galleries, such as the Czartoryski Museum in Kraków, were opened by patriotic aristocrats.

During its Golden Age in the 15C-16C, when Poland was a great European power, artists from Italy and Germany were attracted to the then capital, Kraków. The expressive style of the Nuremberg sculptor Veit Stoss made a lasting impression, influencing the local school of painters in southern Poland in the early 16C. The splendour of the Kraków court is evident from the scale of the great series of Brussels tapestries commissioned by King Sigismund II Augustus in the mid-C16. In the Baltic city of Gdańsk artists from the Low Countries were prominent.

The Wasa kings moved the captial to Warsaw at the end of the 16C, but wars throughout the 17C curtailed Poland's cultural flowering. Coffin portraits painted with startling realism represent a distinctive Polish genre of the period. In the early 18C, when the Electors of Saxony were Kings of Poland, artists from Dresden were active in Warsaw. Later in the century, King Stanislas Augustus surrounded himself with Italian and French artists, among them Bernardo Bellotto, who spent his last years in Warsaw and produced many exquisite views of the capital.

Jan Matejko (1836-93) painted huge scenes from of Polish

history with a strong didactic intent. Outstanding in the Young Poland movement in Kraków at the end of the 19C are the dynamic designs for stained glass and pastel drawings by Stanisław Wyspiański (1869-1907), and the dreamlike symbolism of Jacek Malczewski's allegorical portraits.

Modernism in Polish art was represented by various movements: the Formist group, influenced by Cubism, and the Blok group, which followed Constructivist tendencies. The first decade of Communist rule after World War II was dominated by Socialist Realism, but after 1956 greater freedom of expression was possible, allowing the development of a lively avantgarde.

GDAŃSK

Muzeum Narodowe
Toruńska 1, 80-822 Gdańsk.
Tel (48 58) 3168 04
Fax (48 58) 3111 25
Tues 10-5; Wed, Thurs, Fri 9-3; Sat 10-5; Sun, hols 9-3. Closed Mon.
Collection includes Polish paintings from 19C to 20C, Flemish and Dutch works from 16C to 17C and Gdańsk paintings from 17C to 19C. Most outstanding is an ambitious *Last Judgement** triptych, attrib. to Memling (32 square metres of painted surface, and 150 figures).

KRAKÓW (Cracow)

Muzeum Narodowe
www.muz-nar.krakow.pl
The National Museum occupies several sites in Kraków including the Czartoryski Museum (see below):

Sukiennice (Cloth Hall)
Rynek Główny 1/3, 31-042 Kraków.
Tel (48 12) 422 1166
Tues, Wed, Fri to Sun 10-15.30;
Thurs 10-18. Closed Mon.
The upper floor of the hall in the middle of the market square converted in the 19C to a gallery of Polish art. 18C and 19C painting inc. two vast historical canvases by Jan Matejko.

Gmach Główny (Main Building)
Al. 3. Maja 1, 30-062 Kraków.
Tel (48 12) 633 5331
Fax (48 12) 633 9767
Polish art of the 20C, inc. paintings and stained glass designs by Wyspiański and Józef Mehoffer and symbolist allegorical paintings by Malczewski. Post-war artists inc. Tadeusz Kantor.

Muzeum Książiąt Czartoryskich (Czartoryski Museum)
Św. Jana 19.
Tel (48 12) 2215 28
Fax (48 12) 2254 34
Mon, Tues, Fri, Sat 10-3.30; Thurs 12-6; Sun, hols 9-2.45. Closed Wed.
A gallery of European paintings forms part of this museum, the oldest historical and art museum in Poland, and is displayed on the second floor of the palace, one of three buildings which make up the

museum. Here is the most famous painting of all the Polish museums, Leonardo da Vinci's *Portrait of a Lady with an Ermine***. Also a *Mary Magdalene Writing* by the Master of the Female Half-Lengths, and some 16C and 17C portraits.

Kościół Mariacki
(St Mary's Church)
Main square.
Altarpiece** by Veit Stoss. A vast retable, with over-life size poly-chromed figures.

Zamek Królewski na Wawelu
(Royal Castle on Wawel)
Booking office: (48 12) 4225 155
Tel/Fax (48 12) 422 1697
www.wawel.krakow.pl
zamek@wawel.krakow.pl
Wed, Thurs 9.30-3.30; Tues, Fri 9.30-4.30; Sat, Sun 10-3.
Closed Mon.
Renaissance and Baroque interiors with a superb collection of 16C Flemish tapestries made for King Sigismund Augustus. Paintings inc. 14-16C Italian, 17C Dutch, Flemish and Polish works, recently enriched by Karolina Lanckoronska's donation of her family collection of Italian art.

POZNAŃ

Muzeum Narodowe
Al. Marcinkowskiego 9,
61-745 Poznań.
Tel/Fax (48 61) 5259 69
Tues, Wed, Thurs, Fri, Sat 9-6; Sun, hols 10-3. Closed Mon.
The most famous work is Quentin Massys' *Madonna and Child* (c.1527).

Dutch 17C: large collection mainly of minor masters; two unusual works by Paulus Bor.
Italian: inc. some 17C works; Sofonisba Anguissola's *The Game of Chess.*
Polish art from early 19C to the present day.
Spanish: 17C inc. works by Ribera and Zurbarán.

WARSZAWA (Warsaw)

Muzeum Narodowe
Al. Jerozolimskie 3,
00-495 Warszawa.
Tel (48 22) 621 1031
Fax (48 22) 622 8559
muznw@plearn.edu.pl
Tues, Sun, Wed, Fri and Sat 10-6; Thurs 12-7. Closed Mon.
Best known for its large collection of Dutch pictures (mainly by minor masters but inc. Carel Fabritius' *Lazarus Raised from the Dead**).
Flemish: some good early 17C landscapes and paintings by Jordaens.
Italian: inc. Cima's *Christ among the Doctors**; small collection of Baroque paintings inc. a lovely Cavallino.
Polish: paintings from 16C to 1914, and a separate collection of contemporary art. Polish sculpture is also displayed in the museum park.
Russian: 18C to early 20C inc. Rotokov's portrait of *Daria Dmitriev Mamonova* and works by the Wanderers.

Wilanów Palace

Muzeum Pałac w Wilanowie,
ul. S.K. Potockiego 10/16,
02-958 Warszawa.
Tel (48 22) 842 8101, 842 4809
Fax (48 22) 842 3116
www.wilanow-palac.art.pl
muzeum@wilanow-palac.art.pl
Wed to Mon 9.30-4, 15;
(June to 15 Sept: Sun 9.30-6).
Closed Tues.

The 17C palace of King Jan III Sobieski was opened by its later owner, Stanisław Kostka Potocki, as one Poland's first public museums in 1805. Good collection of Polish portraits, inc. 17C and 18C coffin portraits. The oustanding work is David's equestrian portrait of *Stanisław Kostka Potocki**.

Zamek Królewski
(Royal Castle)

Pl. Zamkowy 4, 00-277 Warszawa.
Tel (48 22) 657 2170
Fax (48 22) 635 7260
www.zamek-krolewski.art.pl
zamek@zamek-krolewski.art.pl
Tues to Sat 10-6; Sun, Mon 11-6.

Palace of the Polish Kings carefully reconstructed after wartime destruction. Paintings inc. 20 *vedute* of Warsaw, the best works of Bellotto. The south wing houses part of the Lanckoronski Collection donated in 1994 (see Kraków, Wawel), inc. paintings once in the collection of the last king of Poland, Stanislas August, among them Rembrandt's *Father of the Jewish Bride*.

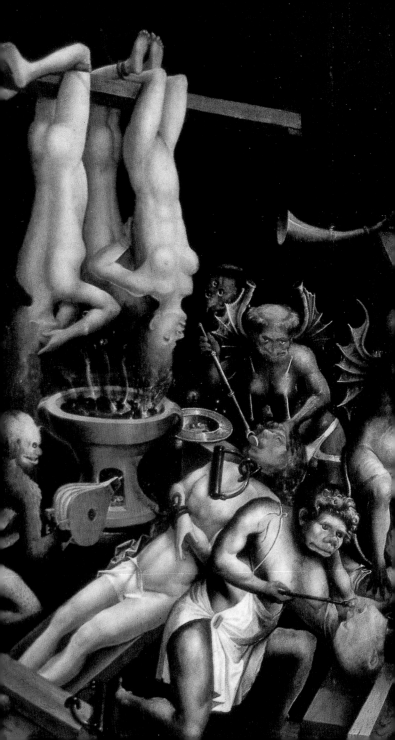

Portugal

Opening hours: museums generally open Tuesday to Sunday 10-5; closed Monday. Entrance free on Sunday.
National holidays: Jan 1, Shrove Tues, Good Fri, Apr 25, June 10, Corpus Christi, Aug 15, Oct 5, Nov 1, Dec 1, 8, 25. Museums close on all holidays and on feast days of local patron saints.
Tourist information: Junta de Turismo; Comissão de Turismo.

Portuguese art

The earliest achievements of Portuguese artists occurred relatively late, under the influence of Flemish 15C masters. Jan van Eyck, in Lisbon in 1428, encouraged a style of Flemish Primitivism which appeared throughout the 15C and 16C and was modified only in the work of the first individual Portuguese master, Nuño Gonçalves (active 1450-71). The Lisbon-Évora school of Jorge Afonso and the Viseu school of Grão Vasco Fernandes maintained the Flemish influence until well into the 16C, but late 16C and early 17C Portuguese artists are characterized by a wildly Mannerist style, reaching a climax in the work of Domingos Vieira. Portugal's greatest painter was Domingos António Sequeira, internationally famous in the late 18C and throughout the 19C. There are few major 20C artists apart from Amadeu da Souza Cardoso, an early Cubist, and the strikingly individual painter, Maria Vieira da Silva who lived mainly in France.

LISBOA (Lisbon)

Museu Calouste Gulbenkian
Av de Berna 45.
Nov-June: Tues to Sun 10-5;
July-Oct: Tues, Thurs, Fri, Sun 10-5; Wed, Sat 2-7.30. Closed Mon.
Magnificent collection of metal-work, porcelain, tapestries and paintings bought mainly from the Hermitage in 1929-30.
British: large collection inc. works by 18C portraitists. Burne-Jones.
Dutch, Flemish and German: large collection of Dutch landscape; Rembrandt's *Pallas Athena*; Rubens' portrait of *Hélène Fourment*.
French: works by Fragonard and

Opposite: Detail of Hell, *anonymous 16th-century Portuguese painter, Museu Nacional de Arte Antiga, Lisbon*

Watteau; the collection is rich in 19C masters ranging from Corot, Millet and Fantin-Latour to Renoir's portrait of *Mme Claude Monet**, an early Impressionist work of great power; Monet's works are represented by an early Boudinesque seascape, *The Boats,* a still life, and the particularly brilliant *Break-up of the Ice.* Sculpture inc. Houdon's *Diana;* works by Barye, a major Romantic sculptor; Carpeaux and Dalou. Cranach's *Salome.*

Italian: 19 paintings by Francesco Guardi* whose. brilliantly idiosyncratic, feathery brushwork creates a view of 18C Venice totally different from the contemporary *vedute* painter, Canaletto.

Museu Nacional de Arte Antiga
Rua das Janelas Verdes.
Tel (351) 2139 128 00
Fax (351) 2139 737 03
www.ipmuseus.pt
Tues 2-6; Wed to Sun 10-6.
Closed Mon.
Installed since 1884 in a 17C palace, the painting collection is the most important and representative in Portugal. Dürer's *St Jerome,* Bosch's triptych *The Temptation of St Anthony**,* Quentin Massys' Retable from the Madre de Deus Church, Cranach's *Salome* are among northern masterpieces.
French: inc. Fragonard (see his charming sketch, *The Two Cousins,* typifying his dynamic mature style), and *Ruins* by Hubert Robert.
Italian school represented by

Piero della Francesca, Raphael, Tintoretto.
Portuguese: the masterpiece of the 15C artist Nuño Gonçalves, *The Adoration of St Vincent*,* a polyptych depicting many striking portraits which achieve a powerful synthesis of realism and stylistic formality. Portraiture also becomes the hallmark of 17C Domingos Vieira, esp. in female characterizations, and Domingos Sequeira's enchanting but unfinished portrait of his children touches a high point of Portuguese pictorial emotion while incorporating a striking French flavour, esp. in its brushwork.
Spanish artists inc. Ribera, Velázquez, Murillo and notably Zurbarán, whose major series of the *Twelve Apostles**,* taken from the monastery of São Vicente de Fora, occupies a whole room and shows dark, impassioned single figures.

OPORTO

Museu Nacional de Soares dos Reis
Palacio dos Carrancas,
Rua D. Manuel II.
Tel (351) 2233 937 70
Fax (351) 2220 828 51
Tues 2-6, Wed to Sun 10-2.30, 2-6
Café.
Netherlandish: works by Adrian Brouwer and Jordaens.
Portuguese: collection of 19C works inc. sculpture by Soares dos Reis.

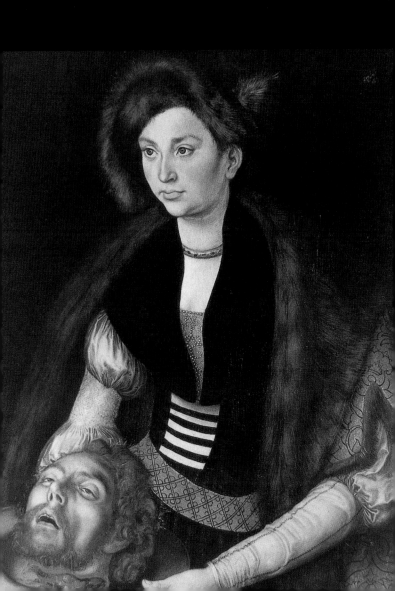

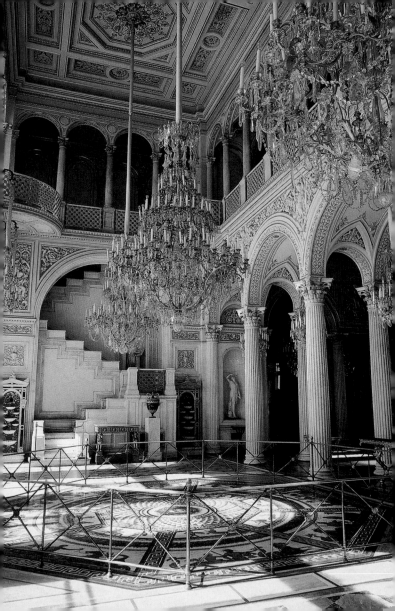

Russia

Opening hours: greatly subject to change and seasonal variation – check before you set out.
National holidays: Jan 1, Mar 8, May 1, 2, 9, Oct 7, Nov 7, 8. Museums close on all these days.
Tourist information: Intourist.

Russian art

The Byzantine tradition continued into the 18C when Russian art and the art of western Europe drew closer together. From the time of Peter the Great to the early 20C European styles overwhelmed Russian courtly, and later, bourgeois art – a tendency that was periodically resisted by a determined striving to create a national style. In the early 19C Venetsianov founded a school of realistic genre; Bryullov painted popular classical and sentimental subjects. A democratic and critical realism developed in the second half of the 19C; the 'Wanderers', a society that sought to bring art to the people, was founded by Kramskoi and later dominated by Repin, the outstanding painter of the 19C.

Between the two Revolutions (1905 and 1917) artistic movements developed rapidly. Late 19C symbolism, represented by 'The World of Art' (Mir Iskusstva), was superseded by the crude primitivism of Larionov and Goncharova; from this developed Rayonnism (a visual expression of the crossing of the reflected rays from objects) which in turn led to non-objective art. In 1913 Malevich produced his first Suprematist painting, *Black Square*, an unmodulated black square against a white ground. His serious exploration of elementary forms and restricted contrasts of colour played an important part in the modern movement, as did the lyrical Expressionist works of Kandinsky (who was working in Munich). Between 1918 and 1922 *avant-garde* artists and the government were apparently at one. Kandinsky returned to Russia from 1915-1922 and after the Revolution was active as a theorist and organizer. In 1918 Chagall became Commissar of Fine Art for Vitebsk where he tried to 'implant Art there ... making ordinary houses into museums and the average citizen into a creator'; he resigned after a row with Malevich who despised his free

combination of natural forms and fantasy. The Constructivists (amongst them Tatlin and Rodchenko) stressed the search for new materials and forms to herald the aspirations of a new society. However, eventually Realism triumphed and abstract art fell out of favour; after 1932 artists adhered to the principles of Socialist Realism, the official art form which celebrated the events of the Revolution and the new lifestyle of the People.

MOSCOW

Pushkin Fine Art Museum

12 Ulitsa Volkhonka,
121019 Moscow.
Tel (7 095) 203 7998
Fax (7 095) 203 9578
Tues to Sun 10-6. Closed Mon.

After the Hermitage, this is the best collection of world art in Russia. The outstanding feature is the collection of **Impressionist, Post-Impressionist and early 20C** painting, inc. many items from the Shchukin and Morosov collections. Works by Monet (sketch for *Déjeuner sur l'Herbe**), Renoir, Cézanne, Van Gogh, Gauguin*, Léger, Matisse*, Picasso* and Bonnard.

French: Claude*, five Poussins ranging from an early battle piece to the fine late *Landscape with Hercules and Cacus**. Between these extremes the *Continence of Scipio** is an imposing example of his *maniera magnifica*, in marked contrast to the luscious *Nymph and Satyr* and *Rinaldo and Armida* (both 1630s). Also works by Watteau and Boucher.

Italian: inc. works by Bronzino, Cima, Dosso Dossi, Strozzi, Tiepolo and Canaletto.

Dutch: several Rembrandt portraits and works by Jordaens and Claesz.

State Tretyakov Gallery

Lavrushinsky perculok 10.
Tel (7 095) 231 1362, 230 7788
Fax (7 095) 953 1051
Tues to Sun 10-8.

Huge collection of Russian art. Icons from 11C to 17C inc. Rublev's *Trinity* (1410). 200 icons displayed in Church of St Nicholas in grounds of gallery. 19C works inc. Kiprensky's *Portrait of Pushkin* and Alexander Ivanov's *Christ Appearing to the People.* Among the realist Wanderers group, Repin is outstanding. Two rooms of his work inc. *Religious Procession in Kursk Province* and a romantic *Portrait of the musician Rubinstein.* Polenov's charmingly fresh *Courtyard in Moscow* illustrates another strand of the Wanderers' art. At the end of the century Serov's strong portraits inc. an exceptional one of the painter *Levitan* (several of whose landscapes, breathing the spirit of Turgenev, are also in the gallery). Early 20C section inc. works by Larionov, Goncharova, Chagall, Kandinsky and Tatlin.

Work after 1917 is separately housed near Gorky Park at 10 Ulitsa Krymsky Val, thereby separating early Soviet *avant-garde* art (inc. Malevich and Rodchenko) from closely related work in the

main gallery. The display goes on to chart Soviet art through all the stages of Socialist Realism. This building is shared with the Central House of Artists, which mounts temporary exhibitions and accommodates several small commercial galleries. In the garden outside are the statues of Soviet leaders, inc. Brezhnev (pulled down 1991).

ST PETERSBURG

State Russian Museum

Inzhenernaya St 2.
Tel (7 812) 595 4248
Fax (7 812) 314 4153
Wed to Sun 10-5, Mon 10-4.
Closed Tues. Restaurant/café.
The largest collection of Russian art, housed in the former Mikhailovsky Palace. Several rooms of 12C to 15C icons. 19C work inc. Bryullov's *Last Day of Pompeii* and four rooms of work by Repin, inc. the *Volga Boatmen* and the full-length *Portrait of Tolstoy**, barefoot and dressed in peasant costume. Another leading member of the Wanderers group was Nesterov whose quintessentially Russian image of *The Hermit* was acquired by the ballet impressario Diaghilev. Diaghilev himself is the subject of one of the most impressive of the portraits by Serov in the museum, which also contains a fine collection of works by Benois and Bakst*.

State Hermitage

Winter Palace, 34 Dvortovaya Naberezhaya, St Petersburg 19000.
Tel (7 812) 110 9625
www.hermitagemuseum.org
Tues to Sat 10.30-6, Sun 10.30-5. Closed Mon.
Housed in the Winter Palace and Hermitage buildings, displayed in over 1,000 rooms, are the collections which were built up by Peter the Great, Catherine the Great, Tsar Nicholas I and the two Moscow merchants Ivan Morozov and Sergey Shchukin, who amassed large collections of contemporary French art in the 1880s and 90s. It is essential to buys plan of the galleries as only the high-points are well signposted.

Dutch: largest collection in existence; a spectacular series of Rembrandts** (well displayed in small bays). The vivid directness and sensuous beauty of the *Danäe*** stand out amongst the darker works. *Haman's Dismissal*** has a deep sense of spiritual isolation. Most moving is the *Prodigal Son***; silent onlookers ponder the deep compassion of the father, merged by gesture and brushwork with the rags of his son. Also a collection of genre**.

17C Flemish: inc. large collection of Van Dycks; altarpieces, landscapes, allegories, modellos and portraits by Rubens*.

French: richest in 17C, 18C, late 19C and early 20C.

17C inc. Le Nain, many Claudes* and Poussins** ranging from the early *Victory of Joshua* 1625/6, through the sensuous poetry and Venetian colour of the 1630s (*Tancred and Erminia*), to the motionless gravity of the late *Holy Family in Egypt*. The *Landscape with Polyphemus* 1649 shows a new feeling for the wildness and luxuriance of untamed nature.

18C (one of the most interesting collections in the world) inc. Chardin, Greuze (whose *Death of the Paralytic* epitomizes the cult of *sensibilité*) and Watteau; many portraits.

Post-Impressionism: rich in Cézanne, Gauguin (paintings from his second Tahitian stay**).

Unrivalled collection of early 20C: Bonnard**, Denis, Fauves (53 canvases by Matisse** inc. *The Red Room, Dance* and *Music*), Picasso's early Cubist works**.

Italian: 13C, 14C and **15C** collections inc. Fra Angelico and Simone Martini. **16C** inc. Raphael, Giorgione's *Judith***, Titian and Veronese. Fewer but good Mannerist works. **17C** inc. Caravaggio's androgynous *Lute Player***, and **Bolognese** painting. **18C** inc. Crespi and Tiepolo. A wonderful array of Canovas*.

British, German, early Netherlandish, Spanish: smaller collections. Good works by Cranach, Gainsborough, Friedrich, Murillo, Velázquez* and Zurbarán.

Serbia see Yugoslavia, Federal Republic of

Slovenia

National holidays: Jan 1, 2, Feb 8, Easter, Apr 27, May 1, 2, Pentecost, June 25, Aug 15, Oct 31, Nov 1, Dec 25, 26.

LJUBLJANA

Narodna Galerija
(National Gallery)
Puharjeva 9, 1000 Ljubljana.
Tel (386 61) 241 5400
Fax (386 61) 241 5403
info@ng-slo.si
Tues to Sun 10-6. Closed Mon.
Collection of Slovenian art from 13C to early 20C, inc. medieval frescoes and Slovenian Renaissance, Baroque and Impressionist works.

Moderna Galerija
Tomisceva 14, 1000 Ljubljana.
Tel (386 61) 2141 06, 2141 01
Fax (386 61) 2141 20
info@lj.sl
Tues to Sat 10-6 (1 June-31 August 10-7); Sun 10-1. Closed Mon.
Slovenian art from Modernism onwards. A growing collection of international contemporary art, esp. those who have made site specific works for exhibitions, inc. Iglesias, Kapoor and Balka.

South Africa

National holidays: Jan 1, Good Fri, Easter Mon, Ascension Day, Republic Day (May 31), Settlers' Day (first Mon in Sept), Kruger Day (Oct 10), Day of the Covenant (Dec 16), Dec 25, 26. Museums close on Jan 1, Good Fri and Dec 25, 26.

Art in South Africa

From the mid-19C onwards artists in South Africa, mostly of British extraction, began to paint records of the landscape and life there, but the most significant movements did not begin until the 20C. For some time landscape painting remained the dominant genre, influenced at first by Impressionism and later by German Expressionism (which had an overriding influence on the work of Irma Stern and J. H. Pierneef). However, South Africa had her own painting tradition too; for Walter Battiss, one of the most influential modern artists, the break with Impressionism came in the late 1930s when he first saw the primitive paintings of South African bushmen, which encouraged him to use simple, flat areas of colour.

CAPE TOWN

Cape Province South African National Gallery

Government Ave, Cape Town.
Tel (27 21) 465 1628
Fax (27 21) 461 0045
Mon 1-5.30; Tues to Sat 10-5.30.
Closed Sun.
South African: mostly 20C works inc. Walter Battiss and Irma Stern's Expressionist paintings of African people.
British: 18C and 19C portraits inc. Lawrence, Raeburn and Reynolds; large collection of British sporting paintings, prints and drawings; some early 20C works.
French: mainly 19C landscapes.
Dutch and Belgian: 17C and 18C works.
Small collection of modern **German** and **Italian** paintings.

Michaelis Collection

Old Town House, Greenmarket Square, Cape Town.
Tel (27 21) 424 6367

Adam and the birth of Eve, *1985-89, Jackson Hlungwani, Johannesburg Art Gallery*

Fax (27 21) 461 9592
Mon to Sat 10-5. Closed Sun.
In the charming Rococo City Hall,
a collection of 17C Dutch and
Flemish paintings esp. Frans Hals'
*Portrait of a Woman** (see ill.
p.262); also Jan Steen, Cuyp and
Van Goyen.

DURBAN
NATAL

Durban Art Gallery
City Hall (2nd floor),
Smith St, Durban.
Mon to Sat 9.30-5, Wed 9.30-2;
Sun 2.30-5.
South African collection inc. a
stylized landscape by J. H. Pierneef
and *Magnolias* by Irma Stern.

British portraits by Kneller and
Lely; Wyndham Lewis' impressive
*Portrait of T. S. Eliot** and Paul
Nash's *Monster Field*.
French 19C landscapes.
Dutch and Flemish: small collec-
tion of minor 17C works. An
outstanding 16C piece is *Madonna
and Child* by Van Aelst. Also
bronzes by Rodin.

JOHANNESBURG
GAUTENG

Johannesburg Art Gallery
PO Box 23561, Joubert Park,
27 2044 Johannesburg.
Tel (27 11) 725 3130
Fax (27 11) 720 6000
jburger@mj.org.za

Michaelis Collection, Cape Town

The Dancing Dog,
Jan Steen,
Michaelis
Collection,
Cape Town

Tues to Sun 10-5. Closed Mon.
Building by Lutyens. The
surrounding park houses sculpture
by contemporary **South African**
artists. South African: 19C, 20C
and contemporary painting.
British: Victorian painting, esp.
Pre-Raphaelites, inc. Rossetti's
Regina Cordium and Millais'
Cuckoo. **French:** landscapes by
Monet, Sisley and Pissarro; *La
Source* by Puvis de Chavannes.
Dutch: 17C paintings, with good
works by minor masters. **International contemporary art** inc.
Calder, Judd, Flavin

PORT ELIZABETH
EASTERN PROVINCE

King George VI Art Gallery
1 Park Drive,
6001, Port Elizabeth.
Tel (27 41) 586 1030
Fax (27 41) 586 3234
www.kgg.gov.za
kgviartg@iafrica.com;
admin@kgg.gov.za
Mon to Fri 9-5 (closed Tues am);
public hols, Sat, Sun 2-5.
Small permanent collection inc.
mainly **South African** works and
some **British** works by members of
the Camden Town Group.

Spain

Opening hours: Monday to Saturday 10-1, 4-6; Sunday open in the morning only. Summer and winter hours may vary.
National holidays: Jan 1, 6, Mar 19, Apr 1, Maundy Thurs, Good Fri, May 1, Ascension Day, Corpus Christi, June 29, July 18, 25, Aug 15, Oct 12, Nov 1, Dec 8, 24, 25. Museums either close or are open for same hours as Sunday on these holidays and on the feast days of local patron saints.
Tourist information: Secretaria de Estado de Turismo.
Useful words: altarpiece *retablo*; art *arte*; catalogue *catálogo*; cathedral *catedral*; chapel *capilla*; church *iglesia*; closed *cerrado*; entrance *entrada*; exhibition *exposición*; exit *salida*; gallery *galería*; guide *guía*; high chapel *capilla mayor*; information *información*; monastery *monasterio*; museum *museo*; open *abierto*; painting *pintura*; restaurant *restaurante*; sculpture *escultura*; square *plaza*; ticket *billete*.

Art in Spain

The traditionally popular medium in Spain is sculpture, especially wood-carving, which can be seen in Toledo, Seville and Valladolid, or stone sculpture, such as that on the façade of Santiago de Compostela. The earliest flowering of painting was among the Catalonian frescoists at the time of the Moorish wars.

In the 15C artists (amongst them Bermejo) were attracted to the realism of Flemish art. Italian influence, which came to Spain in the 16C, was less fruitful, although El Greco (Titian's pupil), who settled in Toledo in 1576-77, was influenced by Venetian art. During this period, Spanish patrons were attracted by Venetian and North European artists; the collection of Philip II forms the basis of the Prado and Escorial museums.

The first Spanish Baroque painter was Francisco Ribalta, who introduced strong contrasts of light and shade; his treatment of the Baroque theme of vision and ecstasy is quiet and intensely naturalistic. Ribera's realism, directly influenced by Caravaggio, is coarser and more robust, his brushwork richer and more

Opposite: Circumcision, from the *retable of San Benito el Real of Valladolid (1520-32)*, *Alfonso Berruguete, Museo Nacional de Escultura, Valladolid*

Knight's Dream, *Pereda,*
Museo de la Real Academia
de Bellas Artes de
San Fernando, Madrid

expressive; he was attracted by themes of violence and torture. Ribera worked in Naples, and the Spanish viceroy sent many of his works to Spain. Francisco de Zurbarán, early influenced by Ribera, moved towards a deliberately archaic style that communicates a deep sense of spirituality; his forms are sharply lit and the detail precisely described, and yet reality seems denied by the strange stillness of the figures and the bareness of the dark backgrounds. In 1625 Velázquez, after painting a series of dignified genre scenes, became court painter, and recorded the stultifying atmosphere of the Spanish court; his royal portraits and paintings of court dwarfs and buffoons have none of the elegance of Van Dyck but are coolly

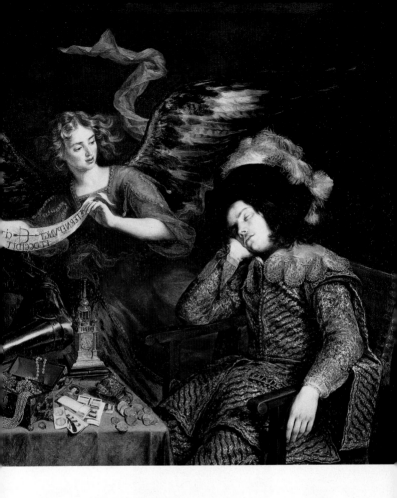

objective. His remarkable brushwork is free and expressive, and underlaid by faultless drawing. In the later part of the century Spanish painting became more emotionally Baroque; Murillo's works, sweet and overtly charming, were influenced by Rubens and Titian. The 17C and 18C were rich in still life painters, especially Cotan and Mélendez; and the enjoyment of still life can also be seen in the *vanitas* pictures popular in the period, such as Pereda's famous *Knight's Dream*.

During the 18C Spanish art was dominated by foreigners whose visits, encouraged by the Bourbons, culminated in 1762 with the arrival in Madrid of the Venetian, Giambattista Tiepolo.

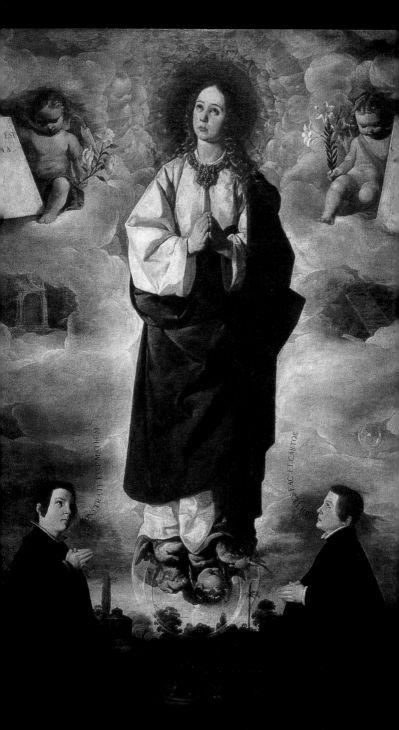

Self-Portrait with
candle-hat, *Goya*,
Museo de la Real
Academia de
Belles Artes de
San Fernando,
Madrid

His success was challenged by the supremacy of the German Neo-Classicist, Mengs. Conflicts between late Baroque and Rococo styles and Neo-Classicism in Spain influenced Francisco Goya, whose idiosyncratic work developed into a highly personal Romanticism. Known outside Spain by his contemporaries for his satirical prints, *Los Caprichos*, Goya achieved national fame as a portrait and subject painter, while his private interest in fantasy appears both in colourful early works and horrifying late masterpieces. Goya dominated the 19C, apart from the Neo-Classical history painter, Madrazo, and the young Picasso who emerged from the artistic world of Barcelona in the 1890s, but who lived mainly in France. Spanish Impressionism with its bright colours and forthright

Opposite: The Immaculate Conception,
Francisco de Zurbarán, 1632,
Museu Nacional d'Art de Catalunya, Barcelona

Self-Portrait,
*Joaquín Sorolla y
Bastida, Museo
Sorolla, Madrid*

brushwork is typified by the bravura work of Joaquín Sorolla.

In the late 19C and early 20C the modernista movement flourished in Barcelona, and Rusiñol and Casas, responding to French art, caught the urban scene; Isidore Nonell, and Picasso in his Blue Period (1901-4) painted the outcasts of society. But artists of the Noucentista (Sunyer, Manolo, Gargallo, Gonzalez), rejecting the urban, favoured pastoral themes and scenes of an unchanging peasant life. Surrealism was influential in Spain and Miró and Dalí among its most celebrated and notorious practitioners; Tapiès, the most influential Spanish artist since the War, creates large gloomy mixed media works, with wire and cloth, scratched and marked like graffiti. The dominant tendency has been abstraction, as in Antonia Suara, Luis Feito, Eduardo Chillida.

BARCELONA

Museu d'Art Contemporani de Barcelona

Pls dels Angels 1, 0800 Barcelona.
Tel (34 93) 412 0810
Fax (34 3) 412 4602
www.macba.es
macba.@macba.es
Daily 11-7.30; Sat 10-8; Sun 10-3.
Closed Tues. Café.

A gleaming white Richard Meier building, attractively open to the surrounding city. But the beauty of space and light makes the art of the last 50 years (Boltański, Tapiès, Pistoletto, Daniel Buren) look sparse and insignificant.

Museu d'Art Modern

Parc de la Ciutadella,
08003 Barcelona.
Tel (34 93) 319 5728
Fax (34 93) 319 5965
Tues to Sat 10-7; Thurs 10-9;
Sun 10-2.30. Closed Mon.

The early sections of this collection of late 19C and early 20C Catalan art are a little dull, despite Rusiñol and Casas' wistful evocations of Montmartre. It picks up with strong works by Isidre Nonell, anticipating Picasso's Blue Period, and a rich collection of Noucentisme, predominantly Arcadian and peasant scenes, inc. Sunyer's *Landscape with Three Nudes*, and works by Torres-Garcia and Togores. A portrait by Salvador Dalí, and sculptures by Gonzalez*.

Museu Nacional d'Art de Catalunya

Palau Nacional, Parc de Montjuïc, 08038 Barcelona.
Tel (34 93) 622 0360
Fax (34 93) 622 0374
www.mnac.es
mnac@correu.gencat.es
Tues to Sat 10-7; Sun, hols 10-2.30. Closed Mon. Café.

A beautiful display of Catalan Romanesque and Gothic art, inc. a series** of frescoes and sculptures from Catalan churches (see ill. p.310) which create an overwhelmingly rich and strange effect. The section devoted to Gothic art fascinatingly traces the response of Catalan artists to Italian and Flemish 14C and 15C painting. A less interesting handful of Renaissance and Baroque works inc. Zubarán (see ill. p.310).

Fundación Joan Miró

Av de Miramar 71-75, Parc de Montjuïc, 08038 Barcelona.
Tel (34 93) 329 1908
Fax (34 93) 329 8609
www.bcn.fjmiro.es
fjmiro@bcn.fjmiro.es
Oct-June: Tues to Sat 10-7;
Thurs 10-9.30; Sun, hols 10-2.30;
July-Sept: Tues to Sat 10-8; Thurs 10-9.30; Sun 10-2.30. Closed Mon.
Restaurant.

A striking building by J. L. Sert displays a collection of Miró's works from 1914-78, inc. paintings, sculptures, ceramics and tapestries. A small group of works by British and American artists indebted to Miró is a little dull, with the exception of Calder's *Mercury Fountain**, which was displayed with Picasso's *Guernica* in Paris.

Museo Pablo Picasso

Calle de Montcada 15-19,
08003 Barcelona.
Tel (34 93) 319 6310
Fax (34 93) 315 0102
mpicasso@intercom.es
Tues to Sat 10-8; Sun 10-3.
Closed Mon. Café.

A medieval palace displays a large collection of Picasso's early works inc. many small landscapes, unexpected large sacred works, (*First Communion* and *Science and Charity*), a *Harlequin* (1917)*. Also some of his 1957 works on the theme of Velázquez' *Las Meninas*. Despite its highly specialised collection, the museum is popular and very crowded.

Collecio Thyssen Bornemisza

Baixada del Monestir 9,
08034 Barcelona.
Tel (34 93) 280 1434
Fax (34 93) 204 1601
museo@museothyssen.org;
fundacion@museothyssen.org
Tues to Sat 10-12.

A small, high quality collection of Old Masters, displayed in a monastery. Richest in Italian painting, with works by Gaddi, Fra Angelico, Titian, Veronese, Canaletto, but also German Renaissance pictures (Cranach, Huber) and Zurbarán.

BILBAO

Museo de Bellas Artes

Plaza de las Naciones,
48011 Bilbao.
Tel (34 94) 441 0154
Fax (34 94) 427 3846
June-Nov: Tues to Sun 10.30-
1.30, 4-7; Mon 4-7;
Oct-May: Tues to Sun 10.30-1.30,
3.30-6; Mon 3.30-6.

A wide-ranging collection, from Gothic altarpieces to Francis Bacon. **Spanish** 17C inc. Zurbarán, Ribera, Coello; 18C late Goya portraits. 19C Basque painters inc. Zuloaga. **Italian:** Orazio Gentileschi*; 17C Genoese painting; Bellotto.

Some Dutch works; also Morisot and Gauguin.

Museo Guggenheim Bilbao

Abandoibarra Et. 2,
48001 Bilbao.
Tel (34 94) 435 9080
www.guggenheim-bilbao.es
Tues to Sun 10-8. Closed Mon.
Entry free for children under 12
and accompanied children.

An extraordinary sculptural building**, composed of bold curves, sharp angles and sloping surfaces, all covered with a gleaming titanium skin which reflects the changing light. It is the most celebrated of the new art museums, and its success in transforming an ugly industrial site, and bringing new life to the city, is now much emulated. Within are giant site-specific sculptures by Oldenburg and Richard Serra. Permanent coll. inc. Clemente, Kiefer, Holzer.

BURGOS

Museo de Burgos

Casa de Miranda, C/ Calera 25,
09002 Burgos.
Tel (34 947) 2658 75
Fax (34 947) 2767 92
Tues to Fri 10-2, 4-7.30; Sat 10-2,
4.45-8.15; Sun 10-2.

Exterior, Museo Guggenheim, Bilbao

Closed Mon, hols.
Set in a 16C Castillian mansion, this collection which inc. a large array of Castillian artefacts is esp. worth seeing. Paintings by L. Giordano, Bayeu, Mostaert. Note esp. the *Portrait of Fray Alonso de S. Vítores* (c.1659) by Fray Rizi (who became a Benedictine monk in 1627). Fluent brushwork and perceptive characterization make this his best work.

Exterior, Museo de Arte Abstracto Español de Cuenca

CADIZ

Academia de Bellas Artes
Plaza del Generalisimo Franco.
Mon to Sat: Summer 10.30-1.30,
4-6; Winter 3.30-5.30, Sun 11-1.
The 'Museo de Pinturas' has works
by Murillo, Alonso Cano, and
Jacopo Bassano; Rubens' tiny
work, the *Holy Family*. Also
Zurbarán's mighty *St Francis**, *St
Hugh of Lincoln* and *St Bruno*,
1638-9, when the artist was at the
height of his powers.

CORDOBA

Museo de Bellas Artes
Plaza del Potro 1,
14002 Córdoba.
Tel (34 957) 4733 45, 4713 14
Fax (34 957) 2927 24
Tues 3-7; Wed to Sat 9-8; Sun,
hols 9-3. Closed Mon.
A collection of medieval, Renais-
sance and Baroque art from
Córdoba, with a group of works by
the Sevillian Valdés Leal. Modern
and contemporary Spanish art.

CUENCA

Museo de Arte Abstracto
Casas Colgadas,
16001 Cuenca.
Tel (34 969) 2129 83
Fax (34 969) 2122 85
museocuenca@expo. march.es
Tues to Fri, hols 11-2, 4-6;
Sat 11-2, 4-8; Sun 11-2.30.
Closed Mon.
The famous 'hanging houses' of Cuenca form a magnificent setting for a collection of art by Spanish artists from the 1950s and '60s.

FIGUERES

Dalí Theatre-Museum
17600 Figueras.
Tel (34 972) 6775 00
Fax (34 972) 5016 66
www.dali-estate.org
Built on the ruins of the old Principal Theatre, this intriguing museum, entirely designed by Salvador Dalí, contains his alarming ceiling dec. and many works inc. the early and unexpectedly conventional, sparkling landscape *Port Alguer*. Other Dalí museums at Púbol and Port Lligat.

The Rainy Cadillac, *Dalí Theatre Museum,* *Figueres*

GRANADA

Capilla Real
Plaza dela Lonja,
Gran Via de Colón 5.
Tel (34 958) 2229 59
Mon to Sun 10.30-1.30, 3.30-6
(Winter 4-7).
In the **Sacristy** is the collection of Isabel 'la Católica' which inc. works by Memling, Van der Weyden and Bouts.

GUADALUPE

Monasterio
Sacristy: renowned series of paintings made by Zurbarán** in 1638-47 for the Hieronymites – 11 large paintings and 8 small panels depicting the *Life of St Jerome.* Luminous painting shows the influence of Caravaggio and is the high point of the artist's career.

ILLESCAS

Hospital de la Caridad
Calle Cardenal Cisneros 2,
45200 Illescas.
Tel (34 9255) 40035.
A religious art museum, with goldsmith's work, and an important series of paintings by El Greco*.

MADRID

Museo de la Real Academia de Bellas Artes de San Fernando
Calle Alcalá 13, 28014 Madrid.
Tel (34 91) 522 1491
Fax (34 91) 523 1599
July-Aug: Tues to Fri 9.30-6.30;
Sat to Mon, hols 9.30-2;
Sept-June: Tues to Fri 9-7; Sat to
Mon, hols 9-2.30.
The Academy was founded in 1744 and exercised a dominant role over the arts in Spain under the Bourbons. The museum was reorganised in the 1990s (with a rather depressing upper floor of modern work). The collection emphasises Spanish art, though it does inc. a few other works, for example, Bellini and Rubens. The powerful Riberas inc. *The Martyrdom of St Bartholomew*; the Zurbaráns inc. a set of strange full-length portraits of monks writing; there are typical Murillos. But the most famous 17C painting here is Pereda's weird *Knight's Dream** (see ill. pp.308-9). The main attraction of the museum is the group of small, late 'subject pictures'** by Goya (see ill. p.311), including the *Madhouse*, the *Inquisition Scene*, and the *Burial of the Sardine.* Other good Goyas inc. his swaggering portrait of the notorious royal favourite Godoy. Among the portraits by the royal painter Mengs is the extraordinary image of the *Marquesa de Llano**, complete with carnival mask and pet parrot.

Monasterio de las Descalzas Reales
Plaza de las Descalzas,
28013 Madrid.
Tel (34 91) 454 8800
Mon to Sun 10.30-1.30
(Mon, Thurs also 4-6).
Collection of religious art inc. painting and sculpture . Gallery of Habsburg portraits inc. Rubens, Sancho Coello, Pourbus. Also a series of tapestries from cartoons by Rubens.

Detail of Marquesa de Llano, *Anton Raphael Mengs,*
Museo de la Real Academia de Bellas Artes de San Fernando, Madrid

Museo Cerralbo
Ventura Rodríguez 17,
28008 Madrid.
Tel (34 91) 547 3646, 547 3647
Fax (34 91) 559 1171
July-Aug: Tues to Sat 10-2;
Sun 10.30-1.30; Sept-June: Tues
to Sat 9.30-2.30; Sun 10-2.
Closed Mon, hols.
Charming museum, evoking atmosphere of aristocratic 19C Madrilenian life. El Greco's *Ecstasy of St Francis*, Ribera's *Jacob with the Flocks**, Zurbarán's *Immaculate Conception*, and works by Magnasco, Alonso Cano and Mengs.

Museo Lázaro Galdiano
Calle Serrano 122, 28006 Madrid.
Tel (34 91) 561 6084
Tues to Sun 10-2. Free on Sat.
Excellent collection of decorative arts; some Renaissance bronzes. Velázquez' *Portrait of Gongora*, 1622, and Rembrandt's *Saskia* are among the best paintings. Zurbarán's *S. Diego de Alcala** is an austere image with striking silhouette. A room devoted to Goya includes two of his first witchcraft paintings (1795-98), more jovial than the 'black' witch scenes in the Prado.

Museo Nacional Centro de Arte Reina Sofia
Santa Isabel 52, 28012 Madrid.
Tel (34 91) 467 5062, 467 5161
Fax (34 91) 467 3163
museoreinasofia.mcu.es
comunicaciones.mncars@cars.mcu.es
Wed to Mon 10-9; Sun 10-2.30.
Closed Tues. (Free entry Sat from 2.30, and Sun am) Café.
A fine museum mainly dedicated to Spanish art of the 20C, whose highpoint is Picasso's *Guernica****, inspired by Franco's bombing of the small market town of Guernica, displayed with its preparatory drawings in Room 7: Picasso's epic work – its bare bulb, shrieking horse, and vicious bull symbolising an apocalyptic 20C horror – is perhaps the single most famous painting of that century. Also works by Gris (inc. *Portrait of Josette Gris**), large displays of Julio González, Miró, Dalí and Surrealism; later art inc. Tapiès, Eduardo Chillida. The museum specialises in video art.

Museo Nacional del Prado
C/ Ruíz de Alarcón 23,
28014 Madrid.
Tel (34 91) 330 2000
Fax (34 91) 330 2856
Tues to Sat 9-7; Sun, hols 9-2.
Closed Mon.
Of all the great national collections, the Prado has one of the strongest individual characters. It is essentially the royal collection, formed notably by Philip II and Philip IV, who were among the greatest collectors ever and who gave legendary patronage respectively to Titian and to Rubens and Velázquez. Venetian, Flemish and Spanish art of the 16C and 17C remains the core of the collection, with a rich group of early Netherlandish work (which fascinated Philip II) and with the later addition of an unmatched collection of work by Goya.

Early Netherlandish inc. Campin, Van der Weyden's *Deposition***, a number of alarming works by Bosch inc. *The Garden of Earthly Delights***, where, against the

charming background of the central panel, pallid nudes exhibit a strange world of sexual fantasy. Bruegel's *Triumph of Death*** is a terrifying vision of the lust for destruction.

Flemish: Rubens came twice to Spain and Philip IV (who is said to have visited his studio daily) became the most avid collector and commissioner of his work. *The Judgement of Paris**, The Three Graces*** and the *Garden of Love**** all now hang in a room devoted to Rubens' mythologies and comprise an unforgettably radiant and tender pæan to the power and pleasure of love. Also several fine portraits and religious works by both Rubens and Van Dyck.

Italian: important group of Raphaels inc. *Christ on the Way to Calvary* ('Lo Spasimo di Sicilia')**, which was one of the world's most famous paintings for centuries. Mantegna*, Parmigianino*, Guido

The Titians in the Prado

The Prado's 35 or so Titians are of such exceptional quality that by themselves they would still justify a pilgrimage to Spain, despite having recently been imprisoned in the lower gallery from which natural light is excluded. Every phase of Titian's wonderful career is illustrated by masterpieces, from the very early, Giorgionesque *Virgin and Child with St Francis and St Roch* to the haunting *Self-Portrait* of his last years. The paintings also reflect the taste of many of the great men whom Titian worked for, beginning with Alfonso I d'Este, Duke of Ferrara, who commissioned *The Worship of Venus*** and the *Andrians***. These radiantly sensuous, yet learned, celebrations of the pagan world were immensely famous from the moment of their creation, and were deeply influential. The breathtakingly virtuoso *Portrait of Federico II Gonzaga, Duke of Mantua*** records the urbane, dissolute, art-loving patron who presented Titian to the Emperor Charles V, who decided that he would only be painted by Titian, as Alexander had only been painted by Apelles. The great equestrian painting** of the emperor brooding over the battlefield of Mühlberg suggests both human frailty and spiritual grandeur, while the *Gloria** was venerated by Charles as he lay dying at the monastery of Yuste. Charles's son Philip II retained Titian as his chief painter until the time of his death, receiving all kinds of paintings from him, but especially the *poesie* such as the astonishingly erotic *Danaë***.

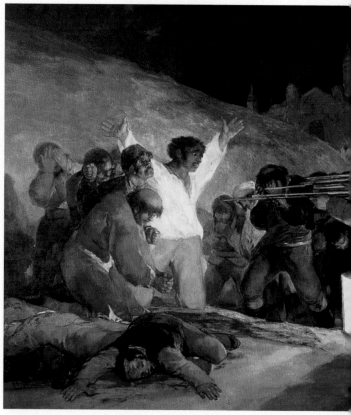

The 3rd of May 1808 in Madrid: The Executions on Principe Pio Hill, *Goya*
Museo Nacional del Prado, Madrid

Reni*, Annibale Carracci* and an overwhelming display of Titian, Tintoretto and Veronese (inc. the latter's *Venus and Adonis***).

Spanish: large displays of all the great names. 16C: El Greco**. 17C: Ribera (note *Martyrdom of St Philip*), Murillo and Zurbarán (inc. a spare, strangely meaningful *Still Life*). Velázquez dominates the central hall with the intimate yet grandly mysterious *Las Meninas***, and this and the neighbouring rooms (always crowded) are laid out in thematic displays of his work. 18C: full show of Goya from the charming early tapestry designs to the terrifying late nightmares, via state portraits, the naked (and sexier) clothed *majas*, etc. Be sure not to miss the 40-odd *Still Lifes* by Meléndez in room 19.

French: Poussin and a spectacular group of paintings in vertical format** by Claude.

Museo Romántico
Calle de San Mateo 13,
28004 Madrid.
Tel (34 91) 448 1045, 448 1071
Tues to Sat 9-3; Sun, hols 10-2.
Closed Mon and Aug.
Main emphasis of the collection

is on 19C Spanish paintings: Leonardo Alenza's *Self Portrait* and *Romantic Suicide* show the influence of Goya. Carnicero's *Portrait of Manuel Godoy.*

Museo Sorolla
Paseo del General Martínez
Campos, 37, Madrid.
Tel (34 91) 301 1584, 310 1731
Fax (34 91) 308 5935
sorolla@museo.mec.es
Tues to Sat 10-3; Su & hols 10-2.
Closed Mon.
Sorolla's former house containing some of his most treasured pieces, including a self-portrait (see ill. p.312) and *After the Bath.*

Museo Thyssen-Bornemisza
Paseo del Prado 8, Madrid.
Tel (34 91) 420 3944
Fax (34 91) 420 2780
mtb@museothyssen.org
Tues to Sun 10-7. Closed Mon.
(Advance booking daily at the
box office). Café.
A magnificent collection which reflects 20C taste in Old Masters and inc. more recent art, exhibited chronologically, with the main emphasis on Italian and Dutch art. **German and Swiss:** *Christ among the Doctors* by Dürer and Holbein's *Henry VIII***, the prototype of a much imitated composition. Good works by Altdorfer, Baldung and Cranach.
Italian: from the followers of Duccio and Giotto to 18C Venetian painting. *Giovanna Tornabuoni** by Ghirlandaio, Carpaccio's *Portrait of a Knight**; Sebastiano del Piombo's *Cardinal Ferry Carondolet with his Secretaries**; a late *St Jerome* by Titian. Caravaggio's

323

*St Catherine**, a disturbingly direct portrayal of a young Roman woman, with Caravaggio's deadly duelling rapier before her.
Netherlandish: Van Eyck**; Memling*, Rubens*, esp. *Venus and Cupid.*
Dutch: Hals' *Family Portrait,* Steen's *Self-Portrait.* Splendid still lifes by Kalf*.
Modern Art: Impressionist and Post-Impressionist works, inc. Manet, Monet, Degas, Gauguin; many works by Picasso; Mondrian, Miró, Kandinsky. There is a strong emphasis on American art from the 19C, with good works by Hopper and Rothko; and on German Expressionism, inc. Beckmann.

Palacio Real
Plaza de Oriente, 28071 Madrid.
Tel (34 91) 542 0059
Fax (34 91) 541 2172
1 April-30 Sept: Mon to Fri 9-6;
Sun, hols 9-3; 1 Oct-31 March:
Mon to Fri 9.30-5; Sun, hols 9-2.
May be closed for State functions.
In the centre of the Plaza de Oriente, Tacca's equestrian statue of Philip IV. In the palace, ceilings by Giambattista Tiepolo in the Throne Room and the Hall of the Halbardiers, by Corrado Giaquinto over the entrance stairway, in the Hall of Columns and covering the dome of the chapel. Also some ceilings by Mengs who supplanted Tiepolo in royal favour.

Most of the paintings (inc. Juan de Flandes) now moved to the picture gallery, where they can be

seen by appointment on Mondays, Fridays and Saturdays: tel. 91 454 88 03 for appointments.

Royal Monastery of San Lorenzo de El Escorial
20 miles north of Madrid (train from Atocha station, Madrid).
Tel (34 91) 890 5902
Apr-Sept: Tues to Sun 10-6;
Oct-Mar: Tues to Sun 10-5.
Enormous and famously gloomy Habsburg mausoleum and monastery founded by Philip II in 1563, it became one of the richest collections of books, manuscripts, tapestries and pictures in the world. Enlarged by succeeding generations, the collection was plundered by the French in 1808 and now the best pictures have been removed to the Prado, Madrid. Both the **Nuovos Museos** and the **Chapter Rooms** contain a lot of uncleaned Venetian painting of quality that is difficult to make out. Titian's celebrated *Martyrdom of St Lawrence* is in the old church, not open to visitors, and his *Last Supper* (Chapter Rooms) is heavily cut down and repainted. But look out for El Greco's *Martyrdom of St Maurice* and Roger Van der Weyden's *Calvary** in the Nuevos Museos, and Bosch's *Mocking of Christ* and Velázquez's *Joseph's Bloody Coat** in the Chapter Rooms. The El Greco painting displeased Philip II who was looking for a starker Counterreformation style. In the cavernous **church**, with its 45 altars, that

Opposite: Henry VIII, *Hans Holbein the Younger, Museo Thyssen-Bornemisza, Madrid*

mindset is exemplified by Luca Cambiaso's dreary ceiling fresco in the west end. Pellegrino Tibaldi was more successful in developing a narrative style within Philip's requirements, and there is a great deal of his work in the church and cloisters. Also in the church, note the Cellini marble *Christ* and Leone Leoni's lifesize bronze effigies of the families of Charles V and Philip II at prayer, in balconies high up at either side of the main altar. An incongruously cheerful note is struck in the church by Luca Giordano's later eight ceiling frescoes. Giordano also executed the *Glorification of the House of Habsburg* fresco over the main stairway, ironically in the very final years of the Habsburg monarchy. The immense **library** is the most aesthetically successful space in the entire complex. The vaulted ceiling carries a splendid fresco by Tibaldi celebrating the branches of science and learning to which the library was devoted.

Sant'Antonio de la Florida

Paseo de S. Antonio de la Florida.
Winter: Mon to Sat 11-1.30, 3-6;
Sun 11-1.30; Summer: Mon to Sat
10-1 ,4-7; Sun 10-1.30.
Closed Mon, hols.
Goya's Pantheon, the *Miracle of St Anthony of Padua**, painted in unorthodox fresco technique in 1798; a brilliant array of characters inside the dome and exuberant angels on the spandrels. Goya is buried here.

OSUNA

Museo de Arte Sacro, Iglesia Colegial

Calle Colegiata, 41640 Osuna.
Tel (34 95) 4810 44
June-Sept: 10-3, 4-7; Oct-May: 4-7.
Paintings by Ribera and Velázquez*.

SEVILLA (Seville)

Seville was a major art centre in the 17C; Velázquez was born there in 1599 and painted sober genre scenes; Murillo was born and worked there throughout his entire career. Seville was particularly devoted to the Cult of the Immaculate Conception, and Murillo became famous for his many treatments of the subject.

Casa de Pilatos

Plaza Pilatos, 1, Seville.
Tel (34 95) 422 5298
winter: 10-1, 3-7;
summer: 9-1, 3-9.
Spectacular Renaissance palace with a small coll. of sculpture and paintings inc. works by Velázquez's teacher Pacheco.

Catedral

Plaza del Triunfo.
Possibly the largest Gothic Cathedral in the world, it enshrines a rich collection of Spanish art.
Baptistery: Murillo's *Vision of St Antony of Padua* and Goya's *St Justa and St Rufina*, unusually classical female figures displaying the precision of Goya's draughtsmanship beneath the uncharacteristically smooth paint.
Capilla S. Pedro: Zurbarán's nine paintings from the *Life of St Peter*

Casa de Pilatos, Seville

(1625-30) – early, rather primitive works.

Hospital de la Caridad
Calle Temprano.
Tues to Sun 10-2 (Apr-June, Sept 4.30-7.30; July, Aug 5-8).
Collection mainly devoted to Murillo contains two masterpieces: *Moses Striking the Rock** and *The Miracle of the Loaves and Fishes**, uncharacteristically crowded compositions with wide landscape backgrounds. See also two *memento mori*, the most famous and horrific works by the Sevillian Valdés Leal.

Museo de Bellas Artes
Convento de la Merced, Plaza del Museo 9, 41001 Seville.
Tel (34 95) 422 1829
Tues 3-8; Wed to Sat 9-8; Sun, hols 9-2. Closed Mon.
A major collection of Spanish art, with emphasis on Murillo, Zurbarán and Valdés Leal. Four paintings of the *Immaculate Conception* by Murillo, and his *Charity of St Thomas Villanueva***. Works by Zurbarán inc. *St Hugo of Grenoble in the Carthusian Refectory* and the *Apotheosis of St Thomas*. 24 works by Valdés Leal. Note El Greco's portrait of his son. Also some Flemish paintings, and sculptures by Torrigiani.

El Greco tour

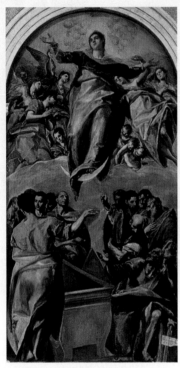

The Assumption of the Virgin, *El Greco,*
Art Institute of Chicago, Michigan

El Greco's work is mainly associated with **Toledo** where he lived for some 37 years. To gain a good idea of his stylistic development go in the morning to the Church of Santo Domingo el Antiguo (where the artist lies buried) and see his first public commission of which only the *Resurrection* now remains. Proceed to the Cathedral and view the dramatic *Espolio* 1577-9, his first Spanish work, paired with Goya's *Betrayal* of 1799, deliberately painted as an exercise in Grecoesque intensity. Then visit Santo Tomé to see El Greco's greatest work, *The Burial of Count Orgaz*. Finally go to the Hospital de Tavera which houses what is possibly his last painting, *The Tears of St Peter.*

In the afternoon take a bus or drive to the medieval town **Illescas**, where the church has a mudéjar tower. Visit the Hospital de la Caridad to see the paintings El Greco executed for the high altar in 1603-5. They include portraits of the artist's son, and Toledo notables, and display his style at its most dramatic and apocalyptic.

TOLEDO

Casa y Museo del Greco
Calle Samuel Levi, 45002 Toledo.
Tel (34 925) 2240 46
Fax (34 925) 2245 59
Mon to Sun 10-2, 3.30-7
(winter 3.30-6).
Now restored, the house has a small collection of paintings by El Greco (inc. a *View and Plan of Toledo*), Velázquez, Murillo, and Zurbarán's *Kneeling Friar*, one of his series of Mercederian martyrs. 18C paintings.

Catedral
Plaza de Ayuntamiento.
Mon to Sun 11-1, 3.30-5.30.
High chapel: Narciso Tomé's famous Rococo altarpiece, the *Transparente**, a high point of 18C sculptural/architectural decoration. 16C larchwood high altar and Renaissance tomb commemorating Cardinal Mendoza, carved by Andrea the Florentine.
Sacristy: a fine ceiling fresco by L. Giordano, *The Miracle of St Ildefonso**; El Greco's first work executed in Spain, the *Espolio*, and his series of Apostles (esp. *St Luke*). Goya's *Betrayal,* painted 220 years later, is the first recognition, without being derivative, of El Greco's achievement by a Spanish painter.

Hospital de Tavera/Musco de la Fundación Duque de Lerma
Calle Vega Baja, 45003 Toledo.
Tel (35 92) 552 0451
Mon to Sun 10-1.30, 4-6.30
(winter 3.30-6).
16C building, contains works by Zurbarán, El Greco (early and late works), Tintoretto, L. Giordano.

Note Ribera's *Bearded Woman* 1631; startling in her livid clarity, she emerges from brooding Caravaggesque darkness. A sinister example of Spanish 17C humour.

Museo Provincial de Toledo/ Museo de Santa Cruz
Calle de Cervantes 3, 45001 Toledo.
Tel (35 92) 522 1036
Fax (34 925) 2258 62
Tues-Sat 10-6.30, Sun 10-2, Mon 10-2, 4-6.30
A fine Plateresque building, with pretty interior courtyard, and paintings by El Greco and Luis Tristàn.

Santo Tomé
www.santotome.org
santotome@santotome.org
Mon to Sun 10-6.45
(winter 10-5.45).
El Greco's mighty *Burial of the Count of Orgaz****, 1586, his most famous painting in which temporal and transcendent realities interfuse disturbingly.

VALENCIA

Catedral
Chapel off R side-aisle: Goya's two paintings showing scenes from the *Life of the Jesuit St Francisco de Boris.* Note *St Francisco at the Death-Bed of an Impenitent* in which, for the first time, Goya paints the demons which haunt his later works.

Museo de Bellas Artes de Valencia
Calle San Pio V 9, 46010 Valencia.
Tel (34 96) 360 5793
Fax (34 96) 360 9721

Tues to Sat 10-2, 4-7.30;
Sun, hols 10-7.30. Closed Mon.
15C and 16C Valencian school,
Jerónimo Espinosa (*The Holy
Family*). Rodrigo de Osona, and
the Masters of Gil and Pulades. See
the dramatic *St Francis Embracing
the Cross* by Ribalta. Also a *Self-
Portrait* (damaged) by Velázquez.
Ribera; Goya.

VALLADOLID

Museo Nacional de Escultura
C/ Cadenas de San Gregorio 1,
47011 Valladolid.
Tel (34 983) 2503 75, 2540 83
Fax (34 983) 2593 00
pymes.tsai.es/museoescultura
museoescultura@tsai.es
Mon to Fri 10-2, 4-6; Sun,
hols 10-2. Closed Mon.
Unique collection of Castillian
sculpture. See esp. Berruguete's
Retable (1527-32) with its dynamic
figures (see ill. p.306); the marvel-
lous polychromatic sculptures by
Francisco and Marcelo Martinez;
new pathetic realism of the *Repen-
tant Magdalen* (1664) by Pedro da
Mena; the works of the 17C master,
Gregorio Fernandez, the first to
use glass eyes and real teeth.

VILLANUEVA Y GELTRÚ

Museo Balaguer
Av. Balaguer,
088000 Villanueva y Geltrú.
Tel (34 938) 1542 02
Fax (34 938) 1536 84
Tues to Sun 10-1, 4-7. Closed Mon.
Worth visiting to see an outstand-
ing El Greco *Annunciation** in

which the central whiteness of the
Host spirals down the canvas
illuminating the main figures –
a breathtakingly dynamic work.
12C-17C sculpture; 16C-20C
painting.

ZARAGOZA (Saragossa)

**Basilica de Nuestra
Señora del Pilar**
Contains Goya's earliest frescoes.
On the ceiling of the coreto (little
choir) is the *Adoration of the
Name of God* (1772), a sparkling
composition showing the influence
of Correggio, after Goya's Italian
visit in 1770. The *Queen of the
Martyrs** adorns one of the main
cupolas and its pendentives, a
masterpiece completed in 1781,
dynamic and flowing figures which
initially displeased the Church
authorities with their unorthodox
display of brilliance.

**Museo Provincial de
Bellas Artes**
Plaza de los Sitios 6,
50001 Zaragoza.
Tel (34 976) 2221 81
Fax (34 976) 2223 78.
Daily 9-2. Closed Mon.
Works by Goya**, the local artist,
inc. his earliest recorded paintings,
St Joseph's Dream and *Portrait of a
Man in a Hat,* (*c.*1773-75); mid-
period and mature portraits inc.
the theatrical *Ferdinand VII,*
thoughtful *Felix of Azara* and the
brilliantly striking *Duke of San
Carlos* and the *Woman in a
Mantilla*. From the 1780s, *St
Lodovico Gonzaga**.

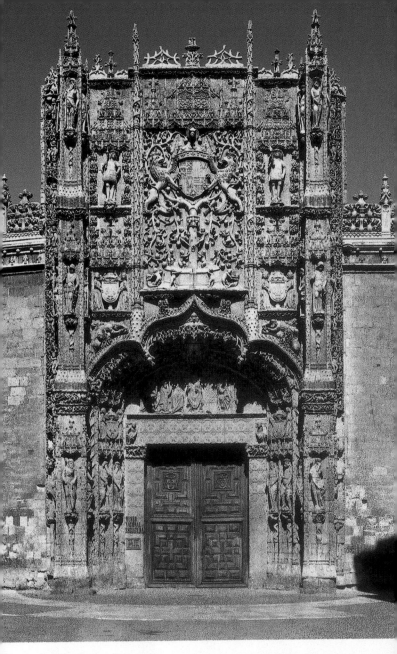

Façade, Colegio de San Gregorio, Museo Nacional de Escultura, Valladolid

Sweden

Opening hours: generally shorter in winter.
National holidays: Jan 1, 6, Good Fri, Easter Mon, May 1, Ascension Day, Whit Mon, Midsummer Day, All Saints, Dec 25, 26.
Opening hours on holidays are the same as those for Sunday.
Tourist information: Svenska Turistrådet.
Useful words: *konstmuseum* art museum; *slott* castle.

Swedish art

In the 17C Sweden, made newly prosperous and powerful as a result of the Thirty Years War, encouraged artists to express her desire for Baroque magnificence. In the 18C Swedish portrait painters (amongst them Lundberg, Pilo – a gifted colourist – and Roslin) worked in a charming Rococo style. In the 1880s many Swedish painters were working in Paris: Josephson and Anders Zorn were influenced by the luminous colours of Impressionism. They painted open-air works, which becae incresingly subjective in the 1890s. In the 1910s and 1920s Matisse was a dominant influence, and on Sweden's west coast there developed a school of colourists painting lyrical landscapes. Since 1945 there has been a reflection of the major trends in international art, esp. abstraction and Pop.

GÖTEBORG (Gothenburg)

Göteborgs Konstmuseum
Götaplatsen, 41256 Göteborg.
Tel (46 31) 6129 80
Fax (46 31) 1841 19
www.kunstmuseeum.goteborg.se
administration@goteborg-konst-museum.se
Sept-Apr: Tues to Fri 11-4, Wed also 4-9; Sat, Sun 11-5; May-Aug: Mon to Fri 11-4; Sat, Sun 11-5.

A representative collection of Scandinavian art from the 17C to the present day; main emphasis on Swedish art, esp. Roslin and Lundberg; Danish (esp. Golden Age painting, Eckersburg, Köbke), Finnish and Norwegian 19C-20C sculpture and painting, inc. Munch's *Sick Girl**.
Old Masters: a small, high quality collection inc. works by Venetian, Flemish (Rubens) and Dutch

Opposite: The Fürstenberg Gallery, Interior, Carl Larsson, Göteborgs Konstmuseum

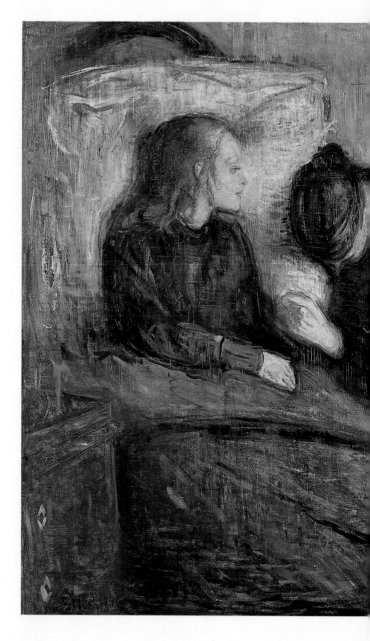

painters, esp. Terbrugghen and Rembrandt*.

Also French* works from 1800-1945; a collection of contemporary art** that illustrates international trends from 1945, inc. Warhol, Allen Jones, Bacon.

STOCKHOLM

Moderna Museet
Skeppsholmen,
103 27 Stockholm.
Tel (46 8) 5195 5200
Fax (46 8) 5195 5210
www.modernamuseet.se
Tues to Thurs 11-8;
Fri to Sun 11-6.
Closed Mon. Café.

An immensely successful and popular new museum, built almost on the waterfront, and merging with its urban setting. It has a quiet, harmonious atmosphere, and shows an important collection of Swedish art and international 20C art, with an emphasis on Modernism and on the New York school from the 50s and 60s. Works by Duchamp, Braque, Léger and Picasso; Surrealism represented by Breton, Miró and Dalí's *The Enigma of William Tell*; works by Oldenburg, Rauschenberg's *Stuffed Goat*. Tatlin, Calder, Judd, Mondrian, Giacometti.

The Sick Child, *Edvard Munch,*
Göteborgs Konstmuseum, Göteborg

335

The Cloud, *Prins Eugen, 1896,*
Prins Eugens Waldemarsudde, Stockholm

Nationalmuseum
Södra Blasieholmen,
103 24 Stockholm.
Tel (46 8) 5195 4300
Fax (46 8) 5195 4450
www.nationalmuseum.se
Tues 11-8; Wed to Sun 11-5.
Closed Mon.
A representative collection of European painting with an emphasis on Flemish and Dutch 17C, and French 19C works.

Flemish and Dutch: collection of Rembrandts inc. three outstanding works***: a fragment of his monumental work, the *Conspiracy of the Batavians* (1661-2), in which the pagan brutality of the figures is transformed by the mysterious splendour of the light; a direct and

warmly human genre painting, the *Kitchen Maid*; and a very late, intensely concentrated treatment of a favourite theme, *Simeon with the Christ Child**. A good collection of Rubens inc. his brilliantly free re-interpretations of Titian's *Bacchanals***.

French inc. Claude and de la Tour**. Rococo is represented by Chardin*, Watteau, and above all by Boucher's *Triumph of Venus***, a spontaneous and light-hearted celebration of the ravishing girlish charms of the Goddess of Love. From the 19C: Courbet*, Delacroix, Manet and Renoir.

Swedish: an important collection inc. works by Josephson, Larason and Zorn. Also works by Cranach and Zurbarán.

Prins Eugens Waldemarsudde

Prins Eugens väg 6, Djurgården, 115 21 Stockholm.
Tel (46 8) 5458 3700
Fax (46 8) 667 7459
www.waldemarsudde.com

May-Aug: Tues to Sun 11-5; Thurs 11-8; Sept-Apr: Tues, Wed and Fri 11-4; Thurs 11-8; Sat, Sun 11-5. Closed Mon.

The residence of the late Prince Eugen of Sweden, beautifully maintained as it was in the Prince's lifetime. The collection consists of the Prince's own landscapes; a large collection of Swedish art inc. Josephson and Zorn; 19C French paintings; and works by Picasso and Munch.

SUNDBORN

Carl Larsson – Garden

790 15 Sundborn.
Tel (46 23) 60053
Fax (46 23) 60653
www.clg.seinfo@clg.se
1 May-30 Sept: daily.

The enchanting and much visited home of Carl and Karin Larsson; Carl Larsson idealised their rustic life here in a series of immensely popular watercolours.

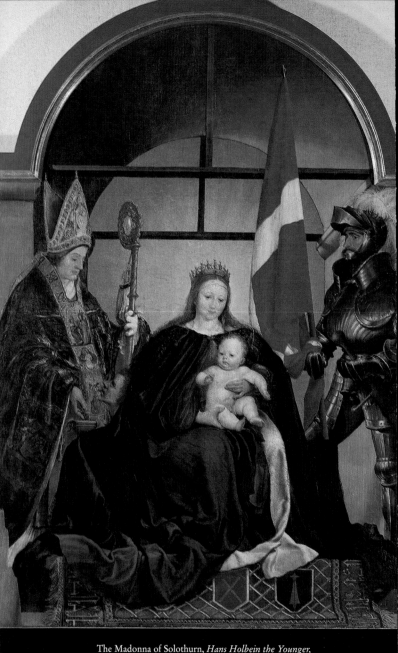

The Madonna of Solothurn, *Hans Holbein the Younger*,
Kunstmuseum Solothurn, Solothurn

Switzerland

Opening hours: museums often close on Monday morning, or all day Monday.
National holidays: Jan 1, 2, Good Fri, Easter Mon, Ascension Day, Whit Mon, Dec 25, 26.
Useful words: see French, German and Italian word lists (pp. 73, 127 and 171).

Art in Switzerland

The influence of the new naturalism of the northern Renaissance became apparent initially in the severe paintings of Konrad Witz, the first great Swiss painter. In c.1515 the Holbein family moved from Augsburg to Basel, an important centre of humanist scholarship. The paintings of Hans Holbein the Younger combine northern realism with southern monumentality; his calm detachment contrasts with the expressive power of Nikolaus Manuel Deutsch. Other important artists at this time were Urs Graf and Hans Leu the Younger.

The 17C and 18C were less interesting, although enlivened by the pastels of Jean-Etienne Liotard and by the Grand Tour landscapes of Ducros. Fuseli, the Swiss Romantic artist working in the second half of the 18C, emigrated to England. In the 19C Arnold Böcklin painted Symbolist mythological works.

Since the late 19C Swiss artists, often working abroad, have reflected the major trends of European art. Hodler made a reputation in Germany. He painted turgid Symbolist canvases, influenced by the simplified forms of medieval art; more attractive are his landscapes, inspired by alpine scenery and painted in brilliant colours comparable to those of the Fauves. Cuno Amiet and Augusto Giacometti were also bold colourists.

Between 1916 and 1921 Zurich became the leading centre of Dada. The most famous 20C artists of Swiss origin are Paul Klee who taught at the Bauhaus, and Alberto Giacometti. Most recently Tachism (represented by René Acht, Charles Rollier and Franz Fedier) and the *Art concret* of Max Bill are predominant trends.

BADEN

Stiftung 'Langmatt' Sidney und Jenny Brown

Römerstr. 30, CH-5400 Baden.
Tel (41 56/2) 2258 42
Fax (41 56/2) 2262 27
www.langmatt.ch
info@langmatt.ch
1 Apr-31 Oct: Tues to Fri 2-5;
Sat and Sun 11-5. Closed Mon.
Collection of Impressionists, esp. Renoir, in early 20C villa.

BASEL

Fondation Beyeler

Baselstr., 4125 Riehen 101, Basel.
Tel (41 61) 645 9700
Fax (41 61) 645 9719
www.beyeler.com
fondation@beyeler.com
Thurs to Tues 10-6; Wed 10-8.
The collector Ernst Beyeler said that he wished this museum, by Renzo Piano, to convey '*luxe, calme et volupté*'; it is a beautiful and reticent museum, open to parkland, where Monet's late *Waterlilies* seem echoed in surrounding light and water. The high quality collection of modernist art, inc. Cézanne, Rousseau, Picasso, Matisse, and a room devoted to Giacometti; displayed amongst them are objects from Africa, Oceania and Alaska.

Museum Jean Tinguely

Grenzacherstr., Solitudepark,
CH-4002 Basel.
Tel (41 61) 681 9320
Fax (41 61) 681 9321
infos@tinguely.ch
Wed to Sun 11-7. Closed Mon, Tues.
A museum devoted to the life and work of the Swiss sculptor in iron, Jean Tinguely; it shows his witty and absurd drawing machines from the 60s, and his later black painted machine sculptures.

Öffentliche Kunstsammlung

St. Albangraben 16,
CH-4010 Basel.
Tel (41 61) 206 6262
Fax (41 61) 206 6252
www.kunstmuseumbasel.ch
Tues to Sun 10-5. Closed Mon.
The collection of early German painting is dominated by Hans Holbein the Younger**. The humanist scholar, Bonifacius Amerbach, a close friend of Erasmus, owned many of Holbein's works which now form the basis of this collection. Facsimiles of many of the drawings are also exhibited. Works inc. *Jacob Meyer** and his wife, *Dorothea Kannengiesser**, in which the figures are shown against backgrounds of sumptuous classical architecture; the simpler portrait of *Bonifacius Amerbach**, from the second Basel period; *The Artist's Family***, influenced by Italian compositions, a moving description of suffering and anxiety. As a religious artist Holbein is shown experimenting with dramatic effects of perspective (*Christ as the Man of Sorrows* and the *Mater Dolorosa**), combining his own pitiless observation with something of the expressionism of Grünewald (*Dead Christ*** 1521), and relating the Passion of Christ with a new human directness in the two shutters of an altarpiece**; note esp. the intensity of *Christ's Agony in the Garden* and the unemotional representation of his body on the

Maestà, *Duccio di Buoninsegna, c. 1290, Kunstmuseum, Berne*

cross; the influence of Mantegna and Raphael is discernible. Early German also inc. Altdorfer, Hans Baldung (esp. a starkly expressionist work *Death and the Maiden**). Cranach, Deutsch, Grünewald and Holbein the Elder.

Dutch and Flemish: inc. David, Van Goyen, Rembrandt, Ruisdael.

19C German and Swiss: a large collection inc. many works by Arnold Böcklin who also painted frescoes in the museum.

French 19C: a good collection of Impressionist and Post-Impressionist works inc. Cézanne, Gauguin* and Van Gogh.

20C art: a representative collection with particular emphasis on Cubism. Important works by Braque inc. *Violin and Pitcher** and *The Portuguese**; in the latter the figure plays a guitar – details, traditionally described, locate him in space, and the spectator is led to contemplate the relationship of intersecting planes projected in shallow space. Works by the pioneers of abstract art inc. Kandinsky, Mondrian, Lissitsky.

American 20C is represented by Kline, Newman, Noland and Still.

BERNE

Kunstmuseum (Museum of Fine Arts)
Hodlerstr. 8-12,
CH-3000 Berne 7.
Tel (41 31) 311 0944
Fax (41 31) 311 7263
www.kunstmuseumbern.ch
kmbadmin@kmb.unibe.ch
Wed to Sun 10-5; Tues 10-9.
Closed Mon.

The Klee Foundation**, with its large collection of works by Paul Klee (who was born in Berne) and the Rupf Foundation, a large collection of Cubist paintings (inc. Braque, Gris and Picasso) are the most important features here.

Swiss: an extensive collection inc. many works by Nikolaus Manuel Deutsch; Symbolist paintings by Hodler (inc. *The Chosen One* and *Night*); portraits and landscapes.

19C French and German: a representative collection inc. a notable Cézanne *Self-Portrait*. Amongst earlier schools the outstanding painting is a panel from Duccio's *Maestà** (Siena) (see ill. p.341).

GENEVE (Geneva)

Musée d'Art et d'Histoire
2 rue Charles Galland,
CH-1206 Geneva 3.
Tel (41 22) 418 2600
Fax (41 22) 418 2601
http://mah.ville-ge.ch
mah@ville-ge.ch
Tues to Sun 10-5. Closed Mon.

The best picture here is the *Miraculous Draught of Fishes*** by Konrad Witz – an important landmark of the northern Renaissance. It depicts Lake Geneva, and is the earliest European painting (1444) of an identifiable landscape. The other unusual feature of the gallery is a collection of pastels by Quentin de la Tour and the Genevan artist Jean-Etienne Liotard. 17-19C French and Swiss painting inc. the Genevan St-Ours and romantic landscape (Calame and Diday), Corot and Hodler and the Impressionists.

Also note the Veronese *Entomb-ment* and the *Sabina Popæa** of the School of Fontainebleau. A growing 20C section inc. Giacometti and New Realism.

Petit Palais
(Musée d'Art Moderne)
2, Terrasse St-Victor,
CH-1206 Geneva.
Tel (41 22) 346 1433
Fax (41 22) 346 5315
petitpalais@rtx.ch
Tues to Fri 10-6; Sat, Sun 10-5.
Closed Mon.
This unusual collection provides an opportunity for those interested in painting from 1880 to 1930 to round out their knowledge. The collection concentrates not so much on the great names (although there are works by Renoir), but on a fascinating selection of minor masters.

LAUSANNE

Musée Cantonal des Beaux-Arts
Palais de Rumine, Place de la Riponne 6, CH-1014 Lausanne.
Tel (41 21) 316 3445
Fax (41 21) 316 3446
musee.beaux-arts@serac. vd.ch
Tues, Wed 11-6; Thurs 11-8; Fri to Sun 11-5. Closed Mon am.
The museum has some good French Impressionist paintings but is mainly devoted to Swiss painters inc. Ducros. Large collection of works by Charles Gleyre, a prolific painter of large-scale academic salon pieces and historical subjects.

LOCARNO

Pinacoteca Comunale
Casa Rusca
Piazza S. Antonio,
CH-6600 Locarno.
Tel (41 91) 756 3458
Apr-Oct: Tues to Sun 9-12, 2-4.
Paintings and sculptures by Arp and his contemporaries and works by local artists.

LUCERNE

Picasso Sammlung
Am-Rhyn-Haus, Furrengasse 21,
CH-6004 Lucerne.
Tel (41 41) 4135 33
Apr-Oct: 10-6;
Nov-Mar: 11-1, 2-6.
A small, high quality collection of paintings, sculpture, ceramics and graphic work by Picasso in a fine 17C building.

SOLOTHURN

Kunstmuseum Solothurn
Werkhofstr. 30,
CH-4500 Solothurn.
Tel (41 65) 3262 223 07
Fax (41 65) 3262 250 01
kunstmuseum@egs.so.ch
Tues to Fri 10-12, 2-5;
Sat, Sun 10-5.
The Solothurn *Madonna*** (see ill. p.338), showing the Virgin with St Martin and St Ursus (the patron saint of Solothurn) was painted by Holbein in 1522. Like much of his work of this period, it shows North Italian influence; the colouring – note the use of ultramarine – is esp. remini-scent of his Venetian

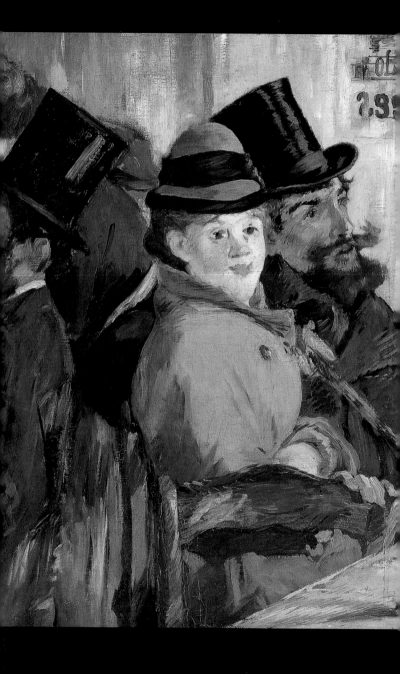

contemporaries. The other well-known painting here is the *Virgin with Strawberries**, a Rhenish panel of *c.*1410 – late Gothic at its richest and most graceful.

19C and 20C Swiss: a large collection of painting. Also Impressionist and contemporary works.

WINTERTHUR

Kunstmuseum

Museumstr. 52, Postfach 378,
CH-8402 Winterthur.
Tel (41 52) 267 5162
Fax (41 52) 267 5317
www.kmw.ch
info@kmw.ch
Tues 10-8; Wed to Sun 10-5.
Closed Mon.

Mainly notable for its collection of Post-Impressionists** (inc. Bonnard, Van Gogh, Maillol, Redon and Vuillard), the museum also has some earlier painting inc. works by Swiss artists. Also some important 20C German paintings.

Museum Oskar Reinhart am Stadtgarten

Stadthausstr. 6,
CH-8400 Winterthur.
Tel (41 52) 267 5172
Fax (41 52) 267 6228
Tues 10-8; Wed to Sun 10-5.

A collection of about 600 German, Swiss and Austrian paintings from 18C onwards. Most notable are works by Romantic artists inc. five paintings by Friedrich*, esp. *Chalk Cliffs of Rügen*; many paintings by

At the Café, *Edouard Manet, 1878, Sammlung Oskar Reinhart 'Am Römerholz', Winterthur*

Boy in a Red Waistcoat, *Cézanne*,
Stiftung Sammlung E. G. Bührle, Zürich

Böcklin; a collection of modern Swiss art inc. Hodler, Giacometti and Segantini.

Oskar Reinhart Collection 'Am Römerholz'

Haldenstr. 95,
CH-8400 Winterthur.
Tel (41 52) 269 2740
Fax (41 52) 269 2744
www.kultur-schweiz.admin. ch/sor
sor@bak.admin.ch
Tues to Sun 10-5.
Closed Mon.
One of the finest private collections in the world. Important Old Masters inc. Bruegel**, Cranach**, Holbein, Rembrandt*, Rubens, Poussin*, Chardin, El Greco and Goya, but the highpoint of the collection is a superb collection of 19C French painting** which inc. Delacroix, Ingres, Géricault**, Manet*, Renoir, Van Gogh and some very fine late still lifes by Cézanne**.

Villa Flora Sammlung Hahnloser

Tüsstalstr. 44, CH-8400,
Winterthur.
Tel (41 522) 1299 66
Fax (41 522) 1299 65
info@villaflora.ch
Tues to Sat 2-5; Sun 11-3.
Closed Mon.
Opened to public in 1997. A good collection of late 19C painting, esp. strong on Nabis and Fauves (Vuillard, Bonnard, Vallotton) partly displayed in 1908 secessionist-style picture gallery. Also a sculpture garden (Maillol).

ZÜRICH

Kunsthaus

Heimplatz 1, CH-8024 Zürich.
Tel (41 1) 251 1722
Fax (41 1) 251 2464
info@kunsthaus.ch
Tues to Fri 10-9; Sat and Sun 10-5.
The collection has mainly 19C and 20C works, though there are some Early Italian paintings and some Dutch 17C works inc. a Rembrandt.
French 19C and 20C inc. Bonnard, Courbet (*The Trout**), Daumier, Manet (*The Escape of Henri Rochefort*), Monet, Rousseau (*Portrait of Pierre Loti*). There is a good collection of Cubist paintings.
Swiss: a good survey of art from 18C to 20C inc. Fuseli, Hodler, and 100 works by Giacometti* inc. *The Chariot Bronze* and *Spoon Woman*. Also works by Beckmann, Kokoschka and Munch*.

Stiftung Sammlung E. G. Bührle

Zollikerstr. 172, CH-8008 Zürich.
Tel (41 1) 422 0086
Fax (41 1) 422 0347
www.buehrle.ch
Tues, Fri and Sun 2-5; Wed 5-8.
Special opening times for groups.
A diverse collection which inc. some 17C and 18C Old Masters*. Swiss paintings, an outstanding group of works by French painters** from Corot to Cézanne and Van Gogh. These inc. Manet, Monet, Degas, Renoir*, Pissarro and Sisley. There are also works by the Nabis, the Neo-Impressionists and the Fauves; some 20C paintings by Braque, Gris and Picasso.

United Kingdom

Opening hours and admission: museums are generally open Monday to Saturday 10-5, Sunday 2-5. Admission to public galleries is often free. Country houses: hours vary greatly with the season. Check before you set out. Entrance fee generally charged.

National holidays: Jan 1 (Jan 2 – Scotland), Good Fri, Easter Mon, 1st Mon in May, Whit Mon, last (first – Scotland) Mon in Aug, Dec 25, 26. Museums close Dec 25 (Jan 1 – Scotland), Good Fri and some Bank holidays or hours as for Sun. Country houses are open on Bank holidays.

Art in the United Kingdom

Throughout the 16C and early 17C England remained an artistic back-water; there was no significant royal patronage, no demand for religious art, and little interest in any form of painting apart from portraiture. A series of painters from abroad, mainly from the Netherlands, brought with them only glimpses, often half-understood, of the great achievements of Renaissance and Mannerist art. Holbein was in England between 1526 and 1528 and between 1532 and 1543, and the astonishing verisimilitude of his portraits must have amazed an untutored English public; yet his late portraits show a tendency towards a flat and intricately patterned surface that was to develop into the Elizabethan costume piece and to persist into the 17C, in the works of Robert Peake and William Larkin. Yet some English names do stand out – those of Nicholas Hilliard, whose exquisite miniatures capture the poetry of the Elizabethan court, and of William Dobson who created a solid and robust portrait style.

The enlightened patronage of Charles I opened a new era. His magnificent collection of Renaissance art was deeply influential; he patronised Rubens, and, above all, made Van Dyck his court painter from 1632-41. Van Dyck's stay profoundly affected the course of English painting; he introduced a wealth of new portrait types, a greater delicacy of pose and gesture, and a brilliantly nervous and flickering treatment of the surface; his elegant courtiers defined forever the ideal English aristocrat. Later 17C portraiture was dominated by the languorous and voluptuous beauties of Lely

and the stiffer and more masculine style of Kneller.

The 18C saw the foundation of a national school. In the early years Hogarth was outstanding: he brought a new warmth and humanity to the middle-class portrait; he encouraged the lightness and informality of the portrait group; he invented a new kind of picture, the 'modern moral subject' which berated the vices of contemporary society. In the 1750s and 1760s Reynolds and Gainsborough transformed the society portrait: Reynolds, learned and deeply aware of artistic tradition, strove to relate his art to the Grand Manner of European painting; Gainsborough, more tenderly poetic, created dreamy images from his fluid handling of the softness of lace and the glamour of silk. Richard Wilson, deeply influenced by the Italian scene and by Claude, founded the English landscape school; Gainsborough's landscapes, influenced by Dutch art, are full of a sense of the countryside as the realm of a lost Golden Age; George Stubbs excelled in sporting pictures and conversation pieces; Joseph Wright in a novel kind of industrial genre.

From c.1750 the rationality of the 18C began to seem stifling; the imagination demanded freedom, and the passions of man sought bizarre and spectacular outpourings – in the macabre dreams of Fuseli, in the melodramatic visions of John Martin, and in the intensely private mysticism of William Blake. Turner responded most passionately to the unleashed fury of the elements; his finest works are visions of light and glowing colour. By contrast, Constable brought to the painting of English landscape a new love for everyday things and a passion for precise observation.

In the mid-19C the Pre-Raphaelites protested against the lack of moral significance in contemporary art; their doctrine was 'truth to nature' and they painted brilliantly coloured, highly detailed works. Yet they remained isolated from European developments; the link between London and Paris was Whistler, whose works show a growing concern for formal and aesthetic values. After 1905 Sickert, the Camden Town Group and painters of the Bloomsbury Group responded to the new developments in France; Fry's Post-Impressionist exhibitions encouraged this influence, apparent in the paintings of Augustus John and the Scottish colourists,

Previous pages: An Election I: 'An Election Entertainment', *William Hogarth, Sir John Soane's Museum*

Opposite: Queen Charlotte, *Johann Heinrich Hurter, Gilbert Collection, London*

especially J. D. Fergusson. By the early 1930s Henry Moore, Barbara Hepworth and Ben Nicholson dominated English painting and sculpture. Abstract forms were inspired by a lyrical response to nature.

Graham Sutherland was influenced by the Surrealist movement and his pupil, Francis Bacon, painted violent images of the terror and isolation of man. Pop Art arose as a movement in the 1950s: Richard Hamilton was fascinated by technology and consumer goods, and his approach is dispassionate and complex, while Peter Blake's work shows a nostalgia for the bric-à-brac of the Victorian and Edwardian eras. The second phase of the movement includes Allen Jones and David Hockney, whose early works are satirical and use graffiti-like drawing. Other British artists have followed the developments of American Abstract painting (Denny, Smith, Cohen, Hoyland, Heron and Caro) albeit with a greater interest in

Thomas Chatterton, *Henry Wallis, Tate Collections, London*

Stained glass window by Patrick Heron, Tate St Ives

pictorial complexity; their work attempts to create a new relationship between picture and spectator. But in recent decades figurative painting has been strong. The angst-ridden paintings of Francis Bacon and Lucian Freud made them international megastars, while in the 1990s the clutch of 'Young British Artists', periodically repackaged by Charles Saatchi under buzz-words such as 'sensation' or 'neurotic art', cornered the market in shocking the bourgeois.

BARNARD CASTLE DURHAM

The Bowes Museum
Barnard Castle,
County Durham DL12 8NP.
Tel (44 1833) 690606
Fax (44 1833) 37163
www.durham.gov.uk/cl/index.htm
Mon to Sun 11-5.
An impressive imitation of a French château set in lovely countryside, which houses a splendid collection of paintings and objets d'art. The atmosphere is pleasantly festive.

An unusual and extensive collection of **Spanish** painting inc. several good works by rare and minor painters; also El Greco's *The Tears of St Peter* and Goya's *Interior of a Prison**.

French: a large collection inc. works by Philippe de Champaigne, Jouvenet, Boucher's *Landscape with Watermill**, a dream of Arcadia. Fragonard and Courbet.

Landscape with a cattle drover, *Jan Asselijn, Holburne Museum, Bath*

Italian: inc. Sassetta, Primaticcio, Giordano, Preti, Solimena, and Corrado Giaquinto's *Venus Presenting Æneas wth Armour*, an unusual blend of greens, greys and pinks. Some good 18C Venetian pictures, Tiepolo.

Netherlandish: good representative collection.

BARNSLEY

Cannon Hall
Cawthorne, Barnsley S75 4AT.
Tel (44 1226) 790270
Tues to Sat 10.30-5; Sun 12-5
(opening times may vary).
English paintings, and a choice collection of Dutch and Flemish works, inc. Cesar van Everdingen's *Child Holding an Apple**, Van der Heyden, Coque, Metsu, Asselyn*.

BATH

Holburne Museum of Art
Great Pulteney Street,
Bath BA2 4DB
Tel (44 1225) 466449
Fax (44 1225) 333121
www.bath.ac.uk/holburne
holburne@bath.ac.uk
Tues to Sat 10-5; Sun 2.30-5.30.
Closed mid-Dec to mid-Feb.
Handsome 18C house and garden with fine collection inc. bronzes (Susini*); Dutch and English paintings, inc. Stubbs, Ramsay, Zoffany, Kauffmann, Gainsborough, Turner.

BIRMINGHAM

The Barber Institute of Fine Arts
University of Birmingham,
Birmingham B15 2TS.
Tel (44 121) 414 7333
Fax (44 121) 414 3370
www.barber.org.uk
info@barber.org.uk
Mon to Sat 10-5; Sun 2-5.
A small, representative collection, with some unusual works of exceptional quality; a *Still Life** by Baschenis, almost modernist in the depiction of space, yet intensely poetic in its evocation of transience, is the only work in England by this great artist. Italian paintings inc. a portrait* by Bellini, and works by Veronese and Dosso Dossi. 17C is especially strong, with good works by Poussin**, Claude* and Rubens*, and a boldly theatrical yet subtle Stom*. 18C and 19C colls inc. Gainsborough*, one of Degas' most daring jockey scenes*, Derain, and Vuillard*.

Museums and Art Gallery
Chamberlain Square,
Birmingham B3 3DH.
Tel (44 121) 303 2834
Fax (44 121) 236 6227
Mon to Thurs, Sat 10-5; Fri 10.30-5; Sun 12.30-5.30. Café.
A major provincial gallery, especially strong in Italian Baroque paintings, recently enriched by works from the Mahon collection, and an enormous holding of Pre-Raphaelite works, which inc. many celebrated paintings.
Old Master paintings: small collection of Dutch landscape and genre; two excellent Claudes* (one

Still Life with Musical Instruments, *Evaristo Baschenis, c.1660,*
The Barber Institute of Fine Arts, The Univesity of Birmingham

an unusual night scene); Bellini. Italian 17C dominated by Gentileschi's *Flight into Egypt*, but also Guercino*, Rosa, Crespi, Gaulli, and the Master of the Annunciation to the Shepherds*. English period Canalettos.* 19C: Pre-Raphaelite works inc. Millais, Rossetti, Ford Madox Brown and a room of works by Burne-Jones. A splendid rotonda shows High Victoriana; also works by Sickert, Camden Town and Bloomsbury painters. An early Degas stands out in the French 19C collection. A large collection of 20C British art inc. Nash, Spencer, Epstein; interesting recent acquisitions inc. works by Ana Maria Pacheco and Shani Rhys James. The gallery has a rich collection of English watercolours which are sometimes on show.

BRIGHTON

Brighton Museum & Art Gallery
Church St, Brighton,
East Sussex BN1 1UE.
Tel (44 1273) 290900
Fax (44 1273) 292741
Tues to Sat 10-5.45; Sun 2-5
(summer 2-6). Closed Mon.
British: mainly 18C and early 19C. An important group of early English watercolours.
Dutch: outstanding is Lievens' *Raising of Lazarus.* Aert de Gelder, Maes and Aert van der Neer. Strong Victorian works inc. Alma-Tadema and Poynter.

BRISTOL

City of Bristol Art Gallery

Queens Road, Bristol BS8 1RL.
Tel (44 117) 922 3571
Fax (44 117) 922 2047
general_museum@bristolcity.
gov.uk
Mon to Sun 10-5.
Some unusual items.

Italian: the most important work in the 15C and 16C collection is a *Descent into Limbo* attrib. to Giovanni Bellini. 17C inc. Pietro da Cortona and Cerano*.

British: the usual collection of portraits; Victorian Academy painting and 20C inc. two large works by Burne-Jones, Danby (a local artist).

French: small, well-chosen collection: an unusually intimate Gros*, Courbet landscape, good Redon, Sisley and Vuillard.

BURGHCLERE

Sandham Memorial Chapel

Burghclere, Newbury RG20 9JT.
Tel/Fax (44 1635) 278394
March and Nov: weekends only
11.30-4; April-end of Oct: Wed to
Sun 11.30-5.
Built in the 1920s and decorated with interesting murals by Stanley Spencer*, drawing on his experience in the First World War.

BURNLEY

Towneley Hall Art Gallery and Museum

Burnley, Lancs BB11 3RQ.
Tel (44 1282) 424213
Fax (44 1282) 436138
www.burnley.gov.uk/towneley.index
Mon to Fri 10-5; Sun 12-5. Café.
The former home of the Towneley family, with a collection of 18C

Towneley Hall, *J. M. W. Turner,*
Towneley Hall Art Gallery and Museum., Burnley

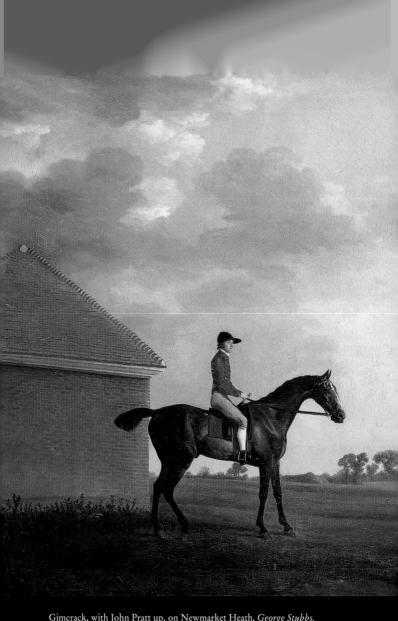

Gimcrack, with John Pratt up, on Newmarket Heath, *George Stubbs,*
Fitzwilliam Museum, University of Cambridge

and 19C English art. The dazzling work here is Zoffany's *Charles Towneley and his Friends**, an extraordinarily detailed depiction of the famous collector surrounded by ancient marbles, most of which are now in the British Museum. Alma-Tadema (see ill. p.348).

CAMBRIDGE

The Fitzwilliam Museum
Trumpington St,
Cambridge CB2 1RB.
Tel (44 1223) 332900
Fax (44 1223) 332923
www.fitzmuseum.cam.ac.uk
fitzmuseum-enquiries@
lists.cam.ac.uk
Tues to Sat 10-5; Sun 2.15-5.
Closed Mon.
A beautiful display of paintings with sculptures, small bronzes, furniture and majolica.

British: good collection from early 16C to 20C inc. all the major 18C portraitists; Gainsborough's *Heneage Lloyd and his Sister.* Van Dyck*, fine Grand Tour Batoni, Works by the Bloomsbury Group.

Dutch and Flemish: some small, spontaneous oil sketches by Rubens*. Dutch inc. portraits by Hals and Rembrandt*; a splendid series of landscapes inc. some charming Italianate scenes by Breenbergh and Poelenburgh; good Ruisdaels*; flower pieces esp. de Heem*.

French: Claude*; early 19C inc. Corot: small but good Impressionist collection inc. Monet, Pissarro, Manet, Degas.

German: small collection. Outstanding are two tiny works on

House Interior, Kettle's Yard, University of Cambridge

copper by Adam Elsheimer*; Dürer. **Italian:** Early Renaissance: three panels by Simone Martini*. Two panels by Domenico Veneziano*. 16C Venetian** dominated by Titian's *Venus, Cupid and a Lute Player***, his *Tarquin and Lucretia*** and Veronese's *Hermes, Herse and Aglauros***. 17C: good collection of Bolognese painting esp. Guido Reni and Guercino. An unusual landscape by Pietro da Cortona. Very striking is Salvator Rosa's *L'Umana Fragilità**, a lugubrious allegory on the vanity of human existence.

Kettle's Yard
Castle St, Cambridge CB3 0AQ.
Tel (44 1223) 352124
Fax (44 1223) 324377
www.kettlesyard.co.uk
Tues to Sun 2-4. (Exhibitions Tues to Sun 11.30-5).
The cottage of the idiosyncratic collector Jimmy Ede, transformed and enlarged into a collection of 20C British art, with an emphasis on Nicholson, Wood, Alfred Wallis and, above all, Gaudier-Brzeska. The cottage, with its emphasis on the beauty of materials, of wood, polished pebbles, flowers, remains powerfully evocative of its creator.

King's College Chapel

Tel (44 1223) 331155
Term: Mon to Sat 9.30-3.15;
Sun 1.15-2.15; Vacation: Mon to
Sat 9.30-4.30; Sun 10-4.30
Public welcome to services.
Rubens' *Adoration of the Magi**.

CARDIFF

National Museum of Wales

Cathays Park, Cardiff CF1 3NP.
Tel (44 29) 2039 7951
Fax (44 29) 2066 5522
Tues to Sun 10-5. Closed Mon.
Café.
A collection with a strong Welsh
emphasis inc. Richard Wilson, (a
deeply elegiac Italian work, *Rome
and the Ponte Molle**), Thomas
Jones, whose *Buildings in Naples**,
(1782) is a fine example of his now
celebrated plein air oil sketches,
and a Batoni portrait of *Welsh
Grand Tourists*. Works by Augus-
tus and Gwen John (surprisingly
Augustus comes out better, with
oil sketches full of life and bright
flat patterns of colour) and David
Jones. European Old Masters inc.
Poussin's *Landscape with the Body
of Phocion*** (1648) and a late
Claude*.
French 19C is a strong section,
with works by Barbizon painters
and the Impressionists, esp.
Cézanne*, a dazzling blue Renoir*,
and Morisot*. Van Gogh**.

DERBY

Derby Museum and Art Gallery

The Strand, Derby DE1 1BS.
Tel (44 (01332) 716659
Fax (44 1332) 716670
*Tues to Sat 10-5; Mon 11-5; Sun
and hols 2-5.*
Best known for its collection of

Landscape near Auvers, *Vincent Van Gogh, National Museum of Wales, Cardiff*

A Philosopher Lecturing on the Orrery,
Joseph Wright of Derby, Derby Museum & Art Gallery

the works of 'Wright of Derby'. Joseph Wright was the first to express in paintings the passionate enthusiasm for scientific research of the eminent figures in intellectual circles in the Midlands. He studied the play of artificial light and is most famous for his candle-light pieces. *A Philosopher Giving a Lecture at the Orrery*, one of his best candle-light pictures, and one of the most original British paintings. *A Hermit Studying Anatomy: Democritus* (c.1771) is a precise study of light but also has an element of macabre sensationalism that developed in British painting in the 1770s.

EDINBURGH

National Gallery of Scotland
The Mound, Edinburgh EH2 2EL.
Tel (44 131) 556 8921
Fax (44 131) 220 0917
www.natgalscot.ac.uk/dean/deangal.html
Mon to Sat 10-5; Sun 12-5.
Perhaps the most enjoyable of all national collections.
British: inc. Constable, Hogarth, Reynolds and an outstanding group of Gainsboroughs. Scottish painting from George Jameson to William MacGregor. Ramsay's *The Artist's Wife**, and Raeburn's funny and touching *Reverend Robert*

*Walker Skating**, are amongst the most celebrated Scottish paintings.
Dutch: small but high quality collection inc. Hals, Rembrandt*, Ruisdael* and Vermeer* (whose *Christ in the House of Martha and Mary* is an unusual early large-scale figure painting).
Early Netherlandish and Flemish: 15C inc. Van der Goes' *Trinity Altarpiece** (on loan from the Royal Collection); 17C inc. Van Dyck* and Rubens*.
French: 17C: Poussin's series of the *Seven Sacraments***, the most moving examples of his most severely classical style; the total effect is of a grave and mysterious immobility. 18C: outstanding works by Boucher, Chardin and Watteau. 19C: esp. 1880-1900 inc. an important group by Degas. Three Gauguins*, ranging from a *Martinique Landscape* to *Vision after the Sermon* (his first great Symbolist work) and *Three Tahitians*. Cézanne, Monet and Vuillard.
German: Lucas Cranach the Elder and Elsheimer*.
Italian: small collection of early works. Two works by Raphael** : the *Holy Family with a Palm Tree* and *The Bridgewater Madonna* (both 1507-8). Rich collection of Venetian works from the early 16C to the development of Titian's later style: compare the tender lyrical beauty and sunlit atmosphere of the *Three Ages of Man*** (1515-20) with the loose handling and tragic mood of the two great mythological compositions, *Diana and Acteon* and *Diana and Calisto*** (1556-9). Also Bassano, Lotto and Tintoretto. 17C: inc. Domenichino and Guercino. 18C:

dominated by Tiepolo's *Finding of Moses**. Sculptures by Bernini* and Canova*.
Spanish: El Greco, Zurbarán, Velázquez (*Old Woman Cooking Eggs* in which the simple objects and figures attain a moving dignity).

Scottish National Gallery of Modern Art

Belford Rd,
Edinburgh EH4 3DR.
Tel (44 131) 624 6335
Fax (44 131) 343 2802
www.natgalscot.ac.uk
enquiries@natgalscot.ac.uk
Mon to Sat 10-5; Sun 12-5. Café.
Collection of 20C art with good works by Vuillard, Ernst, Dix, Kokoschka, Goncharova, Picasso; recent works inc. Hockney and Damien Hirst. Scottish art inc. Fergusson and Redpath.

Across the road is the **Dean Gallery** which shows the Gallery of Modern Art's fine holdings of Dada and Surrealist art*. Also many works by Paolozzi, and a recreation of his London studio, crammed with objects.

GLASGOW

Burrell Collection

Pollok Country Park, 2060 Pollok-shaws Rd, Glasgow G43 1AT.
Tel (44 141) 287 2550
Fax (44 1 41) 287 2597
Daily 10-5, Fri, Sun 11-5. Café.
Just south of Glasgow city centre, the gallery shows the richly eclectic collection of the shipowner Sir William Burrell, with period rooms, ancient art, tapestries, stained glass, needlework, and

Eastern art, in spaces where glass walls seem open to the surrounding woodland, contrasting the delights of art with the peace of nature.

15C-18C European art inc. Cranach, Bellini and a lovely Memling *Annunciation*; Hals; Chardin.

19C French: the richest part of the collection, with works by Géricault, Courbet, Daumier, Millet (a small panel, *The Shepherdess**). Impressionist works by Manet, Cézanne, and Sisley at his best in the autumnal *The Bell Tower at Noisy-le-Roi**. A large collection of Degas** dominates, inc. *The Rehearsal*, a daringly asymmetrical *Jockeys in the Rain*, and a portrait of his friend, the naturalist writer *Edmond Duranty**.

Gallery of Modern Art

Queen St, Glasgow G1 3AZ.
Tel (44 141) 331 1854
Fax (44 141) 332 9957
Mon to Sat 10-5; Sun 11-5. Café.
Worth a visit for the setting in the Royal Exchange building, with its splendid Corinthian hall, and its portico transformed by an installation by Niki de Saint Phalle; small children like its amusement arcade atmosphere. But the collection, anti big names and aggressively populist (Beryl Cooke, Peter Howson), is mainly hideous; two nightmarish Bellanys and a grassy room by Andy Goldsworthy stand out.

Glasgow Art Gallery and Museum

Kelvingrove, Glasgow G3 8AG.
Tel (44 141) 287 2699
Fax (44 141) 287 2690
Daily 10-5, Fri and Sun 11-5. Café.
An extravagant Victorian building, with a jumble of arms and armour and natural history, and some outstanding and unusual paintings. Most remarkable are a Venetian painting, *The Adulteress Brought before Christ***, whose attribution – to Giorgione, Titian, Sebastiano – is controversial (it has been cut down, and is shown with a rediscovered fragment, *The Head of a Man*); Rembrandt's *Man in Armour***, a rare and romantic theme, which, unlike the more famous *Man in a Golden Helmet*, has retained its attribution; and Whistler's *Portrait of Thomas Carlyle***.

British: inc. 18C portraits; Turner; Glasgow School paintings; 20C inc. Joan Eardley and Anne Redpath.

Dutch: a large collection, with good landscapes, Hals and Rembrandt (*The Carcass of an Ox*). Van Gogh *Portrait of Alexander Reid** (see ill. p.264).

French: 19C inc. Cézanne; Degas' *Dancers on a Bench**; Matisse's *The Pink Tablecloth**.

Italian: highlights of Renaissance and Baroque are a large *tondo*, perhaps by Filippino Lippi; two Salvator Rosas**, perhaps the most perfect examples of the wild landscapes, desolate, and with spiky trees dripping with moss,

Opposite: The Shepherdess, *Jean François Millet,*
Glasgow Museums: The Burrell Collection

The Pink Tablecloth, *Matisse, Glasgow Museums:*
Glasgow Art Gallery and Museum

Above: Glasgow Art Gallery and Museum, Kelvingrove
Opposite: Harmony in Red: Lamplight, *J. M. W. Whistler,*
Hunterian Art Gallery, University of Glasgow

which were his most important creation.

Hunterian Art Gallery
University of Glasgow,
Hillhead St,
Glasgow G12 8QQ.
Tel (44 141) 330 4221
Fax (44 141) 339 8855
www.gla.ac.uk/Museum
Mon to Sat 9.30-12.30, 1.30-5.
Closed Sun.
Collection of Old Masters inc. works by Rembrandt** (a sketch) and Chardin** (three beautiful paintings): 19C works inc. the largest collection of Whistler* in the world; its emphasis is on a splendid array of full-length portraits of women. 19C and 20C Scottish paintings; watercolours and sketches by Mackintosh* and a reconstruction of his house.

Pollok House
Pollok Park, Glasgow G43 1AT.
Tel (44 141) 616 6410
1 Apr-31 Oct: daily 10-5;
Nov-31 Mar: daily 11-4.
The Stirling Maxwell Collection:
Spanish paintings are of particular interest and inc. two works by El Greco; Goya; Valdes Leal; Murillo. Also some good Italian paintings and five unusual works by William Blake.

St Mungo Museum of Religious Art
2 Castle Street, Glasgow G4 0RH.
Tel (44 141) 553 2557.
Mon-Sat 10-5; Sun 11-5.
Most famous for Dali's *Christ of St John of the Cross.* Blake's *Adam and Eve*.

HULL

Ferens Art Gallery
Queen Victoria Sq, Hull HU1 3RA.
Tel (44 1482) 613902
Fax (44 1482) 61370
www.hullcc.gov.uk/
navigating_hull
Mon to Sat 10-5; Sun 1.30-4.30.
Café.

A small group of Dutch pictures is dominated by Hals' fresh and direct *Portrait of a Woman*, the best painting in the collection. But there are also a few slightly random and interesting works from other schools, inc. a Caravaggesque piece by Nicolas Régnier; a gleaming Phillipe de Champaigne, and a flamboyant Benedetto Gennari. The British collection emphasises portraiture, and has a varied collection of works from the first half of the 20C, inc. Nicholson, Nash, Dobson, Cadell and Hitchen*. A specialist collection of local views is disrupted by a children's gallery bizarrely thrust into its centre.

University of Hull Art Collection
Middleton Hall, Cottingham Rd,
Hull HU6 R7X.
Tel/Fax (44 1482) 465192
Mon to Fri 2-4; Wed 12.30-4.

A small but unusually attractive collection of British 20C painting, with works by Conder (a fan painted on silk), Sickert, a strong Peploe, Stanley Spencer.

LEEDS

The Henry Moore Institute
74 The Headrow,
Leeds LSI 3AA.
Tel (44 113) 234 3158
Info (44 113) 246 7467
Daily 10-5.30, Wed 10-10.

The Institute is also a research centre and archive; see below.

Leeds City Art Gallery
The Headrow,
Leeds LS1 3AA.
Tel (44 113) 247 8248
Fax (44 113) 244 9689
www.leeds.gov.uk
Mon to Sat 10-7, Wed 10-8; Sun 1-5. Restaurant.

The gallery is next to the Henry Moore Institute (see above), a fine conversion of Victorian warehouses. The two galleries are interconnected, creating a vivid juxtaposition of Victorian and modernist, and a sculpture gallery whose small and varied spaces show themed displays, and works from a fine collection of modern sculpture, inc. Moore, Calder, Hepworth and Arp.

British: a sumptuous display of Victorian painting, inc. romantic night scenes by Atkinson Grimshaw, a local painter. But its main strength is in British 20C paintings, inc. Gwen John, Hitchen*, the Camden Town Group, Rego and Riley.

French: small collection of Barbizon and Impressionist, with good works by Courbet, and Sisley.

Opposite: Cornucopia, *Frank Dobson, 1925-27,*
University of Hull Art Collection

LIVERPOOL

Tate Gallery, Liverpool
Albert Dock,
Liverpool L3 4BB.
Tel (44 151) 709 3223
Fax (44 151) 709 3122
A fine conversion of Victorian warehouses, the Tate Gallery, Liverpool shows changing displays of works from the Tate's collection of modern art, and special loan exhibitions.

Walker Art Gallery
William Brown St,
Liverpool L3 8EL.
Tel (44 151) 478 4199
Fax (44 151) 298 1816
Mon to Sun 10-5. Café.
A major provincial collection. The main emphasis is on British art from 16C, but it also has an unusual and high quality group of early Italian works.
British: important portraits of Henry VIII and Elizabeth I. 17C and 18C inc. most of the major portraitists; important groups by Stubbs, Wilson and Wright. 19C inc. Constable, Sickert, Turner and an important Pre-Raphaelite collection.
Dutch: inc. a *Self-Portrait* by Rembrandt.
French and German: some good 19C works by Courbet, Corot, Degas and Vuillard. Earlier works inc. one of the most celebrated heroic landscapes of Poussin**, and a tiny and magical Elsheimer*.
Italian: inc. Simone Martini*, Ercole de Roberti*, Signorelli, and a group of 17C Neapolitan paintings.
Netherlandish: inc. an important triptych, *The Descent from the Cross,* a copy of a lost work by the Master of Flémalle; Rubens.

LONDON

Apsley House, Wellington Museum
149 Piccadilly, Hyde Park Corner, London W1V 9FA.
Tel (44 20) 7499 5676
Fax (44 20) 7493 6576
Tues to Sun 11-5. Closed Mon.
Fee, which includes sound-guide.
Most famous for the three Velázquez, the highpoints of the collection of **Spanish** art. In the *Waterseller of Seville*** the simple subject is transformed by a haunting gravity and stillness. In Elsheimer's tiny *Judith and Holofernes** the flickering candlelight emphasizes the terror of the action and gives a strange unreality to the richness of the interior.
Dutch school dominated by large and coarsely comic paintings by Steen.
Italian inc. Correggio's small *Agony in the Garden*. Canova.

Courtauld Gallery
Somerset House, Strand,
London WC2R 0RN.
Tel (44 20) 7848 2526
Fax (44 20) 7848 2589
www.courtauld.ac.uk

Opposite: The Waterseller of Seville, *Diego Velázquez, Apsley House, London*

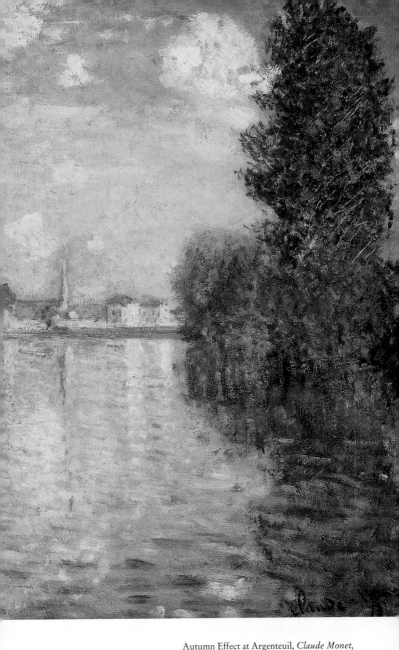

Autumn Effect at Argenteuil, *Claude Monet,*
Courtauld Institute Gallery, London

The Nurture of Jupiter, *Nicolas Poussin, Dulwich Picture Gallery, London*

galleryinfo@courtauld.ac.uk
Mon to Sat 10-6; Sun 12-6. Café.
A fine collection of **Impressionist** and **Post-Impressionist** paintings. Sisleys from his best period in the 1870s; a splendid Renoir, *La Loge** (see ill. p.4); late Monets; Degas;

Manet's *A Bar at the Folies Bergères***, his last and grandest rendering of a theme from modern life. An outstanding group of Cézannes inc. *The Lake at Annecy***. Post-Impressionist works inc. Van Gogh; Gauguin* (the best in

pp.36-7)*, Bruegel*, Claude (a small copper*, with a 17C Grand Tourist crossing a bridge at Tivoli, and, glittering on the skyline, the dome of St Peter's), a fine group of Rubens' paintings and sketches, esp. a *Moonlit Landscape** (see ill. pp.42-3).

Dulwich Picture Gallery

Gallery Rd, London SE21 7AD.
Tel (44 20) 8693 5254
Fax (44 20) 8299 8700
www.dulwichpicturegallery. org.uk
info@dulwichpicturegallery.org.uk
Tues to Fri 10-5; Sat, Sun, Mon 11-5. Closed Mon.

A bizarre gallery, designed by Sir John Soane, combining picture galleries with the mausoleum of Sir Francis Bourgeois and Noël Desenfans, the two principal founders of the gallery.

British: a representative collection of 17C and 18C portraits inc. Gainsborough.

Dutch and Flemish: one of the richest sections. 17C Dutch inc. Rembrandt** and a wide range of landscape painting. Flemish collection is dominated by Rubens (a series of oil sketches and paintings**) and Van Dyck*, ranging from an early biblical scene, *Samson and Delilah,* bold and painterly, to the cool tonalities of his late portraits.

French: an important collection of seven Poussins**, mainly early works (the *Triumph of David* shows the beginnings of a new classicism); Claude*; Watteau*.

Italian: a small collection of early Italian works; Piero di Cosimo and Raphael. 17C inc. Guercino and Reni*.

England) see ill. pp.78-9); Seurat*. **Italian:** an interesting group of early Italian works inc. Bernardo Daddi*; Lorenzo Monaco, and, from the 18C, oil sketches by Tiepolo*. North European schools inc. Master of Flémalle (see ill.

379

Estorick Collection of Modern Italian Art

39a Canonbury Sq,
London N1 2AN.
Tel (44 20) 7704 9522
Fax (44 20) 7704 9531
www.estorickcollection.com
curator@estorickcollection.com
Wed to Sat 11-6; Sun 12-5. Café.

A collection of Italian art from 1890-1950s, shown in changing displays. The highpoints (always on show) are works by De Chirico and Modigliani, and a group of Futurist works inc. Balla, Boccioni (see ill. p.174), Russolo, Severini, Sironi (see ill. p.14) – artists almost unrepresented elsewhere in Britain.

The Foundling Museum

40 Brunswick Sq,
London WC1N 1AZ.
Tel (44 20) 7841 3600
Guided tours of the collection by arrangement only.

The Foundling Hospital Pictures: several history pictures by Hogarth and his contemporaries; 8 roundels of London hospitals (one by Gainsborough, two by Wilson) in the Court room with its original charming Rococo decoration. Good 18C British portraits inc. Hogarth's *Captain Thomas Coram**.

Gilbert Collection

South Building, Somerset House,
Strand, London WC2R 1LA.
Tel (44 20) 7420 9400
Fax (44 20) 7420 9440
www.gilbert-collection.org.uk
Daily inc. pub hols 10-6; 31 Dec: 10-4; 1 Jan: noon-6; closed 24, 25 and 26 Dec.

Opposite: La Musica (Music), *Luigi Russolo, Estorick Collection of Modern Italian Art, London; below:* Plaque with two dogs, *Mosaic, Georgii Wekler, Gilbert Collection, London*

An interesting collection of miniatures (see ill. p.353) and Italian painting rendered in micromosaic, a Roman 19C speciality (see ill.pp.212-3).

Hampton Court Palace

Hampton Court, East Molesey, Surrey KT8 9AU.
Tel (44 20) 8781 9500
Fax (44 20) 8781 9500
www.hrp.org.uk
Mid-Mar to mid-Oct: Tues to Sun 9.30-6, Mon 10.15-6;
Mid-Oct to mid-Mar: Tues to Sun 9.30-6.30, Mon 10.30-6.

Hampton Court, lived in by British kings and queens from Henry VIII to George II, houses an extensive collection of works of art from the Royal collection. Despite their very damaged state the *Triumphs of Caesar** by Andrea Mantegna (Lower Orangery) are among the most impressive monuments of Renaissance art outside Italy. In the Renaissance galleries (quiet and pleasant to visit even in high season) are outstanding 16C and 17C works.

German and Netherlandish inc. Holbein, Cranach and Bruegel **Italian:** inc. Titian*, Savoldo, a charming Costa portrait*, a wonderfully refined Parmigianino*, and a Dosso Dossi*, with eerie effects of noctural light. A group of portraits inc. Giulio Romano* and Lorenzo Lotto's compelling and softly-handled *Portrait of Andrea Odoni**, the sitter surrounded by fragments of antique sculpture. On display elsewhere are works by Annibale Carracci*, Ricci, Cristofano Allori's darkly sensual portrait* of his mistress as *Judith*, carrying the severed head of Holofernes, the artist's self portrait, and the famous *Self-Portrait** by Artemisia Gentileschi.

The Iveagh Bequest

Kenwood, Hampstead NW3 7JR.
Tel (44 20) 7973 3891
Apr-Sept, Mon to Sun 10-6;
Oct-Mar. Mon to Sun 10-4.

An Adam house, overlooking a landscaped corner of Hampstead Heath. One of the most charming places in London. The collection is dominated by Rembrandt's *Self-Portrait*** c.1663, overpoweringly grand and a virtuoso display of his painterly technique; individual works of high quality by Cuyp, Van Dyck, Hals and Vermeer*. Yet the main stress of the collection is on English, and some French, 18C paintings, inc. Boucher, Reynolds, Romney and Gainsborough (*Mary, Countess Howe**).

Leighton House Art Gallery

12 Holland Park Rd, W14 8LZ.
Tel (44 20) 7602 3316
Fax (44 20) 7371 2467
Wed to Mon 11-5. Closed Tues.

An exhibition of Victorian art inc. Millais, Burne-Jones and Waterhouse, displayed in the exotic house of the High Victorian painter, Lord Leighton.

The National Gallery

Trafalgar Square,
London WC2N 5DN.
Info (44 20) 7747 2885
Fax (44 20) 7930 4764
information@ng-london.org.uk
www.national-gallery.org.uk
Daily 10-6, Wednesday 10-9.

The National Gallery is perhaps

the most representative of the great national collections – if you want to study the whole development of European painting from about 1260 to 1900 there is nowhere better to go. It is user friendly, with a good Gallery Guide Soundtrack and Micro Gallery, a computer information room which provides a visual encyclopedia of the collection. In 1991 the new Sainsbury Wing (designed by Roberto Venturi) opened. Here, in a sequence of calm rooms where grey *pietra serena* evokes memories of Florentine churches and palaces, is displayed the **Early Renaissance collection****, one of the glories of the gallery. Northern and Italian works before 1510 are integrated in a chronological hang, stimulating comparisons and a sense of the exchange of ideas. 14C works inc. the *Wilton Diptych***, Sienese works by Duccio*, and Ugolino di Nerio. The Florentine Renaissance opens with Masaccio's *Virgin and Child***, and inc. works by Pollaiuolo and Uccello's *Battle of San Romano***, demonstrating Florentine interest in perspective and anatomy, and contrasting with the lyrical grace of the Sienese Sassetta's *Scenes from the Life of St Francis**. Second generation represented above all by Botticelli, from an early *Adoration of the Magi,* to the *Mars and Venus**, and culminating in the *Nativity* of his last years – an intensely personal visionary painting, which ignores the Renaissance interest in weight and three dimensional space (compare Giorgione's *Adoration of the Magi**, which glows with light and colour). A small room is

devoted to Piero della Francesca's *Nativity*** and *Baptism***. North Italian inc. Crivelli, the best collection outside Italy; Bellini** (esp. the *Doge Leonardo Loredan)*** and Mantegna**. The weight and solidity of Mantegna's *Agony in the Garden* contrasts with Bellini's poignant use of a dusky light in the same subject. Leonardo's cartoon, *Virgin and Child with St Anne and with St John the Baptist***, and *Virgin of the Rocks*** conclude the Italian display. Throughout these works are juxtaposed with Netherlandish and German pictures. Netherlandish are dominated by Van Eyck's *Arnolfini Marriage**** (no longer thought to show a wedding), rich in miraculously observed detail and effects of light. The collection is rich in portraits – compare the three-quarter view and surface realism with the remoteness of the Italian Renaissance silhouette portrait. German inc. the Master of St Bartholomew and Dürer's *The Painter's Father*.

The **Sainsbury Wing** is linked to the main building, which shows the rest of the collection.

British: magnificent examples of 18C English portraiture and 19C landscapes inc. Constable and Turner, and a tiny and intense sketch by Thomas Jones. Also works by Hogarth and Stubbs.

Dutch: an extensive collection, with excellent examples of the best known portraits, genre, marine, and landscape painters, inc. two courtyard scenes by de Hooch**. Hobbema's uncharacteristic masterpiece, *Avenue at Middelharnis**, Rembrandt** – a large collection of

many aspects of his work, from the early fanciful *Portrait of Saskia as Flora* and the flamboyant baroque of *Belshazzar's Feast*, through the dignified yet richly clad *Self-Portrait at 40*, to the austere, grand yet stubbornly realistic *Margareta de Geer* and *Jacob Trip*.

Flemish: Gossaert and Bruegel (a disturbing *Adoration of the Magi**; Rubens coll** outstanding in range and quality, inc. the early *Samson and Delilah*, intensely dramatic and harshly lit, and the late *Judgement of Paris***, funny and tender. A good collection of Van Dyck ranges from the naturalism of his early Antwerp portraits, through the *Balbi Children***, a brilliant evocation of aristocratic childhood, to the silvery colours and refined pastoral charm of his dazzling portraits of Caroline courtiers.

French: 17C richly represented by Claude and Poussin. The Claudes cover his entire range, early naturalistic works, evocations of the Campagna, seascapes and harbour scenes, and mythological paintings, esp. the *Enchanted Castle***. A representative collection of Poussin inc. *Cephalus and Aurora*, the *Adoration of the Golden Calf* and *Landscape with Man Killed by a Snake*. 18C inc. Chardin and Watteau; a dazzling portrait of *Madame de Pompadour* by Drouais. 19C: Ingres* and Delacroix; Corot* and Courbet; a representative collection of Impressionist painting, with good works by Cézanne, Manet, Monet (his *Bathers at La Grenouil-lère* seminal in the early history of Impressionism), Pissarro, Sisley, and Degas. Post-Impressionism inc. Douanier Rousseau and

Redon, but dominated by Seurat's *Bathers***, displayed with eight of his *croquetons* or small sketches.

German: Altdorfer; Holbein** – an oustanding group inc. portraits of *Erasmus* and the *Lady with a Squirrel*; *the Ambassadors,* a complex display of perspectival skills, rich in allusion; and the touching *Christina, Duchess of Milan*, painted for Henry VIII. 17C inc. an unusual group of tiny works on copper by Elsheimer**.

Italian: High Renaissance and Mannerist painting inc. Correggio; Raphael, esp. *St Catherine of Alexandria*; Pontormo and Bronzino, esp. *An Allegory**; 16C Venetian esp. rich: Titian's *Bacchus and Ariadne****, a radiant vision, glowing with light and colour, of joyful love between god and woman, that contrasts with the dark tragedy of his late *Death of Actæon***. Tintoretto; Veronese: North Italian portraiture by Lotto, Moretto and Moroni. 17C dominated by the explosive realism of Caravaggio's *Supper at Emmaus*** and the passion of Salvator Rosa's stormy *Self-Portrait**; Guido Reni's *The Rape of Europa**, with daring contrasts of colour, and a roomful of dazzling oil sketches by Luca Giordano**. 18C inc. works by Canaletto ('*The Stone Mason's Yard*'**); Guardi; Tiepolo's *An Allegory with Venus and Time**.

Spanish: Paintings by Velázquez inc. the naturalistic *Kitchen Scene with Christ in the House of Martha and Mary,* with an elemental still life of eggs and fish; the dazzlingly freely painted *Philip IV in Brown and Silver*; and the '*Rokeby Venus*'***. Two wonderful still

lifes; Zurbarán's small yet magically intense *Cup and Two Roses on a Silver Plate***; Melendez' *Still life with Orange and Walnuts***.

National Maritime Museum

Romney Rd, Greenwich SE10 9NF.
Tel (44 20) 8858 4422
Fax (44 20) 8312 6632
Mon to Sun 10-5.

The best collection of marine paintings in the world inc. many excellent Dutch 17C works (esp. the Van der Veldes) and English paintings inc. Turner's vast canvas of the *Battle of Trafalgar**. Portraits of British seamen and admirals inc. Lely's *12 Flagmen* (Queen's House), unusual amongst his works for their serious interpretation of character; Hogarth's *Lord George Graham in his Cabin;* works by Gainsborough, William Hodges, Reynolds and Romney.

National Portrait Gallery

St Martin's Place,
London WC2H 0HE.
Tel (44 20) 7306 0055
Fax (44 20) 7306 0056
www.ntp.org.uk
Mon to Wed, Sat, Sun 10-6; Thurs and Fri 10-9. Café; restaurant.

A collection of portraits of men and women famous in British history. It is also a history of British portrait painting, and in recent years has become an active patron of contemporary artists.

The collection opens with Tudor portraiture, inc. Holbein's highly illusionistic cartoon of *Henry VIII**, which contrasts with the overpowering and hieratic *Ditchley Portait of Queen Elizabeth I*. The unique *Sir Henry Unton** is

enriched with charming details from his life, inc. his Italian journey. 17C works by Rubens, Van Dyck and Lely evoke the atmosphere of the Stuart courts; 18C Kneller's Kit Kat Club portraits; Hogarth's *Self-Portrait;* Reynold's romantic *Sir Joseph Banks*. From the 19C and 20C portraits of public figures inc. strong works by Sickert and Sutherland; Bryan Organ's haunted *HRH the Prince of Wales*. Portraits of artists and writers inc. self-portraits by Gwen John and Laura Knight; Simon Bussy's informal portrait of *Lytton Strachey;* Hutchison's formidable Renaissance portrait of *Dorothy L. Sayers* smoking. Recent works by Maggi Hambling and Paula Rego (a spiky portrait of *Germaine Greer*, in Jean Muir dress and old tennis shoes).

The Royal Academy of Arts

Burlington House, Piccadilly,
London W1J 0BD.
Tel (44 20) 7300 8000
Fax (44 20) 7300 8001
Mon to Sun 10-6; Fri 10-8.30.
Restaurant.

Major temporary exhibitions. In the Sackler Gallery is Michelangelo's tondo, the *Virgin and Child and St John***

Saatchi Collection

A permenant address is unavailable at the time of going to press. For further information, call (44 20) 7624 8299.

Temporary exhibitions drawn from Charles Saatchi's enormous and taste-defining collection of contemporary British art.

Sir John Soane's Museum

13 Lincoln's Inn Fields,
London WC2A 3BP.
Tel (44 20) 7405 2107
Fax (44 20) 7831 3957
www.soane.org
First Tues of each month 6-9 pm;
Tues to Sat 10-5.

An extraordinary museum, designed by the eccentric architect Sir John Soane, crowded with a strange mixture of objects. Paintings inc. two series by Hogarth: *The Rake's Progress* and *The Election* (see ill. pp.350-1). Also Canaletto's *Riva***.

Tate Britain

Millbank, London SW1P 4RG.
Tel (44 20) 7887 8000
Fax (44 20) 7887 8007
www.tate.org.uk
information@tate.org.uk
Mon to Sat 10-6, Sun 2-6.

Tate Britain shows changing displays of the National Collection of British Art. The collection opens with Tudor and Stuart portraits, esp. Dobson's *Endymion Porter**; a good collection of Hogarth and his contemporaries, and of the major 18C portraitists, esp. Gainsborough's portraits of women. Landscape paintings inc. varied collection of Constable, esp. *Dedham Vale* 1802, and many oil sketches; works by Wilson, Stubbs and Joseph Wright; collection of William Blake. A collection of immensely famous Pre-Raphaelite and Victorian painting inc. Millais' *Ophelia***, Holman Hunt's *The Awakening Conscience**, Rossetti's *Proserpine**, Dyce's *Pegwell Bay** Wallis' *Chatterton* (see ill. p.354). A strong group of works by Whistler (esp. *Miss Cicely Alexander**, indebted both to Velázquez and to Japanese prints) leads on to the intense and frail works of Gwen John, and to the Camden Town Group and Bloomsbury; Stanley Spencer (the *Resurrection**), Nicholson, Hepworth and Francis Bacon. Paul Nash's *Totes Meer***, a haunting and desolate image of an undulating sea of downed German aircraft, contrasts with the idyllic mood of John Nash's *Cornfield**. Amongst more recent works, a strong group of Hockneys**; Maggie Hambling's expressive *Portrait of Frances Rose**; Kitaj; Lubaina Himid.

The Clore Gallery: go in through its own entrance, or you miss the bright architecture and garden terrace. The gallery shows the works of Turner, with changing exhibitions of aspects of his art. At its centre are Turner's Italian paintings, vast and ambitious visions of Italy drenched in allusions to mythology and to a lost classical past; paintings of Petworth show both rolling parkland and almost abstract interiors; the views of Venice* open with a highly detailed *Scene of Canaletti painting*, and move through increasingly abstract works, intensely elegiac and romantic, to the evanescent shimmering whiteness of *Venice with the Salute*. Late works inc. *Norham Castle, Sunrise*.

Opposite: Interior of Sir John Soane's Museum, London, looking from the cast of the Apollo Belvedere towards Sir Francis Chantrey's bust of Soane

Tate Modern, London

Tate Modern
Bankside, London SE1 9TG.
Tel (44 20) 7887 8008
Fax (44 20) 7887 8007
www.tate.org.uk
information@tate.org.uk
Daily 10-6, Sat and Sun 10-10.
Café, restaurant.
A spectacular conversion of a 1950s

power station. Most successful is the Turbine Hall, an immense and gloomy space for contemporary sculpture, and the Millennium Bridge which, linking the gallery with St Paul's like an arrow in flight, is full of meaning and wonderfully effective. But the bleak repetitive spaces of the galleries

create a hostile environment, and the current presentation accentuates this. The exhibition rooms are by way of passages through which the crowds endlessly tramp, and contemporary works are mixed with earlier modernist art to make didactic points that hardly ever work. The Bonnards, Picassos and Braques now seem imprisoned and diminished in an institution that seems cerebral rather than visual.

Representative (though often small) displays of most movements from the early 20C onwards. Unusually fine group of Bonnards*, high quality Cubists* and later Picassos* and Braques*, strong show of German Expressionists* (Schmitt-Rotluff, Kirchner, Beckmann), Matisse's paper cut-out *Snail** and cast bronze *Backs**, Brancusi, Rodin's *Kiss**. Duchamp exhibits inc. version of *The Large*

Glass recreated by Richard Hamilton. Representative American Abstract Expressionism inc. an exceptional Arshile Gorky* and the sombre ensemble** by Rothko is one of the gallery's highpoints. Surrealist work inc. several paintings by Dalí, Magritte and Ernst, and a version of Dalí's *Lobster Telephone*. Giacometti and Barnett Newman. Enchanting constructions* by Naum Gabo; displays of Auerbach and Riley; finely arranged large room of minimalist art (Judd, André, Serra, etc). Video art inc. Bill Viola and Sam Taylor-Wood. Later 20C art inc. Beuys, Baselitz, etc but increasingly concentrates on British artists. All the familiar names are here (Anish Kapoor*, Rachel Whiteread, Cornelia Parker, Mona Hatoum*) but nothing that comes close to the power of Bacon's two triptychs*.

Equivalents for the Megaliths, *Paul Nash, Tate Collections, London*

Stonehenge, *John Constable, 1836, Victoria and Albert Museum, London*

Victoria and Albert Museum

Cromwell Rd, South Kensing-ton,London SW7 2RL.
Tel (44 20) 7942 2000
Fax (44 20) 7942 2266
www.vam.ac.uk
Mon to Sun 10-5.45.

A museum of decorative arts but with strong collections of painting and sculpture. The most important pictures are the Raphael tapestry cartoons***, amongst the most influential designs in Western art. The European galleries hold one of the finest collections of Italian Renaissance sculpture outside Italy (sadly very little visitd) with almost all sculptural types – marbles, small bronzes, terracottas, medals, sketch models in wax and terracotta, all richly shown with majolica, furni-ture, marriage chests, birth trays. Outstanding are works by Agostino di Duccio*, Antonio Rossellino*, Luca della Robbia*, a group of works by Donatello,

inc. *Christ Giving the Keys to St Peter*** and the *Chellini Madonna***; small bronzes by Riccio, esp. the tense *Shouting Warrior***; many works by Giambologna** inc. a case of sketch models. There are also wax models* by Michelangelo, and Cellini's sketch model in bronze for the *Head of Medusa***, which provide fascinating insights into working methods. Now marooned in the didactic British Galleries are Canova's *Three Grace*s** and works** by Bernini; his bust of Thomas Baker**, a *tour de force* of flowing hair and lace, contrasts with the detailed realism of Finelli's bust nearby. Roubiliac's *Handel*.

The Henry Cole wing shows a large collection of Constable**; miniature paintings by Holbein, Oliver and Hilliard, though the best esp. the *Unknown Man Lean-ing against a Tree amid Roses*** (inc. Hilliard's) are now in the

British galleries; many 19C English landscapes and genre paintings. The Ionides collection has some unusual works, inc. a haunting Louis Le Nain* of melancholy peasants, and a Degas.

The Wallace Collection
Hertford House, Manchester Square, London W1M 6BN.
Tel (44 20) 7563 9500
Fax (44 20) 7224 2155
admin@the-wallace collection. org.uk
www.the-wallace-collection.org.uk

Statuette of Seated Goddess, *Giovanni da Cremona,*
North Italian, early 14th century, The Wallace Collection, London

Mon to Sat 10-5; Sun 12-5. Café.
The museum is filled with French furniture and *objets d'art* and the predominant impression is of the French 18C, though there is a great deal more. Most famous is Hals' *Laughing Cavalier**. French 18C inc. perhaps the finest collection of Watteau in existence, esp. the *Music Party* and *La Toilette*; Boucher*, inc. mythological and pastoral scenes (see ill. p.75 and p.512). Fragonard's salacious painting *The Swing*. The voluptuousness of the French Rococo contrasts sharply with the grandeur of the Dutch, Flemish and Spanish 17C painting, particularly rich in portraiture. The tenderness of Rembrandt's *Portrait of Titus** contrasts with the stately grandeur of the Van Dycks and with the quietly objective observation and cool tonality of the three pictures by Velázquez*. There is also a fine collection of 17C Dutch landscape and genre, oil sketches by Rubens, *Perseus and Andromeda** (see ill. pp.238-9) by Titian and works by Claude*, Poussin*, Rosa* and Canaletto. Also an unusual collection of French and English Romantic painting. Fine Italian bronzes.

The Whitehall Banqueting House

Whitehall, London SW1A 2ER.
Tel (44 20) 78398919
Mon to Sat 10-5. Closed Sun.
(Worth telephoning in advance as sometimes closed for functions.)
The only Rubens ceiling painting** still *in situ*; painted for Charles I, it is a celebration of the Divine Authority of James I and of the peace and wisdom of his reign.

Temporary exhibitions also held at:

British Museum

Great Russell St, London WC1B 3DG.
Tel (44 20) 7636 1555
Fax (4420) 732 8480
info@british-museum.ac.uk
www.british-museum.ac.uk
Mon to Sat 10-5; Sun 12-6.
Exhibitions often drawn from the outstanding prints and drawing coll.

St Mary Redcliffe, Bristol, dawn, *John Sell Cotman, British Museum, London*

The Queen's Gallery, Buckingham Palace
Buckingham Palace Rd, London SW1 1AA.
Tel (44 20) 7799 2331
Fax (44 20) 7839 1377
Tues to Sat 11-5; Sun 2-5.
Closed Mon.
Paintings from the Royal Collection.

Hayward Gallery
Belvedere Rd, South Bank, London SE1 8XZ.
Tel (44 20) 7928 3144
sbriggs@hayward.org. uk
Daily 10-6; Tues and Wed 10-10.
Mainly contemporary shows.

A Pre-Raphaelite tour

The great collections of Pre-Raphaelite paintings outside London are in Birmingham, Liverpool, Port Sunlight and Manchester; the last three are within easy reach of one another and make a good tour on their own. For those with more time, begin at Birmingham, which has a very large collection with works by the original members of the Brotherhood and by artists associated with them (especially Burne-Jones). Note Millais' moving *Blind Girl* and the detailed realism of Ford Madox Brown's *An English Autumn Afternoon*. Liverpool has Millais' first Pre-Raphaelite oil, *Isabella* (1849); compare this with works from his final Pre-

Laus Veneris, *Edward Burne-Jones,*
Laing Art Gallery,
Newcastle upon Tyne

Raphaelite phase, the *Sir Isumbras at the Ford* at Port Sunlight
and *Autumn Leaves* in Manchester, both heavily symbolic works·
concerned with death. Also at Port Sunlight are important works
by Burne-Jones and Holman Hunt. The pictures in Manchester
date from the later stages of the movement, when it had become
concerned with Realism and with social action. Ford Madox
Brown's *Work** widened the artists' subject matter: its theme is
the relationship of work with society, and it contrasts the manly
beauty of the navvy with the philosopher and beggar. Holman
Hunt's *Hireling Shepherd** (1851) criticized the conventions of
the Pastoral with bold realism.

MANCHESTER

Manchester City Art Gallery
Mosley St, Manchester M2 3JL.
Tel (44 161) 236 5244
Fax (44 161) 236 7369
www.u-net.com/set/mcag/cag.html
cityart@mcrl.poptel.org.uk
Mon to Sat 10-5; Sun 12-5. Café.
A rich and opulent Victorian gallery, with a new extension. Italian art inc. two unexpected works, a *Crucifixion*** attrib. to Duccio, and a bust** by Algardi.

A good collection of **British** painting from 17C to the present day. 17C: John Souch's *Sir Thomas Aston at the Deathbed of his First Wife* (1635). 18C: Gainsborough, Stubbs, some good landscapes. 19C: the main strength of the gallery. Pre-Raphaelites inc. Ford Madox Brown* and Holman Hunt, whose sketch for the famous *Light of the World* was the first of a series of gloomy night pieces; the saving light of Christ seems curiously powerless against the weeds and barred door of the human soul. Millais' *Autumn Leaves** is perhaps the most beautiful of all Pre-Raphaelite pictures; the young and wistful beauty of the girls contrasts poignantly with the twilit sky and the dead leaves. 20C: a good collection that traces the development from Sickert and Steer to the Bloomsbury Group, Camden Town, the Euston Road Group and to present day developments: Hockney, Bacon and Freud.
European 15C to 17C: a few interesting Italian pictures. Flemish and Dutch inc. Van Dyck, small Dutch pictures by a wide variety of lesser known masters (esp. Ochtervelt

and Van Goyen). A small group of 19C French paintings.

Whitworth Art Gallery
University of Manchester,
Oxford Rd,
Manchester M15 6ER.
Tel (44 161) 275 7450
Fax (44 161) 275 7451
whitworth@man.ac.uk
www.whitworth.man.ac.uk
Mon to Sat 10-5; Sun 2-5. Café.
The great strength of the collection is its English watercolours inc. Blake, Cozens, Cotman, Girtin and many Turners; its prints and drawings; and its contemporary paintings and sculptures. The major trends in modern art, esp. British, are well represented. Since the remodelling of the interior in the 1960s the gallery has become one of the liveliest collections of contemporary art outside London. See also the tapestry designed by Paolozzi.

NEWCASTLE UPON TYNE

The Hatton Gallery
The Quadrangle, University of
Newcastle upon Tyne,
Newcastle NE1 7RU.
Tel (44 191) 222 6057
Fax (44 191) 261 1182
hatton-gallery@ncl.ac.uk
www.ncl.ac.uk
Mon to Fri 10-5; Sat 10-4 during
term time. Closed Sun.
Some interesting Old Masters, but most fascinating is the Dadaist Kurt Schwitters' *Elterwater Merz**, the third of his *Merzbau*, constructed in a barn near Ambleside in 1947. The *Merzbau* are architectural constructions, built from odd

fragments of junk and tattered symbols of Western culture.

Laing Art Gallery

New Bridge St, Newcastle upon Tyne NE1 8AG.
Tel (44 191) 232 7734
Fax (44 191) 222 0952
laing@tyne-wear-museums.org.uk
Mon to Sat 10-5; Sun 2-5.
British painting from early 18C to the present day, inc. several works by John Martin and some good Pre-Raphaelite paintings. Burne-Jones* (see ill. pp.394-5).

NORWICH

Norwich Castle Museum

Norwich, Norfolk NRI 4JU.
Tel (44 1603) 493624
Fax (44 1603) 765651
Mon to Sat 10-5; Sun 2-5. Café.
A charming and busy museum, where disparate collections are crammed into the perfect cube of an 11C castle. The high point is the Norwich school. A group of Cotmans – *On the River Greta, Yorkshire,** the *Marl Pit** and the *Interior of St Peter Hungate Church, Norwich** are amongst the finest watercolours ever painted; Crome's *Norwich River, After-noon** is distinguished by its beauty of design and reflections. Among later pictures, Alfred Stannard's bold and painterly *On the River Yare.* Other British paintings inc. large group Tillemans, and some Pre-Raphaelite works. Small collection of Dutch pictures inc. W. Claesz Heda.

Sainsbury Centre for the Visual Arts

University of East Anglia, Norwich NR4 7TJ.
Tel (44 1603) 593 199
Fax (44 1603) 259401
Tues to Sat 11-5. Café.
A new kind of university museum which combines gallery and study spaces. It brings together Modernist art (Bacon, Giacometti, Picasso, Henry Moore) with mainly small scale and high quality works of art from non-Western traditions and cultures.

OXFORD

Ashmolean Museum

Beaumont St, Oxford OX1 2PH.
Tel (44 1865) 278000
Fax (44 1865) 278018
www.ashmol.ox.ac.uk
Tues to Sat 10-5; Sun 2-5.
A grand but gloomy collection, with good **Italian** pictures sump-tuously displayed amongst bronzes, medals, majolica. The star pieces are Uccello's *The Hunt***, disarmingly fresh in its appeal but showing a characteristic preoccu-pation with problems of spatial construction, and Piero di Cosimo's eccentric *Forest Fire***. 16C inc. Bronzino's *Don Garzia de Medici**, with unusual frame. An rare group of Baroque works inc Cecco da Caravaggio's *Musician**, a strongly lit, oddly compelling work, distantly related to Caravag-gio. From the 18C, a splendid Tiepolo*, and Canaletto*.
Dutch and **Flemish**: good 17C landscape and genre, and an inter-esting group of Caravaggesque

A Boy Drinking, *Annibale Carraci, Christ Church, Oxford*

works. Oil sketches by Rubens; Van Dyck. Special collection still life pics.

French: an austere Poussin*, eclipsed by Claude's *Ascanius Shooting the Stag of Sylvia***, his last painting, and a moving evocation of the stormy Campagna with the tall, insubstantial figures characteristic of his late style.

19C and **early modern** period: a room of Pre-Raphaelite works; Barbizon school inc. lovely Corot; a dullish group of works by Pissarro and British painters (Gertler, Spencer).

Christ Church Picture Gallery

Canterbury Quadrangle,
Christ Church, Oxford OX1 1DP.
Tel (44 1865) 276172
Fax (44 1865) 202429
www.chch.ox.ac.uk/gallery
Mon to Sat 10.30-1, 2-4.30;
Sun 2-4.30.

An unusual small collection, most remarkable for its Italian paintings. These inc. interesting Early Italian and Renaissance pictures (see ill. pp.186-7); an unusual small portrait by Pontormo; a powerfully expressive Bassano*. A good Baroque collection is dominated by a group of four Annibale Carraccis, esp. the *Butcher's Shop***, which introduced a new scale and seriousness to genre painting. Also Van Dyck's *Continence of Scipio**.

PORT SUNLIGHT

NR LIVERPOOL

The Lady Lever Gallery

Lower Rd, Port Sunlight,
Wirral CH62 5EQ.
Tel (44 151) 478 4136
Fax (44 151) 478 4140

www.nmgm.org.uk
Mon to Sat 10-5; Sun 12-5. Café.

The collection, formed by the first Lord Leverhulme, has a strong individual character; housed in an imposing Neo-Classical building that dominates the model village of Port Sunlight, the pictures are shown with his collection of furniture and ceramics. 18C and early 19C portraits and landscapes inc. Gainsborough, Reynolds and Romney; a number of Italianate landscapes by Wilson; works by Constable and Turner. Of particular interest are a series of paintings in enamel on Wedgwood plaques by Stubbs. From the later 19C: Leighton's *The Garden of Hesperides*; important Pre-Raphaelite works inc. Hunt's *The Scapegoat*, Millais' *Sir Isumbras at the Ford,* and works by Burne-Jones.

ST IVES

Tate Gallery St Ives

Porthmeor Beach, St Ives TR26 1TG.
Tel (44 1736) 796226
Fax (44 1736) 794480

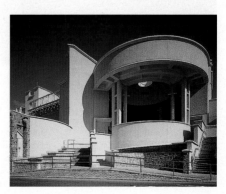

Exterior,
Tate Gallery, St Ives

The Blue Ship, *Alfred Wallis, c. 1934, Tate Gallery St Ives*

www.tate.org.uk
Tues to Sun 10.30-5.30; July and
Aug also open Mon. Opening
hours may be subject to change.
Telephone before you go. Café.

Almost on the beach, the building
has a wonderful relationship with
sea and air, and light and colour; a
large coloured glass window by
Patrick Heron (see ill. p.355) opens

to show the collection – of paintings, ceramics and sculptures by St Ives' artists from 1925-75 – to their best advantage. Highpoints are the collection of pictures* by the retired seaman, Alfred Wallis, highly sophisticated 'naïve' works; ceramics by Bernard Leach; abstract and modernist works by Nicholson, Hepworth and Gabo; landscape and still lifes by Lanyon, Hilton and Scott. Works by Heron inc. an early, sumptuous still life and horizontal stripe paintings.

Barbara Hepworth Museum and Garden

Barnoon Hill, St Ives TR26 1TG. Tel (44 1736) 796226 Tues to Sun 10.30-5.30; July and Aug also open Mon. Opening hours may be subject to change. Telephone before you go.

The studio where Barbara Hepworth lived and worked from 1949 to 1975, now in the care of the Tate Gallery. The garden* is particularly moving, with monumental bronzes displayed in the flickering light and shadow created by dense and lush plantings of ferns and palm trees.

SHEFFIELD

Graves Art Gallery

Surrey St, Sheffield S1 1XZ. Tel (44 114) 273 5158 Tues to Sat 10-5, Sun 2-5.

The main emphasis is on British painting and sculpture c.1900-1980 (inc. Gwen John). Also varied collection of art from 16C to 20C, with some unusual items inc. a large Procaccini.

the display, creating, in the intense whiteness, shifting patterns of light and shade. The building is perhaps more memorable than the works, and some of the spaces are too small

SOUTHAMPTON

Southampton City Art Gallery

Civic Centre, Commercial Road,
Southampton SO14 7LP.
Tel/Fax (44 1703) 632 601
Tues to Sat 10-5; Sun 1-4.
Closed Mon. Café.

A slightly bleak 1930s civic build-
ing, its main hall now transformed
by an installation of stripes
by Daniel Buren, the gallery
regularly rotates its permanent
collection. A handful of European
old masters inc. Bellini, Arcim-
boldo and Van Dyck. Impressionist
works inc. Degas and a fine early
Sisley*. The emphasis is on British
painting: some 18C works but
mainly a lively collection of 20C
art, with works by most Turner
Prize-winning artists. A strong
collection of Camden Town Paint-
ing and works by Lucian Freud,
Richard Long and Gilbert and
George. Outstanding are the 10
large studies (tempera on paper)
from Burne-Jones' *Perseus* series,
well displayed on their own in a
panelled room.

STOCKTON

Preston Hall Museum

Yarm Rd, Stockton on Tees
TS18 3RH.
Tel (44 1642) 781184
1 Oct-Easter: Mon to Sat 10-4.30;
Sun 2-4.30. Easter-30 Sept: Mon
to Sun 10-5.30. Café.

Georgian country house displaying
19C British watercolours and some
European paintings. Most famous
is *The Dice Players**, a picture

rediscovered in the 1970s and
attrib. to Georges de la Tour. It is
a poetic scene, of soldiers and
onlookers, elegant and simplified
figures, mysteriously lit by the
almost concealed flame of a candle.

The New Art Gallery, Walsall

WALSALL

The New Art Gallery
Walsall Gallery Square, Walsall,
West Midlands, WS 2 BLG.
Tel 01922 654 400
Fax 01922 654401
info@artatwalsall.org.uk

Closed Mon except Bank Hols.
Tues to Sat 10-5; Sun 12-5.
A stunning new building shows
the collection created by Kathleen
Epstein, the sculptor's widow, and
Sally Ryan, his pupil. Its charm lies
in its being a private collection, a
slighly random and idiosyncratic

mixture of art from many cultures and centuries, which includes works by Epstein, one or two Old Master prints, and minor works by celebrated 19C artists (a Gauguin woodcut; a van Gogh drawing; a weak Monet).

WINDSOR

Windsor Castle
Windsor, Berkshire SL4 1NJ.
Tel (44 1753) 831118
www.royal.gov.uk
information@royalcollection.co.uk
Nov-Feb: 9.45-4.15;
Mar-Oct: 9.45-5.15.
Most important are a series of portraits of the kings and queens of England and of the members of their court: a small but outstanding group of Holbeins; from the early 17C paintings by Paul van Somer and Honthorst. The aspirations of the later Stuart era are brilliantly seen by Van Dyck. His paintings inc. a *Triple Portrait of Charles I***, intended as a working model for the sculptor Bernini; a group portrait of Charles I's *Five Children*, in which their lively charm is suppressed by all the trappings of the state portrait; two fine double portraits. Portraits by Lawrence of the great figures involved in the defeat of Napoleon. A somewhat miscellaneous collection of other pictures inc. Claude, Clouet, Dürer, three Rembrandts*, a group of works by Rubens, and an outstanding collection of Canalettos*.

WOLVERHAMPTON

Wolverhampton Art Gallery
Lichfield St,
Wolverhampton WW1 1DU.
Tel (44 1902) 312 032
Fax (44 1902) 552 053
Mon to Sat 10-5.
A lively gallery, with Georgian and Victorian paintings, and a fine collection of Pop and contemporary art.

YORK

York Art Gallery
Exhibition Sq,
York YO1 2EW.
Tel (44 1904) 551861
Fax (44 1904) 623839
Mon to Sat 10-5; Sun 2.30-5.
A good small collection of European painting. Outstanding are two Italian portraits, Parmigianino's *Portrait of a Man with a Book** and Annibale Carracci's *Portrait of Monsignor Agucchi*** – an astonishingly vivid painting of an important classical theorist. Charming early Italian panels* inc. Bernardino Fungai, and good 18C works by Bellotto and Batoni. Dutch inc. some unusual works by Baburen, Berchem and Wtewael. British dominated by William Etty, a native of York; also Frith and Gwen John. Two unusual works: Bernini's *Portrait of Poussin** and a Mélendez *Still Life**.

Portrait of a Young Girl, *C. de Vos, Chatsworth House, Derbyshire*

The English country house

The collections of paintings in English country houses illustrate the history of English taste from the 16C onwards. Some of the collections, such as Petworth, have grown slowly and illustrate the changing interest of several generations of patronage and collecting: from sporting pictures and portraits, to Rome and the Grand Tour, and the Golden Age of Dutch art. In the late 19C collectors widened their scope and built up less personal but spectacular collections, such as those at Polesden Lacy, Upton and Waddesdon. Some highlights are detailed below.

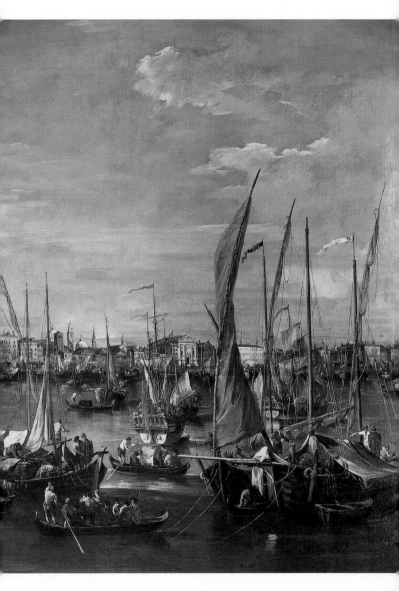

The Bacino di S. Marco with the Molo and the Doge's Palace, Venice, *F. Guardi,*
Waddesdon Manor, Buckinghamshire

BUCKINGHAMSHIRE

Waddesdon Manor
nr Aylesbury,
Bucks HP18 0JH.
Tel (44 01296) 653226
Fax (44 01296) 653208
www.waddesdon.org.uk
Apr-Oct: Thurs to Sun 11-4.
A Rothschild 1880s version of a
Loire château, with important
French decorative pieces by
Boucher, Watteau and Pater.
Outstanding paintings inc. two
large Guardis (see ill. pp.406-7) and
a ravishing series of portraits by
Gainsborough*, Reynolds and
Romney. The Morning Room was
built to show a rich display of
Dutch landscapes and townscapes:
a wall of glowing Cuyps*, genre
scenes by Terborch, Metsu and de
Hooch. Leon Bakst's magical
panels of *Sleeping Beauty* add an
unusual 1920s element.

CAMBRIDGESHIRE

Anglesey Abbey
Lode, Cambs CB5 9EJ.
Tel/Fax (44 01223) 811200
www.angleseyabbey.freeserve.co.uk
aayusr@smtp.ntrust.org.uk
Apr-Oct: Wed to Sun 1-5.
The collection is notable for the
Altieri Claudes**: *Landscape with
the Father of Psyche Sacrificing to
Apollo* and *Landscape with the
Arrival of Æneas at Pallanteum*,
considered, since the 18C, to be
amongst Claude's most famous
paintings. Collection of English
paintings with some interesting
Norwich School works. Etty.

DERBYSHIRE

Chatsworth House
Bakewell, Derbyshire,
DE45 1PP.
Tel (44 01246) 582204
Fax (44 01246) 583536
www.chatsworth-house.co.uk
visit@chatsworth-house.co.uk
House: mid-Mar-Oct, daily 11-5.30.
Garden: mid-Mar-Oct, daily 11-6.
Elaborate illusionistic wall- and
ceiling-paintings by Verrio,
Laguerre and Thornhill. Illusion-
istic door-painting of violin by van
der Vaardt. Rich coll. of paintings
inc. Rembrandt, Hals, C. de Vos
(see ill. p.405), Tintoretto, Veronese,
Ricci and Freud, and family
portraits inc. Van Dyck). Impor-
tant collection of Neo-Classical
sculpture inc. works by Canova
and Thorvaldsen. Modern patron-
age includes a Freud double
portrait and sculpture by Frink and
water-sculpture by Angela Conner
in garden.

LEICESTERSHIRE

Belvoir Castle
nr Grantham,
Lincs NG32 1PD.
Tel (44 01476) 870 262
Fax (44 01476) 870 443
info@belvoircastle.com
1 Apr-31 Oct: Tues to Thurs,
Sat, Sun 11-5.
A gloomy 19C version of a
medieval castle, where pictures of
outstanding quality have recently
been cleaned, restored and rehung
(inc. many pictures not previously
on show). Collection inc. works
by Gainsborough, Reynolds, and

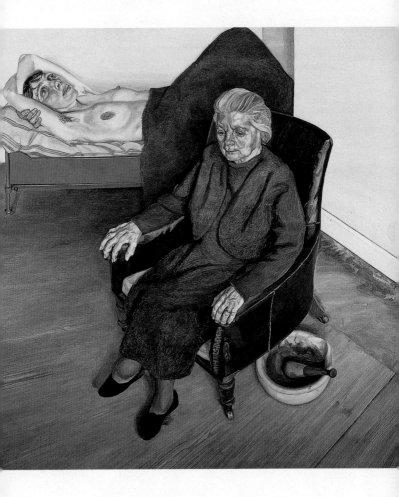

Large Interior, W9, *Lucian Freud,*
Devonshire Collection, Chatsworth, Derbyshire

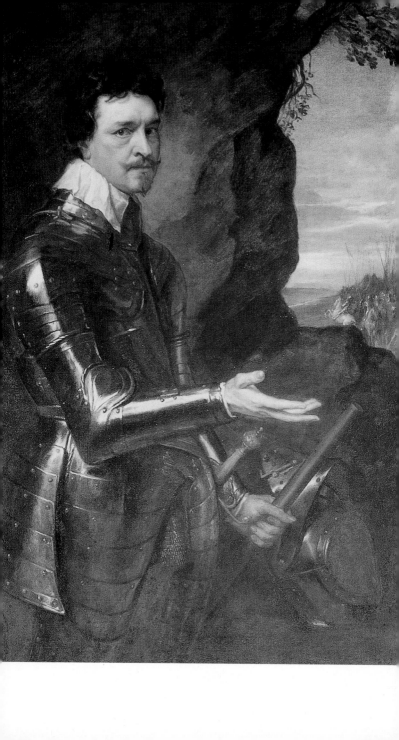

five of Poussin's first series of the *Seven Sacraments** commissioned by Cassiano dal Pozzo in the late 1630s (not hung together: two are in the chapel).

OXFORDSHIRE

Buscot Park
nr Faringdon.
Apr-Sept: Wed to Fri 2-6; 2nd and 4th weekends in each month, 2-6.
The saloon contains Burne-Jones' famous decorative scheme *The Legend of the Briar Rose** (four large canvases and ten connecting scenes). Two Rembrandts, one the late *Clement de Jongh****. An early Rubens portrait of the *Marquesa Brigida Spinola Doria** (damaged but still flashily impressive).

SURREY

Polesden Lacy
nr Dorking,
Surrey RH5 6BD.
Tel (44 01372) 452048
Info (44 01372) 458203
Fax (44 01372) 458023
spljac@smtp.ntrust.org.uk
29 Mar-29 Oct: Wed to Sun 1-5.
Some unusual early Italian painting, but outstanding are 17C Dutch paintings, inc. Terborch and de Hooch, tavern scenes by Ostade and Teniers, and landscapes by Salomon van Ruysdael and Jacob van Ruisdael.

WARWICKSHIRE

Upton House
nr Banbury, Oxon OX15 6HT.
Tel/Fax (44 01295) 670266
www.ntrustsevern.org.uk
upton_house@smtp.ntrust.org.uk
Apr-Oct: Sat to Wed 2-6.
Early Netherlandish paintings and a first rate collection of 17C Dutch genre and landscapes. Good English paintings, esp. Stubbs, and Romney. A version of the Bosch *Adoration* in the Prado and a grisaille of the *Dormition of the Virgin** by Bruegel. Also El Greco.

WEST SUSSEX

Petworth House
Petworth, W. Sussex GU28 0AE.
Tel (44 01798) 342207
Fax (44 01798) 342963
Apr-Oct: Mon, Tues, Wed, Sat, Sun 1-5.30.
Best known for the collection of works by Turner* – many paintings of Petworth itself. Also the eight *Patriarchs, Martyrs and Saints* by Elsheimer, works of great weight and grandeur, despite their minute size. Note Claude's *Landscape with Jacob and Laban* and Van Dyck's pair*, *Sir Robert Shirley* and his *Wife* in Persian dress, and his portraits of the *Earl of Strafford* and the *Countess of Bedford*.

Opposite: Ist Earl of Strafford, *Van Dyck,* Petworth House, West Sussex

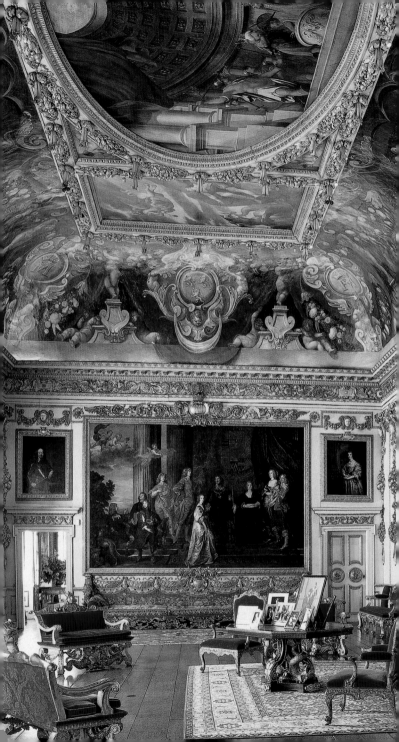

WILTSHIRE

Corsham Court
Chippenham SN13 0BZ.
Tel (44 01249) 701610
Fax (44 01249) 444556
Oct-Nov, Jan-Maundy Thurs:
Tues-Thurs, Sat, Sun 2-4.30;
closed Mon, Fri.
Good Fri-Sept: Tues-Sun;
closed Mon. Closed Dec.
A splendid Grand Tour collection of mainly 16C and 17C Italian painting inc. works by Pietro da Cortona*, Dolci, Reni, Rosa and Strozzi. Also a tumultuous early Van Dyck*.

Wilton House
Wilton, Salisbury, Wilts SP2 0BJ.
Tel (44 01722) 746720
Fax (44 01722) 744447
Apr-Oct: Mon to Sun 10.30-5.30.
The fine 'double cube' room contains many works by Van Dyck.

Interior, (Double Cube Room),
Wilton House, Wiltshire

413

United States of America

Opening hours and admission: generally open Tuesday to
Saturday 10-5, Sundays and national holidays 2-6. Often closed on
Mondays. Admission is often free, but in many cases a 'voluntary'
contribution is expected.
National holidays: Jan 1, 3rd Mon in Feb, July 4, 1st Mon in
Sept, Nov 11, 4th Thurs in Nov, Dec 25. Museums usually close
at Christmas, New Year's Day, July 4 and Thanksgiving (4th
Thurs in Nov). Opening hours same as Sunday on other holidays.
NB: A public collection of art is referred to as an 'art museum', not
a gallery, which would imply that it was commercial. 'Docents' are
lecture-guides.

For easy reference, towns are grouped by state in the following list.
Arizona: Tucson; **California**: Berkeley, Los Angeles, Malibu,
Pasadena, San Diego, San Francisco, San Marino, Santa Barbara;
Connecticut: Farmington, Hartford, New Haven; **Delaware:**
Wilmington; **District of Columbia:** Washington; **Florida:** Sarasota;
Georgia: Atlanta; **Illinois:** Chicago; **Indiana:** Indianapolis, Notre
Dame; **Louisiana:** New Orleans; **Maryland:** Baltimore;
Massachusetts: Boston, Cambridge, Williamstown, Worcester;
Michigan: Detroit; **Minnesota:** Minneapolis; **Missouri:** Kansas
City, St Louis; **New Hampshire:** Manchester; **New Jersey:** Prince-
ton; **New Mexico:** Santa Fe; **New York:** Buffalo, New York,
Purchase; North Carolina: Raleigh; **Ohio:** Cincinnati, Cleveland,
Dayton, Oberlin, Toledo; **Pennsylvania:** Merion, Philadelphia,
Pittsburgh; **Puerto Rico:** Ponce; **Rhode Island:** Providence; **South
Carolina:** Greenville; **Texas:** Austin, Dallas, Fort Worth, Houston,
Marfa; **Virginia:** Norfolk, Richmond.

For over a century the American collectors have been amongst the
world's richest and most pertinacious. An early interest in the
Impressionists and Post-Impressionists was fostered by the dealer
Durand-Ruel in the mid-1880s. In the mid-19C travellers began to

Opposite: The Artist in His Museum, *Charles Wilson Peale, 1822,*
Pennsylvania Academy of the Fine Arts, Philadelphia, Pennsylvania

Penn's Treaty with the Indians, *Benjamin West,*
Pennsylvania Academy of Fine Arts, Philadelphia, Pennsylvania

bring back Old Masters, particularly by the Italian primitives, and the millionaire collector continues to provide lavish museums and highly specialized collections. The regional collections and study collections created by the Kress Foundation play a special role and the university art collections are unique in their importance. A knowledge of contemporary art has been fostered by the influence of the Museum of Modern Art, New York.

Art in America

American painting, developed under the patronage of a predominantly middle-class society, is characterized by a strong tradition of Realism; portraiture, landscape, genre and still life have flourished. Throughout the 18C artists, mainly artisans and craftsmen, received little formal training, and a vigorous tradition of naïve or folk art persisted until the 1870s. The *Peaceable Kingdom* paintings of Edward Hicks (1780-1849), in which the lamb lies down with the wolf and the lion, are some of the most attractive products of this style.

Mrs James Russell (Katherine Graves), *John Singleton Copley, North Carolina Museum of Art, Raleigh, North Carolina*

Young Omahaw, *Charles Bird King*,
Smithsonian American Art Museum, Washington DC

The first to rise above these limited conditions, John Singleton Copley (1738-1815), a Bostonian, developed a powerfully sincere and direct style of portraiture before his departure for Europe in 1774. Here he became famous for his revolutionary treatment of scenes from modern history; *Brook Watson and the Shark*, lurid, contemporary and un-heroic, anticipates aspects of French Romanticism. In London the American, Benjamin West, had become one of the leading painters. At first deeply influenced by Raphael, his renderings of contemporary history became increasingly baroque and dramatic. Gilbert Stuart studied with West in London and returned to make a highly successful career in portraiture, a genre in which a strong American style began to flourish.

From the 1830s landscape and genre became as important as portraiture. Soon after 1800 Washington Allston introduced an intensely romantic kind of landscape painting; from 1825-70 the Hudson River School painters, dominated by Thomas Cole, glorified the grandeur of untouched nature. In the mid-19C the Luminists concentrated on the special qualities of light and at mosphere in nature. In the later 19C many American artists – Cassatt, Sargent, Whistler – emigrated and became part of the

Cape Cod Morning, *Edward Hopper,*
Smithsonian American Art Museum, Washington DC

European tradition. Others remained independent; Winslow Homer
brought a new realism, inspired by Courbet and the Impression-
ists, to scenes of the sea; Thomas Eakins, insistently realistic,
painted an important series of group portraits of the medical
faculty. Ryder, a visionary and romantic artist, stood outside the
realistic tradition.

At the turn of the century this tradition persisted; the Ashcan
School, of whom the most important was George Bellows, painted
the seamy side of life in New York. In 1913 the Armory Show
introduced, with overwhelming impact, modern European art to
New York. The 1930s saw a revival of regionalism in both style and
subject matter; the work of the Mexican mural painters – Rivera,
Orozco and Siqueros – encouraged artists to try to evolve, in the
face of fascism, a democratic art of social protest.

Yet these developments were overwhelmed by the arrival in
New York, shortly after the outbreak of the Second World War,
of a prominent group of Surrealist painters, who gave a powerful

Opposite: The Bath, *Mary Cassatt, 1891-92,*
The Art Institute of Chicago, Chicago, Illinois

Number 8, 1949 *oil, enamel and aluminium paint on canvas, Jackson Pollock,*
Neuberger Museum of Art, Purchase, New York

stimulus to the development of Abstract Expressionism. At the
centre of Abstract Expressionism is the desire to reveal, through
the spontaneous act of painting, without recourse to any
preconceived style, the depths of the human mind. The vigour of
Jackson Pollock, who poured paint on to the canvas, creating a
surface pattern of swirls and spatters, may be contrasted with
Rothko's soft rectangles of colour that induce a state of almost
mystic contemplation. Other important artists are de Kooning, Still,
Motherwell, and Gorky. Gorky's works, with their suggestion of
claws and parts of the body, form the closest link with Surrealism.
Artists who followed Abstract Expressionism, loosely linked
together under the title Post-Painterly Abstraction, are character-
ized by a narrow concentration on purely formal considerations.
Morris Louis developed a technique of staining large canvases

with bands of acrylic colour; Barnett Newman's large canvases of a single colour are divided by strips, or zips.

In the mid 1950s artists began to bring art back to life. The assemblages of Rauschenberg preceded the development of Pop Art. Loud, brash and glossy, Pop artists drew their imagery from urban life, from magazines, TV commercials, foodstuffs and the world of popular entertainment. Lichtenstein, in the early 1960s, painted a powerful series of enlargements from comic strips; Warhol's material, even more unexpected and banal, depends on apparently meaningless repetition. At the same period the Minimalists developed a bleak art that stresses the self-sufficiency of painting.

Since then movements and sub-movements have proliferated so rapidly, and in so complex a pattern, that it is almost impossible to follow them – they include Op Art, Earth works, Conceptual

Untitled (water/stones), *Ann Hamilton, 1993,*
Museum of Contemporary Art, Chicago, Illinois

art, Performance, Video, Realist Revival, Post-Minimalism, Body
Art, Process Art and Scatter Works. In the 1970s and 1980s many
artists (Brice Marden, Cy Twombly, Julian Schnabel) were
redefining painting. On the West Coast Miriam Schapiro and Judy
Chicago opened the way for a new women's art. In the 1970s there
was a strong interest in photographic activity (Cindy Sherman).

Video art emerged in the 1960s; its founder was Nam June Paik,
who created installations using rows of television sets. More recent
video art has moved away from his sculptural approach; Gary
Hill unites the image with spoken and written texts and sculpture;
Bill Viola uses space, time, sounds, and light and dark in deeply
moving sequences which reflect his interest in eastern spirituality.

Opposite: Merce C, *Franz Kline, Smithsonian American Art Museum*

ATLANTA GEORGIA

High Museum of Art
1280 Peachtree St NE,
Atlanta GA 30309.
Tel (1 404) 733 4400
Fax (1 404) 733 4502
www.high.org
Tues to Sat 10-5; Sun 12-5.
Closed Mon. Café.
One of the first and most dazzling of the new museums, designed by Richard Meier, with white enamelled surfaces. European paintings inc. small collections of **Dutch** and **Italian** works, inc. a Bellini *Madonna*; **French** inc. Tournier*, Bazille; and 18C-20C American pictures, inc. Henri, Rothko.

AUSTIN TEXAS

Jack S. Blanton Museum of Art
The University of Texas at Austin, 23rd and San Jacinto, Austin TX 78712.
Tel (1 512) 471 7324
www.utexas.edu/cofa/bma
Mon to Fri 9-5; Thurs 9-9; Sat, Sun 1-5. Closed all university hols.
The Suida Manning collection of north Italian, Genoese and French Baroque art makes this one of the finest university art museums, and one of the largest collections of Italian old masters outside Europe. It has early works by both Claude and Poussin; good works by the Caravaggisti, inc. Vignon's *David with the Head of Goliath**, very close to Caravaggio in composition and in mood, and an exceptionally lovely Vouet*, painted when the artist was turning away from Caravaggio towards Bolognese elegance and to subtle and daring harmonies of colour; unusual works by the Genoese Luca Cambiaso, and Guercino. Also good collection of 20C and contemporary American art.

BALTIMORE MARYLAND

The Baltimore Museum of Art
Art Museum Drive,
Baltimore MD 21218.
Tel (1 410) 396 7100
Fax (1 410) 396 7153
www.artbma.org
Wed to Fri 11-5; Sat and Sun 11-6. First Thurs of the month 11-9. Closed Mon, Tues.
The high point is the Cone Collection, a superb collection of French 19C and 20C painting and sculpture, with special emphasis on Matisse and the early paintings and drawings by Picasso. The Cone sisters met Matisse in 1905-6, and the room in which their collection is displayed evokes the atmosphere of the rooms in the Marlborough apartments where they lived. Introduced by charcoal portraits of the two sisters, the 42 oils** by Matisse cover the period 1895-1947, and inc. still lifes, landscapes, odalisques (see ill. p.428), and *The Pink Nude* (1935).

The collection of Old Masters inc. Van Dyck's *Rinaldo and Armida** (see ill. p.38), one of his major mythological works, profoundly Titianesque in its fiery colour and sentiment; works by Poussin, Hals and Chardin. A collection of 20C sculpture emphasizes the human figure.

David with the Head of Goliath, *Claude Vignon, c. 1620,*
Jack S. Blanton Museum of Art, Austin, Texas

Purple Robe and Anemones, *Henri Matisse,*
The Baltimore Museum of Art, Baltimore, Maryland

Walters Art Gallery

600 North Charles St,
Baltimore MD 21201.
Tel (1 410) 547 9000
Fax (1 410) 783 7969
www.TheWalters.org
Tues to Fri 10-4; Sat and Sun
11-5. First Thurs of the month
10-8. Closed Mon. Entry fee on
1st Thurs 5-8; every Sat 11-1. Café.
Famous for the grandeur of its
collection of Italian painting which
'strongly resembles the *galleria* of
a noble European, specifically an
Italian' (Zeri). The great pleasure of
the collection is that in addition to
the famous works by Sienese and
Florentine 14C and 15C painters,
and works by Filippo Lippi,
Pinturicchio and Raphael, it
contains many works by schools
such as those of Umbria and the
Marches, that are rarely found
outside those areas. Well-known
names may be viewed not in
isolation but with their lesser
known contemporaries. Florentine,
Sienese, Umbrian and North Ital-
ian schools of the 14C and 15C are
well represented, and inc. Giovanni
di Paolo* and Fra Filippo Lippi.
From Central Italy is the famous
*View of a Piazza**, an architectural
perspective that has been attrib. to
many painters; an *Annunciation* by
Bicci di Lorenzo, wonderfully
preserved with frame and
baldacchino. 16C inc. Raphael's
*Virgin of the Candelabra** and
paintings by the Tuscan Manner-
ists. Also a good collection of 17C
Baroque and one of the most repre-
sentative collections of 18C
paintings in America. Elsewhere in
the gallery, exhibited with examples
of decorative art, are paintings by

Boucher and Monsù Desiderio. A
good collection of French 19C
painting inc. the Barbizon school,
works by Delacroix, Ingres,
Pissarro and Sisley. Manet's *At the
Café** is an outstanding example
of his desire to capture the rapid
tempo of modern life. The Barye
Gallery houses a large coll. of sculp-
tures and watercolours by Barye.

BERKELEY CALIFORNIA

University of California, Berkeley Art Museum and Pacific Film Archive

2626 Bancroft Way,
Berkeley CA 94720-2250.
Tel (1 510) 642 0808
Fax (1 510) 642 4889
www.bampfa.berkeley.edu
Wed to Sun 11-5; Thurs 11-9.
Closed Mon, Tues.
The excellent building of aggres-
sively modernist exposed concrete
is one of the largest university art
museums in the US. Outstanding
for 20C American painting and
conceptual art, inc. the largest
single collection of Hans Hofmann.
Also a good collection of Euro-
pean 20C painting. Individual
works from earlier periods
(Rubens, Caracciolo, Cézanne).

BOSTON MASSACHUSETTS

Boston Public Library

700 Boylston St, Boston MA 62116.
Tel (1 617) 536 5400
Fax (1 617) 236 4306
www.bpl.org
Mon to Fri 9-9; Sat 9-6.
Closed Sun (Oct-May: 2-6).

On the second floor loggia of the main staircase, a cycle of Arcadian allegories by Puvis de Chavannes. In the Delivery Room, the frieze between the wainscot and the ceiling was painted by Edwin Austin Abbey with scenes from the *Life of Sir Galahad and the Knights of the Round Table.* The Sargent Hall is decorated with a sequence of murals by Sargent on Judaism and Christianity, a strange blend of Egyptian and Assyrian styles, and gilded Byzantine casts applied in relief to the surface.

Isabella Stewart Gardner Museum

The Fenway, Boston MA 02115.
Tel (1 617) 566 1401
Fax (1 617) 232 8039
www.boston.com/gardner
Tues to Sun 11-5. Closed Mon.
Isabella Stewart Gardner (1840-1524) built this museum which she planned with her husband, John Lowell Gardner; the building is a recreation of a 15C Italian palace, enriched with decorative details – panelling, balconies, window-frames and sculpture – from Venice. The centre court is filled with flowers and has a Roman mosaic floor. In this rich and highly personal setting are works of very high quality. It has a strange, Sleeping Beauty atmosphere, as change is not allowed.
Dutch and Flemish inc. Rembrandt*, Rubens*.
Italian: early collection inc. Fra Angelico, Botticelli, Simone Martini*, Pesellino, Piero della Francesca and Uccello. 16C collection inc. Raphael*, and Titian's *Rape of Europa***, one of the most

famous Italian paintings in America. **19C and 20C** paintings inc. portraits by Degas, Manet and Sargent, and landscapes by Matisse, Sargent and Whistler.

Museum of Fine Arts

Huntington Ave, Boston MA 02115.
Tel (1 617) 267 9300
Fax (1 617) 267 0280
Web www.mfa.org
Mon, Tues 10-4.45; Wed to Fri 10-9.45; Sat and Sun 10-5.45.
One of the foremost collections of painting in America, particularly rich in French paintings from 1826-1900.
American: one of the richest coll., inc. many portraits by Copley and Gilbert Stuart and paintings by Homer, Eakins and Whistler.
British: 18C represented by several individual masterpieces, inc. Gainsborough and Stubbs. 19C school inc. Turner's *The Slave Ship**.
Dutch: a small collection, inc. two exceptional pairs of Rembrandt portraits from the 1630s, and some good landscapes.
Early Netherlandish: inc. Bosch, Van der Weyden*, Lucas van Leyden*.
French: 17C collection inc. Poussin* and Claude* – compare the lively naturalistic detail and sparkling light of the early *River Landscape* with the grandeur and more generalized treatment of *Parnassus*. 19C collection particularly rich in works by Millet and the Impressionists Manet, Monet, Renoir and Sisley. A superb array of varied and overwhelmingly attractive Monets cover the period of High Impressionism, when Monet was fascinated by snow scenes and by the brilliant contrasts

of red flowers against the complementary green of fields and foliage. A group of Mediterranean scenes of the late 1880s shows him moving towards a heightened range of pinks, oranges and mauves. Also late works painted in Venice and London. Post-Impressionism represented by Van Gogh, Redon and Gauguin's *Whence Come We? What are We? Where are We Going?*** 1857 – a majestic recapitulation of themes and ideas that recur throughout his work.

Italian: Duccio's altarpiece of the *Crucifixion* and works by Fra Angelico and Giovanni di Paolo. Venetian school: works from 16C and 18C inc. Tiepolo.

Spanish: inc. an exceptional altarpiece by 15C Aragonese master Martin de Soria, and major works by 16C and 17C painters, inc. El Greco* and Velázquez's *Don Balthasar Carlos and his Dwarf**; the child, striving for regality, and the dwarf, aping childishness, present a moving contrast.

Early modern: collection inc. Cubists and Expressionists.

Post 1955: inc. very large group of American Colour-field artists, esp. Morris Louis. Europeans inc. Baselitz, Kiefer, Richter, Polke.

The gallery houses an outstanding collection of contemporary painting, but also has a Rubens sketch, a collection of British paintings, and an important collection of French 19C works inc. Gauguin's *Yellow Christ* and the *Spirit of the Dead Watching*.

The artistic trends of the first half of the 20C – Cubism, Surrealism, and Constructivism – are well represented by works by Picasso, Braque, Matisse, Mondrian, Miró and the Russian Constructivists. A varied and representative collection of the first and second generation of Abstract Expressionists inc. Gorky, Motherwell, de Kooning and Pollock. Sam Francis and Clyfford Still* are particularly well represented (a number of monumental works by Still on permanent display). Also Colour-field, Minimal and Conceptual artists; Pop, assemblage and *Nouveau réalisme*. A large group demonstrates the use of movement, light apparatus and optical phenomena, colour vibrations and such materials as neon tubes and coloured plexiglass. Samaras' *Mirrored Room*, a mirror-covered cube room, reflects to great effect the surrounding paintings and sculptures. Segal, *Cinema*.

BUFFALO NEW YORK

Albright-Knox Art Gallery
1285 Elmwood Ave,
Buffalo NY 14222.
Tel (1 716) 882 8700
Fax (1 716) 882 1958
www.albrightknox.org
Tues to Sat 11-5; Sun 12-5.
Closed Mon.

CAMBRIDGE MASSACHUSETTS

Busch-Reisinger Museum
Harvard University, 32 Quincy
St, Cambridge MA 02138.
Tel (1 617) 495 9400
Fax (1 617) 495 9936
www.artmuseums.harvard. edu
Mon to Sat 10-5; Sun 1-5.

Daniel Henry Kahnweiler, *1910, Picasso,*
The Art Institute of Chicago, Chicago, Illinois

Closed public hols.

A collection of late medieval, Renaissance and Baroque sculpture from Central and North Europe, but its main strength is in modern and contemporary art from German-speaking Europe. Large collection of Bauhaus materials: Beckmann's *Self-Portrait in a Tuxedo**; Heckel's *Convalescence of a Woman**. Expressionism, Constructivism and the Austrian Secession well represented. Many works by Beuys.

Fogg Art Museum
Harvard University, 32 Quincy St, Cambridge MA 02138.
Tel (1 617) 495 9400
Fax (1 617) 495 9936
www.artmuseums.harvard. edu
Mon to Sat 10-5; Sun 1-5.
Closed public hols.
American: large coll. of Copleys.
French: inc. two works by Poussin*, *The Holy Family in a Landscape*, brilliantly coloured and clear in design, and the *Nurture of the Infant Bacchus*, a profound late work which contrasts fertility with sterility.
19C: collection rich in works of the Romantic era. Paintings by Delacroix, Ingres and an unmatched group by Géricault*: the cool exoticism of Ingres' *Odalisque and Slave* may be contrasted with the passionate treatment of Eastern themes by Delacroix and with Moreau's heavy languor. Impressionism represented by high quality works by Monet, Manet, Renoir and Degas. Early works by Picasso.
Italian schools inc. a varied and high quality collection of early painting inc. Botticelli, Taddeo

Gaddi and Simone Martini. A few good 16C and 17C works, and a group of *bozzetti* by Bernini*.
British: the coll. of Pre-Raphaelites is one of the largest in America (on the top floor and you may have to ask for permission to see it).

CHICAGO ILLINOIS

The Art Institute of Chicago
111 South Michigan Avenue, Chicago, IL 60603.
Tel (1 312) 443 3600
Fax (1 312) 443 0849
www.artic.edu/aic/
Mon to Fri 10.30-4.30, Tues 10.30-8; Sat, Sun 10-5. Café.
A vast collection of world art, where Warhol's portrait of *Chairman Mao* dominates the view of the Chinese, Japanese and Korean galleries. The most famous works are Seurat's Sunday on *La Grande Jatte – 1884**** and Grant Wood's *American Gothic**.
American: Winslow Homer, Mary Cassatt (esp. *The Child's Bath**, a response to the unusual viewpoints of Degas, but strongly individual – see ill. p.420), Hopper's *Nighthawks***, a celebrated image of 20C alienation.
French: some good 17C and 18C works (inc. David*) but outshone by the very rich collection of Impressionism* and Post Impressionism. Many works by Monet inc. *On the Bank of the Seine***, (1868), a seminal work of Early Impressionism. A vast and imposing Caillebotte*; Degas.
Dutch: good 17C pics inc. *Girl at the Window*, a much debated attribution to Rembrandt.

Italian: Giovanni di Paolo* (see ill. p.227), Correggio, Bartolomeo Manfredi (*Venus Chastising Cupid*, an anti-heroic rendering of an erotic Caravaggesque theme), Tiepolo.*
Spanish: El Greco *Assumption of the Virgin** (see ill. p.328), Goya.
20C: Early modern art inc. ten paintings by Monet after 1900; a group of Picassos** that cover the period 1900-59, with emphasis on his early Cubist works, esp. *Portrait of Kahnweiler**; four early Gris, inc. *Portrait of Picasso**, Delaunay. A beautiful group of Redons; early Expressionism; De Stijl; Matisse.

Later 20C inc. Soutine, Miró, Bonnard and the Abstract Expressionists. Nauman and Richter.

Museum of Contemporary Art

220 East Chicago Avenue,
Chicago, Illinois 60611.
Tel (1 312) 280 2660
Fax (1 312) 397 4095
Wed to Sun 10-5, Tues 10-8. Closed Mon. (Free entry Tues). Café.
A very large museum of contemporary art, showing painting, sculpture, video, film and performance art since 1945. The emphasis is on Chicago-based artists and on Minimalism, Conceptualism and Surrealism. Calder, Christo. Ann hamilton (see ill. p.425).

CINCINNATI OHIO

Cincinnati Art Museum

953 Eden Park Drive,
Cincinnati, OH 45202.

Tel (1 513) 721 5204
Fax (1 513) 639 2888
www.cincinnatiartmuseum. org
Tues to Sat 10-5; Sun 12-6.
Closed Mon. Café.
The highlights are a large American collection, and a strong collection of European Old Masters, esp. Dutch and English.
American: 19C inc. Cole; 20C Wood, Hopper, Rothko and representative collection of the 1970s and 80s.
British: 11 paintings by Gainsborough inc. *Mrs Philip Thicknesse**, in which Gainsborough combines the grandeur of Van Dyck with a Rococo surface charm and boldly original serpentine. Raeburn, *The Elphinstone Children**.
Dutch: A good collection in which most of the important 17C masters are represented, esp. Hals*, de Hooch, Terborch and landscape painters, esp. Van der Neer and Ruisdael. Hague school.
French: Claude; two rare landscapes by Boucher; 19C works by Ingres, Corot and the Impressionists.
Italian: the highpoints are a grisaille by Mantegna*, and a sketchy *Portrait of Philip II** by Titian, perhaps unfinished. A fine baroque collection inc. a flamboyant Strozzi*, Rosa, Preti and an unattractive late Guercino.

Taft Museum of Art

316 Pike St,
Cincinnati OH 45202.
Tel (1 513) 241 0343
Fax (1 513) 241 7762
Mon to Sat 10-5; Sun 1-5.

Opposite: Memorial to the Idea of Man If He Was An Idea,
H. C. Westermann, 1958, Museum of Contemporary Art, Chicago, Illinois

Taft Museum of Art, Cinicinnati, Ohio

An historic house displays a small but unusually rich and crowded collection of treasures, with exceptional English and Dutch works. Whistler's *At the Piano***, painted in England, but indebted to Dutch art in its contemplative mood and geometric composition, fits in well, as does the collection of French Barbizon paintings.

British: portraits and landscapes of the late 18C and early 19C.

Dutch: 17C inc. Hals*, esp. a fine pair of portraits; two Rembrandts – the fashionable and lively Baroque of the *Man Rising from a Chair* 1633 contrasts with the later *Man Leaning on a Window Sill*, more a study of mood. Hague school pictures.

CLEVELAND OHIO

The Cleveland Museum of Art
11150 East Blvd,
Cleveland OH 44106.
Tel (1 216) 421 7350
Fax (1 216) 229 5095
www.clevelandart.org
Tues to Thur, Sat, Sun 10-5;
Wed, Fri 10-9. Closed Mon.
One of the major museums in America, the Cleveland Museum has a superb display of art from both East and West; decorative art pieces are displayed alongside paintings and sculptures; lofty galleries and natural lighting supply a good background for the grandest of the works.

Flemish and Dutch schools inc. works by Geertgen, Rembrandt, and Van Dyck*.

436

French: 18C inc. Boucher and Lancret and Watteau. 19C inc. group of works by Corot*, Courbet, David and Daumier. The great period of Impressionism is well represented. Group of early works by Picasso, dominated by *La Vie**. Rodin*.

Italian: early schools inc. Giovanni di Paolo, Botticelli, Filippino Lippi* and Spinello Aretino. From the 16C two important works by Andreas del Sarto* and good Venetian paintings inc. Titian* and Tintoretto*. A late Caravaggio, *Crucifixion of St Andrew**.

Spanish: El Greco*, Zurbarán* and Goya*.

American: inc. Church and Cole. A growing collection of 20C art inc. Warhol, Christo, Kiefer, Richter and Clemente.

DALLAS TEXAS

**Meadows Museum
and Sculpture Court**
*Southern Methodist University,
Dallas TX 75275.*
Tel (1 214) 768 2516
Fax (1 216) 768 3272
*Mon, Tues, Fri, Sat 10-5; Wed,
Thurs 10-8; Sun 1-5.*
A small collection founded for the preservation and study of Spanish art in SW America. inc. works by Murillo, Velázquez, Goya (inc. *The Madhouse at Saragossa**). 19C art (rarely seen outside Spain) is particularly strong; most attractive work is Antonio Maria Esquivel's *Girl Fastening her Garter*. From 20C works by Gris and Picasso, and Rivera's *Portrait of Ilya*

Ehrenburg. Collection of 19C and 20C sculpture.

DAYTON OHIO

Dayton Art Institute
*456 Belmonte Park North,
Dayton OH 45405.*
Tel (1 513) 223 5277
Fax (1 513) 223 3140
www.daytonartinstitute.org
Daily 10-5, Thurs 10-9. Café.
A small collection, with emphasis on American art (Cassatt, Hopper, O'Keeffe). Dutch inc. Ruisdael and Utrecht Caravaggisti; 17C and 18C Italian works, inc. Lodovico Carracci's *Portrait of a Widow;* works by Guercino, Saraceni, Strozzi.

DETROIT MICHIGAN

Detroit Institute of Arts
*5200 Woodward Ave,
Detroit MI 48202.*
Tel (1 313) 833 7900
Fax (1 313) 832 1623
*Wed to Fri 11-4; SAt, Sun 11-5.
Closed Mon, Tues.*
A well balanced, world class collection, showing painting, sculpture, furniture and decorative arts together, and with many works of outstandingly high quality.

American: one of the best and most representative collections of 18C, 19C and early 20C inc. colonial portraits, Copley's *Brook Watson and the Shark**, landscapes by Church and Martin Johnson Heade's *Seascape: Sunset**, a disturbing Luminist work, whose strange colours and eerie emptiness are

almost surreal; Bingham's *The Trapper's Return**, an American genre scene whose classic composition creates a sense of timelessness. **Early Netherlandish and Dutch:** inc. Van Eyck, Bruegel*, Ruisdael*, Rembrandt. Good genre collection inc. an unusual Sweerts, *In the Studio**.

Italian and French: a rare Niccolo dell'Abate, *Eros and Psyche**; Bellini, Correggio, Titian. At the centre of an unusually rich Baroque collection is Caravaggio's *The Conversion of the Magdalene**, displayed with fine works by his followers, Orazio and Artemesia Gentileschi. Poussin's lyrical *Diana and Endymion***, perhaps the most beautiful mythological painting of the 17C, forms a sharp contrast. An archetypally windswept Rosa landscape; good 18C pictures; Piazzetta.

19C and 20C European and American: Impressionist and Post-Impressionist works inc. Van Gogh's *Portrait of the Postman Roulin**; Whistler's *Nocturne in Black and Gold; the Falling Rocket**, described by Ruskin as a pot of paint flung in the public's face. Cassatt. Major 20C movements well represented. *The Detroit Industry Fresco* in the *Rivera Court* is a strong example of Mexican muralist work.

FARMINGTON CONNECTICUT

Hill-Stead Museum
35 Mountain Road,
Farmington CT 06032.
Tel (1 860) 677 4787
Fax (1 860) 677 0174

www.hillstead.org
May-Oct: Tues to Sun 10-5;
Nov-Apr: Tues to Sun 11-4.
Closed Mon.

The paintings, predominantly French 19C, are arranged as decoration in a private home. Major works inc. paintings by Cassatt, Degas, Manet, Monet and Whistler; sculpture by Barye. Degas' pastel *The Tub** 1886 with its unusual viewpoint illustrates his belief that the nude should be shown 'as if you looked through a keyhole'.

FORT WORTH TEXAS

Kimbell Art Museum
3333 Camp Bowie Blvd,
Fort Worth TX76107.
Tel (1 817) 332 8451
Fax (1 817) 877 1264
Tues to Thurs, Sat 10-5; Fri 12-8;
Sun 12-5. Closed Mon.

Small but choice collection enhanced by the light and space of Louis Kahn's stunning building (for some people, the most beautiful museum in the world). Some rare and unusual works inc. Claude Lorrain's *Landscape with the Rape of Europa** (1634), an unusually ambitious early work with which Claude first caught the attention of the Italian aristocracy; and Caravaggio's *Cardsharps***, which introduced a new naturalism into 16C Roman art. It ensured his early success, and was immensely famous, but throughout the 20C it was lost, until its reappearance at Fort Worth in 1987.

The **17C European** section is esp. strong, with works by Van Dyck, Hals, Rembrandt, Rosa's *Pythagoras*

The Tub, *Edgar Degas, Hill-Stead Museum, Farmington, Connecticut*

Emerging from Hades, a late, large scale figure painting with startlingly Neo-Classical elements.

British: a good collection of 18C portraits, esp. Gainsborough and Romney.

French: four large and spectacular Bouchers*; Hubert Robert; Barbizon paintings; Fauve and Nabis paintings.

Italian and Spanish: Duccio;* El Greco, Goya and Picasso.

GREENVILLE
SOUTH CAROLINA

Bob Jones University Museum of Sacred Art and the Bowen Bible Lands Museum

Wade Hampton Boulevard, Greenville SC 27834.
Tel (1 919) 758 1946
Tues to Sun 2-5. Closed Mon.

A Protestant and evangelical collection which restricts its choice to the religious art of Western Europe from the 14C to 19C. A few early

439

Saint Anthony Abbot Shunning the Mass of Gold,
Fra Angelico, The Museum of Fine Arts, Houston, Texas

Italian and north European paintings, but its main strength lies in less well-known Dutch, French and Italian artists of the 17C, inc. Dolci, Lanfranco, Bigot, Jouvenet and artists of the Utrecht school.

HARTFORD CONNECTICUT

**Wadsworth Atheneum
Museum of Art**
*600 Main St, Hartford CT 06103.
Tel/Fax (1 203) 278 2670
www.wadsworthatheneum.org
Tues to Sun 11-5; first Thurs most
months 11-8. Closed Mon, hols.*
The gallery has a small collection of

them is Whistler's *Coast of Brittany*. **Dutch and Flemish** inc. Hals, Rubens, Sweerts*; minor masters well represented.

French: 17C inc. Claude, Poussin and Vouet. 19C inc. early Corot, David, Delacroix and the Impressionists.

Italian: at the centre of the Baroque and Rococo collection is Caravaggio's *The Ecstasy of St Francis**, an early work with rare landscape elements. Effects of his style on Italian painters are illustrated by works of Gentileschi, Saraceni and Strozzi. Also a dark and sour portrait of his mistress as *Poetry* by Rosa. 18C inc. Crespi, Longhi, Tiepolo and Traversi.

Spanish: 17C collection varied and of high quality, inc. less well-known painters. *Still Life* by Valdés Leal and Zurbarán's *St Serapion** 1628; tangible, almost sculptural and yet remote from time and place, it attains a visionary intensity.

American: inc. 19C Hudson River School landscapes and 20C Abstract Expressionists, Calder, Cornell.

HOUSTON TEXAS

The Museum of Fine Arts, Houston

1001 Bissonnet at Main, Houston TX 77005.
Tel (1 713) 639 7300
Fax (1 713) 639 7399
www.mfah.org
Tues, Wed, Sat 10-7; Thurs, Fri 10-9; Sun 12.15-7.

A sprawling museum with a good general collection, displayed in two 20C houses, a 1924 Beaux-Arts

early Netherlandish and German works, a modest number of 15C and 16C Italian paintings inc. Piero di Cosimo's *The Finding of Vulcan**, and one of the finest collections of Baroque and Rococo painting outside the major cities. **British** painting inc. Gainsborough, Joseph Wright, Burne-Jones and Holman Hunt. Displayed with

The Menil Collection, Houston, Texas:
Opposite: Richmond Hall, *Dan Flavin; above: North Promenade*

building, a pavilion by Mies van der Rohe, and a new building by Rafael Moneo. Also Isamu Noguchi's *Cullen Sculpture Garden*.

Close by is the **Contemporary Arts Museum** which shows large scale works.

American: Pollock, Still, O'Keeffe, Stella.

European Renaissance and Baroque works: Fra Angelico, Giovanni di Paolo, Van der Weyden, Memling, esp. *Portrait of an Old Woman**. 16C Venetian inc. Sebastiano del Piombo. Some good 18C pictures, esp. Batoni.

French: a strong section, with 17C and 18C works, but main emphasis on Impressionism (Caillebotte, see back cover), Post-Impressionism and early Modernism; Derain's the *Turning Road* (1906) is a highpoint of Fauvism, while Braque's *Fishing Boats* (1909) was a seminal early Cubist work.

The Menil Collection

1515 Sul Ross, Houston TX 77006.
Tel (1 713) 525 9400
Fax (1 713) 525 9444
www.menil.org
Wed to Sun 11-12.
Closed Mon, Tues.

Renzo Piano designed this quiet, contemplative museum for the world famous collection of John and Dominique de Menil, who were fascinated by bringing together arts of different cultures. The exceptionally beautiful display shows the major movements of 20C art with palæolithic art and with tribal art from Africa, Oceania and the Pacific Northwest. A separate pavilion* is dedicated to the dull works of Cy Twombly, while close by is the sublime Rothko chapel**. See also **Richmond Hall**, site of a permanent fluorescent light installation by Dan Flavin.

443

INDIANAPOLIS INDIANA

Indianapolis Museum of Art
1200 W 38th St,
Indianapolis IN 46208.
Tel (1 317) 923 1331
Fax (1 317) 926 8931
web.ima-art.org
Tues to Sat 10-5; Thurs 10-8.30;
Sun 12-5. Closed Mon, hols.
The Krannert and Clowes Pavilions house a good representative collection inc. paintings and watercolours by Turner (esp. *The Fifth Plague of Egypt*); French Post-Impressionist paintings; Gauguin and School of Pont-Aven and Seurat and the Neo-Impressionists. Dutch and Flemish works inc. Cuyp and Van Dyck's *Entry of Christ into Jerusalem*. Pleasant grounds with sculpture.

KANSAS CITY MISSOURI

Nelson Gallery – Atkins Museum
4525 Oak St, Kansas City
MO 64111.
Tel (1 816) 751 1278
Fax (1 816) 561 7154
Tues to Thurs 10-4; Fri 10-9;
Sat 10-5: Sun 12-5. Closed Mon..
Early Netherlandish and Italian schools inc. works by Petrus Christus, Lorenzo di Credi and Pieter Cornelisz.
Dutch: inc. Terbrugghen's *Beheading of the Baptist*, a subtle response to a Caravaggesque theme, and Rembrandt's *Youth with a Black Cap*. Interiors, still lifes and landscapes well represented.
Flemish school inc. works by Van Dyck, Jordaens and Rubens.

Baroque and Rococo in France and Italy are well represented.
Italian: highpoint of Italian Baroque is Caravaggio's *St John the Baptist***; other works show his influence and there are good paintings of the Neapolitan and North Italian schools. Rosa's *Landscape with Mercury and Argus*, one of his most poetic, attains a beautiful balance between classic harmony and windswept violence. Crespi, Traversi, Procaccini*.
French: inc. major 17C and 18C painters; an austere *Crucifixion* by Philippe de Champaigne. Poussin's elaborate *Triumph of Bacchus***, long thought to be a copy.
Spanish: a 14C altarpiece dedicated to the *Life of the Virgin*; El Greco, Ribera and Zurbarán. **19C and 20C collections** inc. Ingres; Impressionists; de Kooning; Pop Art.
American coll. inc. many Bentons.

LOS ANGELES CALIFORNIA

Armand Hammer Museum of Art and Culture Center
University of California at Los Angeles (UCLA), 10899 Wilshire Boulevard, Los Angeles CA 90027.
Tel (1 310) 443 7020
Fax (1 310) 443 7099
www.hammer.ucla.edu
Tues,Wed, Fri and Sat 11-7;
Thurs 11-9; Sunday 11-5.
Mainly Impressionist and Post-Impressionist works, inc. Van Gogh's compositionally daring *Hospital at Saint-Rémy* influenced by Delacroix in his attempt 'to give the things body by a drawing style which tries to depict the interlocking of the masses'.

Franklin O. Murphy Sculpture Garden

UCLA, 405 Hilgard Ave.
Works inc. Arp, Caro, Matisse, Rodin.

The Getty Center

1200 Getty Center Drive,
Los Angeles CA 90049.
Visitor Services (1 310) 440 7300
Tues, Wed 11-7; Thurs, Fri 11-9;
Sat, Sun 10-6. Admission free, but
parking reservations (which must
be made – sometimes weeks – in
advance) charged.

A visit to the Getty centre requires planning, and, ideally, at least a day. The centre is a vast, gleaming white complex, a play of geometric shapes against glittering views of city, mountains and sea; a visit there is a high tech experience with trams taking the visitor up the hill, and restaurants and bars operating with super efficiency. Building and grounds are the stars, above all Robert Irwin's *Central Garden**, a post-modern play on the gardens of the Italian Renaissance.

Italian: 14C inc. Bernardo Daddi's *Triptych**; Renaissance and Baroque some unusual 16C and 17C pictures by rare artists, and works by Carpaccio*, Pontormo's *Halberdier** and Dosso Dossi's *Allegory of Fortune.*

Small collection of Dutch and Flemish paintings.

French: works by Poussin, inc. *Landscape with a Calm**, Géricault, a voluptuous David*, a good collection of Impressionism inc. a flower painting* by Monet, and a still life by Cézanne. Other 19C pics inc. Van Gogh's *Irises*, and Ensor's *Christ's Entry into Brussels.*

Los Angeles County Museum of Art

5905 Wilshire Boulevard,
Los Angeles CA 90036.
Tel (1 213) 857 6000
Fax (1 213) 931 7347
www.lacma.org
Mon, Tues, Thurs 12-8; Fri 12-9;
Sat, Sun 11-8. Closed Wed.

A collection with some individual works of high quality by Fra Bartolommeo, Veronese, Reni, Hals, Rembrandt, Georges de la Tour*, and Chardin. 20C works by artists of the New York School and California artists of the 1960s. Rodin bronzes.

MARFA TEXAS

Chinati Foundation

P.O. Box 1135, Marfa TX 79843.
Tel (1 915) 729 4362
Fax (1 915) 729 4597
By tour only. Tours, lasting two
hours, are given free of charge, and
without booking, every Thurs, Fri
and Sat between 1 and 5.

A vast site – 400 acres of land, with both converted and new buildings – the Chinati foundation was created by Donald Judd to show large scale installations in a desert landscape. At its centre are Judd's 15 outdoor concrete works and 100 aluminium works displayed in artillery sheds.

MANCHESTER NEW HAMPSHIRE

The Currier Gallery of Art

201 Myrtle Way,
Manchester NH 03104.
Tel (1 603) 669 6144

Fax (1 603) 669 7194
www.currier.org
Sun, Mon, Wed, Thurs 11-5; Fri
11-8; Sat 10-5 (free 10-1).
Closed Tues and public hols. Café.
One of the finest small art museums in the USA. Strongly slanted towards 18C, 19C and 20C American painting – Copley, Homer, Wyeth, Hopper and O'Keeffe. Also an arbitrary European collection from 16C to Picasso, all of quite good quality. 19C and 20C American and European sculpture.

MERION PENNSYLVANIA

The Barnes Foundation
300 North Latch's Lane,
Merion PA 19066.
Tel (1 610) 667 0290
www.thebarnes.org
Sept-June: Fri, Sat, Sun 9.30-5
July-Aug: Wed to Fri 9.30-5
By advance reservation only.
A fine collection of 19C and modernist French painting. Recently restored, it preserves the contrasts of cultures and eras loved by its founder, Albert Barnes, and the pictures are shown amid an extraordinary array of objects and with daring juxtapositions of style and colour. The high-points are Matisse's *Joie de Vivre****, a seminal 20C work, and Seurat's *Poseuses***. Also important Cézannes (esp. *The Cardplayers**), very many Renoirs (a lot of them dull), works by Monet, Van Gogh*, and Matisse's murals of dancing nudes and *The Red Madras Headress.*

MINNEAPOLIS MINNESOTA

Minneapolis Institute of Arts
2400 Third Ave S,
Minneapolis MN 55404.
Tel (1 612) 870 3131
Fax (1 612) 870 3004
www.artsMIA.org
Tues to Sat 10-5; Thurs 10-9; Sun
12-5. Closed Mon.
British: a representative collection of 18C portraits and some good early 20C works.
French: inc. Poussin's *Death of Germanicus**, his first truly mature work; its passionate sobriety, complex spatial design and intense colour were a defining influence on later history painting, especially David. Good 18C pictures; a fine collection of Barbizon school inc. Corot and Diaz; Impressionism and Post-Impressionism, inc. Degas and Gauguin. Cézanne*.
German: inc. Cranach and several works by Nolde. Beckmann.
Italian: richest in 17C and 18C inc. Castiglione and Rosa.
Spanish: inc. Goya*.

Walker Art Center
Vineland Place,
Minneapolis MN 55403.
Tel (1 612) 375 7622
Fax (1 612) 375 7618
www.walkerart.org
Mar-May: Tues to Sat 10-5, Wed
10-8; Sun 11-5. Closed Mon.
Main emphasis on modern art, esp. modern American sculpture some of which is displayed on outdoor terraces and in an 11-acre outdoor sculpture garden.

NEW HAVEN CONNECTICUT

Yale Center for British Art
1080 Chapel St, New Haven,
CT 06520-8280.
Tel (1 203) 432 2800
Fax (1 203) 432 9628
www.yale.edu/ycba
Tue to Sat 10-5; Sun 12-5.
Closed Mon.
The collection offers an unrivalled opportunity to study every aspect of British painting from 16C to 19C. The painting galleries are arranged in a series of room-like spaces on the skylit top floor of the centre; the effect of natural light and muted colours – pale blues and greys, linen covered walls and white oak panelling – recreates the quietly civilized atmosphere of the English country house. The large space of the Library court, reminiscent of the Grand Hall, is hung with a series of works by George Stubbs. 16C and 17C schools inc. Dobson, Van Dyck, Johnson and Rubens. A collection of 18C portraits and conversation pieces move from the touching complacency of Devis, to the direct realism of Hogarth and Gainsborough whose early works are remarkable for their light, airy colours and fresh Suffolk backgrounds. Good collection of portraits by Reynolds, and a gentle evocation of the charms of English country life by Zoffany and Wheatley. Good examples of Neo-Classical history painting and landscape; the most dramatic of a large collection of

Library Court,
Yale Center for
British Art,
Newhaven,
Connecticut

Estelle Musson, *Edgar Degas, New Orleans Museum of Art, Louisiana*

Stubbs* preludes English Romanticism, well represented by Turner and Constable*; works by Bonington, Crome, Blake, Palmer and Martin's visionary epics; Victorian works, Camden Town and Bloomsbury. Contemporary works inc. Hirst and Whiteread.

A study gallery, where pieces are hung as close together as possible, allows a large part of the reserve collection to be on permanent view.

Yale University Art Gallery
1111 Chapel St, New Haven
CT 06520.
Tel (1 203) 432 0600
Fax (1 203) 432 8150
www.yale.edu/artgallery
Tues to Sat 10-5 (Sept-May:
Thurs also 6-9); Sun 1-5.

European art inc. Impressionists, Post-Impressionists, Van Gogh's *The Night Café** and the Nabis. The **early modern** collection, formed by Katherine Dreier and Marcel Duchamp, is the most extensive of any university museum. It inc. a collection of Cubist, Dada, Futurist and De Stijl works. Malevich's *The Knife Grinder** is an almost futurist attempt to represent in a series of patterns the movements of a man and machine. The large windows of the modern unit look out at different levels over the Gothic sculpture terrace and courtyard of which the focal point is Moore's *Draped Seated Woman.*

See also *Beinecke Rare Book & Manuscript Library*
121 Wall St
(Postal address: Box 208240,
New Haven, CT 06520-8240).
www.library.yale.edu/beinecke/
Year-round: Mon to Fri 8.30-5;
Sat (Sept-July) 10-5. Closed Sat in
Aug and during Yale recesses.
Sculpture court* designed by Noguchi, executed in radiant white Vermont marble.

Closed Mon.
Only a small part of Yale's collection of **early Italian** pictures, a comprehensive study collection unsurpassed by any other university museum, is on show at any one time. It inc. Gentile da Fabriano, Pollaiuolo, Paolo Veneziano, and a *Circumcision* attrib. to Titian. Other Old Masters inc. Claude, Hals, Holbein* and Rubens. **19C**

NEW ORLEANS LOUISIANA

New Orleans Museum of Art
1 Collins Diboll Circle, City Park, New Orleans LA 70124.
Tel (1 504) 488 2631
Fax (1 504) 484 6662
www.noma.org
Tues to Sun 10-5. Closed Mon.
Café.
New Orleans has strong French connections, and the museum is richest in American and French

paintings. But also Kress collection 13C to 18C Italian pictures, and some 16C and 17C Dutch and Flemish works.

American: 18C inc. Copley and Peale; 20C O'Keeffe, Hofmann, Rauschenberg.

French: Gros' fiery sketch* for his *Pesthouse at Jaffa*. Degas, esp. the *Portrait of Estelle Musson**, his brother's blind wife, painted on Degas' visit to New Orleans in 1872-3. Salon and Barbizon pictures, and Impressionists.

NEW YORK NEW YORK

The Brooklyn Museum
200 Eastern Parkway,
Brooklyn NY 11238.
Tel (1 718) 638 5000
www.brooklynart.org
Wed to Fri 10-5; Sat, Sun 11-6.
Closed Mon.
A small collection of Italian primitive and Renaissance schools inc. works by Maso di Bianco and Crivelli. Few works from 16C to 19C; French Impressionists inc. Degas' *La Source**. Some of Tissot's watercolour illustrations to the New Testament are occasionally exhibited. A good coverage of 19C American art, remarkably well labelled, a collection of second generation and younger artists of the New York School. An unusual sculpture garden, picturesquely overgrown with ivy, displays sculptural elements from destroyed New York buildings. Comprehensive collection of Rodin bronzes in late castings.

The Cloisters
Fort Tryon Park,
New York NY 10040.
Tel (1 212) 923 3700
Fax (1 212) 795 3640
Tues to Sun 9.30-5.30;
Fri, Sat 9.30-9. Closed Mon.
(Nov-Feb closes at 4.45).
The medieval collections of the Metropolitan are displayed here, and inc. *The Mérode Annunciation*** attrib. to Robert Campin, an early attempt to show the Annunciation in a domestic setting with a view of a Flemish town seen through the windows.

Dia Center for the Arts
548 West 22nd Street,
New York NY 10011.
Tel (1 212) 293 5540
www.diacenter.org
Wed to Sun 12-6.
Closed Mon, Tues.
A vast converted warehouse, this is the exhibition space of Dia, a charitable backer of contemporary art, and supporter of large scale, single artist projects. Before it are basalt columns paired with trees, part of Beuys' *7000 Oaks* project, and within a fluorescent light installation by the tediously ubiquitous Dan Flavin. The best bit is the shed on the roof with café and video viewing room, beside Dan Graham's magical transformation of the roof into an urban park*, with an architectural glass pavilion of mirrored glass. **Other longterm installations** inc. Walter De Maria's *The New York Earth Room* (141 Wooster St) and *The Broken Kilometer* (393 West Broadway).

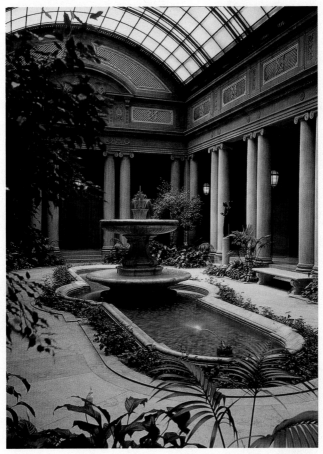

The Garden Court, The Frick Collection, New York

The Frick Collection
1 E 70th St at 5th Ave,
New York NY10021.
Tel (1 212) 288 0700
Fax (1 212) 628 4417
www.frick.org.
Tues to Sat 10-6; Sun 1-6.
No children under 10 admitted.

Perhaps the most enjoyable museum in New York. In the centre is the Garden Court with flowers and a fountain. The small rooms, furnished in an 18C style, retain the atmosphere of a private house; the basic tone is set by the many light-hearted and decorative

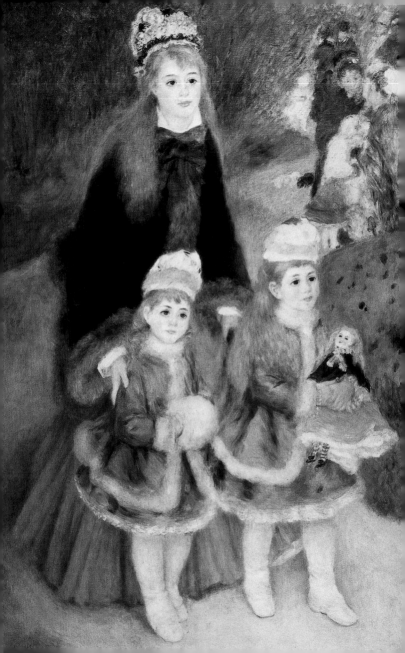

works of the 18C by Fragonard*, Boucher, Gainsborough, and dashing works by Reynolds. Yet the other works displayed, by the famous artists of the major European schools, are of outstandingly high quality. These inc. Bellini's *Ecstasy of St Francis***, *Holbein's Sir Thomas More***, a perfect balance between Italian grandeur and northern realism, a tiny Bruegel* El Greco*, a vast Claude*, Van Dyck, Piero della Francesca*, Rembrandt *Self-Portrait***, *The Polish Rider** (now restored to Rembrandt after a period of controversy), Vermeer* (see ill. p.10), David and Whistler*. Two busts** by Francesco Laurana.

The Hispanic Society of America

155th St and Broadway
(Audubon Terrace),
New York NY 10032.
Tel (1 212) 926 2234
www.hispanicsociety.org
info@hispanicsociety.org
Tues to Sat 10-4.30; Sun 1-4.

A collection of Spanish art shown in a charming setting; the main court is executed in terracotta in Spanish Renaissance style where archæological finds, ceramics, fabrics and tiles are displayed. From 15C are panels by Luis de Morales; six paintings by El Greco, the most unusual an oval miniature on cardboard. A good collection of 17C southern Spanish painters; three works by Velázquez, inc. an exceptionally personal painting of

a little girl; works by Goya, inc. *Duchess of Alba and Pedro Mocarte*, handled with fine freedom. In the Sorolla Room are 14 huge murals of the *Provinces of Spain* by Joaquín Sorolla.

Metropolitan Museum of Art

5th Ave at 82nd St,
New York NY 10028.
Tel (1 212) 879 5500
Fax (1 212) 570 3879
www.metmuseum.org
Tues to Thurs, Sun 9.30-5.30; Fri, Sat 9.30-9. Closed Mon.

The museum is filled with flowers and alive with a general air of festivity. It is most famous for its early Italian and Flemish masters; Rembrandt and Vermeer; and for its 19C French pictures. The labelling is exceptionally useful and the remarks about the condition of the paintings are of great help. **American:** a representative collection of American painting. It includes works by Copley; paintings by Cole, Church, Hudson River School painters, Albert Bierstadt's *The Rocky Mountains**, all inspired by the sublimity and grandeur of a new country. Martin Johnson Heade's *The Coming Storm*** stands out amongst Luminist works for its haunting, almost surrealist effects of light and space. George Caleb Bingham's *Fur Traders Descending the Missouri***, with its geometric composition and golden light, has become an American icon, expressing the myth of the frontiersman. Later works inc. Homer and Sargent, and from the

Opposite: Mother and Children, *Renoir, The Frick Collection, New York*

Art outside the museums

Take a guided tour to see some of the sculptures and murals in the **Lincoln Center for the Performing Arts** (*62nd-66th St Columbus to Amsterdam Aves*). In the **Plaza** is Henry Moore's 6-ton bronze sculpture, *Lincoln Center Reclining Figure* and Calder's *Guichet*. The following may not all be included in the tour so take the opportunity of seeing them during performances in the evening; **The Metropolitan Opera House:** on the Grand Tier Promenade facing the plaza, large murals by Chagall. **Avery Fisher Hall:** Richard Lippold's space sculpture, *Orpheus and Apollo*, extends the length of the Grand Promenade. On plaza level are Seymour Lipton's *Archangel* and Dmitri Hadzi's *The Hunt*. **The New York State Theater** has large marble sculptures of women, enlarged versions of smaller works by Elie Nadelman; also works by Lee Bontew and Jasper Johns.

Look for the work of **Albers, Hepworth, Noguchi** and **Picasso:** Josef Albers' mural in the lobby of the Pan Am Building, reliefs in the lobby of Corning Glass building (*6th Ave and 56th St*); Barbara Hepworth's *Single Form* (1962-3) in front of the United Nations Secretariat; Isamu Noguchi's *Cube* in front of the Marine Midland Bank (*140 Broadway*), *Shinto*, 1976, at the Bank of Tokyo, Plaza Garden, Chase Manhattan Bank, fountain in the Metropolitan Museum and his studio museum in Brooklyn; Picasso's monumental enlargement of *Portrait of Sylvette* in the forecourt of University Plaza at W Broadway and Houston St, and his backdrop for Le Tricorne in the Four Seasons Restaurant, which also has works by Miró and Rivers (tours Thurs 3pm). Also Louise Nevelson's chapel** at St Peter's Church, Lexington Ave between 53rd and 54th Sts, Jim Dine's huge caryatids on 6th Ave opposite Radio City.

Although by no means as cutting-edge as in past decades, dealers' shows in SoHo and on 57th St are still lively and times spent exploring them especially on a Saturday will always yield at least one experience worth remembering.

20C, Gorky, Hopper, Pollock and Abstract Expressionists.

British: inc. 18C portraitists, Constable and Turner.

Early Netherlandish: inc. Van Eyck*, Petrus Christus, David, Van der Weyden, Bruegel**.

Dutch: famous for its five works by Vermeer** inc. *The Young Woman with a Water Jug* and for many works by Rembrandt, mostly portraits with a stress on the period from 1653 and *Aristotle Contemplating the Bust of Homer***, commissioned from Rembrandt by an admirer in far-off Sicily. Works by Hals, Hobbema, and three late landscapes by Ruisdael, done when he was most interested in flat landscape subjects where space is created by alternate bands of shadow and sunlight.

Flemish: inc. Van Dyck* and Rubens*.

French: inc. Claude, de la Tour*, Poussin (*The Rape of the Sabine Women* demonstrates his interest in expression and gesture, and was highly influential), 18C: a good collection of portraits and Watteau's *Mezzetin***. David's *Death of Socrates***, acme of the Neo-Classical sublime but unusually for David, a cabinet-sized painting; coveted by Napoleon.

In the André Meyer galleries the collection of 19C European sculpture and paintings, one of the finest in the world and particularly rich in works by the great Impressionists, is beautifully displayed. The galleries show large groups by single artists, inc. Cézanne, Corot, Ingres, Monet and Renoir; sculpture inc. Degas and Rodin. Post-Impressionism represented by Seurat, *La Parade**, by Gauguin's decorative *La Orana Maria,* by the Nabis, Van Gogh, Rousseau* and Toulouse-Lautrec.

German: inc. portraits by Holbein.

Italian: Renaissance paintings inc. the Sienese Sassetta; the Florentines Botticelli, Andrea del Castagno, Piero di Cosimo, and the Paduan Mantegna; the Venetians Bellini and Carpaccio's highly charged *Meditation on the Passion,* where the contrasts in the landscape between barrenness and fertility echo the theme; 16C paintings by Dossi, Raphael, Titian and Veronese*. A well-balanced collection of 17C and 18C schools, inc. examples of Florentine, Genoese, Neapolitan and Bolognese schools, two unusual Rosas, a melancholy *Self-Portrait* and a late, silvery and poetic figure painting, *The Dream of Æneas.* Caravaggio's *Musicians** and, attributed to him, *The Lute Player.*

Spanish: El Greco's *View of Toledo*** (his only pure landscape painting) and Velázquez*; outstanding Goyas inc. *Majas on a Balcony.* Ribera. Picasso.

The Museum of Modern Art

11 W 53rd St, between 5th and 6th Ave, New York NY 10019.
Tel (1 212) 708 9400
www.moma.org
Sat to Tues, Thurs 10.30-5.45;
Fri 10.30-8.15. Closed Wed.

The museum is nearly always very crowded, even in the middle of winter, but it is worth noticing that it is one of the few places in New York that is open on a Monday. Once famous for its encouragement of contemporary art and for its still unrivalled collection of 20C

art, the museum now somewhat curiously demonstrates how the word 'modern' has gradually come to represent an historical period; it now seems backward-looking. The collection is dominated above all by Picasso, whose two large works the *Demoiselles d'Avignon**** (1906) and *Night Fishing at Antibes* (1939) are seminal not only to his career but to art of the 20C. *The Demoiselles*, with its ugliness, its harsh colouring, its use of angular and shifting planes and its avoidance of conventional perspective, marks a decisive break with the art of the past. The violence of Picasso contrasts with the sumptuous colouring and decorative patterns of Matisse, whose whole career is also well represented.

Impressionism and Post-Impressionism* inc. Cézanne, Monet, Rousseau, Gauguin, and Van Gogh (his *Starry Night* (1889) is perhaps his most visionary and ecstatic work). **Fauves** inc. Derain, Rouault, Vlaminck. **Expressionists** inc. Kokoschka, Nolde. **Futurists:** at the centre is Boccioni's *The City Rises**, a glorification of urban power, and his sculptures; Severini's *Dynamic Hieroglyphic of the Bal Tabarin*. **Cubism** may be traced in all phases of its development. Works by Picasso and Braque. Compare Braque's *Road near L'Estaque* (1908) with Cézanne's *Pines and Rocks* (c.1896-99). Analytical Cubism inc. Picasso's *Woman with Mandolin* (1914); Synthetic and late Cubism. **Dada and Surrealism** inc. Duchamp; Masson; Miró; Picabia, inc. *I see again in Memory my Dear Udnie* with its disturbing suggestions of

mechanical sexual parts; Schwitters. **Abstract** art inc. works by Kandinsky and Mondrian. **Abstract Expressionists** inc. works by all the major artists inc. Gorky's *Garden in Sochi* and Newman's *Vir Heroicus Sublimis* (1950-1). **Pop Art:** a smaller collection. Sculpture inc. Brancusi, Giacometti, Oldenburg, Samaras. In the **sculpture garden** are works by, amongst others, Moore and Rodin.

The Solomon R. Guggenheim Museum

1071 5th Ave between 88th and 89th Sts, New York NY 10128.
Tel (1 212) 423 3500
Fax (1 212) 423 3650
www.guggenheim.org.
Sun to Wed 9-6; Fri, Sat 9-8.
Closed Thurs.

The museum usually shows temporary exhibitions and only selections from its permanent collection are on show (inc. a large group of early 20C paintings, esp. Chagall, Delaunay, Kandinsky, Klee*, and Léger). The Justin K. Thannhauser Bequest, an autonomous part of the museum's modern collection, is housed in a separate gallery and inc. works by the Nabis, Rousseau, Van Gogh and Cézanne; a group of works by Picasso inc. interesting early pieces (*End of the Road* and *Moulin de la Galette*). The pictures are overwhelmed by the beauty of Frank Lloyd Wright's building; even if you do not look at one of them you must take the lift to the top and work your way down the spiralling ramp, so wonderfully unsuitable for the hanging of geometrical modern art.

Whitney Museum of American Art

945 Madison Ave at 75th St,
New York NY 10021.
Tel (1 212) 570 3676
Fax (1 212) 570 1807
www.echonge.com/~whitney
Tues to Thurs 11-6; Fri 1-9; Sat,
Sun 11-6.

A large collection of American art since 1900 inc. works by artists of the Ashcan school; by early American modernists; by Abstract Expressionists and Pop artists. The museum more often shows special exhibitions; the huge exhibition spaces of this magnificent Brutalist building are easily varied and are particularly suitable for exhibitions of modern painting and sculpture with their stress on vast scale.

NORFOLK VIRGINIA

Chrysler Museum

245 West Olney Rd,
Norfolk VA 23510.
Tel (1 757) 664 6200
Fax (1 757) 664 6201
www.chrysler.org
museum@chrysler.org
Tues to Sat 10-5; Sun 1-5.
Closed Mon. Café.

One of the foremost collections of Italian art in America.
Italian: inc. good collection of Venetian art esp. an altar by Veronese*. 17C Bolognese, Genoese and Neapolitan art well represented, inc. works by Reni, Rosa and a lovely Rococo paraphrase of Titian's *Bacchus and Ariadne* by Luca Giordano.
Dutch: unusually good in history paintings.

French: the scope of the French 19C is wider than that of most American collections; inc. many examples of academic art, Couture, Gleyre, Gérôme. Gauguin *Loss of Virginity*. 19C and 20C American painting and sculpture.

NOTRE DAME INDIANA

The Snite Museum of Art

University of Notre Dame,
Notre Dame IN 46556-0368.
Tel (1 219) 631 5466
Fax (1 219) 631 8501
www.nd.edu/~sniteart
Tues,Wed 10-4; Thurs to Sat 10-5; Sun 1-5. Closed Mon and public hols.

Renaissance: Kress collection of Italian, German, Flemish works.
Baroque and Rococo: inc. Boucher, Claude, Maes, Ruisdael and Stanzione.
19C and 20C: Picasso's *Le Miroir* and Chagall's *Le Grand Cirque*, paintings by Ben Nicholson, Georgia O'Keeffe and Jim Dine; sculpture by Cornell, Calder and Meštrović.

OBERLIN OHIO

Allen Memorial Art Museum, Oberlin College

87 N. Main St, Oberlin OH 44074.
Tel (1 440) 775 8665
Fax (1 440) 775 6841
www.oberlin.edu/~allenart
Tues to Sat 10-5; Sun 1-5.
Closed Mon.

A teaching collection with high quality works inc. Mola, Rubens and Terbrugghen's *St Sebastian Attended by St Irene**. Fine Dutch

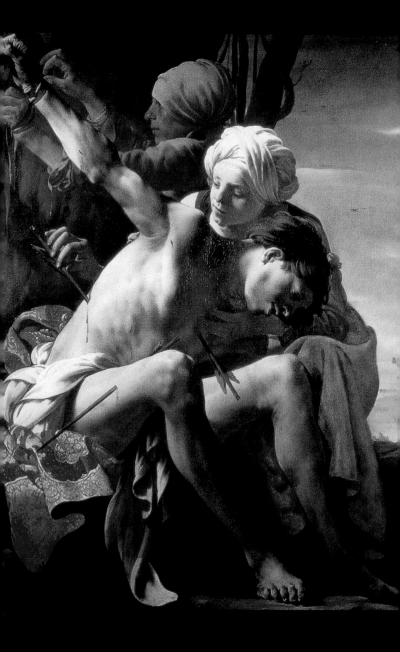

landscapes inc. Hobbema* and Dutch Italianates. A small but good collection of early modern art inc. Impressionism, Cubism, Surrealism and Expressionism (esp. Kirchner). An adventurous collection of 20C American art inc. a major Eva Hesse sculpture, an early Barnet Newman and Elizabeth Murray.

PASADENA CALIFORNIA

Norton Simon Museum
411 W Colorado Blvd,
Pasadena CA 91105.
Tel (1 626) 449 6840
Fax (1 626) 796 4978
www.nortonsimon.org
Wed, Thurs, Sat to Mon 12-6;
Fri 12-9. Closed Tues.
A rich collection of European art, with an emphasis on unusual and high quality works. The museum has been entirely transformed by the celebrated architect Frank Gehry.
Dutch and Flemish inc. *Resurrection** by Dirk Bouts. Rembrandt, Rubens. Several Van Goghs.
French: 17C and 18C inc. Chardin, Poussin, Rigaud and Watteau. Impressionism and Post-Impressionism are well represented, inc. the *modèle* set of Degas bronzes. Manet *Ragpicker**.
German: the Galka Scheyer collection of the Blue Four painters inc. Feininger, Jawlensky, Kandinsky and Klee.
Italian: inc. Giovanni di Paolo,

Filippino Lippi, Lorenzetti, Raphael and Tiepolo.
Spanish: inc. Goya, Murillo and Zurbarán (his *Still Life with Lemons, Oranges and a Rose*** magically still and contemplative). Sculpture garden has works by Rodin and Moore.

PHILADELPHIA PENNSYLVANIA

Pennsylvania Academy of the Fine Arts
Broad and Cherry Sts,
Philadelphia PA 19102.
Tel (1 215) 972 7600
Fax (1 215) 972 5564
www.pafa.org
Mon to Sat 10-5; Sun 11-5.
Closed hols. Café.
A collection of American art housed in a highly original and vigorously detailed Gothic building by Frank Furness (1872-6); it is the oldest art institution in North America and students and teachers inc. many distinguished American painters. Paintings by Benjamin West inc. *Treaty of William Penn with the Indians (1771)* which, composed in the manner of a Poussin, presents the dramatic contrast between two cultures with serious dignity and human warmth (see ill. pp.416-7),. Also Peale's trompe l'œil *The Artist in his Museum* (see ill. p.414), and works by Eakins, Homer (*Fox Hunted by Crows**) and Wyeth.

Opposite: St Sebastian Tended by Irene, *Terbrugghen, Allen Memorial Art Museum, Oberlin College, Ohio*

Philadelphia Museum of Art

26th St and Benjamin Franklin Parkway, Philadelphia PA 19130.
Tel (1 215) 763 8100
Fax (1 215) 236 4465
www.philamuseum.org
Tues to Sun 10-5; Wed 10-8.45.
Closed Mon. (Some galleries are often closed: check before you set out.)

The two most important sections of the museum are the John G. Johnson collection of Old Masters and the Arensberg and Gallatin Collections. The pictures are arranged by collections rather than by artists or by school and important works by a major artist may be found scattered rather randomly through the museum. Walter S. Arensberg was a friend of Marcel Duchamp, and there is an unrivalled collection of his works, inc. the ready-made *Paris Air*, a glass globe enclosing air brought by Duchamp from Paris in 1915 as a present for his friend; his paintings trace his development through early phases, influenced by Cézanne, Fauvism and Cubism, to the notorious *Nude Descending a Staircase** (1911-12) and the *Bride,* both disturbing attempts to transform the human being into a mechanical contraption. *The Bride Stripped Bare by her Bachelors, Even***, a large composition on glass, is an elaborate love-making machine, full of witty sexual puns and innuendoes, at once ironic, debunking and poetic (studies and good notes may aid one's glimmers of understanding). Duchamp's last work, *Etant Donnés, 1 la Chute d'Eau, 2 le Gaz d'Eclairage* returns to the same themes in a different style: through two small peepholes in a rough wooden door a shockingly realistic nude woman sprawls before a pond and wooded landscape. The Arensberg and Gallatin Collections are rich in Cubist works***. These inc. major works by lesser-known Cubists and by artists associated with Cubism; Léger's *The City* (1919) suggests the garish vitality of the modern urban environment through crude colours and intersecting planes. Also a series of collages** by Braque, Gris and Picasso. Picasso's *Three Musicians**. An unrivalled coll. of works by Brancusi*. Other works in the gallery, inc. those in the John G. Johnson coll., inc.
British: a fine coll. (Gainsborough, Raeburn, Romney, Turner and a series of oil sketches by Constable).
Dutch: a rich collection of minor landscape and genre painters.
Flemish: two works by Rogier van der Weyden, Rubens' *Prometheus.*
French: inc. Poussin, 19C inc. Courbet, Delacroix, Manet, Cézanne and Renoir. Renoir's *Les Grandes Baigneuses** 1884-7 shows an attempt to return to traditional subject matter and compositional principles, and may be compared with Cézanne's concern with spatial relationships in the *Bathers** (1898-1905), his last variation on this theme.

PITTSBURGH PENNSYLVANIA

The Andy Warhol Museum

117 Sandusky Street,
Pittsburgh PA 15212.
Tel (1 412) 237 8338
Fax (1 412) 237 8340

www.warhol.org
Wed, Sun 11-6; Sat 11-8.
Closed Mon, Tues. Café.
A brilliant conversion of a Pittsburgh warehouse, with a demonic Warhol self portrait gleaming in the entrance hall, creating an eerie contrast with the elegantly classical terracotta façade. A vast single artist museum, it traces Warhol's career, moving through his early Pop period, with plenty of Coca Cola and soup cans, on through Chairman Mao and skull paintings, to his celebrity portraits and late works.

Carnegie Museum of Art
4400 Forbes Ave,
Pittsburgh PA 15213.
Tel (1 412) 622 3131
Fax (1 412) 622 3112
cmoa.org/html/home/frame.htm
Tues to Sat 10-5; Sun 1-5.
Closed Mon. Café.
A vast, eclectic museum, whose main strengths are in **French Impressionist** (Degas, Monet*, Manet*, Pissarro) and **Post-Impressionist** pictures, and late 19C American, with good works by Winslow Homer* and Whistler. From the 18C a Chardin *Still Life**, a magical study of light on glass and garlic. **Dutch:** early Hals; Ochtervelt*; and Hague school painters. **20C American and European:** Hopper*, de Kooning, Kiefer, and film and video works.

The Frick Art Museum
7227 Reynolds St,
Philadelphia PA 15208.
Tel (1 412) 371 0600
Fax (1 412) 371 6140

Tues to Sat 10-5.30; Sun 12-6.
Café.
The collection of Italian Renaissance works inc. Duccio, Sassetta, Giovanni di Paolo, Tintoretto. Also French and Flemish 17C and 18C inc. Rubens and major French 18C artists.

PONCE PUERTO RICO

Museo de Arte de Ponce
2325 Avenida de las Americas,
Ponce, Puerto Rico 00732.
Tel (1 787) 848 0505
Mon to Sun 10-5. Café.
The collection inc. some outstanding works, inc. Guido Reni's *St Sebastian*; and Philippe de Champaigne's *Presentation in the Temple** but its main strength lies in its collection of less well-known Italian and French 17C painters, inc. Vignali's lyrical Scene from an *Italian Romance*. **British:** inc. paintings by Pre-Raphaelites*, Lord Leighton (*Flaming June*), and three panels from Burne-Jones' *Briar Rose* series.

PRINCETON NEW JERSEY

The Art Museum
Princeton University,
Princeton NJ 08544-1018.
Tel (1 609) 258 3788
Fax (1 609) 921 6939
www.princeton.edu/artmuseum
Tues to Sat 10-5; Sun 1-5.
Closed Mon and hols..
Renaissance is well represented, mainly by Italian works (inc. Guido da Siena), and Lucas Cranach the Elder. A collection of

Barber Shop, *1931, Edward Hopper,*
Neuberger Museum of Art, Purchase, New York

18C and 19C French paintings inc.
Manet's *Gypsy with a Cigarette**;
20C art inc. Duchamp, Johns,
Motherwell, Segal and Stella. Part
of the museum's collection, located
on the university campus, is the
John B. Putnam Jr Memorial
Collection of contemporary out-
door sculpture which has pieces
by Calder, Gabo, Moore, Noguchi,
Picasso and David Smith.

PROVIDENCE RHODE ISLAND

**Museum of Art; Rhode Island
School of Design**
224 Benefit St,
Providence RI 02903.
Tel (1 401) 454 6500
Fax (1 401) 454 6556
www.risd.edu/museum

Tues to Sun 10-5. Closed Mon.
A small collection with paintings
by Tintoretto, Tiepolo, Poussin
and a good collection of French
19C paintings, culminating in
Picasso. An expanding collection
of contemporary art.

PURCHASE NEW YORK

Neuberger Museum of Art
Purchase College, State Univer-
sity of New York, 735 Anderson
Hill Rd, Purchase NY 10577-1440.
Tel/Fax (1 914) 251 6100
www.neuberger.org
Tues to Fri 10-4; Sat, Sun 11-5.
Closed Mon. Café.
The Neuberger combines the scale
and excitement of a city museum
with the charm of a country setting.

Mainly 20C American art; Hans Richter's bequest of Dada works; Clive Gray's *Threnody* 1972-3, commissioned by the museum to fill a windowless ground floor gallery. Avery, Hopper, O'Keeffe, Pollock (see ill. pp.422-3).

RALEIGH NORTH CAROLINA

North Carolina Museum of Art
2110 Blue Ridge Rd, Raleigh NC 27607 (Postal address: 4630 Mail Service Center, Raleigh, NC 27699-4630).
Tel (1 919) 833 6262
Fax (1 919) 733 8034
www.ncartmuseum.org
Tues to Sat 9-5; Fri 9-9; Sun 11-6.
Closed Mon. Restaurant.
An eclectic collection of world art. **American:** Copley (see ill. p.418), Winslow Homer, O'Keeffe. **European:** small group of Early Italian panel pictures; Reni (see ill. p.178); two Melendez still lifes; 18C British portraits; Claude; Monet. But the richest sections are the Flemish (Snyders, Jordaens) and esp. the Dutch, which inc. Terbrugghen's *David Saluted by Women* (the head of Goliath, a lurid green, may be a self-portrait); the *Feast of Esther*, an ugly and controversial early work by either Rembrandt or Lievens; unusually fine cityscapes by Berckheyde*; still lifes, esp. Van der Ast.

RICHMOND VIRGINIA

Virginia Museum of Fine Arts
Boulevard and Grove Ave, Richmond VA 23221-2466.
Tel (1 804) 367 0878
Fax (1 804) 367 9393
Tues to Sun 11-5; Thurs 11-8.
Closed Mon. Café.
A small but well-balanced coll. with

Ships in a Stormy Sea off a Coast, *Ludolf Backhuysen,*
North Carolina Museum of Art, Raleigh, North Carolina

Old Master paintings of high quality by Claude, Poussin and Rosa. Rosa's savage *Death of Atilius Regulus** is his masterpiece as a history painter; it combines ferocity with a grave and meditative quality that emulates Poussin. British school inc. a collection of portraits from 16C to Lawrence, with examples of all the major artists. Mellon collection: English sporting art. Early modern paintings inc. Derain, Lurçat and the Cubists. American paintings inc. Copley (see ill. p.418). The extensive Lewis Galleries of Modern and Contemporary Art feature the big American names, but inc. Kiefer, Clemente etc.

ST LOUIS MISSOURI

The St Louis Art Museum
1 Fine Arts Drive, Forest Park,
St Louis MO 63110 - 1380.
Tel (1 314) 721 0072
Fax (1 314) 721 6172
www.slam.org
Wed to Sun 10-5; Tues 1.30-8.30.
Closed Mon.
A good coll. that emphasizes art in northern Europe from the Renaissance (inc. Holbein*) to the 17C; 16C Venetian school; French Impressionism and Post-Impressionism inc. Fantin-Latour *The Two Sisters*; Seurat; German Expressionism. Collection of 20C European art.

Opposite: Dance,
Robert Motherwell,
North Carolina Museum of Art,
Raleigh, North Carolina

Right: façade, San Diego
Museum of Art, California

SAN DIEGO CALIFORNIA

San Diego Museum of Art
1450 El Prado, Balboa Park,
San Diego CA 92101.
Tel (1 619) 232 7931
Fax (1 619) 232 9367
www.sdmart.com
Tues to Sun 10-4.30. Closed Mon.
European paintings from the Renaissance to the 20C, and American paintings of the 19C and 20C. Unusual **Italian** works inc. a pinnacle from Giotto's Baroncelli altarpiece, and Giorgione's *Portrait of a Man***, inscribed on the back 'from the hand of Master George of Castelfranco'. **Spanish** Baroque works inc. Zurbarán and an outstanding Cotan, *Quince, Cabbage, Melon and Cucumber** (*c.*1607) which creates an almost surrealist tension between detailed naturalism and geometrical composition. Dutch inc. Hals* and good still lifes, esp. a charming *Still Life*

with Gold Finch, attrib. to Van der Ast; 20C inc. Matisse, Dove, O'Keeffe, the Mexicans Rivera and Tamayo, and recent California artists. Good sculpture garden.

Timken Museum of Art
Balboa Park, San Diego
CA 92101.
Tel (1 619) 239 5548
Fax (1 619) 233 6629
http://gort.ucsd.edu/sj/timken
Tues to Sat 10-4.30; Sun 1.30-
4.30; Closed Sept.
One of the finest small American art museums, with emphasis on small, high quality works, esp. early Flemish and Dutch, Spanish and Italian.
Dutch inc. a Claesz *Breakfast Still Life* and Metsu's *Love Letter*.
French: a perfect Claude *Pastoral Landscape** (1646), evocative of an ideal and Virgilian Italy.

SAN FRANCISCO CALIFORNIA

California Palace of the Legion of Honor
Lincoln Park, nr 3411 Ave and Clement St, San Francisco
CA 94121.
Tel (1 415) 863 3330
www.thinker.org
Tues to Sun 9.30-5. Closed Mon.
A museum devoted mainly to the arts of France, from the 16C to Monet and Matisse. 16C inc. a touchingly simple and direct small panel by the rare artist Nicolas Dipre; 17C Claude*, de la Tour*, a strikingly realistic but intensely poetic Le Nain*. A wide range of 18C artists inc. Watteau, Fragonard, and strong works by less well-known painters, esp. Etienne

Aubry, and a small still life, magically refined in surface and texture, by Anne Vallayer Costa. Large collection of Rodin. Other schools inc. El Greco; Fra Angelico; Preti; a festive Tiepolo.

San Francisco Museum of Modern Art (sfmoma)
151 Third St, San Francisco
CA 94103.
Tel (1 415) 357 40000
Fax (1 415) 357 4037
www.sfmoma.org
commassistant@sfmoma. org
Fri to Tues 11-6; Thurs 11-9.
Closed Wed. Summer: Mon to Sun 10-6; Thurs 10-9. Café.
Now in a dazzling new building by Mario Botta, which threatens to overshadow all else. But growing collection modern and contemporary art inc. Matisse; Cubist works; Mondrian; major artists of Abstract Expressionism; groups of works by Rauschenberg* and Ryman; recent works by Kiefer and Louise Bourgeois' monumental sculpture, *The Nest* (1994). An important centre of West Coast *avant-garde*.

SAN MARINO CALIFORNIA

Huntington Library and Art Gallery
San Marino CA 91108.
Tel (1 626) 405 2100
www.huntington.org
Tues to Fri 12-4.30; Sat, Sun 10.30-4.30 (Summer: Tues to Sun 10.30- 4.30). Closed Mon.
18C British and French art (esp. a large collection of British portraits between 1770 and 1800) shown in

a domestic setting; high quality furniture and decorative objects recreate the atmosphere in which a wealthy 18C aristocrat would have lived. Most famous is Gainsborough's *Blue Boy***, a work of unusual directness. It is a portrait of a friend of the artist, whom he painted for his own pleasure in the Van Dyck dress favoured by some of his clients. Large collection of works by Gainsborough inc. a series of powerful full-length portraits*, and *The Cottage Door* 1780, a work full of Gainsborough's sense of the idyllic charms of country life. Important works by Lawrence, Reynolds, Romney, Constable and Turner. 18C **French** painting and **18C to 20C American**.

SANTA BARBARA CALIFORNIA

Santa Barbara Museum of Art
1130 State Street,
Santa Barbara CA 93101.
Tel (1 805 963 4364)
www.sbmuseat.org
Tues to Wed 11-5; Thurs 11-9;
Sun 12-5. Café.
Some early European works, inc. Lorenzo Monaco and Baglione, but the main emphasis is on French, British and American 19C and 20C works.
French: inc. Monet, Morisot's *View of Paris from the Trocadero** and Vuillard.
American: good works by O'Keeffe, Milton Avery, Demuth and Henri. Southern Californian painters, esp. Larry Bell, Ron Davis, Diebenkorn.

SANTA FE NEW MEXICO

Georgia O'Keeffe Museum
217 Johnson Street,
Santa Fe NM 87501.
Tel (1 505 995 0785)
www.okeeffe-museum.org
Tues to Sun 10-5; Fri 10-8.
Closed Mon. Café.
Georgia O'Keeffe spent many summers in New Mexico, and from 1949 she lived there. The museum has a good range of her works, inc. landscapes, flower paintings, and still lifes.

SARASOTA FLORIDA

The John and Mable Ringling Museum of Art
5401 BayShore Rd,
Sarasota FL 34243.
Tel (1 941) 359 5700
Fax (1 941) 359 5745
www.ringling.org
Mon to Sun 10-5.30.
The Baroque dominates this collection but it also has some good Italian Renaissance works, inc. Piero di Cosimo, Fra Bartolommeo, and works by Milanese artists in the circle of Leonardo.
Italian school inc. 16C Venetian paintings, esp. Veronese; 17C paintings by artists of the Roman, Bolognese and Neapolitan schools, inc. Pietro da Cortona; landscapes and a portrait by Rosa; Mola, Carlo Dolci, and a spectacular Francesco del Cairo*.
Dutch and Flemish inc. Hals and eight works by Rubens* (inc. four cartoons for *Eucharist* series), Van Dyck, Jordaens.
French: inc. Dughet and Poussin.

British 18C: a good collection inc. Gainsborough's *Portrait of General Honeywood*.
Also a collection of **20C American** works.

TOLEDO OHIO

Toledo Museum of Art
*2445 Monroe St
(at Scottwood Avenue),
Toledo, OH 43697-1013.
Tel (1 419) 255 8000
Fax (1 419) 255 5638
www.toledomuseum.org
Tue to Thurs, Sat 10-4; Fri 10-10;*
Sun 11-5. Closed Mon. Café.

A major, well-balanced collection from Renaissance to international contemporary art. Collections of British, Italian (Primaticcio*) and American works but high-points are:

Dutch and Flemish: inc. Rubens *The Crowning of St Catherine** 1633; Dutch landscape and portraiture inc. Hobbema* and Rembrandt's *Young Man in a Plumed Hat.* Van Gogh.

French: 17C works, esp. Claude*; 18C inc. a version of David's *Oath of the Horatii*; 19C collection of Barbizon and Impressionists.

*Ulysses and Penelope, Francesco Primaticcio,
Toledo Museum of Art, Toledo, Ohio*

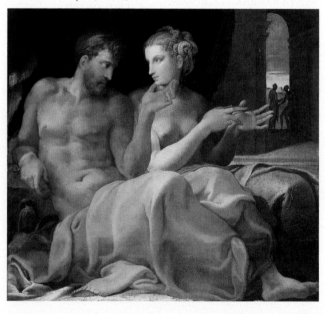

468

TUCSON ARIZONA

University of Arizona Museum of Art

Speedway & Park Avenue,
Tucson, Arizona 85721.
Tel (1 520) 621 7567
Fax (1 520) 621 8770
artmuseum.arizona.edu
Mon to Sat 10-4; Sun 12-4.

Main emphasis on American art inc. Benton, Hopper, O'Keeffe. Important exhibit of plaster models, bronzes, and drawings by Jacques Lipchitz; his *Lessons of a Disaster* is outside.

WASHINGTON DC

Washington is perhaps the pleasantest city in America in which to look at painting. The galleries have unusually long opening hours, they are free, and generally have rather good restaurants. Many of the museums of the Smithsonian Institution (inc. all those listed except the Freer and Phillips Collection) are located on or near the National Mall.

Corcoran Gallery of Art

17th Stand New York Ave,
Washington DC 20006.
Tel (1 202) 639 1700
Fax (1 202) 737 2664
www.corcoran.org
Wed to Mon 10-5; Thurs 10-9.
Closed Tues. Café.

Collection of **American** art inc. Hudson River School, Homer and Eakins, and works by contemporary Washington artists. Some **19C French** works.

Freer Gallery of Art

Mall, South Side at 12th St SW,
Washington DC 20560.
Tel (1 202) 357 2700
Fax (1 202) 357 4911
Mon to Sun 10-5.30.

Charles Freer knew Whistler well, especially in his last years, and saw him as the artist who most perfectly united the art of the West with that of the Orient. The Freer Gallery, predominantly a collection of Oriental art, also houses Whistler's *Peacock Room* and a representative collection of paintings. The spectacular blue and gold decorations of the Peacock Room have as their focal point the languorous Pre-Raphaelite beauty of *Rose and Silver: La Princesse du Pays de la Porcelaine (*1864); her pose is based on a figure in a Japanese print. Other paintings inc. Whistler's early Japanese themes of the 1860s – inc. the *Golden Screen**, a Victorian genre scene in fancy dress, *The Music Room* and *The Balcony (*1868), in which Whistler began to exploit the spatial ambiguities of Japanese prints. Fresh and spontaneous landscapes of the 1860s are close to early Impressionism; nocturnes and portraits of the 1870s; and a series of small sketches on wooden panels of shop-fronts and sea-shore.

Hirshhorn Museum and Sculpture Garden

Independence Ave at 7th St,
Washington DC 20560.
Tel (1 202) 357 3091
Fax (1 202) 786 2682
www.si.edu.hirshhorn
Mon to Sun 10-5.30. Garden 7.30 to dusk.

The Hirshhorn Museum, a striking cylindrical structure, is rapidly becoming one of the most stimulating and varied collections of modern and contemporary art in America. Its collection of modern sculpture** is one of the most important anywhere; large works by Di Suvero, Calder, Rodin, Matisse, Cragg, Muñoz, Moore and others are installed in the sculpture garden, and smaller sculptures along inner-ring ambulatories on the second floor (well-equipped with comfortable armchairs). Only about an eighth of the permanent collections on show at any one time; the most popular works, inc. the very strong holding of Abstract Expressionism, remain on exhibition fairly constantly but elsewhere small 'unit' displays illustrate a particular theme, artist, school or medium.

National Gallery of Art
*6th St at Constitution Ave NW
Washington DC 20565.
Tel (1 202) 737 4215
Fax (1 202) 842 6176
Mon to Sat 10-5 (summer 10-9);
Sun 12-9.*
The gallery houses one of the grandest collections of European and American painting (from 13C to the present day) in the world. It is most famous for its collection of Italian painting (the most comprehensive in America); for a fine group of Rembrandts; a splendid array of Van Dycks; an extensive collection of French Impressionism and high quality works by American, British, German, Flemish and Spanish artists. The sense of partaking in a special experience is

created by the grandeur of the marble Neo-Classical building; the visitor proceeds from the main entry to the Rotunda, with its great collared dome and the halls for monumental sculpture, into a series of smaller rooms where the paintings are displayed without the distractions of decorative objects (a concentration unusual in America). The information supplied in each room is especially useful.

British: good collection of 18C portraitists; landscapes by Constable (*Wivenhoe Park, Essex**, 1816) and Turner.

Dutch: dominated by 15 paintings by Rembrandt** and Vermeer (*Woman Weighing Gold***).

French: 17C inc. Claude, de la Tour* and Poussin*; 18C** inc. Boucher, Watteau* and Fragonard*, inc. two decorative panels, *Blindman's Buff* and the *Swing*, perfect examples of the lightness and artificiality of Rococo landscape. Two very different portraits by David, the highly finished *Napoleon*, and the forthright, painterly portrait of his wife. 19C particularly rich in Degas*, Manet* and Renoir and also inc. Cézanne, Gauguin and Monet. Whistler's *White Girl* should be seen in this context.

Early German and Flemish art inc. Van Eyck*, Van der Weyden*, Grünewald and Holbein. Flemish 17C inc. works by Rubens and Van Dyck, ranging from the *Marchesa Elena Grimaldi***, the most sumptuous of his Italian portraits, to the silvery colours and flickering brushwork of his English period.

Italian: Florentine and Central Italian art; one of the largest collections

in the world of early Italian art**, inc. Duccio, Simone Martini, Fra Filippo Lippi, and Domenico Veneziano*. A collection of Renaissance portraits culminates in Leonardo da Vinci's *Ginevra da Benci*** (the only undoubted Leonardo in America). 16C inc. Perugino, Raphael, inc. the *Alba Madonna***. Venetian and North Italian art inc. Bellini, Giorgione**, Titian** (his haunting portrait of the youthful *Ranuccio Farnese*) and Tintoretto*.

20C art inc. Picasso's *Saltimbanques***. The East Wing shows more of the 20C collection in a soaring interior space (dominated by a Calder mobile) and other more intimate galleries on the ground floor; its asymmetry and variety deliberately contrasting with the clarity of the older building. Many of the works of art were especially commissioned for the building.

In the plaza: an immense bronze by Henry Moore; over the door from the main court, Caro's *National Gallery Ledge Piece* projects energetically into space.

National Museum of Women in the Arts
1250 New York Avenue,
NW Washington DC 20005.
Tel (1 202) 783 5000
Fax (1 202) 393 3235
www.nmwa.org
Mon to Sat 10-5; Sun 12-5. Café.
A museum whose building ensures a grand and impressive presence, but the pictures are a little disappointing. It was founded to celebrate women artists from the Renaissance to the present day; unexpectedly the early works – a

fine Lavinia Fontana, a painterly Elisabetta Sirani (celebrated in 17C Bologna) a flower piece by Rachel Ruysch – are the most interesting. It has lively exhibitions.

The Phillips Collection
1600-1612 21st St, NW,
Washington DC 20009.
Tel (1 202) 387 2151
Fax (1 202) 387 2436
Tues to Sat 10-5; Sun 2-7. Closed Mon. (Entry fee at weekend.)
Café.
An outstanding collection of late 19C and early 20C European and American painting and sculpture, pleasant to visit in the domestic setting of the former home of the Phillips family. The highpoint of the collection is Renoir's *Luncheon of the Boating Party**. Also works of outstanding quality by Degas and Van Gogh: a large group of Bonnards; a small room of works by Klee; important paintings by Braque and Matisse, and a Rothko room* with four works, where the spectator is surrounded and absorbed by the radiance of the colour.

Smithsonian American Art Museum
750 9th St,
Washington DC 20001.
Tel (1 202) 275 1500
www.nmaa.si.edu
Closed for renovation until 2003.
A vast collection – over 37,000 pieces – covering every aspect of American fine art, as well as folk, primitive and craft art, and photography. Many classic images (see ill. pp.419, 421, 425, 472).

Early Morning Work, *William H. Johnson, Smithsonian American Art Museum*

WILLIAMSTOWN
MASSACHUSETTS

Sterling and Francine Clark Art Institute
225 South St,
Williamstown MA 01267.
Tel (1 413) 458 2303
Fax (1 413) 458 2318
www.clark.williams.edu
Sept-June: Tues to Sun 10-5;
July, Aug: Mon to Sun 10-5.
(Free entry Nov-June).
An elegant, spacious museum, in lovely grounds, it has a fine collection of French 19C painting inc. over 30 canvases by Renoir* but it also has some high quality works from earlier periods, inc. ?Piero della Francesca*; portraits by the Netherlandish artists Gossaert and Memling; examples of French, Flemish and Dutch 17C artists.
French: 19C inc. Barbizon school works by the Academic masters; Impressionists, inc. Degas and Monet, Renoir esp. *Sleeping Girl with a Cat* (1880).
American: 19C inc. Sargent, Cassatt, Homer.

WILMINGTON DELAWARE

Delaware Art Museum
2301 Kentmere Parkway,
Wilmington, DE 19806.
Tel (1 302) 571 9590
Fax (1 302) 571 0220
www.udel.edu/delart
Tues to Sat 9-4; Sun 10-4; Wed 9-9. Closed Mon. Café.
The largest collection of Pre-Raphaelite art on view in America; also extensive holdings of American art from 1840 to the present.

473

WORCESTER MASSACHUSETTS

Worcester Art Museum
55 Salisbury St,
Worcester MA 0169.
Tel (1 508) 799 4406
Fax (1 508) 798 5646
www.worcesterart.org
Wed to Fri, Sun 11-5; Sat 10-5.
Closed Mon, Tues.

The main emphasis is on British portraits; a varied group of Dutch works; French paintings from 18C to 20C inc. Fragonard and Courbet. Also Italian works from the Renaissance to 18C; good collection of American art esp. 17C.

Yugoslavia,
Federal Republic of

National holidays: Jan 1, 7, Apr 27, May 1.

BEOGRAD (Belgrade)

**Galerija moderne umetnosti
(Gallery of Modern Art)**
Ušće, Novi Beograd.
May-Sept: Wed to Mon 10-7
Oct-Apr: Wed to Mon 10-5.
Closed Tues.
Collection of 20C Yugoslavian painting and sculpture.

**Narodni muzej
(National Museum)**
Trg Republike 1.
Tel (381 11) 624 322
Tues, Wed, Fri 10-5; Thurs 10-8;
Sat 9-5; Sun 10-2. Closed Mon.
Collection of 17C to 20C Serbian art. A handful of Italian and Flemish Old Masters, inc. Carpaccio, Joos van Cleve, Guardi. French 19C and 20C are well represented; Degas*; Nabis, Fauves, School of Paris.

Candle in a Dark Room, *Colin McCahon, 1943,*
Auckland Art Gallery Toi o Tamaki

A-Z of artists/selective index

Entries are given under the name by which the artist is most commonly known (this is often the first name, eg Leonardo da Vinci, Claude Lorrain).

Page numerals in roman refer to major collections of the artist's work; page numerals in *italics* refer to an illustration. This A-Z has been conceived to supplement the main text: it includes some artists not mentioned in it by name who are therefore not indexed.

Abbate, Niccolò dell' *c.*1512-71. Italian Mannerist who worked at Fontainebleau; he made an important contribution to the sophisticated fantasy of Mannerist landscape.

Aertsen, Pieter 1508-75. Dutch painter who brought a new grandeur and gravity to genre and still life. His foregrounds are often piled high with detail, with a tiny religious scene in the background.

Agostino di Duccio 1418-81. Florentine sculptor of delicate marble reliefs. 209, 211

Albers, Josef 1888-1976. German painter and designer, member of the Bauhaus. In 1933 became a leader of the American Bauhaus. His interest in the interaction of colours culminated in his famous series *Homage to the Square.*

Aix Annunciation, Master of (?Jean Chapus) a. 1437-48 in Aix. 82

Algardi, Alessandro 1598-1654 Italian Baroque sculptor, the creator of monumental sculptural projects and small scale works in bronze and silver; he is best known for the powerful realism of his portrait busts and for the lyrical grace of his reliefs.

Alma-Tadema, Sir Lawrence 1836-1912. Dutch-born English painter who specialised in meticulously detailed and coyly erotic scenes from the daily life of ancient Greece and Rome.*348*

Altdorfer, Albrecht *c.*1480-1538. German painter and engraver. Inspired by the beauty of the Austrian Alps, he became the first true landscape painter. 28, 139, 156.

Amberger, Christoph *c.*1500-62. Augsburg portrait painter influenced by Venetian art.

André, Carl b. 1935. US Minimal sculptor who uses ready-made and found materials (bricks, stones, etc). Influenced by Brancusi's late works.

Andrea del Sarto 1486-1530. One of the most important High Renaissance painters in Florence; a great portraitist. His late works anticipated the Mannerism of his pupil Pontormo. 213

Angelico, Fra *c.*1387-1455. One of the greatest Florentine painters to profit from the discoveries of Masaccio; his paintings, brightly coloured in blues and pinks, are sweet, direct and pious. 182, 191, 226, *440-1*

Antonello da Messina *c.*1430-79. Sicilian Renaissance painter whose

minute portrayal of landscape detail and use of oils indicates Flemish influence. Worked in Venice. 207

Appel, Karel b. 1921. Dutch Abstract Expressionist; founder member of the CoBrA group. His violent works, stridently coloured and thickly painted, reveal a fascination with primitive art. 271

Archipenko, Alexander 1887-1964. Russian Cubist sculptor, who moved to Paris in 1908.

Arcimboldo, Giuseppe 1527-93. Milanese Mannerist painter. Became court painter to the Hapsburgs in Prague. He specialized in grotesque figures composed of fruits, animals etc. *183*

Arp, Jean (Hans) 1887-1966. French sculptor, a dominant member of the Dada and Surrealist movements. After experimenting with wooden reliefs and automatic drawing moved towards the biomorphic abstraction of his later sculpture. 121, 343

Asam, Cosmas Damian 1686-1739 and **Egid Quirin** 1692-1750. Bavarian artist-architects and decorators, influenced by Roman Baroque. 161

Asselijn, Jan c.1615-52. Dutch landscape painter, who worked in Italy c.1640-44. His brightly lit landscapes show such Italianate scenes as Mediterranean harbours, panoramic views of the Campagna with classical ruins, and Roman street scenes with lively genre figures. *356*

Avercamp, Hendrik 1585-1634. Dutch landscapist, the first to specialize in winter scenes with colourfully dressed skaters and tobogganers.

Avery, Milton 1885-1965. US painter, whose landscapes and beach scenes, painted in flat areas of colour, attracted early abstract painters.

Baburen, Dirk van c.1595-1624. One of the most important Utrecht Caravaggisti. Painted religious subjects and genre scenes.

Baciccio, Giovanni Battista *see* Gaulli.

Backhuysen, Ludolf 1608-51. Dutch marine painter, mainly of stormy seas. *463*

Bacon, Francis 1909-92. Self-taught Irish-born English painter, influenced by Picasso and figurative Surrealism. His images are powerful, often violent and repulsive. 166, *166-7*, 389

Baglione, Giovanni 1566-1644. Italian painter and writer on art; he contributed to many fresco cycles in papal Rome, but was an early convert to Caravaggism, and is now most celebrated for a very public row with Caravaggio.

Baldovinetti, Alesso 1425-99. Florentine fresco painter, influenced by Veneziano and Fra Angelico. 192

Baldung, Hans 1484-1545. German artist influenced by Grünewald in his interest in the macabre. 148

Balla, Giacomo 1871-1958. Italian Futurist. His paintings try to show motion in the manner of time-lapse photography. His later style is more abstract.

Bamboccio *see* Laer, Pieter van

Barbari, Jacopo de c.1440-1516. Venetian painter of portraits and mythological subjects, a. mainly in the N European courts. His masterpiece is the first ærial view map of Venice

Barlach, Ernst 1870-1938. German Expressionist sculptor and graphic artist. In his use of powerful symbols of human isolation he is indebted to Russian folk art and to Gothic wood carvings. In 1933 the Nazis destroyed over 300 of his despairing works.

Barocci, Federico 1526-1612. Italian painter, a. in Urbino. The windswept drama and emotional appeal of his religious works led on to the Baroque.

Barry, James 1741-1806. Irish painter, a protégé of Edmund Burke, who travelled in Italy and worked in London, where he painted ambitiously grandiose history paintings. *164*

Bartolommeo, Fra Baccio della Porta 1476-1517. Florentine painter of religious subjects, whose emphasis on large and noble forms and on balanced compositions led on to the ideals of the High Renaissance.

Baschenis, Evaristo 1617-77. Italian still life painter, who worked in Bergamo; his paintings of musical instruments, books, globes, spent candles, are highly sophisticated spatially, and intensely poetic in their evocation of the passage of time. *358*

Baselitz, Georg b. 1938. German artist who emigrated to the west from East Berlin in 1957. He painted in a violently expressionist style with – from 1969 – figures pointlessly upside down. 389

Bassano, Jacopo c.1517-92. Italian Mannerist. Portrayed biblical themes as pastoral genre scenes. The most important of a family of artists. 175

Batoni, Pompeo 1708-87. Italian painter, who worked in Rome; he painted religious and history paintings, but is celebrated for his Grand Tour portraits, which show British aristocrats proudly posed before the most celebrated buildings and sculptures of ancient Rome, thereby enhancing their learning and status.

Baziotes, William 1912-63. US Abstract Expressionist, using biomorphic shapes. Saw the act of painting as painting's chief subject.

Beccafumi, Domenico (Domenico della Pace) c.1486-1551. Sienese Mannerist painter. Used distinctive luminous colours. 229

Beckmann, Max 1884-1950. German figurative painter w. in Berlin and Frankfurt, Holland and finally the USA. Painted portraits as well as large, powerful compositions, often cruel and harsh in feeling. 141, *146*

Bellini, Gentile 1429-1507. Venetian painter of portraits, civic and religious ceremonies and panoramic views. **Giovanni** c.1430-1516. First great painter of the Venetian Renaissance; Titian and Giorgione were his pupils, 240, 243, 261. **Jacopo** c.1400-70. Father of Gentile and Giovanni. Founder of Venetian Renaissance art.

Bellotto, Bernardo 1720-80. Venetian topographical artist. Painted in an almost identical style to Canaletto (his uncle and teacher). Also w. in Dresden, Vienna, Munich and finally Warsaw. Sometimes signed himself Canaletto. 144, 291

Bellows, George Wesley 1882-1925. US painter, whose grittily realistic scenes of urban life, esp. boxing subjects, are handled in a broad and vigorous style.

Benedetto da Maiano 1442-97. Florentine; pupil of Antonio Rossellino. His pictorial reliefs (eg pulpit in S. Croce, Florence) are in the narrative tradition of Donatello and Ghiberti. Famous for his decorative architectural settings. 192

Berchem, Nicolaes 1620-83. Dutch painter of Italianate landscapes, a. mainly in Haarlem. His pastoral scenes, full of nostalgia for the south, led on to the Rococo.

Berndtson, Gunnar 1854-1895. Finnish landscape painter and portraitist, pupil of Gérome. *68*

Bernini, Gianlorenzo 1598-1680. Italian sculptor, architect and painter, the greatest Baroque artist. His works transformed the appearance of papal Rome. He used daring illusionistic effects and dramatic combinations of architecture, sculpture and painting to make religious drama intensely real. 214, 221, *222-3*, 222, 223, 224

Berruguette, Alonso c.1488-1561. Spanish Mannerist painter and sculptor, who brought the Italian High Renaissance to Spain. *306*

Beuys, Josef 1921-86. One of the most radical and influential 20C artists, who, believing art to be central to human experience, has extended its meaning. But his works from fat, felt, wax, tallow, copper, etc are completely incomprehensible. *132, 143, 149, 389*

Bierstadt, Albert 1830-1902. German-born US painter, who specialised in sublime scenes of the American West.

Bingham, George Caleb 1811-79. US painter, who worked in Missouri; he is best known for such classically composed scenes of Missouri life as *Fur Traders Descending the Missouri* (c.1845; New York, Met. Mus.).

Blake, Peter b. 1932. British Pop Art painter, whose works reveal a nostalgia for the Victorian and Edwardian eras.

Blake, William 1757-1827. English Romantic painter, engraver and poet. A visionary artist who used powerful visual symbols to express his intensely private mystical experience; his sharply linear style is indebted to 16C Mannerism. *387*

Bloemaert, Abraham 1564-1651. Utrecht-based Mannerist painter taught in France; trained many of the next generation of Dutch painters.

Boccioni, Umberto 1882-1916. The most powerful and consistent of the Italian Futurists, he created new techniques to express the movement and vitality of modern life. *174, 200, 218, 456*

Böcklin, Arnold 1827-1901. Swiss painter, who worked in Rome and Munich; he developed from an early lyrical naturalism to a majestic Symbolist style, and in his late years his imaginary landscapes and mythological scenes made him one of the most celebrated artists in Europe.

Bologna, Giovanni da *see* Giambologna

Boltraffio, Giovanni Antonio 1466/7-1516. Italian painter of the Lombard school. Follower of Leonardo da Vinci.

Bonington, Richard Parkes 1802-28. English painter a. mainly in France. Influenced by Constable and known chiefly for his light watercolours depicting land and seascapes.

Bonnard, Pierre 1867-1947. French painter, associated with the Nabis until 1899. Most famous for the radiance of his colour, he painted landscapes, interior scenes, women bathing, dressing or sleeping.389

Bosch, Hieronymus c.1450-1516. Flemish painter. He created a nightmare world that gave expression to the fears of the waning Middle Ages. His hellish landscapes are peopled by demons, monstrous growths, strange instruments of torture, and weird creatures half-animal, half-human.

Both, Andries 1612-41. Dutch genre and biblical painter, pupil of Bloemaert. Worked in Rome from 1635 until his death. Known chiefly for lively peasant scenes. His brother **Jan** (c.1615-52) was also a pupil of Bloemaert. In Italy from c.1638 to 1641, he painted the Roman Campagna, peopled with picturesque peasants. His later Dutch landscapes are also bathed in the golden sunlight of the south.

Botticelli, Sandro 1445-1510. Florentine painter; his mythological works – complex Neo-Platonic allegories – are made intensely poetic by the evocative and ornamental power of line. Later, perhaps influenced by Savonarola, his religious works move from sweet refinement to wild intensity. *186-7, 188*

Boucher, François 1703-70. French court painter and decorator whose ornamental style typifies the Rococo. He is most famous for his ravishingly pretty female nudes, lightly disguised as goddesses or partially concealed by the beribboned gowns of coy shepherdesses. Also painted unexpectedly natural portraits. *75, 392, 514*

Boudin, Eugène Louis 1824-98. French *plein-air* painter of sky and sea. In the early 1860s he painted the fashionable resorts of Trouville and Deauville.

Bourdelle, Emile Antoine 1861-1929. French sculptor, trained in Rodin's studio, and celebrated during his lifetime for monumental public commissions.

Bouts, Dirk d. 1475. Flemish painter of religious scenes and portraits; a. in Louvain. His work is unusually sensitive to the effects of light. *46, 48*

Brancusi, Constantin 1876-1957. Romanian sculptor who w. in Paris from 1904. His most beautiful works are smooth and simple shapes in whose purity he saw the real 'essence of things'. *111, 460*

Brangwyn, Sir Frank 1867-1956. Welsh painter b. in Bruges. Apprenticed to William Morris. *44*

Braque, Georges 1882-1963. French painter. Pioneered Cubism working with Picasso (1907-14). Moved from analytical to synthetic Cubism after 1910, using collage. His later works rely more on sensuous colour. *342*

Breenberg, Bartholomeus 1598-1657. History and landscape painter, a. in Amsterdam. Returning from his stay in Rome (1619-33), he painted Italianate landscapes with biblical and mythological figures.

Breughel, Jan (Velvet) 1568-1625. Flemish painter, second son of Pieter Bruegel the Elder. Worked mostly in Antwerp. Best known for his brilliantly coloured wooded landscapes and flower paintings.*200*

Bril, Matthew 1550-83 and **Paul** 1554-1626. Flemish landscape painters (brothers) who went to Italy *c.*1575. Paul Bril, who painted frescoes and small oils, became the leading landscape specialist; he developed from Mannerist fantasy towards a greater naturalism.

Bronzino, Agnolo 1503-72. Florentine Mannerist; his polished, cold paintings of Cosimo de' Medici and his entourage initiated a court portrait style.

Brouwer, Adriaen *c.*1605-38. Flemish genre painter. He delighted in sordid peasant low life scenes – drunken peasants vomiting and brawling in smoky taverns – which were relieved by the delicacy of his touch and colour. *148*

Brown, Ford Madox 1821-93. English Pre-Raphaelite who tackled social themes, notably in his painting *Work* (Manchester City Art Gallery). *396*

Bruegel, Pieter, the Elder *c.*1520-69. The greatest 16C Flemish painter; he moved from parables of Folly (indebted to Bosch) to religious scenes and genre; his finest works are the *Months*, painted with an unprecedented sensitivity to weather. *See* also Breughel. *29, 46*

Buren, Daniel b. 1938. French artist, most of whose works are elegant striped painting-installations, dependent on repetition, and created for institutions.

Burgkmair, Hans 1473-1531. German painter and woodcut designer, a. in Augsburg. Pupil of Schongauer. His altarpieces, portraits and battle scenes show Italian influences combined with a northern realism.

Burne-Jones, Sir Edward Coley 1833-98. A late follower of the Pre-Raphaelites, deeply attracted by 15C

Italian artists. He created a morbid and melancholy art characteristic of the *fin-de-siècle*. 160, *394-5*, 402, 411

Burra, Edward 1905-76. English painter. Abandoned his early satirical works, reminiscent of Grosz, in favour of Surrealism, to paint the seamy bars and brothels of Paris and Haarlem. After Second World War he painted landscapes.

Caillebotte, Gustave 1848-1894. Rich patron and champion of Monet, Renoir, Sisley and Pissarro; his own work, originally neglected, has affinities with the precise composition of Degas. *Back cover*

Calder, Alexander 1898-1976. US sculptor. Began making wire sculptures in Paris (1926-27), developing these into mobiles of wire and metal discs painted in primary colours or in black. Also made non-moving 'stabiles'. 66, *66*

Cambiaso, Luca 1527-88. Founder of the Genoese school, most famous for his unusual nocturnes.

Campin, Robert *c.*1378-1444. Flemish painter, a. in Tournal. He is now sometimes identified with the artist known as the Master of Flémalle, the founder of Flemish realism. *36-7*, 146, 450

Canaletto, Antonio 1697-1768. The great painter of Venetian scenes, whose clarity and detail contrast with the sketchiness of Guardi. *See also* Bellotto, Bernado. 384, 387, 404

Canova, Antonio 1757-1822. The greatest Neo-Classical sculptor born in the Veneto. From 1781 w. mostly in Rome. 210, 300

Cappelle, Jan van de *c.*1624-79. Dutch self-taught but highly professional painter of seascapes and landscapes.

Caracciolo, Giovanni Battista (Battistello) 1578-1635. Italian painter, mainly of altarpieces and religious subjects, the most gifted of Caravaggio's Neapolitan followers. His dark naturalism is Caravaggesque, but his sense of space, and his emphasis on expression and gesture, are more classical, and these qualities together create a poetic and meditative quality.

Caravaggio, Michelangelo Merisi da *c.*1573-1610. Italian painter; his revolutionary naturalism and dramatic contrasts of light and shade deeply influenced 17C painting. He moved from half-length genre scenes to deeply compassionate religious works, in which the protagonists are shown as humble peasants. 110, 214, 221, 253, *253*

Caro, Anthony b. 1924. English sculptor. Assistant to Henry Moore 1951-53. After 1960 he moved away from traditional techniques and began using brightly painted prefabricated sections of welded metal to form finely balanced geometrical compositions.

Carpaccio, Vittore *c.*1450-*c.*1525. Venetian painter, influenced mainly by Gentile Bellini. He painted religious subjects set in the pageantry of 16C Venice, crowded with charming details and incidents. 240, 244

Carrà, Carlo 1881-1966. Italian painter who moved from restless Futurist paintings to the simplicity of his mature style when, with de Chirico, he founded the Scuola Metafisica in 1917.

Carracci, Annibale 1560-1609. Bolognese painter, who, after the extremes of Mannerism, sought to return to the grandeur of the High Renaissance and the glowing colours of Venice. He encouraged an intense study of nature. His works are more classical than the emotional Baroque paintings of his cousin **Ludovico**; his brother **Agostino** is more important as an engraver. 179, 219, *398*

Carriera, Rosalba Giovanna 1675-

1757. Italian portraitist working mainly in pastels. Her delicate style suited the Rococo age and she was a sensational success at court.

Cassatt, Mary 1845-1926. US painter w. mostly in Paris. Influenced and encouraged by Degas. The mother and child was her main theme, but she also painted society women. *420*

Castagno, Andrea del *c.*1420-57. Florentine painter, foremost fresco painter in the generation after Masaccio. 192

Castiglione, Giovanni Benedetto *c.*1610-*c.*1665. Genoese Baroque painter and etcher. Specialized in scenes crowded with animals and pots and pans. In Rome painted romantic and mythological subjects; his latest works were ecstatically spiritual. 196

Caulfield, Patrick b. 1936. English painter, influenced by Lichtenstein. Uses popular illustrations as source material.

Cavaliere d'Arpino (Giuseppe Cesari) 1568-1640. Italian painter, the most succesful fresco painter in papal Rome in the years around 1600. His work is uneven, and many of his frescoes vapid; he also painted small cabinet pictures much prized by 17C collectors.

Cavallino, Bernardo 1622-54. Neapolitan painter of small, elegant religious scenes. 204

Cellini, Benvenuto 1500-71. Florentine Mannerist sculptor and goldsmith. Worked in Rome and for François I at Fontainebleau (1537-45); the mannered grace of his figures epitomizes the Second School of Fontainebleau. 190

Ceruti, Giacomo fl.1728-60. Italian painter, a. in Brescia. Best known for his repulsive studies of beggars and cripples. 180

Cézanne, Paul 1839-1906. French painter. The least spontaneous and one of the most intellectually rigorous

of painters, he was essentially concerned with implying volume by colour and tone; his analysis of form influenced the Cubists. He painted landscape, still life portraits, and a monumental series of *Bathers*. 113, *346*

Chagall, Marc 1887-1985. Russian painter and print-maker w. mainly in France and USA. He created a highly personal sentimental style of richly coloured figures loosely related to each other in dreamy ambiguity. His subjects are drawn from Russian village life and Jewish and Christian religious themes.105

Champaigne, Phillipe de 1602-74. Flemish-born French painter. Famous as a portraitist. Court painter to Marie de Médicis and highly regarded by Louis XIII and Richelieu. After 1643, influenced by the Jansenists, he painted austerely simple religious works.

Chardin, Jean-Baptiste-Siméon 1699-1779. French still-life genre painter, concentrating on humble household objects and unsentimentalized domestic scenes which have a directness of vision and sureness and delicacy of touch. 110

Charonton, Enguerrand b. *c.*1410. French painter active in Avignon (also known as Quarton, Charton). 109, 125

Chavannes, Puvis de *see* Puvis de Chavannes

Chirico, Giorgio de 1888-1978. Italian painter, most famous for his ghostly paintings of deserted city squares peopled only by faceless mannequins who symbolize the loneliness and anguish of the human condition. Co-founder with Carrà of the Scuola Metafisica.

Christo (Christo Javacheff) b. 1935. Bulgarian-born US sculptor, best known for his packaging, or wrapping of objects; Christo has wrapped both buildings, such as the Pont Neuf

in Paris, 1985, and landscapes, such as a mile of coastline near Sydney.

Christus, Petrus c.1410-c.1472. Flemish painter. Thought to have trained in Van Eyck's workshop.

Church, Frederick 1826-1900. US painter, whose vast canvases show sublime natural scenes, such as volcanoes, waterfalls, icebergs.

Cima da Conegliano c.1460-c.1518. Venetian, working in the style of Giovanni Bellini. Famous for his Madonnas. 244

Cimabue (Cenni di Pepi) a. c.1272-1302. Florentine, traditionally regarded as Giotto's teacher. 188

Claesz, Pieter c.1596-1661. Still-life painter from Haarlem. His best works show very simple objects, simply arranged, their muted colours dominated by a silvery tonality. 273

Claude Lorrain 1600-82. French landscape painter, w. in Rome. He perfected the conventions of 'ideal landscape'. Based on an intense study of nature and filled with light, his landscapes suggest the lost harmony of a remote Golden Age. 109, 323, 384, 408

Clouet French painters of Flemish descent. **Jean the Younger** (c.1485-c.1541). His portrait drawings recorded the court of François I. His son **François** (c.1510-72), who succeeded him, was a more important artist and painted jewelled court portraits and nudes.

Cole, Thomas 1801-48. US landscape painter, who travelled in Italy, and painted sublime landscapes influenced by Claude, Rosa and Turner. A leading member of the Hudson River School.

Constable, John 1776-1837. English landscapist who brought to landscape painting both a new quality of precise observation and a new depth of feeling. Subjects inc. his native Suffolk, Salisbury and Hampstead Heath. 387, 390, *390*, 447

Copley, John Singleton 1738-1815. US portrait painter, b. in Boston. Here he developed a vigorously realistic portrait style before going to England in 1775, where his contemporary history paintings anticipated aspects of French Romanticism. *418*, 430, 433, 453

Corinth, Lovis 1858-1925. German painter, initially influenced by Impressionism and Symbolism, who developed a violently expressive style in his later years.

Corot, Jean-Baptiste Camille 1796-1875. French landscapist. His early works are notable for their clarity of light; later works are in shades of grey and green. 117

Correggio, Antonio Allegri c.1490-1534. Italian High Renaissance painter from Correggio, a link between the illusionism of Mantegna and that of the great Baroque ceiling painters. Soft *sfumato* characterizes his major works. 208

Cortona, Pietro da (Pietro Berrettini) 1596-1669. Italian painter and architect, one of the creators of the Roman High Baroque. His style developed from the overpowering illusionism and glowing Venetian colours of the ceiling fresco in the Palazzo Barberini, Rome, towards a greater elegance and lightness of colour. 188, 220, 221

Cossa, Francesco del c.1435-76/7. Ferrarese painter who contributed to the courtly and decorative splendour of the frescoed series of the *Months* in the Palazzo Schifanoia, Ferrara; later he painted altarpieces in Bologna. *184*

Cotan, Juan Sanchez 1560-1627. Spanish painter; b. near Toledo, and established as an artist there, but in 1603 he moved to Granada, to profess as a lay brother of the Carthusian Order. He created a new

kind of still life, with fruits and vegetables, hanging from strings, and framed by a window; the forms are intensely naturalistic, but the compositions are abstract and geometric, and the mood poetic.

Cotman, John Sell 1782-1842. British watercolourist, major artist of the Norwich school; his best works are distinguished by the abstract beauty of almost geometric patterns of flat washes. *392-3*, 397

Courbet, Gustave 1819-77. French Realist. Rebellious and anti-intellectual, he broke dramatically with the conventions of his day, and painted scenes from everyday life with all the grandeur of history painting. His later works are less violently provocative; they inc. seascapes, landscapes, hunting scenes and nudes. *101*, 103, 112

Coysevox, Antoine 1640-1720/21. French Baroque sculptor, one of the most outstanding to work at Versailles. Encouraged and supervised by Lebrun, he is noted for his portrait busts, particularly those produced after Lebrun's death in 1690.

Cozens, John Robert 1752-97. British watercolourist, whose Alpine and Italian scenes, painted in a narrow range of blues and greys, are amongst the most evocative Grand Tour watercolours ever painted.

Cranach, Lucas the Elder 1472-1553. German painter. In 1504 he became court painter to the Elector of Saxony; he is most famous for his invention of the full-length portrait and for the highly sophisticated and courtly eroticism of his slender female nudes. *95*, *295*

Credi, Lorenzo di c.1458-1537. Florentine painter and sculptor. Verrocchio's chief assistant. Also strongly influenced by Leonardo, though the glossy surfaces and detail in his paintings are reminiscent of Netherlandish art.

Cremona, Giovanni da *fl. c.* 1500 HIghly accomplished Italian sculptor of small bronzes, known only by one signed work in the Wallace Collection, London *391*

Crespi, Daniele c.1598-1630. Italian painter of the Lombard school w. in Milan. His austere religious works reflect the spirit of the Counter-Reformation. 202

Crespi, Giovanni Battista 'Il Cerano' c.1575-1632. Major Lombard painter, who combined the light effects of Caravaggio with the audacious forms of Tintoretto

Crespi, Giuseppe Maria 1665-1747. Bolognese painter, strongly influenced by Ludovico Carracci and Guercino. Painted intimate genre scenes in subdued colours, though he also produced dec. works and altarpieces. 179

Crivelli, Carlo fl. 1457-93. Venetian painter of religious subjects. The surface of his highly patterned paintings – still indebted to late Gothic – is filled with elaborate details. 383

Cuyp, Aelbert 1620-91. Dutch painter from Dordrecht; he painted landscapes, often with animals, bathed in golden sunlight. 271, 408

Daddi, Bernardino. c.1290-1348. Florentine painter, younger contemporary of Giotto, by whom he was greatly influenced.

Dalí, Salvador 1904-89. Spanish Surrealist, the creator of powerful images of death, of sexual fantasies, of the infinite, whose ultra-realistic technique gives them a convincingly hallucinatory quality. 317, *317*

Daubigny, Charles-François 1817-79. French landscape painter of the Barbizon school.

Daumier, Honoré 1808-79. French caricaturist, painter and sculptor. In his time, he was known chiefly as a

political and satirical caricaturist, though he began painting in 1848. 112

David, Gerard c.1460-1523. Flemish painter, leading master of Bruges school after Memling's death in 1494 and often copied. *168*

David, Jacques-Louis 1748-1825. French painter, chief exponent of Neo-Classicism. Supervised all matters of art in revolutionary France: designed monuments, processions, and painted martyrs of the Revolution. Court painter to Napoleon I. 46, 88, 109, 291

Davis, Stuart 1894-1964. US painter. Moving from Cubism in the 1920s, his work encompassed almost every style in 20C US art. Much of his inspiration came from modern everyday objects.

Degas, Edgar 1834-1917. French painter and sculptor; his art developed from sharply observed contemporary subjects – jockeys, ballet and café scenes – to the colouristic splendour of his late nudes and dancers. Fundamentally a draughtsman, he was fascinated by the human form in movement. *436, 448-9*

Delacroix, Eugène 1798-1863. Foremost Romantic painter in France; he painted violent and exotic subjects – shipwrecks, Arab horsemen, wild animals etc. Influenced by Rubens and the Venetians; his use of colour influenced the Impressionists and Post-Impressionists. 107

Delaunay, Robert 1885-1941. French painter. He introduced vibrant colour into Cubism (a movement that Apollinaire called Orphism), which tried to emulate the rhythm of nature. 151

Delaunay-Terk, Sonia 1885-1979. French painter, b. in Russia, who with her husband Robert Delaunay developed the ideas of Orphism.

Delvaux, Paul 1897-1994. Belgian painter. In 1935, impressed by Dalí, de Chirico and Magritte, he abandoned Neo-Impressionism and Expressionism in favour of Surrealism. His paintings of transfixed female sleepwalkers are typical of this phase. 46

Demuth, Charles 1883-1935. US painter, who studied in Paris; he was a dominant member of the American art movement, Precisionism, whose adherents, influenced by Cubism and Futurism, painted industrial landscapes and machinery in a sharp edged, geometrically simplified style.

Denis, Maurice 1870-1943. French painter and writer on art. Foundermember of the Nabis group. In 1910 he began painting religious works.

Denny, Robyn b. 1930. British abstract painter. His large works are ornamental compositions of symmetrically arranged rectilinear forms.

Derain, André 1880-1954. French painter and sculptor. His most exciting works are brilliantly coloured Fauve paintings: later he was influenced by Cubism and became increasingly academic. 81

Desiderio da Settignano c.1430-64. Florentine sculptor closely associated with the Rossellino brothers. His virtuoso control of marble was unsurpassed by any other 15C sculptor; his busts of women and children have great sweetness, charm and spontaneity. 190, *190*

Devis, Arthur 1712-87. British painter, popular in the middle years of the 18C for his conversation pieces. His small scenes, with slightly stiff figures, posed before their possessions, have a charming provincial freshness.

Dibbets, Jan b. 1941. Dutch conceptual artist. His best-known works are 'perspective correction' photographs. 152

Diebenkorn, Richard 1922-93. US painter. Influenced by Abstract

Expressionism until 1955 when he returned to a figurative style. 467

Dine, Jim b. 1935. US artist. One of the creators of Happenings and Environments (1959-60). In 1960 he returned to painting, often attaching real objects (tools, clothing) to his painted canvases.

Dix, Otto 1891-1969. German Expressionist painter and draughtsman. Deeply affected by horrors of First World War. In the 1920s and '30s he took his subjects from working-class life, the social criticism contained in his works causing their suppression by the Nazis. 144

Dobson, Frank 1886-1963. English sculptor whose classicising works were influenced by Maillol and Picasso. *372*

Dobson, William 1610-46. English portraitist. His portraits, all of Royalists, are painted in rich Venetian colours and rough impasted paint, often on coarse canvas.

Doesburg, Theo van 1883-1931. Dutch artist and architect. Founder of the magazine *De Stijl* with Mondrian in 1917 and one of the leaders of the movement, De Stijl. 274, *274-5*

Dolci, Carlo 1618-86. Florentine painter. He painted mostly religious subjects, emotionally highly charged and with an emphasis on sorrow and suffering.

Domenichino 1581-1641. Italian painter. Pupil of the Carracci and the leading exponent of Bolognese Classicism. His landscapes influenced Poussin and Claude. 220, 221, 225

Domenico Veneziano *c.*1400-61. Florentine painter. An important figure of the early Renaissance, though only two authenticated works survive. Influential in his use of colour and light to depict perspective.

Donatello 1386-1466. The greatest Florentine sculptor of the Early Renaissance. He was the first to use the new science of perspective; he had a deep understanding of classical antiquity and his *David* (1430-32) was the first freestanding nude of the Renaissance. His late style was violently expressive and very moving. 189, 191, 193, 390

Dongen, Kees van 1877-1968. Dutch painter who settled in Paris in 1897. Short-term member of the Fauvists. Best known for his technically clever but shallow portraits of society women.

Dossi, Dosso *c.*1479-1542. Leading Ferrarese painter, executing church frescoes and tapestry cartoons for the Duke of Ferrara. 185

Dou, Gerard 1613-75. Dutch genre painter from Leyden. Rembrandt's pupil from 1628-31. His paintings are extraordinarily highly finished and minutely detailed.

Dubuffet, Jean 1901-85. French painter and sculptor. Advocate of *art brut*. His best-known works consist of assemblages of glass, sand, rope, tar etc.

Duccio di Buoninsegna a. 1278-1318. The greatest painter of the Sienese school. His only fully documented work (the *Maestà*, Siena) clearly breaks with Byzantine traditions in its colouring, sensitivity and mastery of pictorial narrative. 188, 228, *341*

Duchamp, Marcel 1887-1968. French painter. After 1915 he lived mostly in the USA, becoming leader of the New York Dadaists. He scandalized the public with his ready-mades, esp. a urinal signed R. Mutt. 460

Dughet, Gaspard (Gaspard Poussin) 1615-75. French landscape painter w. in Rome; he adopted the name of his famous brother-in-law. His classical landscapes show a deep feeling for the wildness and grandeur of the

Roman Campagna. 215

Duquesnoy, François 1594-1643. Flemish Baroque sculptor who settled in Rome in 1618. His works are restrained, and show the influence of his friend Poussin. His small bronzes were inspired by classical art.

Dürer, Albrecht 1471-1528. German painter and graphic artist. A man of great intellectual distinction, whose artistic life was devoted to reconciling the visionary power of German art with the ideals of the Italian Renaissance. His *œuvre* is enormous and his technique as a designer of engravings and woodcuts unsurpassed. 139, *158*, 189

Dyck, Sir Anthony van 1599-1641. One of the most influential Flemish painters. Rubens' assistant and collaborator. Went to England in 1632 at Charles I's invitation and settled there, becoming court painter. His portraits endow his noble sitters with patrician elegance and dignity. *38*, 404, *410*, 413, 470

Eakins, Thomas 1844-1916. US painter b. in Philadelphia. Influenced by Velázquez and Ribera. Painted mainly landscapes, portraits and outdoor sports. 469

Elsheimer, Adam 1578-*c*.1610. German painter. His works are tiny and intensely poetic paintings on copper; he was famous for his night scenes and for his use of several sources of light. His fresh landscapes show new sensitivity to the moods of nature. 148, 374

Ensor, James 1860-1949. Belgian painter, b. in Ostend. In the 1880s grotesque and macabre elements, such as skeletons and garish carnival masks, began to appear in his work. Regarded as one of the great innovators of late 19C art and a precursor of Surrealism. 40, 48

Epstein, Sir Jacob 1880-1959. US

sculptor, settled in London in 1905. He was considered the greatest monumental sculptor of his day in the Romantic tradition of Rodin, though public reaction was critical.

Ernst, Max 1891-1976. German painter and sculptor. Founder member of the Dada movement and Surrealism. Used collage and photomontage in his dream-like landscapes. His sculptures are of plaster, with wood, cork and canvas, usually painted.

Etty, William 1787-1849. English painter, who produced some fine nudes. 404

Eyck, Jan van d. 1441. Flemish painter, in Bruges from 1430. The greatest artist of the northern Renaissance, who perfected the technique of oil painting. He built up a convincing world through his tireless observation of infinitesimal detail, unified by the fall of light. The Ghent altarpiece is thought by some art historians to have been begun by his brother, **Hubert** (d. 1426) of whom little is known. 40, 45, 47, 144, 383

Fabritius, Carel 1622-54. Dutch painter; Rembrandt's outstanding pupil. His cool colours and light backgrounds foreshadow those of Vermeer (probably his pupil); he painted genre, still life and street scenes.

Fantin-Latour, Henri 1836-1904. French painter of attractively direct genre scenes, portraits, still lifes and flower paintings and some extravagant Symbolist figure subjects.

Feininger, Lyonel 1871-1956. US painter who lived in Europe from 1887-1937 and taught at the Bauhaus. His best works are poetic and visionary treatments of Gothic architecture and the sea.

Feti, Domenico *c*.1589-1624. Italian painter who w. mainly in Mantua

and Venice. His most original works are a series of small scenes from the Parables.

Flavin, Dan 1933-96. American sculptor who has decorated number-less contemporary galleries with installations of electric and fluorescent light. *442*, 443

Flémalle, Master of Founder of Flemish realism, sometimes identified with a recorded painter, Robert Campin. *36-7*, 146, 379

Fontana, Lucio 1899-1968. Italian artist, best known for his series of all white canvases (1946) and for his slashed canvases. Also experimented with electric light and with total environments.

Foppa, Vincenzo c.1427-1515. North Italian painter of the Early Renaissance. *201*, 202

Fouquet, Jean c.1420-c.1481. Leading French painter of the 15C. Introduced strict theories of perspective after his stay in Rome (1443-47). In 1475 became court painter to Louis XI. His miniatures and larger panel paintings have a monumental character. 93

Fragonard, Jean-Honoré 1732-1806. The most frivolous and wittily erotic of the French Rococo artists; his diaphanous landscapes typify the style. 392, 453

Francis, Sam b. 1923. US painter. Leading member of second-generation Abstract Expressionists. Pupil of Still.

Frankenthaler, Helen b. 1928. US painter. Turned to Abstract Expressionism in 1950 after seeing the work of Pollock and de Kooning.

Freud, Lucian b. 1922. German-born English painter, best known for his powerfully realistic portraits and nudes. *409*

Friedrich, Caspar David 1774-1840. German painter; one of the greatest of the Romantics. Painted hitherto unrecorded aspects of nature – rocky beaches and barren mountains seen at sunrise, sunset or in moonlight. Many works reflect his pessimism. *130*, 135, 153, 344

Fuseli, Henry 1741-1825. Swiss painter, w. in England. A Romantic artist, obsessed by the macabre and the sensational; he painted nightmares, Shakespearean scenes of horror, and erotic fantasies.

Gabo, Naum 1890-1977. US sculptor and architect, b. in Russia, where he founded Constructivism. Taught at the Bauhaus (1922-32), then moved to England before settling in the USA in 1946. 389

Gaddi, Taddeo c.1300-c.1366. Florentine painter and mosaicist, son of Gaddo Gaddi. Close follower of Giotto. 213

Gainsborough, Thomas 1727-88. English portrait and landscape painter; w. in Ipswich, Bath and London. His style developed from a charming *naïveté* to a dreamy elegance. 387, 434, 447, 467

Gallén-Kallela, Akseli 1865-1931. Finnish painter, influential pioneer of a nationalistic art based on Finnish myth and folk culture. 71

Gaudier-Brzeska, Henri 1891-1915. French sculptor and draughtsman. Settled in London in 1911, where he joined the Vorticist movement. His sculptures inc. simplified portrait heads, figures in action and sensitive studies of animals. 362

Gauguin, Paul 1848-1903. French Post-Impressionist painter. Influenced the Symbolist movement by his ideas that form and colour may express states of mind. Went to Tahiti in 1891, producing his most famous work there: native figures and landscapes painted in strong outlines and flat, bold colours. *79-80*, 300, 365

Gaulli, Giovanni Battista (Baciccia) 1639-1709. Italian Baroque painter, b.

in Genoa. Painted ceiling frescoes, portraits.

Geertgen tot Sint Jans *c.*1465-*c.*1495. Dutch painter w. mainly in Haarlem. He painted a few highly personal pictures; they reveal a new interest in landscape and the figures are strangely melancholic.

Gelder, Aert de 1645-1727. Dutch painter, Rembrandt's pupil 1661-63. Continued in his master's style, though lightened his own dark palette in accordance with 18C taste. Specialized in biblical subjects. During his lifetime he was held in greater esteem than Rembrandt. 134

Gentile da Fabriano *c.*1370-1427. Italian painter, whose art – crowded with charming decorative detail – perfected the International Gothic style in Italy. 188

Gentileschi, Artemisia *c.* 1597-*c.*1652. Daughter of Orazio Gentileschi and known for her portraits and violent biblical scenes. 209, 38

Gentileschi, Orazio 1563-*c.*1647. Italian painter. Influenced by the early style of Caravaggio, he later developed a Florentine grace; he brought a hint of Caravaggio's style to the courts of northern Europe. p.230

Géricault, Theodore 1791-1824. French Romantic painter whose paintings of horses, of grisly episodes from contemporary history, and of madmen and women, introduced themes characteristic of French Romanticism. 109, 118-9, 433

Gérome, Jean Leon 1824-1904. French painter and sculptor. He painted polished genre scenes, set in ancient Greece or Rome, in the Orient, or in 17C Europe, crowded with carefully observed archæological and historical detail.

Gerstl, Richard 1883-1908. Self-taught Austrian Expressionist, close to the avant garde circle around the composer Arnold Schoenberg. *31*

Ghiberti, Lorenzo 1378-1455. Florentine sculptor, goldsmith, architect, painter and writer, who formed a major link between the late Gothic and Renaissance worlds. The two sets of richly gilded bronze doors for the Florence Baptistery are his most famous works. He also executed many bronze and marble statues. 189, 191

Ghirlandaio, Domenico 1449-94. The leading and most prolific Florentine fresco painter of his time, best known for introducing contemporary life and manners into his religious paintings. Numerous Florentine churches boast an altarpiece from the workshop he ran with his brothers, **Benedetto** (1458-97) and **Davide** (1452-1525). 194

Giacometti, Alberto 1901-66. Swiss sculptor and painter, among the leading post-Second World War European sculptors. He produced his best work in the 1940s and 50s – attenuated plaster of Paris figures on a wire base. His paintings and drawings have the same agitated, mystical quality. 340, 347

Giambologna 1529-1608. Italian Mannerist sculptor (b. in Flanders), the most successful of his day. Complex, sinuous outlines encourage the spectator to walk around his groups. 190

Gilbert and George (Gilbert Proesch b. 1943, George Passmore b. 1942). British artists who live in the East End of London; they first became known, in the late 1960s, as 'living sculptures'; more recently they have created vast photo montages, in crude and strident colours, of subjects intended to shock and disturb.

Giordano, Luca 1634-1705. Neapolitan decorative painter, whose light and airy style preludes the Rococo. Called Fa Presto for his speed of execution. 191, 326

Giorgione 1475-1510. Venetian painter, generally accepted as a great innovator although the lack of signed and dated works makes attribution difficult. He introduced a new kind of painting – small oils of pastoral subjects – in which figures are united with the setting by the use of atmosphere. 30, 110, 144, 180, 240

Giotto di Bondone 1266/7-1337. Florentine painter and architect. He introduced into Western painting a new sense of sculptural solidity and weight that replaced the flat patterning of the Byzantine tradition; his sense of the nobility of man became a central theme in Italian painting. 175, 192, 207, *207*

Giovanni di Paolo 1403-c.1482. Italian painter. With Sassetta, the leading Sienese painter of the 15C. In his later works he used less violent colours, and the forms of his graceful, ecstatic and often wistful figures became more ponderous. *227*, 228

Giulio Romano 1492-1546. Italian painter and architect, leading exponent of Mannerism. The exaggerated dramatic quality of his later works shows Michelangelo's influence. 198, *198-9*

Goes, Hugo van der *fl.* 1467-82. Flemish painter. His boldly expressive works introduced a new grandeur into 15C Flemish art. 139, 189

Gogh, Vincent van 1853-90. Dutch Post-Impressionist. In his major works – still lifes, portraits, the landscape of Provence – he used pure colour and an undulating line to express the violent intensity of his feelings. *264*, 270, 278, 363, 456

Gorky, Arshile 1904-48. US painter, b. in Armenia. His early Cubist pictures (strongly defined and brightly coloured still lifes) imitated Picasso and then Miró. His paintings, with their suggestion of claws and parts of the body, form a link between Surrealism and Abstract Expressionism.

Gossaert, Jan (called Mabuse) c.1478-c.1536. Flemish Mannerist w. in Bruges from 1503. Influenced by Roman sculpture and contemporary Italian art while in Italy (1508/9). Erotic mythological themes often inspired his work. He also painted portraits.

Gottlieb, Adolph 1903-74. US painter. His early work is basically naturalistic, but in the early 1940s he developed a semi-abstract style, based on grid-like compartments. By the 1950s his style was fully Abstract Expressionist.

Goya y Lucientes, Francisco José 1746-1828. Spanish Romantic painter, whose works developed from Rococo charm to the ruthless realism of his royal portraits and culminate in the savage violence and monstrous imagery of his late works. *311*, 322, *322-3*, 326

Goyen, Jan van 1596-1656. Pioneer of Dutch realistic landscape painting. Tried to capture natural light and calm atmospheric effects, working almost in monochrome, Painted from drawings executed *in situ*.

Gozzoli, Benozzo c.1421-97. Florentine painter. Famous for the charmingly decorative frescoes in the Medici Palace, Florence. 191, 203

Greco, El (Domenikos Theotocopoulos) 1541-1614. Cretan-born Spanish painter. Established in Toledo by 1577. He created an intensely spiritual style that uses nervous elongated figures, sharp cold colours and irrational contrasts of scale. 322, 328, *328*, 329, 455

Greuze, Jean-Baptiste 1725-1805. French painter of genre and portraits. He painted sentimentalized and often titillating scenes of peasant life, with a spurious didactic content. 300

Gris, Juan 1887-1927. Spanish painter who began to paint Cubist pictures in 1911 and made a highly important contribution to the French Cubist movement.

Gros, Antoine-Jean 1771-1835. Painter of Napoleonic battles, key figure between the Neo-Classicism of his teacher David and the Romanticism of his admirer Delacroix. 109

Grosz, George 1893-1959. German-US artist. Leading Berlin Dadaist (1918-24) and founder member of the Neue Sachlichkeit, he expressed his anti-militarism and anti-capitalism in savagely critical drawings. Moved to the USA in 1933. His later work has a nightmarish Surrealist quality. *154-5*

Grünewald, Mathias *c.*1480-1528. German painter. A visionary artist whose powerfully Expressionist style has had a lasting influence on German art. His Isenheim altarpiece is a work of unparalleled emotional power. *94, 129*

Guardi, Francesco 1712-93. Venetian painter; his studies of little-known corners of Venice, sketchy and vibrant with light and atmosphere, contrast with the more public and sharply detailed pictures of Canaletto. *406-7*

Guercino 1591-1666. Bolognese painter, whose bold illusionism, sweeping diagonals and flickering contrasts of light and shade were seminal to the development of the early Baroque; his later works are duller and more classical. *179*

Guido da Siena *c.*1260-80. Italian painter, founder of the Sienese school, greatly influenced by Byzantine art.

Guston, Philip b. 1913. US painter. His early works (eg 1930s murals) are figurative, but between 1947 and 1950 he became a prominent Abstract Expressionist.

Guttuso, Renato 1912-87. Italian Expressionist painter of Social Realist subjects. Uses bright colours and complex patterns.

Haarlem, Cornelis van 1562-1638. Leading Dutch Mannerist. Famous for his large historical and biblical works with their muscular, acutely foreshortened life-size nudes.

Hals, Frans *c.*1580-1666. Dutch painter a. in Haarlem. Famous for the bravura of his technique and his ability to capture a fleeting expression; he painted single portraits, vivid group portraits and genre. *262, 269, 276, 392*

Hamilton, Ann b. 1956. Ohio installation and experience artist whose pieces are often deliberately overwhelming to the spectator. *425*

Hamilton, Richard b. 1922. English painter, pioneer of Pop Art. Influenced by the anti-art philosophy of Duchamp and the collages of Schwitters. His montages aim to raise the banal to the level of art.

Hanson, Duane 1925-96. US Super-Realist sculptor. Takes his subjects from lower- and middle-class American society and aims to portray their loneliness and emptiness through an uncompromising realism.

Hare, David b. 1917. Leading US Surrealist sculptor. Self-taught, he works primarily in metal.

Hartley, Marsden 1877-1943. US painter. Experimented with Cubism, but after 1919 turned to landscapes, characterized by massive form and strong outline.

Hayez, Francesco 1791-1882. Italian Romantic painter, of portraits and historical subjects. *216-7*

Heckel, Erich 1883-1970. German Expressionist; founder-member of Die Brücke. Influenced by the bright colour and restless linear style of Van Gogh and Munch, producing his

best-known work from 1905 to 1913. Painted in a calmer style after 1914. 138

Heda, Willem Claesz. 1594-1682. Dutch still-life painter from Haarlem. Like Pieter Claesz he is best known for his meticulous, almost monochromatic paintings of simple objects or the remains of a meal.

Henri, Robert 1865-1929. US painter, who studied in Paris, (1888-91) and worked in Philadelphia and from 1904 New York; he was the inspiration of a group of American painters who created a new genre, sketchily handled scenes of American urban life.

Hepworth, Dame Barbara 1903-75. English abstract sculptor. Influenced by Moore and, from 1932, Arp and Brancusi. Her work (in stone or wood) consists of hollowed-out organic and geometric forms. 401

Heron, Patrick (1920-2000) English abstract painter, whose Tachist-influenced works celebrate pure, intense colour. *355*

Hicks, Edward 1780-1849. US folk painter. A Quaker, Hicks, who worked in a naive style, created a genre of painting known as the Peaceable Kingdom, illustrating Isaiah 11, 6-9 'the wolf also shall dwell with the lamb, and the leopard shall lie down with the kid'.

Hilliard, Nicholas 1547-1619. English miniaturist. His linear and shadowless miniatures often bear emblems and exquisite inscriptions. 390

Hirst, Damien b. 1963. British artist, most famous for his animals (sometimes dissected) suspended in formaldehyde.

Hobbema, Meindert 1638-1709. Last of the great 17C Dutch landscape painters and a pupil of J. van Ruisdael. 383

Höch, Hannah 1889-1978. German painter. Member of the Berlin Dadaists; produced photomontages and collages, as well as some Surrealist and nonfigurative paintings.

Hockney, David b. 1937. English painter. Member of the Pop Art movement. His early work, based on modern urban life, was often witty and autobiographical; it has become more controlled and less personal. His subjects inc. still lifes, portraits, landscapes and a series of swimming-pool paintings.

Hodgkins, Francis c.1869-1947. New Zealand-born painter, w. mainly in England. Principally famous for her poetic landscapes. *282*

Hodler, Ferdinand 1853-1918. Swiss painter, who created large symbolical paintings which depend on simplified, monumental forms arranged with strict symmetry and repetition; he admired Holbein, Dürer and Early Italian painting.

Hofmann, Hans 1880-1966. German-US painter and teacher. Influenced by the Cubists. Greatly influenced the development of Abstract Expressionism in the 1940s by his abstract canvases covered in dribbled paint. 429

Hogarth, William 1697-1764. The first great native English painter: a satirical artist who invented a new kind of narrative in series. *350-1*, 387

Holbein, Hans the Elder c.1465-1524. German Gothic painter, mainly in Augsburg. His formal early style grew freer after 1501. His silverpoint portraits foreshadow those of his younger son. 135

Holbein, Hans the Younger c.1497-1533. German painter, major realist portrait painter of the northern Renaissance. He moved from the warmth and solidarity of his portraits of humanist scholars to a linear, decorative style as court painter to Henry VIII. 139, 143, *338*, 340, 384

Homer, Winslow 1836-1910. US painter, who visited Paris (1867) and lived (1881-2) on the Northumberland coast in England before settling at Prout's Neck on the Maine Coast; he painted the life of fishermen, and, in his late years, increasingly dark and tragic images of stormy seas.

Honthorst, Gerrit van 1590-1656. Dutch painter, best known of the Dutch Caravaggisti; most important are his genre paintings, often night scenes illuminated by artificial light.

Hooch, Pieter de 1629-*c.*1685. Dutch genre painter w. in Delft, Leiden, The Hague and finally (*c.*1667) Amsterdam. His quiet courtyards and domestic interiors are reminiscent of Jan Vermeer, who was his contemporary in Delft. In Amsterdam he turned to painting elegant society life. 269

Hopper, Edward 1882-1967. US artist. His urban and rural landscapes and figure paintings show a personal and poetic interpretation of the realistic Ashcan School. *421, 433, 461, 462*

Houdon, Jean-Antoine 1741-1828. French sculptor famous for his naturalistic portrait busts.

Housebook, Master of the Late 15C German painter and engraver in the Gothic style.

Huber, Wolf *c.*1490-1553. Austrian painter, working in Passau as episcopal court painter and city architect. Leading poetic landscape painter of the Danube school; also painted altarpieces.

Hunt, William Holman 1827-1920. English painter, co-founder of the Pre-Raphaelite Brotherhood. His works are symbolic, with a strong didactic element and minute attention to detail. 387

Hurter, Johann Heinrich 1734-99. Swiss miniaturist. Worked in London 1779-84, linked with Reynolds. *353*

Huysum, Jan van 1682-1749. Dutch painter of luscious and decorative still-lifes of fruit and flowers.

Indiana, Robert (Clarke) b. 1928. US painter, sculptor and graphic artist.

Ingres, Jean-Auguste-Dominique 1780-1867. French painter and outstanding draughtsman; the Classicist opponent of Delacroix's Romanticism. Most successful are his languorous Odalisques and his portraits, characterized by the expressive beauty of his line and his meticulous, polished treatment of detail. *2, 76, 101, 110*

Inness, George 1825-94. US painter, regarded as a major 19C US landscapist. Visited Europe several times (1847-54) and was influenced by the Barbizon school. In the late 1850s his landscapes became more personal, relying on subtle colour harmonies and the juxtaposition of light and shade.

Isenbrandt, Adriaen d. 1551. Flemish painter, a. in Bruges. Said to have been a pupil of Gerard David, and most of the religious paintings ascribed to him are derivative of David.

Jawlensky, Alexej von 1864-1941. Russian-born Expressionist painter. Settled in Munich in 1896. 162

John, Augustus Edwin 1878-1961. Welsh painter; a dazzling draughtsman and portraitist; his large canvases are indebted to Puvis de Chavannes.

Johns, Jasper b. 1930. US painter, leading neo-Dadaist and forerunner of Pop Art. His 1950s paintings of familiar emblematic objects (flags, targets, numbers) force the viewer to look at the commonplace in a new way.

Johnson, William H. 1901-70. Black South Carolina Expressionist painter

of the Black experience. *472-3*

Jones, Allen b. 1937. English Pop Art painter and sculptor. Often inspired by erotic magazines and advertisements; his colour and brush-work are reminiscent of Matisse.

Jordaens, Jacob 1593-1678. Flemish painter; pupil of Rubens. Best known for his large genre scenes of boisterous drinkers.

Jorn, Asger 1914-73. Danish painter, one of the major post-Second World War Expressionist painters. The dominant figure in the CoBrA group.

Jouvenet, Jean 1644-1717. French history painter w. in Lebrun's studio in the 1660s – his early works are imitative; his later style more Baroque.

Judd, Donald 1928-94. US sculptor. In 1964 he helped to launch object sculpture – simple geometric constructions, usually made industrially in plywood, plastic or galvanized iron, placed on the floor to reach no higher than eye-level. 445

Kahlo, Frida 1910-54. Mexican painter who drew on both Mexican folk art and European painting. Her works, rooted in her own sufferings, are powerful images of the female condition.

Kalf, Willem 1619-93. Dutch still life painter; his works are harmonious arrangements of precious objects, made mysteriously beautiful by rich chiaroscuro and exquisite blues and yellows.

Kandinsky, Wassily 1866-1944. Russian painter, pioneer of abstract art. Gauguin and the Fauves inspired his experiments in pure colour in 1908. In his 'cold' Bauhaus period (1922-33) his work was precise and geometric. His later works were serene and rich, his Miró-inspired forms more fluid and Surrealist. 456

Kauffmann, Angelica 1741-1807. Swiss Neo-Classical painter, w. in England, 1766-81, friend of Reynolds and a founder-member of the Royal Academy.

Kelly, Elsworth b. 1923. American painter in the 'hard-edge' manner of Post-Painterly Abstraction. Uses only primary or pure colours and never more than two or three together. In 1965 turned to single-colour Minimal art works. 55

Khnopff, Fernand 1858-1921. Belgian Symbolist. His brooding paintings and drawings express anxiety in a style marked by Burne-Jones and Moreau. 46

Kiefer, Anselm b. 1945. A painter of German themes, of empty interiors, forests and wildernesses, cellar mausoleums, railway tracks, using oils, acrylic, sand, straw on wood. 139, 142, 286

Kirchner, Ernst Ludwig 1880-1938. German Expressionist painter. Influenced by Neo-Impressionism, Fauvism and esp. Primitive art. His works, violent and emotional, are notable for their striking juxtapositions of brilliant colours. By 1928 his work had become semi-abstract. 141

Kitaj, Ron B. b. 1932. US painter. Spent most of the 1950s and '60s studying, teaching and working in Europe, Britain in particular. A major figure in the development of British Pop Art, he was one of the first to introduce a cultural and political element to the movement.

Klee, Paul 1879-1940. Swiss painter and etcher. Member of the Blaue Reiter and teacher at the Bauhaus. His apparently simple style is described in his own words as 'taking a line for a walk'. 146, 342, 456

Klein, Yves 1928-62. Revolutionary French artist. Rejected the traditional vehicle of canvas, and experimented

variously with sponges, the eroding effects of rain, wind and fire. Painted entirely in monochrome (blue). Important contributor to the Minimal art movement. 104, 111

Klimt, Gustav 1862-1918. Foremost Art Nouveau painter in Austria, founder-member of the Vienna Secession (1898). His decorative and erotic style was influenced by Japanese art and the Pre-Raphaelites. *25*, 31

Kline, Franz 1910-62. US Abstract Expressionist. His works are large and powerful, consisting of bold, calligraphic-style black strokes against a white background. In the late 1950s he began to introduce colour. *424*

Købke, Christen 1810-48. The leading painter of the Danish Golden Age. His early works are small landscapes and portraits, highly individual in their tight compositions and narrow range of colour; later he created grander scenes whose simplicity and clear life evoke the Romantic atmosphere of the Danish landscape. *62, 64*

Kokoschka, Oskar 1886-1980. Major Expressionist; b. in Austria. Lived in England 1938-53, then Switzerland. Famous for his psychological portraits and striking posters and his bird's-eye-view landscapes and townscapes. Later he also painted many political allegories.

Kollwitz, Käthe 1867-1945. German expressionist passionately devoted to the socialist cause. 139

Koninck, Philips de 1619-88. Dutch landscape painter, who specialized in majestic panoramic landscapes.

Kooning, Willem de 1904-97. US painter, b. in Holland. He became a leading Abstract Expressionist. His brutally expressive works rarely abandon the image; best known are his powerfully sexual series of *Women*.

Kupka, Frantisek (Frank) 1871-1957. Czech painter and graphic artist, w. in Paris. His early works pioneered abstract art. 61

Laer, Pieter van (called Bamboccio) 1592-1642. Dutch painter, a. in Rome 1627-39. Painted small studies of peasants, brigands and Roman street life which became very popular in Italy and the Low Countries.

Lancret, Nicolas 1680-1743. French painter of genre and *fêtes galantes.* With Pater he was the chief of Watteau's imitators, though he never approached his psychological penetration.

Landseer, Sir Edwin Henry 1802-73. Popular English animal painter and engraver; Queen Victoria's favourite. His vigorous and naturalistic style became increasingly sentimental.

Lanfranco, Giovanni 1582-1647. Italian painter, whose development of a free spatial illusionism derived from Correggio, was seminal to the creation of the High Baroque. 220

Lastman, Pieter 1583-1633. Dutch history painter whose lively narrative skill influenced Rembrandt, his pupil in 1624.

Laurana, Francesco a. *c.*1430s-?1502. Dalmatian sculptor, of portraits, religious sculptures and vivid narrative reliefs, who worked in France and Italy. His celebrated portrait busts of court ladies are distinguished by an almost abstract beauty of form. 207

La Tour, Georges de 1593-1652. French painter; his most beautiful works are calm and contemplative candlelit scenes. *103*, 104, 110

La Tour, Maurice Quentin de 1704-88. French pastel portraitist, whose works, which concentrate on fleeting expression and gesture, capture the vivacity of 18C society.

Lebrun, Charles 1619-90. French

painter and director of state art under Louis XIV; unadventurously sober paintings on a vast scale. 124

Leck, Bart Anthony van der 1876-1958. Dutch painter. Began with naturalistic genre scenes of factory workers, moving to a geometric style, though he did not become a purely abstract painter. Influenced Mondrian's Neo-Plasticism and the De Stijl movement. 278

Léger, Fernand 1881-1955. French painter; a major Cubist, fascinated by mechanical forms; he used crude colours and fragmented forms to express the vitality of urban life. 91, 278

Lely, Sir Peter 1618-80. A Dutch artist, principal painter to Charles II. 385

Le Nain brothers, French painters, w. in Paris after 1630. **Antoine** (c.1588-1648) is credited with small domestic scenes on copper; **Louis** (c.1593-1648), the greatest of the three, painted solemn and dignified peasant families; **Mathieu** (c.1607-77) painted portraits in the manner of Frans Hals.

Lenbach, Franz von 1836-1904. German painter, fine landscapist who later turned to society painting. 157

Leonardo da Vinci 1452-1519. One of the towering geniuses of the Renaissance and the creator of the High Renaissance style. His scientific and biological interests became more important to him than painting but as a painter he developed a new mastery of composition, expression and gesture, and an extraordinary delicacy of *chiaroscuro*. 110, 202, 470

Leyden, Lucas van c.1493-1533. Dutch painter of portraits, genre scenes and religious subjects and one of the greatest engravers. 276

Liberman, Alexander b. 1912. American painter and sculptor, who turned to 'hard-edge' Post-Painterly

Expressionist works based on the circle from the 1950s.

Lichtenstein, Roy 1923-97. US painter, one of the leading exponents of Pop Art. His works are inspired by cartoon strips and images from mass advertising, blown up and reproduced in the same typographic manner. He has also produced pastiches of Cubist and De Stijl painting.

Limbourg brothers a. c.1400-20. French miniature painters in the International Gothic style. *73*, 93

Liotard, Jean-Etienne 1702-89. Swiss painter of pastel portraits distinctive in their lucid clarity; a. throughout Europe.

Lippi, Filippino c.1457-1504. Florentine painter, son of Fra Filippo Lippi, whose bold, dramatic frescoes exemplify the transition from the Early to the High Renaissance.

Lippi, Fra Filippo c.1406-69. Leading painter of Florentine Renaissance. His early works were influenced by Masaccio and he was interested in the use of perspective. His later frescoes contain Gothic elements. 211, 229

Lippold, Richard b. 1915. US abstract sculptor. Best known for his suspended geometrical shapes of thin wire and sheet-metal ('space cages'), inspired by Constructivism. 454

Liss (Lys), Johann c.1595-c.1630. German painter who w. in Venice. He reinvigorated 17C Venetian art by the soft beauty of his colours and freedom of handling; he painted religious and mythological subjects.

Lissitzky, El (Eleazar Markovich) 1890-1941. Russian painter and designer. In 1921, under Malevich's influence, began painting geometrical works in primary colours. Visited Germany, introducing the West to Constructivism and Suprematism.

Lochner, Stefan c.1400-51. German

painter, leading master of the Cologne school; his style unites the grace of International Gothic with the new naturalism of Flanders. 152

Long, Richard b. 1945. British artist, the leading practitioner of Land Art; he makes long walks, collects objects, and then creates evocative patterns from them, such as circles of stones; sometimes he adds texts and maps.

Longhi, Pietro 1702-85. Venetian painter of pleasingly vapid genre scenes.241. His son **Alessandro** (1733-1813), the official portrait painter to the Venetian Academy, was the foremost portraitist of his day, though his portraits lacked depth.

Lorenzetti, Ambrogio a. c.1319-?1348. Sienese painter. His under-standing of perspective anticipated Giotto's realism, and he was the first to depict landscape in a naturalistic manner. 228. His elder brother (a lesser painter) **Pietro** a. 1306-?1348 was influenced by Duccio, and also showed an interest in Florentine developments. 175, 248

Lorenzo Monaco c. 1370-c. 1422 or later. Italian painter and illuminator, probably from Siena, who worked in Florence. His frescoes and altar-pieces are characterised by their brilliantly decorative colour and graceful line. 194

Lotto, Lorenzo c.1480-1556. Italian painter. Superficially influenced by the Venetian school but after 1529 his manner became more agitated, his canvases more crowded and his portraits more penetrating. 176, *176-7*, 177

Louis, Morris 1912-62. US painter, pioneer of Colour-field painting. Worked in a Cubist style until 1952, when contact with Pollock and Frankenthaler led to works consisting of vertical and later sinuous bands of colour. 431

Lys, Johann *see* Liss, Johann

Mabuse *see* Gossaert, Jan.

Macke, August 1882-1914. Founder-member of the German Blaue Reiter group. *131*, 142

Maes, Nicolaes 1634-93. Dutch portrait and genre painter; pupil of Rembrandt.

Magnasco, Alessandro 1667-1749. Italian, w. chiefly in Milan. He painted wild, stormy landscapes with spiky figures. His subjects were bizarre – witches, torture chambers, ecstatic saints and monks.

Magritte, René 1898-1967. Belgian Surrealist influenced by de Chirico. His works rely heavily on the disturbing juxtaposition of objects drawn to different scales.

Maillol, Aristide 1861-1944. French sculptor of female nudes. Rejected Rodin's emotional expressionism in favour of a calm, classical manner, using smooth surfaces and rounded forms. 117, 347

Malevich, Kasimir 1878-1935. Russian Suprematist. Formulated his theories between 1912 and 1915, producing the first strictly geometrical work in 20C art in c.1914. In 1920 his work was condemned by the Bolsheviks. 271, 449

Manet, Edouard 1832-83. French painter; his frank rendering of contemporary themes and handling of paint (in vivid patches of light and shade that suppressed half-tones) led on to Impressionism. 77, 112, *136-7*, *344-5*

Mantegna, Andrea 1431-1506. Italian Renaissance painter who w. in Padua and Mantua. An intellectual artist, passionately involved in Roman antiquity. He created a hard, dry style, loaded with archæological detail, in which forms seem made from stone or metal. 198, 207, *237*, 248, 382

Marc, Franz 1880-1916. German Expressionist, leading member of the Blaue Reiter. Favourite subjects were animals (esp. variations on the theme of the Blue Horse). After 1912 began painting abstract works.

Maria, Walter de 1935. US artist, organiser of happenings and land artist.

Marin, John 1870-1953. US landscape painter. Influenced by Whistler while in Paris (1905-9).

Martini, Simone see Simone Martini

Masaccio 1401-28. Founder of the new style of 15C Florentine Renaissance art. True heir to Giotto; his art is solid, austere, and the human figure attains an epic grandeur; he profited from Brunelleschi and Donatello's interest in perspective and anatomy. 193

Masolino da Panicale c.1383-c.1447. Florentine painter. Influenced by Masaccio through to his Roman period, 1428-31. Later he reverted to the Gothic decorativeness of his youthful style. 193, 180

Massys, Quentin c. 1465-1530. Flemish painter whose religious works combine the realism of the north with a new grandeur of effect influenced by Italian art. He created a new style of humanist portrait. 90

Mathieu, Auguste 1810-64. Dijon-born painter of urban landscapes and architectural interiors. 96-7

Matisse, Henri 1869-1954. French painter; a major 20C artist. He led the Fauves from 1905-6 and later, with a series of Odalisques and still-lifes, created a richly decorative, joyful and radiantly coloured art; his late works are dazzling cut-paper gouaches. 106, 300, 368-9, 428, 426, 446, 456

Maulbertsch, Franz Anton 1724-96. Immensely prolific Austrian frescoist, who introduced a dramatic chiaroscuro to Baroque decorative painting.

Melendez, Luis 1716-80. Spanish painter, who created a series of still lifes of extraordinary power and originality; he painted simple objects and foodstuffs, arranged in the studio on a table top; his compositions are geometrically pleasing, while his virtuoso technique created varying textures and powerful forms.

Melozzo da Forlí 1438-94. Worked chiefly in Rome and Urbino. Friend and perhaps pupil of Piero della Francesca. He was a skilled draughtsman and used bold foreshortening. 197, 225

Memling, Hans c.1430-94. Flemish painter of biblical subjects and portraits, w. in Bruges; his style has an attractive placidity and calm. 45

Mengs, Anton Raphael 1728-79. Bohemian-German portrait and history painter; an apostle of Neo-Classicism. 319

Menzel, Adolf von 1815-1905. German painter, trained in Berlin; he recorded the deeds of Wilhelm I of Prussia, but is now most admired for his paintings of light filled domestic interiors. 135

Meštrović, Ivan 1883-1962. Croatian sculptor. Produced small intimate works, heroic figures and large portentous official commissions in a classicizing style. From 1948 he worked in the USA. 457

Metsu, Gabriel 1629-67. Dutch genre painter; he painted mainly domestic scenes representing the well-to-do bourgeoisie.

Meunier, Constantin Emile 1831-1905. Belgian sculptor of the heroic proletariat, especially miners. 45

Michelangelo Buonarroti 1475-1564. Italian sculptor, painter, architect and poet; a universal genius and perhaps the greatest artist who has ever lived. He expressed the most sublime concepts through the perfect beauty

of the human form and was deeply concerned with religious and philosophical ideas. His works inc. *David* and the Sistine ceiling. 185, 193, *193*, 226

Millais, Sir John Everett 1829-96. Co-founder of the Pre-Raphaelite Brotherhood. After 1855 he became a celebrated painter of portraits and genre scenes in the sentimental, richly detailed High Victorian manner. 396

Millet, Jean François 1814-75. French painter. From 1849 he worked at Barbizon; he painted the harsh realities of peasant life with almost biblical solemnity. 93, *366*

Miró, Joan 1893-1983. Spanish abstract painter, influenced by Cubism and Surrealism. His most typical paintings show bright amoeba-like forms on a plain background. *85*

Modersohn-Becker, Paula 1876-1907. Forerunner of German Expressionism. Her use of flat blocks of colour, strongly outlined, shows Gauguin's influence. 142, 143

Modigliani, Amedeo 1884-1920. Italian painter and sculptor of portraits and female nudes, w. in Paris from 1906. Influenced by Brancusi and African sculpture, his best paintings show a superb sense of linear design and a simplification and distortion of form. 145

Moglia, Domenico 1780-after 1862. Cremonese-born sculptor and mosaicist, working mainly in the north of Italy *212-3*

Moholy-Nagy, László 1895-1946. Hungarian-born painter, sculptor and experimental artist (Kinetic art). Influenced by the Russian Constructivist, El Lissitzky. Taught at the Bauhaus 1923-28, and in Chicago from 1937.

Mola, Pier Francesco 1612-66. Italian Baroque painter in Rome from 1650; his most beautiful works are Romantic Venetian landscapes with anchorite saints or mythological figures.

Monaco, Lorenzo see Lorenzo Monaco

Mondrian, Piet 1872-1944. Founder of the Dutch periodical *De Stijl* (1917), devoted to a form of abstract painting he called Neo-Plasticism. 272

Monet, Claude 1840-1926. Leading French Impressionist. Introduced to *plein-air* painting by Boudin. Obsessed with the instantaneous effects of light, he painted several series of canvases on the same subject. 111, 116, *376-7*

Moore, Henry 1898-1986. Leading English sculptor (and draughtsman). Abandoned his early angular style by 1930 for smooth, rounded masses with hollows based on the human form (esp mother and child and reclining figure). 56, 373

Morandi, Giorgio 1890-1964. Italian still life and landscape painter. His most characteristic works are arrangements of bottles, painted in a narrow range of brownish tones, and creating an intensely meditative mood. 179

Morazzone Il 1575-1625/6. Lombard painter of frescoes, altarpieces and religious works. His highly dramatic, visionary style conveys the fervent spirituality of Counter Reformation Milan. *235*

Moreau, Gustave 1826-98. French painter. His works are decadent, cruelly sensual and intricately detailed; he revelled in scenes of death and destruction drawing his subjects from the Bible or mythology. 107

Morisot, Berthe 1841-95. French Impressionist painter. Shared Impressionists' love of iridescent light, but not their use of short, broken brush strokes.

Moro, Antonio c.1519-76. Dutch painter, chiefly of portraits. Court

painter to the Hapsburgs and Mary Tudor.

Moroni, Giovanni Battista 1520-78. Italian painter, who worked mainly in Bergamo. He painted religious works, but is best known for the warm and direct realism of his many portraits. *181*

Morris, Robert b. 1931. US sculptor associated with the Minimal art school. Uses a wide range of forms and materials, eg peat, copper, brick and grease.

Motherwell, Robert 1915-91. US painter and theorist, champion of Abstract Expressionism. His works are dominated by large amorphous shapes in strong colours. *464*

Moulins, Master of *fl.*1480-1500. French painter. His work shows the influence of Van der Goes.

Mucha, Alfons 1860-1939. Czech painter, graphic artist and designer. Famous for his Art Nouveau posters, characterized by flowing lines and light, clear colours. 60

Munch, Edvard 1863-1944. Norwegian Expressionist. His works, portraying the anxieties and terrors of modern man, are painted in bright Fauvist colours, with sweeping brush strokes indebted to Van Gogh. 286,

Murillo, Bartolomé Esteban *c.* 1618-82. Spanish painter from Seville; he painted religious subjects and sentimental genre in a charming and graceful Baroque style influenced by Rubens and the Venetians. 327

Nash, Paul 1889-1946. English painter; one of the chief founders of the 'modern' movement. Official painter in both World Wars. Best known for his fantastic landscapes.387, *389*

Nattier, Jean-Marc 1685-1766. Fashionable French portrait painter at Louis XV's court. Painted court ladies thinly disguised as the goddesses of mythology.

Nauman, Bruce b. 1941. American sculptor who has worked in performance and film, and created many works in neon and video. His art is ironic, nihilistic and often banal.

Neer, Aert van der *c.*1603-77. Dutch painter. Famous for his treatment of fires, sunsets and moonlight and his night and winter landscapes.

Nevelson, Louise 1900-88. Russianborn US sculptor. Her works consist of large, enclosed box arrangements, filled with a combination of wood, cast-iron and found objects, painted in gold, black or white.

Newman, Barnett 1905-70. US painter. Inspired by pre-Columbian and NW Coast Indian art. His works are large and often painted in a single intense colour broken by vertical stripes.

Nicholson, Ben 1894-1982. One of the earliest and most important abstract artists in England. Painted still-lifes in the post-Cubist manner of Gris in the 1920s; in the 1930s he painted geometric reliefs with a muted and restricted palette. 401

Noguchi, Isamu 1904-88. US sculptor. His environmental sculptures of marble, alabaster, anodized aluminium, stone and bronze are influenced by Oriental art and by Brancusi. 169

Nolan, Sidney 1917-92. The first important modern Australian artist. Began as an abstract painter, but turned to figurative art in 1941. 19

Noland, Kenneth b. 1924. US abstract painter, one of the most important artists to break away from Abstract Expressionism. Paints pure bands of colour in circles, chevrons and parallels, often on shaped canvases.

Nolde, Emil 1867-1956. One of the foremost German Expressionists. Painted mystical landscapes and mask-like 'primitive' portraits. 152, 160

O'Keeffe, Georgia 1887-1986. US painter. Began by painting photo-like close-ups of flowers. Also painted Surrealist landscapes, marked by barren hills, deserts, skulls and bones. Her later work is more abstract. 467

Oldenburg, Claes b. 1929. Swedish-born US artist, a leading exponent of Pop Art. Uses soft materials for his sculptures of everyday objects, eg cheeseburgers. Distortion of shape and scale suggests good-humoured criticism of the cultural values of modern society.

Olitski, Jules b. 1922. Russian-born US abstract painter. Since 1963, in an effort to remove form and all tactile and spatial references, he has used a spray gun to paint soft, pastel-coloured canvases in the Minimal art style.

Onnes, Menso Kamerlingh 1860-1925. Belgian watercolourist and portraitist. 277

Orley, Barend van c.1492-1541. Flemish painter and designer influenced by Raphael and Dürer.

Orozco, José Clemente 1883-1949. Mexican painter. Politically committed, many of his often huge murals (many in fresco) deal with poverty and oppression. Evolved a realistic form of Expressionism using strong colours and bold outlines. 257, *257*

Oudry, Jean-Baptiste 1686-1755. French painter of royal hunts and still-life.

Ouwater, Albert fl. 1450-80. Dutch history and landscape painter. Perhaps a pupil of Van Eyck and teacher of Geertgen.

Overbeck, Friedrich 1789-1869. German painter, who studied in Vienna, and became a founder member of the Nazarenes; from c.1810 he worked in Rome.

Pacher, Michael c.1435-98. Major Austrian painter and woodcarver whose late Gothic manner also reveals an interest in Italian art. 26, 156

Palma Vecchio c.1480-1528. Important Venetian painter. Famous for his brilliant colour and light and his individual *sacra conversazione* altar-pieces.

Palmer, Samuel 1805-81. English landscape painter and etcher. Remembered chiefly for his series of visionary moonlit landscapes drawn in sepia (1827-35).

Panini, Giovanni Paolo c.1691-1765. Italian painter of landscapes and architectural subjects. Settled in Rome in 1715, where he painted ruins and *vedute*.

Paolozzi, Eduardo b. 1924. Scots-Italian sculptor and graphic artist, fascinated by popular culture and by the machine. He was a key figure in the development of Pop Art in London in the 1950s. 365, 396

Parmigianino, Francesco 1503-40. Italian, w. in Parma, Rome and Bologna. An early Mannerist; his figures are gracefully elongated, his treatment of space irrational, his colour cold and strange. 188, 194

Pasmore, Victor b. 1908. English painter of portraits, still lifes and landscapes. Co-founder of the Euston Road School. In 1945 he turned to Constructivism.

Pater, Jean-Baptiste 1695-1736. French painter of *fêtes galantes*. Watteau's only pupil and, with Lancret, his chief imitator.

Patinir, Joachim c.1485-1524. Flemish painter; one of the earliest to paint landscape for its own sake. Religious figures are set before vast sweeps of land seen from above – fantastic rocks, valleys, rivers and villages lead into blue distances.

Peale, Charles Wilson 1741-1827. The most important member of a US

family of inventors and painters. Painted portraits, esp. of Revolutionary heroes, in a Neo-Classical manner. *414*, 459

Pechstein, Max Hermann 1881-1955. One of the founders of German Expressionism. Member of Die Brücke from 1906-12. After an early Fauvist period, his works became increasingly decorative and facile after First World War.

Pellegrini, Giovanni Antonio 1675-1741. Venetian painter. His airy Rococo style won him wide patronage.

Pereda, Antonio de 1599-1669 Characteristic painter of Spain's Golden Age, patronised by the Count-Duke Olivares. History paintings, altarpieces and moral still lives. *308-9*

Permeke, Constant 1886-1952. One of the most important of the second-generation Belgian Expressionists. His studies of country life and people, with their almost monumental figures and sombre colours, are quite unlike the works of German Expressionists. 48

Perugino, Pietro c.1445-1523. Umbrian painter who taught Raphael. His religious works are gracefully composed, sweet in feeling, and set against the calm of the Umbrian countryside. 208

Piazzetta, Giovanni Battista 1683-1754. Venetian painter; his sober colours, solid forms and melancholy poetry contrast with the easy brilliance of the Rococo. 153

Picabia, Francis 1879-1953. French painter; from c.1911 one of the wittiest publicists of Cubist, Dada and Surrealist ideas; his mechanistic images make sharp satirical comments on society.

Picasso, Pablo 1881-1973. b. Spain, w. in Spain and France. The most famous and influential of 20C artists, whose work is marked by an extra-ordinary ease of invention, by the deep feeling of his tragic political statements and by a quality of playful humour. Blue period (1901-4); Rose period (1905-7); Cubism; Surrealism (1926-36); Expressionism. 87, 113, *140*, 141, 320, 343, *432*, 457

Piero della Francesca c.1419-92. Italian painter of the Umbrian school. The mathematical beauty of his compositions, the solemn grace of his figures and the cool light seem to create a silent, timeless world. 175, 203, 226, 383

Piero di Cosimo c.1462-c.1521. Florentine painter of conventional religious works and of highly imaginative mythological subjects.

Pinturicchio, Bernardino di Betto c.1454-1513. Umbrian painter. Pupil and follower of Perugino. 228, 229

Pisanello, Antonio c.1390-c.1455. Italian painter: heir to the International Gothic style of Gentile da Fabriano. 197

Pisano, Giovanni c.1245-c.1315. Pisan sculptor whose style was more Gothic than that of his father, **Nicola**, a. c.1258-84. His pulpit in Siena Cathedral (1265-66) imitated classical forms within a Gothic style. 228

Pissarro, Camille 1830-1903. Major French Impressionist. Flirted with Pointillism in the mid-1880s, reverting to a freer style by the 1890s. 113

Pistoletto, Michelangelo b. 1933. Italian painter. In the 1960s worked as a sculptor and was involved with Happenings in the 1970s. He is now best known for his works with reflections; he mounts a life size monochrome figure on a sheet of polished steel, which reflects the surrounding space, including the viewer and other works of art.

Poelenburgh, Cornelis van c.1586-1667. Dutch landscape and history painter. His small, brightly coloured, idyllic scenes were important in

developing the Italianate style of 17C Dutch landscape.

Polke, Sigmar b. 1941. A student at the Düsseldorf Academy, and member of the Capitalist Realism group, he created an ironic art about art, playing on the West German passion for kitsch, and using motifs from mass media and film. 142, 149

Pollaiuolo, Antonio c.1433-98, and **Piero** c.1443-96. Florentine brothers: painters, goldsmiths and sculptors. Antonio was interested in expressing dramatic action; he studied anatomy and landscape with scientific exactitude.

Pollock, Jackson 1912-56. US painter, leading Abstract Expressionist. He wanted the act of painting to express his deepest feelings – he poured and dripped the paint directly on to the canvas. *422-3*

Pontormo, Jacopo Carrucci 1494-1557. Florentine early Mannerist. His pale colours, agitated draperies and crowded compositions create an intensely emotional effect. 193, 194

Pordenone, Giovanni Antonio c.1483-1539. Venetian painter of chiefly biblical subjects, mostly church frescoes. His dramatic and illusionist style anticipated Mannerism. 182

Poussin, Gaspard *see* Dughet, Gaspard

Poussin, Nicolas 1594-1665. The greatest representative of French Classicism. His Romantic and Titianesque paintings of the loves of the gods were followed by austere and learned works based on a profound study of ancient literature and art. 109, 299, 365, *378-9*, 379, 408

Pozzo, Fra Andrea 1642-1709. Italian painter; master of *trompe l'œil* illusionism. 220

Preti, Mattia 1613-99. Neapolitan Baroque painter whose dark and dramatic works introduce the late Baroque. 252

Primaticcio, Francesco 1504-70. Italian Mannerist painter, sculptor and architect. Worked on the decoration of Fontainebleau Palace with Rosso. Did much to bring the Italian manner into France. 98, *468*

Procaccini, Giulio Cesare c.1570-1625. A leading painter of the Milanese Seicento; the most gifted of a family of painters who moved from Bologna to Milan c.1590. His emotional religious works are indebted to Correggio and Parmigianino.

Puvis de Chavannes, Pierre 1824-98. French painter. Noted chiefly for his murals which, with their muted colours and flattened forms, recreated the monumental Italian fresco style. 100, 430

Quercia, Jacopo della 1374-1438. The foremost Sienese sculptor of the early Renaissance. Under the influence of Donatello and Ghiberti, his early Gothic style gave way to the new Italian manner.

Raphael Santi 1483-1520. Italian painter. His Vatican frescoes are the most perfect examples of High Renaissance art; he painted many versions of the Virgin and Child, his portraits are powerfully realistic. 144, *186*, 219, 225, 390

Rauschenberg, Robert b. 1925. US painter, whose witty and varied art challenges the separation of art from life; his 'combines' of the junk material of industrial society influenced Pop Art, Environmental Art and the Happening. 335, 466

Ray, Man 1890-1978. Leading *avant-garde* figure of 20C US art. Co-founder of the New York Dada movement. One of the world's foremost 'art photographers'.

Redon, Odilon 1840-1916. French Symbolist painter and graphic artist. His lithographs drew their fantastic imagery – monsters, floating eyes, grinning spiders – from the world of dream; his oils and pastels are radiantly coloured (after 1890). 113, 434

Regnier, Nicolas 1599-1667. Flemish painter, who worked in Italy, where he painted Caravaggesque scenes of gypsies and fortune tellers etc; from 1625 he worked in Venice, and developed a more elegant, sumptuous style.

Reinhardt, Ad 1913-67. US painter. Best known for his severely geometrical works of the 1950s.

Rembrandt Harmensz van Rijn 1606-69. The greatest Dutch painter, etcher and draughtsman. His art, based on *chiaroscuro*, excels in its power to suggest the complexity of human feeling and spiritual values; he painted portraits, landscapes, biblical and mythological subjects. *147*, 151, *260-1*, 266, *268-9*, 273, 299

Reni, Guido 1575-1642. Bolognese Classical artist, whose works seek to recreate the ideal beauty of Raphael and of the Antique; the highly charged emotion of his religious works typify this aspect of the Baroque. *178*, 214, *283*

Renoir, Pierre-Auguste 1841-1919. French Impressionist best known for portraits and nudes, using feathery brushwork and warm colours. His later works show the use of a lighter palette and an emphasis on line drawing. *4*, 93, *452*, 471, 473

Reynolds, Sir Joshua 1723-92. English portraitist and theorist, he became first president of the Royal Academy in 1768 and principal painter to George III in 1784. 447, 453

Ribalta, Francisco de 1565-1628. One of the first Spanish Baroque artists; his direct, austere naturalism suggests the influence of Caravaggio.

Ribera, Jusepe de c.1591-1652. Spanish painter; the most important of the Neapolitan Caravaggisti. The dark violence and rich brushwork of his early years yielded to a softer more classical style. 204, 322

Ricci, Marco 1676-1729. Italian painter, nephew and pupil of Sebastiano Ricci. In England 1708-16 when he returned to Venice; he painted *capricci* and decorative landscapes with ruins.

Ricci, Sebastiano 1659-1734. Venetian painter; the lightness and gaiety of his pictures and their debt to Veronese were seminal to the Venetian Rococo.

Richter, Hans 1888-1976. German painter, sculptor and film-maker. Joined the Zürich Dadaists in 1917 and began painting purely abstract geometrical canvases. *524*

Riemenschneider, Tilman c.1460-1531. German sculptor, who worked in Wurzburg; the most celebrated of the late Gothic sculptors, he created splendid limewood altarpieces with a dazzling array of pinnacles and spires and dramatic and expressive figures. 162

Rigaud, Hyacinthe 1659-1743. French painter, brilliant portraitist to Louis XIV and XV. 116

Riley, Bridget b. 1931. Since the early 1960s the leading English exponent of Op Art, having produced a series of predominantly black and white canvases in which the lines appear to oscillate. 389

Riopelle, Jean-Paul b. 1922. Canadian abstract painter from Montreal. Has painted brilliantly coloured Action paintings resembling stained glass. 54, 55

Rivera, Diego 1886-1957. Mexican painter, the most influential of the Mexican Mural Renaissance. *254*, 256

Rivers, Larry b. 1923. US painter, sculptor, designer. Began as an

Abstract Expressionist, but a visit to Paris in 1950 turned him to a more figurative style. His use of popular images anticipated the Pop Art movement.

Robbia, della, family. Florentine sculptors and ceramists. **Luca** (c.1399-1482), one of the early masters of the Florentine Renaissance, executed marble reliefs in lively classical designs and glazed terracotta polychrome reliefs. *528* His workshop was carried on by son **Giovanni** (1469-1529) and nephew **Andrea** (1435-1525). 189, *528*

Robert, Hubert 1733-1808. French painter of landscapes and ruins. He studied in Italy (1754-65) with Fragonard, whose late Rococo style was close to his own.

Roberti, Ercole de' c.1453-96. Italian painter of religious subjects, from Ferrara. *184*, 185

Rodin, Auguste 1840-1917. French sculptor, famous for the rugged grandeur and mutilated nobility of his bronze figures, and the sensual smoothness of his marbles. Fine erotic draughtsman. Major figure in the late 19C. *80*, 113, *114-5*, 116

Romanino, Gerolamo 1484/7-c.1560. Italian painter, who worked in Brescia. He painted portraits, frescoes and altarpieces, and his best works are powerfully expressive and dramatic. 206

Rops, Félicien 1833-98. Decadent Belgian painter and etcher. 48

Rosa, Salvator 1615-73. Neapolitan Baroque painter; w. in Rome and Florence. His dark and macabre art inc. rugged, desolate landscapes with *banditti*, fiery battles and scenes of witchcraft. 65, 463

Rossellino, Bernardo 1409-64. Florentine early Renaissance sculptor of statues, tombs and bas-reliefs. Skilled at decorative ornament. His brother **Antonio** (1427-c.1479) is

known for his portrait busts. 194

Rossetti, Dante Gabriel 1828-82. English painter and poet. Co-founder of the Pre-Raphaelite Brotherhood.

Rosso, Giovanni Battista di Jacopo (Il Fiorentino) 1495-1540. Florentine early Mannerist painter. His religious works are intensely emotional. At Fontainebleau he created a new style of decoration. 98, 249

Rosso, Medardo 1858-1928. Italian sculptor whose works come close to Impressionism.

Rothko, Mark 1903-70. US Abstract Expressionist b. in Russia. One of the founders of Colour-field painting. In 1948 he began painting works consisting of soft-edged areas of colour. 389, 443, 471

Rottmayr, Johann Franz Michael 1654-1730. The founding father of Austrian High Baroque painting, he painted major frescoes in palaces and churches.

Rouault, Georges 1871-1958. French artist. Painted deeply expressive religious works characterized by glowing Fauvist colours and strong outlines.

Rousseau, Henri (Le Douanier) 1844-1910. French Primitive painter. Evolved a highly personal and colourful style, best seen in his series of exotic jungle scenes.

Rousseau, Théodore 1812-67. French painter, leading figure of the Barbizon landscape school.

Rubens, Sir Peter Paul 1577-1640. Flemish painter whose vast output has never been paralleled. The energy of his hunts and portraits, his altarpieces, allegories and mythologies, glowing with colour and full of powerful movement, lie at the centre of the Baroque. 40, 41, *42-3*, 110, 321

Ruisdael, Jacob Isaacksz van 1628/9-82. The greatest and most varied Dutch landscapist. He painted

northern landscapes, majestic forest scenes, and panoramic views lit by shifting patterns of cloud. Nephew of Salomon Ruysdael. *269*

Russolo, Luigi 1885-1947 Italian musician, poet and painter. Signatory of the Futurist Manifesto, first Futurist to paint a speeding machine. Contributed to the development of *musique concrète* with his theory of *Bruitism* ('Noisism'). *380*

Ruysdael, Salomon van *c.*1600-70. Dutch painter important to the development of realist landscape in Haarlem; his lyrical river scenes are painted in harmonies of grays and greens. Uncle and perhaps teacher of Jacob Ruisdael.

Sacchi, Andrea 1599-1661. Italian painter; the leader of a Classical movement that opposed the extremes of the High Baroque. His grave easel paintings are most successful.

Saenredam, Pieter Jansz 1597-1665. Dutch painter of architectural subjects. Travelled widely; best known for his airy, softly painted church interiors. *269*

Samaras, Lucas b.1936. US painter and sculptor, b. in Greece. In the 1950s and early '60s he sculpted figures out of plaster-soaked rags moulded into shape. He later widened his range of materials to inc. kitchen sinks, stuffed birds and liquid aluminium. *431*

Sansovino, Andrea 1460-1529. Italian sculptor and architect. Pupil of Pollaiuolo. Worked in Florence and Rome and at Loreto. Human tenderness softens the classical elegance of his work.

Saraceni, Carlo *c.*1579-1620. Italian painter, born in Venice, but settled in Rome *c.*1598. His altarpieces are indebted to Caravaggio in their lighting and naturalism, but are more elegant and in feeling, while his small

cabinet pictures, with naturalistic landscapes, are closer to Elsheimer.

Sargent, John Singer 1856-1925. US portrait painter, b. in Florence. Settled in London in 1884. Painted fashionable society portraits in a style derived from Velázquez and Manet.

Sarkis (Zabunyan Sarkis) b. 1938. French-Armenian installation and multimedia artist. *105*

Sarto, Andrea del see Andrea del Sarto

Sasseta, Stefano di Giovanni *c.*1400-50. One of the most important 15C Sienese painters. Combined traditional ideals of 14C Sienese religious art with current Florentine advances.

Savoldo, Giovan Gerolamo a. 1506-48. Italian painter, probably from Brescia, who settled in Venice by 1521. He painted mainly altarpieces and religious works, distinguished by their Lombard naturalism, and by their gleaming draperies and poetic exploration of effects of artificial light.

Schedoni, Bartolommeo 1578-1615. Italian painter, of religious subjects, who worked at Modena and Parma, and was influenced by the 16C Parmese art and by Lanfranco; his best paintings are distinguished by a highly original use of strange, cold colour, angular draperies, and expressive lighting.

Schiele, Egon 1890-1915. Austrian Expressionist, taught and deeply influenced by Klimt. The nude, anguished and pitiful was the main subject of his linear, intensely coloured paintings.

Schlemmer, Oskar 1888-1943. German artist. Taught theatrical design at the Bauhaus (1920-29). After early Impressionist and Cubist phases, he developed his own abstract style, combining Constructivism with natural forms.

Schmidt-Rottluff, Karl 1884-1976.

German Expressionist; founder-member of Die Brücke. Influenced by Van Gogh and Fauvism. After 1911 his work became more naturalistic.

Schonfeld, Johann Heinrich 1609-84. German painter and printmaker. He travelled to Italy, and spent around ten years in Naples, (1637-c.1648); his elegant scenes from ancient history and the Bible show a response to Poussin, to Callot and to Neapolitan painting, above all to the macabre subjects of Salvator Rosa. In 1651 he returned to Germany, where he worked mainly in Augsburg.

Schongauer, Martin c.1430-91. Generally regarded as the greatest German painter and engraver before Dürer. Settled in Colmar, where he came under Van der Weyden's influence.

Schwitters, Kurt 1887-1948. German Dadaist painter and collage artist. In 1920 invented *Merz* (derived from a word found at random in a dictionary, and used to denote a haphazard collection of objects arranged into a flat or 3-D collage). Settled in England in 1940. 396

Scorel, Jan van 1495-1562. Flemish painter of religious subjects and portraits. Travelled widely, settling in Utrecht in 1524.

Scott, William 1913-89. English painter. His early style was influenced by the Pont-Aven group. He was later influenced by US abstract art and became a leading figure in the British abstract movement.

Sebastiano del Piombo c.1485-1547. Venetian artist. Early influenced by Giorgione, he came under the spell of Michelangelo in Rome after 1511; his works combine Roman grandeur with Venetian colour and poetry. 221

Séchas, Alain b. 1955. French artist inspired by narrative techniques of cartoons and television. 99

Segal, George b. 1924. US sculptor, b. in New York. He is famous for sculptures based on life casts, with rough, unpainted surfaces of white plaster, which create a melancholy and eerie effect.

Seghers, Hercules c.1590-c.1638. Dutch artist; his etchings and rare paintings of desolate mountain scenery and immense plains influenced Rembrandt's landscape.

Seurat, Georges 1859-91. Leading French Neo-Impressionist, founder of Pointillism. Primarily interested in achieving precise form and balanced order in his works. 384, 433, 446

Severini, Gino 1883-1966. Italian Futurist and Cubist painter, w. in Paris.

Shahn, Ben 1898-1969. US painter, leader of a group of socially conscious artists that emerged during the depression of the 1930s; he depicted in a sharp, dry style, scenes of urban American life.

Sickert, Walter Richard 1860-1942. English painter. Co-founder of the Camden Town Group. Influenced by Degas and Whistler.

Signac, Paul 1863-1935. French painter. Took up Pointillism in 1884 after meeting Seurat and rivalled him in importance. In the 1890s began exaggerating the technique. 120

Signorelli, Luca c.1441-1523. Italian painter of the Umbrian school. His skill at rendering muscular power influenced Michelangelo. 205

Simone Martini c.1285-1344. Sienese painter, Duccio's principal successor, w. for the French kings in Naples and the papal court in Avignon. The linear elegance of French Gothic affected his later, courtly style. 188, 195, 228

Siqueiros, David Alfaro 1896-1974. Great representative of the Mexican Mural Renaissance. He aimed to

place realistic art at the service of socialism.

Sironi, Mario 1885-1961. Italian painter, leading member of Il Novecento, who painted murals and easel paintings in an archaic and classicising style. *14*

Sisley, Alfred 1839-99. English painter, b. and w. in France. Leading Impressionist. Painted landscapes and town views using a light palette. 113

Sluter, Claus *c.*1340-*c.*1405. Great Flemish sculptor, whose powerful realism marked a turning point in northern Renaissance art. 94, 97

Smith, David 1906-65. One of the first US abstract sculptors. Best known for his large welded iron and steel structures.

Sodoma, Il (Giovanni Antonio Bazzi) 1477-1549. Italian painter, w. chiefly in Siena. Leonardo's influence can be seen in his use of *sfumato*. 203

Solimena, Francesco 1657-1747. Foremost exponent of late Neapolitan Baroque. He used exaggerated foreshortening, agitated figures and dramatic light effects in his frescoes. His later style was more Classical.

Sorolla y Bastida, Joaquín 1863-1923 Spanish impressionist, whose vigorous, large brushwork and brilliant colours work particularly well for beach scenes. *312*, 323

Soutine, Chaim 1893-1943. Russian painter, w. in Paris from 1913. Cézanne's influence can be seen in his many brilliantly coloured distorted landscapes. Painted still lifes and portraits in the Brücke style after 1926.

Spencer, Sir Stanley 1891-1959. English painter of portraits, landscapes and religious subjects, he evolved an eccentric, primitive style to communicate powerful religious feeling. 359

Stäel, Nicholas de 1914-55. French painter, b. in Russia. Painted abstracts in the early 1940s, adopting the Tachiste technique in the late 1940s. In 1952 returned to his original representational style.

Stanzione, Massimo 1585-1656. Leading Neapolitan painter of altarpieces.

Steen, Jan *c.*1626-79. Dutch painter of portraits and still lifes, mythological and religious subjects, but best known for his humorous tavern scenes and illustrations of Dutch proverbs. *65, 305*

Steer, Philip Wilson 1860-1942 English landscape painter. Combined the Impressionists' stress on light and atmosphere with the naturalism of Gainsborough and Constable.

Stella, Frank b. 1936. US painter. Began as an Abstract Expressionist, but in 1958 turned to Minimal art. Until the late 1960s painted curved or straight concentric bands of pure colour, often on shaped canvases.

Still, Clyfford 1904-1980. US Abstract Expressionist painter. Sharp-edged areas of pure colour often predominate in his large-scale works, characteristically painted with very thick impasto. 431

Stoss, Veit *c.*1450-1533. German wood-carver and sculptor. 135, 159, 290

Stosskopf, Sebastian 1596-1657. Strasbourg still life painter, whose meticulously detailed still lifes have an almost trompe l'oeil effect. The objects have symbolic meaning, and suggest the vanity of earthly things. *12-13*

Strozzi, Bernardo 1581-1644. Genoese painter; moved to Venice *c.*1630. He painted rustic genre and powerfully direct religious scenes.

Stubbs, George 1724-1806. English self-taught painter and engraver. Specialized in animals, esp. horses,

and studied their anatomy. *360*, 399, 447

Stuck, Franz von 1863-1928. Gloomy Bavarian Symbolist painter; teacher of Kandinsky and Klee. 158

Sutherland, Graham 1903-80. English painter. Official war painter but best known for his powerful, penetrating portraits.

Sweerts, Michiel 1624-*c*.1664. Dutch painter of portraits and historical subjects (many of which he engraved). Best remembered for his silver-toned genre scenes of Roman street life (in Rome 1643-56).

Tabachetti (Wespin, Jean) *c*.1568-1615. Flemish sculptor w. in northern Italy; specialized in large-scale terracotta figures for for Sacra Monte ensembles. *235*

Tamayo, Rufino b. 1900. Mexican painter. Revived easel painting when the fashion in Mexico was for huge revolutionary murals. Abandoned Abstract Expressionism in the 1950s for Cubism. 257

Tanguy, Yves 1900-55. French Surrealist, inspired by de Chirico. Painted underwater landscapes and moonscapes filled with imaginary creations. Settled in the USA in 1939.

Tapiès, Antonio b. 1923. Spanish painter, largely self-taught, with a great influence on Pop and abstract art. His most original contribution is his use of mixed media (glue, plaster, straw, parts of doors). 313

Terborch, Gerard 1617-81. Dutch genre painter; his scenes of middle-class life are distinguished by the subtlety of his psychology and by the exquisite treatment of materials. 269

Terbrugghen, Hendrick *c*.1588-1629. Dutch painter, leading member of the Utrecht school. Studied Caravaggio while in Rome (1604-14). Painted religious subjects and

genre. The light yellows and blues of his last works foreshadowed Vermeer and the Delft school. 279, *458*

Thorvaldsen, Bertel 1770-1844. Danish sculptor. Worked in Rome 1797-1838, Next to Canova, regarded as one of the greatest Neo-Classicists, his figures characterized by a cool, austere nobility. 66

Tibaldi, Pellegrino 1527-96. Leading Italian Mannerist painter, sculptor and architect. Worked chiefly in Rome; also in Bologna and in Spain (at the Escorial). 180, 326

Tiepolo, Giambattista 1696-1770. The greatest Venetian 18C painter, whose vast frescoes both revived and concluded the splendours of the Venetian decorative tradition. 162, 233, *233*, 241, 243, 248

Tiepolo, Giandomenico 1727-1804. Older son of G.-B. Tiepolo with whom he collaborated extensively. Developed a more personal, poignant style after his father's death; fine draughtsman famous for his Carnival scenes.

Tintoretto, Jacopo Robusti 1516-94. Venetian Mannerist; his dramatic religious works depend on his bold compositions and strange effects of light. 240, 243, 244

Titian (Tiziano Vecellio) *c*.1487-1576. The greatest Venetian painter and perhaps the greatest painter who has ever lived; his handling of oil paint is unrivalled. He painted every kind of subject; his art developed from an early Giorgionesque style to the dramatic works of his middle years and culminated in the freedom and tragic intensity of his final pictures. 110, 189, *238-9*, 240, 243, 321, 365, 384

Tobey, Mark 1890-1976. US painter. Most famous for his 'white writings' (white calligraphic brushstrokes over pale colours), developed after his visit

to China and Japan in 1934-35.

Toulouse-Lautrec, Henri de 1864-1901. French painter, draughtsman, lithographer and poster designer. Influenced by Degas and by Japanese prints, his works recreate the frantic and somehow melancholy gaiety of Parisian night-life – of brothels, restaurants, dance-halls and cabarets. 83

Tournier, Nicolas 1590-1639. French painter, who studied in Rome, and by 1632 had settled at Toulouse. A shadowy figure, whose output remains controversial, he probably painted a group of Caravaggesque genre paintings, of drinkers, gamblers, musicians. From his late years, more securely documented, come a series of large and austere altarpieces.

Troost, Cornelis 1697-1750. Dutch painter of portraits, conversation pieces and genre scenes, a. in Amsterdam. 263

Tura, Cosmè c.1430-95. Founder of the Ferrarese school. Mantegna's influence can be seen in his use of intricate lines and the brilliant, enamel-like colours. 185

Turner, Joseph Mallord William 1775-1851. Great master of English landscape painting. Drama, movement and atmospheric luminosity mark his Romantic works of the early 1800s. In his works from the 1830s form is dissolved by light and colour. *359*, 387, 411, 447

Twombly, Cy b. 1928. American painter who settled in Italy in 1957 and is best known for works consisting of irresolute scribbled words and figures. 443

Uccello, Paolo c.1396-1475. Florentine painter. He was obsessed by the study of perspective, though his works retain hints of the decorative gaiety of International Gothic. 188, 194

Utrillo, Maurice 1883-1955. French painter of Parisian street scenes. Member of the École de Paris.

Valdés Leal, Juan de 1622-90. Spanish painter, the last important Baroque religious painter in Andalusia. Worked in Seville from 1657. Employed the dramatic effects of light and movement to portray intense human emotions. 327

Valentin de Boulogne, Moise c.1591-1632. French painter, one of the leading Caravaggisti. Best known for his genre scenes of soldiers and gypsies.

Vasarély, Victor 1908-97. French artist of seminal importance to the development of Op Art. 82

Vasari, Giorgio 1511-74. Florentine painter, architect and art historian, who wrote *Lives of the Artists*, a book which first defined the Renaissance as a new development. Painted Mannerist frescoes. 175, *191*

Velázquez, Diego Rodriguez de Silva y 1599-1660. Great Spanish painter, whose detached art moves from Caravaggesque genre to stiffly formal royal portraits of the court of Philip IV. His impressionistic brushwork is indebted to Titian. 322, 374, *375*, 384

Velde, Esaias van de c.1591-1630. Dutch painter, important to the development of realistic landscape in Haarlem. Probably unrelated to **Adriaen** (1636-72), Dutch landscape painter, son of **Willem I**, who like his other son, **Willem II** (1633-1707), was a marine painter; the latter of outstanding importance.

Veneziano, Domenico *see* Domenico Veneziano

Vermeer, Jan 1632-75. The greatest Dutch genre painter. His simple domestic interiors are given extraordinary beauty by the clarity of his compositions and by the cool, silvery

daylight. *10, 258,* 269, 273, 455

Vernet, Claude Joseph 1714-89. French landscape painter, who worked for 20 years in Rome. He worked for the Grand Tour market, producing many paintings of the Roman Campagna and the Italian coastline, distinguished by their eerie effects of moonlight or glimmering dawns. *89*

Verona, Stefano da 1374/5-*c.*1438. French painter, who worked in Italy; his lyrical works, rich in minutely observed detail and gorgeously decorative effects, epitomise the International Gothic style. *173*

Veronese, Paolo Caliari *c.*1528-88. Venetian painter of biblical and mythological scenes. His works generally feature richly dressed figures against a classical, silver-toned architectural background: they are enlivened by playful elements of genre. 110, 246

Verrocchio, Andrea del *c.*1435-88. Important Florentine painter, goldsmith and sculptor. The leading pupil of his workshop was Leonardo. Best remembered as a sculptor of elaborate bronzes. 192, 244

Vignon, Claude 1593-1670. French painter, of religious and historical subjects, who travelled in Italy and Spain, settling in Paris in 1623. He moved from a powerfully Caravaggesque style to a more brightly coloured, lyrical and expressive manner. *86, 247*

Vinci, Leonardo da *see* Leonardo da Vinci

Virgo inter Virgines, Master of the *fl.* late 15C. A highly individual Flemish artist, probably w. in Delft, he often painted richly dressed figures against stark, unpeopled backgrounds.

Vivarini family. Venetian painters, specializing in polyptychs,244. **Antonio** (*c.*1415-*c.*1484) painted in a decorative Gothic manner, usually with collaborators, eg his brother **Bartolommeo** (*c.*1432-*c.*1499). The latter's work shows Gentile da Fabriano's influence. **Alvise** (*c.*1445-*c.*1505), Antonio's son, specialized in carefully drawn portraits and was influenced by Bellini.

Vlaminck, Maurice de 1876-1958. French Fauve painter.

Vos, Cornelis de *c.*1584-1667. Flemish portrait painter w. in Antwerp, sometimes with Rubens; close friend of Van Dyck. *34, 405*

Vouet, Simon 1590-1649. French history and portrait painter. Strongly influenced by Caravaggio while in Rome (1614-27). As court painter to Louis XIII, he decorated his palaces in a modified Italian Baroque style.

Vuillard, Edouard 1868-1940. French painter. Member of the Nabis in the 1890s. Painted portraits and small, lamplit, middle-class interiors.

Waldmüller, Ferdinand 1793-1865. The most celebrated artist of early 19C Austria, who painted meticulously detailed portraits, genre and landscape. *22*

Warhol, Andy 1930-87. US painter, graphic artist and film-maker, leading exponent of Pop Art. Came to the fore in the early 1960s with paintings of Campbell's soup cans, sculptures of Brillo pad boxes and photographic silk-screens of famous film stars, particularly Marilyn Monroe. 460

Watteau, Jean-Antoine 1684-1721. French Rococo painter, inventor of the *fête galante*, influenced by Rubens and the Venetians. His works, with their delicate brushstrokes and gleaming colours, have an underlying melancholy and gravity. 110, 141, 392

Wekler, Georgii 1800-91. Leading Russian (though Latvian-born) mosaic artist. *381*

Wesselmann, Tom b. 1931. US Pop Art collage artist. Distorted fragments of the nude, usually female, body form the basis of his huge, cartoon-like paintings.

Westermann, H. C. 1922-81. Assemblage artist linked with Pop Art and with Chicago's Monster School. *435*

West, Benjamin 1738-1820. US painter. Moved to England in 1763, becoming a founding member of the Royal Academy (and its second president) and history painter to George III. A successful portrait painter, but best known for his Neo-Classical history paintings. 55, *416-7*

Weyden, Rogier van der *c.*1399-1464. Major Flemish painter. His style is more poignant and more monumental than Van Eyck's; it depends on strong linear rhythms and unusual colour harmonies. 91, 138, 320

Whistler, James Abbott McNeill 1834-1903. US painter, w. in London and Paris. His pictures, entitled *Symphonies, Nocturnes and Arrangements* reveal his preoccupation with a sensitive arrangement of forms in harmony with subdued tones and colours. 370, *371*, 387, 453, 469

Wiertz, Antoine Joseph 1806-65. Belgian painter and sculptor. Painted historical works based on classical antiquity and enormous Romantic compositions on philosophical and apocalyptic themes. 47

Wilson, Richard 1714-82. Welsh painter. Began as a portraitist, but after his stay in Italy (1752-56) started painting classical idealized landscapes in the manner of Claude and Poussin. 363

Witz, Konrad *c.*1400-46. German late Gothic painter and wood sculptor. Worked in Basel and Geneva. Jan van Eyck's influence can be seen in his strong colours and heavily delineated figures. 121, *122*, 342

Wright of Derby, Joseph 1734-97. English painter, w. in Derby, first as a portraitist, then as painter of industrial genre scenes, for which he is best known. He achieved romantic effects by skilful rendering of moonlight and candlelight. 364, *364*

Wouters, Rik 1882-1916. Belgian sculptor and painter, the most celebrated Belgian Fauve. 40

Wyeth, Andrew Newell b. 1917. Leading US figurative painter. Paints meticulously detailed, nostalgic scenes of Pennsylvania. 459

Ysenbrandt *see* Isenbrandt

Zurbarán, Francisco de 1598-1664. Spanish Baroque painter, w. in Seville and Madrid. He was patronized by the austere monastic orders and his paintings of scenes from the lives of the saints combine realistic detail with unreal lighting. *310*, 318

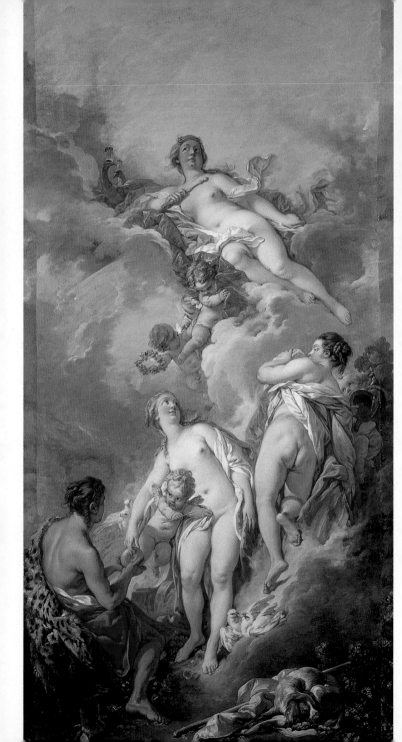

Glossary (schools, movements, styles, terms and techniques)

Abstract art Non-representational painting or sculpture that relies entirely on line, form and colour, dissociating itself from any reality. though it may conjure up images for the viewer.

Abstract Expressionism Non-representational style, fl. in New York in the 1940s (and often referred to as the New York School) which aimed to express the artist's subconscious. Growing out of Surrealism and the Expressionist works of Kandinsky, it includes: *Action painters* (eg Pollock, de Kooning), who used a spontaneous technique; and *Colour-field* painters (eg Rothko, Newman) who worked with large, carefully planned areas of colour. 431

Academic painting Art conforming to traditional conventions and theories, usually those of a particular academy. Now used pejoratively to denote undistinguished representational art.

Action painting *see* Abstract Expressionism

Altarpiece Decorated screen or panel(s) on or behind the altar. Also called a retable. It may have two panels (*diptych*), three (*triptych*) or more (*polyptych*).

Art brut Literally 'raw art', a term describing work which is the spontaneous expression of people untrained in art and supposedly therefore free of its inhibiting conventions. Often associated with psychotics and criminals. The phrase was coined by Dubuffet.

Art nouveau Literally 'new art', a decorative style of art and design marked by asymmetrical sinuous lines based on plant forms. It grew out of the English Arts and Crafts movement and spread throughout Europe and the USA fl. 1890-1910. Variously known as Jugendstil (Germany), Stile Floreale or Stile Liberty (Italy), Modernismo (Spain), Sezession (Austria).

Arte Povera, or poor art, an Italian movement of the 1960s, which attempted to challenge the commercialism of the art world and the primacy of painting by using such materials as soil. 249

Ashcan school Eight US painters. a. early 1900s, united by a rejection of Academicism and an endeavour to portray realistically the ordinary, often unpleasant, aspects of urban life. 457

Attribution Term for the assignment of a work of unknown authorship to a particular artist on the basis of stylistic similarities to his authenticated works.

Automatism Method of producing a painting without conscious control, resulting in an arbitrary free 'doodling'. Used by the Surrealists and the Abstract Expressionists.

Avant-garde Literally 'vanguard'; term used to describe art or artists rejecting accepted tradition in favour of new methods and ideas.

Bambocciani Group of mainly Dutch and Flemish artists working in

Opposite: The Judgement of Paris, *1754, François Boucher, The Wallace Collection, London*

Rome in the 1620s and 1630s; they painted charming scenes of every-day life in Rome and the campagna, showing cardplayers, inns, water-sellers, brigands,which became popluar wih Roman collectors. The name derives from their leader, Pieter van Laer, nicknamed 'Banboccio'.

Barbizon school Mid-19C French school of landscape painting based in the village of Barbizon in Fontainebleau Forest. Its members, inc. Rousseau, Daubigny and Millet, painted direct from nature, without sentimentalizing, and prepared the way for Impressionism. 112

Baroque European style of art and architecture fl. 1600-1740, reaching its culmination in Rome. It is charac-terized by confidence and flam-boyancy, evident in the dramatic use of light and colour, and a dynamic urgency emphasizing the unity of the whole rather than its component parts. The Baroque depends on involving the emotions of the spec-tator, often by a dramatic use of illusionism. Outstanding artists include Cortona, Bernini, Rembrandt and Rubens.

Bauhaus Literally 'building house', a German school of architecture, art and design founded by Walter Gropius in Weimar in 1919 which acknowledged the machine age and aimed to create a link between fine arts and industry. It moved to Dessau in 1925, then Berlin, where the Nazis closed it in 1933. The new Bauhaus was set up in the USA by Moholy-Nagy in 1937.

Blaue Reiter Literally 'blue rider', a loose association of Expressionist painters formed in Germany in 1911 by Marc and Kandinsky, taking their name from the title of an earlier work by Kandinsky. Other mem-bers included Klee, Macke, Vlaminck, Delaunay, Henri Rous-seau, Derain

and Braque. Each artist retained his own style. The group was disbanded at the start of the First World War. 149

Bloomsbury Group British artists in the 1920s and '30s, inc. Vanessa Bell, Roger Fry and Duncan Grant.

Brücke, Die Literally 'the bridge', a German Expressionist group founded in Dresden in 1905 by Heckel, Kirchner, and Schmidt-Rottluff. They admired Gauguin and Van Gogh and developed individual styles characterized by simplified forms and violent colours. Members included Nolde and Van Dongen. They disbanded in 1913. 149

Camden Town Group Association of English painters formed in 1911, inc. Sickert and Augustus John, which played a leading part in bring-ing Post-Impressionism to England. 373

Capriccio Picture in which real buildings and scenes are rearranged in an imaginative composition.

Cartoon Full-size preparatory draw-ing for a painting, fresco or tapestry, often in colour and possibly only of a detail.

Caravaggisti Followers of Caravag-gio in the early 17C mainly in Italy and the Netherlands.

Chiaroscuro Literally 'bright-dark', a method of creating total balance and greater illusion of form and depth by heightening the contrast between areas of light and shade. Used particularly by Rembrandt and Caravaggio.

Cinquecento Used of 16C Italy and its art.

Classicism Term describing art inspired by a desire to imitate Clas-sical art, seeking to express emotion through order, relying on simplic-ity, harmony and proportion.

CoBrA Association of painters (inc.

Appel and Jorn) from Copenhagen, Brussels and Amsterdam (hence the name) a. 1948-51. The use of fantastic, often nightmarish, figures distinguishes CoBrA from Action painting, its American counterpart. 66, 266

Colour-field painting *see* Abstract Expressionism

Constructivism An abstract Russian movement, mainly sculptural and architectural, evolved in 1917 by Gabo and Antoine Pevsner, which lasted until 1921. New machine-age materials were used in constructing suspended or uplifted forms, reflecting the artists' interest in movement in space. 433

Cubism First of the major innovative art movements of the 20C, begun by Picasso and Braque in 1907. Influenced by African art and Cézanne's advice to 'deal with nature by means of the cylinder, the sphere and the cone'. *Facet Cubism* (1907-9): natural forms reduced to basic geometrical shapes. *Analytical Cubism* (1910-12): further fragmented objects depicted from all angles and open from inside. *Synthetic Cubism* (1913-14): a total rejection of imitation with recreation of new objects.

Dadaism Movement that began in Zurich in 1916 as a reaction against the senseless horror of the First World War. Stressing the illogical and absurd, its purpose was to outrage. Artists inc. Arp, Ernst, Picabia and Man Ray. Developed into Surrealism. 449

Danube School Term used to describe a group of artists, who, in the early years of the 16C, painted in the Danube valley in southern Austria. Most important were Altdorfer, Cranach the Elder and Wolf Huber; their paintings show blue mountains, deep forests, and moss clad pines, and create an intensely poetic mood.

De Stijl *see* Stijl

Diptych *see* Altarpiece

Divisionism *see* Pointillism

Euston Road Group London-based school of painting and drawing (1937-39) which aimed to counteract the influence of abstract and Surrealist art by stressing the importance of an objective approach to nature.

Expressionism Early 20C movement concerned with expressing heightened emotions and inner vision through the use of violent distortion, exaggeration and dramatic colour. Esp characteristic of German and Scandinavian art (eg Blaue Reiter and Die Brücke groups, Munch and Ensor). 433

Fauvism Literally 'wildness', a derogatory label first used in 1905 to describe the work of artists experimenting with flat, strident colours and effects of distortion. The group inc. Matisse, Rouault, Derain, Vlaminck. 122

Fête champêtre, fête galante Genre scene with elegant lovers in an idealized park setting. Watteau's *fêtes champêtres* typified the spirit of the Rococo.

Figurative art Painting or sculpture which contains recognizable objects.

Found object From the French, *objet trouvé*, an object selected and displayed without any alterations as art. It may be a natural form or a manufactured one (known as a ready-made). Used by the Dadaists and Surrealists.

Fresco Wall painting of water-based pigments on plaster. A small area of under-plaster, on which a preliminary sketch (*sinopia*) has been drawn, is covered with a layer of lime-plaster and painted while still wet. Paint and plaster fuse as they dry, forming

a matt, stable surface.

Futurism Italian movement fl. 1909-15 which sought to glorify the beauty of speed and movement. Exponents inc. Boccioni, Balla, Carrà and Severini. 218, 381

Genre Paintings of scenes from everyday life, the naturalistic style sometimes being complemented by a didactic tendency. Flourished particularly in 17C Holland.

Gothic Term first used during the Renaissance to denote a style that was thought barbaric because it did not derive from classical art. Gothic painting is stylized rather than naturalistic and does not use perspective. Fl. until 15C, and therefore not covered in detail in this book.

Grisaille Painting in tones of grey or neutral greyish colours. Used to produce the effects of sculptural modelling or as a preliminary sketch.

Hard-edge painting Abstract painting in which shapes are executed in flat colour with sharply defined edges.

History painting Themes taken from classical history and mythology and the Bible to convey heroic concepts. After the Renaissance taken to mean painting of contemporary history as well as of the more distant past.

Hudson River School A group of mid-19C US landscape painters, led by Cole, who painted the romantic landscape of the Hudson River valley and of the Catskill Mountains.

Illusionism Technique of creating an illusion of visual reality on a 2-D surface. Methods inc. foreshortening, perspective, *chiaroscuro* and microscopic detail.

Impressionism Major late 19C art movement that sought to analyse the effects of light and produces a spontaneous rather than a calculated impression of an object or scene. Exponents included Monet (the leader), Pissarro and Sisley. Deeply influenced almost every other modern movement in painting. 112

Inpasto The thick application of oil paint often used for Bravura or expressive effect.

International Gothic Late 14C form of Gothic that spread throughout Europe; realistic detail is subordinated to linear pattern and decoration. Notable artists inc. Melchior Broederlam and Gentile da Fabriano.

Jugendstil *see* Art Nouveau

Kinetic art Form of art that relies for its effect on real or apparent movement, created by light, optical illusion or a motor.

Land art/Earth art A 'back to nature' form of art begun in the US in the late 1960s as a reaction against the slick artificiality of Pop or Minimal art. Consists of arrangements of earth mounds, trenches or markings scored into the ground, located in uninhabited areas.

Macchiaioli Literally 'blot' or 'stain', a group of Italian *plein-air* painters, a. mainly in Florence c.1855-65. 185

Maestà Literally 'majesty', used to describe a painting portraying the Virgin and Child enthroned and surrounded by saints or angels.

Manner Method of artistic execution; or the characteristic style of a particular artist.

Mannerism Any distinctive style or technique carried to excess, but more specifically a style that fl. c.1520-c.1600 in Europe characterized by highly sophisticated, elongated figures, irrational use of space, sinuous

rhythms, cold colour harmonies, and disturbing emotional undertones. Artists inc. Michelangelo (late phase), Tinto-retto, El Greco, Giambologna, Bronzino, Parmigianino, Pontormo and Rosso.

Minimalist art US school of painting that rejected the emotionalism and tactile qualities of Abstract Expressionism in the 1960s in favour of the impersonality of geometric arrangements and pure colour and line.

Modello A detailed preliminary painting, drawing or sculpture, generally produced to secure a commission.

Nabis, Les Group of French artists inspired by Gauguin's anti-Impressionistic use of bold outlines and large slabs of flat colour. The artists, inc. Bonnard, Paul Sérusier, Vuillard and Denis, exhibited as a group 1892-99. Little held them together apart from a common dislike of Impressionism ('Nabis' derives from a Hebrew word for 'prophet') and after 1900 they were disbanded.

Naturalism The accurate, objective representation of objects without interpretation or regard to the distorting effects of light.

Nazarenes Group of early 19C German and Austrian painters, w. in Rome, united by their desire to reanimate religious art by turning to medieval and Renaissance models.

Neo-Classicism The mid-18C revival of classical art, a reaction against Baroque and Rococo. The style combined noble simplicity and calm grandeur, best seen in the works of Canova, Houdon, David, Thorvaldsen, Reynolds and Ingres, and lasted until the early 19C.

Neo-Impressionism Pre-Cubist movement that aimed at the 'scientific' development of Impressionism and reacted against its spontaneity by stressing the classical virtues of form and order. Artists inc. Seurat, Signac and Pissarro. *See* Pointillism

Neo-Plasticism Term used by Mondrian to describe his style of pure abstract art which he advocated in the magazine *De Stijl*. Its principles were the use of primary colours, the right-angle and the complete avoidance of elements abstracted from nature.

Neue Sachlichkeit Literally 'new objectivity', a form of Realism developed in Germany in the 1920s and 30s, marked by its strong social comment. Artists inc. Dix and Grosz.

New York School *see* Abstract Expressionism

Op Art A style of art seen as a successor to Constructivism and Neo-Plasticism characterized by hard-edged black and white or coloured patterns and arrangements of shapes and lines to produce an optical illusion of often dazzling and vibrating movement. Artists inc. Albert, Bridget Riley and Vasarély.

Orphism Term coined by the poet Apollinaire in 1912 to describe a short-lived abstract movement founded by the Delaunays, Kupka and the Duchamp brothers. Sometimes called 'Orphic Cubism', it glorified movement and pure colour and tried to soften the harshness of Cubism.

Pastel Stick of dry colour bound with gum, used for both painting and drawing.

Pietà Literally 'pity', applied to a painting or sculpture of the Virgin Mary supporting the dead Christ on her lap.

Plein-air Literally 'open-air', used in the latter half of the 19C to denote painting executed out of doors, or the 'open-air' quality in the painting

itself. Chief exponents were the Barbizon school and the Impressionists.

Pointillism/Divisionism A method of painting in which small dabs of pure colour are applied straight onto the canvas, letting the eye mix them optically and thus producing greater luminosity. The technique was used by some Neo-Impressionists, eg Seurat, Signac and Piasarro. *See* Neo-Impressionism.

Polyptych *see* Altarpiece

Pont-Aven School Painters drawn to and inspired by Gauguin during his stay in Pont-Aven, France, in the 1880s and 90s. Their style was characterized by the use of pure colours and the absence of subtle light effects and naturalistic perspective.

Pop Art Style of art based on the products of the modern consumer society and popular culture (eg soup cans, advertisements). Has its roots in Dadaism and originated in the mid-1950s as a reaction against Abstract Expressionism and 'high art'. Artists inc. Warhol, Lichtenstein and Oldenburg.

Post-Impressionism Term coined by Roger Fry, used to describe painters in Western Europe, esp. France in the late 19C and early 20C, whose work, whilst indebted to Impressionism, reacts against its limitations. Major artists inc. Cézanne, Seurat, Van Gogh and Gauguin. The artists rejected naturalism in different ways: by a more scientific analysis of colour, by an emphasis on purely formal considerations, and by a renewed interest in religious and symbolic themes and in the power of colour and line to express emotion.

Post-Painterly Abstraction Term coined to describe the various styles that developed in the late 1950s and 60s as a reaction against Abstract Expressionism. Common factors are dispassionate, anonymous brushwork (often achieved by pouring on paint), interest in pure colour relationships and an acknowledgement of the painting's two-dimensionality and material quality.

Pre-Raphaelite Brotherhood Group of British painters, formed in 1848, that strove to emulate the simplicity, serious subject matter and moral tone of early Florentine art. Artists inc. Hunt, Millais and Rossetti. The group was disbanded in 1853. 394-5, 399

Primitive Term applied to a highly individualized, often naïve, painting style adopted by painters who are largely self-taught. Also loosely applied to early Italian and Netherlandish painters (ie working before *c.*1450).

Quattrocento Used of 15C Italy and its art.

Rayonnism Semi-abstract style of painting developed in Russia 1911-12 by Mikhail Larionov and Natalya Goncharova, aiming to extend the effect of the work beyond the four-sided frame by projecting rays of colour. Greatly influenced Italian Futurism.

Ready-made *see* Found object

Realism Often used loosely to denote a naturalistic adherence to reality, but more specifically an artistic movement that dominated European art from *c.*1840-70. The artists, inc. Courbet, attempted to represent contemporary reality objectively and without idealization. *Socialist Realism:* an officially sanctioned and socially committed form of naturalistic art in some Socialist countries. *New Realism* or *Nouveau Réalisme:* a 20C term for art which is not merely imitative but seeks to extend the perception and interpretation of

objects into a realm beyond the everyday. *Photo Realism* or *Super Realism*: a style prominent in the USA and England in the late 1960s which aimed to reproduce the physical particularity of an object in an hallucinatory fashion. Used highly finished surfaces and slightly altered proportion and perspective.

Relief (*relievo*) Sculpture that projects from, but is still attached to, a background: high, bas (or low) relief. **Intaglio** carved into the surface.

Renaissance Literally 'rebirth', a term applied to the intellectual and artistic movement, inspired by a rediscovery and reinterpretation of Classical culture, which originated in 14C Italy and eventually became the driving force behind the creative arts throughout much of Europe. In painting and sculpture the tendency was towards a humanist view of the world, with works of naturalistic beauty and grandeur drawing on a new awareness of the laws of mathematical perspective, a scientific study of anatomy and observation of the fall of light. In this humanist atmosphere great secular patrons emerged, such as the Medici family in Florence and François I of France. In Italy the period is divided into Early Renaissance (up to *c.*1500), which includes artists such as Giotto, Duccio and Uccello; the High Renaissance (*c.*1500-30), including Leonardo da Vinci, Michelangelo, Raphael and Titian; and the Late Renaissance (*c.*1530-60), including Correggio, Veronese and Cellini. The Renaissance took some time to spread northwards; Dürer tried to introduce the new style into Germany in the early 16C, but only with Hans Holbein the Younger, working until 1543, and Dutch artists such as Quentin Massys, could the northern

tradition be said to have been assimilated within the Renaissance. England and France, while strongly influenced by the Renaissance in literature and architecture, did not produce any great Renaissance artists. **Rococo** From the French *rocaille,* 'rock-work', a light elegant style adopted mainly by French painters (Watteau, Boucher), and also by Venetian artists (Ricci, Tiepolo).

Romanticism Literary and artistic movement that fl. in Europe *c.*1780-1840. The art is characterized by emotion and imagination, movement, colour, and asymmetry. Artists inc. Delacroix, Géricault, Blake, Turner, Constable, Friedrich and Fuseli. 116

Sacra conversazione Literally 'holy conversation', a representation of the Virgin and Child with Saints where the figures are united in a common action, where previously figures were isolated in separate panels. First developed by Fra Angelico in 15C Italy, used by Bellini.

School Group of artists under the common influence of the same teacher or following the same methods and principles.

Scuola Metafisica Literally 'metaphysical painting', a short-lived, quasi-Surrealist art movement founded in Ferrara in 1917 by de Chirico and Carrà and lasting until 1920. A magical and dream-like effect was achieved by taking ordinary objects out of context and presenting them in incongruous isolation.

Seicento Used of 17C Italy and its art.

Sfumato Literally 'smoke', a method of producing a soft hazy effect by the imperceptible blending of colours.

sinopia In fresco painting this term means a full scale preparatory drawing executed beneath the intonaco, or

penultimate layer of plaster. It takes its name from the reddish brown earth, from Sinope in Asia Minor, which was used for these drawings.

Stijl, De Literally 'the style', an influential Dutch abstract movement in art and architecture following the ideas expounded in the magazine *De Stijl* (founded by Mondrian and Van Doesburg in 1917). Alternatively known as Neo-Plasticism after 1920. 270

Suprematism A pure geometrical abstract art based on the circle, triangle and square. Invented by Malevich in 1913, it greatly influenced Kandinsky and the De Stijl movement.

Surrealism An early 20C movement that aimed to express the inner reality behind external appearance. Devices inc. the irrational juxtaposition of objects, freeing them from their normal associations, automatic writing, etc. in an effort to explore the subconscious. Artists inc. Arp, de Chirico, Dalí, Man Ray, Magritte, Duchamp and Miró.

Symbolism A movement in art and literature that originated in France in the late 19C as a reaction against Realism. Artists were concerned with expressing ideas, subjective emotions and psychological states through form, colour and line, and inc. Puvis de Chavannes, Moreau and Rouault.

Tachism/*Tachisme* Art form in France in early 1950s in which the painter applied paint at random. Known as Abstract Expressionism or Action painting in the USA.

Tempera Paint made with pigments in a medium of egg and water mainly used until the 16C and the discovery of oil medium.

Trecento Used of 14C Italy and its art.

Triptych *see* Altarpiece

Trompe l'œil Literally 'deceive the eye'. Illusionistic effect which uses minute detail to give the appearance of reality.

Veduta Literally 'view', a detailed painting, etching or drawing of an identifiable city, town or place. Canaletto and Guardi are amongst the best-known *vedutisti*.

Vorticism A short-lived English movement, an offshoot of Futurism, formed in 1914 as a reaction against Impressionism – curves, angles and machine-like forms arranged around a vortex characterized the works.

Wanderers, The Russian art movement of the late 19C which sought to bring art to the working classes. 298

Acknowledgements

The author and publishers would like to thank the following people for their generous help in the preparation of this book, ranging from general research to specialized contributions: Sue Bond, Hugh Brigstocke, A. S. Byatt, Ian Chilvers, Michael Davenport, Margaret Drabble, Ted and Susanne Fields, Clare Ford-Wille, Roseanna Hindmarsh, Michael Jacobs, Anthony Langdon, Ava Li, Paul McQuail, Gerald Studdert-Kennedy, Frank Stack, Sue Starks, James Sutton, Jenny Wilson and Sebastian Wormell. We would also like to thank the many tourist offices and embassies who gave us help.

All the illustrations in this book were provided free by the museums concerned, with some institutions being particularly forthcoming. Without their generosity, this book would not have been possible, and it is to be hoped that readers will be inspired to visit cities and museums, and enjoy paintings they might otherwise have missed.

Picture Credits

Front cover: by courtesy of the Spanish Tourist Office, London; Back cover: © The Museum of Fine Arts, Houston, Texas. Gift of Audrey Jones Beck (98.273); Frontispiece: ©RMN/R.G. Ojeda, Musée Bonnat, Bayonne; p. 4 Courtauld Institute Gallery; p. 10 The Frick Collection, New York; pp. 12-3 Musées Strasbourg; p. 14 Estorick Collection of Modern Italian Art524

AUSTRALIA
p. 16 David Daymirringu and Bula'bula Arts, Ramingining, NT/photo Greg Weight (by courtesy of the Museum of Contemporary Art, Sydney)

AUSTRIA
p. 22, 31 © Österreichische Galerie Belvedere, Vienna; p. 25 © Neue Galerie der Stadt Linz; pp. 26-7 © Stift Klosterneuburg p. 32 © Matthius Herrmann Badhausgasse 22-24/3 A-1070 Vienna, by courtesy of the Wiener Secession

BELGIUM
p. 34 © Kunsthistorische Musea, Stad Antwerpen; pp. 36-7, 42-3 © Courtauld Institute Gallery; p. 38 © Baltimore Museum of Art

CANADA
p. 52 © National Gallery of Canada/ photo Stephen Poulin

CZECH REPUBLIC
© National Gallery, Prague

DENMARK
p. 62 © Den Hirschsprungske Samling, Copenhagen/photo Hans Petersen; p. 65 © Nivaagaards Malerisamling, Niva; p. 66 © Louisiana Museum of Modern Art/photo Jens Frederiksen

FINLAND
p. 68 ©Turku Art Museum, Finland; p. 70 © Hvitträsk, Luoma, Finland

FRANCE
p. 72 © Musée Condé, Chantilly/photo Giraudon; p. 75 © The Wallace Collection, London; p. 76 © Musées de Rouen; p. 77 © Städtische Kunsthalle Mannheim; pp. 78-9 © Courtauld Institute Gallery; p. 80 © Musée Rodin, Paris, S. 1304 bronze/photo Jean de Calan; p. 81 © L'Annonciade, Musée de Saint-Tropez; p. 85 © Fondation Maeght/photo François Fernandez; p. 86 © Musée des Beaux-Arts d'Arras; p. 89 © Musée Calvert, Avignon; p. 90 © Musée Bonnat, Bayonne; p. 95 © Musée de Unterlinden, Colmar; pp. 96-7 © Musée des Beaux-Arts de Dijon; p. 99 Langenstein; p. 101 © F. Jaulmes, Musée Fabre, Montpellier; p. 102 © Musée Lorrain, Nancy/photo p. Mignot; p. 105 © Musée des Beaux-Arts, Nantes/Sarkis 1997; p. 107 © Musée Nationale Eugène Delacroix/photo G. Blot; pp. 114-5 © Musée Rodin, Paris, S. 1155/photo Adam Rzepka; pp. 118-9 © Musée des Beaux-Arts, Rouen; p. 120 © L'Annonciade, Musée de Saint-Tropez; p. 121 © Œuvre Notre-Dame, Musées Strasbourg; p. 123 © Musée des Beaux-Arts, Valenciennes

GERMANY
p. 126 © Presseamt Stadt Bonn/photo Michael Sondermann; p. 129 © Staatliche Kunsthalle Karlsruhe; p. 130 © Österreichische Galerie Belvedere, Vienna; p. 131, 145 © Kunstsammlung Nordrhein-Westfalen, Düsseldorf; p. 132 photo © Germanisches Nationalmuseum; pp. 136-7 © Staatliche Museen zu Berlin–Preußischer Kulturbesitz Nationalgalerie/photo Jörg P. Anders, Berlin, 1988; p. 140 © Sammlung Berggruen, Berlin/

Opposite: Woman Descending the Staircase, *Gerhard Richter*
Art Institute of Chicago, Chicago, Illinois

photo Jens Ziehe; p. 147 © Blauel Kunst-Dia, 8035 Gauting; p. 150 © Staatliche Kunsthalle Karlsruhe; p. 155 Städtische Kunsthalle Mannheim/photo Kunsthalle Mannheim, Margita Wickenhäuser; p. 158 photo © Germanisches National-museum; p. 161 © Staatsgalerie Stuttgart

REPUBLIC OF IRELAND
p. 164, 168 © The National Gallery of Ireland; pp. 166-7 © The Estate of Francis Bacon/photo Perry Ogden (Collection Hugh Lane Municipal Gallery of Modern Art, Dublin)

ITALY
p. 170 © Pinacoteca di Brera, Milan/ Ministero per i beni e le attività cultur-ali; p. 173 © Museo di Castelvecchio, Verona; p. 174 Estorick Collection of Modern Italian Art; pp. 176, 176-7, 181 © Accademia Carrara di Belle Arti, Berg-amo; p. 178 © North Carolina Museum of Art; p. 183 © Museo Civico ala Ponzone, Cremona; p. 184 © Palazzo Schifanoia; p. 186-7 © Governing Body, Christ Church, Oxford; pp. 190, 191, 193, 242 © Alexander Fyjis-Walker; p. 195 © Galleria di Palazzo Reale, Genoa; pp. 198-9 © Museo Civico di Palazzo Te, Mantova; p. 201 © Museo di S. Eustorgio; p. 206 © Musei Civici, Padua; p. 207 By kind permission of the Asses-sorato alla Cultura del Commune di Padova – Musei Civici; p. 212-3 © Gilbert Collection; pp. 216-7, 218 © Galleria Nazionale d'Arte Moderna, Rome; pp. 222-3 © Alexander Fyjis-Walker; p. 227 The Art Institute of Chicago: Charles H. and Mary F.S. Worcester Collection, 1964.336; p. 231 © Castello del Buon-consiglio, Trento; pp. 232-3 © Museo Diocesano e Gallerie del Tiepolo, Udine; p. 235 © Archivio della Riserva Naturale Speciale del Sacro Monte di Varallo/photo Marco Genova; pp. 237, 247 © Museo di Castelvecchio, Verona; pp. 238-9 © The Wallace Collection, London; p. 245 Scuola Grande Arcicon-fraternità di San Rocco

MALTA
p. 253 © St John's Museum, Valetta

MEXICO
p. 254, 275 by courtesy of the Mexican Embassy to the United Kingdom

THE NETHERLANDS
pp. 258, 260-1, 268-9 © Rijksmuseum, Amsterdam; p. 262 © Michaelis Collec-tion, Cape Town; p. 263 © National Gallery of Ireland; p. 264 © Glasgow Museums; p. 267 © Museum het Rembrandthuis Amsterdam; p. 270 © Van Gogh Museum/photo Jannes Linders; p. 272 © Groninger Museum, Groningen; pp. 274-5 © Stedeliijk Museum de Lakenhal; p. 277 © Collec-tie Stedelijk Museum de Lakenhal Oude Singel 28-32, 2312 RA Leiden/dia na gebruik retour s.v.p.

NEW ZEALAND
pp. 280, 282, © Auckland Art Gallery Toi o Tamaki; p. 283 ©Mackelvie Collec-tion Auckland Art Gallery Toi o Tamaki

NORWAY
p. 284 © Vigeland-Museet, Oslo

PORTUGAL
pp. 292, 295 © Museu Nacional de Arte Antiga, Lisbon

RUSSIA
p. 296 by courtesy of Sue Bond Public Relations

SOUTH AFRICA
p. 302 © Johannesburg Art Gallery; pp. 304, 305 © Michaelis Collection, Cape Town

SPAIN
p. 306 © Museo Nacional de Escultura, Valladolid; pp. 308-9 © Museo de la Real Academia de Belles Artes de San Fernando; p. 310 © Museu Nacional d'Art de Catalunya, Barcelona; pp. 311, 312, 319, 322-3 by courtesy of the Span-ish Tourist Office; pp. 315, 327 © Alexander Fyjis-Walker; p. 316 © Museo de Arte Abstracto Español de Cuenca; p. 317 © Fundació Gala-Salvador Dalí 2000; 324 © Museo Thyssen-Bornemisza, Madrid; p. 328 by courtesy of the Art Institute of Chicago, Michigan; p. 331 © Museo Nacional de Escultura, Valladolid

PICTURE CREDITS

SWEDEN
p. 332 © Göteborgs Kontsmuseum, GKMF67; pp. 334-5 © Göteborgs Kontsmuseum, GKM975; p. 336 © Prins Eugens Waldemarsudde, Stockholm

SWITZERLAND
p. 338 © Kunstmuseum, Solothurn; p. 341 © Kunstmuseum, Bern; pp. 344-5 © Sammlung Oskar Reinhart 'Am Römerholz', Winterthur; p. 346 © Stiftung Sammlung E. G. Bührle/photo Dräyer, Zürich

UK
pp. 348, 359 © Towneley Hall Art Gallery & Museum, Burnley; pp. 350-1 by courtesy of the Trustees of the St John Soane's Mueum; p. 353 © Gilbert Collection; pp. 354, 355, 389 by courtesy of the Tate Gallery, London; p. 356 © Holburne Museum of Art, Bath; p. 358 © The Barber Institute of Fine Arts, The University of Birmingham; pp. 360-1 © The Fitzwilliam Museum, University of Cambridge; p. 362 by courtesy of Kettle's Yard, University of Cambridge; p. 363 © National Museum of Wales, Cardiff; p. 364 © 1998 Derby Museum & art Gallery; p. 366 © Glasgow Museums: The Burrell Collection; pp. 386-9, 370 © Glasgow Museums; p. 371 © Hunterian Art Gallery, University of Glasgow; p. 372 © University of Hull Art Collection; p. 375 © Apsley House, London; pp. 376-7 © Courtauld Institute Library; pp. 378-9 by permission of the Trustees of Dulwich Picture Gallery; p. 380 © Estorick Collection od Modern Italian Art; p. 381 © Gilbert Collection; p. 386 © Martin Charles, Sir John Soane's Museum; p. 388, 402-3 © Alexander Fyjis-Walker; p. 390 by courtesy of the Board of Trustees of the Victoria & Albert Museum, London; p. 391 © The Wallace Collection, London; pp. 392-3 by courtesy of the British Museum, London; pp. 394-5 © Laus Veneris, Laing Art Gallery, Newcastle upon Tyne; p. 398 © Christ Church, Oxford; p. 399 © Tate Gallery St Ives; pp. 400-1 © Tate Gallery; pp. 405, 409 © Devonshire Collection, Chatsworth. By kind permission of the Duke of Devonshire and the Chatsworth Settlement Trustees; pp. 406-7 © The National Trust, Waddesdon Manor/ photo Pru Cuming Associates 1993; p. 410 © National Trust/photo Geoff Hamilton (Petworth House); p. 412 © Wilton Estate/photo Ian Jackson

USA
p. 414 © Pennsylvania Academy of the Fine Arts. Gift of Mrs Sarah Harrison; pp. 416-417 © Pennsylvania Academy of the Fine Arts; pp. 418, 463, 496 © North Carolina Museum of Art; pp. 419, 472-3 © Smithsonian American Art Museum; p. 420 © The Art Institute of Chicago: Robert A. Waller Fund, 1910.2; pp. 421, 424 © Smithsonian American Art Museum; pp. 422-3 © Neuberger Museum of Art; p. 425 © Museum of Contemporary Art, Chicago; p. 427 © Jack S. Blanton Museum of Art; p. 428 © Baltimore Museum of Art BMA 1950.260; p. 432 © The Art Institute of Chicago: Gift of Mrs Gilbert W. Chapman, in memory of Charles B. Godspeed, 1948.561; p. 435 © Collection Museum of Contemporary Art, Chicago. Gift of Susan and Lewis Manilow; p. 436 © Taft Museum of Art, Cincinnati; p. 439 © Hill-stead Museum, Farmington, CT; pp. 440-1 © The Museum of Fine Arts, Houston. The Edith A. and Percy S. Straus Collection (44.550); p. 442 © The Mencil Collection, Houston; p443 © The Menil Collection/photo Hickey-Robertson, Houston; p. 447 © Yale Center for British Art/photo Richard Caspole; pp. 448-9 © New Orleans Museum of Art; pp. 451, 452 © The Frick Collection, New York; p. 458 © Allen Memorial Art Museum, Oberlin College, Ohio; p. 462 © Neuberger Museum of Art; p. 465 © San Diego Museum of Art

A-Z OF ARTISTS/SELECTIVE INDEX
p. 476 © Auckland Art Gallery Toi o Tamaki

GLOSSARY
p. 514 © The Trustees of the Wallace Collection, London;

PICTURE CREDITS
p. 524 © Art Institute of Chicago

Front cover: Detail of *Marquesa de Llano,*
Anton Raphael Mengs, Museo de la Real Academia de
Bellas Artes de San Fernando, Madrid, Spain
Back cover: *The Orange Trees*, Gustave Caillebotte,
The Museum of Fine Arts, Houston, Texas, USA
Picture on this page: *Head of a Young Woman*, Luca della Robbia,
Museo Nazionale (Bargello), Florence, Italy

Text copyright © Helen Langdon 2002
The moral right of the author has been asserted

First published as
The Mitchell Beazley Pocket Art Gallery Guide, 1981
This edition, completely revised and updated with additional
material and new illustrations, published 2002 by:
Pallas Athene (Publishers) Ltd
59 Linden Gardens
London W2 4HJ
WWW.PALLASATHENE.CO.UK

Editor: Alexander Fyjis-Walker
Assistants: Jenny Wilson, Ava Li
and Sebastian Wormell
Design Consultant: James Sutton

ISBN 1 873429 46 0

Printed in Slovenia